Forts and Palaces of India

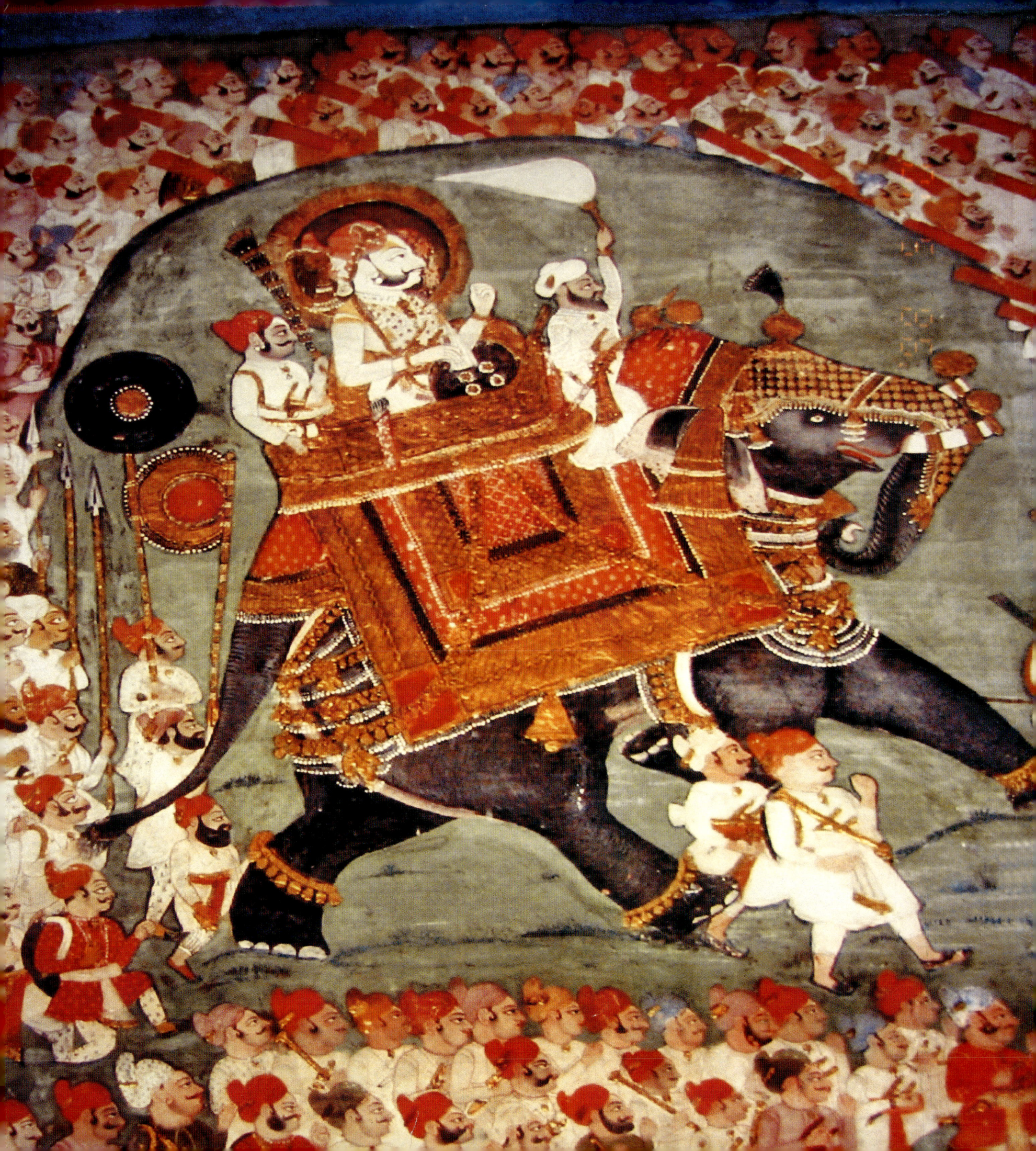

Forts and Palaces of India

Text and Photographs
DR. SURENDRA SAHAI

PRAKASH BOOKS

ACKNOWLEDGEMENT

Writing on a subject which requires so much of research and extensive travel has been a daunting task, and I am thankful to Mr. Ashwani Sabharwal, MD Prakash Books for entrusting me with the assignment and for his confidence in my capability to complete it. I am also thankful to Mr. Wanshai Shynret, Mr Munish Tamang, Ms. Toya Sinha, my colleagues at Motilal Nehru College and to Ms. Amar Jit of the History Department at Mata Sundri College for offering their suggestions.

My wife Ms. Meenakshi Sahai deserves thanks for her patience and the fortitude with which she accompanied me on my journeys throughout the country.

Reprint 2018 by
Prakash Books India Pvt. Ltd.
1, Ansari Road, Daryaganj
New Delhi-110002, India
Phone:+ 91 11 2324 7062-65
Fax:+ 91 11 2324 6975
sales@prakashbooks.com
www.prakashbooks.com

© 2011 Prakash Books India (P) Ltd

Book Design by Supriya Sahai

All Rights Reserved
No Part of this publication may be reproduced or transmitted in any form by any means without prior written permission of the publisher

ISBN : 978 81 7234 179 4

Printed and Bound in India

Additional Photo Credits:
Images for Falaknuma Palace, Hyderabad,
by D Ravinder Reddy (pp 190-193)
Images for Kapurthala Palace
by Ayesha Sarkar (pp 236-241)
Paintings on Delhi, from DELHIE BOOK, a set
of paintings on Delhi monuments commissioned
by Sir Thomas Metcalfe in the 1840s, courtesy
The Golden Calm (pp 32)
Mughal Miniatures courtesy
Victoria & Albert Museum, London (pp 90, 128, 151)
Portrait of Shahjahan, courtesy
Windsor Palace Library (pp 135)
Images on (pp 72, 73 top, 242–247)
from Dinodia photo library.
Images on (pp 248–249)
from photoindia.com

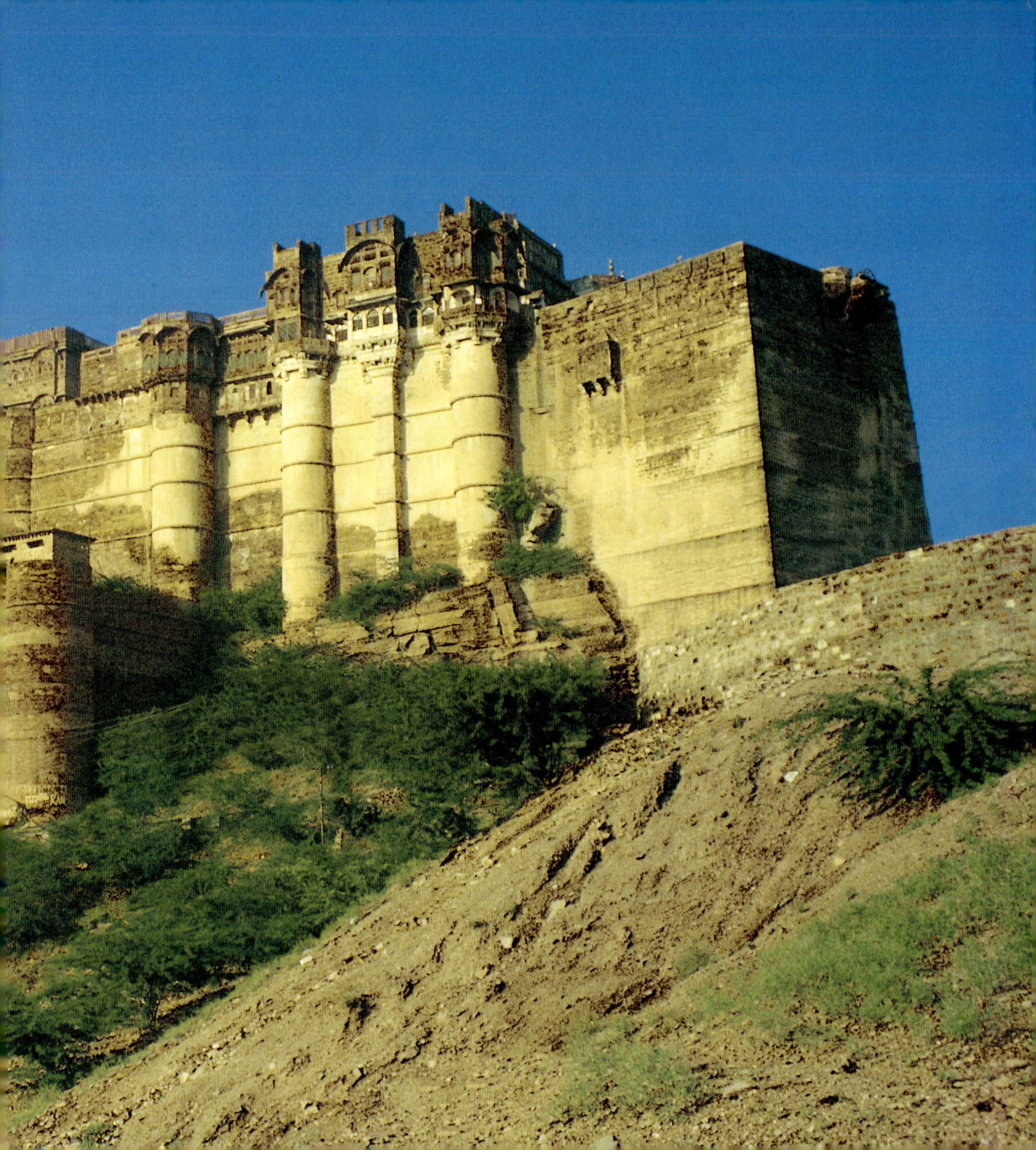

CONTENTS

INTRODUCTION	9
DELHI	23
JAIPUR, AMBER AND SAMODE	42
JODHPUR	61
JAISALMER	74
UDAIPUR	83
CHITTAURGARH	93
BIKANER	99
BUNDI	108
KOTA	118
RANTHAMBORE	126
AGRA AND FATEHPUR SIKRI	133

GWALIOR	149	MYSORE	194	KAPURTHALA	237
MANDU	158	MADURAI	200	VADODARA, WANKANER AND MORVI	243
ORCHHA	167	VIJAYANAGARA	206		
KALINJAR	175	GULBARGA AND BIDAR	215	COOCH BEHAR	248
GARHKUNDAR	185	GOLCONDA	223	glossary and bibliography	250
HYDERABAD	190	PATIALA	228		

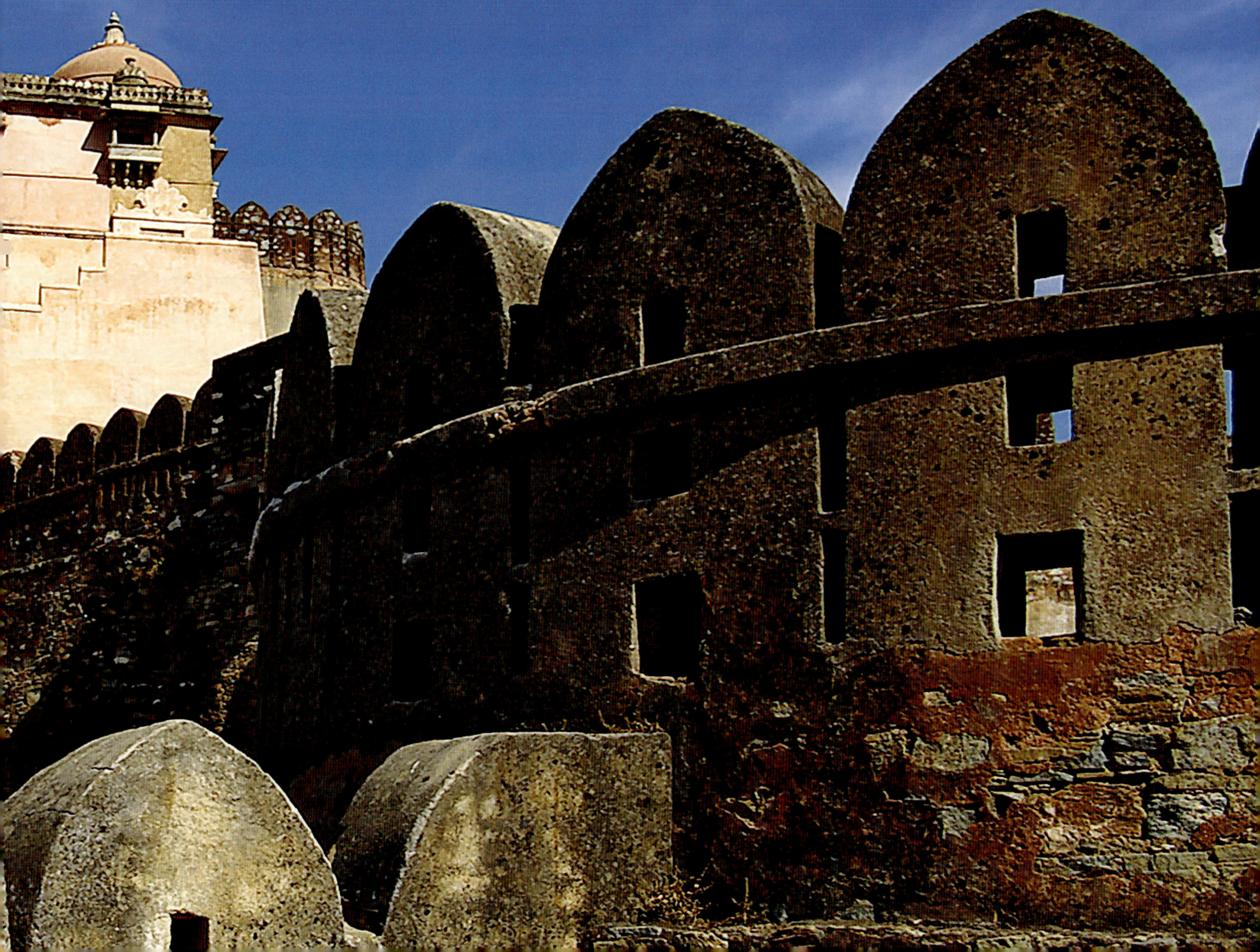

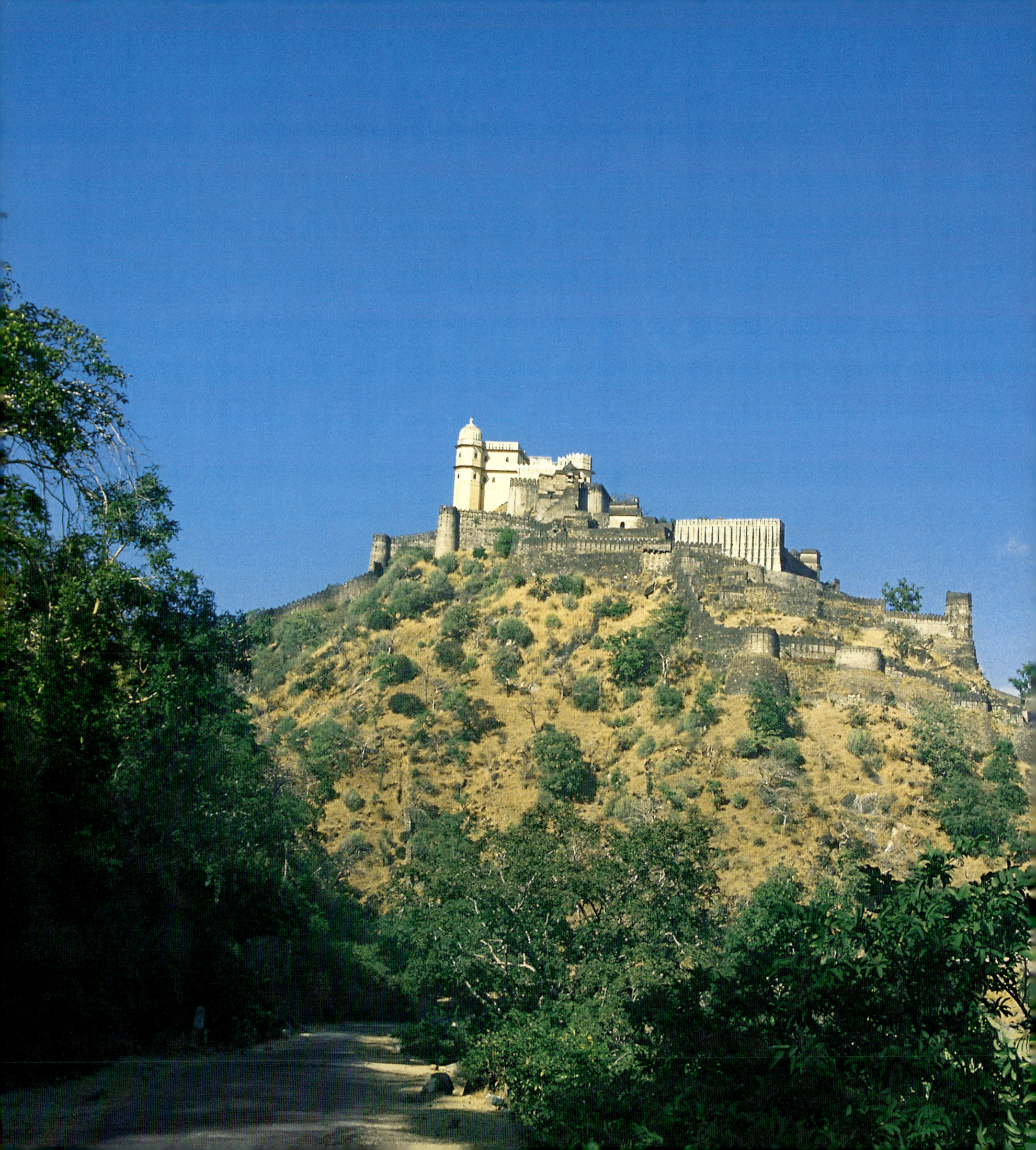

INTRODUCTION

The need for security and defence of human settlements and kingdoms has, since the earliest times, led to the building of protective boundaries, strong fortifications and forts big and small, where the treasures of the state were kept safely, providing at the same time a well defended haven to the ruler and his family. The instinctive human desire to decorate one's dwellings and to embellish these with objects of luxury to match their social status, gradually transformed these rudimentary, functional structures into glorious palaces. The history of forts and palaces in India follows the socio-economic developments since ancient times. The ruins of the major cities of the Indus-Valley like Mohenjo-Daro and Harappa clearly indicate the importance of a well-knit housing complex dotted with some large houses, indicating the embryonic form of the forts and palaces.

Summing up the wisdom of centuries of work preceding his times, Kautilya, author of The Arthashastra, stipulates the building of the capital, "in the center of the country. The site (or the capital) shall be chosen by experts in the science of building and be naturally best fitted for the purpose- (for example) at the confluence of rivers or near a perennial lake; near an artificial (round, rectangular or square in shape, depending on the nature of the land) with canals to fill it. The palace shall be well served by both land and water trade routes and (be capable of being) a market town". The importance of an unassailable fort has never been doubted: "It is in the fort that the treasury and the army are safely kept, and it is from the fort that secret war (intrigue) control over one's partisans, the upkeep of the army, the reception of allies and the driving out of the enemies and of the wild tribes are successfully practised. In the absence of forts, the treasury is exposed to the enemy, for it seems that for those who own forts, there is no destruction".

Most of the ancient sacred texts on architecture, the vastushastras, have classified forts into various categories, each of which is built to meet various strategic considerations and availability of natural resources, most importantly rivers, lakes and wells with a perennial water supply. Traditionally, forts have been classified under six categories, a classification accepted by Manu, Kautilya and vastushastras with little variation: 1. Mahidurga; 2. Abdurga and Jaladurga; 3. Vanadurga or Varksyadurga; 4. Nrudurga or Baladurga; 5. Giridurga; and 6. Dhanudurga.

Mahidurga is the fort made of earthen ramparts and fortification walls. This is one of the most rudimentary foundations for a fort which is primarily meant to protect the habitation against the enemy and wild animals. Such forts have the same structural elements as the other forts. It is their construction in mud and brick which distinguishes them, built in regions where stone is in short supply or where the fort has to be built in a very short time. Such forts have been built in various parts of the country. The last important mud fort or Mahidurga was Badalgarh-the fort built by Sikandar Lodi in Agra on whose foundations Akbar built the Red Fort in the 16th century CE.

The Abudurga and Jaldurga are forts provided with a natural defence by the surrounding rivers or lakes. Crossing the river in spate would always be difficult and the enemy was forced to wait for a fall in the water level. The availability of a perennial supply of water enabled the occupants of the fort to continue a long resistance against a siege by the enemy. The Jaldurga is difficult to conquer and has its advantage over a fort built on ground level. But it can be reached through bridges of boats or even elephants lined in a row. Once the roads connecting a Jaldurga with the land are cut off, it loses its contact with the world outside, and, denied renewed supplies of arms and food, soon surrenders to the

The fort at Kumbalgarh, near Udaipur, Rajasthan

*Previous pages:
Close-up wall of the Kumbalgarh fort*

enemy. The fort of Gagron in the Jhalawad district of Rajasthan is the most splendid example of a fort of this kind. The other great Jaldurga is Janjira, the strongest marine fort in the country. It was built by the Abyssinians in 1511 CE on an island south of Alibagh (Mumbai).

The Vanadurga is a fort built in the heart of a forest and functions as a retreat. Ranthambore in the Sawai Madhopur district of Rajasthan best illustrates the features of a Vanadurga. For miles the hill, crowned by this impregnable fort, is covered with a dense forest (now a Tiger Reserve) and remains obscured from view till one reaches the steps ascending to the fort. Mandu in Madhya Pradesh is built over a hill-top covered with a rich forest and ample water sources.

Nrudurga or Baladurga is the type of fort defended by a four-fold army employing elephants, horses, charitos and infantry. In fact, forts in this category are built on the ground level where the onus of defence lies with the garrison stationed within. A considerable portion of the fort area is occupied by soldiers and the stores for arms and ammunitions too remain in a state of preparedness to meet a sudden attack. The most representative example of this category of forts are the Mughal forts at Agra, Delhi and Allahabad. Without the advantage of a hill top location, these forts exploit the natural advantage of the river flowing under the bulwark on the eastern side and wide moats fed by river water, girdling the gigantic structures on the remaining sides. These forts function as mini cities with all provisions for daily necessities made available within the walls. There are well-stocked markets and *karkhanas* (manufacturing units) for carpets etc, gardens and even separate residential accommodation for the harem. The movement of the soldiers is facilitated by a network of roads and secret passages to be used as escape routes under extreme circumstances. In fact, it is well known that most of the medieval forts had a great many underground chambers, some even used for hanging offenders of various kinds to death. The basement chambers below Rana Kumbha's palace at Chittaur are believed to have been the site of *jauhar* (self-immolation) by the legendary beauty Padmini in the 14th century and few have been able to explore the extent of underground construction at Garhkundar which supposedly housed several units of the army and harem quarters. Today, these basement dark chambers are full of bats, wild hyenas and sinister tales of murder and retribution.

It has been mentioned in the Agni Purana that the forepart of the fortification of a city should be in the form of a bow and that the palaces built on the riverfront should be in the shape of bow-string i.e. a straight line. This is called the Dhanudurga. Both the forts; at Agra built by Akbar and at Delhi built by Shahjahan follow these outlines, perhaps in a tacit tribute to the formidable Indian tradition of architecture.

The Desert fort forms a special category of its own. It is built in a terrain surrounded by a harsh, parched landscape without any source of perennial water supply. It is inaccessible because of the extreme unrelenting heat. The forts in the western part of Rajasthan-Bikaner, Jaisalmer, Pokharan and Nagaur have only recently been drawn closer by trade and civilization.

Giridurga or the mountain fort on the crest of a high hill is the most difficult to conquer, since the unapproachable terrain surrounding it presents tremendous obstacles to the approaching enemy. The fort remains in view from far distances. The defenders of the fort can watch over any movement of the enemy troops through the countryside cleared of all thick vegetation and forests. The great forts in northern India- Gwalior, Chittaur Mehrangarh, Jodhpur, Kumbhalgarh, Mehrangarh and Mandalgarh exploit the tremendous advantages of location on a high top. In Indian mythology gods dwell on high mountain tops and for this reason too these hill forts acquire a certain aura of greatness.

Below, from left:
Gagron fort, near Jhalawar, Rajasthan;
Ranthambore fort, Rajasthan

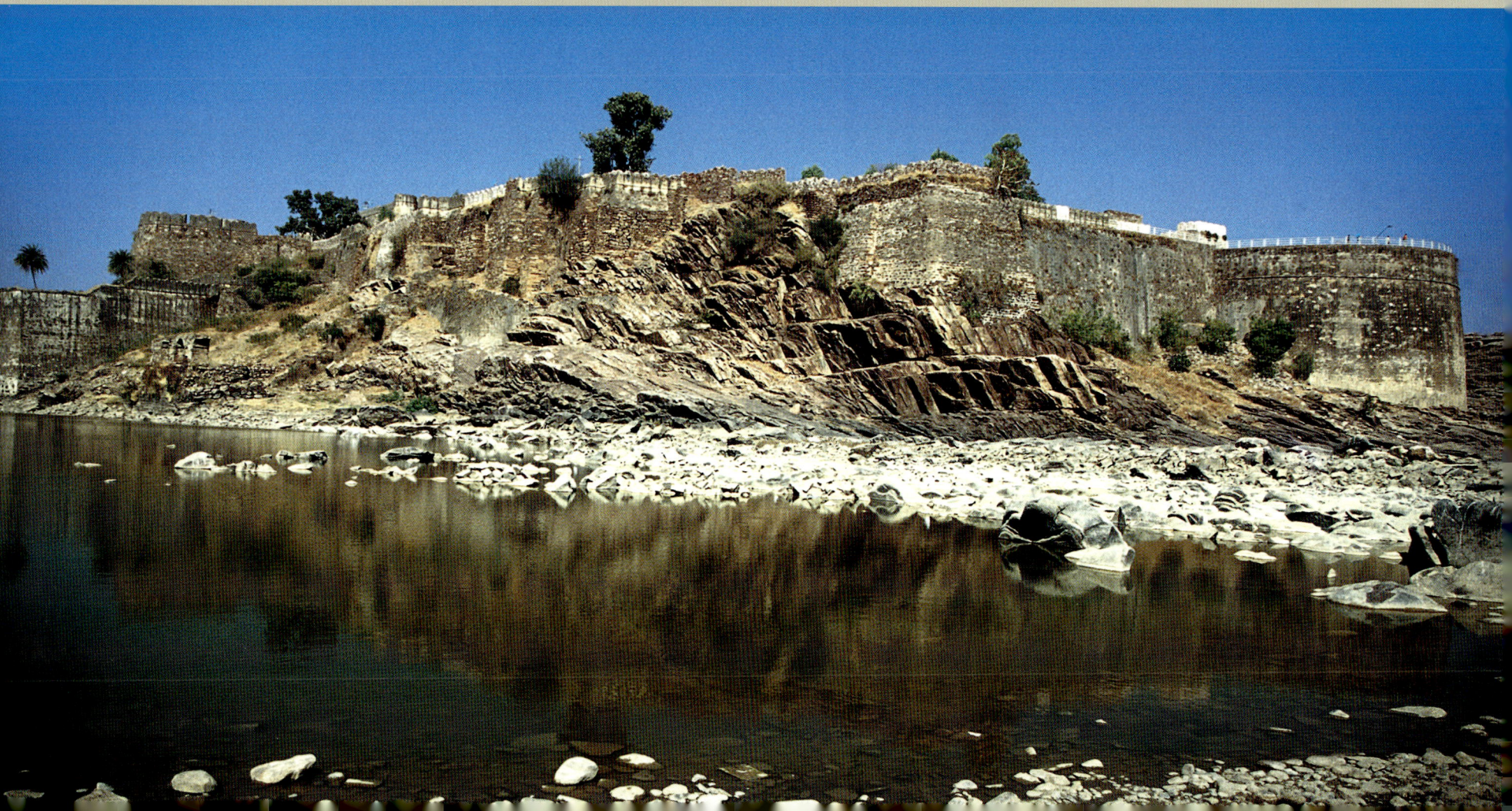

The building of a great fort has always been regarded as of paramount importance. Indian scriptures and classics only state a time-tested maxim that a small garrison of soldiers hidden behind the curtain of ramparts can harass large contingents of invaders pounding on the walls from outside. Most of the great battles of the Mughal armies against Rajput rulers resulted in protracted sieges for this simple reason. Scaling the high fortifications was an extremely daunting task and only clever military strategists could provide a solution to the challenge. Alauddin Khilji resorted to deceit to gain entry into the Chittaur fort. Akbar built concealed passages (*sabat*) under the shadow of the ramparts and could fire into the fort only after he had raised the level of the hill adjoining a corner of the Chittaur fort. At Ranthambore; another impregnable Rajput fortress perched on top of a high rocky prominence abruptly rising out of the level land; the ditches skirting the rocky base of the fort had to be filled up with sand bags so that ramps could be built for carrying guns to the top. Only a strong Giridurga or hill fort has this advantage of holding on for long against the most formidable enemy armies.

The shilpashastras have elaborately dealt with the nature of fortifications, requirements of the ruler and, most importantly, security and defence of the fort. The Arthashastra of Kautilya provides crucial information on various aspects of constructing a fort.

The first most important consideration in starting the process of construction is the laying down of strong foundations. These foundations are dug deep into the ground and the earth removed can be used for raising the ground level within the enclosed area. Sometimes the foundations are dug up and left open to the elements for a season or two so that the base acquires firmness and does not sink when the heavy rampart walls are built over it. An interesting story relates to the building of the Red Fort in Delhi by Shahjahan in 1639 CE. The two architects' incharge of the construction had the foundations dug up and then left the scene. When they returned to resume work after a year they explained that they had not abandoned work or run away but simply allowed the freshly dug up earth to settle down under rains and gain firmness to prevent further sinking. It was absolutely necessary since the mammtoh rampart walls required a base solid as a rock.

The moats surrounding the rampart walls are generally filled up with water and covered with thick vegetation as a camouflage. These moats also function as nurseries for crocodiles. The enemy soldiers trying to reach the ramparts are compelled to negotiate the deep water-filled moats. The moat at the bttoom of the inner citadel at Daulatabad is reported to have been particularly noteworthy for its scarped flanks and a large population of treacherous crocodiles. The triple moats around the Bidar fort are found to be extremely useful as part of the city's drainage system.

The ramparts on the fort wall indicate the strength of the fort. The shilpashastras provide detailed prescriptions for the construction of ramparts. The walls have a splayed base, thickest at the bttoom, decreasing in width with the rise of the ramparts. The ramparts are subjected to elephant attacks and gun powder, hence utmost care is taken to build them as resistant to extreme pounding. Frequently animals like lions, horses and elephants are depicted on the ramparts in relief carving or murals. Sometimes warriors with swords are also painted on the ramparts. The upper portions of the ramparts are generally built like battlements which provide cover to the defending soldiers who patrol the area. The rampart walls have sometimes inbuilt wide passages to facilitate movement of mounted soldiers swiftly shifting guard from one corner to another. The embrasures on the wall let in light and air and are also used to keep an eye on the world outside. The ruins of Alauddin

Clockwise from top:
Moat at Daulatabad fort; Hiran Minar at Fatehpur Sikri, Watchtower at Vijayanagar; Hathi Pol, Gwalior fort; Watchtower, Sultanate period, near the Qutb Minar, Delhi; Double defence walls at Siri fort, Delhi

Khilji's rampart walls at Siri have exposed wide tunnel-like passages running through the entire length of the outer double walls. The Purana Qila in Delhi, built by Humayan, also has similar-Quila provisions for movement of troops within the outer double walls.

Bastions are a very important feature of the fort architecture. The exterior wall of the fort is interspersed at regular distances by well formed bastions, sometimes crowned with ornamental pavilions. Bastions not only provide stability and strength to the massive wall structures but also add considerable charm to the monotony of the stone or brick-faced walls. The fort at Jaisalmer is particularly noteworthy for its 99 bastions on the exterior wall. These bastions are large enough to provide accommodation to troops of guards. Also some bastions have staircases and ramps for mounting guns. At the Mughal forts the exterior walls are mostly straight, hence the number of bastions is relatively small as compared to some forts in Rajasthan where every turn of the wall, following the contours of the hill, has a bastion and is generally crowned with a chattri from where the guards kept their vigil over the surrounding area.

Kautilya also mentions in some detail the construction of a parapet "of height between 18 and 36 feet and breadth half its height…on top of the rampart, with stone or bricks; on no account shall it be made of wood for in it fire finds a happy home. Along the rampart, there shall be turrets and between every two turrets, a square tower. Between each tower and turret, a high wooden board with holes and covers shall be erected big enough for three archers (to defend the ramparts using the board as protection). In between these structures there shall be strong wooden planks projecting outwards (to make boarding difficult). Paths for soldiers to go out on attacks, an escape and an exit door shall also be built in an unassailable part of the rampart. Various defence structures (such as speed breakers and concealed traps) shall be made outside the ramparts (in order to obstruct the movement of an attacking force)". The

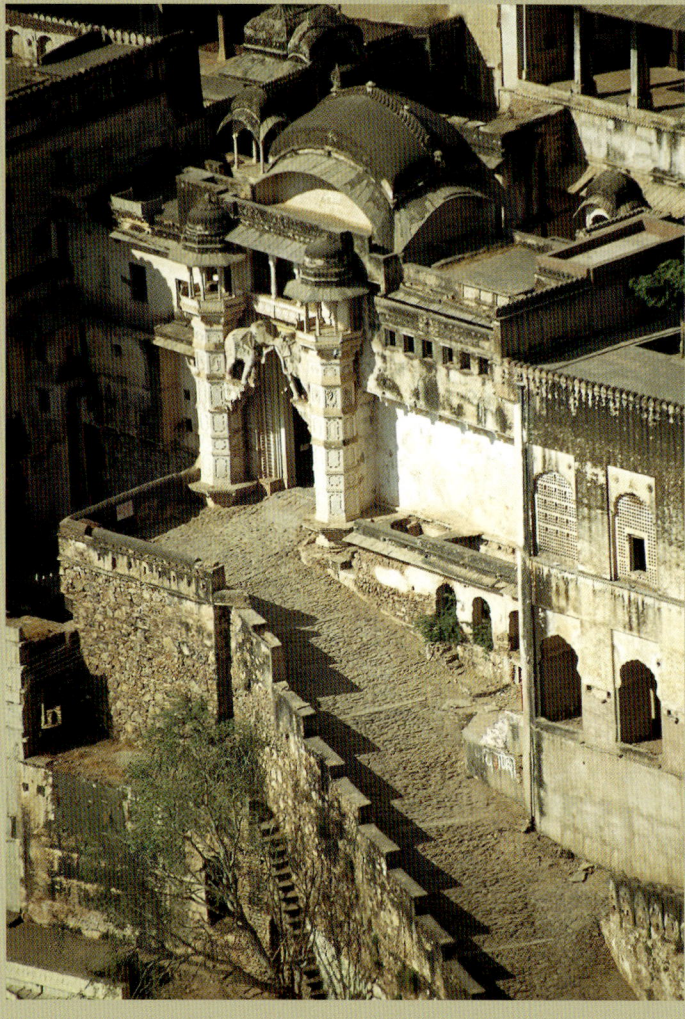

Clockwise from left:
Hathi Pol at Bundi fort; Relief at Sanchi, depicting a royal procession passing under a gateway

security of the forts was scrupulously maintained in Rajput forts and palaces by provisions of look out stations sited at the summit of towers, sometimes projecting outwards from the immense walls.

The Jaigarh fort at Amber (Jaipur) has the tallest watch tower which provides a bird's eye view over the extensive territory surrounding the fort and palaces lying below in the foothills.

The *chattris* not only add a picturesque quality to the grim walls but also serve as stations for relaying messages to guards on the ramparts. Fatehpur Sikri has a watch tower, Hiran Minar, standing away from the Hathi Pol. The tower stands in a low lying area. It is constructed over a high platform and has a built-in staircase. Vijaynagara or Hampi has square staircase towers with spacious pavilions at the top to guard the palace area containing the Lotus Mahal. The palace area at Thanjavur has a huge square staircase tower with multiple tiers of open arcades.

The most striking structural feature of the outer wall is the gateway, the main entry to the fort. There are also many smaller gates for various other functions. As commonly observed, the structure of a gateway consists chiefly of two massive bastions joined by a beam or an arch over which are built the upper storeys for the purpose of defence. The arched openings provide a greater facility for elephant processions because it was customary for the ruler to descend from the canopied *howda* on the elephant only at the palace portal. The spectacular elephant processions have always been part of the royal magnificence. The gateway is not so much an example of architectural splendour as it is a solid and formidable structure concerned at all times with the security of the fort. There are usually a number of storeys built over the arched entrance, and the passage is flanked by arcaded chambers for the guards and soldiers. The identity of each visitor is carefully scrutinized before he is admitted into the fort. These gateways have doors made of thick solid

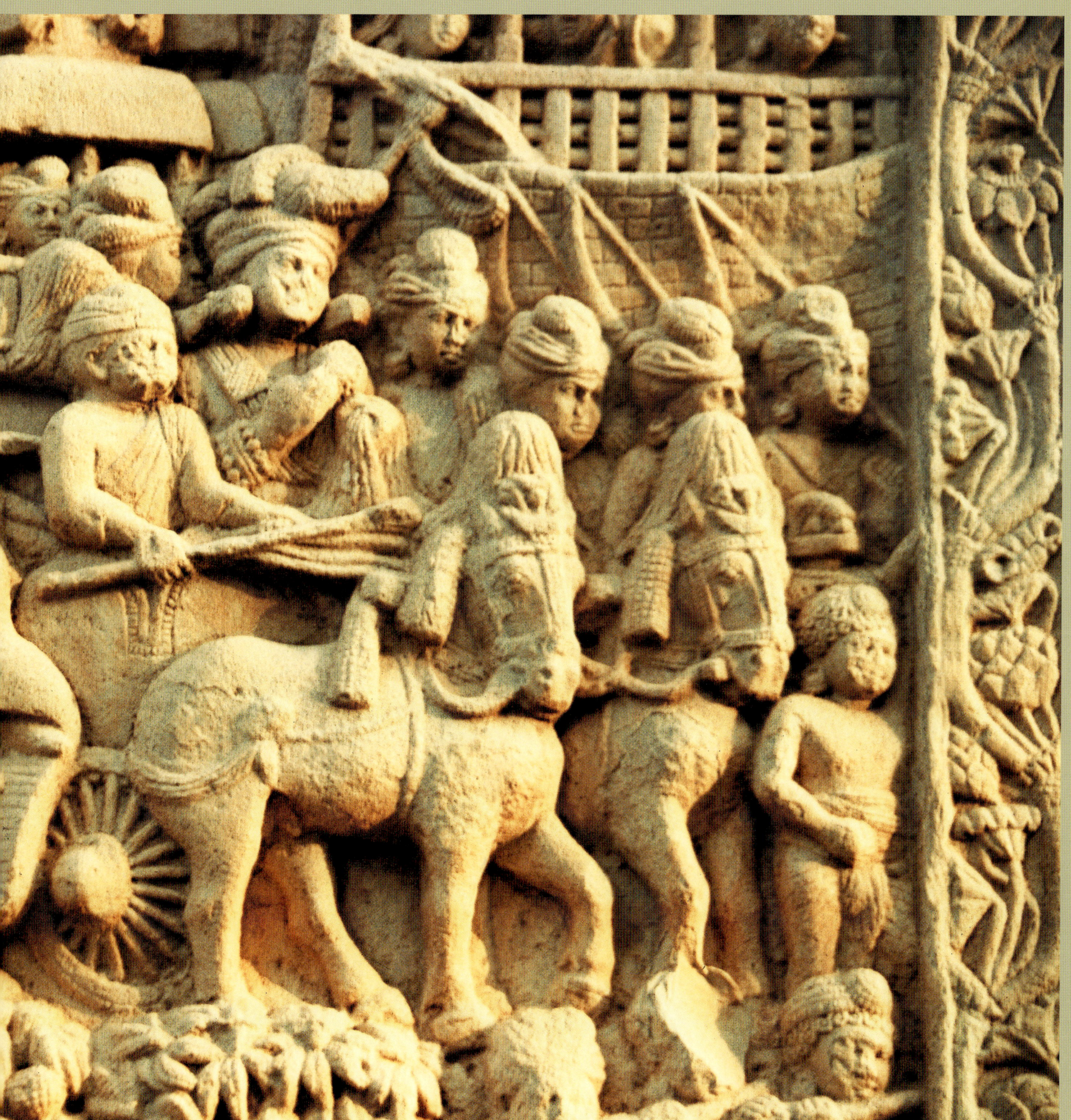

wood studded with elephant spikes. There is, however, a small window on the door to regulate the entry of only one person at a time. The visitor can enter only after bending his neck in a gesture of submission and, if so required, can easily fall under the sword of the guards positioned inside.

The grand entrance gateways are sometimes flanked by large elephant statues. Elephants, in the Indian context, are held as symbols of royal strength and stability. The elephant statue at the Gwalior fort was noticed for its grandeur but was destroyed after the Mughal conquest of the fort. Akbar was so impressed by the courage and valour of two Rajput warriors-Jaimal and Patta of Chittaur that he set up two elephant statues mounted by these heroes at the northern gateway of the Red Fort at Agra. Also, at Fatehpur Sikri, Akbar had two sculptures of elephants on both sides of the gateway called Hathi Pol near the Hiran Minar.

Shahjahan also had two gigantic elephant statues placed on both sides of the southern gateway of his fort at Delhi. These great symbols of royalty were destroyed by Aurangzeb, the sixth Mughal emperor, whose iconoclastic zeal tolerated no such depictions. However, at the Rajput forts and palaces, elephant statues are accorded great honour. At the palace gateway at Bundi and Kota, elephant statues are placed over the spandrel of the Central arch. At Bikaner, two huge elephant statues border the Suraj Pol. At Orcha, small elephant statues are placed under canopies on both sides of the gateway at the Jahangir Mahal. In Rajasthan the depiction of fully armed soldiers on horsebacks and elephants is a ubiquitous part of the traditional mural decorations.

At forts which are girdled by moats, a drawbridge provides the passage to the gateway. During difficult times the wooden planks wee raised and the enemy denied an easy access across the may which could also be flooded suddenly. The central gateway is often defended by a barbican, which functions as a certain obscuring from view the goings-on at the gate. Aurangzeb had such barbicans built in front of Shahjahan's Red Fort in Delhi to make it look in the latter's opinion like the veiled face of a bride. Sometimes there are a series of smaller gateways each approached after a sharp and blind turn to thwart sudden thrust of invaders and provide an effective obstacle to the elephants at head of an army. Another architectural feature designed specially to check the speeding invaders, is the steep ramp. Most of the Rajput palaces have these ramps which have to be crossed before reaching the palace area. Mehrangarh, Kumbhalgarh, Mandalgarh, Jaigarh, Bundi and many other Rajput forts have these ramps and sharp bends. The Red Fort in Agra also has a ramp which clearly indicates the part it has played in the defence of the fort.

Besides the lofty and magnificent gateways built on the exterior wall of the fort, there are numerous small gateways on the boundary walls around the capital. Since medieval times, these gateways have been named after the cities towards which they open. Most of the outer city walls in Rajasthan and even in southern India have a Delhi Gate, pointing toward the imperial capital in northern India.

PALACE ARCHITECTURE

The beginnings of palace architecture in India are wrapped in the mist of time. It is a commonly held view that a palace occupied by the chief of the community or the ruler of the kingdom is built within the fortified area. However, no palace ruins have been traceable at the sites of Mohenjo-Daro and Harrapa and our impressions about the architecture of the earliest palaces are based chiefly on the literary sources; the two great epics-the Ramayana and the Mahabharata. In the Ramayana the city of Ayodhya has been extolled for "the gold-plated high-rise palaces of the city (which) were studded with varied jewels and secret chambers and looked like mountains. The whole city was comparable with Indra's Amaravati". (Balkanda, Chapter 5). Also, the city of Lanka, ruled by the demon king Ravana, is described as a city of splendour: "That great city was also protected by gold-plated massive walls and white-coloured high roads. Hundreds of high-rise buildings with flags fluttering on their roof tops enhanced the glory of the city. Hanuman, the great monkey, felt as if the celestial city of lanka built by the divine architect Vishvakarma and protected by the king of *rakshasas* was floating in the sky. His imagination knew no bounds and he envisioned this divine creation in the form of a beautiful damsel...." (Sundarakand, Chapter 3). The Mahabharata also mentions the great palaces at Indraprastha, the newly founded capital of the Pandava brothers. In the absence of archaeological evidence supporting the existing of such grand edifices at such early dates, these cities and palaces appear creations of poetical minds.

Some indication of palace architecture is provided by their depiction on the relief carvings at Sanchi and Bharhut. The Sanchi reliefs show high-walled structures with only a few small windows at high levels admitting light and air but no view of the streets outside. The upper floors of these close-knit structures show balconies with railings high enough to show only heads of those sitting inside watching the street scenes outside and horse-shoe shaped, gabled forms of roofs. The streets and the houses are secured by watch towers and the gateways are splendid examples of contemporary architecture-double storeyed structures in the trabeate style The panel depicting Buddha's return to Kapilavastu on the northern gateway shows a city with massive walls, topped by battlements and picturesque balconies with railings and surmounted by barrel vaulted structures terminating in *chaitya* windows. On other reliefs are also seen a moat with a palisade or railing from the Vedic period. These architectural depictions are apparently based on

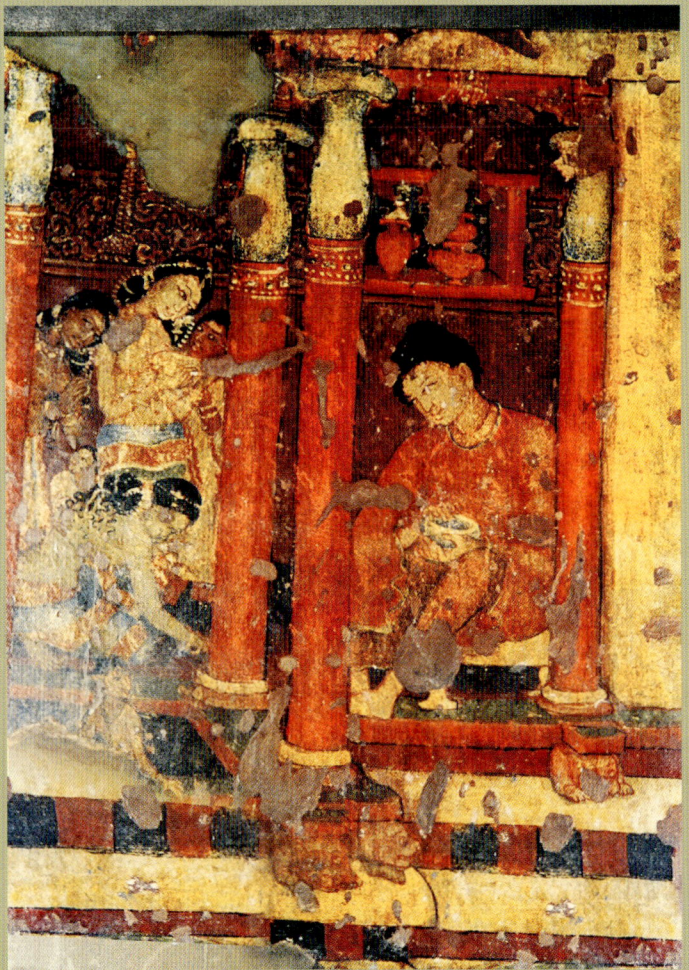

Clockwise from top left:
Capital from Pataliputra, Mauryan period 3rd century BC, Patna Museum; Pillars at Karle chaitya; Mural in Ajanta caves depicting interiors of a royal palace

models of similar architecture from the Buddhist period. These palaces, built in wood have all perished leaving no trace behind. In fact, stone was used only in the construction of temples. Secular architecture had no tradition of buildings in stone. The four gateways at Sanchi covered with lavish relief ornament, reproduce the architecture of their protoypes in stone.

It is generally accepted that the palace ruins excavated at Kumrahar (in Patna) belong to Pataliputra, the Mauryan capital during the 3rd century CE. Megasthenese, a Greek ambassador, was much impressed by this palace built as a parallelogram surrounded by a wide moat and protected by a wooden wall which had 570 towers and 64 gates. The carved wooden columns here were specimens of superb craftsmanship. A rare surviving piece of capital from one of these columns shows a strong influence of the Achaemenid palaces of Persia, particularly remarkable for its fluted sides and stylized foliate ornamentation. Traces of a magnificent hall with gigantic wooden columns suggest the opulence of the court and the importance of the hall as a reception or darbar hall resembling Persian models, which, according to Benjamin Rowland suggests were, "the first indication of the tremendous influence exerted upon Mauryan India by the art of the Achaemenid Empire that Alexander destroyed. The conscious adoption of the Iranian plan by the Mauryans was only part of the paraphernalia of imperialism imported from the West". The 75 m (nearly 250 feet) long wooden palisade unearthed at Kankarbagh (Patna) has been carbon-dated between c. 720 and 550 CE. A more vivid likeness of columns at Pataliputra is provided by the columns at the *chaitya* at Karle (50-70 CE). Some of the reliefs on the northern gateway at Sanchi also depict a royal personage holding court in a palace with stone columns bearing a striking similarity to the Karle columns and the form of the extant capital from the palace at Kumrahar.

Yet antoher source to provide some vital clues to early palace architecture can be traced from frescoes at the Ajanta Caves which contain some depictions of royal splendour-royal personages attended by damsels, dancers, musicians and attendants. The wooden columns of the palaces are shown painted in gorgeous colours. A remarkable feature of the architecture is the curved sloping *chajja*. These palaces stand within walled enclosures in solid masonry.

The palace ruins excavated at Kumrahar are amongst the rarest examples of ancient Indian architectural tradition. The various sacred texts on architecture and treatises have been the guiding source of building forts and palaces, making precise recommendations regarding dimensions and proportions of palaces in mathematically calculated concentric squares to create complicated geometrical patterns-called the *mandala*. Zones within the *mandala* represent the different levels of the universe and the most prominent deity occupies the central square. The number of squares in a plan differs but the presiding deity is never dethroned from the central area.

In plans for the royal palaces the ruler's residence occupies the central square which matches his divine status. The close relationship between the priest and the ruler has been based on mutually agreeable terms: the priest created glorified genealogies for the ruling dynasty which in turn makes generous land grants to priests for the maintenance of temples who, in due course of time, emerged as a ptoent class in the socio-economic development of society. In most of the forts and palaces in northern India, an important section is especially reserved for the observation of religious rituals and worship of the family deity under a specially appointed priest and the royal chapel-mosque or a temple forms an integral part of the palace architecture.

Most of the palaces built during the 11th and 12th centuries CE were destroyed by the Muslim invaders. Mercenaries on a treasure hunt ransacked palaces and destroyed all palaces where fabulous royal

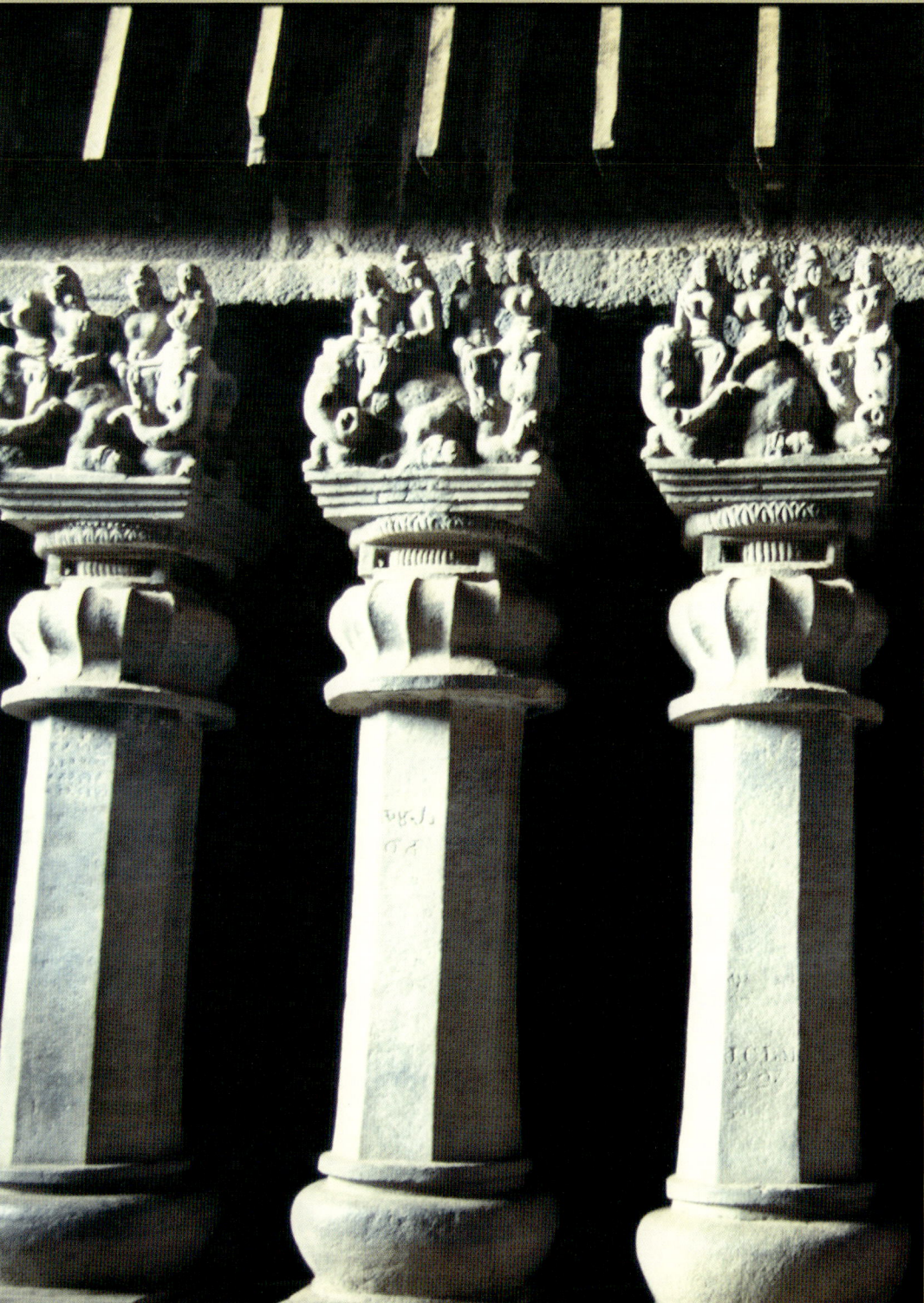

treasures could be found. It was only after the arrival of the Mughals that forts and palaces in northern India were rebuilt or strengthened, particularly between the 15th and 17th centuries CE. These Rajput palaces were built to meet the requirement of rulers who sometimes could only add a few apartments to the existing structures, not strictly in accordance with the stipulations of the vastushastras. These palaces remain the only surviving examples of palace architecture which had its beginnings in the ancient times.

Whereas most of the palaces follow their scheme of layout according to the necessities of the time and the whims of the patron, some commonly observed features deserve a mention. The focal point in a fortified enclosure is the single largest palace belonging to the ruler and his family members. Generally there is a separate provision for the accommodation

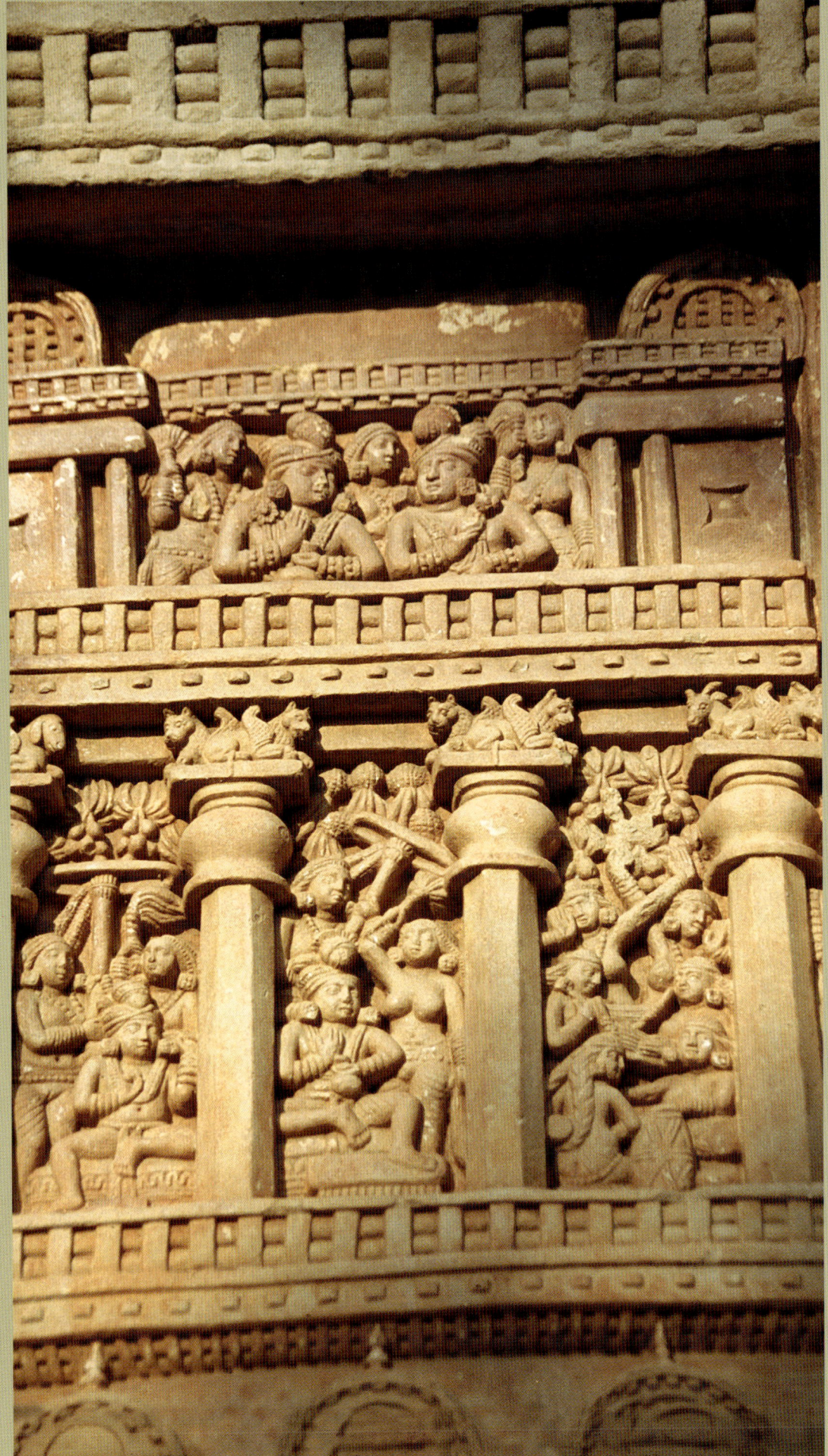

of women in the *zenana* which is connected with the ruler's private apartment through galleries and covered passages and heavily guarded by soldiers specially chosen for the job. A great number of Rajput rulers who had entered into matrimonial alliance with the Mughal kings were assigned jobs in various parts of the country, far away from their mother states and for long periods. During their long absence, the *zenana* had to be provided maximum security and comfort. The guards were obliged to report cases of indiscretion to the ruler. Hence the *zenana* quarters in these palaces were built as a close set of apartments, a world complete in itself. In many palaces there are basement chambers which were used for purposes other than just cooling. There are pavilions at the upper most terraces surrounded by *jali* screens, and the stairs are built under the shadow of the rising wall providing no indications of the proceedings here to the world outside.

The ruler's sleeping chambers are carefully chosen and arrangement for the greatest security of his life made at every step. At most of the Rajput palaces, these rulers have their private chambers at the top of the structural pile as can be observed at Bikaner, Kota, Jaisalmer, Mehrangarh and Udaipur etc. The sleeping chamber is the epitome of royal luxury with a picture gallery covered with murals mostly depicting *Krishna-Leela* scenes, royal hunts, processions festivities and dance performances etc. The Bundi palace is noted chiefly for exquisite murals and the Kota palace has the ruler's pavilion decorated with grand panels of architectural vistas, gardens and royal celebrations besides a vast number of miniature paintings in the authentic Kota kalam, secured in glass frames. From the floor level upwards, upto the ceiling, it is a vast canvas of gorgeous colours. The Takht Mahal at Mehrangarh is also decorated with stunning miniatures on the walls.

A very remarkable feature of the Rajput palaces is their easy convertibility of space to suit various purposes and occasions. There is no particular furniture and no particular function assigned to a room. Soft furnishings and carpets can be easily removed and reset. The royal bedroom at Bikaner has a small low bed (wooden *charpai*) placed under a large punkhah hanging from the ceiling which is covered with some enchanting scenes depicting Krishna dancing with the *gopis* (cowherd women). The beds here, as at most other palaces is extremely low to prevent any enemy hiding under it. Also, there are mirrors placed at strategic corners to warn the inhabitants about the approaching intruder.

Provision of a large chamber for the ruler's consultation with nobles and ministers is of great importance. Generally there is a hall with mattresses covered with soft sheets and large cushions and lavish decoration on the walls and ceiling. Such consultation chambers are built within a strictly guarded enclosure. There are, however, few Halls of Private and Public Audiences in Rajput palaces built separately for this specific purpose. Only at a later date, Sawai Jai Singh II built a separate *Diwan-i-Aam* at Amber and a *Diwan-i-Khas* (now called *Diwan-i-Aam*) at the City Palace, Jaipur in imitation of such structures at the Mughal forts at Agra and Delhi.

The most conspicuous section of the royal palace is the central courtyard surrounded by arcaded cloisters. These courtyards form the focal points of the architectural scheme. Here, in the open space are held meetings and celebrations, evening entertainments and festivities. This multi-purpose area is the most functional section in the palace. During the day, the inmates stay within the small private apartments but the evening draws them out in the open. Man Singh's palace at Amber has a spectacular courtyard at the centre of which stands an ornamental *baradari*. This is known to be a *zenana* palace and still shows well-preserved conveniences provided to the royal women. The rooms are built on an intimate small scale but the large courtyard, in its contrasting openness, has an air of informal get-togetherness. Very few

Rajput palaces have gardens within the precincts. Such gardens were introduced into the architectural scheme at a much later stage during the 17th Century CE in imitation to the garden palaces of the Mughal Kings. The most exquisitely laid out garden at the foot of the Amber palace lies surrounded by the charming Matoa lake. The geometrical patterns of the flower beds and the provision for small flowering shrubs instead of tall trees suggest the essentially Mughal concept of the palace garden as seen at the Angoori Bagh in front of the Khas Mahal at the Agra fort. In fact there is also a small ornamental garden laid out in front of the Sheesh Mahal at Amber, a creation of Sawai Jai Sigh II.

Rajasthan is known to be the desert land of India. Whereas the western section of the state is mostly dry and sandy, the eastern part has a few rivers, high, forested hills and a cooler climate. Still the state is dotted with a few huge lakes which contain some of the most impressive palaces built in the midst of shimmering waters. Nearly all the important cities like Jaipur, Kota, Bundi, Bikaner, Jaisalmer, Udaipur and Alwar have enchanting island palaces. Udaipur, popularly known as the lake city of Rajasthan has two splendid palaces on the Pichola lake. Bikaner rulers built a small but very charming palace on the lake at Gajner. Such palaces reflect the ingenuity of the architects in using artificial lakes to a tremendous enhancement of the architectural splendour of these stone edifices. These lakes also supply water to the cities and collect every drop of rain water. The building of lake palaces is a feature typical of Rajasthan.

The forts and palaces in northern India are the accumulated work of several dynasties of rulers who embellished the capital cities of their kingdoms with splendid architectural creations. Their pretensions to glory led them to compete with each other in creating greater and more glorious palaces than their rivals. The best artisans and craftsmen were employed to work at these various capitals. Most of the palaces in Rajasthan show a common feature- a nearly complete absence of white marble. First, because Akbar kept these rulers far away from their kingdoms for long periods forbiding any grand architectural project to be undertaken at these capitals: secondly, Shahjahan demanded all marble to be carted away to Agra for the construction of the Taj Mahal, forbidding rulers, particularly Mirza Raja Jai Singh I of Jaipur, to detain or employ artisans and labour to work in their capitals. This is one strong reason why in the state of marble quarries, we have palaces covered with stucco polished with lime plaster. The best craftsmen and the best materials were reserved for the Mughal emperors only. Despite this basic handicap, these Rajput palaces have a unique charm of their own and their enchanting picturesqueness owes little to marble or forced employment.

Most of the forts and palaces in northern India suffered irreparable damage at the hands of the Delhi sultans and later on the Mughals. But there has been a small blessing attached to this factor. Chittaur, which is the most important example of destruction by Akbar, was forbidden to repair the ruins. These provide the only substantial evidence of the architectural style of the Rajput palaces between the 14th and 16th centuries CE. The ruins of Rana Kumbha's palace are a great source of information on the Rajput architecture preceding the advent of the Mughal Rule in northern India. Also, the 15th century CE palaces of Raja Kirti Singh and Raja Man Singh Tomar at the Gwalior fort, which were spared destruction by the invaders, have survived to provide a mine of information on the development of the Rajput architectural styles upto the 16th century CE, where after the influence of the contemporary Mughal architecture started manifesting itself on Rajput architecture.

The Mughals were to exercise a significant influence on the Indian architectural style but at first, most significantly during Akbar's ruler, this appeared as tremendous appreciation and assimilation of some salient features of Gujarati architecture.

As historian Ebba Koch explains, "Akbari architecture developed into a dramatic supra regional synthesis characterized by extensive borrowing of features from earlier Timurid, Transoxanian, Indian and Persian styles. Stylistic clashes resulting from the amalgamation of such hetrogenous elements were mollified by the favourite building material, red sandstone, whose unifying hue carried an additional attraction in being the colour reserved for imperial tents". In fact, the use of red sandstone on such an unprecedented scale was to become the most striking feature of Akbari architecture. The city of Fatepur Sikri remains the most glorious example of a city built entirely in red sandstone.

The architectural scheme of Mughal palaces, however, remained unaffected by the growing interaction with the great Indian architectural traditions, particularly noticeable in the arrangement of various structural parts, massing, planning and setting of the major royal edifices. In the Mughal forts, royal palaces or apartments stand as separate structures formally disposed on a ground level, as seen at Fatepur Sikri, Agra and Delhi forts. Quite apparently, the imperial Mughal architecture follows the layout of Arab and Central Asian tent encampments in a style vastly different from the close-set style of the Rajput and Gujarati royal palaces. As John F. Richards observes: "Akbar re-created a comfortable and certainly grand encampment in stone within the boundaries of Fatehpur Sikri.,.It was an urban form somewhere between a camp and an imperial city". At the Agra and Delhi forts important royal palaces stand in a clearly discernible formal arrangement on the eastern wall facing the river. Only some buildings at the Agra fort are more closely integrated with each other but such examples have few precedents in the annals of Indo-Islamic architecture.

Whereas the "creative dialogue" between Mugal and Indian architectural traditions during Akbar's rule showed striking results in the red sandstone structures at Fatepur Sikri and Agra, the essentially Islamic features were to assert themselves more emphatically under Shahjahan when Mughal architecture appeared in the full glory and maturity. This period is characterized by the increasing use of white marble as facing and an extremely sophisticated and refined form of marble *intarsia* or the *pietra dura* ornamentation. There is under Shahjahan "a strict systematization of architecture to conform to the now prevailing ideal of classical equilibrium governed by hierarchical accents…the favoured planning principle was that of placing bilateral symmetrical features on either side of a central axis, which was accentuated by a unique feature. Consistent axial planning was now also employed for the large imperial palaces". Perhaps the most distinctive feature of Shahjahani architecture relates to the perfection of the bulbous dome constricted at its neck, the engrailed arches or the nine-cusped arches, pillars with baluster columns and foliated bases. The purity of these architectural forms appears highly accentuated in white marble. Yet another feature of Shahjahani architecture is the use of water canals and fountains within the palaces. The water canal constructed by Ali Mardan Khan ran through most of the palaces in the fort at Delhi feeding fountain basins and gardens.

The Mughals loved displaying their power and splendour in magnificent halls of public and private audience. The emperor appeared in full regal pomp and command. Sometimes it is suggested that the Rajput rulers built similar halls in their palaces under a Mughal inspiration. But such halls have been part of the Indian architectural tradition for long. Nearly all the great temples in south India have a thousand-pillared hall, which serves a great number of functions, including the most important ceremonial *darshan* (appearance) of the presiding deity on certain occasions. The image on such occasions is decked in full finery and the richest array of gold ornaments and diamonds. The Delhi sultans built such peristylar halls as *Diwan-i-Aam*, where they granted audience to ambassadors and nobles and dispensed justice and ordered

Relief at Sanchi, eastern gateway

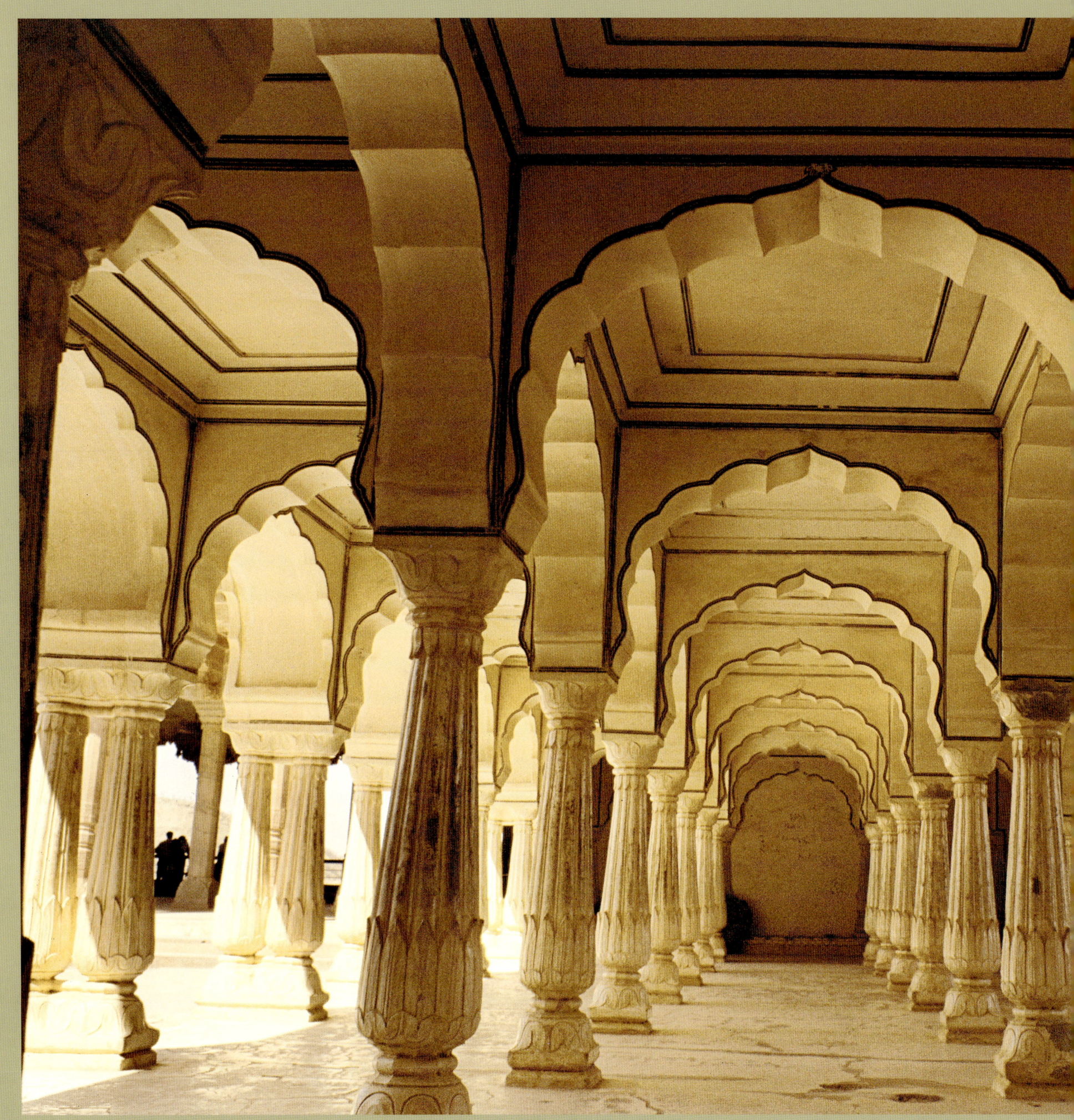

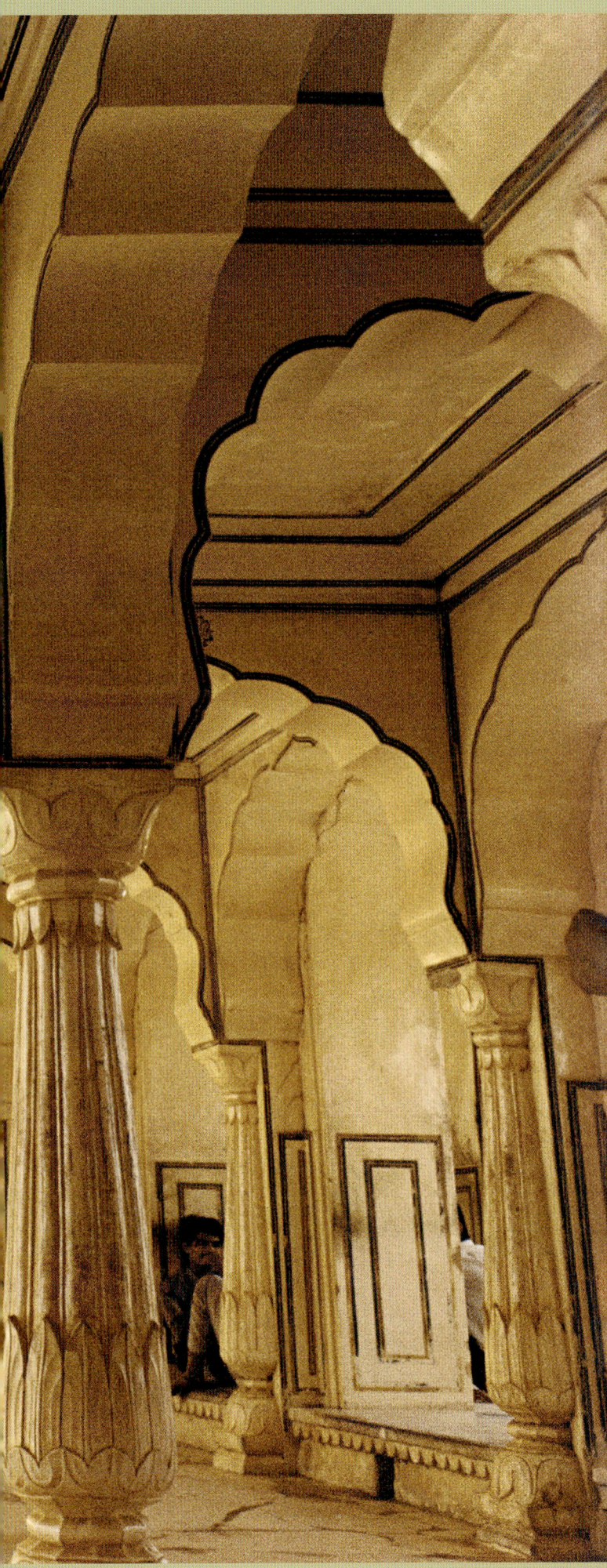

punishments, inspected troops and other performances. The Mughals only revived this tradition by building grand halls where the emperor sat on a throne as the 'master of the universe'. Sawai Jai Singh I built a magnificent *Diwan-i-Aam* at Amber in the Mughal Style, and his other buildings in Jaipur, like the city built by him 1727 CE, illustrate the trend of re-introducing architectural features, which had once formed part of the great Indian architectural heritage, but this time it came via the Mughal courts.

The recurring feature of the architectural vocabulary appearing in both Rajput and Mughal buildings deserve a note. Besides the partiality towards florid Gujarati forms, there is a marked appreciation of the decorative value of Bengali and Deccani forms. Cusped arches, the *bangaldar* and ribbed domes with *padma-kosha* are in common use. The post, bracket and beam, *chajja* (eave), *chattri*, balcony and *jali* screens came to be increasingly used in both styles. Christopher Tadgell observes, "a preference for the centralized in plan and elevation, the *bangaldar's* corners brought down beyond the semi-circular, the cupolas virtually spherical, the architectonic ceding to the vegetal- as it had done in Rococo Europe-until columns became baluster-like bundles of reeds and arches were overcome by creeper-like cusps."

What one observes in both Rajput and Mughal secular architecture of the 16th, 17th and 18th centuries CE is, in Tilltoson's opinion "a convergence of two diverse traditions; while each retains its essential character, there is also a process of mutual adjustment. This might be described as the establishing of a counterpoint-a metaphor intended to suggest simultaneous separation and relation." Both the styles adopt features from their opposite styles. Hence, Mughal style incorporates the corbel capitals, *chajjas* and brackets derived from the Rajput tradition and the Rajput style adopts the baluster columns and certain types of applied decoration. This 'mutual borrowing' explains the similarities between the two styles. The *bangaldar* roof and the cusped arch had their beginning in the ancient Indian tradition only to find a fond acceptance and frequent use in Mughal and Rajput architecture.

The court at Amber palace, near Jaipur

Both the Rajput and Mughal architectural styles share some common features but remain different from each other, not losing their distinctive character. Perhaps the most lasting difference between the two styles relates to their planning. Most of the Rajput palaces were rebuilt on old foundations during the prime of Mughal architecture. Old palaces were altered and received additions without altering the character of the original massing and planning. The Mughals began their building progamme in northern India on a fresh note. If an old palace structure had to be demolished it was only to build in a new form. Some portions of the Bengali Mahal at the fort in Agra were demolished by Jahangir and Shahjahan but only to procure building material for their palaces ultimately covered in white marble, beginning an entirely new chapter in the history of Mughal architecture.

Both the Rajput style, which is essentially a continuation of the ancient Hindu traditions, and the Mughal style, which also had its roots in the Islamic architectural traditions, continued to flourish simultaneously without really merging into each other. Till the end, the Hindu style remains Hindu Rajput style and the Mughal style stands apart in full imperial glory.

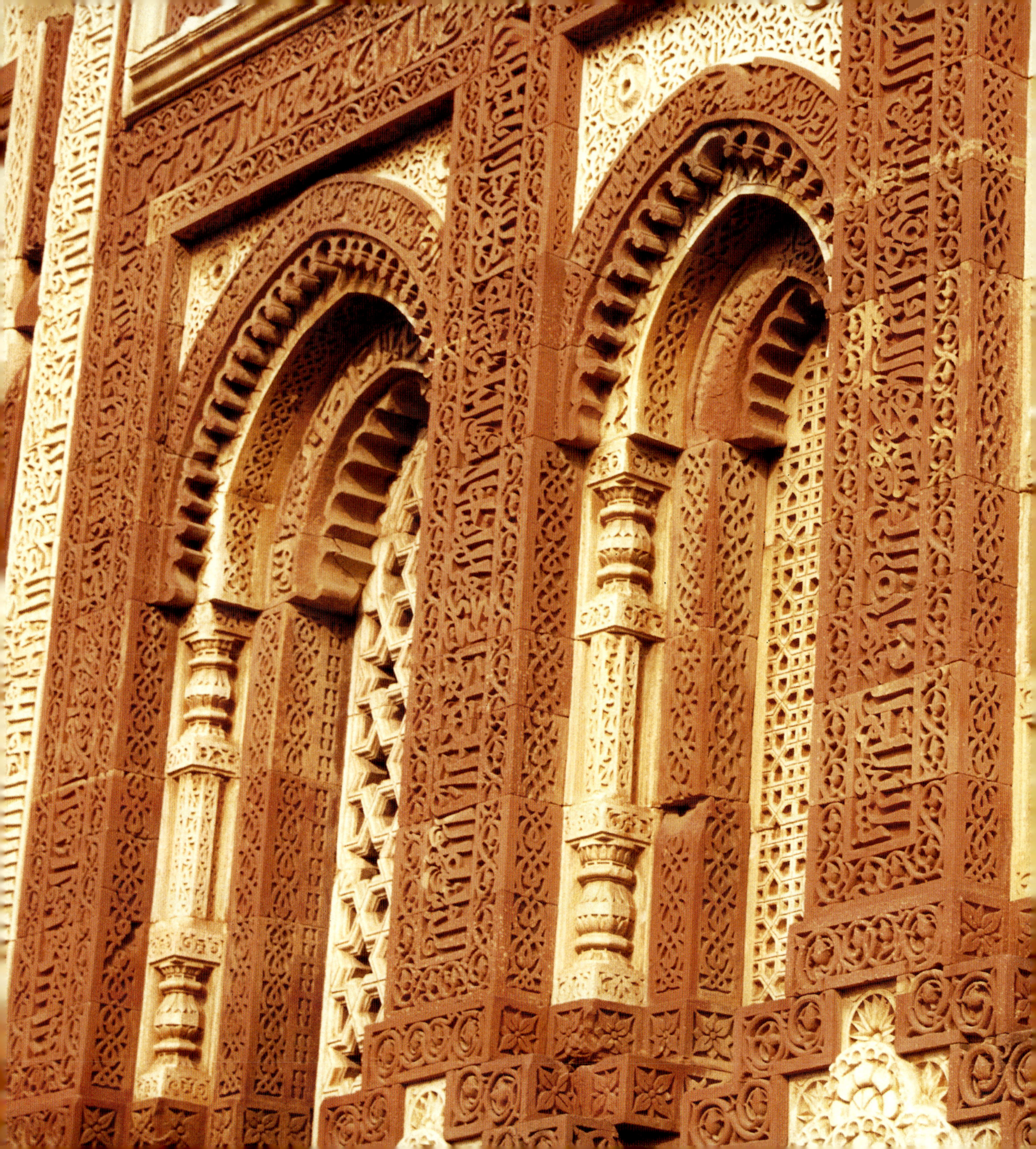

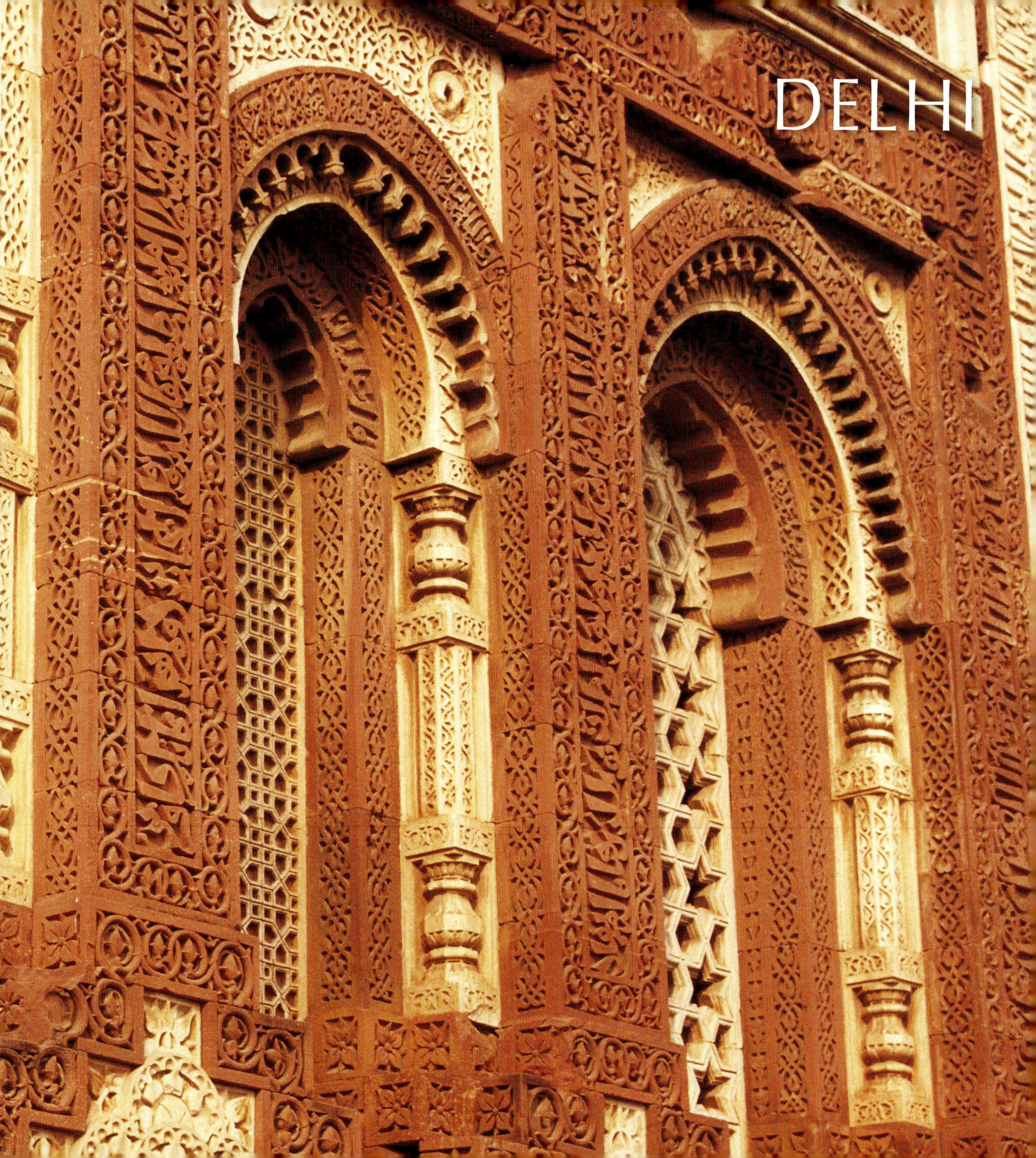

DELHI

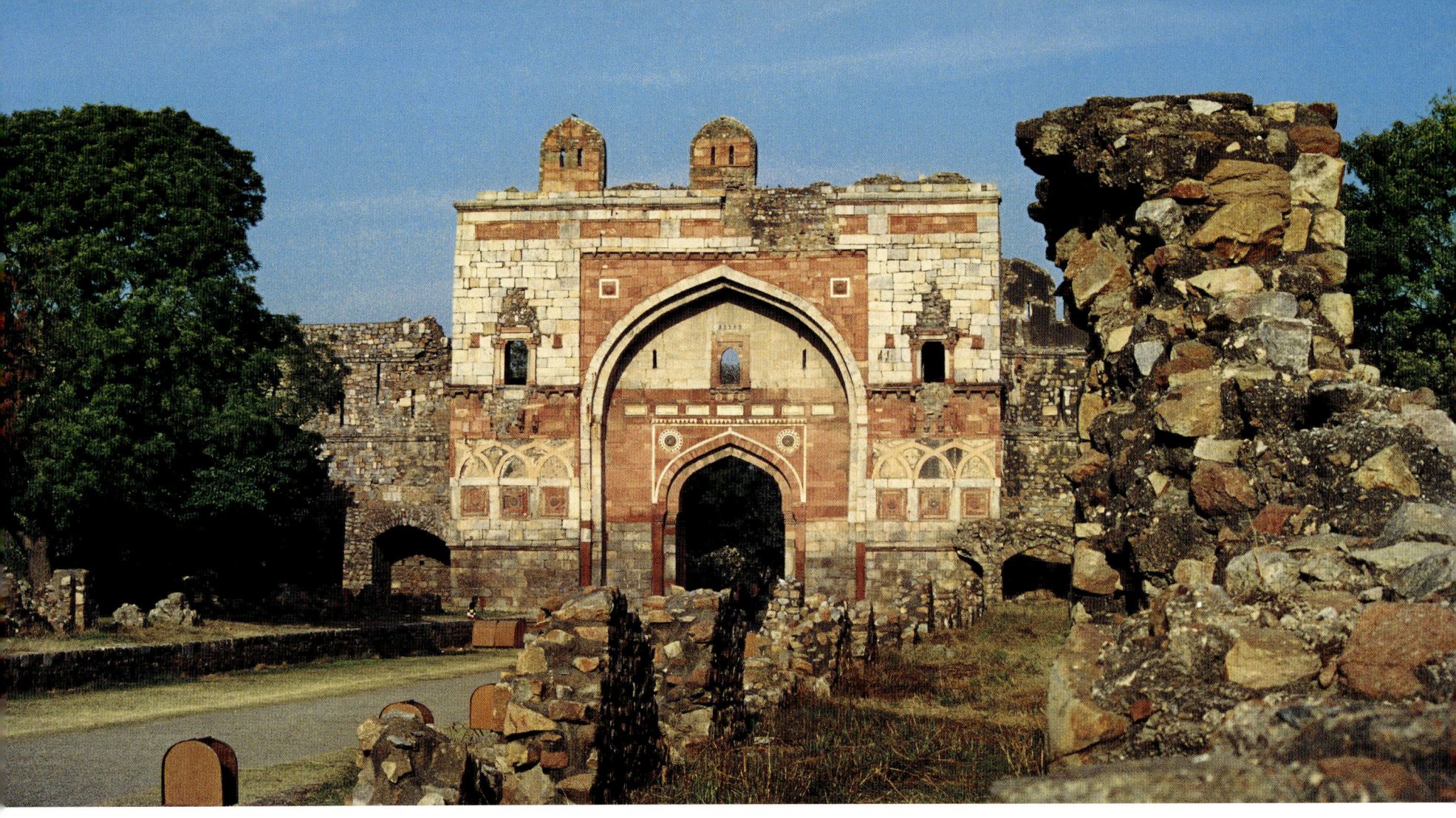

Forts of the Pre-Mughal period

Previous pages:
Detail of the Alai Darwaza, the magnificent gateway built by Alauddin Khilji of the Delhi Sultanate to decorate the Qutab complex

Clockwise from top:
Sher Shah's gate in front of the Old fort, Delhi; Ranjit Gate at Qila Rai Pithora, Delhi; Ruins of the defence fortifications at Qila Rai Pithora

The history of Delhi is steeped in the strains of unsettled and unverifiable traditions. Against these difficulties, it is generally agreed that Indraprastha, the capital of the Pandavas, was the first important settlement on the present site. The Mahabharata gives vivid description of the construction of the city and fort of Indraprastha, situated between the last stretches of the Aravali range and the Yamuna river. It was a city of marvelous proportions, massive fortifications, and splendid palaces built in the Khandava tract which was a forested area cleared with the help of the fire god-Agni. On an auspicious occasion, the Pandava brothers started work on the fort of Indraprastha: "It was made strong by moats that were like oceans and surrounded by a wall that covered the sky, white like clouds, or like a mountain of snow. That grand city shone as Bhogavati shines with its Snakes, and it was protected by double-hung gates, with gate towers that towered like packed-clouds, like so many Mount Mandaras…Guarded by warriors, it was splendid with spiraling turrets and resplendent with sharp pikes and hundred-killers and movable trellises".

"The fortress sported massive iron wheels and a well-laid plan of streets that avoided collisions with Fate; and it shone wide with beautiful white buildings of many kinds. Thus, Indraprastha stood out wide in the image of heaven…In this lovely and beautiful place stood the splendid seat of the Kauravas, filled with treasure, which was like the seat of the God of Riches…There were houses, white like mirrors and all kinds of pavilions made of *lianas*; and lovely painted houses, and pleasure hillocks, and many ponds filled with pure water; and the most charming lakes redolent with the fragrance of lotuses and water lilies".

The city and fort of Indraprastha are generally believed to have existed on the site presently occupied by the fort built by Humayun and Shershah in the sixteenth century CE. No trace of that fabled grandeur has survived, not even the scantiest archaeological evidence to support belief in the existence of such a great city. Possibly inspired by the excavations at the sites of the Homeric cities, the Indraprastha site has only recently been excavated. The findings of these excavations indicate that the earliest settlement here did not go beyond 1000 BCE.

Further investigation has brought to light evidence of a continued occupation of the site from the Mauryas to the Mughals, i.e. 300 BCE to 1650 CE. This confirms the antiquity of Indraprastha or the Purana Qila site. Even the pre-Mauryan strata, the earliest levels associated with the Northern Black Polished Ware provide no clue to the city of the Mahabharata. Discovery of an Ashokan epigraph in the southern part of Delhi has only further emphasized the city's ancient origin and lent credence to the belief that Delhi was part of the sixteen great kingdoms or *Mahajanpadas* in northern India stretching between Afghanistan and the eastern extents of the country. Delhi was part of Kuru Rattha, one of the *Mahajanpadas*, and the city of Indraprastha was a flourishing settlement connected by road to Varanasi. Indraprastha was not an imaginary creation. Abul Fazl, Akbar's court historian wrote: "Delhi is one of the greatest cities of antiquity. It was first called Indrapat…Humayun restored the citadel of Indrapat and named it Dinpanah (asylum of the faith)…". This keeps the belief in the existence of Indraprastha alive, despite the absence of archaeological evidence. This city and fort of the Mahabharata survives, if only in name, as the earliest settlement in the region.

With the decline of Buddhism in northern India and some sociological and political factors, the importance of Delhi was reduced considerably and little was heard of the city till about the eighth century CE, when, as Dilli, Dhilli, Dhillika and Yoginipura, it came to be known as the capital of the Tomar Rajputs in 736 CE. Here we have similar difficulties with the

historical authenticity of dates and location as with Indraprastha, though not really as vague as the poetical allusions of the great epic. One of the earliest Tomar Kings, Suraj Pal, built the Suraj Kund beyond Tughlaqabad. This circular water reservoir still lies in an excellent state of preservation. The date of its construction is given as Vikram Samvat 743 by Sir Syed Ahmad Khan and 1061 CE by Gen. Cunninghan. A Village in the rocky terrain around Suraj Kund is still called Arangpur or Anandpur. Here also stands a dam built by Anang Pal and also ruins of some fortifications. Even as the Tomars concentrated here, Anangpur remained overlooked by the Ghaznavi invaders. But the fears of a possible sack and plunder by invaders must have haunted the Tomars who realized the vulnerability of this small settlement to attacks and plunder.

The Tomars shifted capital to the Mehrauli area. The inscription on the Iron Pillar, standing in the courtyard of the ruined Vishnu temple remodelled as the Quwwat-ul-Islam mosque, mentions '*Samvat Dihali 1109 Anang Pal bahi*' (Anang Pal peopled Dilli). In 1051 CE Anang Pal II constructed the fortress of Lal Kot. It was to be the first extant fortress of Delhi.

Lal Kot is oblong in plan and the high walls of the local quartzite stone are surrounded by a deep moat running along the outer defence fortifications. The rubble-built walls of the ramparts are 2.5 to 3 mts in thickness. There are strong bastions at regular intervals and several gates. The most prominent among them being the Ghazni, Ranjit and Sohan gates. The ruler Vigrahraja IV (C. 1153-64 CE), also known as Visaladeva or Bisaldeo of the Chauhana dynasty of Sakhambari captured Delhi from the Tomars and established Delhi as their northern capital. Ajmer continued as their chief capital. His grandson Prithviraj III, also known as Rai Pithora, enlarged the Lal kot fortress by constructing huge defence fortifications around it. Lal Kot, however, remained at the core of these additions, occupying the south-western corner of the *Qila* Rai Pithora.

In Batuta, the Moroccan traveller at the court of Muhammad Tughlaq in the fourteenth century CE, has left a vivid account of Lal Kot: "The wall which surrounds the city of Delhi is unparalleled. The breadth of the wall itself is eleven cubits and inside it there are rooms where night watchmen and keepers of the gates are lodged. The wall also contains stores for provisions which they call 'granaries' as well as stores for war equipment and for mangonels and stone throwing machines…There is room inside the wall for horsemen and infantry to march from one end of the town to the other. It also has window openings pierced on the town side, through which the light enters. The lower courses of the wall are constructed with stone and the upper courses with baked brick, and its towers are numerous and set at short intervals". The best preserved portions of Lal kot stretch between the tomb of Adham Khan and the Fateh Burj at the northern corner.

On its northern front is Ranjit Gate, the most important gate of Lal Kot. It is seventeen feet wide and two upright stone shafts meant for maneuvering the opening and closure of the gate still stand amid heaps of stone debris strewn all around. The Ranjit Gate is guarded by three small outworks crucial for defence purposes. It is sometimes identified as the Ghazni Gate, because, as Sir Syed Ahmad Khan states on the authority of Ziauddin Barni, the invading forces of Muhammad Ghori entered Lal Kot through this gate and restrengthened it soon after their victory. Between the Ranjit Gate and Fateh Burj runs a parallel wall of defence with independent bastions for additional security. These ramparts have the thickness of 28-30 feet rising to a height of 60 feet from the bottom of the ditch girdling the entire length of the wall. At the northern corner, wall of Jahanpanah joins the Fateh Burj. A huge gap in the wall towards the southern side is all that remains of the Sohan Gate. The wall moved towards the Qutb Minar and the tomb of Balban, from where it goes on to join the portion near Adhan Khan's tomb. Lal Kot was not a massive fort but the northern most stronghold of the Ajmer-based Chauhana rulers.

Recent excavations in the Lal Kot area have revealed the stone embankments of the Anang Tal, attributed to Anang Pal II. The circular

wide steps around the central rain-water pool show its tremendous importance as a source of water in the rocky terrain on which Lal Kot stands. It is recorded that Alauddin Khilji used water from Anang Tal for the construction of Alai Minar, near the Qutb Minar. As per Cunningham's measurement, the reservoir is 169 feet long from north to south and is 152 feet wide from east to west. Its depth is 40 feet.

The early sultans of Delhi built a few palaces in the Lal Kot area but their precise location has been a matter of speculation. Recent excavations have also revealed nearly ten feet high ruins of palace walls covered with white plaster and floral ornamentation. Water chanels, cisterns and fountains evidence the lavish scale of conveniences provided to the royal occupants of the palace. The skeleton of this palace gives a fair idea of the scale of construction during the early phase of the Delhi Sultanate.

Lal Kot remained central to Qila Rai Pithora which was only an extension of its outer circuit by Prithviraj III. Ruined walls of the Qila Rai Pithora can

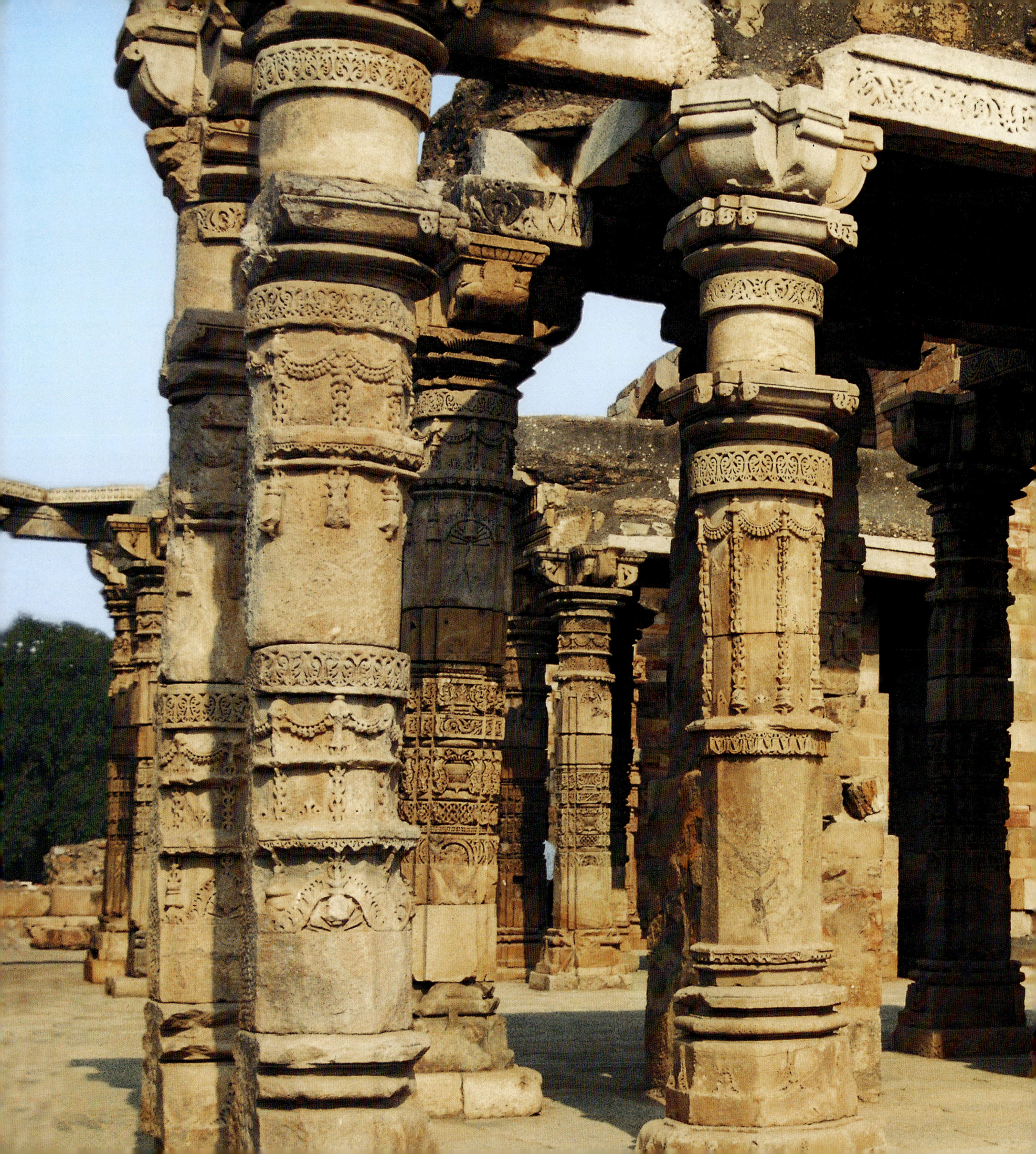

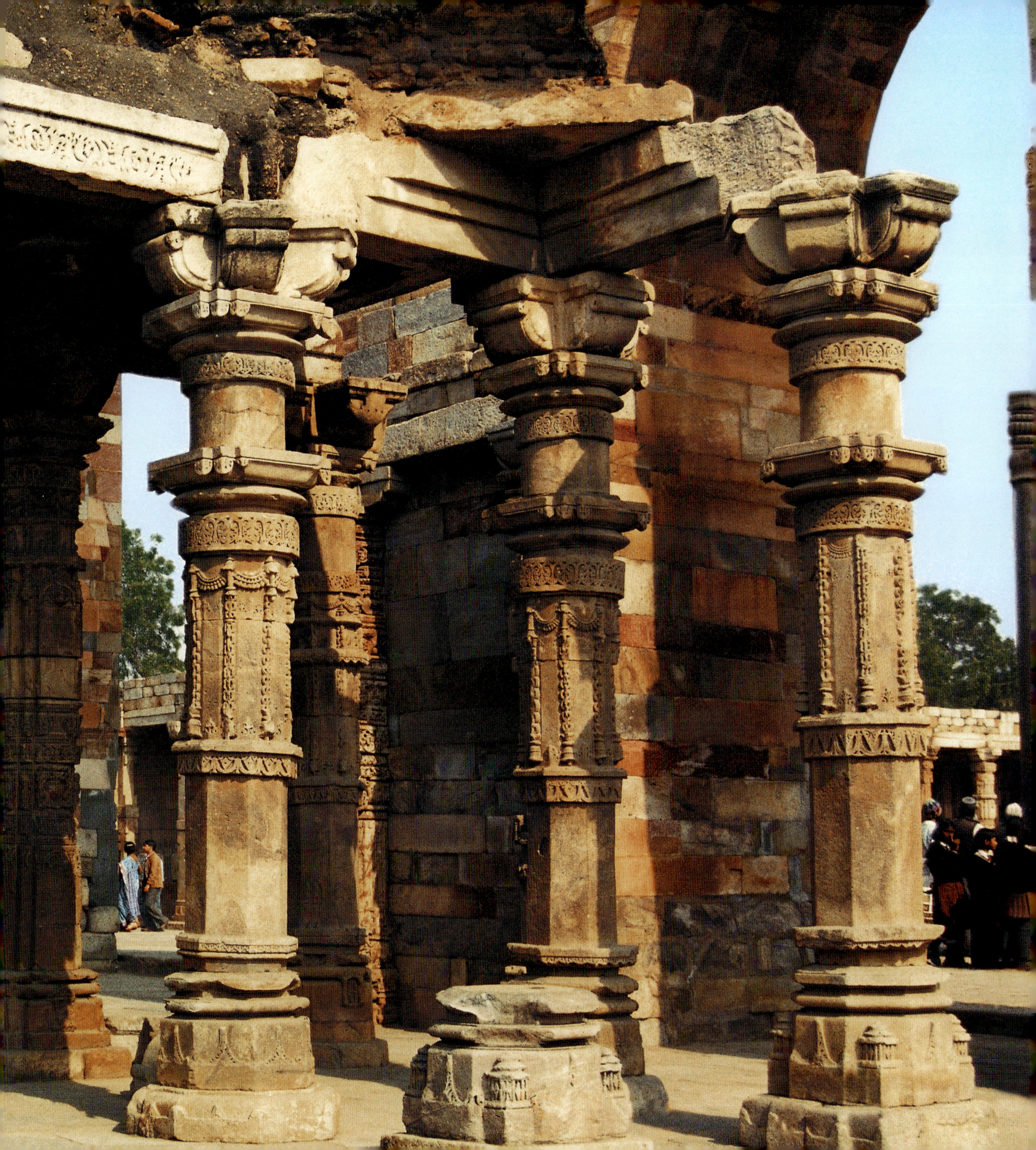

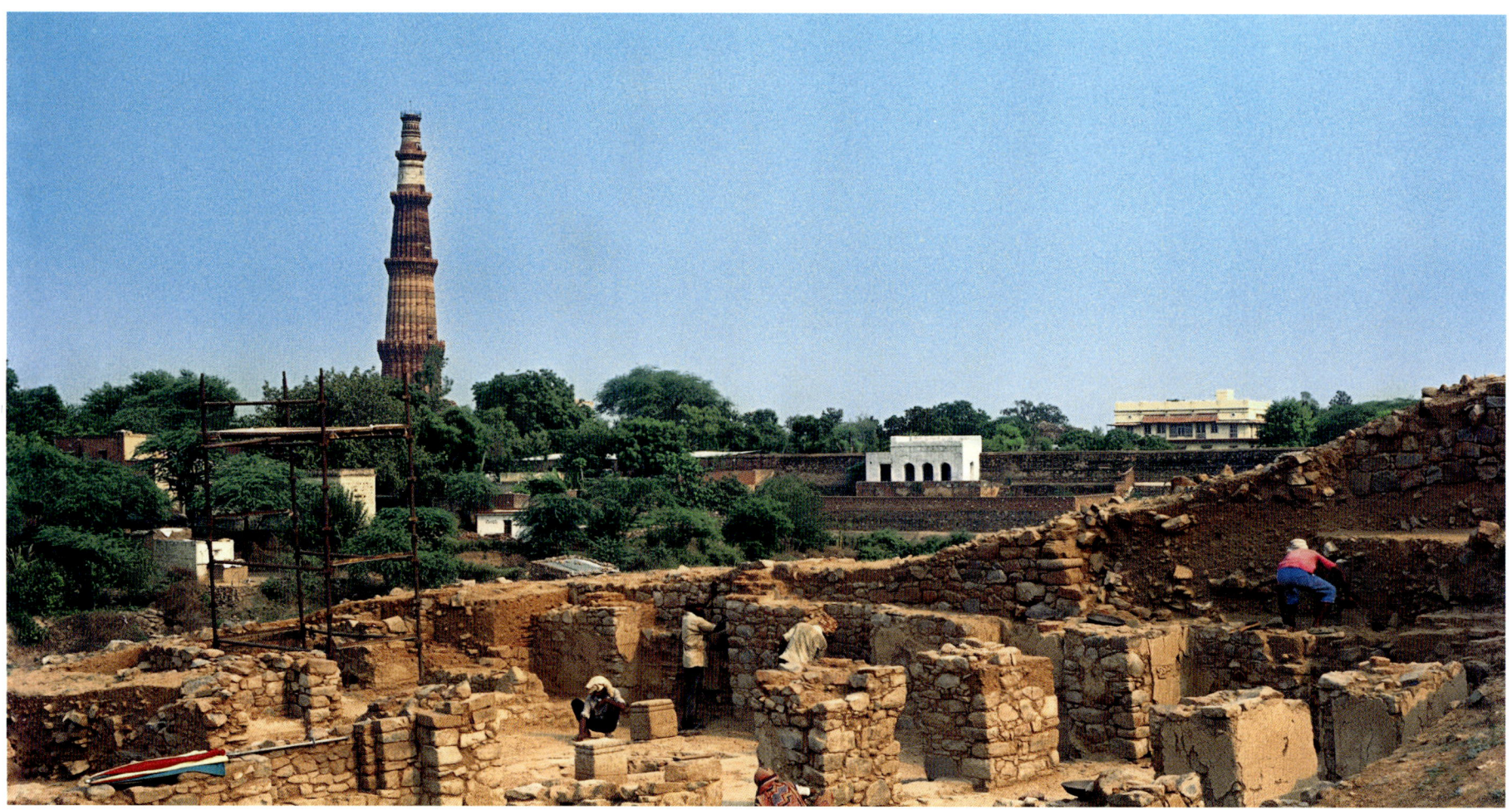

Previous page:
Pillars of Hindu temple at Qutb
Clockwise from left:
Excavations showing remains of a palace at the Qutb complex; Ruins of Tughlaqabad

still be sighted meandering through the neighbourhood country. According to Timur who sacked Delhi in 1398 CE, Qila Rai Pithora has ten gates. The Hauz Rani and Badaoni Gates (so named during the Sultanate period) were the most important gates toward the north-eastern side. Ibn Batuta, however, is more informative: "the city has twenty eight gates... amongst these gates is the *darwaza* of Badhawun, which is the largest gate; the *darwaza* of al Mindawi, besides which, is the grain market; the *darwaza* of Jul, where the gardens are; the *darwaza* of Shah, which is the name of a man; the *darwaza* of Palam, the name of a village; the *darwaza* of Najib, which is the name of a man; the *darwaza* of Kama, the same; the *darwaza* of Ghazna, called after the city of Ghazna; in the province of Khurasan and outside which is the place set apart for festival prayers as well as cemeteries; and the *darwaza* of al-Bajalisa. Outside this are the cemeteries of Delhi".

It was at the Badhawun Gate that Alauddin Khilji ordered the wine caskets to to be emptied of their contents. "All the china and glass vessels of his banqueting room should be broken, and the fragments of them thrown out before the gate of Budayun, where they formed a heap. Jars and casks of wine were brought out of the royal cellars and emptied at the Budayun Gate in such abundance, that mud and mire was produced as in the rainy season." For fear of the Mongol invaders, the Badhawun Gate was kept heavily guarded. Public executions took place at this gate. All these gates of the Qila Rai Pithora have been destroyed and except for wide yawning gaps between streteches of the wall, nothing remains of their existence. Some localities are however, still named after these gates which have disappeared long ago.

Besides the long stretches of its walls and some massive ramparts, the only portion of the original Tomar-Chauhana structure lies at the back of the five-arch screen of the mosque built by Qutbuddin Aibak. This is the core of the Vishnu temple with its grand sculpted columns. The rear entrance to the temple interior and the sanctum has escaped destruction. It is small and the door is framed by sculptured scrolls and animal figures at the base. The reassembled inverted lotus ceiling at the eastern entrance porch of the mosque gives a fair idea of the superior stone craftsmanship. Aibak, who destroyed 27 temples within the Lal Kot precincts, retrieved the broken columns from the various temples-Hindu, and Jain, defaced their figural ornament, considered so offensive to the Islamic injunction and reset these small broken columns to form the arcades around the mosque courtyard.

The approximate number of columns reset in the arcades is about 240; each pillar consisting of two or three pieces. The demolished temples were mostly peristylar temples of a modest size. The sculptural ornament on the pillars is of a refined and sophisticated standard typical of the post-Gupta period in northern India.

The image of Vishnu reclining under the seven hooded cobra, installed in the sanctum, was removed to a nearby village just before the soldiers of Muhammad Ghori entered the temple and wraught havoc on the structures. A rare feature of the sanctum ornamentation is the appearance of small erotic panels near the concentric rings of the ceiling. Their height and small size saves these panels from destruction. Even today, these erotic panels are rarely noticed by historians, archaeologists and photographers.

The Iron pillar, standing in *situ* at the centre of the temples courtyard, has a history of its own. The pillar is 23 feet and 8 inches in height. It functioned as the Vishnudhwaj (staff of Vishnu) originally crowned with the image of *garuda*. The fluted bell capital with its melon-shaped member is cast in the characteristic mould of the post-Gupta period. The inscription on the pillar refers to a ruler Chandra who vanquished the Valhikas at the mouth of the Indua. Perhaps this pillar was brought here from some other place. It is believed that Anag Pal II had it installed in the courtyard of the Vishnu temple. A literary tradition mentions that Anang Pal II was warned not to uproot the pillar as it rested on the head of the *sheshnag*. His kingdom

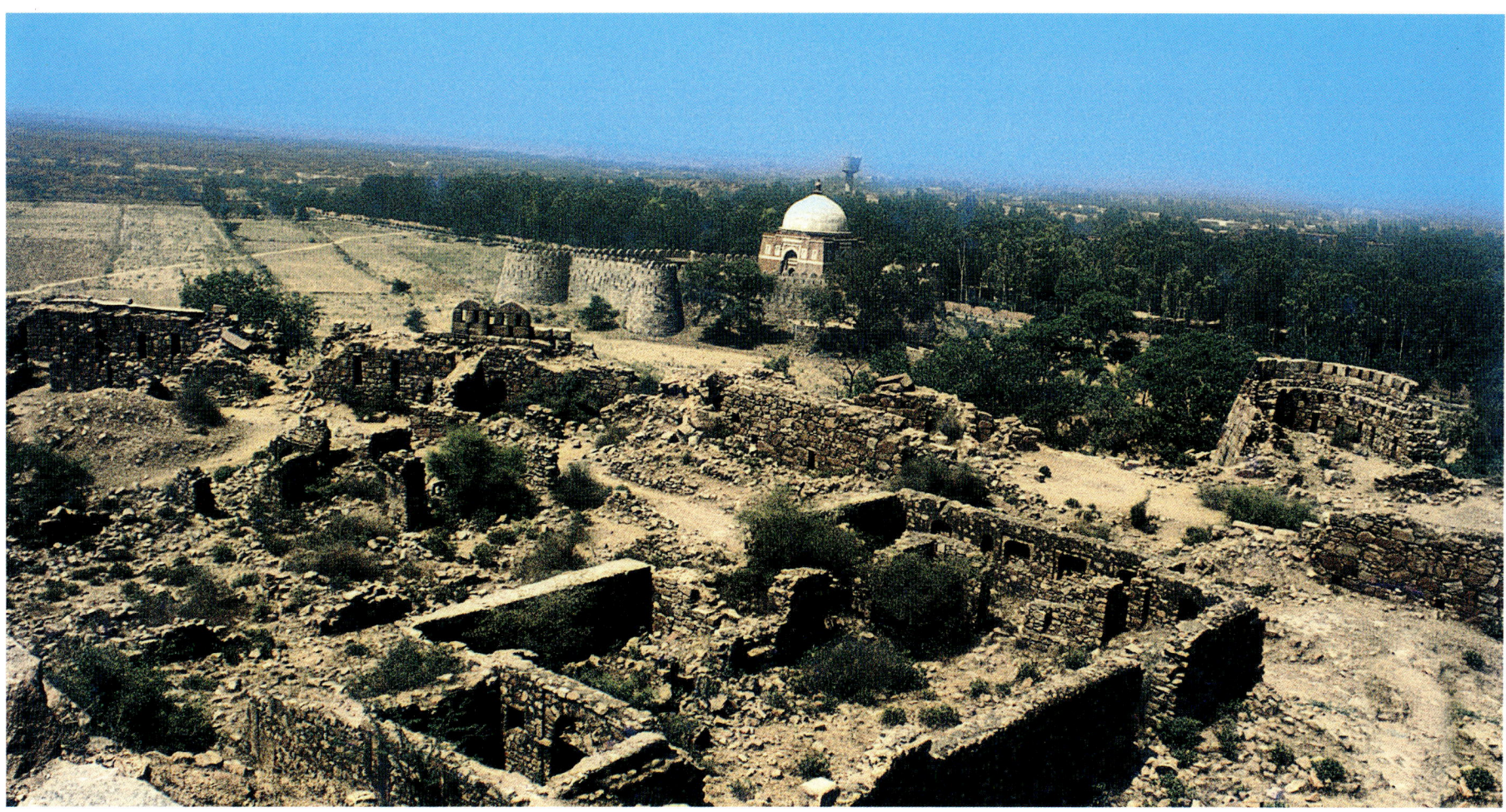

would be secure till the pillar stood firm. Anang Pal II was skeptical of the warning and had it uprooted to see it for himself if it was firmly set. It is said that the uprooted pillar base was besmeared with blood. The pillar was reset but the damage had been done. The pillar had become loose or *dhilli*, giving the locality its name-Dhillika. The 1170 CE inscriptions at Bijolia, near Udaipur in Rajasthan, mention Dhillika in the Haritana country. The Tomars were defeated by the Chauhanas who, in turn, were vanquished by the Turks in 1192 CE, as if in fulfillment of the prophecy and warning.

Cast in ancient times, the Iron Pillar remains a metallurgical marvel for its rust-defying character. The pillar which weighs more than 6 tons, has 99.770 percent iron along with 0.080 percent Carbon, 0.046 percent Silicon, 0.114 percent Phosphorous and 0.246 percent other elements, totaling 99.966. This chemical analysis of the Iron Pillar by Sir Robert Hadfield, referred to by J.A. Page, remains largely acceptable. Both Nadir Shah and the Marathas tried to uproot the Iron Pillar but, except for damaging it a little, failed completely.

Both Qutbuddin Aibak and Iltutmish, who founded and strengthened the Delhi Sultanate, had little time to build new forts. They only repaired the fortifications and built a few palaces within the Lal Kot area. One of these palaces has been excavated but others are still lying under huge mounds of earth waiting to be excavated. Aibak ran the affairs of the sultanate from Lahore which he retained as his capital but Iltutmish stayed at Lal Kot.

Alauddin Khilji, who stayed out of Delhi on long campaigns, was forced to build Siri, a new fortified city between Kilokhiri and Mehrauli in defence against the increasing frequency of the Mongol invasions. Siri, built in 1303 CE, had strong fortifications. Timur, who wrought terrible devastation on Delhi in 1398 CE, wrote about Siri: "Siri is a round city (*shahr*). Its buildings are lofty. They are surrounded by fortifications (*kilah*) built of stone and brick and they are very strong…Siri has eleven gates, four towards the outside and three on the inside." The thick outer double walls had in-built passages through which mounted battalions could move freely from one section of the fort to another without being observed by the enemy. These walls now survive in certain portions as most of its stone was removed and reused subsequently in the building of forts by the Tughlaq rulers.

Siri is said to have had a grand hall of thousand pillars *hazar sutun*, in the architectural tradition of south Indian temples. This grand hall has now completely disappeared but one can still see on the rocky floor holes set at regular distance. The wooden poles set in these holes held magnificent superstructures. All this has disappeared and Siri is identifiable by a few portions of the exterior defence walls. The brief Khilji rule afer Alauddin is a story of effete and incompoment rulers, conspiracies and murders.

To rescue the state from complete destabilization under Mubarak Shah Khilji, Ghazi Malik rose to power, originally a Turkish slave of Balban, known to history as Sultan Ghiyasuddin Tughlaq. He killed Khusro Khan, seized the Khilji throne and crowned himself the new sultan in the Hazar Sutun palace of Alauddin. Ghiyasuddin ordered the construction of a magnificent fort on a rocky prominence, south of the Qutb Minar. Ibn Batuta writes: "The reason why he built it was that one day as he stood before Sultan Qutb-al-Din, he said to him 'O Master of the World, it were fitting that a city should be built here'. The Sultan replied to him ironically 'When you are Sultan; build it". It came to pass by decree of god that he became *sultan*, so he built it and called it by his own name…." Tughlaqabad. The stone quariers in the area provided building material and the scarped hillsides reinforced the fortifications. It was a huge, awesome fort.

The Tughlaqabad fort is an irregular half-hexagon in form and the whole circuit of battlement walls is nearly 6.5 km, girdled by deep ravines. The main part of the citadel, now in sheer ruins, is on the south-west sector of the fort. Numerous towers and bastions stand guard over the wilderness of the ruins. The fort had thirteen gates. There were mosques, reception halls, palaces, baolis and dungeons to make it suitable for the powerful

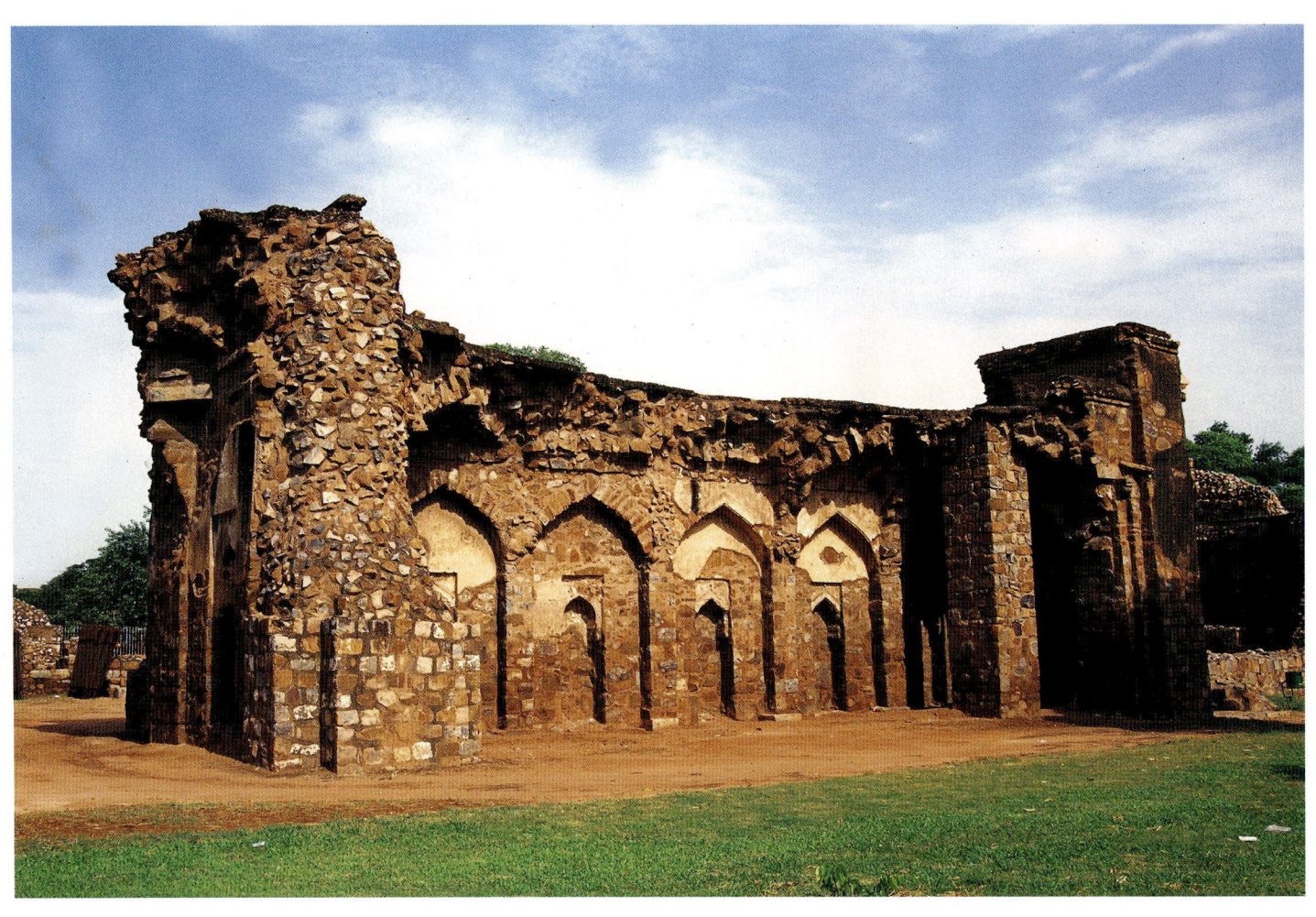

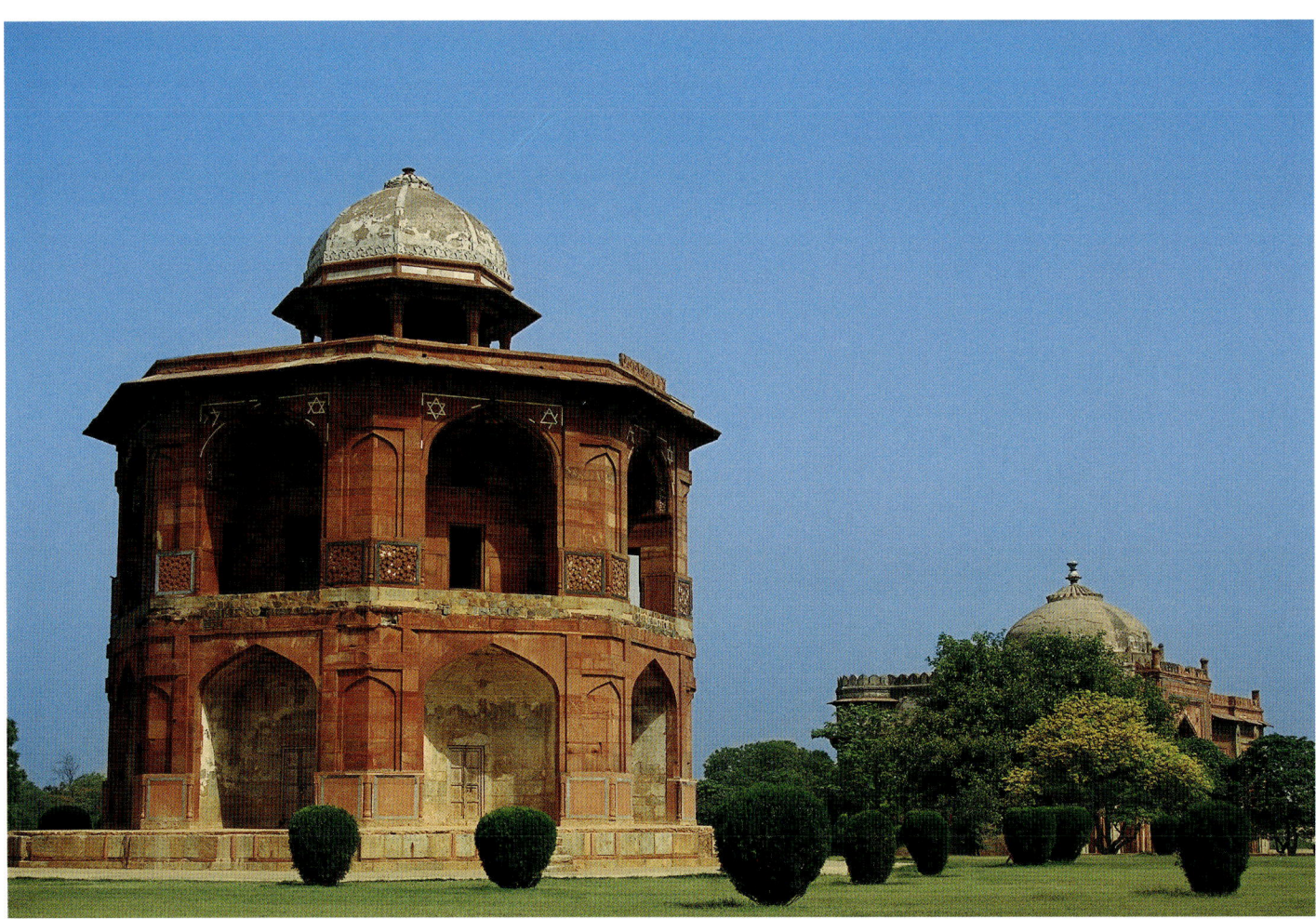

Clockwise from top:
Ruins of palace at Firozshah Kotla; Ruins at Tughlaqabad; Sher Mandal at Old Fort, Delhi

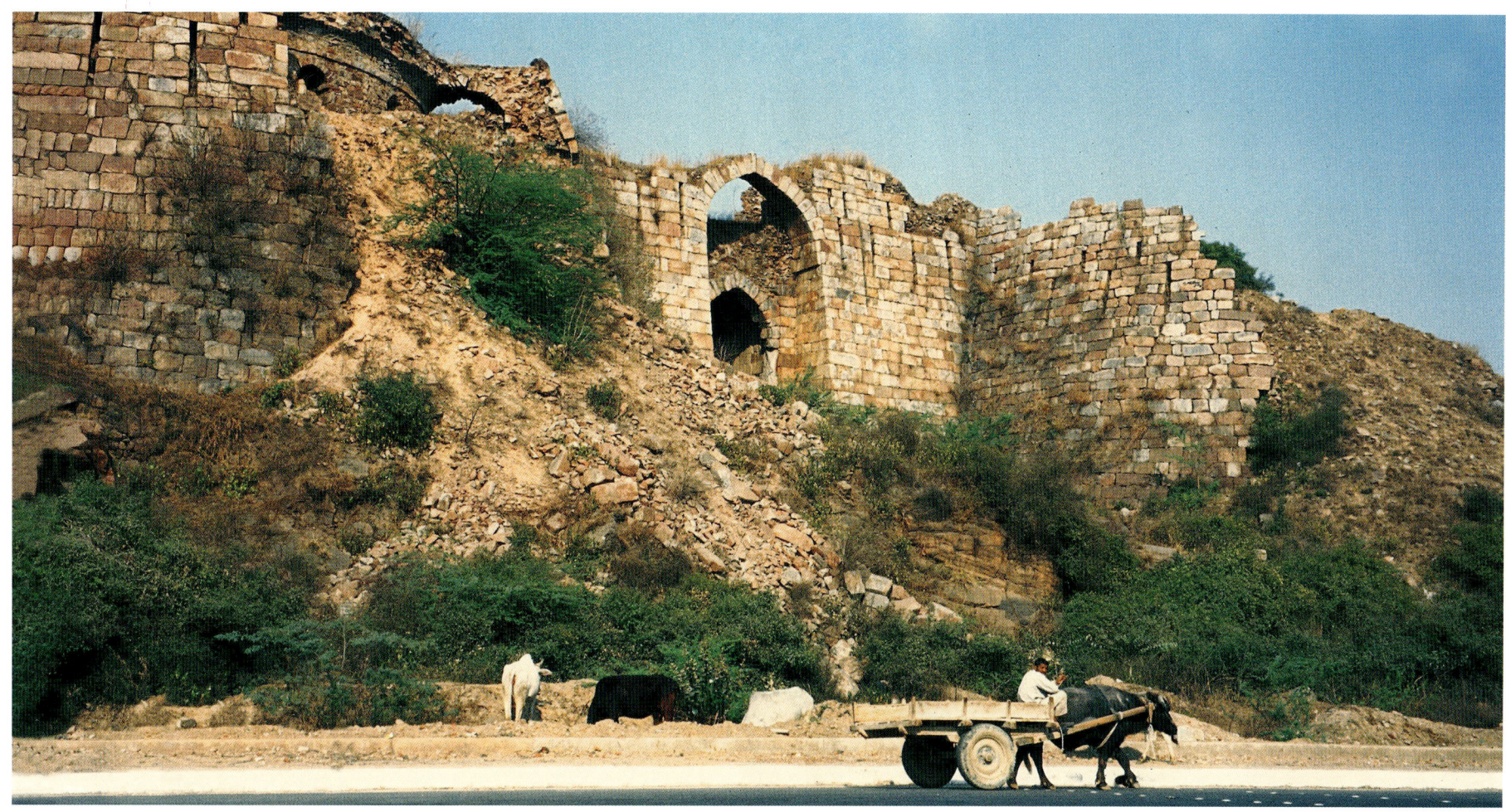

sultan's residence. Within three years of continuous work, the Tughlaqabad fort was nearly complete in 1323 CE. In every asepect of its construction, the fort structure illustrates the typical features of the Tughlaq architecture: use of battered ramparts and little or sparing ornamentation. The savage splendour of Tughlaqabad was greatly enhanced by the use of mammoth blocks of stones on the great exterior walls which required tremendous labour and engineering skill. Sultan Ghiyasuddin Tughlaq ruled only for four years (1320-24 CE). Before the fort could be fully completed, the *sultan* died and Tughlaqabad was abandoned to decay.

It is generally believed that Tughlaqabad was cursed by Hazrat Nizamuddin Auliya, the renowned Sufi saint of Delhi. An interesting episode of conflict between the state and religion took place when Ghiyasuddin forbade his men to work at the *baoli*, then under construction, because it delayed work at the fort. Nizamuddin miraculously caused water to emit light to facilitate work at night. When matters became too bad, the saint cursed the city of Tughlaqabad: "*Ya rahe usar, ya base gujjar*" (Either it remains barren or else it be peopled by men of the Gujar tribe). The Sultan, then out campaigning in Bengal, heard this and swore to settle scores with the saint on returning to Delhi. Nizamuddin quietly said "*Hunuz dilli dur ast*" (Dilli is yet far away).

It so transpired that when Ghiyasuddin returned to Delhi, his son Muhammad arranged a reception for his father at Afghanpur, a village outside Delhi. A grand wooden canopy was erected on this occasion. During the reception, one of the elephants put its foot on the wooden contraptions causing the canopy to collapse over the Sultan and his infant son, killing both instantly. Ghiyasuddin Tughlaq failed to reach Delhi. Muhammad Tughlaq was crowned the new sultan but he had no wish to occupy the fort built by his father. Muhammad Tughlaq abandoned Tughlaqabad. Both the prophecies of the saint came true. Ghiyasuddin failed to return to Delhi and Tughlaqabad lay deserted frequented only by cowherdmen (*gujars*).

The tomb of Ghiyasuddin Tughlaq stands within a small fortress surrounded by a vast open reservoir, now dried up. A 550 mt long causeway raised on 27 arches connects the fort with this tomb. The fortress, pentagonal in plan, has conical bastions at the angles and the only entrance to its inner court is through a heavy doorway built in the lintel and bracket style. The extreme batter of the battlement walls contributes immense strength to the structure and the formidable exterior. The vestibule containing the ascending steps is actually a trap with a blind turn to thwart any sudden invasion. The inner court has arcades on the three sides containing underground vaults where Ghiyasuddin Tughlaq, his infant son Mahmud who died with him under the canopy, and the queen Makhdum-i-Jahan.

At the north-eastern corner of the court is Dar'ul Aman, an extremely sanctified area. It is a small octagonal, domed pavilion where at the centre lies Zafar Khan, a son of Ghiyasuddin who had predeceased the *sultan*. The other grave belongs to Muhammad Tughlaq whose coffin was brought to Delhi from Sehwan by Firoz Shah Tughlaq for an official burial. Guided by piety and a determination to exonerate his predecessor of the latter's crimes against the people, Firoz Shah paid large sums of money to survivors or heirs of people killed or incapacitated by Muhammad Shah and secured their deeds of pardon: "These deeds were put into a chest which was placed in the Dar'ul Aman at the head of the tomb of the late Sultan in the hope that God in his great clemency would show mercy to his late friend and patron and make these people reconcile to him". Dar'ul Aman was the safest place even for the most serious criminals to hide themselves beyond the reach of law.

The small Adilabad fort, near Tughlaqabad, was built by Muhammad Tughlaq 1325 CE. Built on the architectural plan of Tughlaqabad,

Adilabad is a small but strong fort. It has huge bastions, gigantic ramparts and contained a thousand-pillar hall. There are two gateways, one with barbican between two bastions on the south-east and the other on the south-west. East of Adilabad stands the smaller fortress called Nai-Ka-Kot. It was Muhammad Tughlaq's residence before he occupied Adilabad. Both these forts are now reduced to sheer heaps of stone, and excavations have not brought to light anything of particular importance. Among the more ambitious plans of Muhammad Tughlaq was his project of building Jahanpanah. He intended to unite the existing cities of Mehrauli, Siri and Tughlaqabad within a single wall but abandoned the plan in view of the enormous expenditure involved in executing it. Only some portions of the wall have survived to this day.

Muhammad Tughlaq, it is believed, also built a thousand-pillar hall in Jahanpanah, outside the walls of Siri. Its splendour fascinated the ladies of Timur's harem. It is recorded in the Zafarnama: "The wife of Jahan Malik Agha and other ladies went into the city to see the palace of the Thousand Columns (*Hazar Sutun*) which Malik Juna (Muhammad Bin Tughlaq) had built in the Jahanpanah". Badi Manzil or Vijay Mandal is today identified as the ruins of the palace built by Muhammad Tughlaq. Ibn Batuta called Muhammad Tughlaq's palace-Dar-Sara where the protocol was extremely terrorizing and the council chamber could be reached after crossing several heavily guarded doors. Sometimes, these ruins are mistaken for the hazar sutun built by Alauddin Khilji. Vijay Mandal, however, remains the only building in Jahanpanah ascribed to Muhammad Tughlaq.

The rubble-built octagonal structure of the upper portion of the Vijay Mandal commands a prominent location. The set of oblong rooms in the lower storey is at level with the rocky surface of the hillock. The rooms have two large holes-all that remains of the vaults of the treasury. South Indian gold coins were found in these vaults. Both Malik Kafur, Alauddin's general and Muhammad Tughlaq himself had plundered the Deccan kingdoms and brought enormous treasures to Delhi from the tower, the sultan viewed elephant processions and inspected his troops. Ibn Batuta records that the thousand-pillar hall raised on wooden columns functioned as the audience hall of Muhammad Tughlaq. It measured 300 feet by 210 feet. Perhaps, both Alauddin Khilji and later Muhammad Tughlaq held court here.

On the northern side of the Vijay Mandal can be seen the cluster of graves belonging to Sheikh Hasan Taher and his men who visited Delhi during the reign of Sikandar Lodi. He lived here and died in 1503 CE.

Firoz Shah Tughlaq, the third Tughlaq sultan, ascended the throne in 1351 CE, and ruled for thirty seven years without any remarkable military campaign. He had learnt his lessons from history and was fully aware of the critical shortage of water supply in the southern part of Delhi. Maintenance of Hauz-i-Shamshi and Hauz-i-Alai (Hauz Khas) was a great burden on the state. He moved his capital north of Nizamuddin at Kotla, overlooking the Yamuna river. Here, Firoz Shah built a strong citadel. This was destined to be the last capital fortress of the Delhi Sultanate. The Kushk-i-Shikar on the riedge was the northern most limit of Firozabad and stretched right upto Mehrauli including the *Kasba* (small settlement or town) of Indrapat.

Firoz Shah Kotla, 'the Windsor of the Sultanate' contained some impressive palaces: Mahal-i-Sahan-i-gilin (Palace of the Clayey quadrangle), Mahal-i-chajja-i-chobin (palace of the wooden gallery), and Mahal-i-bar-i-aam (Palace of the public court), all joint together by long winding corridors and underground passages. Palaces at Firoz Shah Kotla, like palaces in all other parts of Delhi, were devastated by Timur who carted away not only gold, silver and diamonds but even marble, removed from these palaces along with hundreds of architects and masons who had created these architectural landmarks in Delhi. Mercifully, the Ashokan Pillar from Topra, near Ambala, brought to Kotla and installed over a pyramidal structure by Firoz Shah in 1367 CE was spared the wrath of Timur. The other Ashokan Pillar removed from a palace near Meerut and installed on the northern ridge also survived the invader's fury.

The Jami Masjid at Kotla is in ruins today, deprived of its glorious dome and decorations which so fascinated Timur. The cloisters on all sides have disappeared. The mosque is raised on a terrace of vaulted chambers and is reputed to have space enough for ten thousand men at prayer. The cloisters were supported on 260 stone columns, each nearly 16 feet high. The centre of the courtyard lay under a 25 feet high octagonal dome upheld by a gigantic shaft on which Firoz Shah had inscribed his achievement. The whole structure was grand with a marblesque finish made possible by the use of *chunam* (lime plaster). In the thickness of the western walls are built covered passages to let the royal ladies attend prayers at the mosque. The domed entrance on the northern side alone has survived to this day. It is learnt that the ruins at Firoz Shah Kotla provided the building stones for Shahjahan's fort.

The city of Firozabad and the fortress built by Firoz Shah Tughlaq in the 14th century CE was the last building project on such a massive scale.

Clockwise from left:
19th C paintings depicting Royal palaces within the Red Fort, Delhi; Gateway of the Old Fort

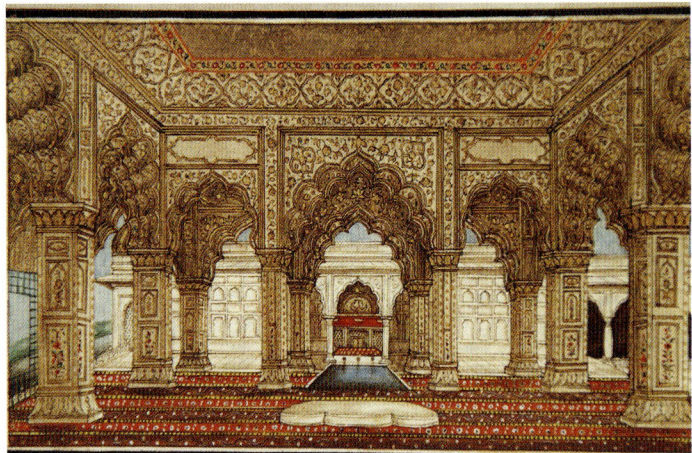

The Sayyads and Lodis who held Delhi after the Tughlaq rulers inherited an impoverished treasury and extensive ruins. They built no new fort or palace in Delhi. Prof. Gavin R.G. Hambly correctly states: "Timur's visitation of the city... marked the demise of the Delhi Sultanate as it had evolved under the rule of the Ilbari Turks, the Khiljis and the Tughlaqs. After his departure, the city itself was a burnt-out shell, and the Delhi Sultanate merely one among a number of rival sultanates, surviving in this fragmentary state until the coming of the Mughals in 1526."

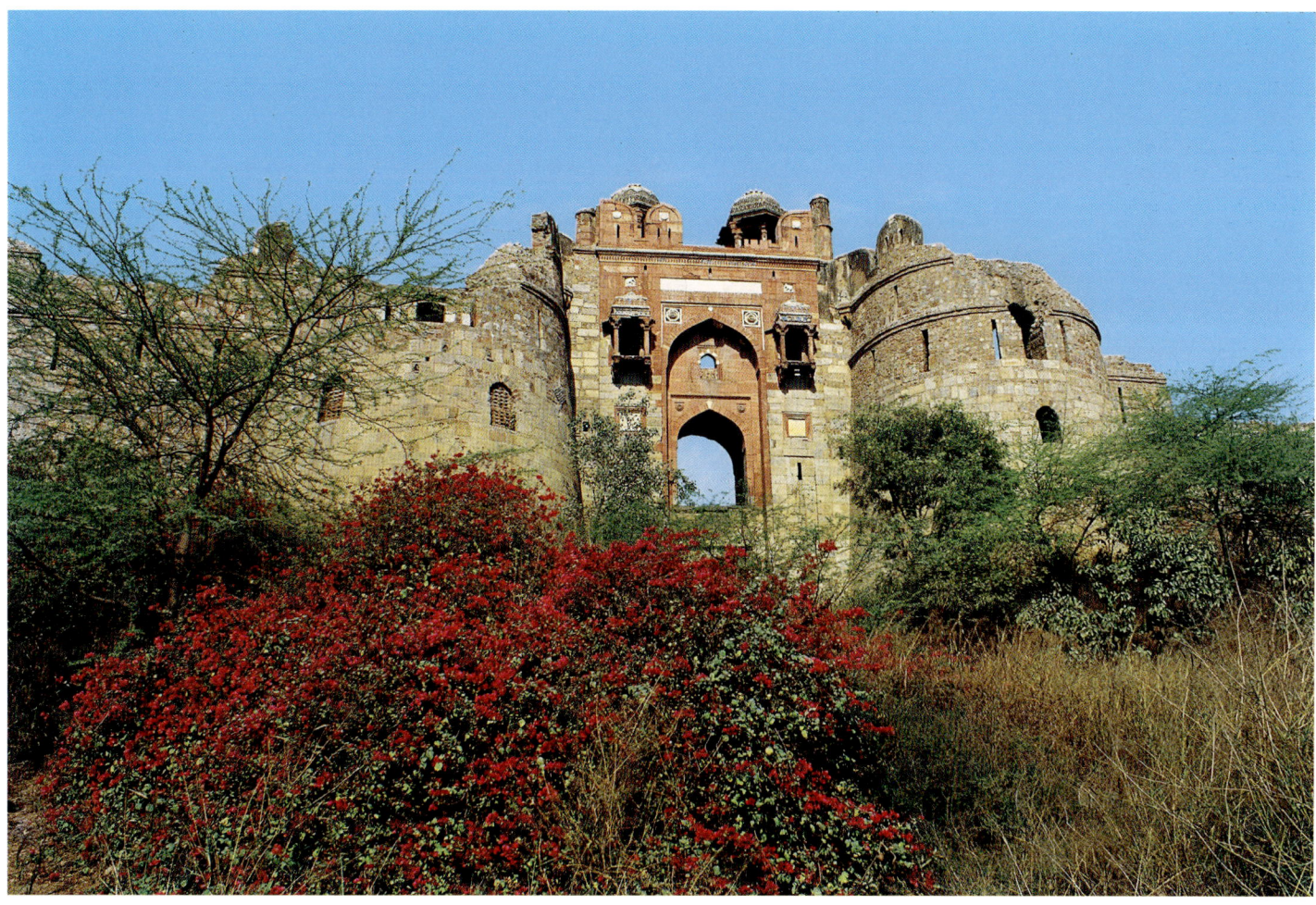

Forts of the Mughal period

The Mongols had set their eyes on Delhi for a long time. In fact, they made twelve invasions between 1245 and 1329 CE and finally descended on the ancient north Indian capital city as an invincible force led by Babur who defeated Ibrahim Lodi at Panipat in 1526 CE to establish the great Mughal empire. Babur preferred to stay at Agra, the Lodi capital. Babur's successor Humayun chose to find a new city in Delhi. He found the city of Dinpanah on the ancient site of Indraprastha, the capital of the Pandavas in the epic Mahabharata. Humayun dreamt of a large city "the ramparts of which from their loftiness might open the tongues of reproach and scorn at Khawarnak and Sawir, the palaces of Bahram, and that the keeper of its bastions might claim equality with Saturn. Also, that in this city a magnificent palace of seven storeys should be created…" The plan was put into action. In 1538 CE, within five years of its commencement, the fort of Dinpanah was ready with its high walls, ramparts and magnificent gateways. The building material was obtained from the ruins of Siri and Kotla-cities founded by Alauddin Khilji and Firoz Shah Tughlaq.

The gates at Dinpanah, (presently called the Purana Qila or the Old fort) built of red sandstone, are double storeyed and surmounted by *chattris* in the Rajput style. The northern gateway, called the Talaqui Darwaza (forbidden gate) has Islamic pointed arches, oriel windows, a solar orb and the image of a man in combat with a leogryph. The southern gateway, called the Humayun Darwaza, is like the Talaqui Darwaza. It has been closed with brickwork. The river Yamuna which used to flow under the eastern wall has receded too far away. The gateway on the western ramparts is called the Bada Darwaza. It is a massive construction with a central pointed arched entrance flanked by rounded bastions. On the inner side, the rampart wall has a two-bay depth to facilitate secret movement of the troops. Unfortunately Humayun lost his kingdom to the Afghan chief Sher Shah in 1540 CE and had little time to build palaces or towers within the fort.

Sher Shah decided to build Sher Garh, his own new fort and city. It is generally believed that Sher Garh was founded on the site of Dinpanah. Abdulla recorded in Tarikh-i-Daudi that Sher Shah built his fort "on the bank of the Jun, between Firozabad and Kilu Khari, in the village of Indrapat, a new city, about two or three *Kos* (distant) from the old one. He filled it with inhabitants, as it remains today". General Cunningham offers another view: "The southern gate of Sher Shah's city must have been somewhere between Barapul and Humayun's Tomb. The eastern wall of the city is determined by the line of the high bank of the Yamuna, which formerly ran due south from Feroz Shah's Kotilla towards Humayun's tomb. On the west, the boundary line of the city can be traced along the bank of a torrent bed, which ran south of the Ajmer Gate of Shahjahanabad and parallel to the old course of the Jamuna, at a distance of more than a mile. The whole circuit of the city walls was, therefore, close upon a mile or nearly double that of the modern Shahjahanabad".

Despite some controversy regarding the exact location of Sher Garh, it is generally agreed that Sher Shah built his fort at the site of Dinpanah making the necessary changes in the plans of Humayun. The Lal Darwaza, facing the western gateway of the fort, is lined up with the ruins of residential and market areas. The Kabuli Darwaza, also called the Khuni Darwaza, was built at the northern limits of Sher Shah's city.

Inside the fort, there are two structures built by Sher Shah-Qala-i-Kuhna mosque and a double storeyed pavilion called Sher Mandal. The Mosque is noted for its architectural refinement and a general impression of

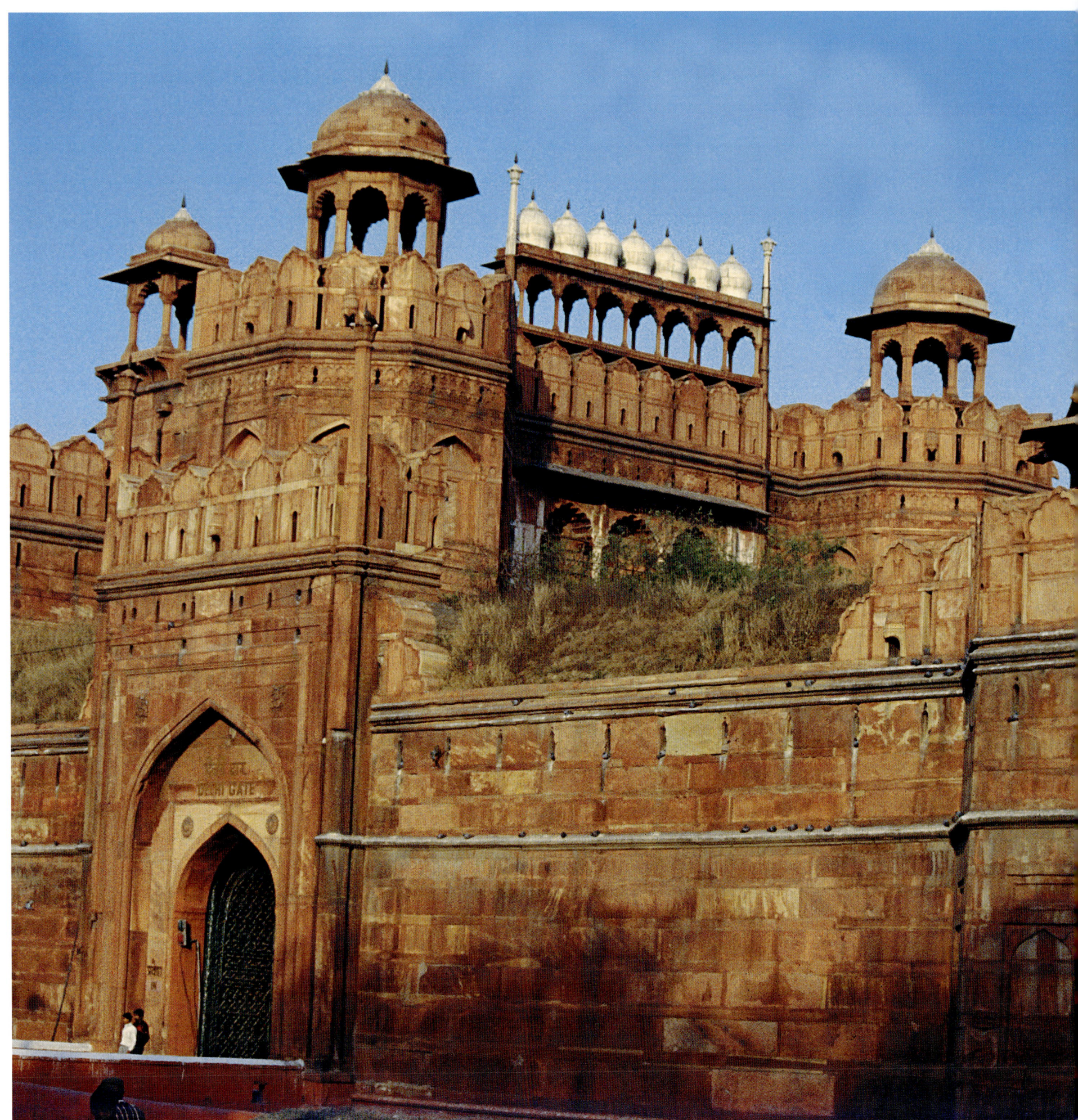

strength. In harmonizing the various architectural components and surface ornamentation, Sher Shah's mosque is a much improved version of the Jamali Kamali Masjid. The single bay prayer hall measures 51. 20 mts. by 14.90 mts. The five arched façade is very impressive. Each arch is set within a larger reacessed arch. The central arch set within a rectangular frame, with narrow turrets on either side has fluted mouldings inspired by stellate flanges of the Qutub Minar. These turrets culminate in the small pinnacle over the upper corners of the central frame.

The mosque carries some distinctive features. The lotus bud fringe and the rosettes on the spandrels; an oriel window set within panels inlaid with marble and a decorative application of marble on panels etc.The central *mihrab* is a showpiece of great craftsmanship in stone. The treatment of the imposts, foliation of the arch, elegant borders and a masterly finish by sinking one arch into another recessed arch, bespeak highly of the man responsible for such an artistic work done during those trouble-torn days. Most noteworthy is the use of the squinch, stalactite and semi-vault of an unusual design on the 'phase of transition'. This mosque, attributed to Sher Shah, is amongst the most beautiful mosques in India.

The only other structure at the fort is the Sher Mandal, an octangonal double storeyed tower in red sandstone. A grand octagonal domed *chattri* is placed on top of this structure. It was used by Humayun as his library and perhaps the young Akbar got his lessons in painting here from Mir Syed Ali and Khwaja Abdus Samad, the two painters brought by Humayun from Persia. The Sher Mandal is mentioned as the tower from whose steps Humayun fell down as he knelt down in prayer. His feet got entangled in the flowing robe, causing his fall. Humayun was fatally injured in this accident on January 24, 1556 CE and died three days afterwards. His dead body was kept in the rooms on the ground floor, which are now closed. Small rooms on the upper floor are arranged in a cruciform fashion. The Sher Mandal carries only a very restrained decoration in white marble and blue tiles.

Salim Shah (1545-54 CE) who succeeded Sher Shah built a small fortress called Salim Garh on the Yamuna river in 1546 CE. It was built as a bulwark against the return of Humayun from Persia where he had gone to seek the help of Shah Thamasp in defeating Sher Shah. Salim Garh is noteworthy for its lofty and thick rubble-built ramparts and circular bastions. Standing on the north-east corner of the Red fort, Salim Garh offers fine views over the riverside. Later, the Mughal kings used Salim Garh as a prison for troublesome heirs and claimants to the throne.

Akbarabadi Gate at Red Fort, Delhi

After Humayun's death in 1556 CE, the days of Delhi as the capital city were numbered. Akbar began his rule at Dinpanah but was soon disenchanted with it and moved to Agra. He was to build the great Red fort there, on the site of the Lodi mud fort and an entirely new city at Fatehpur Sikri, besides building forts at Allahabad and Lahore. Jahangir moved between Agra and Lahore. Shahjahan, the fifth Mughal emperor, also liked Agra but after the death of his beloved queen Arjumand Bano Begum, also called Mumtaz Mahal, he decided to build an entirely new city of Shahjahanabad in Delhi, which had witnessed the rise and fall of so many dynasties of kings from the most ancient times of the Mahabharata. His great-great grand-father Humayun had built Dinpanah but that was a short-lived period in Mughal history. Shahjahan chose a new site for his city, lying north of Dinpanah. In Shahjahan, Delhi got its greatest lover who embellished it with great buildings as no other king had done in the past. Shahjahan built the last and most beautiful Mughal fort in Delhi and also the Jama Masjid which is the most splendid architectural work in the Mughal Delhi.

Red Fort, Delhi

The new capital had to be the *axis mundi*-the centre of the earth and the intersection of the celestial and the mundane; hence the new choice had to be perfect. The city of Delhi fulfilled these requirements well for its two-fold significance: it had been the seat of the Muslim Kings since the

days of Qutubuddin Aibak and was also the seat of Islam (*markaz-i-dairah* Islam), also, according to Muhammad Salih, Shahjahan's court historian, "its four walls... enclosed the centre of the earth" (*markaz-i-khak*). Afer some deliberations it was decided to find the new capital at Delhi and on May 12, 1639 CE the foundation of the city was laid amid great rejoicings and celebrations. Within 9 years, 3 months and a few days the new fort was completed in 1648 CE. The citadel in red sand-stone was called Qala-i-Mubarak, the fortunate citadel. Since it was to occupy the centre of Shahjahan's new city, the fort was also called Qala-i-Shahjahanabad. Towards the end of the Mughal rule, the fort was called Qala-i-Mualla. This huge fort was built on a site along the river, between Firoz Shah Kotla and Salim Garh. The Red fort has a circumference of about 2.5 Km.

When the emperor rode in a procession to occupy the Red Fort, most of its structure was fully completed and furnished to receive the royal occupants-Diwan-i-Aam, Rang Mahal, Mumtaz Mahal, Diwan-i-Khas, royal baths etc. The gardens, markets and workshops were also ready. Entrance to the fort was provided through two imposing gateways-the Lahori Gate in the west and the Akbarabadi Gate on the south side. The great battlement walls secured the royal household within a great heaven on earth. The fort itself was the centre of a walled enclosure which girdled the main residential area on three sides. Many residential sectors in the city, surviving since the buildings of Firoz Shah's Kotla-Bulbuli Khana, Kalan Masjid, Ballimaran and the area around Turkman Gate were enclosed within the walled city of Shahjahanabad. The original mud walls were soon replaced by walls in stone to prevent damage by rain.

The fort was designed in the shape of a bow, with the straight riverside forming the string. Both Hindu and Muslim principles of architecture were employed to give it strength and beauty. The semi-elliptical design called *karmuka* (bow) was found especially suitable since the river Yamuna formed one side of the fort and the city. The north-south road between the Akbarabadi Gate and the Kashmiri Gate on the outer wall represented the bow string. As Prof Stephen Blake explains: "Streets connecting city gates;those running from south to east and connecting the Turkomani and Ajmeri gates with the Lahori Gate represented, along with the outer wall of the city, the curved shaft of the bow. Chandni Chowk, which ran from the Lahori Gate of the fort to the Lahori Gate of the city was the arm of the archer.In a city laid out according to the *karmuka* plan, the most auspicious spot was occupied by the temple of Vishnu or Shiva. In Shahjahanabad the palace fortress of the emperor stood at this location, the meeting place of Chandi Chowk and Faiz Bazar". The location of the fort at Shahjahanbad justified the name Qala-i-Mubarak.

The Red fort was the centre of a flourishing city with rich and magnificent markets-Chandni Chowk and Faiz Bazaar besides numerous other mandis. Many *kuchas*, *katras* and *muhallas* had grown into densely populated areas around the grand *havelis* of ministers and nobles. The whole city was supplied water through the canal built by Ali Mardan Khan and ran through the gardens, markets and residential areas of the walled city before entering the fort. In front of the fort was built the most prominent and beautiful Jami Masjid. Shahjahanabad was embellished with many other small but splendid mosques built by the queen and princesses. The most prominent garden- Begum Ka Bagh was built by the emperor's favourite daughter Jahanara Begum. This garden lay on the northern side of Chandni Chowk, also created by Jahanara.

The first important structure in Red fort, as one enters from the Lahori Gate is, Chatta Chowk, an arcade market. This roofed passage is "the noblest entrance known to any existing palace", as Fergusson describes it. This was the shopping centre for the royalty. It measures 266 feet in length and 22 feet in width. The central Gothic arch, the long vaulted aisle and the octagonal open court in the centre made it a unique architectural feature of the fort. At the end of the passage is a courtyard surrounded by a colonnade and used by the emperor's guards and officials. On the other side stands the Naqqar Khana, a double storeyed massive structure where the royal musicians played five times a day. Visitors to the fort pass through this gateway before reaching the Diwan-i-Aam. In a zealously maintained tradition all, except the royal princes, had to dismount from their horses at this gate, breaking this etiquette at their own peril.

The Diwan-i-Aam, hall of public audience, was at one time resplendent in its original covering of white shell plaster and gilding over the red sandstone pillars. It stands on a plinth of four feet height, measuring 185 feet by 70 feet with a 30 feet high ceiling. The hall is divided by pillars into three aisles with nine compartments each, and each compartment is formed by four pillars 16 feet apart supporting engrailed arches standing between the back wall and the façade. The most conspicuous part of the Diwan-i-Aam is the marble throne or '*baldachino*'- *Na-shiman*.... *Zilli-i-Illahi* (seat of the shadow of God) inlaid with most costly coloured stones. Under it the vizier stood on a white marble platform to present the petitions for royal consideration, surrounded by the whole assembly of *omras*, *Rajas*, nobles and ambassadors. The hall used to be decorated in golden curtains, gorgeous carpets, gold and silver railings. The Italian *pietra dura* work on the throne is marvellous. Flowers, brids and fruits have been depicted exhibiting consummate craftsmanship. The portrait of Orpheus playing the flute to his charmed audience of a lion, leopard and hare is a piece of sheer beauty. After the capture of the fort by the British in 1857 CE, these panels were removed to the South Kensington Museum in Lodon, but restored to their original position at the intervention of Lord Curzon. The standard of craftsmanship on these Italian panels may not compare well with the Taj but it is still of a superior quality. Sitting on the throne the emperor watched the processions of his troops, animals and some exhibitions of human power like cutting through the four tied -up legs of a sheep in a single stroke. The emperor personally listened to all the petitions and dispensed justice on the spot. When he retired the fall of a red curtain announced the closure of the day's proceedings.

The Mumtaz Mahal, palace for the royal seraglio, stood just behind the Diwan-i-Aam, built along the river front like most other palaces. It was a splendid palace in its heydays, being coverd with white shell plaster. Recent excavations at the Red Fort have revealed a square pool in front of the structure, with a small marble basin at the centre. Many such pools and water channels got buried under the earth and debris of the palaces and the corridors between these structures when the British demolished many structures only to provide space for the troops housed within the fort.

The Rang Mahal used to be the most lavishly decorated palace which, it is said, "in excellence and glory surpasses the eight-sided throne of heaven and in lustre and colour is far superior to the palaces in the promised paradise".This rectangular palace was decorated with the most gorgeous furnishings. The original silver ceiling was removed during the reign of Farrukhsiyar and replaced with one of copper; which again was removed and replaced with a wooden ceiling during the rule of Akbar II. The semblance of its former glory has not yet entirely faded away. The most enchanting central basin, carved in the shape of a full-blown lotus with dexterously fashioned petals set amid water channels is a specimen of exquisite craftsmanship. This lotus is carved out of a single marble slab brought from Makrana in Rajasthan. The Rang Mahal hall consists of fifteen bays, each twenty feet squares divided by ornamental piers. The riverside wall is pierced by five windows through which the ladies could watch elephant fights arranged on the *reti* (sand stretch) below the ramparts.

North of the Rang Mahal is the emperor's special apartment, called Aramgah or Khwabgah (sleeping apartment). A single wall placed on the water channel is a gem of fabulous carving, so intricate and delicate in design and extremely fragile-looking. The octagonal tower for *jharokha-i-darshan* stood on the eastern wall. Each morning the emperor's morning rituals would begin with the customary appearance at the balcony and

Khwabgaah, Red Fort

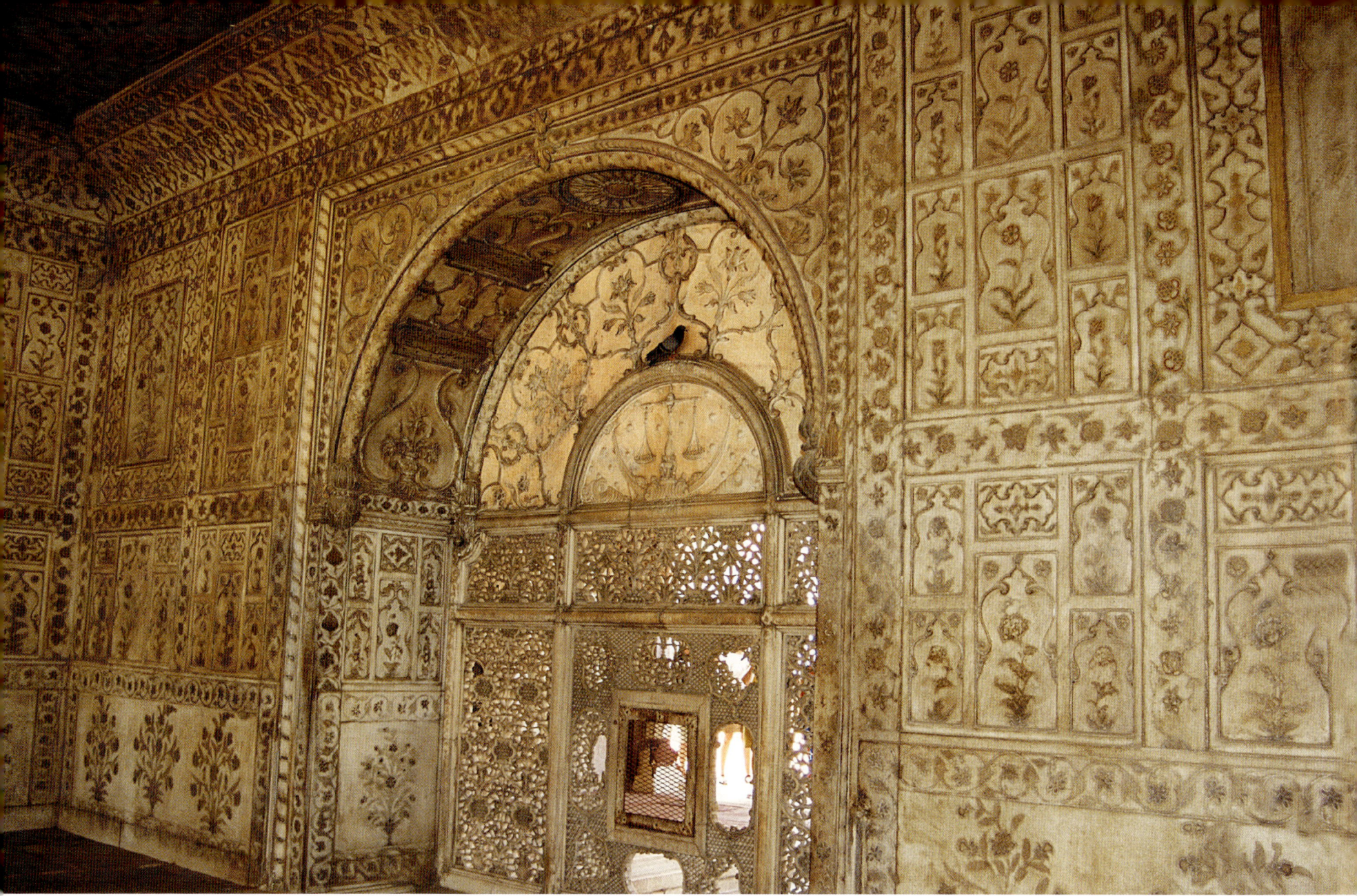

listening to petitions, if any. These apartments were covered with glorious decoration in floral motifs over the walls and ceilings creating an extremely pleasant interior.

The Diwan-i-Khas or the Hall of Private Audience stood north of the *Aramgah*. More than any other structure in the Red Fort, the Diwan-i-Khas has witnessed scenes of both sheer splendour and degradation, associated with the rise and fall of the Mughal empire. Here the emperor sat in consultation with princes and ministers for very crucial decisions. It was the show-piece of royal spelndour. The *pietra dura* on pillars of pure white marble is excellent. Cornelieas, corals and other precious stones are inlaid on the *dado* and *guldastas* inlaid on the square base of the pillars. The ceiling in pure silver cost nearly 39 lakh rupees. In 1760 CE this ceiling was removed and sold by Sadasiva Rao Bhao. The marble dais, on which stood the world - famous Peacock Throne of Shahjahan, stood at the centre. The throne was valued at £ 12, 037,500.00 by the contemporary traveler Tavernier. In 1739 CE the Persian invader Nadir Shah captured it and carried it to Persia where it was ultimately dismantled.

Just below the ceiling on a panel are inscribed the famous lines of Amir Khusro: "if there is a paradise on the face of the earth, it is this, it is this, it is this". Here Shahjahan sat on the Peacock Throne, the epitome of Mugal splendour and power. But the Diwan-i-Khas also mutely witnessed scenes of utmost degradation of the Mughal emperors. Here Nadir Shah humiliated Muhamad Shah of Delhi in 1739 CE. Another Mughal ruler Shah Alam was physically tortured and blinded by the Afghan Ghulam Qadir in August 1788 CE. In 1857 CE, the last Mughal ruler Bahadur Shah was tried for treason by the British and banished from this 'paradise on earth'. This brought the curtain down on the Mughal rule in India afer nearly three hundred and twenty two years since its founding by Zahir Muhammad Babu in 1526 CE. The Diwan-i-Khas was the stage where the scenes of glory and downfall were enacted.

The legendary Mughal grandeur is summed up in a detailed description of the Peacock Throne or the Takht-i-Taus, the grandest showpiece of Shahjahan's opulence in the Badshahnama: "Orders were issued that all kinds of rubies, diamonds, pearls and emeralds the value of which was estimated at two hundred lacs of rupees, and in addition, those in the charge of provincial treasury officers, should be brought for his Majesty's inspection, excepting only the emperor's personal jewels, kept in the jewel office of the heaven-like place.

"Great and valuable jewels, the weight of which was fifty thousand *mithqal* and the value of which was eighty six lacs of rupees were selected and entrusted to Bebadal Khan, the superintendent of the goldmith's office, in order that the jewels might be studded in a slab made of one lac of *tolas* of pure gold, which is equal to two hundred and fifty thousand *mithqals*, and the value of which was fourteen lacs of rupees. This slab was 31/4 by 21/4 imperial *gaz* with a height of five *gaz*.

"It was decided that the inside of the ceiling of the throne should be principally enerald and the rest set with jewels, and that the outside should be adorned with rubies and other precious stones. It was to be supported

by twelve emerald coloured columns. Above the ceiling two images of peacocks, set in bright gems, were to be made and between them a tree of rubies, diamonds and emeralds and pearls was to be fixed. To ascend the throne three steps studded with beautiful gems were to be prepared.

"In the course of seven years, this heaven like throne was completed at the cost of a hundred lacs of rupees which are equal to three hundred and thirty three thousand *tumans* of Iraq and to four crore *khani* current in Transoxinia. (Mawarau-n-Nahr)."

A verse inscribed inside the throne concluded an exaltation of Shahjahan:

"As long as a trace remains of existence and space,
Shahjahan shall continue to sit on the throne.
May such a seat be his throne everyday,
Which was the tribute of seven climes under one of its steps
When the tongue asked the heart for its date,
It replied "This is the throne of Shahjahan".

The chronogram Aurang-i-Shahnishah-i-Adil mentions the date A.H. 1044 (A.D. 1634). The Takht-i-Taus was amongst Nadir Shah's proudest possessions as part of the loot along with the world's most effulgent and costliest diamond- the Kohinoor.

The royal baths or *hammams* are located north of the Diwan-i-Khas and held a ceremonial importance in the scheme of architecture at the Red Fort. The *hammam* is made entirely of white marble and has different compartments to serve different purposes. Decorated with mosaics, coloured-glass windows and inlays with semi-precious stones, the structure formed a part of the royal palaces facing the river. This line of structure on the eastern wall of the fort terminates at the three-tierd octagonal corner tower called Shah Burj. It was one of the most ornamented buildings and was meant to be a pavilion of pleasure for the royalty. A pavilion in white marble is attached to the Shah Burj. It has a marble scalloped basin with a sloping marble chute. The most noteworthy feature appears in the highly ornamental, heavily sculptured engrailed arches and the baluster columns. The Nahr-i-Bahisht (stream of Paradise) flowed through these pavilions before being channelized into the two gardens- Hayat Baksh and Mahtab Bagh with two beautiful pavilions called Sawan and Bhadon after the two months of the Indian rainy season. The Nahr-i-Bahisht, designed by Ali Mardan Khan, flowed through every royal apartment and was really the chief source of sustenance in the life within the fort.

Besides Shahjahan, Aurangzeb also made a significant addition to the fort. He constructed the barbican in front of the Lahori Gate. The small but exquisitely designed mosque-Moti Masjid was built for the exclusive use of the royalty. Aurangzeb found it inconvenient to visit the Jami Masjid for this purpose. The three domes of the mosque appear a little disproportionate and the courtyard is too cramped for space. Whereas in the interior of the Moti Masjid, the columns and the engrailed arches are covered with elegant sculptural excellence with the relief carving on the inner side of the entrance wall depicting two architectural forms-domes and pillars. With the Moti-Masjid a marked decline in the architectural grandeur of the Mughals is all too discernible.

Bahadur Shah II (Zafar) added a red sandstone *baradari* at the central pool between the Sawan-Bhadon pavilions in the garden. Another small structure in marble- the Hira Mahal is equally quite impressive but compares rather poorly with the high standard of Shahjahan's creations. The Red fort contained many other subsidiary structures of no mean beauty but these were removed by the British. The corridors connecting the Diwan-i-Aam with the Rang Mahal were levelled along with a few other structures on the Mumtaz Mahal side. Pools were filled up. Basins were removed. Gardens were destroyed to find space for the hideosus looking barracks.

Previous page:
Khwabgah, Red Fort
Clockwise from left:
Lotus fountain at the Rang Mahal; Royal throne in the Diwan-e-Aam

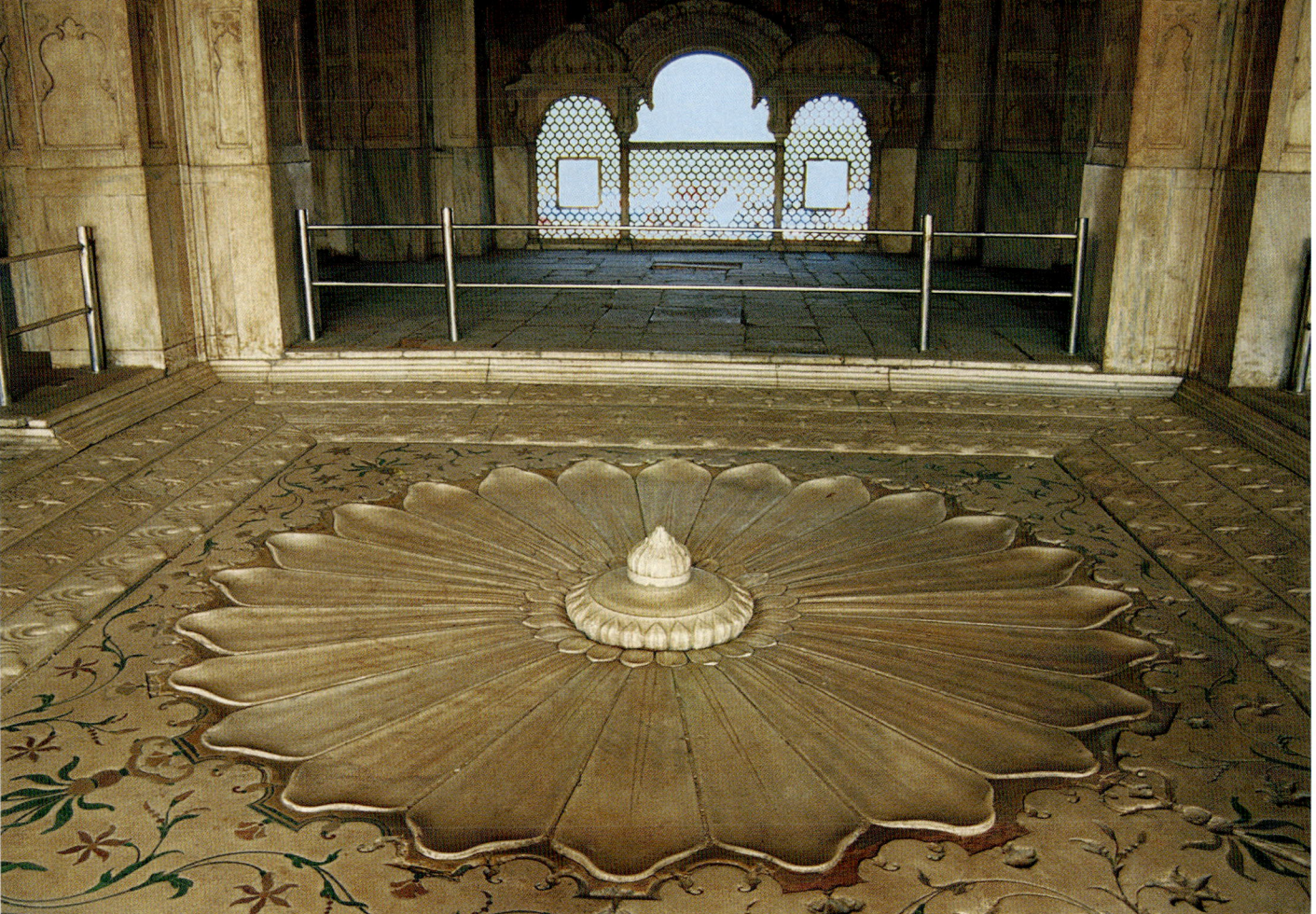

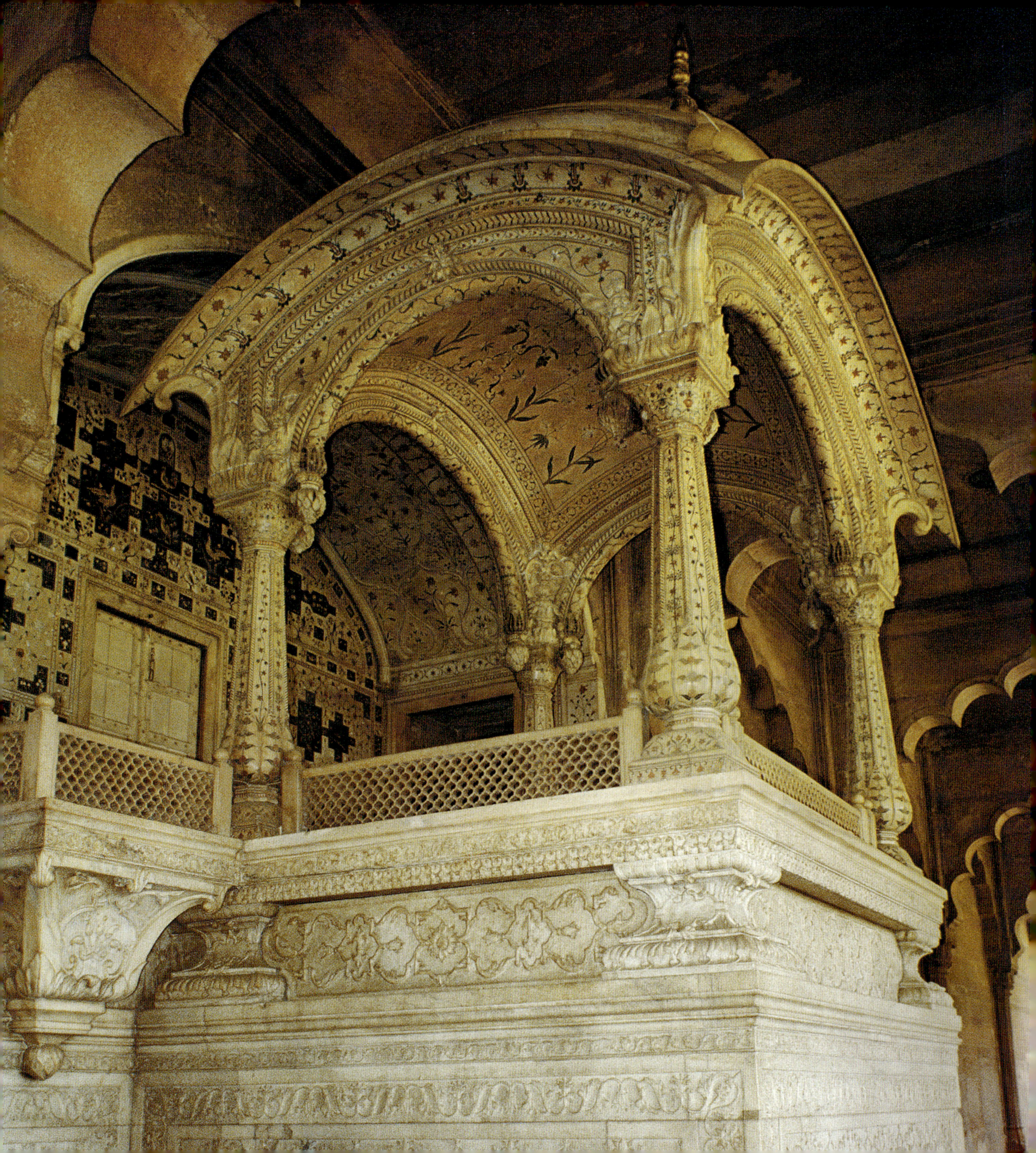

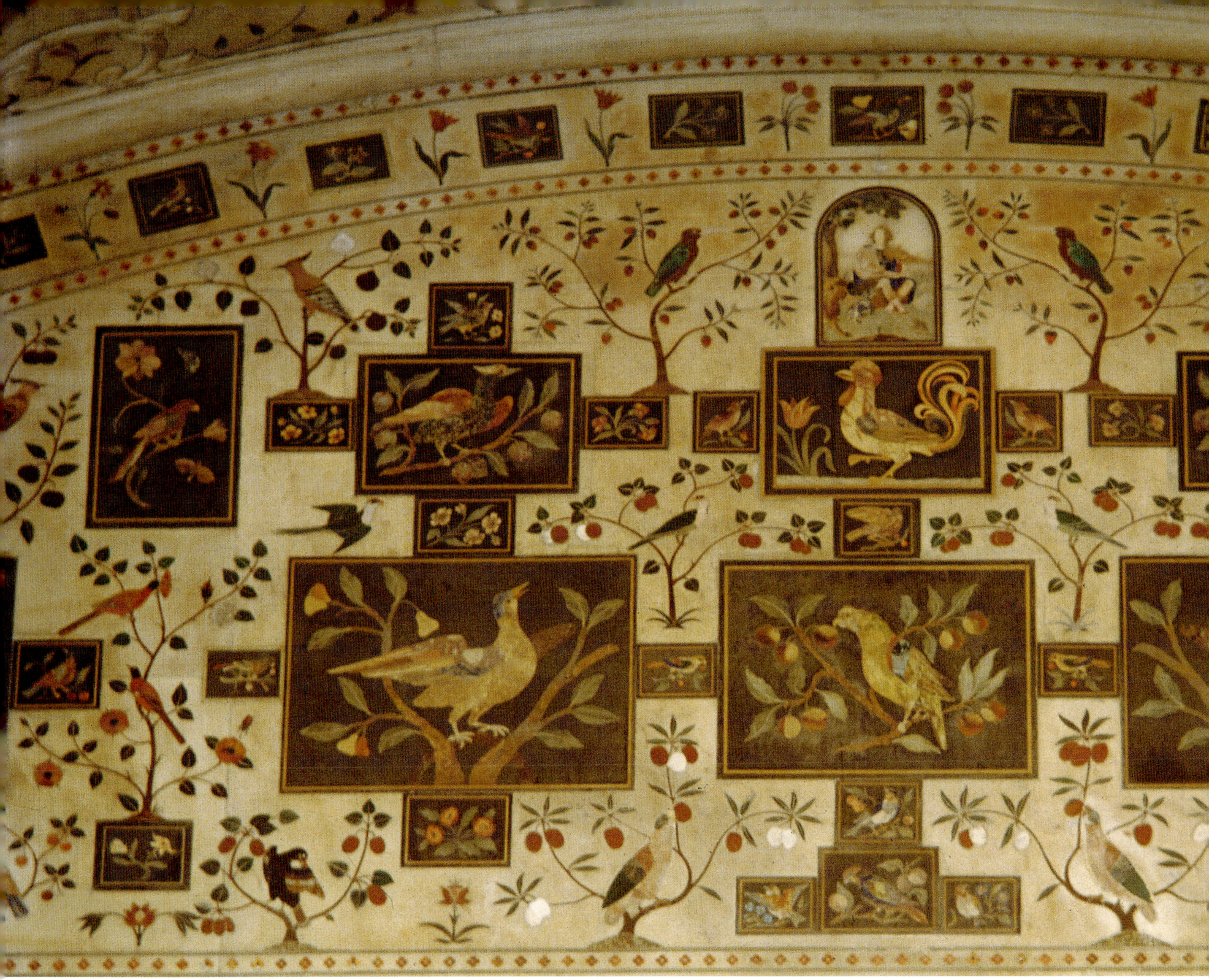

Perceval Spear makes a very perceptive observation regarding the architectural style of the palaces which "relates to the migratory habits of the Mughals themselves. Turks of the Sultanate had enough time in Punjab during which to foreget their nomadic habits but Babur and his begs came almost straight from the steppes and the wilds. Babur spend most of his adult life under canvas (or felt), wandering and fighting, ever on the move, more familiar with tents than palaces. These habits the Mughals brought with them. They expressed them in stone. Their palaces were petrified tents; their *khanas* or halls were *shamianas* anchored with sandstone and marble." The contemporary accounts and miniature paintings depict these palaces standing behind grand awnings for shade and cover.

A closer observation of the architecture of Shahjahan reveals that the planning and massing of the palaces are based on Islamic prototypes outside India. The palaces and pavilions are all single storeyed and stand detached from each other on a plain level ground. At the Delhi Fort these structures are built in a single line over the eastern wall. The horizontality of these compositions is an unmistakable feature of the architectural scheme. The *chattris* and the *chajja* are derived from the traditional Hindu architecture but now "various elements have been modulated to form a new style, with its own logic and conventions. The complicated arrangement of small chambers within the Khas Mahal, for example, shows that even some of the planning priciples were drawn from local traditions; while the *chattris* have been Islamicized by onion domes. Ideas from the two widely differing traditions are here not just assembled, but synthesized. This synthesis is given a particular emphasis by the type of arch, not the Hindus corbelled one, but the cusped arch-a form which had been developed over time by both traditions within India". The use of white marble and profuse ornamentation in *pietra dura* is the other outstanding feature of the

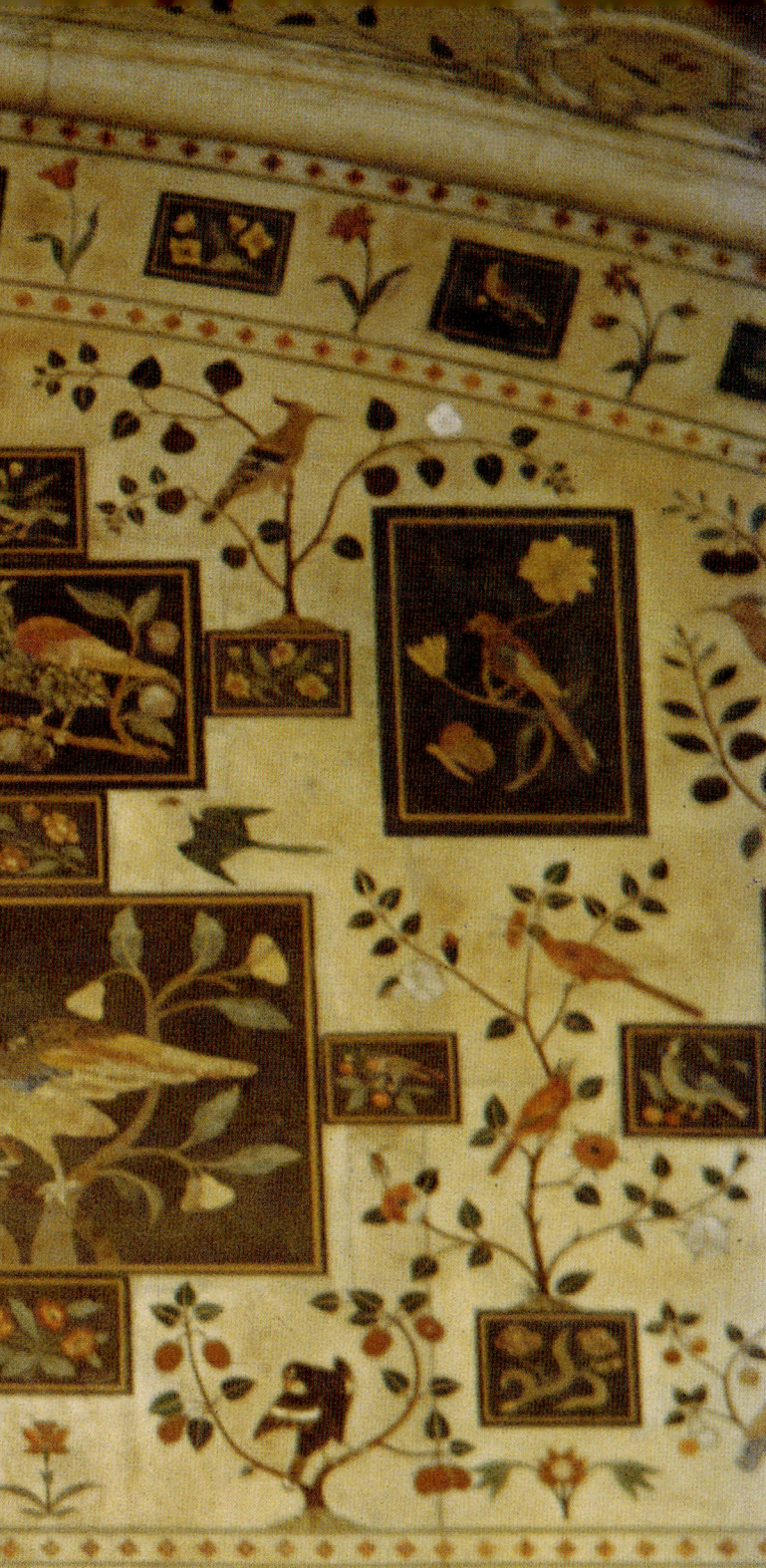

Shahjahani architecture appearing at the fort in Shahjahanabad. In fact there is no structure built by Shahjahan at the Red fort which shows the slightest decline in excellence.

After Shahjahan and Aurangzeb, the Mughal empire suffered a steady decline-Azam Shah, Bahadur Shah I, Jahandar Shah, Farrukhsiyar, Muhammad Shah, Ahmad Shah,Shah Alam,Akbar Shah II and Bahadur Shah II- all pushed the Mughal empire to an inglorious end. To add to their misfortune, came the vandals, invaders and insurgent groups who destroyed all traces of the former Mughal glory.

The Red fort in Delhi witnessed disastrous events; disastrous, because they destroyed the dignity of the Mughals and precipitated the ultimate fall of the empire. On February 11, 1739 CE Nadir Shah crushed the token Mughal resistance at Karnal and was received by the Mughal king Muhammad Shah, a weakling surrendering himself at the mercy of the triumphant invader. The Persians looted Delhi and on Sunday, the 11th March, Nadir Shah witnessed, from the roof of the Roshan-ud-Daula mosque in Chandni Chowk, the massacre of innocent men, women and children from 8 A.M. to 3 P.M. Muhammad Shah begged for mercy for those left alive. When Nadir Shah returned to the fort, he had the Mughal treasures ransacked, emptied the vaults, deprived women of all their jewels, scratched all precious stones from the Diwan-i-Khas, packed up the Takht-i-Taus and, as the last gesture of goodwill, foxed the Mughal king into exchanging his turban with that of his tormentor, and thus, taking possession of the Kohinoor diamond. After the departure of Nadir Shah, only fear, famine and death hovered on Delhi. "Not even a lamp of clay now burns where once the chandeliers blazed with light", says a contemporary eyewitness account.

Nadir Shah's son Allah Mirza was married to Aurangzeb's grand daughter to complete the humiliation and submission of the Mughals. Nadir Shah not only took away the treasure valued at some 70 crore Rupees but also took with him 300 masons, 100 stonecutters, 20 carpenters and 130 scribes to Persia. Interestingly enough, 340 years before Nadir Shah, another Persian invader Timur had wrought havoc on Firoz Tughlaq's Firozabad and taken with him a great number of masons, carpenters and stonecutters and also building material to his capital.

The dust raised by the departing troops of Nadir Shah had hardly settled down on the ravaged face of Delhi when the Afghan Ahmad Shah Abdali descended on Delhi with his marauding bands for another round of general plundering, humiliation and massacre both of the royal loyalists and the common man. Perhaps a littlel less awesome than Nadir Shah, Ahmad Shah was no less determined to sack Delhi and dug deep into the vaults to acquire wheatever was left after the previous sack of the fort. "Everywhere was a terrible emptiness", said Mri Taqi Meer, a contemproray poet and eyewitness. After the devastation of the city and the treasure hunt, the Mughal king had to walk on foot to the Jami Masjid- there was no carriage for him. His horses were also taken away by Abdali who also took away Zuhra, a Mughal Princess, for his son.

The Maratthas caused immense damage to the fort and removed the silver ceiling from the Diwan-i-Khas. In 1788 CE the Rohillas captured the fort, and not finding any treasure, dug up floors in search of concealed vaults and physically tortured members of the royal household, insulted queens and princesses and in sheer frustration blinded the king-Shah Alam. Delhi was a picture of misery and hunger. Frightened for his life, Shah Alam sought succour from the British and on Sept 2, 1803 CE. Lord Lake marched into Shahjahan's fort as if on cue for his entry on the stage. The Mughal King was to be now onwards a mere prisoner of his rescuer and step by step deprived of all traces of royalty. The last Mughal ruler Bahadur Shah II was tried for treason in the Diwan-I-Khas, ironically, standing under the inscription "if there is a paradise on the face of the earth, it is this, it is this, it is this". The British banished him to Rangoon to die in misery and isolation.

For some time, the British toyed with the idea of razing the whole of Shahjahanabad, but eventually, following a disapproaval of the plan, nearly half of the palace complex, including the *zenana* quartes, colonnaded gardens were simply blown up to make room for the garrison and the parades. The *chattris* at the four corners of many a palace were stripped of their copper gild plating by a prized agent. The *pietra dura* panels behind the royal throne in the Diwan-i-Aam were removed and sold for £ 50.00 to the Victoria and Albert Museum, London. These were restored to their original setting at a later date. But the Diwan-i-Aam was used as a military hospital. The ceiling of the Diwan-i-Khas was repainted in black, red and gold instead of the original pattern and the central rose converted into a starfish. The effect was terrible. Cole restored the original red, blues and greens and removed the starfish. The damage done to the structure in the fort was much more in magnitute than the cosmetic restoration. Still, Shahjahan's Qala-i-Mubarak has so much left to be admired for its architectural gems.

Decorative marble panels behind the royal throne, Diwan-e-Aam

JAIPUR, AMBER and SAMODE

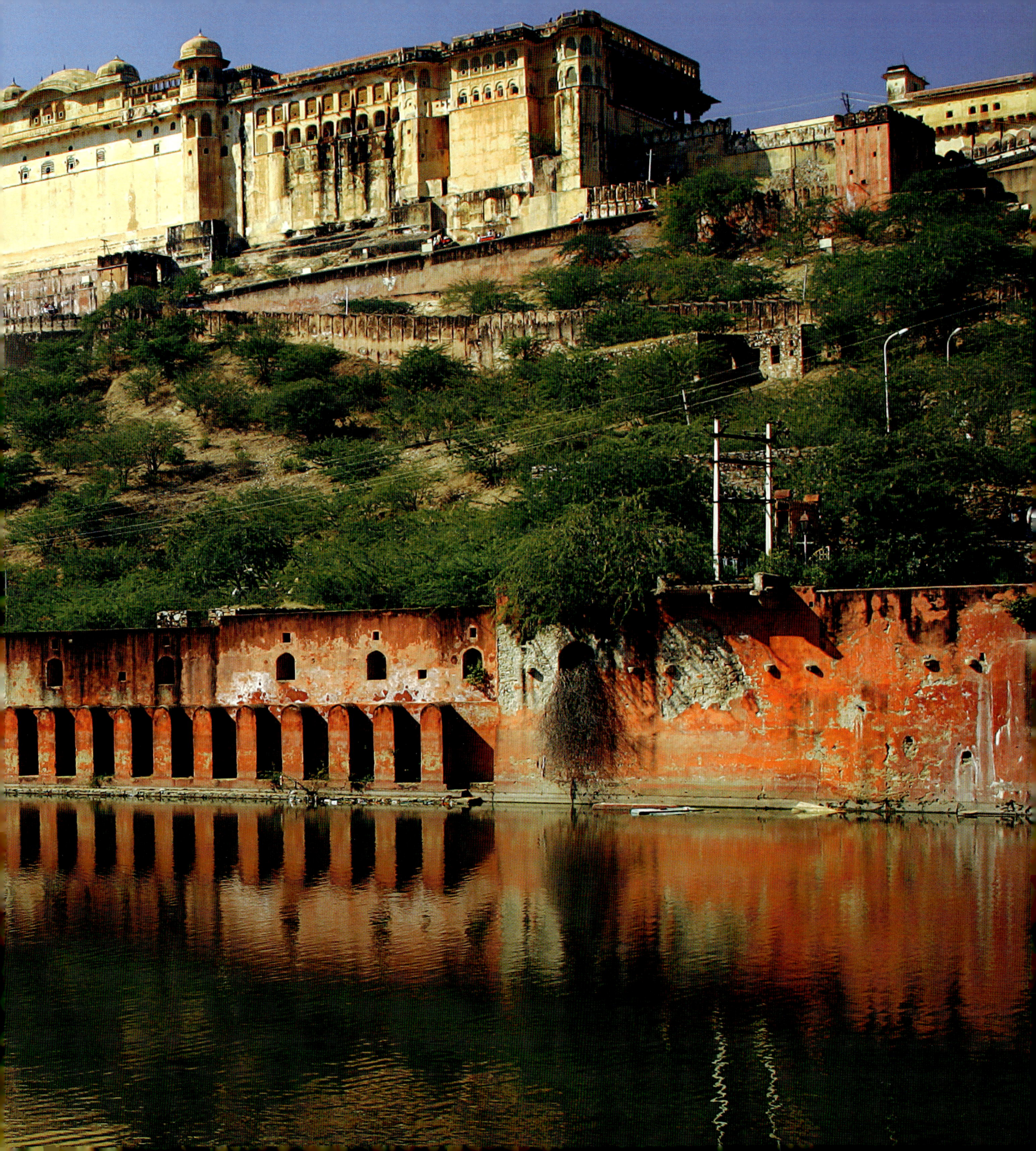

Jaipur is a charming city, well planned and built to order in 1727 CE by Sawai Jai Singh II, Raja of Amber. He ordered building of a new city where he could create architectural splendours to equal the grandeur of Delhi and Agra, the Mughal capitals, where he had served Aurangzeb and Muhammad Shah. Sawai Jai Singh was a multi-faceted genius-architect, engineer, astronomer, mathematician, connoisseur of art and a diplomat of high excellence. Jaipur was to be the realisation of his dream city-fortified bastions over cerenellated walls, magnificent gateways, splendid palace, long wide avenues laid out on a grid pattern to form eight squares with the central royal palace in the auspicious ninth square. The shilpashastras were consulted by Vidyadhar, the chief architect, and the new city-called Jaipur after the name of the illustrious builder, turned out be the most elegant and spectacular city in Rajasthan. In fact, Jaipur is among the very few cities so well laid out in accordance with the prescriptions of the ancient texts on architecture and city planning.

Jaipur wears the stamp of Sawai Jai Singh's impeccable taste and sophistication. An interesting story is being told about the young Amber prince at the Mughal court. As a thirteen year old young lad, Jai Singh was presented before Aurangzeb. The Mughal emperor dispensed with courtesy and rudely asked his young visitor:"Your ancestors gave me much trouble. Now say what you deserve of me before saying what you desire." And to confound the lad's wits held both his hands in his age-old hands, and glowered over him:" Tell me what use are your arms now?" Jai Singh kept his cool and answered "Your Majesty, when a bridegroom takes his bride's hands in one of his own during the wedding, he is bound by duty to protect her all his life. Now that the Emperor of India has taken my hand in his right hand, what have I to fear? With your Majesty's long arms to protect me, what other arms do I need?" Aurangzeb was stunned at this smart repartee. The prince had clearly outwitted the emperor but the latter was pleased. He admitted Jai Singh as 'Sawai' (one and a quarter literally, metaphorically-superior) over his contemporaries. All subsequent rulers of the Kachchwaha dynasty have since been called Sawai.

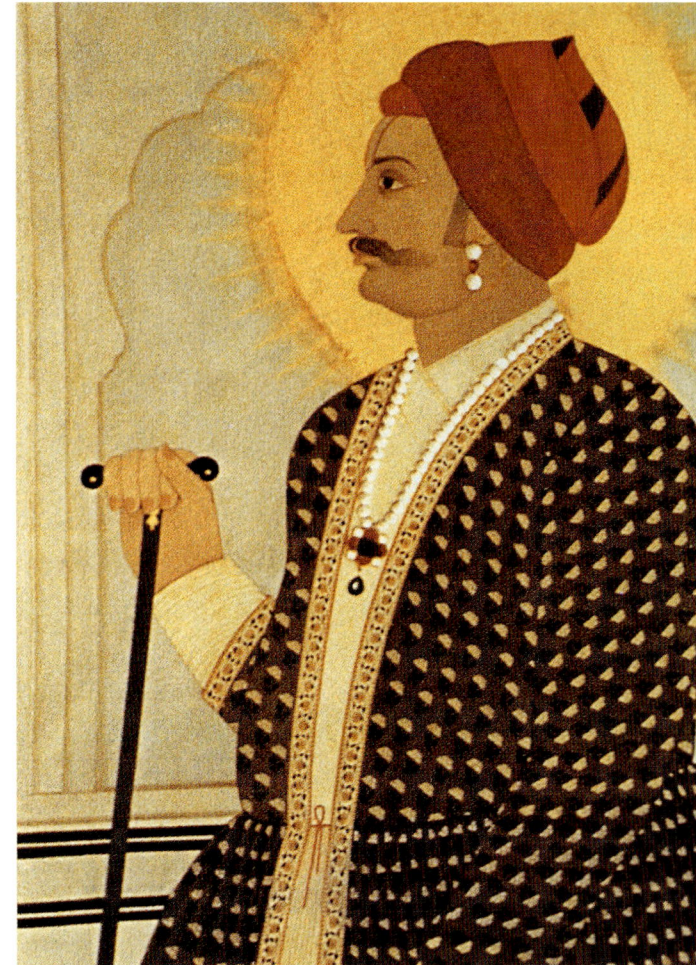

Chandra Mahal, the royal palace, is the most appended showpiece of Jaipur. It stands surrounded by a host of various smaller and multi-purpose structures- indispensable accoutrement of a royal centre -- audience halls, offices, guest houses, stables, and of course, exclusive sections for the queens and princesses. Most of these structures are independent of each other and stand within high walled enclosures to allow privacy and security to the royalty, pehaps a compulsion forced on the architect because the palace stands in close proximity to the chief market area on the same ground level. As with the Mughal cities, particularly Fatehpur Sikri which seems to have inspired Jai Singh, the private residential apartments are built behind curtain walls and heavily guraded gateways. Life in royal palaces, as in the humble houses of the common folk, centres around the courtyard which serves as the meeting place for the inmates. This has been a time-honoured practice both in villages and cities. The City Palace is no exception to this. Each structure occupies the centre of its own courtyard so that Chandra Mahal is arrived at after passing through a number of courtyards and security guards. It is not a practice exclusive to the Mughal palace architecture but has been basic to Indian cultural traditions and architecture.

The Tripolia Gate is meant for use by the royalty. The Sire Deorhi Gate was originally built to serve this purpose. It is still in use but, as a path from here leads to the Govind Deo Mandir, visitors to the temple stand here to feed the hordes of pigeons. This gate now provides unceremonious entry to the palace area. The Gainda ki Deorhi or the Rhinoceros Gate provides access to the palaces. It has the ticket booth for the common man.

The first courtyard is a vast area surrounded by double-storeyed ranges with projecting balconies. At the centre of this courtyard stands the elegant Mubarak Mahal, built by Madho Singh II in 1900 CE, an excellently designed royal guest house. The upper storey has very ornamental decorations in white marble and the projecting balconies surrounding the structure on all sides create the magnificent look required for a ruler's guest house. At present, the Mubarak Mahal houses the textile museum displaying a rare collecton of *zari*, block prints from Sanganer, silks and brocades. The royal garments are heavily embroidered with silver and gold threads. The pink silk dress worn by Madho Singh I (1750-68 CE) is particualry remarkable for its size-this Jaipur ruler was a real big man nearly two metres (6 ft. 6 inches) in height and weighed 496 pounds (225 kgs). The Mubarak Mahal is an exquisitely designed small palace, a good introduction to the splendour of Jai Singh's palaces standing behind a high gate.

The Sileh Khana (armoury), in the same courtyard is a fascinatig collection of Indian weaponry from the medieval times. It includes exquisitely fashioned daggers, helmets and shields. But the rarest pieces on display include the swords of Man Singh I and Shahjahan and Jai Singh I's turban-helmet.

The Sarhad Ki Deorhi or the gateway on the boundary wall is a charming gateway decorated with marble inlay on panels flanking the huge bronze doors. The pair of elephants in white marble guarding the gateways was added to the structure in celebration of the birthday of Man Singh II, an ex-Maharaja in 1931 CE. At the centre of the courtyard stands the Diwan-i-Khas on a podium. It is a simple but functional assembly hall comprising a double row of columns supporting engrailed arches. There is no attempt here to recreate the splendour of the Diwan-i-Aam at Amber where every single architectural feature- tall columns with elephant brackets and the vaulted ceiling in stripes of coloured marble created a grandeur rarely seen on Rajput palace architecture. Ornamentation on this audience hall has been achieved by "the metretricious white line decorations". The whole exterior wall surface of the Diwan-i-Khas and the inner walls of the courtyard carry niches outlined with white lines. "This is an architecture in

Previous pages:
Amber fort reflected in Maota lake

Clockwise:
Portrait of Sawai Jai Singh II, builder of Jaipur; Ridhi-Sidhi Pol, City palace gateway

which functional forms are reduced to symbolic drawings, an architecture which deliberately avoids plasticity by reducing to two dimensions and to outline those forms which would most create it. Even the cusps of arches are feeble: on most of the arches only the outer faces are cusped and the main body is a smooth curve, so that the arch seems to be assembled from insubstantial planes rather than being a solid form; and on all of them the cusps are shallow so that from any distance the overall shape is indistinct". This Diwan-i-Khas building, as observed by Tillotson, is most clearly inspired by Mughal architecture, particulary for its placement in an exclusive courtyard.

The Diwan-i-Khas has on display the two largest pieces of silver in the world. These huge urns were specially made by craftsman Govind Narain for Madho Singh II so that he could take drinking water from the Ganges to England in 1901 CE. Each urn weighs 242.7 kg (535 pounds) and holds 8.182 litres (1.800 gallons) of water, enough for his use during his stay abroad. Madho Singh II chartered a liner, built a temple on board and offered *puja* at every opportunity. But he returned a genuine Anglophile who ordered specially made British furniture and cooks.

Ridhi Sidhi Pol, a four storeyed grand portal, separates the Diwan-i-Khas area from the inner precincts of the palace. This is an absolutely charming example of Rajput architecture framed within a long triple-storeyard façade of wall. The windows are all covered within decorative *jali* screens. Two staggered doors lead into the Pritam Chowk, a small courtyard exclusive to the royalty. On the eastern and western flanks of this courtyard are four small doors covered with frescos in gorgeous hues depicting moods of the four Indian seasons. The door used for entry from the Ridhi Sidhi Pol is the Peacock door, so called for its depiction of splendid peacock motifs in turquoise, blue, amber and acqarmarine. This courtyard and the painted doors were added to the original structure by Pratap Singh (1778-1803 CE) who built the famous Hawa Mahal.

Chandra Mahal stands on the northern side of Pritam Chowk. It is a grand pile in seven storeys, perhaps the tallest Rajput palace which has received additions from successive rulers. The upper storeys have rows of engrailed arches symmetrically arranged on the projecting balconies. The striking uniformity of the small balconies superimposed on each other remains unrelieved by any structural feature breaking through the monotony on the elevation. "An exceptional and unfortunate feature of the Chandra Mahal is its symmetry. The picturesque quality achieved by the irregularity of the majority of Rajput palaces is here eschewed, but nothing is offered in its place…the regular bulk of the Chandra Mahal lacks both grace and interest," as Tilottson observes.

Visitors are admitted to the ground storey only. A notable feature of this section is the marble channel in the floor conducting water to a cascade which empties itself into the formal garden laid out on the Mughal pattern. The low columned interior is merely suggestive of splendid interiors on the upper floors. The brass doors at the Pritam Chowk are really fabulous pieces of craftsmanship, particularly the door with panels depicting episodes from Krishna's life. Sukh Niwas and Shobha Niwas- two beautiful portions of the palace are in actual use of the present ex-Maharaja Ltd. Col. Bhawani Singh. Chabi Niwas at the fifth level has chambers covered with exquisite decoration. Chabi Niwas has a section painted in Wedgewood blue marked with white lining. Mukut Mahal, the upper most pavilion, is in white marble with a *bangaldar* roof flanked by two small domes. The palace provides ramps in place of regular staircases. This was to facilitate an easy climb for the palanquin bearers. A particular Maharaja was afflicted with rheumatism, hence the arrangement.

The extensive garden with its water canal and square divisions of plot stretches upto the Govind Deo Mandir which was, in fact, the first palace built in Jaipur for Jai Singh. It was built amidst the hunting grounds on which Vidyadhar built the new city. Jai Singh II had a vision instructing him

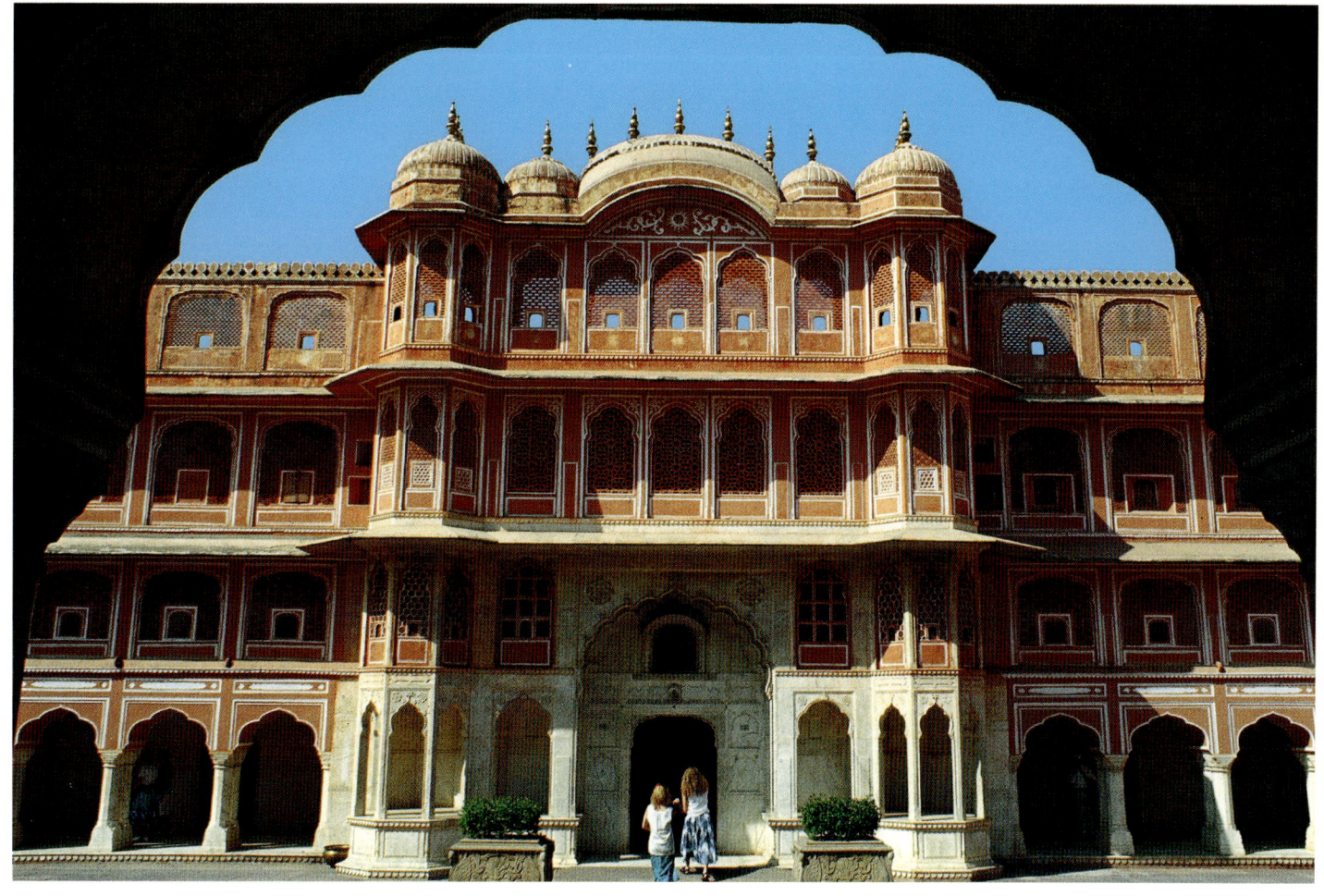

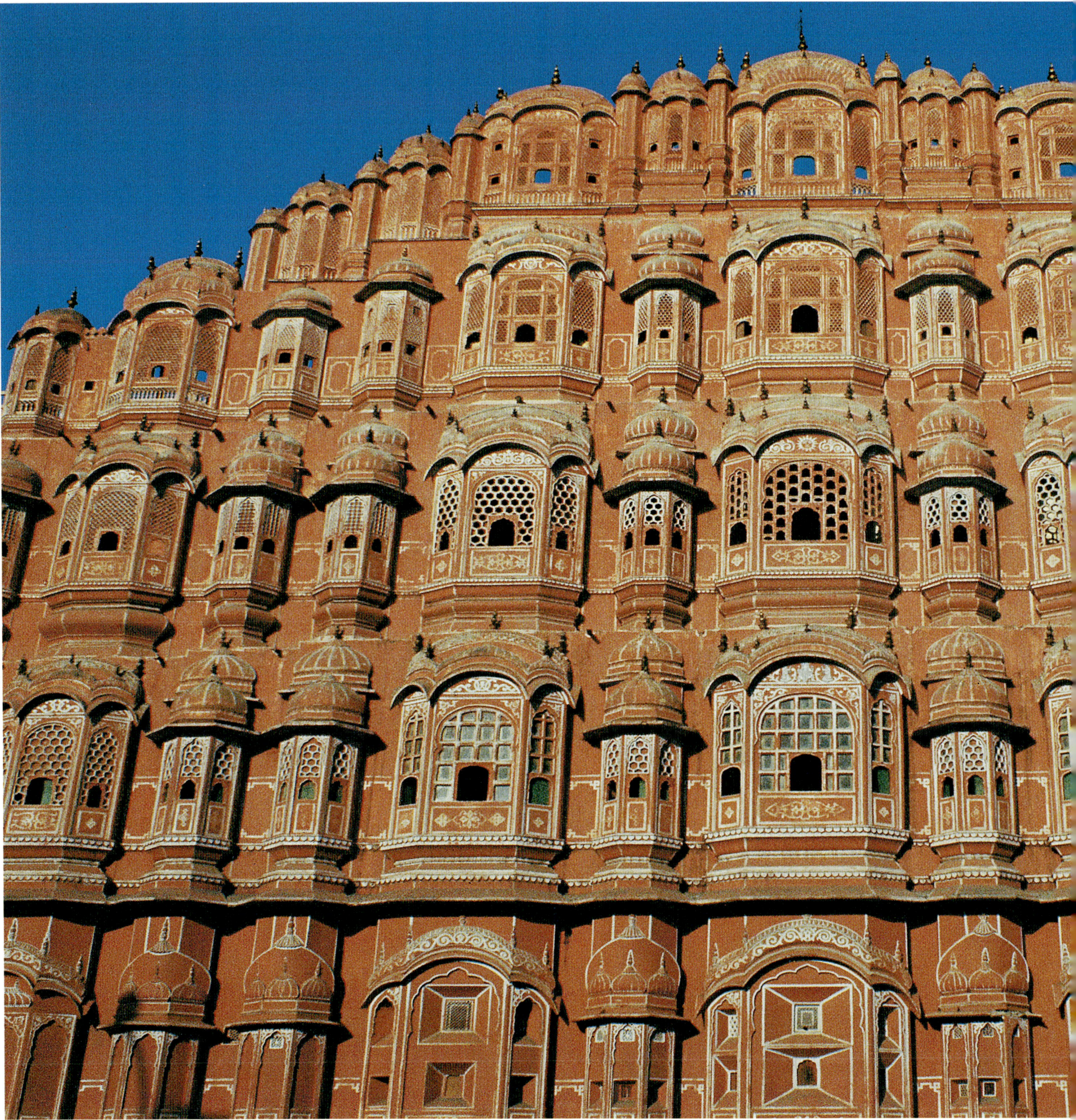

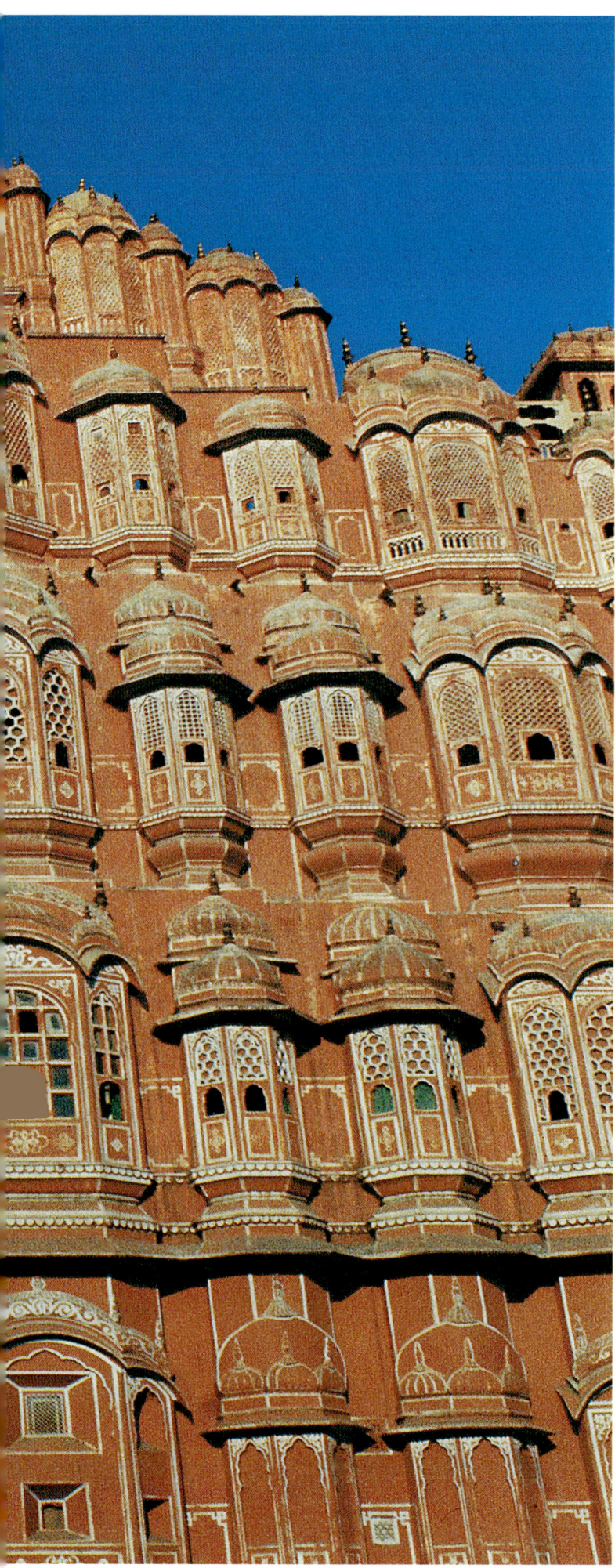

to vacate the premises to house the image of Krishna that he had brought from Mathura.

The Diwan-i-Aam is now being used as a museum. It is a great treasure of art objects-magnificent carpets made at Heart, Lahore and Agra creating fascinating floral patterns and geometrical designs, exquisite miniatures showcasing the art traditions of Rajasthan from Kota, Bundi, Kishangarh and Jaipur; manuscripts of Sawai Jai Singh II's work on astronomy, Abul Fazl's translation of the Mahabharata in Persian called Razmnamah, an illustrated scoll of the Bhagvata Gita and a copy of the ancient Shiva Purana rendered in minute calligraphy and also an illustrated copy of the Geet Govinda. The collection of palanquins and *howdahs* used by Maharajas of the Jaipur state is fascinating for its great variety. Queen Elizabeth II of England was here accorded a grand reception befitting the grandeur and heritage of Jaipur.

The Jantar Mantar- the open-air observatory of large astronomical instruments stands close to the Gainda Ki Deorhi. Jai Singh II had already built observatories at Delhi, Ujjain, Varanasi and Mathura between 1724 and 1727 CE. This observatory is built in stone and marble. Muhammad Shah II of Delhi encouraged Jai Singh II to pursue his interest in astronomy and the Jaipur ruler dedicated his book Zij-i-Muhammad Shahi to his Mughal *suzerain*. The Jaipur observatory built in 1734 CE is the largest and most elaborately planned. It has been described as 'the most realistic and logical landscape in stone'. The 16 instruments are extremely futuristic resembling a gigantic sculptural composition. Some of these instruments are still in use to study the movement and intensity of the monsoon.

The Samrat Yantra is 23 mts (75 feet) high, and a sundial is used to forecast the crop prospects for the year and the Rashivalaya Yantra is composed of 12 piecs, each representing a sign of the zodiac and, therefore, facing a different constellation. The Jai Prakash Yantra consists of two sunken hemispheres to map out the heavens. It was invented by Jai Singh II to test the accuracy of all the other instruments in the observatory. The Chakra Yantra comprises two circular metal instruments used to calculate the angle of stars and planets from the equator. The rest of the instruments are equally accurately designed.

In the Preface to his Table of Stars Jai Singh II (speaking of himself in third person) wrote; "he found that the calculation of the places of the stars, as obtained from the tables in common use (Sanskrit, Arabic and European) in many cases give them widely different positions from those determined by observation, especially in appearance of the new moons… that the disagreement between the calculated times of those phenomena and the times which they are observed to happen, may be rectified…". Jai Singh II sent envoys to procure for his study and comparison the tables published abroad (*Pere de la Hire's Tabulae Astronomicae*, completed in 1702 CE as well as the European tables anterior to these especially Flamsteed's *Historia Coelestis Britannica* (1712-1725 CE). He notices "On comparing these tables with actual observations, it appeared that there was an error of half a degree in the former in assigning the moon's place, and there were also errors in the other planets, although not so great especially in the times of the eclipses. Hence he concluded that, since in Europe astronomical instruments have not been constructed of such a size and such large diameters, the motions which have been observed with them may have deviated a little from the truth."

Jai Singh II had foreign authoritative studies translated into Sanskrit, chiefly Ptolemy's Syntaxis from its Arabic version Almagest, under the title Siddhanta Samrat and Euclid's Elements, and Newton's Principia etc. He had greatly admired the studies made by the Turkish royal astronomer Ulugh Beg who had built an observatory in Smarkand in the 15th century CE and produced the most correct readings. Jai Singh II's "avowed object was the rectification of the calendar, the prediction of eclipses and so on……..Considering the state of the country in which Jai singh II lived; the ignorance of his contemporaries; his work was a pioneering step in

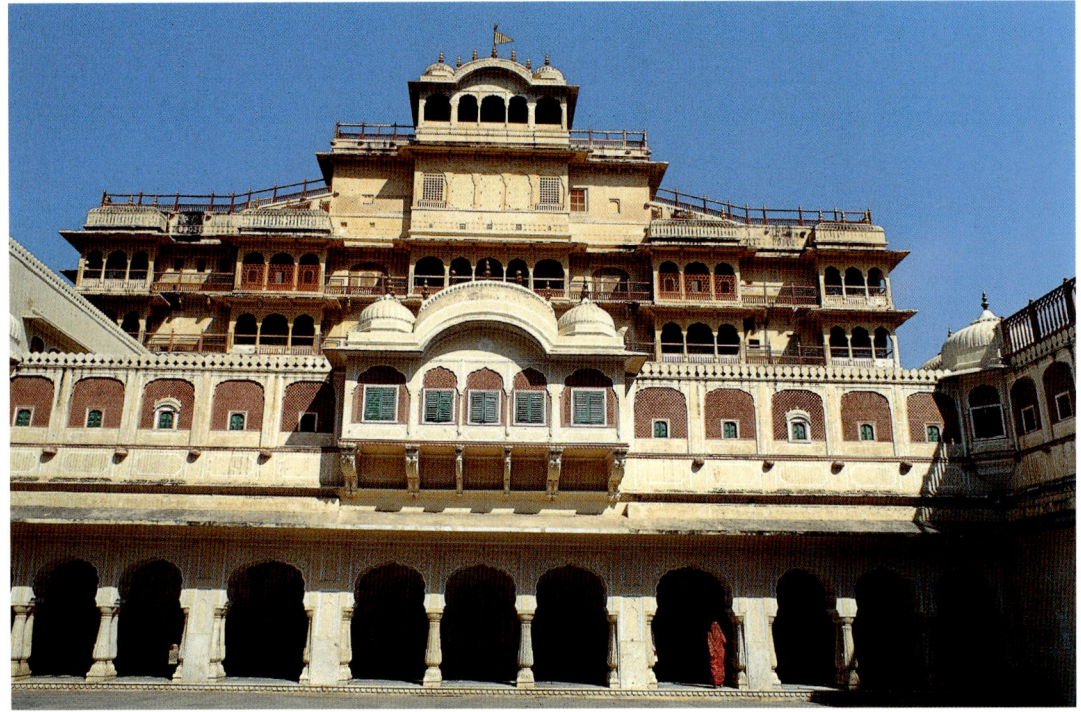

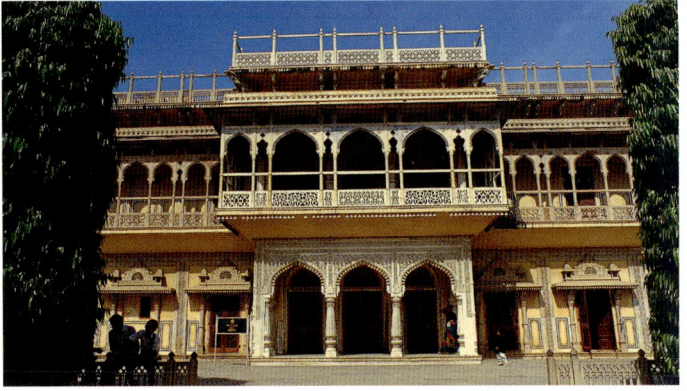

Previous pages:
Hawa mahal

Clockwise from top:
Chandra Mahal, or the City Palace;
Elephants ascending the ramp to the entrance gateway at Amber;
Mubarak Mahal, now the textile museum

astronomical studies. Jai singh II erected monuments which irradiate this dark period of the history of India". James Tod, not a great admirer of Jai Singh II conceded that on the Jaipur ruler's death in 1743 CE, "three of his wives and several concubines ascended his funeral pyre, on which science exspired with him."

To the north of Jaipur's main road intersection, Badi Chaupad, stands the Hawa Mahal, the world famous landmark of Jaipur, the best known specimen of fanciful architecture. It was built in 1799 CE by Sawai Pratap Singh, the aesthete among the Jaipur rulers (1778-1803 CE). It is an integral part of the City Palace though it stands at some distance from the main complex. At first glance, the structure looks whimsical in design. To some Hawa Mahal looks like a mere facade. In fact, it is the last, rear wall of the palace exclusively occupied by the royal seraglio. From the small windows the women could watch processions on the city's main throughfare.

Approached from the city palace side, you first enter stately *deorhi* (door) on a courtyard which has double-storeyed ranges on three sides. But above these two storeys, only the eastern wing has three higher storeys comprising small intimate chambers with small apertures admitting light and fresh air. The upper floors are reached through a ramp rather than stairs. The ramp terminates at the top of the free standing square tower.

The façade of the Hawa Mahal has some times aroused unfair comments as 'a baroque folly' and 'a bizarre piece of architecture'. The five storeyed façade encrusted with elegant, trellis work on windows and small balconies has 953 niches. Lal Chand Usa designed this charming structure to house the images of Radha and Krishna. But Sawai Pratap Singh found it more suitable for the queens and princesses rather than the divine lovers.

The pyramidal structure has one outstanding architectural feature-symmetry and, as in Hindu temples, uses repetition of structural motifs for a great artstic effect. Still, some of its defects are only too obvious: the bays are crammed, piled and multiplied so that they combine to form a larger version of themselves, in a manner strikingly similar to a temple *sikhara*. It has been observed that the Hawa Mahal indicates a certain decline in the architectural standards of Jaipur following a similar trend noticeable at the Moti Masjid built by Aurangzeb at the Delhi fort. Any architectural tradition which over a passage of time has created great works sooner or later finds itself at a *cul-de-sac* where repetition of old familiar forms is perhaps the only way left for survival. Only induction of a completely new style may infuse new life into it. This denied, it must carry the weight of experience and dullness following it at every step. The Hawa Mahal is perhaps among the last few specimens of Rajput architecture struggling to be itself. A genuine appreciation of such a structure need not always be subject to academic investigation. It can be admired for what it is rather than being criticized for what it is not.

The Hawa Mahal earned immense appreciaton of Sir Edwin Arnold as "a version of daring and dainty loveliness, of storeys of rosy masonry and delicate overhanging balconies and latticed windows. Soaring with tier after tier of fanciful architecture in a pyramidal form, a very mountain of airy and audacious beauty, through the thousand pierced screens and gilded aroches of which the India air blows cool over the flat roofs of the very highest house. Aladdin's magician could have called into existence no more marvelous abode." "The beauty of the Hawa Mahal lies in its fragile appearance which, like a vision, could vanish into thin air. It is, of all royal palaces in Jaipur and Rajasthan, the most romantic and delicate which cannot be said of some better known examples of architecture".

The Amber Palaces

The Kachchwaha Rajputs, holders of the Amber seat, are believed to be Suryavanshis, descendants of the Sun from Kusha, son of the epic hero Rama. In ancient times they moved from Ayodhya to Rohtas, and later founded Narwar, near Gwaliorin 295 CE. In 967 CE, Dhola Rai, the infant heir to the throne was expelled from Narwar by his scheming uncle who usurped the throne. The destitute queen begged with her son for a living and moved westward to the Dhundhar region near Jaipur where a ruling Mina tribe chief accepted her as his sister. When Dhola grew up, ambition raised its head. He killed the Mina chief and usurped power. With new marital alliances, Dhola became a power to reckon with at Amber, seat of the Minas. Amber, dedicated to the goddess Amba, the great goddess or 'Ghata Rani '. Queen of the pass, had been the ancient stronghold of the Minas who continued to give Dhola's successors-the Kachchwaha Rajputs frequent battles over territorial supremacy. Later on the Minas shed their hostility towards the Kachchwahas and accepted to work as guardians and protectors of the royal treasury at Amber with an unfailing loyalty. The Kali Koh ranges provided the best natural defences to the palace at Amber. The destinies of both the Minas and Kachchwahas remained inseparable from each other.

With the arrival of the Mughals the Amber rulers enjoyed considerable security against regional skirmishes. Bhar Mal (l548-l574 CE) offered his daughter in marriage to Akbar and was given important military assignments at Agra. Later, Man Singh I consolidated his small kingdom and rose to enviable prominence at Akbar's court as the commander of the Mughal forces. Man Singh I built some important palaces at Amber; a spectacular setting for royal palaces under the shadow of the Kali Koh ranges. The palaces seem to grow out of a prominent rocky base and cast a fascinating reflection in the Maota lake below. The narrow zigzag roads,

gingerly climb to Suraj Pol, the magnificent gateway to the palaces. From this point of entry, the splendour of charming palaces and spectacular courtyard unfolds itself step by step. Man Singh's palace stands at the southern end of this site and the Suraj Pol stands at the northern extremity, where the extensions to the original buildings were made by Mirza Raja Jai Singh and Sawai Jai Singh in the 17th and 18th centuries CE during the rule of Jahangir , Shahjahan and Aurangzeb.

Jaleb Chowk is a grand courtyard where armies assembled before marching out. It is the largest section at Amber where grand public functions were held. On the opposite western side is a gateway leading to the backside of the palaces and narrow footpaths descending into the valley where the small township of Amber still shows ruins of temples and grand but deserted havelis, wells and baolis dwindling old mansions. The Kali temple, built by Man Singh I, stands atop a flight of steps at the south-west corner of the Jaleb Chowk. It contains an image of the goddess brought by Man Singh I from Jessore in Bengal in 1604 CE. A small family of Bengali priests also came with the deity. Later, Vidyadhar Bhattacharya, a descendant of this family of priests became the chief architect of Jaipur, the new capital of the Kachchwahas in 1728 CE. The royal family maintained the Kali temples as their royal chapel, coming here on every occasion of importance. In 1939 CE Man Singh IT added silver doors to the shine which remains the most sacred shrine of the Kachchwahas.

Singh Pol, a grand portal, provides entry into a stately court yard. At the north-eastern section of this court stands the Diwan-i-Aam, a columned hall with red sandstone tall columns, particularly remarkable for the small sculptured elephant heads on brackets. It is the most lavishly built hall. The stone has been imported from far off places. The ceiling is remarkable for its distinctive appearance with the four curved sides rising to join the flat central portion. The differently coloured stone stripes add considerable colour and splendour to the hall. Mirza Raja Jai Singh was advised to cover the splendid columns with stucco to conceal its grandeur from Jahangir who would certainly have taken affront at a subordinate ruler building structures challenging the beauty of the Mughal palaces. The Diwan-i-Aam is certainly the finest structure built in the Rajput style.

Some art historians have assiduosly worked out their theory of a dominant influence of Mughal architectural style on this hypostyle hall of public audience."The truth ", as Tillotson observes, "must be simpler. The architects of the Amber Diwan-i-Aam did not need to rely on Muslim imitations of the Hindu tradition; they could rely on that tradition directly, especially since it was, after all, their own. The Amber Diwan-i-Aam was part of a continuing Hindu development. A Muslim patron might contribute to that development by commissioning a Hindu-style building but such contributions performed supporting rather than leading roles." If there is any particular place where this influence appears pointedly, it is on the design of the column bases which seem to have been inspired directly if not exactly copied from the column bases at the contemporary garden pavilions in Kashmir. But this only shows "a willingness to incorporate Mughal innovations where they improve details without upsetting the predominantly conservative scheme."

The open colonnaded hall on the eastern wall is another hall for official purposes. The elegant *baluster* columns and the engrailed arches marked with a black line add a particular charm to the structure.

The grandeur of this courtyard is mainly due to the massive gateway on its southern side- the Ganesh Pol, built by Sawai Jai Singh, This magnificent ceremonial gateway stands between the public and the private residential section of the Amber palaces. The high central arch is flanked by two ornamental double-storeyed small arched niches. The Ganesh Pol is planned on a grand scale. The ornamentation on the polished plaster is chiefly floral. A small image of Ganesha appears at the apex of the central arch. The pillared arcades on both sides of the gateway emphasize the importance of this structure.

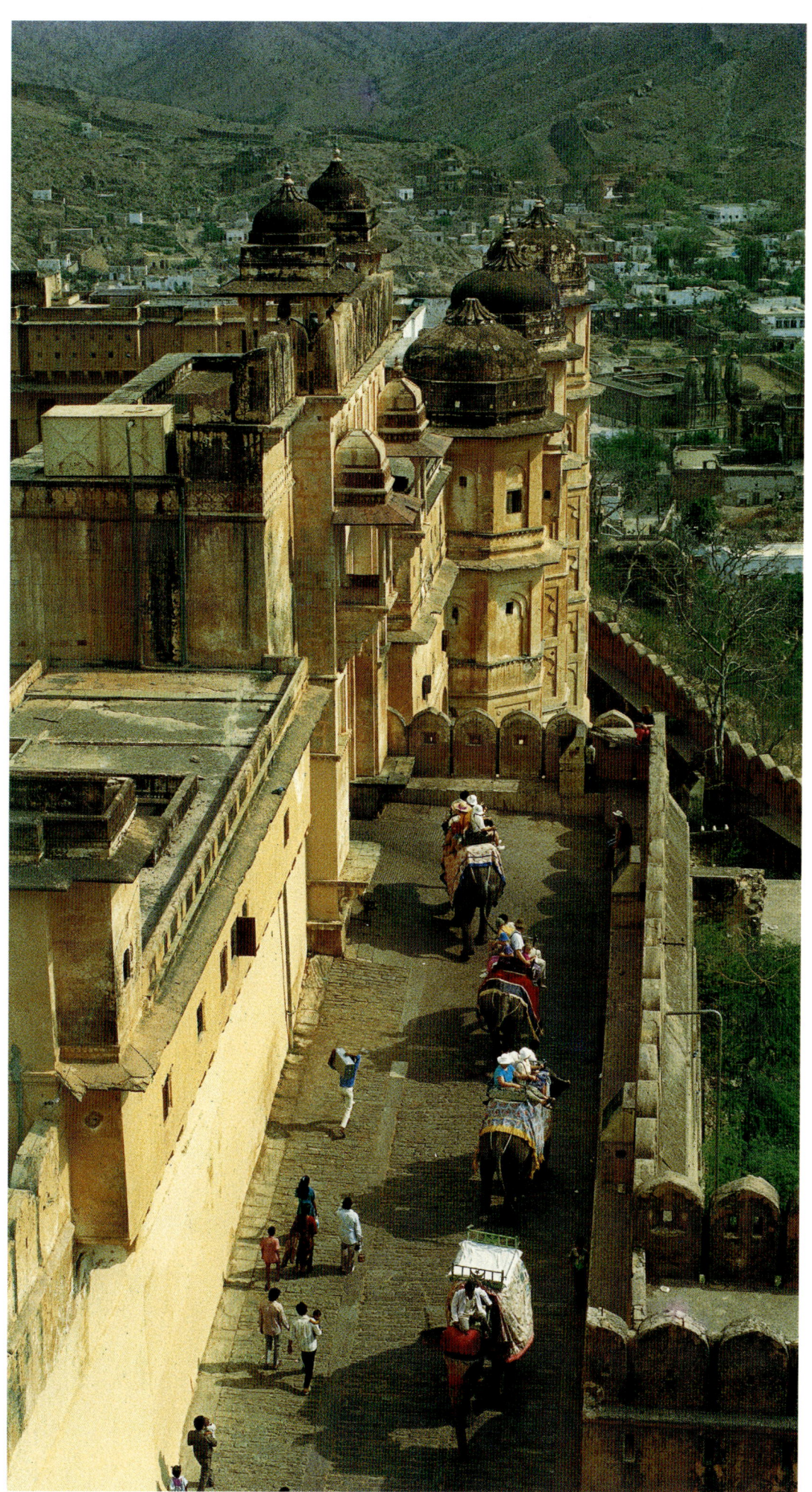

The upper portion of the structure has Sohag Mandir, the triple-arched pavilion with splendid *jali* screens. This pavilion opens into the terrace facing the inner palaces. In the absence of marble and *pietra dura* decoration commonly seen on the gigantic portals of the Mughal palaces, the Ganesh pol has a sumptuous decoration in gorgeous colours.It is the most picturesque section at Amber –both the Diwan-i-Aam and the Ganesh Pol stand as proud specimens of Rajput architecture.

The thick walls of the Amber palace contains numerous ramps, secret passages, dimly lit and winding, opening out suddenly into sun-filled areas. Through the Ganesh pol, the route to the private palaces passes through two right angled corners, a security device to thwart sudden burst of intruders. The passage leads to a small courtyard with a sunken garden with water channels and raised pathways. It is a small formal garden built undeniably after the gardens of the great Mughals. The cypresses planted in this small garden recreate the magic of the Mughal gardens on a much diminished scale. On its southern side stands the Sukh Niwas, a small pavilion with water chutes and channels in white marble. It was meant for the ladies of the royal family, a cool resort for evening entertainments and gatherings.

The Diwan-i-Khas or Jas Mandir, the palace opposite the Sukh Niwas, stands on the eastern side of the garden. It is the most ornate and splendid palace in Rajasthan.It was used for those exclusive meetings with important personages and ministers when confidentiality of the proceedings had the utmost importance. It is also a pleasure pavilion. An open *verandah* surrounds on three sides a rectangular hall flanked by two smaller rooms. It is the most gorgeously ornamented palace with charming glass mosaics covering the entire walls and the ceiling. Myriad coloured glass pieces studded on white plaster create fantastic reflections when a single matchstick lighted under the ceiling assumes enchanting forms on the countless pieces of glass. Three large windows admit light and air. The Jas Mandir is the show piece of Rajasthani ornamentation.

Jas Mandir, a smaller version of the Jai Mandir, was built on the roof of the palace below it. It is a *verandah* decorated with convex mirrors on stucco reliefs, arabesques and an exquisitely designed interior. It has three magnificent arched windows with *jali* screens. From the small openings in these screens can be had splendid views of the deep gorge and the spectacular Maota lake with the most elaborately laid out ornamental garden. The rugged splendour of the Kali Koh hills adds a charming dimension to the beauty of this rooftop pavilion.

The charms of the glass mosaics at these two palaces have been noticed by visitors from distant lands. The author Aldous Huxley was much impressed by the glass work here:"There is a mirror room in the fort at Agra; there are others in almost all the palaces of Raputana, but the prettiest of them all are the mirror rooms in the palace of Amber. Indeed I never remember to have seen mirrors anywhere put to better decorative use than here, in this deserted Rajput palace of the seventeenth century. There are no large sheets of glass at Amber; there is no room for large sheets. A bold and elegant design in raised plaster work covers the walls and ceiling; the mirrors are small and shaped to fit into internices of the plaster pattern...their greatest charm is that they are slightly convex, so that every piece gives back its own small particular image of the world and each, when the shutters are opened, or a candle is lit, has a glint in its grey surface like the curved high-lighted in an eye.

They are wonderfully rich, these mirror rooms at Amber...the Indian rooms are a marvel of cool and elegant refinement...Here in India, there are only small rooms adorned with elaborate decoration that is meant to be looked at closely and in detail. Such are the mirror rooms at Amber." Both these palaces-the Jai Mandir and the Jas Mandir are small palaces, only large enough for gathering of an intimate kind. When carpets and cushions, Jai Singh's palaces must have been the epitome of luxury and opulence, pictures of the real oriental charm.

Ganesh Pol at Amber;
Far right: *Diwan-i- Aam*

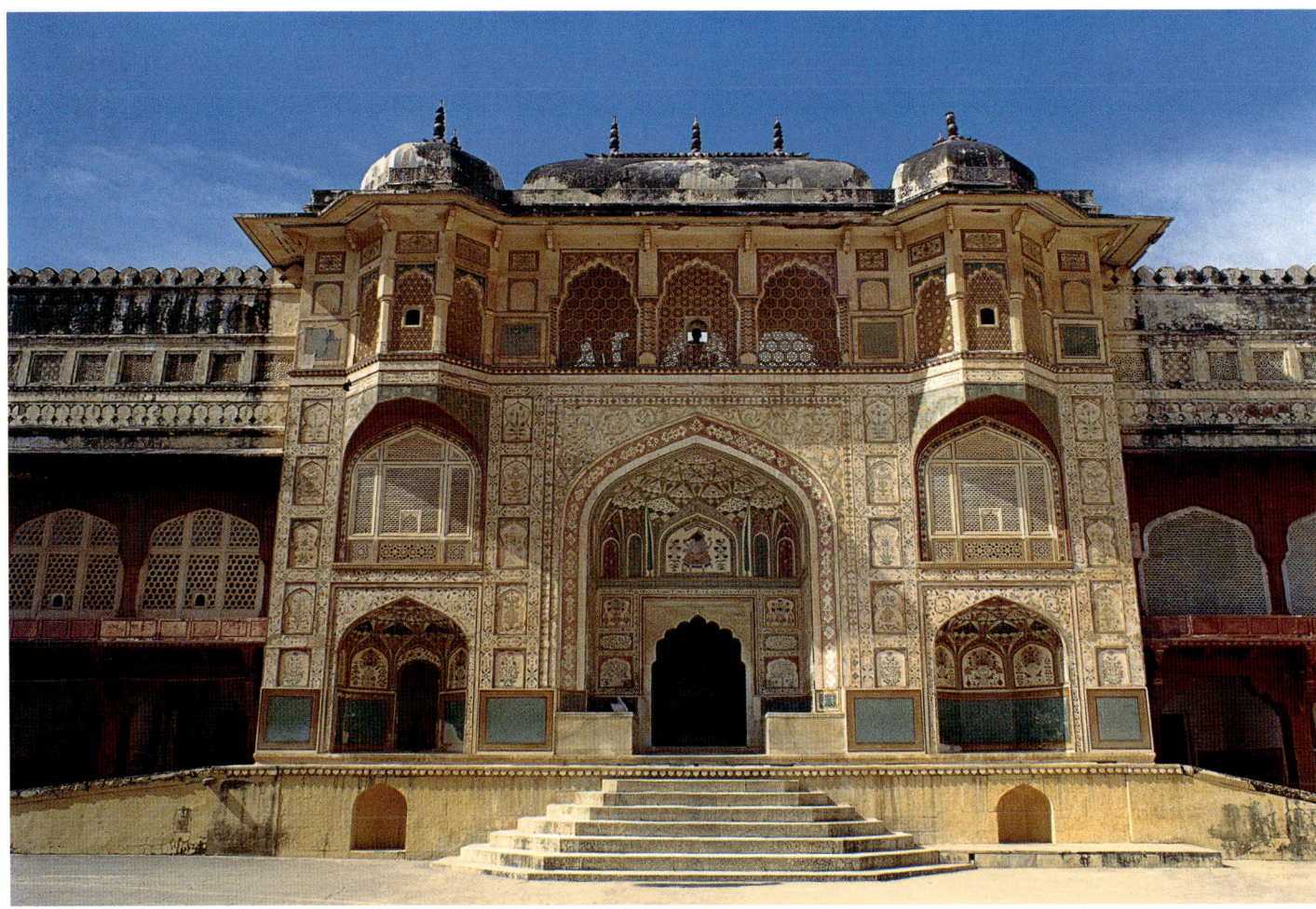

Standing on the Ganesh Pol terrace is Sohag Mandir, a beautiful pavilion with gorgeous decoration in floral murals and exquisite *jali* screens. The royal ladies could watch the proceedings in the Diwan-i-Aam without being noticed by the assembly below. There is no glass work decoration at the Sohag Mandir but the colourful murals more than compensate the want of any such extravagance.

These four pavilions-Sukh Niwas, Jai Mandir, Jas Mandir and Sohag Mandir are the contributions of Jai Singh I who had an opportunity to watch and take note of the Mughal gardens and palaces, the cusped arches and the *bangaldar* roofs and the exquisite *pietra dura* work. These pavilions find use for some of these features and surprise us for the artisan's skill in adapting his work, to the new demands. Of course, the identity of the Rajput architecture asserts itself every where at these Amber palaces.

Man Singh I's palace stands at the southern end of the building complex at Amber. It has at its centre a spectacular courtyard surrounded by double-storeyed ranges. The apartments are large and spacious. Most of the walls and niches still carry faint vestiges of mural decoration depicting devotional themes. It is believed to have been a *zenana* palace but more likely to have had separate wings for men and women. The Raj Mahal at orcha has a similar utilization of space. The corner towers add immense strength and a character typical of the contemporary royal palaces.

This palace makes ample provisions for security through secret passages which could be used during an emergency. Small subsidiary structures built on the western periphery of the wall and narrow footpaths lead into the maze of narrow alleys in the small township of Amber. On the eastern side, the walls were raised by Jai Singh I when he made extensions on the existing structures. The *baradari* at the centre of the courtyard is a later day addition to Man Singh's palace. The engrailed arches and the *baluster* columns used at the *baradari* suggest the need for a central focal point in a grand architectural scheme: it is the ornamental formal garden between Jai Mandir and Sukh Niwas and here it is the *baradari*. Both the heat of the place and the need to stir out suggested such an addition to the palace. The parapet on the eastern exterior wall also had to be suitably raised. The elegant cupolas and small box-like balconies on the high parapets look immensely charming from the lakeside though the original structure appears to have gained no particular advantage by such changes. The use of pitched roofs over the southern towers and the domes over the northern towers add a new feature to Amber architecture.

The palaces at Amber have always fascinated visitors. There are no architectural marvels and no stunning ornamentation. Still the palace and the hills surrounding it create a truly romantic picture of a medieval world which is better expressed in the words of Bishop Heber who visited Amber in 1824 CE: "I have seen many royal palaces containing larger and more stately rooms…but for varied and picturesque effects, for the richness of carving, for wild beauty of situation, for the number and singularity of the apartment, and the strangeness of finding such a building in such a place and country, I am able to compare nothing with Amber…I could not help thinking what magnificent use Ariosto or Sir Walter Scott would have made of such a building."

Jaigarh

The Jaigarh fort was opened to the public only in July 1983 CE. It has remained enveloped in sheer mystery for the thousands of visitors who stand spellbound by the picturesque charm of the Amber palaces and watch the awe-inspiring battlemented high walls of the great fort crowning the Dhundhar hills. It has been reputed to be the strongest bastion of the Kachchwaha rulers whose treasures were hoarded in the subterranean chambers built within the gigantic water tanks. Legends have been woven around these treasures. The Kachchwaha rulers-Bhar Mal, Bhagwan Das,

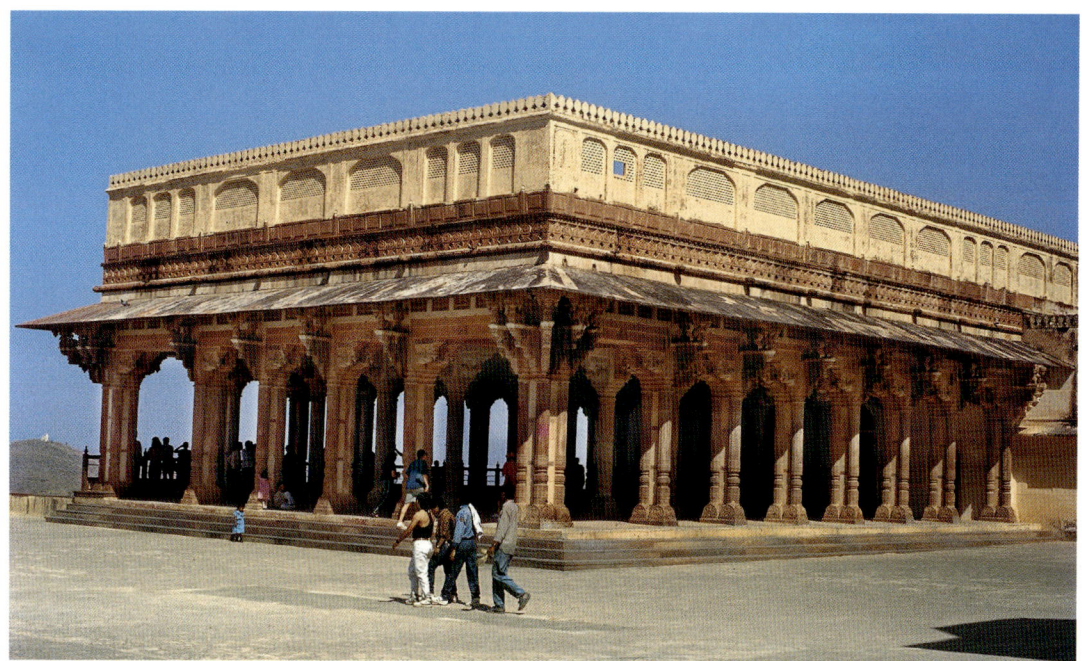

Man Singh I, Mirza Raja Jai Singh and Sawai Jai Singh II held high profile assignments under the great Mughals and fought battles for their overlords. They amassed unimaginable treasures as their share of spoils in battles and kept it at Jaigarh.

But who built Jaigarh? Perhaps it was Mirza Raja Jai Singh who built it since the fort is named after him –Jaigarh. It was the invincible citadel of the Kachchwahas who were the most powerful and trusted Rajput allies of the Mughals. The daunting height of the hill and strong fortifications kept the enemies at bay. Jaigarh was never invaded by any army.

Amber had been the capital of the Kachchwahas, held only by this illustrious dynasty. It shot into political prominence when Bhar Mal gave away his daughter in marriage to Akbar in 1562 CE, the first Rajput state to have entered into matrimonial alliance with the Mughals. For this Bhar Mal was awarded prestigious assignments. The princess was held in high esteem by Akbar as the mother of his son and heir to the throne-Salim. Palaces were built for her at Fatehpur Sikri and Agra. It is not a mere conjecture that the Kachchwaha rulers before Bhar Mal had built a small fort to defend themselves against the Mina tribes from whom they had wrested this territory. The Kachchwaha ancestors had built forts at many a place – Rohtas, Gwalior, Narwar and Dubkhund etc. Perhaps it was not a great fort but it is reasonable to believe that the Kachchwahas restrengthened and also rechristened it- Jaigarh, in the 17th century CE.

Dhola or Dulhe Rao who founded the Kachchwaha rule in 967 CE was followed by many warrior heroes who remained locked in battle with the irrepressible Minas. The Dhundhar ranges afforded the vanquished tribal chiefs, places to hide themselves and launch surprise attacks on their victors. Finally, in 1036 CE the Minas were completely routed and the Kachchwahas breathed in peace for the next 700 years till they moved to their new capital – Jaipur in 1727 CE. 27 rulers are supposed to have ruled between Kakil Deo and Sawai Jai Singh. It is too long a period for the Kachchwahas to have survived without a fort. When Jai Singh I raised the heights of the walls at the Amber palaces, he might have restrengthened the fort atop the Dhundhar hill and called it Jaigarh. But, in all likelihood, Jaigarh remained as the fort of defence only, to be used as residence during emergencies, which somehow always spared the Kachchwahas. Sometimes, referred to as '*Chilh ka tola*' (eagle's nest) because of the stupendous height, Jaigarh commands landscape for miles.

The Jaigarh fort occupies a vast area. It is three kilometers in length from north to south and one kilometer in width from east to west. It has three

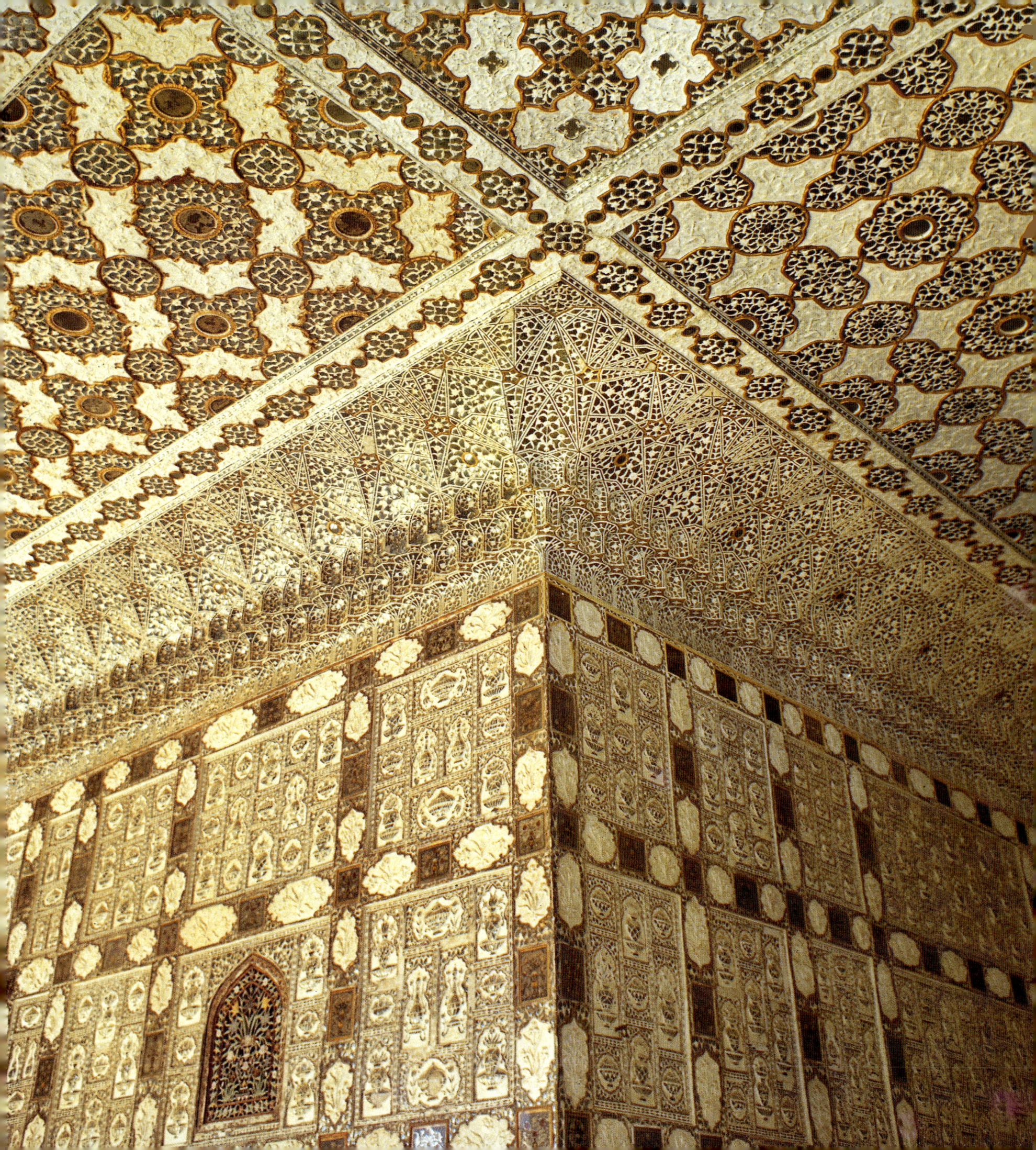

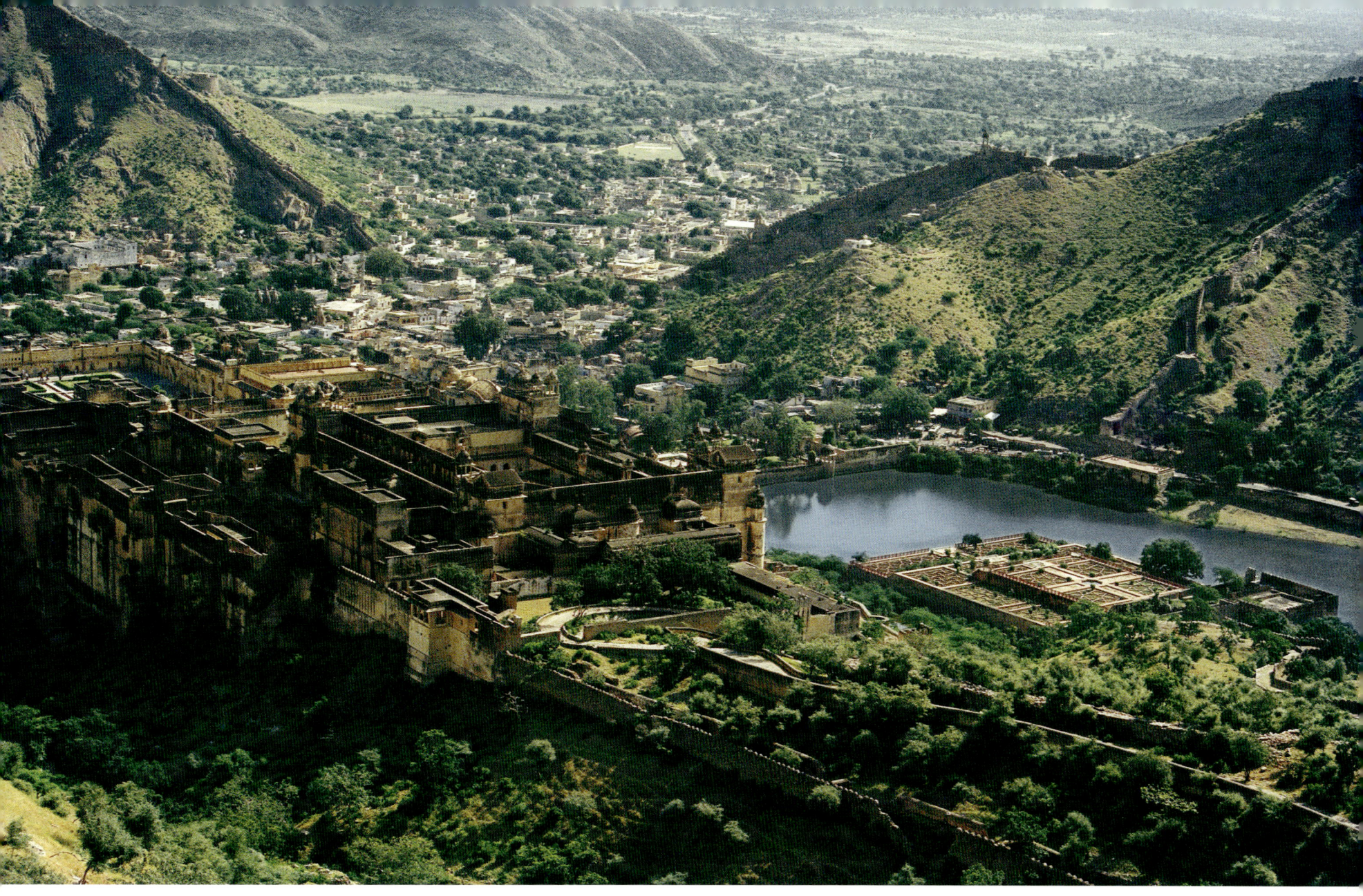

gateways for entry. The Doongar Gate is the first gate, used today as the central entrance to the fort, built by Man Singh II in 1942 CE. There are two more gates after this leading to the central open area known better for the three famous water tanks. Another gate stands on the northern side leading to the Jaleb Chowk. The road connecting Amber palaces with the Jaigarh terminates at the Awani Gate. This gate stands close to the gun foundry within the fort. Kheri Gate is the third important gate opening towards Sagar-the grand artificial lake, chief source of water supply to the fort. In addition to these important gates, some other smaller gates also stand in the township of Amber. The palace complex stands behind the steep and high crenellated walls of the fort. The most noteworthy feature of complex is its openness. The Subhat Niwas is an impressive hall reached through an arched entrance surmounted by a small triple-arched pavilion and a *bangaldar* roof. Five small copper spires over the roof are the only ornamental features of the structure, so strikingly plain and functional. The hall with eighteen pillars stands on a slightly raised plinth. The cusped arches suggest a late date of construction. Here the ruler addressed his soldiers. For the security and defence of the ruler and the inmates of the fort there is an escape tunnel leading to the palaces. This tunnel is, at places too dark and narrow to prevent a sudden rush of invaders, allowing a fair chance for residents to defend themselves.

The Khilabat Niwas is a small hall of private audience, only 32 feet 9 inches in length. The paved courtyard is an example of a remarkable engineering skill-the footsteps are echoed all around. It is impossible to take a step without being heard by the security guards. This is a security measure of the highest order.

The Laxmi Niwas is meant for the royal ladies. There is a small pavilion facing this palace for the musicians and other entertainments. The hall has twelve double columns. The lower sections of these columns are in white marble. Some of the doors are in sandalwood decorated with inlay work in ivory. These doors are excellent specimens of woodwork, each door made of 164 pieces of sandalwood joined together. An interesting feature of the Laxmi Vilas palace is the use of cotton –stuffed curtains to ward off cold and hot winds, an example of skilful air-conditioning in the 17th century CE. Vidyadhar Bhattacharya, the architect of Jaipur , was given a state award for making additions to this palace.

Lalit Mahal, on the upper floor has bed rooms, covered passages and balconies. The provision of a toilet attached to a bedroom is certainly an advanced feature of Jaigarh architecture. The Kathputlighar or the Puppet theatre is a double- storeyed auditorium with balconied separate arrangement for both male and female members of the royal familiy. The stage is large, twenty one feet by seventeen feet. It is a small window to the simplicity of life in royal palaces which depended much on the folk cultural traditions for their entertainment.

The Aram Mandir and the garden occupy the north-eastern corner of Jaigarh. The central hall is supported on twelve pillars joined with tall cusped arches. A notable feature of architecture here is the use of polished lime plaster or the *arayish* on the walls which gives an admirable sheen to

Clockwise from left:
Glass mosaics in Jas Mandir (Diwan-i-Khas); Amber Fort and palaces, bird's-eye view

the surface and is a great substitute for marble. The floral motifs frescoed over this smooth surface simulate grandeur of the Mughal interiors. The garden has been laid out on the familiar *char bagh* pattern of the Mughal garden. The fountains are supplied water from large over- head tanks. At the cross-section of the four pathways lies the central pool with a raised platform. A great effort has been made to make this section the most beautiful section of the fort. The parapets on the high northern ramparts of the fort provide magnificent views of the rugged hills surrounding Sagar, the great artificial lake which is the source of water supply to the fort and the township. From the two corner canopies can be obtained spectacular views of the cluster of the Amber palaces. Apparently this section of Jaigarh has undergone a few alterations during the last few centuries. Man Singh II had three grand arched openings on the northern wall, axially aligned with the central sunken pool and the palace. This garden is the chief attraction of the Jaigarh fort.

Among the other palaces at Jaigarh are the Vilas Mandir meant for the royal ladies and the Surya Mandir, now exhibiting the tools of the gun foundry. The most interesting feature of Jaigarh are the numerous tunnels connecting different palaces and providing passages sequestered from the heat, and observant eyes. It required great strategic planning and architectural skill to provide an immaculate defence system. The Kachchwaha rulers had surely learnt a lot from their observation and experiences at the Mughal courts and eternal vigilance was the first requirement for a peaceful life in these medieval palaces. The Jaigarh fort has been known for a remarkable system of water supply, the life-line of a hill-top fort. The magnificent Sager lake, just below the northern ramparts of the fort, is the most crucial source of water harnessing. Rain water from the higher reaches of the fort finds its way to the lake, passing through many drains, canals and small tanks where the dirt and waste in the water gets deposited at their beds and rain water gets cleaned of the impure extraneous matters before the gates of the canals are finally opened. The tremendous engineering skill required to implement such a grand scheme speaks well of the immense and elaborate planning.

Within the fort there are five large tanks or subterranean tanks. The three main tanks are located in the southern section. The largest tank is 158 feet long, 138 feet wide and 40 feet deep. There is a gigantic arched substructure supported on 81 pillars. This large tank is unique to Jaigarh fort. The second tank is equally large with nine holes in the roof under each aperture. It is believed that the Kachchwaha rulers hoarded their legendary treasure in these tanks. The Minas who fiercely guarded these treasures would take each new ruler blindfolded into the vaults and allow him to pick just one piece of his choice, only once during his tenure. The legendary Jaigarh treasure was the greatest treasure of its times. In 1976 CE, the taxmen got some hint of the whereabouts of this treasure in the tanks, the government of India ordered digging the area with the most scientific tools. The exercise went on for six months to end in naught. Not a single coin was found in the tanks. The treasure hunt destroyed the great legend. It has been suggested that Sawai Jai Singh II used up the treasure in building his new city-Jaipur. Some believe that the treasure is still there, and some believe it has just moved away.

The common foundry or the karkhana at Jaigarh is a rare surviving example of medieval foundries. Man Singh I was a great military general, fully aware of the needs of a powerful state. He

Clockwise from top:
Dira Burj; Aram Mandir palace and garden, north-eastern section of jaigarh overlooking the Amber palaces; Jai Van– the great gun

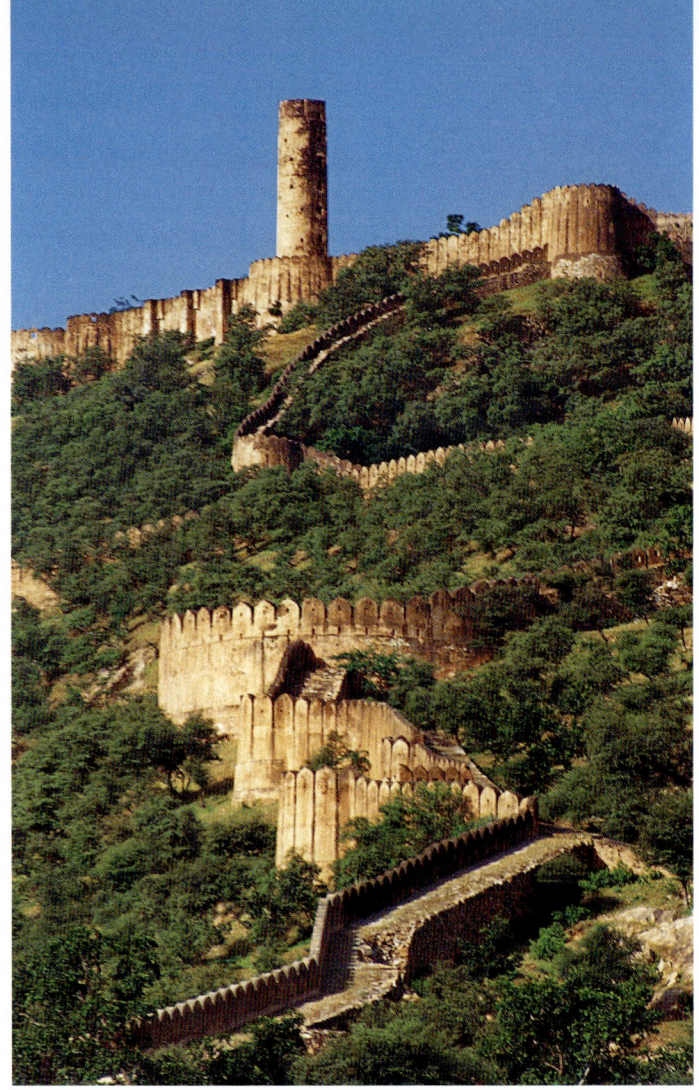

acquired the necessary expertise on the use of gun-powder during his tenure at Kabul. The Rajput confederacy led by Rana Sanga of Chittaur lost to the Mughal king Babur at the battle of Khanwa in 1527 chiefly because the Mughals had the advantage of gun powder and cannons over brave-hearted but ill-equipped Rajput soldiers. Man Singh I imported a few models of cutters and drilling bits to Amber. His father Bhagwan Das, successor to Bhar Mal, built this foundry at Jaigarh in 1586 CE in complete secrecy. Even the Mughals did not know of this move. The exhibitions of works at the foundry show the huge casts, furnaces and all other technical aspects of such an enterprise. Both for the unimaginable amount of treasure and the gun foundry, the Jaigarh fort shut its gates to visitors who were allowed only upto the Amber palaces.

Jaivan, the greatest showpiece of the Jaigarh foundry, was cast in 1726 CE. It is certainly Asia's largest cannon on wheels with a length of 35 feet, barrel of 20 feet and a bore of eleven inches. It required sixty kilogrammes of powder to shoot a round projectile weighing sixty kilogrammes. The Jaivan could fire within a range of forty eight kilometers. The front wheels are enormous measuring nine and a half feet. It was not easy to manouevre the cannon which required four elephants to change its direction on a rolling pin system set between the two smaller rear wheels. The barrel alone weighs fifty tons. Cast during the reign of Sawai Jai Singh II, the great cannon was set up on its present platform by Sawai Ram Singh in the mid nineteenth century CE. It has been test-fired only once when the shot landed at Chaksu, a village forty kilometers away from Jaigarh. The importance of this magnificent fort required careful planning. An array of ten cannons was installed on the ramparts to thwart any possible invasion. The fort was secretly prepared for any eventuality. During those days an attack by the Mughals themselves could not be counted out. The Mughals were extremely uncomfortable against any ambitious rising political power even amongst its own vassal Rajput states.

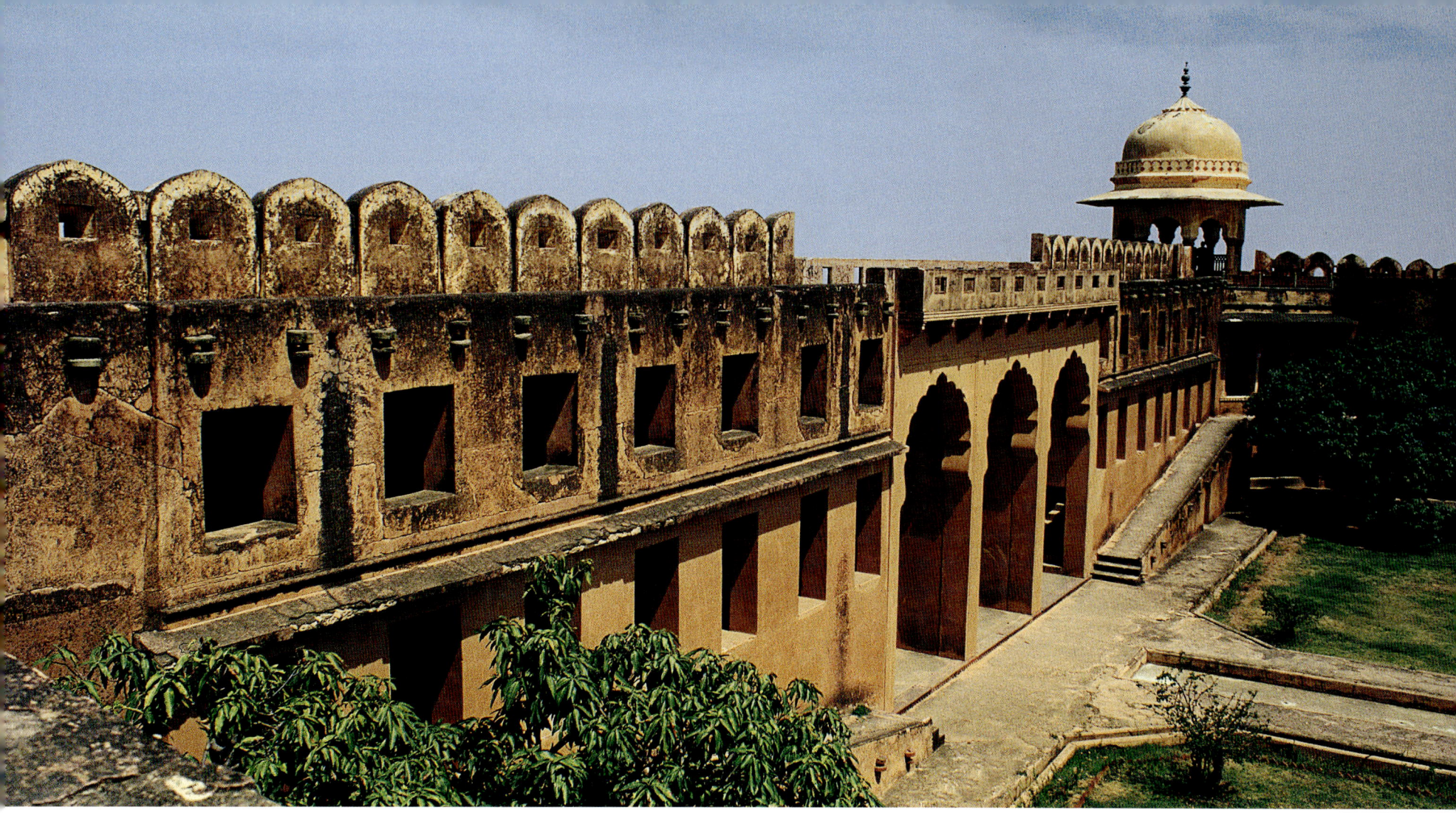

The Jaigarh fort may not have stunning Sheesh Mahals or great gardens but it certainly has some unique features which must include the Diva Burj, a seven storeyed lamp tower for keeping watch over the Dhundhar hills for enemies approaching through gorges and ravines. It is one of the most famous landmarks of Jaigarh.

This magnificent fort was put under the strict watch of the five Qila Jaats or fort castes comprising Achrol, Boraj, Dhula Jobner and Pipla- the five feudal states obliged to maintain security forces at Jaigarh. The Minas remained the chief Qiladars or keepers of the fort, responsible for nearly everything in and around the fort. Nothing would escape their watchful eyes.

The Sudarshangarh or Nahargarh fort was built by Sawai Jai Singh II in 1734 CE. This fort stands high over the hills on the north-western side of Jaipur. In view of its late date of construction Nahargarh looks a more contemporary structure than the much older Jaigarh. The height of its outer walls is low. It shows a more notable Mughal influence on its domes, towers and ornamentation. There are different but identical sets of palace apartments following a uniform architectural pattern-Suraj Prakash, Khushal Prakash, Jawahar Prakash, Anand Prakash, Laxmi Parkash, Ratan Prakash and Vasant Prakash. The Madhavendra Bhawan was built by Maharaja Madho Singh (1902-03 CE). The delicately frescoed walls, elegant cusped arches and an overall Mughal ambience show the far reaching influence of the imperial architecture.

The Nahargarh fort presides over the city of Jaipur. It is from here that the official Jaipur time was boomed out. It was built to house the Jaipur treasury but soon Moti Dungari Palace in the city was found more suitable for reasons of security. The Nahargarh fort was soon transformed into a pleasure resort of the Jaipur royalty.

The site where the Nahargarh fort stands today was once a thickly forested area held by the Minas. The spirit of Nahar Singh, a dead Mina chief, would not let the fortification walls rise and a day's work was raised to the ground at night. The spirit had to be propitiated before the work could make any progress. Finally, the angry spirit was propitiated by the performance of some *Tantrik* rites and work was resumed. Tiger fort or Nahargarh perches on the hill in the posture of a tiger ready to leap over its prey. It is a grand site from the city.

Samode

Samode Palace, 42kms from Jaipur, is amongst the few splendid palaces in Rajasthan in need of greater publicity. In fact, the small fortress containing this grand palace lies hidden behind the high barren hills-brown and denuded of all greenery and a long grim wall of fortification. For miles around this small inconspicuous village, the golden sand has smothered vegetation. The ribbon-thin desert road lies deserted for most part of the day coming alive only with the arrival of buses and tempos heading for destinations in the interior of Rajasthan. At Chomu, where you change the bus for Samode, it is sheer pandemonium at the bus stand with passengers running after buses amidst vehicles and transport of every imaginable kind-buses, trucks, tempos, jeeps, camel-carts, three-wheelers, two-wheelers, cars and cycles. Amongst the jostling, milling crowd of eager passengers, the lone tourist will have the experience of a life-time. The arrival of a bus starts a grand commotion of turbaned men with ferocious moustaches and women in spectacular costumes heading for the narrow entrance at the speed of an approaching storm. Before one gets down, five passengers push themselves in. Here, as if lifted by a tornado, the tourist could find himself inside the ranshackle carrier where men, women and children

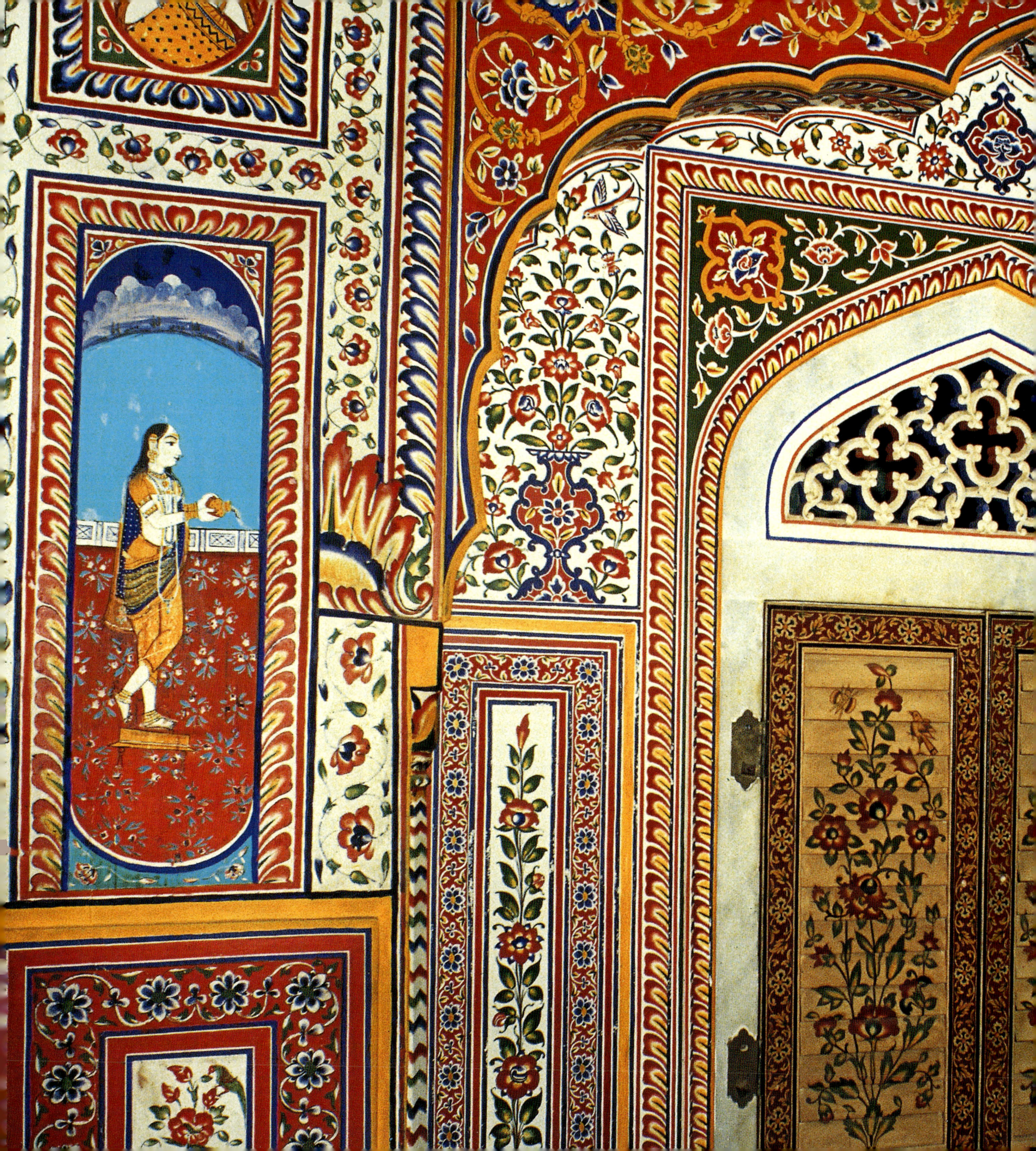

create a strange but terrible chorus of noises-shouts, cries, instructions, farewells, abuses, recriminations, endearments, blaring transistor sets and constant hooting of the horn and much more. It all settles down amicably within ten minutes. What a relief! Be prepared for another shock-this bus is heading towards Jaipur and not Samode. This is the charm of catching a bus on a roadside stand.

The Samode Palace crowns a small, low hill and the village around it is typical of villages in Rajasthan. As the road winds its way to the top, you can see groups of old folks engaged in animated conversation, women in their extravagantly colourful dresses gathered at the hand-pumps along the road, children enjoying their innocent rustic games, older people sitting on a charpoy under the Bunyan trees-creating unforgettabe vignettes of authentic village life. Houses on both sides of the cobbled road are decorated with colourful murals of Hindu deities, horses and elephants, and battle scenes-themes so dear to the heart of the simple folks. Huge Bunyan trees appear at every corner. The road passes through three huge gateways. A very large open area appears at the end of the road. There are three ancient Bunyan trees where groups of people sit to exchange news and gossip. The view stretches upto the crest of the yonder hill where a small fortress solemnly guards the barren precincts. In fact, the fortifications girdling the palace lie hidden behind the houses and this gateway appears in view rather suddenly.

The gateway leads into a spectacular courtyard surrounded by arched galleries, stables, offices and a small parking for royal vehicles. You stand alone but watchful eyes observe your movements from the various security check-points.

The western corner of this grand rectangular court is occupied by the magnificent gateway standing atop a stately flight of steps. It is the most impressive gateway to a palace which is yet to reveal its splendours to the visitor. The huge arched entrance is surmounted by galleries with trellis

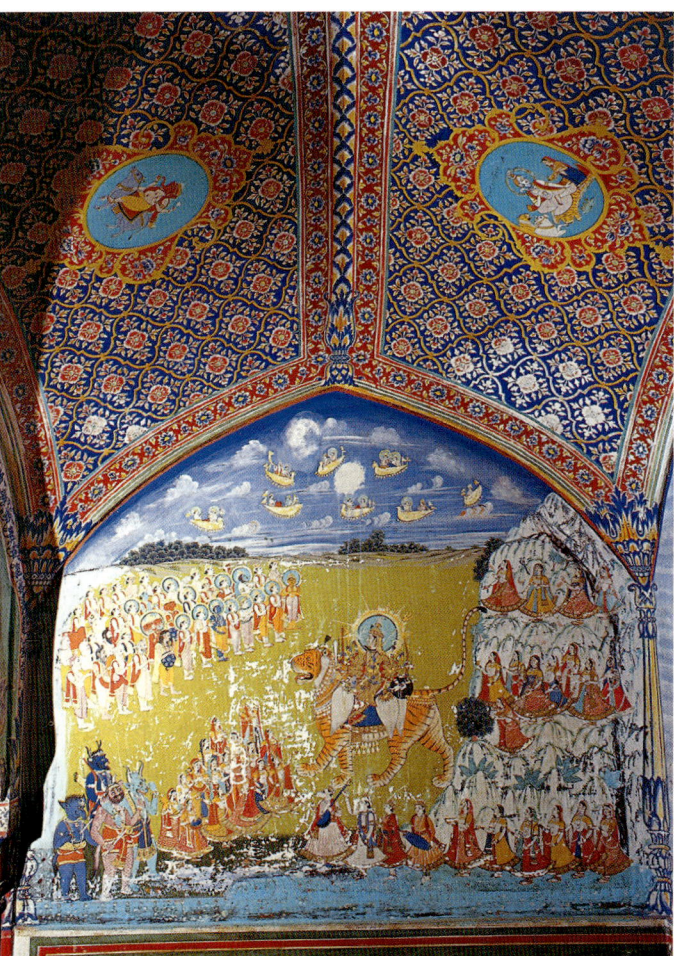

Clockwise from left:
The gallery over the Darbar Hall;
Splendid mural in an alcove

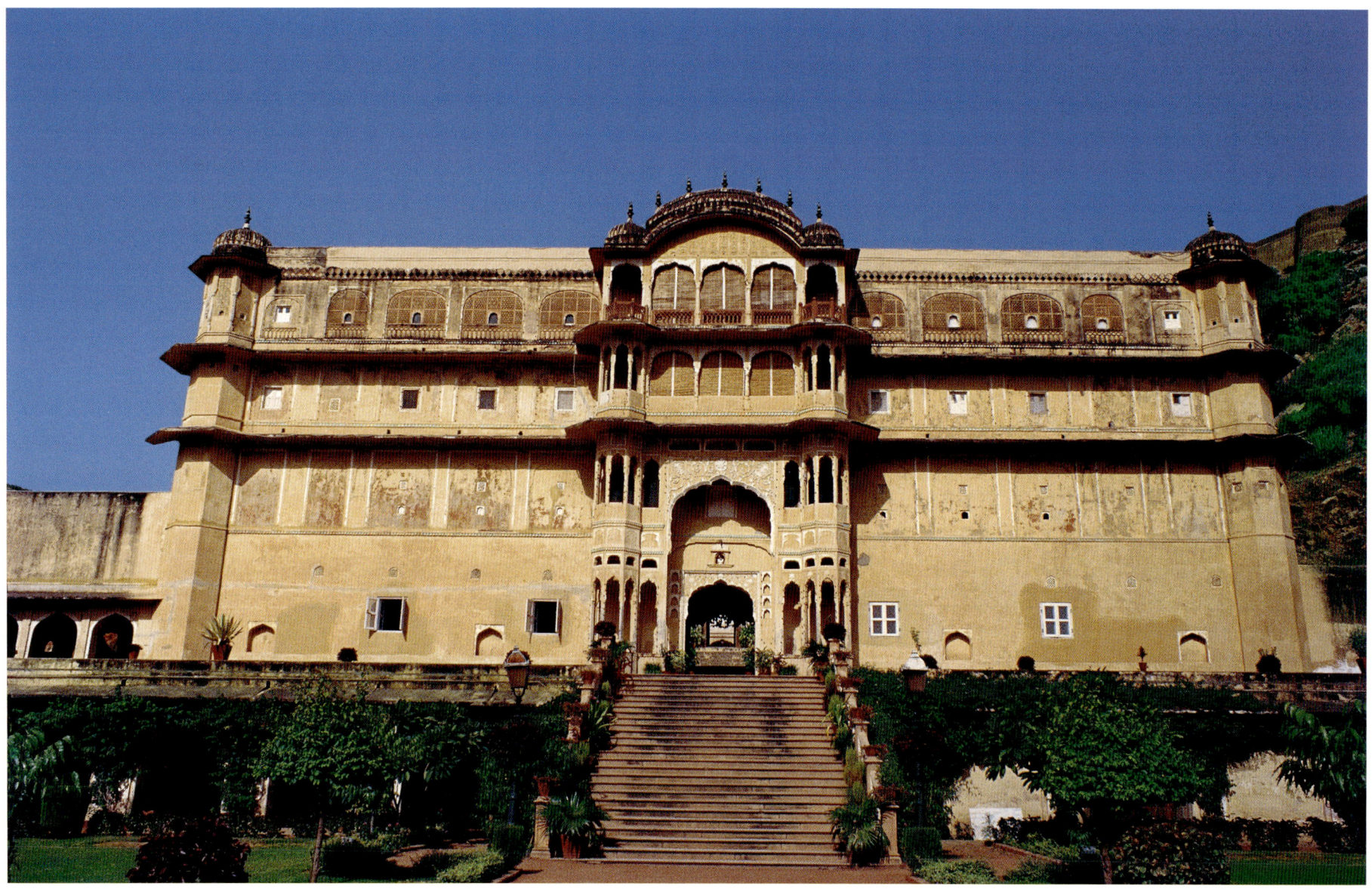

This page:
Samode Palace exterior

windows from where the royal ladies could watch the state functions held in the open court. This gateway is a triumph of architecture as it rises against the backdrop of brown hills and a blue sky.

In another courtyard, a marble fountain stands at the centre of the court. This area is transformed into a five-star restaurant in the evenings when folk musicians and dancers perform here for the guests, mostly foreigners staying at this heritage hotel.

Close to the reception desk on the first floor is the Sultan Mahal covered with an incredible wealth of murals. The front lobby functions as the reception lounge. The alcoves here contain large-format paintings depicting royal hunting scenes and some deities. Also on these murals are scenes depicting the Krishna legend and scenes from the Ramayana. Court scenes include celebrations and dances, typical forms of royal entertainments.

The inner oblong room is covered with the most sumptuous mural decoration in gorgeous colours still retaining their pristine grandeur. In the subdued light, the golden streaks of the murals acquire a magical splendour. These murals show an influence of both the Jaipur and Mughal styles. These murals were executed during the eighteenth and nineteenth centuries when Rawal Brisal Singhji and Sheo Singhji spent lavishly on this artistic ornamentation. The Samode Rawala are the descendants of Gopal Singhji, one of the Kachwaha Rajput Raja Man Singh's twelve sons who were awarded *jagirs* of their own land.

Down the stairs and through dimly lit corridors, one reaches yet another courtyard with some greenery. Herein lies the Darbar Hall, the area where the subordinate chiefs assembled for meetings. In grandeur and decoration this hall has but few equals. Every inch of the wall and ceiling has been painted over with the deftness and indulgence made possible only by long periods of prosperity and artistic inclination of the rulers. The dazzling desert colours have withstood the test of time, defying decay and discolouration. The floor is covered with magnificent carpets with bolsters arranged in a semi-circular formation. These days here are arranged performances by folk artistes on special occasions recreating the royal aura of the past.

Still more fabulous is the Sheesh Mahal, an amazing world of fantastic glass mosaics on stucco. A candle lit under the ceiling or the arches takes enchanting forms of dancing reflections. The murals on the dadoes depict the familar hunting scenes, rich and green countrysides huge trees with countless birds and butterflies, flower vases and, of course, women in colourful desert costumes etc. The colours are bright yellow, mustard, red, orange, green, maroon and indigo blue outlined with streaks of gold.

The Samode Palace is one of the most charming palaces in Rajasthan which deserve a leisurely observation of its exquisite ornamentation and a feel of life in the rich but secluded sector of the desert close to Jaipur.

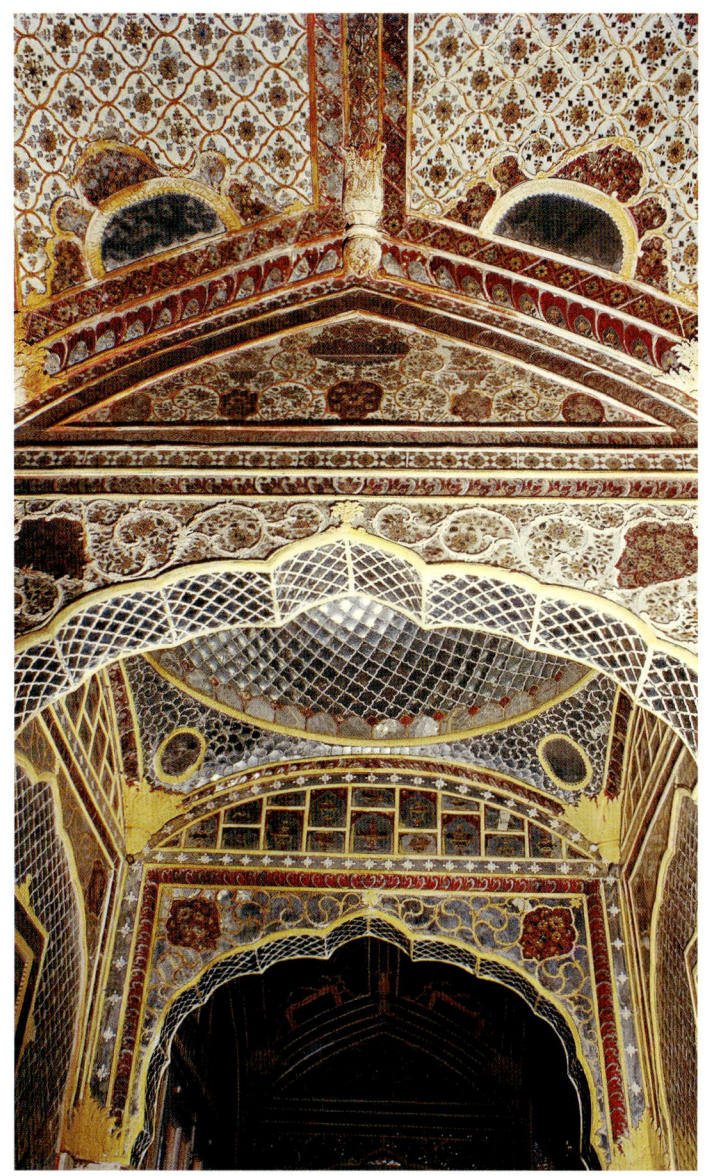
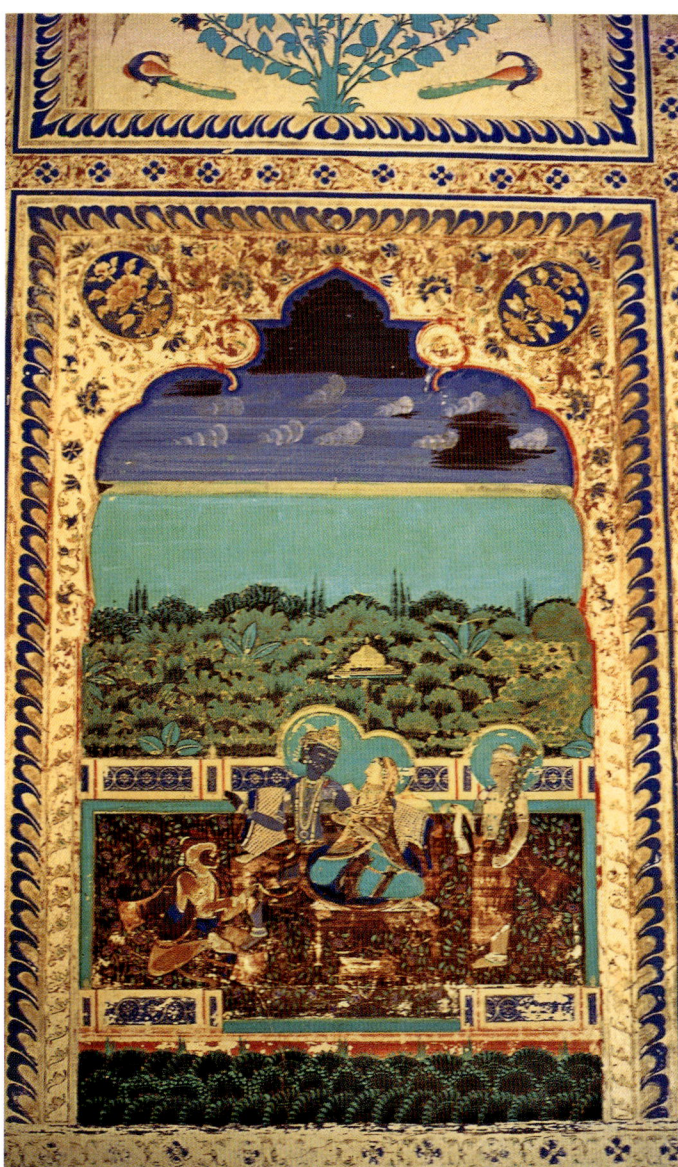

Clockwise from top:
Sheesh Mahal corridor of arches; A mural in the Sultan Mahal; Interior of Sheesh Mahal

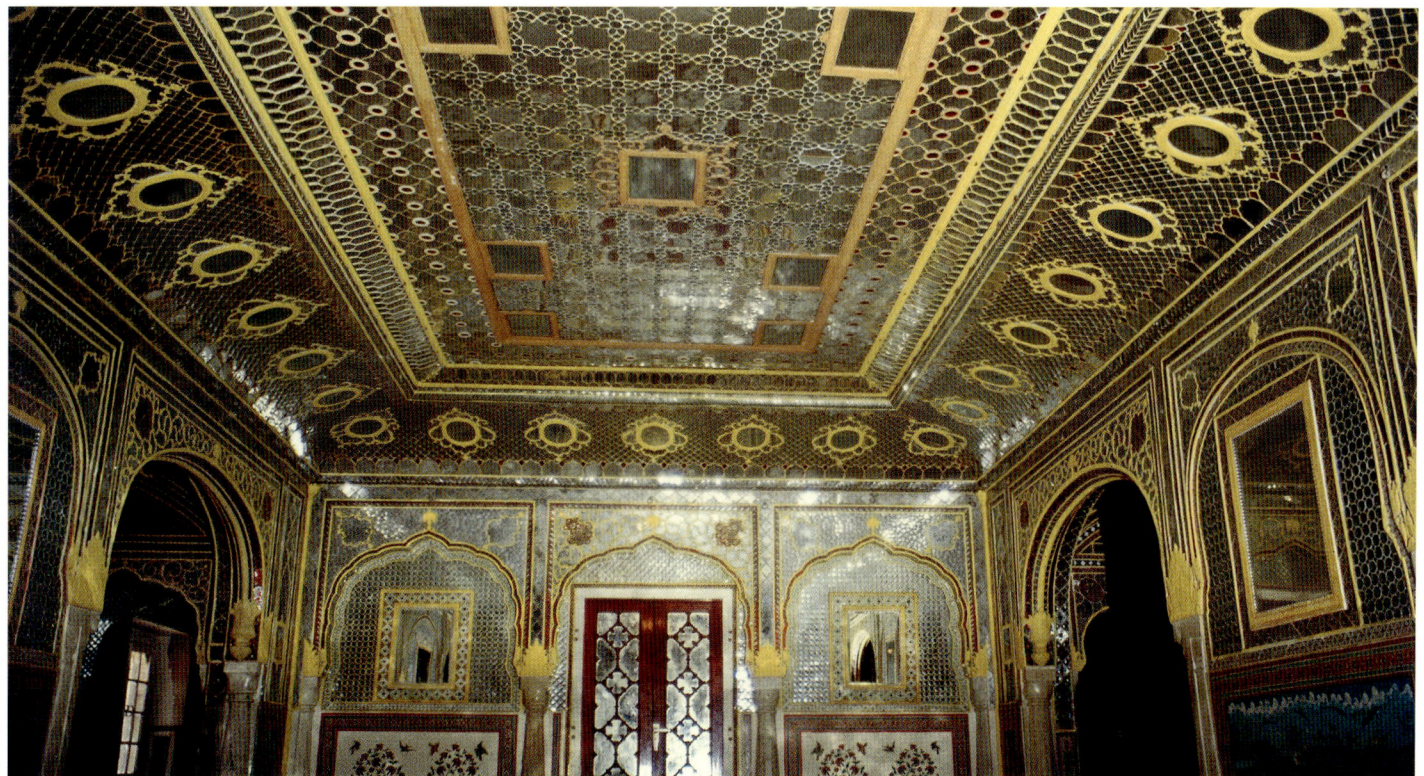

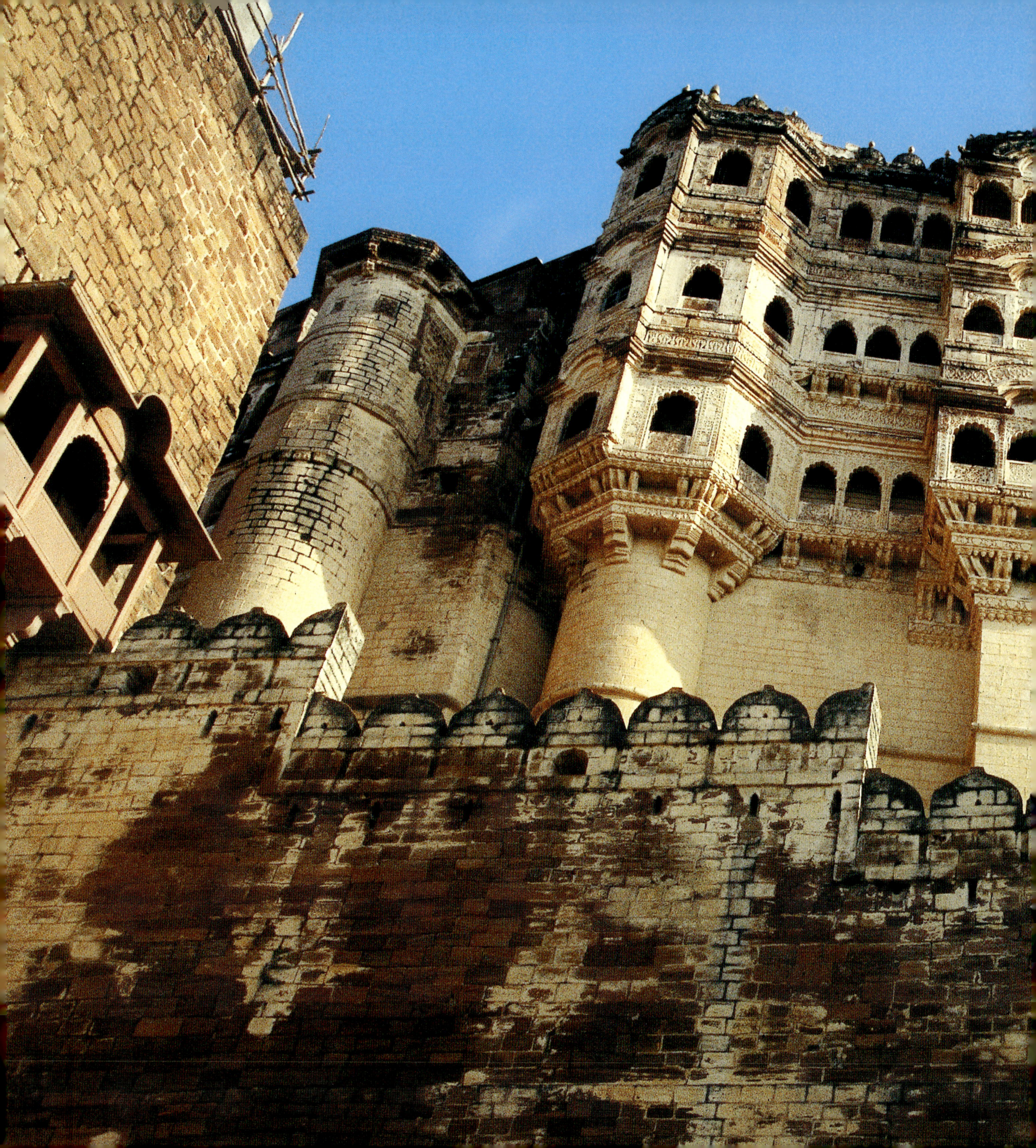

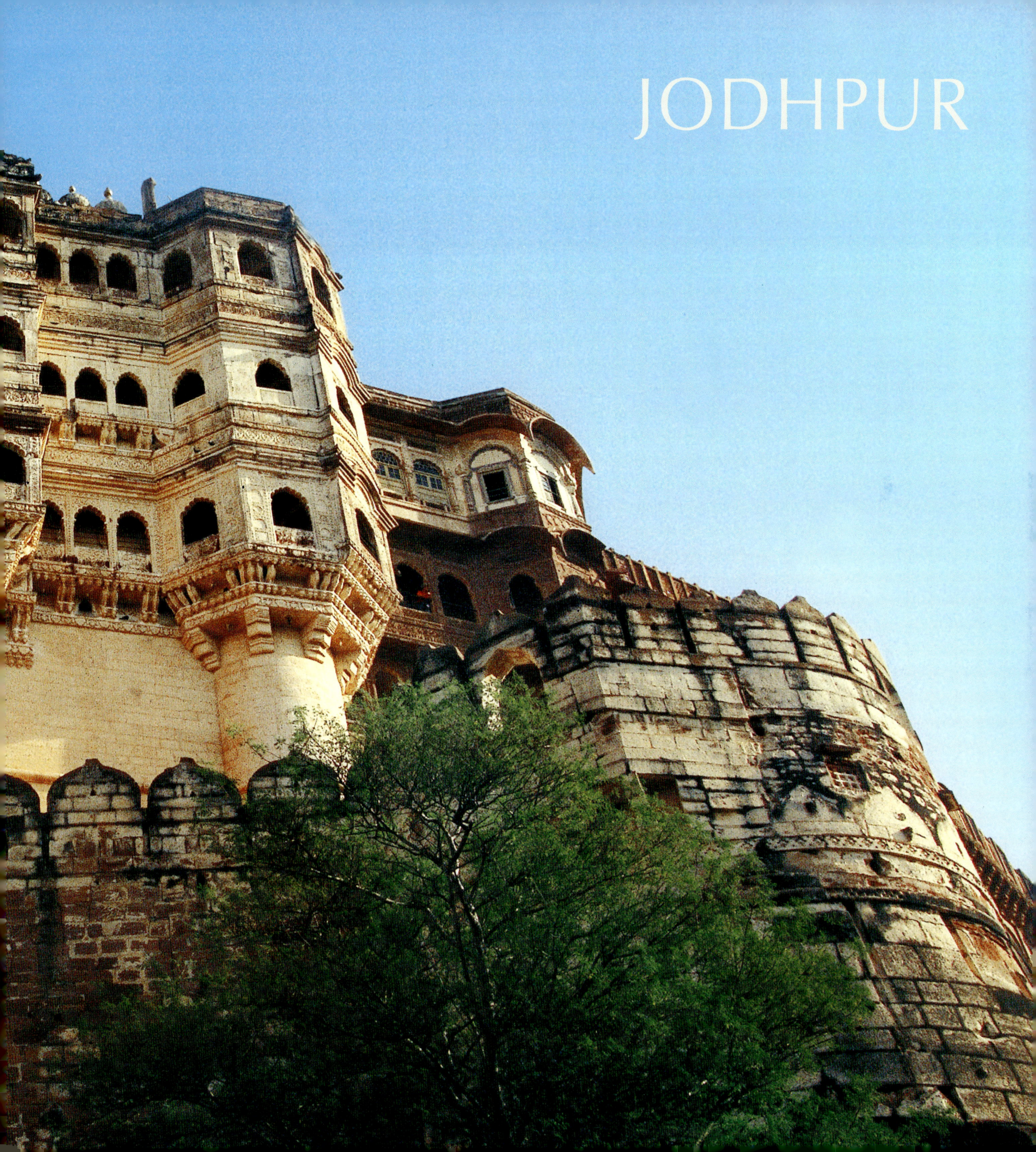
JODHPUR

Mehrangarh

The Rathores of Jodhpur claim their descent from Rama, hero of the epic Ramayana and are, thus, *suryavanshis*. They held Kannauj in Uttar Pradesh, since 470 CE when Nayan Pal established his rule there. The most important ruler of the Rathores was Jai Chand, a contemporary of Delhi's Prithviraja Chauhan III. Muhammad Ghori annihilated both the Chauhans from Delhi and Rathores from Kannauj in 1193 CE. Jai Chand was drowned in the Ganges and his grandson, leading a handful of Rathores held the *panchranga*, the five-coloured flag of the vanquished dynasty and moved towards the Thar region to carve out a new kingdom for the Rathores. The Rathores found their new home in Pali in 1212 CE. Hereafter through courage, determination and marital alliances with other clans, they soon consolidated their position. They acquired Mandore, near Jodhpur, and became a very important political force to reckon with in Marwar (or the Land of Death as it was called).

In 1459 CE Rao Jodha moved to Jodhpur and laid the foundation of a magnificent fort on a 400 feet high rocky hill. The Rathores were the new political force in the desert state. Maldeo (1532-73 CE) was brave and ambitious. He offered to help Humayun when the latter, defeated by Shershah, was in need of a shelter. Neither Maldeo nor Humayun could match the guile of the Afghan chief. When he could have arrested the fugitive Mughal emperor and surrendered him to Shershah, he let Humayun slip away, only to confront Shershah at Merta in 1544 CE. It was a battle of attrition. Shershah foxed his rivals by having forged letters dropped in the Rathore camp indicating a conspiracy amongst the Rajpur nobles to desert Maldeo at the last moment. Maldeo was in panic. To prove their honest and steadfast support to Maldeo, the nobles rushed at the enemy in a wild charge and perished. Shershah quipped, "I had nearly destroyed the Empire of Hindustan for a handful of *bajra* (millet)."

Akbar remembered Maldeo's betrayal of Humayun and captured Merta. He also set Bikaner against Jodhpur. Like the Kachchwahas of Amber, The Rathores saw that their only chance of survival against the mighty imperial armies lay through matrimonial alliance with the Mughals. The marriage of a Rathore princess Jodhabai with Salim (later called Jehangir) restored peace and prestige to Jodhpur. The Amber princess had given birth to Salim. The Jodhpur princess gave birth to Khurram, later called Shahjahan.

The Rathores, despite all their bravery and diplomatic alliances were not particularly reliable allies. Jaswant Singh, the first Maharaja of Jodhpur, held numerous prestigious assignments at the Mughal court. He found himself fighting for Aurangzeb in the war of succession among Shahjahan's son whereas his real sympathies lay with Dara Shikoh. When he returned as a defeated Rajput from the battlefield of Malwa in 1658 CE, Jaswant's proud Rajput queen had the doors of the Loha Pol at the fort closed on him: a defeated Rajput brought no honour to his race. The imprints of *Sati* hands on the fort walls speak volumes of this Rajput rite of death before dishonour.

The true Rajput courage manifested itself in the struggle of Durga Das, a minister of Jaswant Singh who rescued the child prince Ajit Singh from Aurangzeb's prison and had him restored to the Jodhpur *gaddi* (throne) in 1709 CE. He showed extraordinary courtesy to the daughter of Akbar II who was among Rathores initially to conquer the land for Aurangzeb but compelled by circumstances to change sides and seek Rathore support for his claim to the Mughal throne. Akbar II lost the Rathore support when Aurangzeb had a forged letter dropped in the Rathore camp suggesting that Akbar II was there to destroy them. Still, Durga Das escorted Akbar II to safety. It was the second time after the Sheh Shah episode that a forged

Previous pages:
Palace balconies overlooking the fort walls at Mehrangarh

This page:
Mehrangarh Fort overlooking the city

Following pages:
Phool Mahal interior

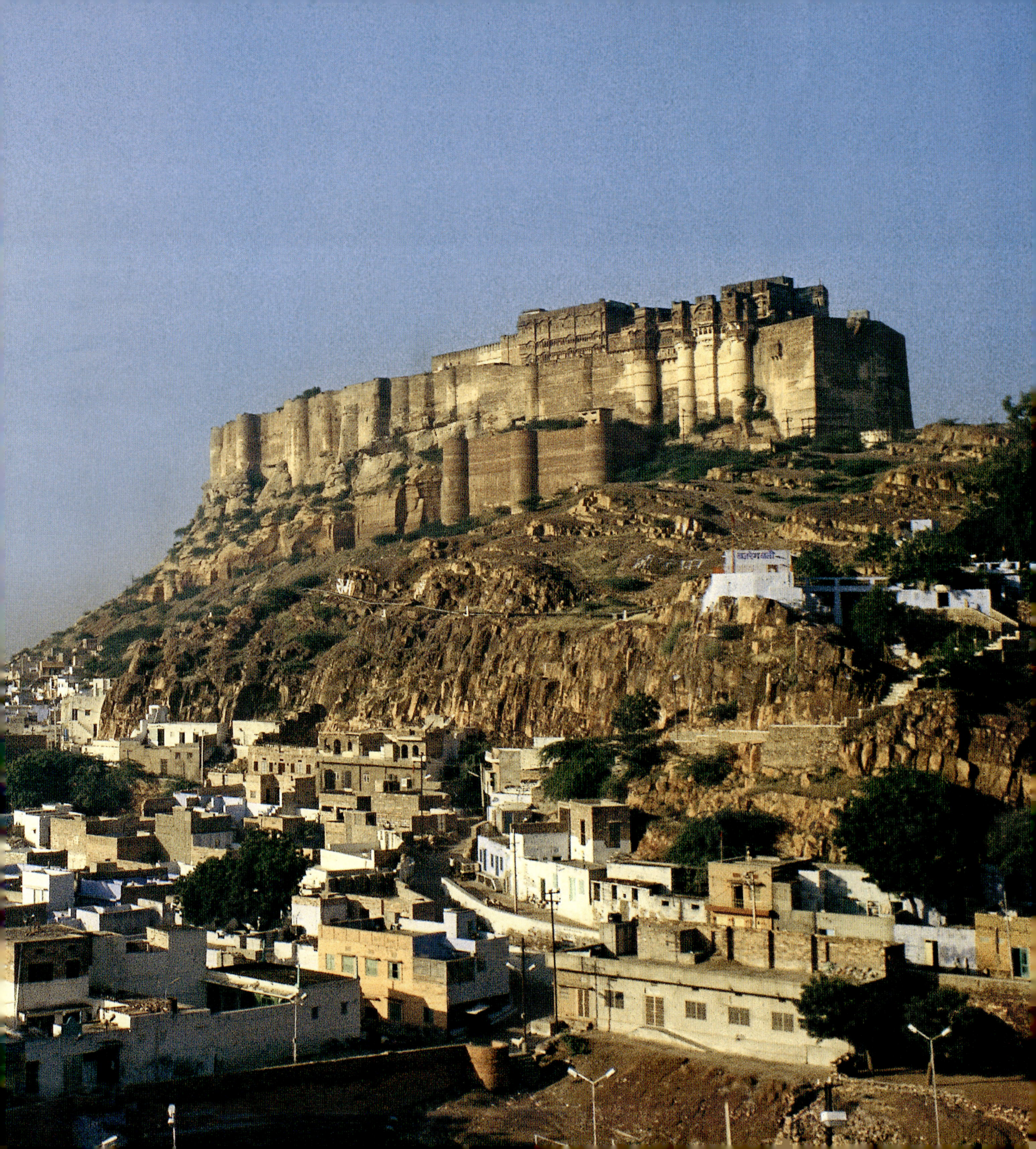

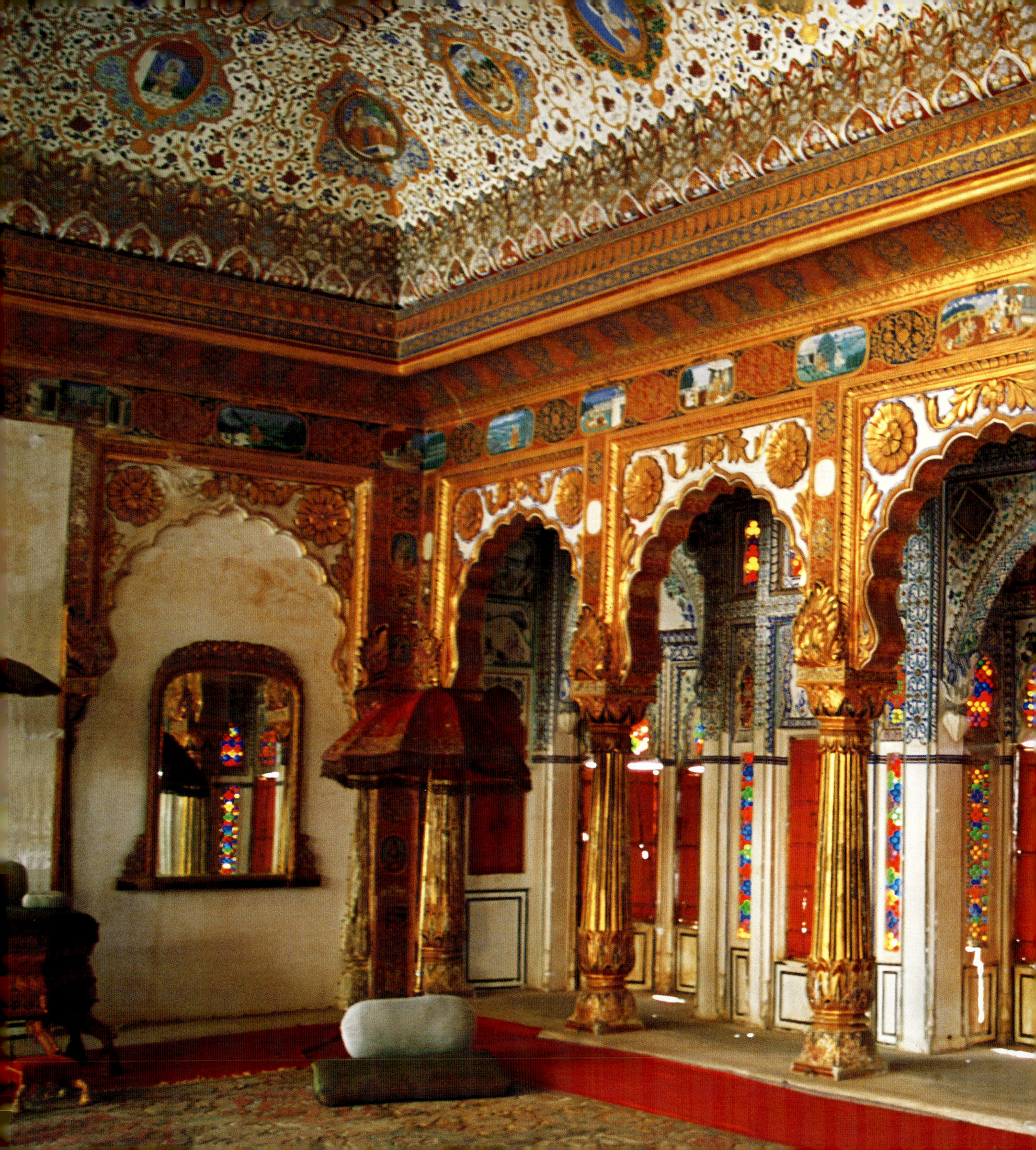

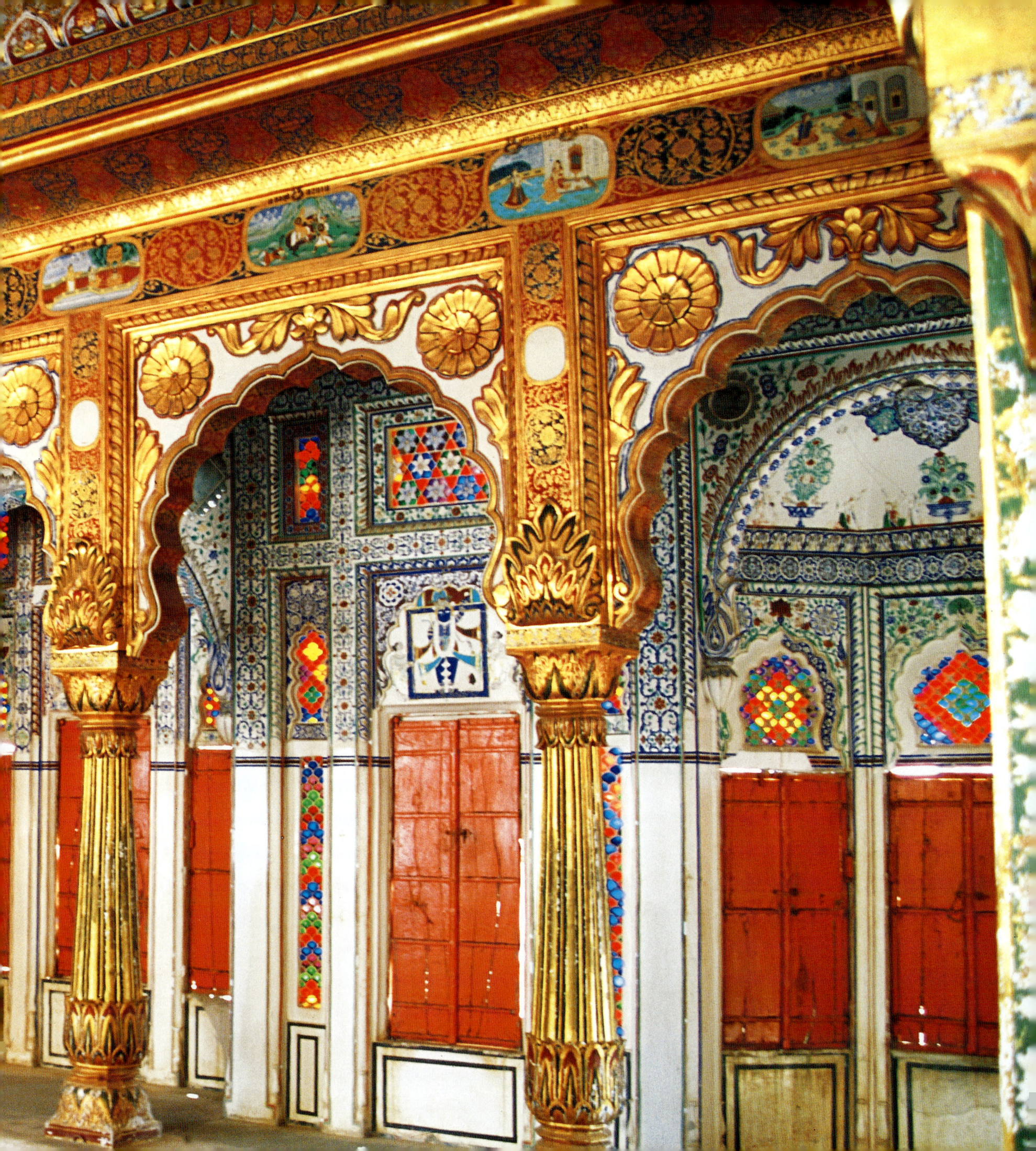

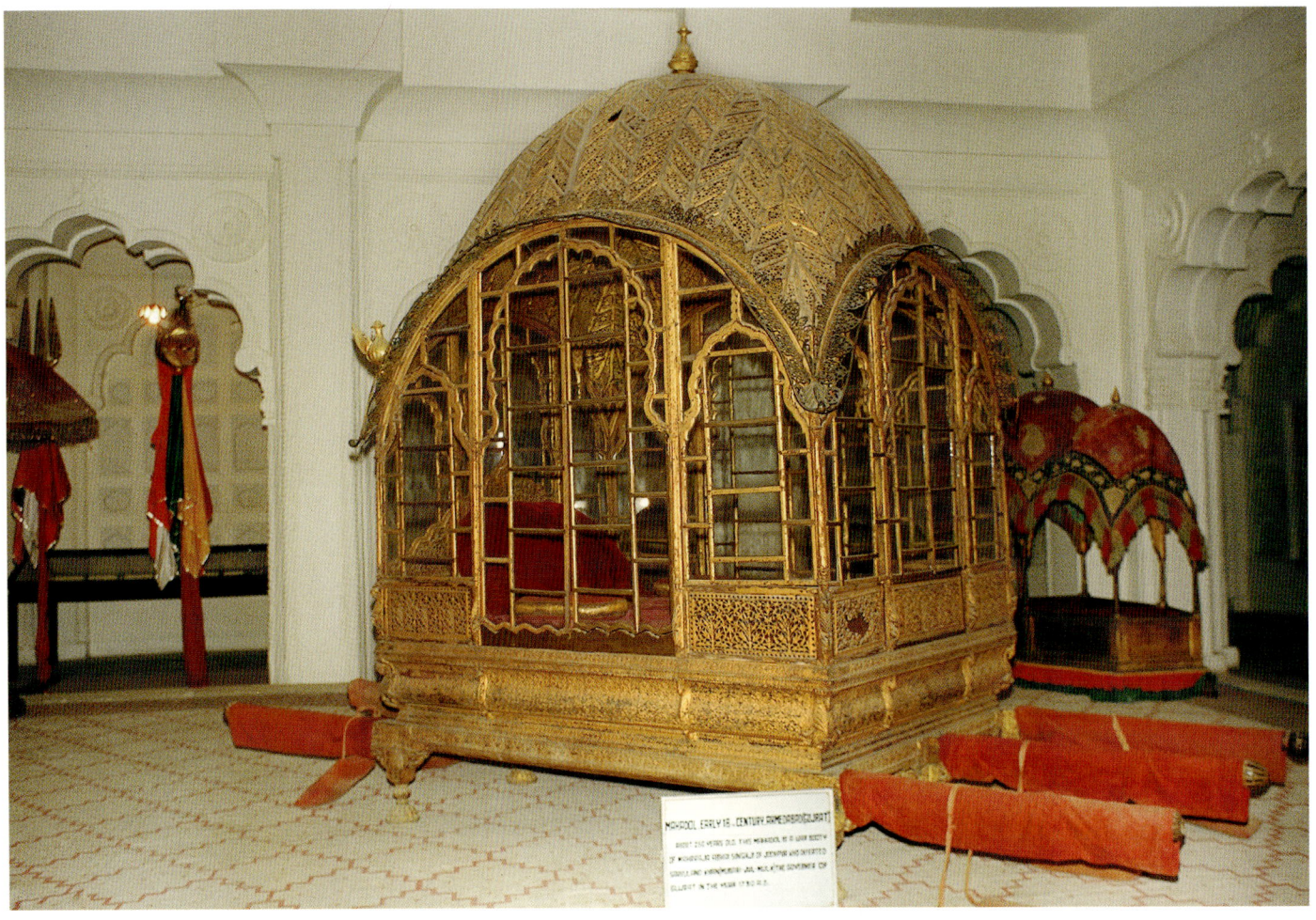

letter had done what armies failed to do.

Ajit Singh found himself involved too much with the Mughal court intrigues following the death of Aurangzeb in 1707 CE. At one time, after his confederates, the Sayyid brothers, had imprisoned Farrukhsiyar, Ajit Singh held the Red Fort in Delhi for four days. If he dared Ajit Singh could have changed the political scenario of the country. Instead, he settled for the governorship of Ajmer and Gujarat.

The Mehrangarh fort, initially called Mordhwaj and Chintamani fort, occupies a rocky prominence 400 feet above the plain, and has the most commanding presence in the barren desert land surrounding it. The uninterrupted views over the stark land leads the eye, on dust-free mornings, to the Kumbhalgarh fort, nearly 120 km away. Since the fortifications and palaces were built out of the stone excavated here itself, the whole stupendous structure of the fort seems to grow out of the rock itself. "Perched high like an eerie on its rocky outcrop, its eastern towers and bastions stand out like tough sinews, gleaming with a copper tinge where the rock itself was hewn to form the walls and ramparts", observes Virginia Fass about the Mehrangarh fort. The word Mehran in the Dingle dialect means the sun.

The palaces at Mehrangarh are reached up by a narrow and steep ramp passing through six gateways. Jai Pol, the first gateway, stands close to gigantic towers surmounted with balconies on the eastern side. This was built in 1806 CE by Maharaja Man Singh to commemorate Jodhpur's victory over the Jaipur forces. Also, a *chattri* stands at the gate to mark the site where Kirat Singh, a Rathore soldier, died fighting against the Jaipur soldiers. The Dedh Kangra Pol is an important gate which shows the marks of cannon balls fired at the structure by the invaders. Rao Maldeo built the Amrit Pol. On its left is Rao Jodha's Falsa or barrier. Wooden logs were fixed into holes on both sides of the inner walls to provide a strong barrier

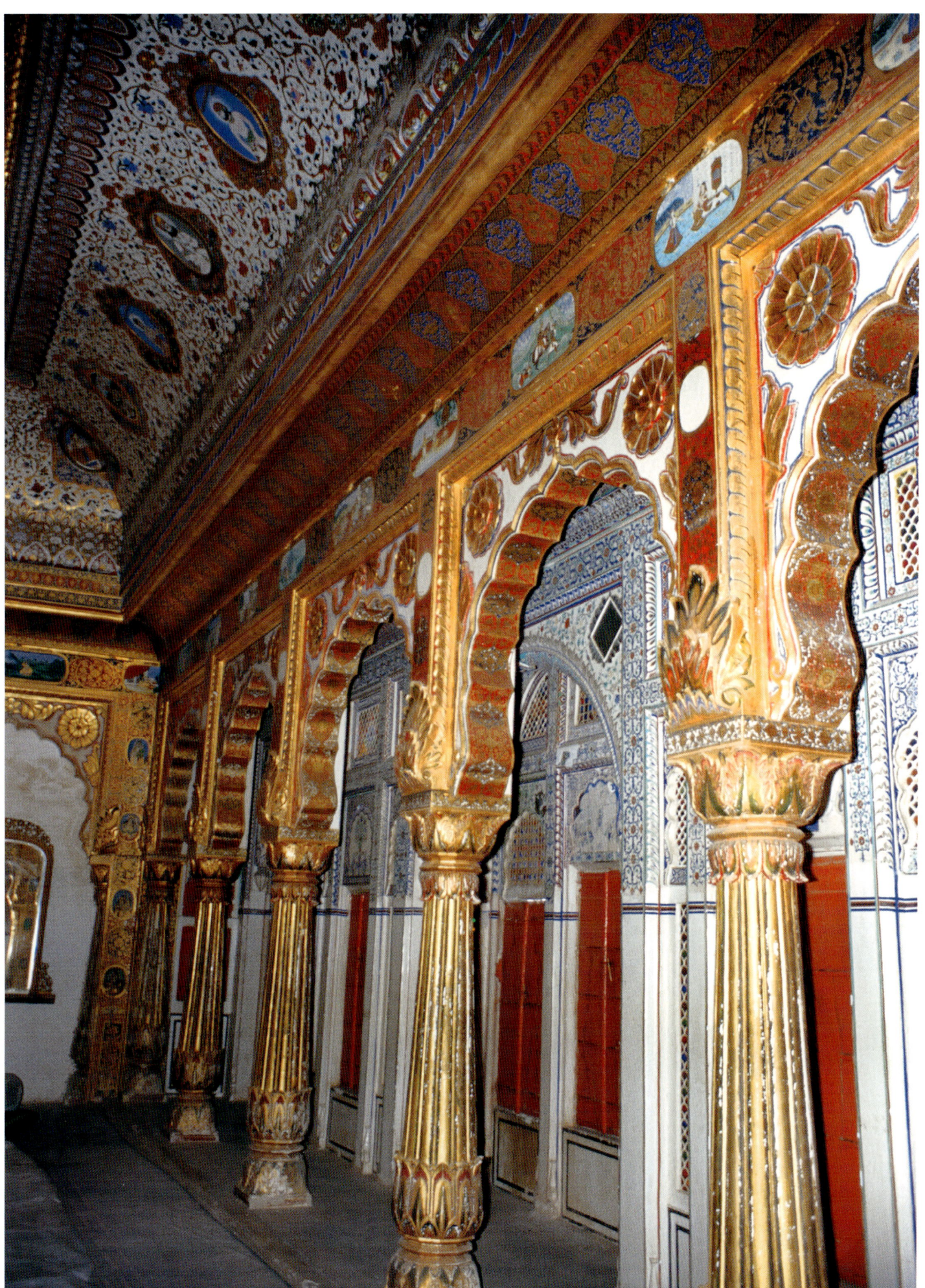

Clockwise from far left:
Mahadol palanquin;
Phool Mahal corridor;
Royal Rathore rulers

MEHRANGARH AND JODHPUR

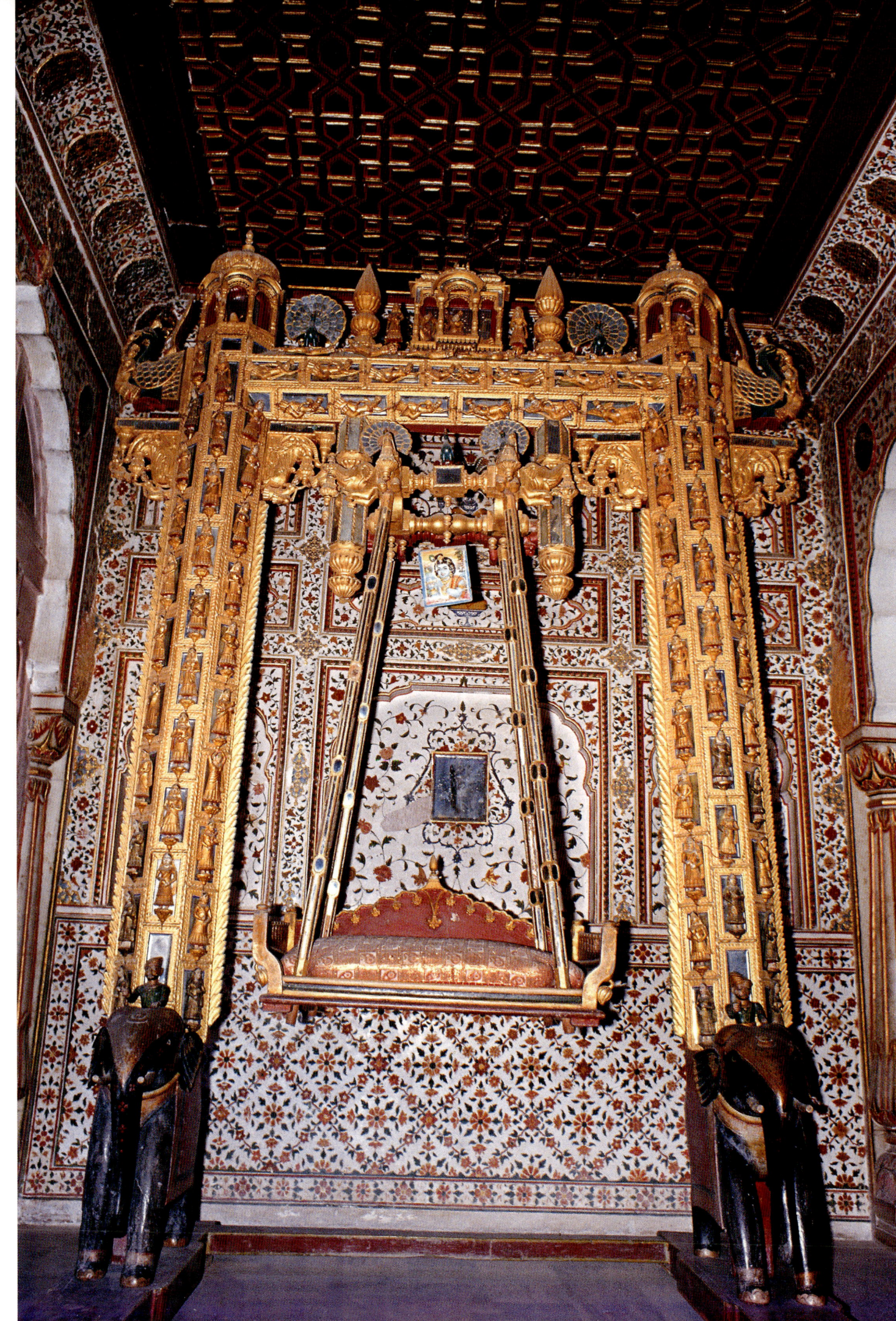

Clockwise:

Swing for Lord Krishna; Takhat Mahal- royal sleeping chamber

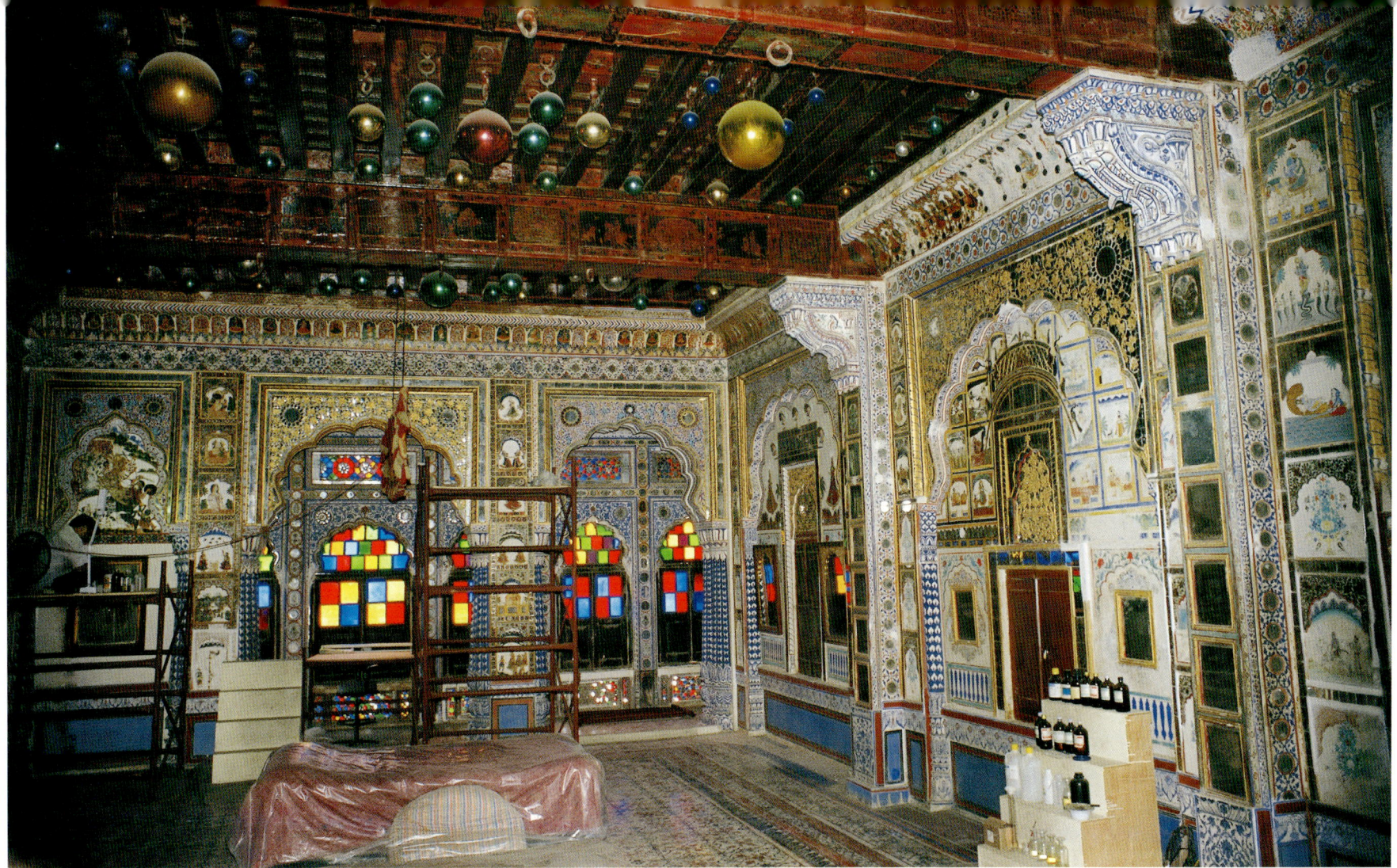

to the enemy forcing entry into the fort. The sudden bends in the passage could surprise any army. The iron spikes on the Loha Pol could stop even mad elephants charging against the heavy doors. The Loha Pol is the most strategically located gate at Mehrangarh, built in the 15th century CE. Here can be seen thirty one hand prints of women who committed *sati*, in testimony of the great character of Rajput women who would rather end their lives on the death of their husbands.

The fort and its numerous grand palaces are the accumulated work of rulers at different times. The original palace built by Rao Jadha has been transformed into a series of palaces built around courtyards. There are open and secret passages leading from one into another palace. By and large, all these palaces have been built in a homogenous style deriving mainly from the Rajput architectural traditions and borrowing but little from the contemporary Mughal architectural trends. It is in the profusion of interior embellishment and the memerising quality of stone craftsmanship where the genius of these Rajput architects finds its fullest expression.

The Suraj Pol admits visitors to the palace which now houses the Mehrangarh Trust Museum. The white marble throne is the most conspicuous object in this court. It is the coronation seat of the Jodhpur rulers and all, except Rao Jodha, have been anointed and crowned at this seat. The plain and unadorned stone furniture speaks well of Rajput character. The Shrinagar Chowki is surrounded by a range of palaces including the Jhanki Mahal. The upper ranges of the Jhanki Mahal are only one room deep. It functions more as a viewing gallery for the royal ladies who could observe the various celeberations held in the courtyard below these charming balconies. The most attractive feature of the Jhanki Mahal is the splendid series of *jali* screens illustrating the legendary craftsmanship in stone. It is believed that more than 250 different *jali* patterns have been used in the Jodhpur palaces. Today, the Jhanki Mahal houses the collection of royal cradles.

The Jhanki Mahal has splendid balconies or *jharokhas* projecting over the court. These *jharokhas* with grand *bangaldar* roofs create an exhibition of exquisite *jali* work with an ethereal gossamer finish. Mostly these *jharokhas* appear placed one over the other, a recurring feature of embellishment on the exterior walls. Whereas the upper floors are in the typical Jodhpur stone, the ground storeys are covered with polished stucco.

Since some of the palaces now house the museum, their original function cannot be reliably ascertained. The Daulat Khana and Silesh Khana display a unique collection of weapons in the armoury. The swords and daggers, some covered with amazing calligraphy, are the most remarkable exhibits here.

Among the most prized exhibits is the huge royal Mughal tent in red silk velvet covered with floral designs embroidered with gold threads. It was for Shahjahan and used a portable audience hall. Aurangzeb inherited it but when Jaswant Singh reneged on Aurangzeb for the second time, the Rathore plundered the Mughal camp and chose this tent amongst many other objects of greater monetary value.

The collection of royal palanquins at the museum is extremely fascinating. The most attractive palanquin is the golden dome-like huge carrier, called Mahadol. This was brought by Maharaja Abhay Singh from Gujarat after his victory over Sarbuland Khan in 1730 CE. This magnificent palanquin has a large number of transparent glass panes on all the four sides and has been fashioned like a glass house allowing the occupant full view of the surroundings from within and closing it with curtains if the sun and glare became too oppressive. The palanquins for the queens are small portable luxury palaces with richly embroidered cushions and curtains. These palanquins carry interesting names like Tam-Jham, Khasa, and Pinja. The peacock-shaped wooden frame of Tam-Jam si very beautiful, fit for the royalty.

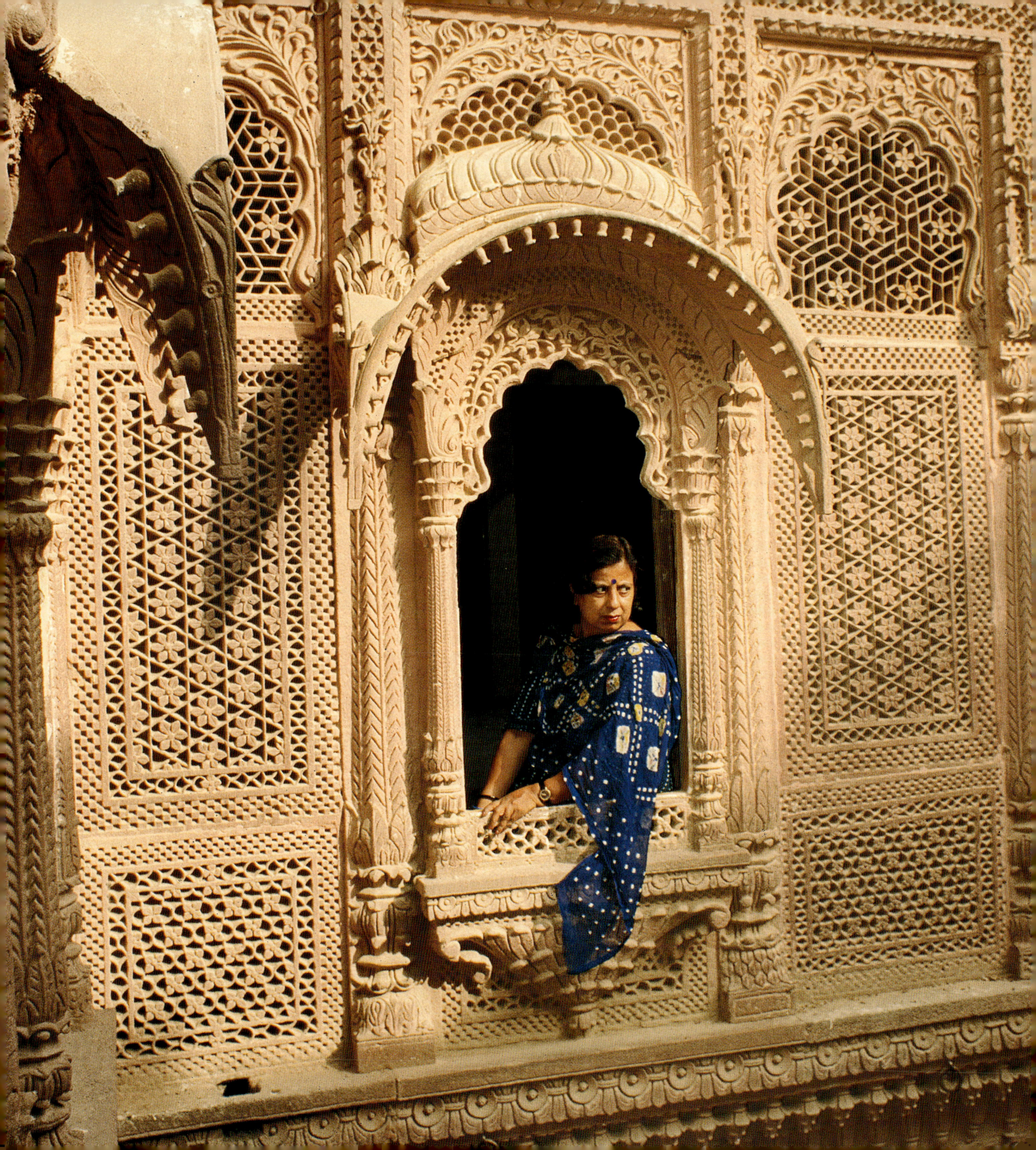

The collection of *howdaha* (enclosed seat placed over an elephant) is one of the most fascinating sections of the fort museum. The gold and silver *howdahs*, called Ambaris, are the examples of their kind in the country. The most remarkable *howdah* here is the one gifted by Shahjahan to Jaswant Singh I. It is a silver *howdah* covered with the figures of a lion, a fish, a peacock and a woman surrounded by flowers. This great collection includes *howdahs* from the nine Rathore states-Jodhpur, Bikaner, Idar, Ratlam, Kishangarh, Sitamau, Jhabua, Sailana and Ahirajpur.

The Umaid Vilas houses an excellent collection of miniature paintings. Various schools of Rajput miniature painting are represented. The Marwar style as it evolved out of the Jain style was subsequently influenced by the contemporary Mughal paintings. The exhibition here has paintings on courtlife, pusuits of pleasure and hunting scenes.

Phool Mahal or the Diwan-i-Khas is on the upper floor. It is undoubtedly the most ornate hall at Mehrangarh. It is a veritable picture of opulence and splendour covered with gorgeous frescos, floral motifs and portraits of the former Jodhpur *maharajas*. The miniatures in this hall are based on the Ragamala or the musical modes-*ragas* and *raginis*. The consummate artisry exhibited on these miniatures is superb. The palace decoration here has been done on an extravagant scale by a single artist who nearly completed the whole work all by himself. The gold ceiling is embellished with 80 kgs of gold plating. The doors and windows are covered with multi-hued stained-glass. At the farthest end of the hall stands the couch-like royal seat in front of the Jodhpur coat of arms. The narrow gallery surrounding the rectangular hall secures it from diret sun, heat and glares which are so detrimental to the interior decoration.

The Sheesh Mahal creates an image of colourful splendour through its use of regular, large sections of glass in various resplendent colours. The use of small pieces of glass, so common in the Mughal pavilions, has been found to be of little use in large door panels where the aim is to block direct sun light and create patterns of colourful shadows on the floor. Perhaps the use of small pieces of glass is more feasible on stucco etched in premeditated designs. The rooms give access to a long cantilevered balcony over the massive round towers with heavy string courses in an architectural composition reminiscent of the Man Mandir at Gwalior. The small cradle *jharokhas* with those very charming *bangaldar* roofs and lace-like *jali* work appear most regulary on the *zenana* palaces. The height of these balconies at the Sheesh Mahal appears enhanced by the tassel-like curtains below the projecting sections. These balconies are extremely impressive and have a certain rugged charm of their own, all the more remarkable if contrasted with the delicate work on the *jharokhas* at the Jhanki Mahal.

The Takhat Mahal is among the later day additions to Mehrangarh. It was built by Maharaja Takhat Singh (1843-73 CE). It has little architectural beauty but the decoration in this large sleeping room of the ruler is most lavish. The miniature paintings on the walls in this room depict episodes from the Krishna Lila, charming damsels and scenes of royal splendour. The ceiling has two noteworthy features in its use of enormous wooden

Clockwise from left:
The bangaldas canopy, and exquisite jali-work; Mehrangarh rock projecting into the city

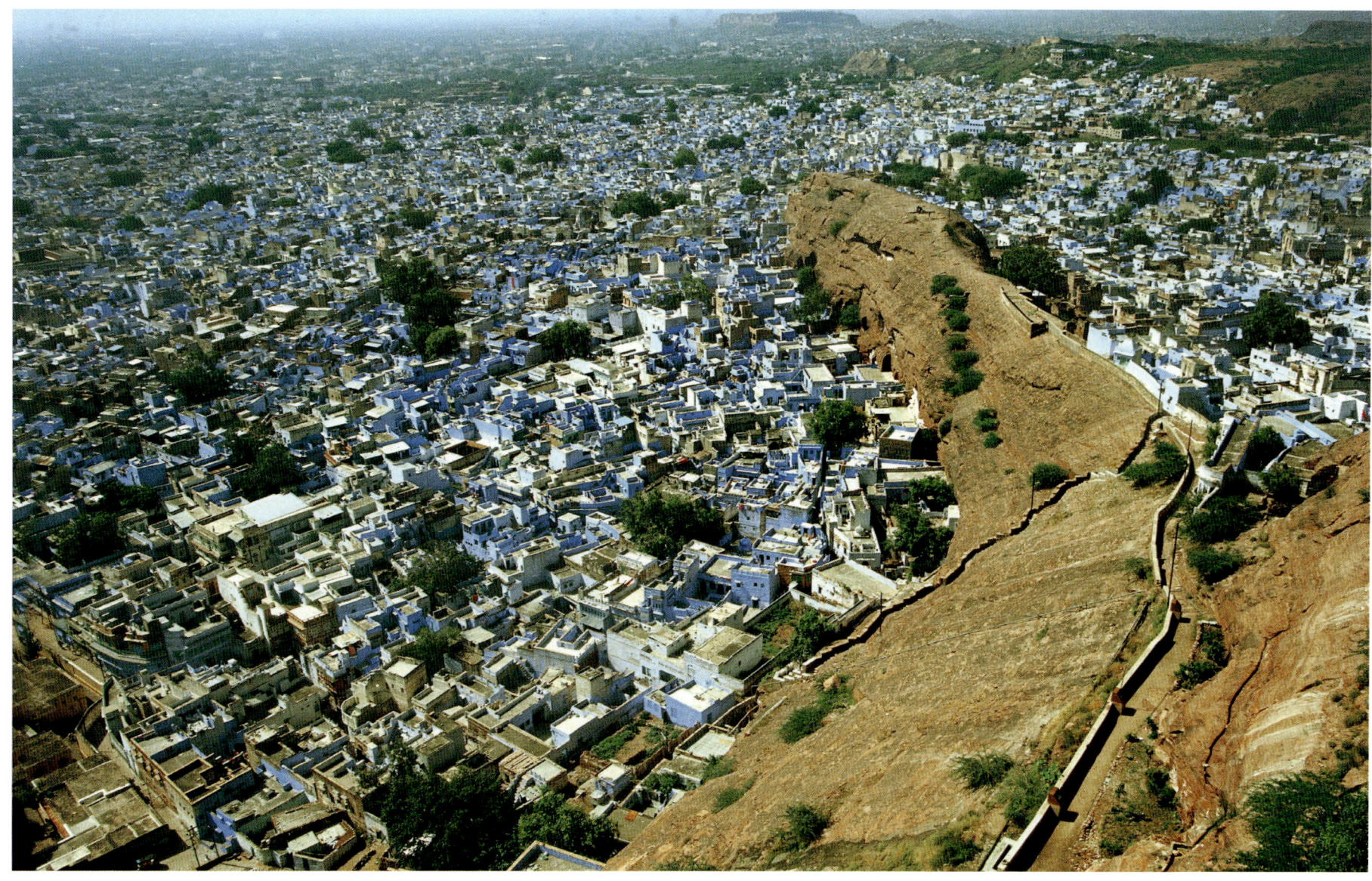

beams resting on corbels and the use of huge colourful Christmas balls. A small low bed supposedly belongs to the ruler who took his lessons from stories narrating how conspirators and murderers hid themselves under the royal bed before executing their plans at night. This sleeping chamber of Maharaja Takhat Singh is built amidst large open terraces all around, well connected with the *zenana* palaces. This Rathore ruler is believed to have had 35 queens.

The Moti Vilas holds an exhibition of weapons, the finest of its kind in India. These war weapons include medieval mortars to shields decorated with precious stones. The swords in this collection are a special attraction, particulary the exquisitely damascened Mughal swords, including one belonging to Akbar. Rao Jodha's *khanda* weighing over seven pounds is the most prized here. Turbans from different parts of Rajasthan represent yet another aspect of the cultural life of the desert people. These turbans indicate the region and social status of the person who wears it. In fact, there are strict norms governing the use of this most essential and extremely colourful headgear of the Rajputs. The display of match-lock guns decorated with gold and silver work, swords with Persian inscriptions, jewel studded shields, armour and other accessories at the Man Vilas is simply stunning in its range and rarity of the exhibits.

Moti Mahal is the 16th century throne room, though it could be of a later date. It is chiefly remarkable for the splendid decoration with glass work. Lustrous, polished walls create stark grandeur in the room which were used, perhaps, as the Diwan-i-Aam. The five magnificent *jharokhas* on the upper floor provide grand views of the proceedings below. The object of central attraction in the large hall is the octagonal silver throne gifted by Shahjahan to Jaswant Singh I.

The most striking feature of these palaces in the *zenana* is the enhanting beauty of the overhanging *jharokhas*, corbelled out to appear more prominently on the facade. These *jharokhas* follow a uniform style. The *jalis* are the pride of artisans who only try to excel each other. The profusion of these grand screens on the projected gallery keeps the interior cool and well protected from the gaze of the people. The narrow gallery may be "indeed inessential to the structure", as Tillotson observes, but it certainly meets the requirement of providing shade and cover at Mehrangarh which is supposed to get the maximum sun during a year. The heat turns stifling and unbearable at times.

Mehrangarh has yet another unique feature-on its bulwarks has been set up an extraordinary exhibition of cannons siezed at various battles. Some cannons are Gaj Singh's spoils of his warring in Jalore. Some of the cannos were brought here by Maharaja Abhay Singh from Gujarat. The view over the city of Jodhpur from these ramparts is breathtaking. "From the bastions of the Jodhpur Fort", wrote Aldous Herley, " one hears as the Gods must hear from Olympus the Gods to whom each separate word uttered in the innumerable peopled world below, comes up distinct and individual to be recorded in the books of ommiscience". Aldous Huxley looked at the city from the towering ramparts.

E.M. Forster, author of 'A Passage to India', looked at the Mehrangarh fort from the city as it lies divided by a strip of rock :"There must be some mistake: it was surely impossible that a dragon, flapping a tail of stone, should crouch in the middle of houses; that, having reached an incredible height, his flanks should turn to masonry; that he should be ridged with a parapet and bristled with guns; and that upward again a palace should rise, crowning the dragon, and, like him, coloured pearl... This is the land of heroism, where deeds which would have been brutal elsewhere have been touched with glory. In Europe heroism has become joyless or slunk to museums: it exists as a living spell here. The civilization of Jodhpur, though limited, has never ceased to grow. It has not spread far or excelled in the arts, but it is as surely alive as the civilization of Agra is dead."

From these high ramparts the view of the white marble memorial of Maharaja Jaswant Singh II appears in full grandeur. In fact, this is the

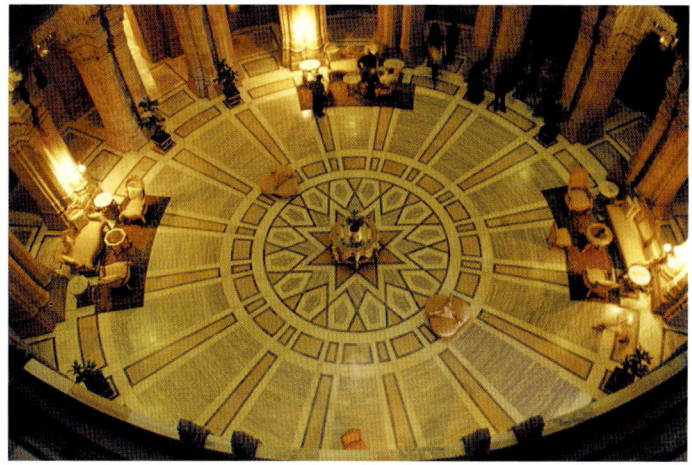

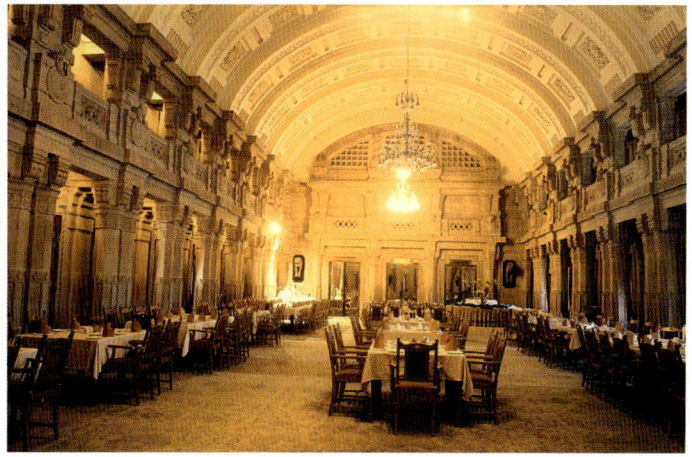

only structure in Jodhpur built entirely in white marble. Also, seen on the horizon is the Umaid Bhawan Palace on Chittaur Hill. It was started as a famine-relief project providing employment to thousands of people. This 347 room palace was designed by H.V. Lanchester and completed in 1947 CE. The present royal family lives in a part of the palace. The rest now functions as a five-star hotel.

Mandore, 8 km from Jodhpur, was the capital of the Parihara Rajputs from the sixth to the fourteenth century CE, when in 1381 CE Rao Chanda brought it under the Rathore rule. From the ancient fort on the craggy hills, now in complete ruins, the Rathores kept at bay the Khilji and Tughlaq armies. In 1485 CE Rao Jodha decided to shift his capital to Jodhpur when he was guided by a sage to build a mighty fort. This was to be the most invincible fort of Rajasthan-Mehrangarh.

Mandore is a historical place, certainly worth a visit for the *dewals* or cenotaphs of six Rathore rulers -Maldeo, Sur Singh, Uday Singh, Gaj Singh, Jaswant Singh I and Ajit Singh. These cenotaphs are built in imitation of temple architecture in a medley of different styles. The cenotaph of Ajit Singh has a pyramidal *shikhara* with columned interiors. Also to be seen here is the architectural curiosity-the Ek Thamba Mahal.

The Hall of Heroes is a very interesting open pavilion containing statues of various deities and Rajput folk heroes, each beside his favourite steed. These statues are painted in bright colours. Mandor is remarkable for another reason as well. It has the oldest artificial lake in Rajasthan, excavated in 1159 CE.

Clockwise from left:
The great dome at the Umaid Bhavan Palace; Reception area under the dome; The royal dining room

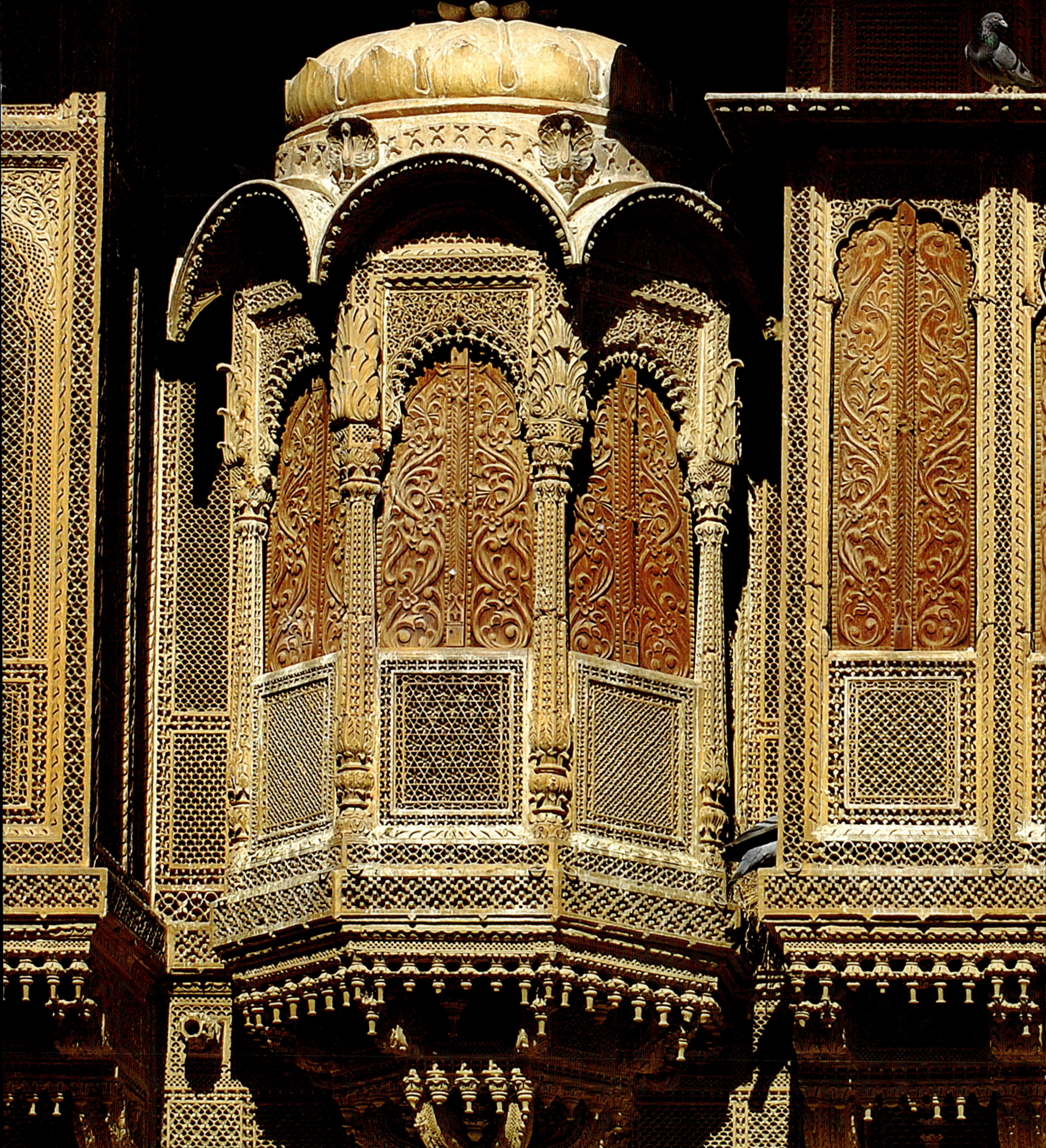

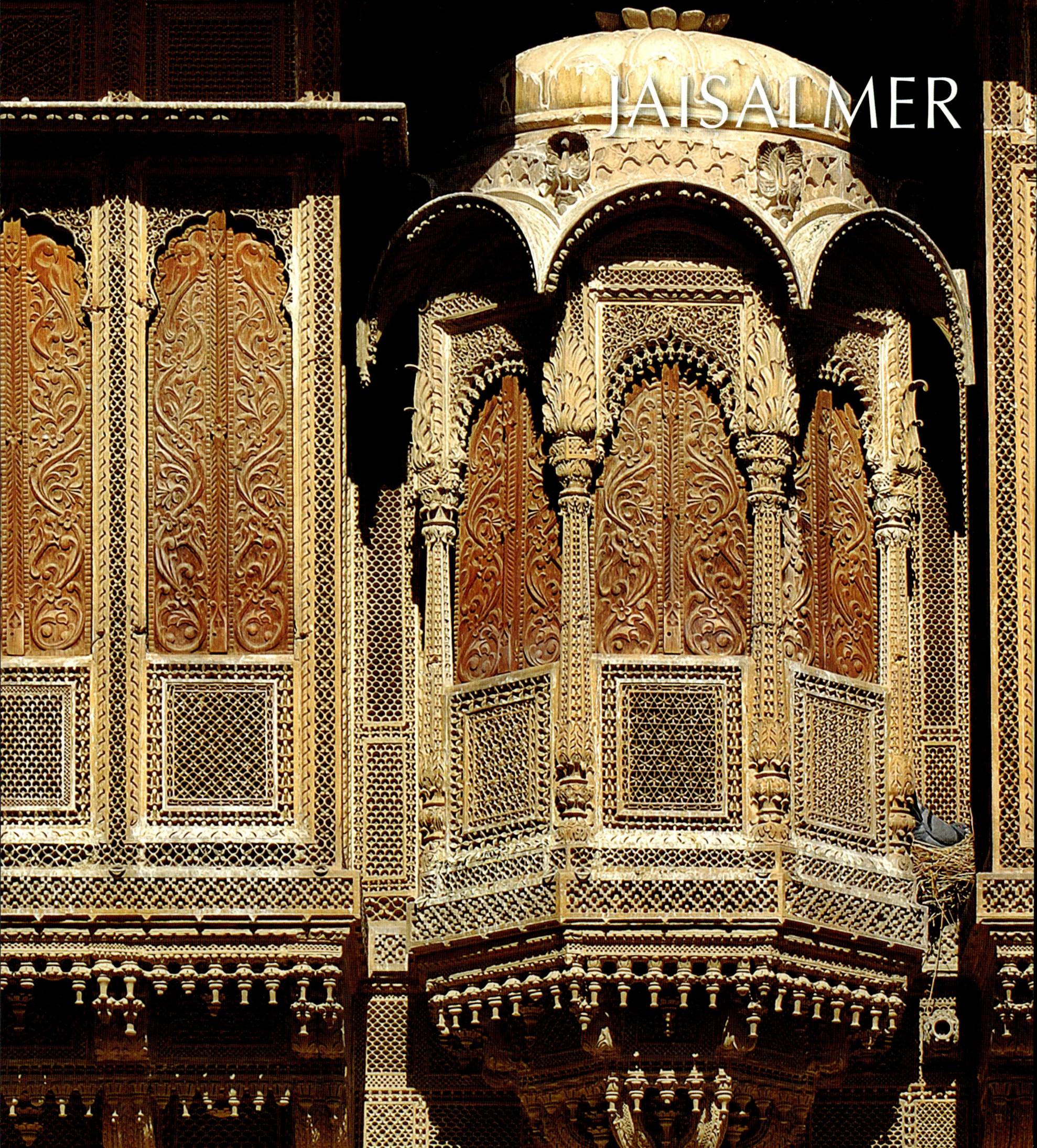
JAISALMER

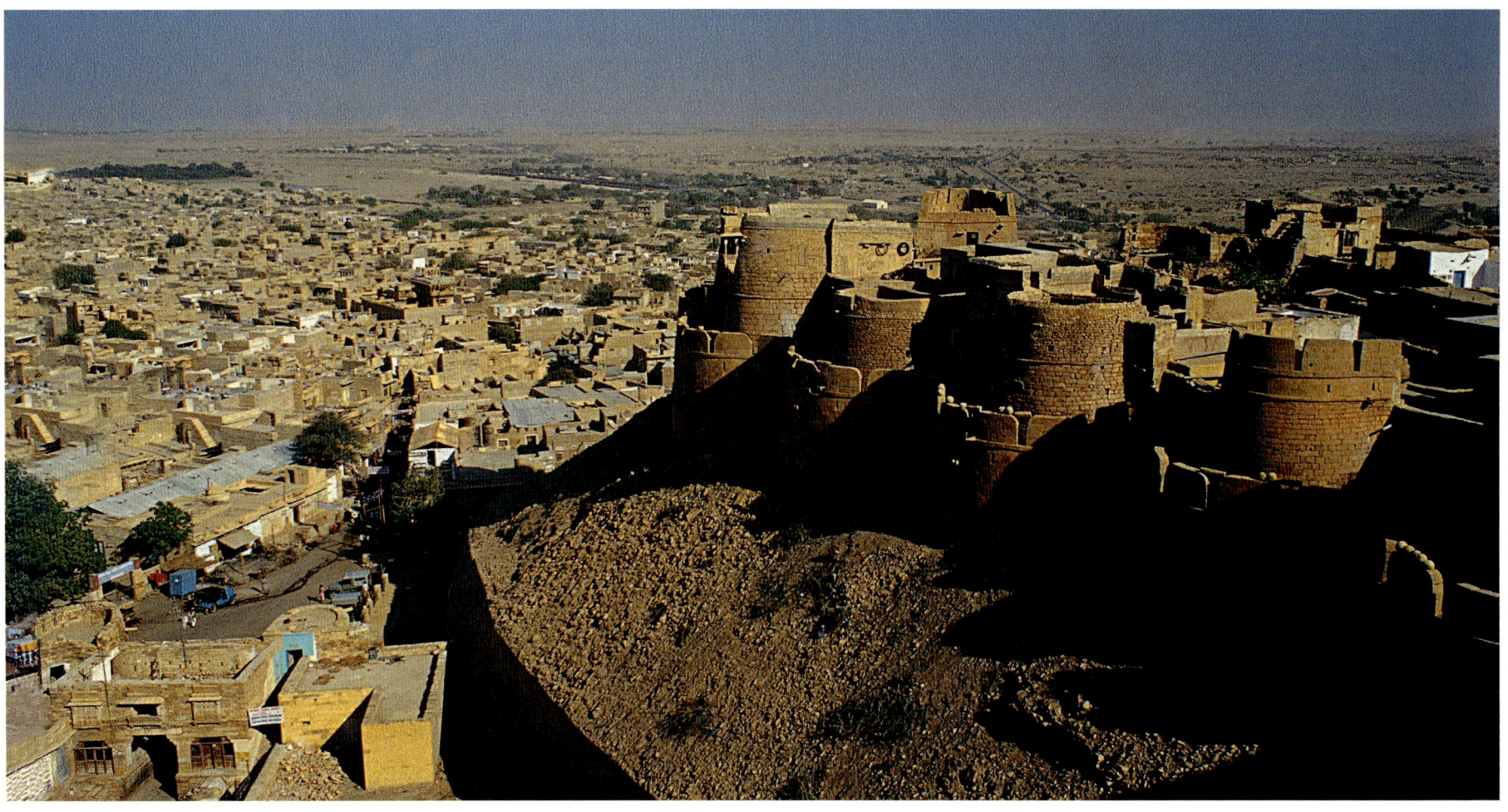

Previous pages:
Details of jali work on jhorokha windows

Clockwise from above:
Circular bastions of the fort guarding the city; Rang Mahal, exquisitely painted interior

Dominated by the great fort perched on a 76 meter high stupendous rock, the first view of Jaisalmer is stunning. Miles before one reaches the city, the fort appears like a mirage in the flat stretches of sand: it is a majestic sight: In the early morning sunlight, the ramparts, bastions and the long stretching serpentine walls appear swathed in a distinctive crimson look which dazzles gloriously amid the magnificent golden yellow sandstone fortifications. Situated in one of the most extoic cities of the Orient in the heart of the Thar Desert, the fort has for centuries weathered with immense fortitude the vicissitudes of fortune and furious onslaughts of nature. The fort standing in its solitary grandeur looks like a jewel casket abandoned in the desert. Satyajit Ray the famous film director called Jaisalmer fort Sonar Qila, The Golden Fort.

The city of Jaisalmer was founded in 1156 CE by the Bhatti Rajput chieftain Rawal Jaisal (also one of the distant scions of the Yadava clan of Lord Krishna, ruler of Dwarka) who, while seeking a palace secure from foreign invasions, shifted his capital here from the ancient Lodurva. As per the legend, Lord Krishna, in order to quench the thirst of Arjuna, hero of the Mahabharata, is said to have miraculously created a spring by striking his mace on the ground. When Jaisal came to this palace looking for a suitable spot to find his new capital, he met a saint here. The saint recalled Krishna's prophecy that a scion of the Yadav clan would find a city here and his rule would last for centuries. The Trikuta hill top offered the safest location for the new fort.

The Lunar clan of Bhattis, known to be Krishna's descendants, remained for centuries ferociously independent, inordinately proud of the tenuous divine lineage, brave, even foolhardy in battle and often treacherous as allies-the most feared of the desert marauders. The Bhattis remained perennially locked in territorial skirmishes with Jodhpur and Bikanar. One Bhatti scion known as Gaj had founded the city of Ghazna in Afghanishtan but ultimately lost it to forces from Khurasan. Later one of his grandsons reclaimed Ghazna, embraced Islam and his men came to be called Chagattas (Mughals) who, under Mahmud Ghazni returned to plunder and devastate the land of his ancestors. Again, led by Zahiruddin Muhammad Babur, the Chagattas founded the most illustrious and powerful Mughal kingdom in India.

The city of Jaisalmer lies at the foot of the fort. Life here has always been at the mercy of scant water resources. Situated on what was the camel-trade routes between India and central Asia, Jaisalmer was in the past an important caravan-*serai* for traders. It earned for itself a share of profits without actually producing anything of its own. The fierce insularity of the Bhattis owes much to the isolated location of the city surrounded on all sides by the desert.

The Jaisalmer fort, the second oldest fort in Rajasthan after Chittaurgarh, has a commanding presence in the desert. Three strong walls protect the fort. The first buttress wall was constructed by the local Jain Panchayata in the 15th century CE. Subsequently, the rulers known as Rawals added further fortifications. Interestingly, some round shaped stones still to be seen on the ramparts were used as weapons of defence against invaders attempting to scale the walls. Such stones are known to have been used to great advantage by the garrisons at Chittaur and Ranthambore against the Khilji and Mughal attacks. Steep cobble-stone pathways leading to the *garh* palace pass through four gateways-Akhai Pol (Ganesh Pol), Suraj Pol, Bhuta Pol and Hawa Pol. The Bhuta Pol has witnessed scenes of fierce battles and is believed to be haunted by the spirits of the Rajputs soldiers-hence the name Bhuta Pol or the gate visited by ghosts.

The passage through these gateways and the ascent on the hill terminates at the courtyard in front of the chief royal palace-the Gaj Mahal. The façade of this beautiful palace is an enchanting assembly of oriels

and balconies, multi-cusped arches, semi-circular domed roofs and a luxuriant sculptural ornament. The triple storeyed palace has on its main southern façade, two parapets indicating the floor levels of the second and third storey. The design of these parapets is different. The lower parapet has exposed brackets and there are five prominent *chattris*. The brackets on the upper parapet are concealed behind a curtain of carved tassels. The continuous arcade of *chattris* on the upper level is too closely packed together without creating any particular architectural effect except that of a style different from the style of *chattris* at the lower land which have flat eaves and a severe look. Since each ruler built new apartments, the original structure is now completely untraceable. There are five palaces namely- Sarvttoam Vilas, Akhai Vilas, Gaj Mahal, Rang Mahal and Moti Mahal-all interconnected behind the triple storeyed façade of the Gaj Mahal. Narrow stairs lead from one court to antoher with superb *jali* screens used as curtains to protect the interiors from the heat and dust of the desert, also to shut out the sun from the chambers and yet suck in the slightest breeze at night. These intimate interiors retain an architecturally provided coolness when outside it is a sheer furnace.

The architectural grandeur of the *jharokhas* breaks the montoonous look of the high walls. The *jali* screens, carved in the most amazing and intricate patterns, are the most charming and essential part of the architectural scheme. Tillttoson regarded the use of *jali* screens an important feature of the ancient Hindu architecture. The *jali* screens at the mid-fifth century CE temple of Lad Khan at Aihole in northern Karnataka demonstrate the usefulness of such screens in lighting the dark interiors, circulating the air, besides adding that element of ornament so essential to any structure. Whereas in other buildings the outer walls indicate the dimensions of the interior, here the interior walls are further secured within the additional curtain of *jali* screens which cover the entrie wall rather than decorate only the *jharokha* windows. Many a 16th century CE buildings utilize these *jali* screens as an architectural expedient. This is best illustrated at the tombs of Shaikh Ahmad Khatttu Ganj Baksh at Sarkhej (1473 CE), Rauda of Shah Alam in Ahemdabad (1531-32 CE), tomb of Shaikh Salim Chisti at Fatehpur Sikri (1580-81 CE), Itmad-ud-Daula in Agra (1626-28 CE) and nearly at all important Mughal palaces and pavilions.

The *jali* screens at the Gaj Mahal are some of the most lavishly executed examples of the unexcelled stonecraft of Jaisalmer. The honey-coloured stone appears transformed miraculously into an amazing work of filigreed ornamentation. His hereditary craft appears in glorious jali screens which transform an open gallery or passage into a viewing gallery for queens and princesses.

These different palaces are accommodated within the same single structure, separated by small courtyards and floors. The Rang Mahal built by Mool Raj II, appears at the uppermost level. It has some exquisite murals painted on the arches and spandrels. These murals depict dancing maidens, love scenes and architectural vistas. The gorgeous costumes, typical of the desert people, appear in resplendent colours. Music and dance pieces were often held here for small intimate gatherings. The balconies provided breathtaking views of the massive fortifications guarding the city in the *talehti* below. On top of the palace structure is placed the Meghadamber (an umbrella) which, it is believed, was held over Krishna's head on special state occasions. The Bhattis, descendants of Krishna, are head of the lunar race and it's off shoots. It must be a particularly enchanting sight to observe the sun rise and set over the horizon, a view uninterrupted by any vegetation. For miles there are only unending stretches of sand, breaking out only occasionally into patches of burnt scrub.

The Jaisalmer fort is the accumulative work of various rulers at different periods of time. Between 1577 and 1623 CE were added the three massive gateways in addition to the Suraj Pol, the earliest gate at the fort. The second wall running parallel to the first wall was also built during these times. This wall is 15 feet high with seven bastions built over the walls raising the total number of bastions to 99, varying in height from 40 to 60 feet. The fort wall thus appears to be a string of bastions surmounting the

structure. Between 1750 and 1850 CE the city of Jaisalmer was enclosed within a strong wall, 10 to 15 feet in height and 5 to 7 feet in thickness. This wall on the periphery of the city has six massive gateways guarding entry to the city-Gadisar or Tilowali Pol, Amarsagar Pol, Beson Ki Pol and Mulka pol; the other two are now closed.

The Jaisalmer fort has always been special to the Jain community The Jains built a few temples here known for their sculptural splendour and architectural beauty. The temple of Parsvanatha, built in 1416 CE is remarkable for its spires. It contains nearly 1253 images. The *toranas* or the multi-lobed arches have a remarkable beauty. The dancing figures add immense charm to these *toranas*. The temple of Sambhavanatha was built by two Oswal brothers in 1420 CE. Here the total number of images is 604.

Clockwise :
Bhuta Pol, entrance gateway to the fort interiors; Gorgeous murals at Rang Mahal; Tazia Mahal, or Badal Vilas; Salim Singh's Haveli

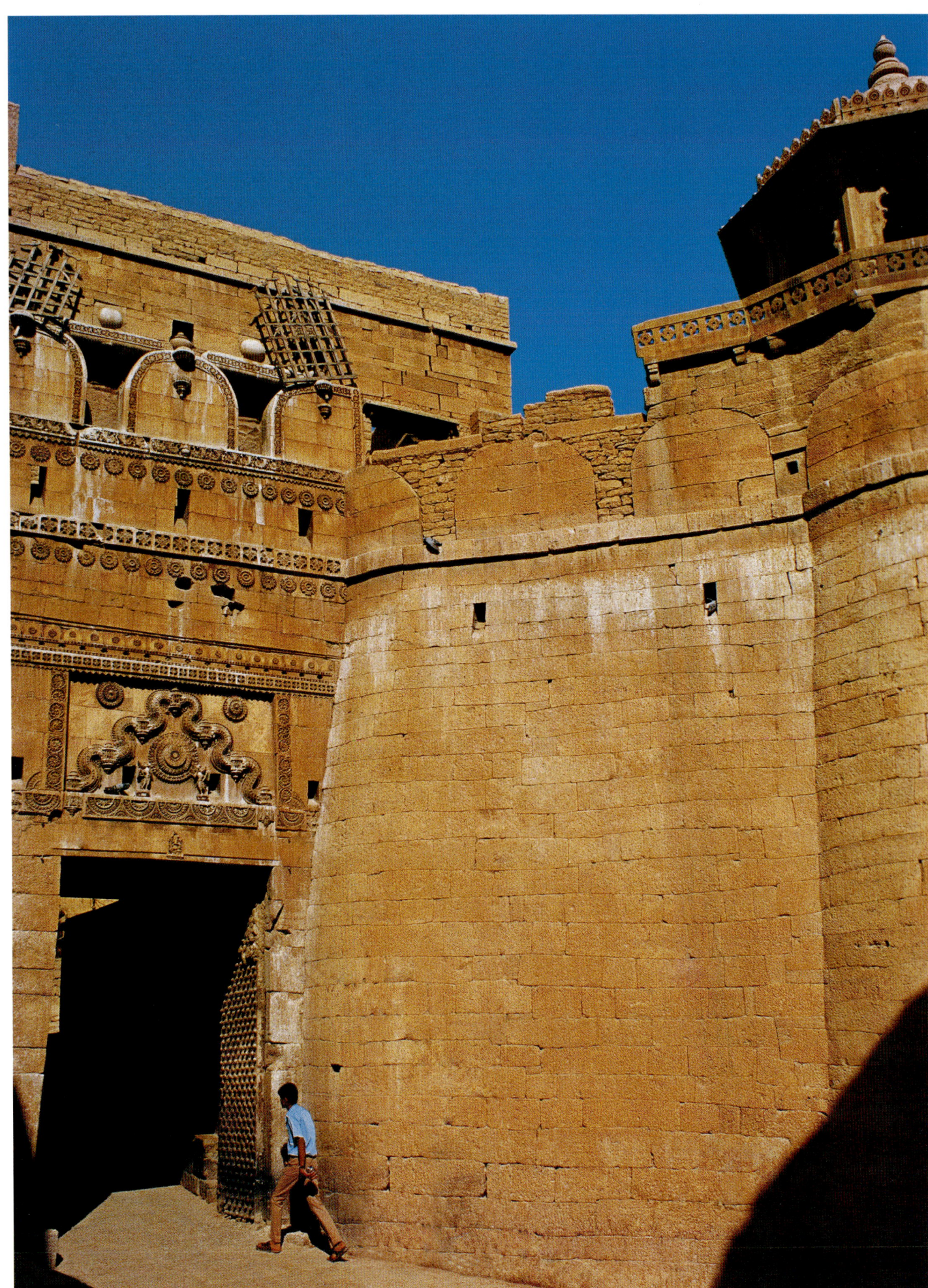

The ceiling of the rangamandapa with a magnificent lotus pendant is an example of splendid sculptural art. The dancing figures and the Jina figures sitting cross-legged between the structs are very impressive. The other two important Jain temples in the fort are the temple of Shithalanathaji, built in 1451 CE, and the temple of Kunthnathaji, built in 1490 CE.

The temple of Chandraprabhuji stands close to the Parsvanatha temple. It is a large temple with a triple-storeyed structure. The eight decorative pillars in the rangamandapa and amorous couples on the struts evidence a perfection of sculptural art at this temple. The lotus pendant is a recurring feature of these temples. The now of miniature *shikharas* on the parapet wall is a feature perhaps borrowed from the Chaumukha temple at Ranakpur, near Udaipur. The temple of Chandra-prabhuji was consecrated in 1479 CE. The Jaisalmer fort contains no temple dedicated to Krishna, supposedly the progenitor of the Bhattis who built this fort.

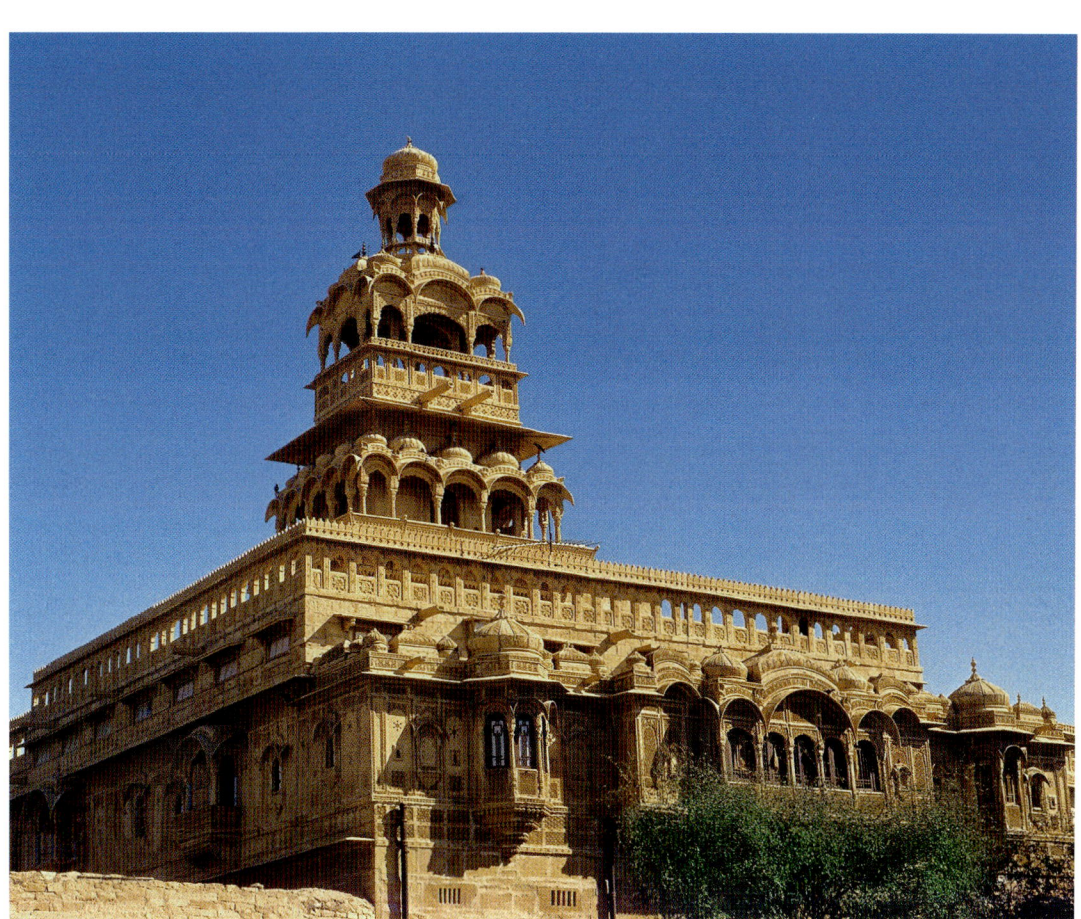

The two most outstanding structures built outside the fort are the two palaces-Badal Vilas and Jawahar Vilas. Badal Vilas was built in the 19th century CE. The six storeyed structure has open pillared pairtions, balconies and galleries. The structure is designed like a *tazia*. It was built by the Muslim silavate craftsmen free of cost for their royal patron. It is a splendid palace of winds. The Jawahar Vilas is the latest addition to palaces in Jaisalmer. It was built in the twentieth century. The relief decoration on the triple-arched domed *chattri* projecting from the wall is sheer beauty.

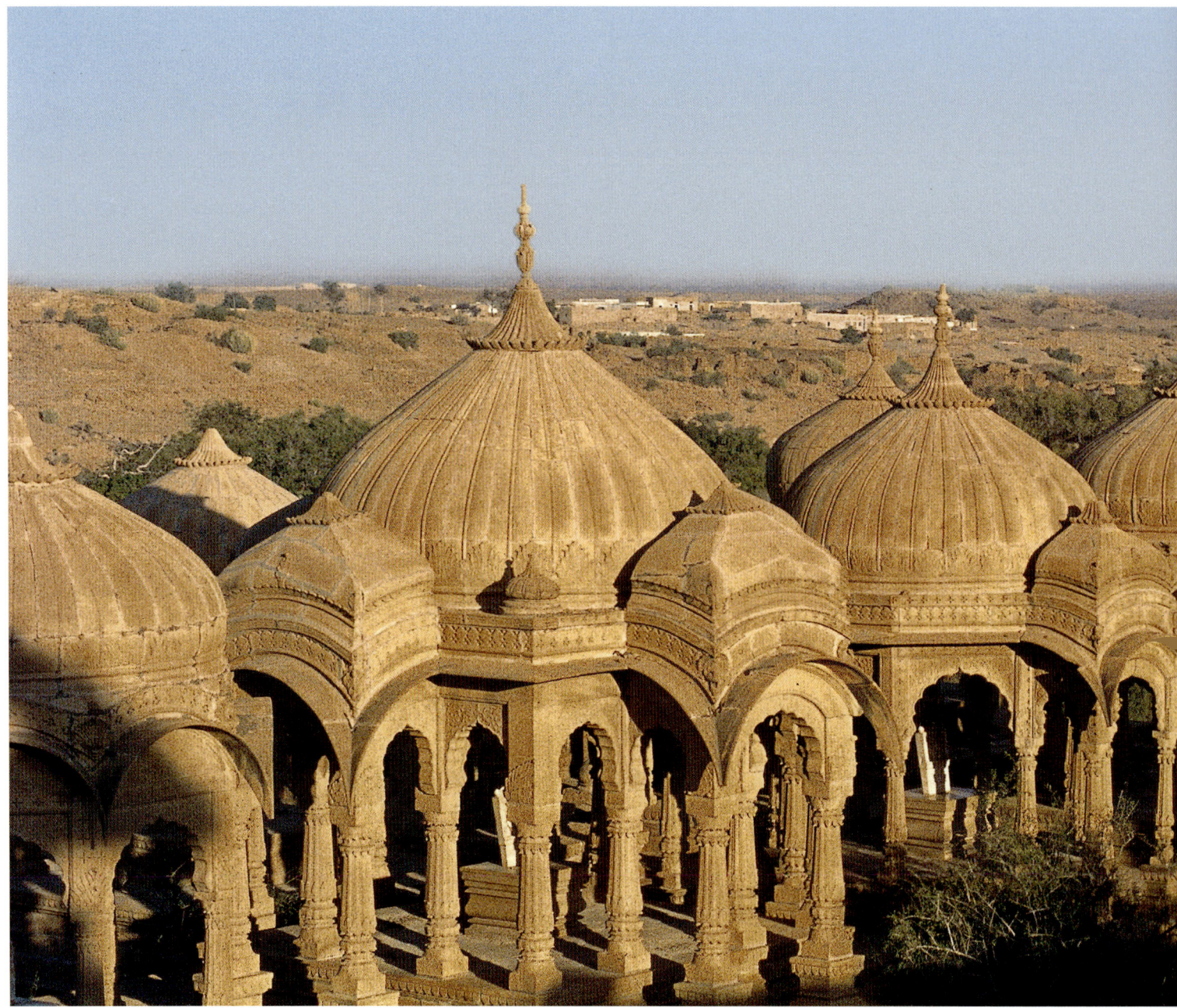

The havelis of Jaisalmer are now part of the World Heritage monuments in India. Remarkable architectural splendour and glorious relief decoration are the hallmarks of these *havelis* or mansions of nobles and business community. These *havelis* are built in the narrow alleys and lanes of the city.

One cannot but marvel at the fabulous architectural splendour of Salim Singh's *haveli* in the eastern sector of the city. The whole structure resembles a single stalk blossom emerging out of a vase with the lower storeys having the trapping of an average dwelling in Rajasthan. The third floor has a rectangular hall with cantilevered balconies running the entire length and breadth of the structrure. There are twelve balconies on its longer side, each surmounted with arches under exquisitely fashioned *bangaldar* roofs with exaggeratedly drooping corners. Similar arrangement of seven balconies exists on the shorter sides. The rows of peacocks below the projected arched balconies are illustrative of the consummate artistry of the *silavats* (artisans), here straining itself to creat an architectural splendour of on extraordinary standard.

Salim Singh, prime minister to Rawal Gaj Singh, was known for his ruthless vengeance on the royalty indebted to him for money. He also resorted to extreme extortionist measures driving hordes of villages to leave their houses *en masse*. It is said that Salim Singh planned a bridge between the royal palace and his *haveli*, a move foiled by the Rawal. The uppermost two storeys-Rang Mahal and Kanch Mahal had to be demolished to prevent a possible collapse of the whole structure. This *haveli* shows stone craftsmanship at its best. It was built in 1815 CE and is also called the Jahaz Mahal.

The Patwon ki Haveli is actually a group of five *havelis*, built towards the end of the 18th century CE by Guman Chand, a trader in *Zari* and *badla* (silver and golden threads). His five sons had business dealings with Kota, Jhalarpatan, Ratlam, Udaipur anhd Jaisalmer states. On façade, each of these five *havelis* display extraordinary craftsmanship on carvings best seen on *jharokhas* and oriel windows. It is a really exhilarating experience to see how the lifeless stone yielded to the magical strokes of the rudimentary chisel of the *silavats*. These five *havelis* or suites, to be precise, are the veritable showpieces of Jaisalmer's legendary filigree work on stone. The oblique sun rays create enchanting shadows infusing a life into these relief carvings.

The *haveli* of Nathmal, a later day prime minister of the state, Maharawal Barisal is of an extraordinary standard. It also has magnificent *jharokhas* and oriel windows. The *haveli* has two identical portions built by two

Royal cenotaphs at Bada Bagh, outside Jaisalmer

architect brothers. Here, once again, the splendour and delicacy of the carvings leave you marveling at the wondrous beauty of stonecraft.

In fulfillment of the prophecy made by the saint who had advised Jaisal to find a city here and construct a fort on the Trikuta hill, Jaisalmer was sacked thrice; in 1295 CE by Alauddin Khilji, in the 1380s by Firoz Shah Tughlaq and in 1585 CE during the regin of Maharawal Lunakaran.

The first sack of Jaisalmer is most memorable for two reasons: first, it was a long seven year siege; and, secondly, it reveals the desert folks's eagerness to make friends even with their staunch enemies. In retaliation for the plundering of his baggage by the Bhattis, Alauddin Khilji's forces besieged the fort. The enemy's armies camped around the fort. During these years, Rattan Singh, son of Raal Jait Singh, struck friendship with his adversary Mehboob Khan. Their soldiers would fight during the day and, at night, the two would play chess. The victors-Khiljis could not retain the fort for long. The desert heat and isolation caused disenchantment with Jaisalmer and after some time the fort was regained by the Bhattis.

The second sack of Jaisalmer was brought about over a trifle matter. Some Bhatti soldiers stole a steed from the Tughlaq camp. For eight long years the Tughlaq armies surrounded the fort, ultimately surrendered by the Bhattis to the enemy. In the 16th century CE, Rawal Lunakaran befriended Amir Ali, an Afghan who had collected all the relevant information about the fort and its treasures and now planned to play his treacherous game. He expressed a desire to show the fort to ladies of his harem. The Bhatti ruler saw no harm in this request. He permitted palanquins carrying Afghan women inside the fort. In fact, the palanquins carried soldiers disguised as women. The Bhattis were cheated. A great fight between the two groups of soldiers ultimately led to Lunakaran putting to the sword his queens and princesses, and himself died fighting. It was only the providential return of a contingent of Bhatti soldiers to the fort which saved Jaisalmer falling into the hands of an Afghan.

The fort was saved but the ruler and members of his family lost their lives. It was the half sack, as they call it. Amir Ali was captured, tied to a canon and blown to pieces. On each of these three sacks thousands of Bhatti soldiers perished and hundreds of women committed *jauhar*. Folk balladeers narrate romantic tales about the Bhatti courage and valour though recorded history is not so forthcoming on these episodes. These romantic tales, however, instill some romance and charm into the dull and dry lives of these folks who experience the ecstasies of pride and delight in the most trifling incidents in their lives.

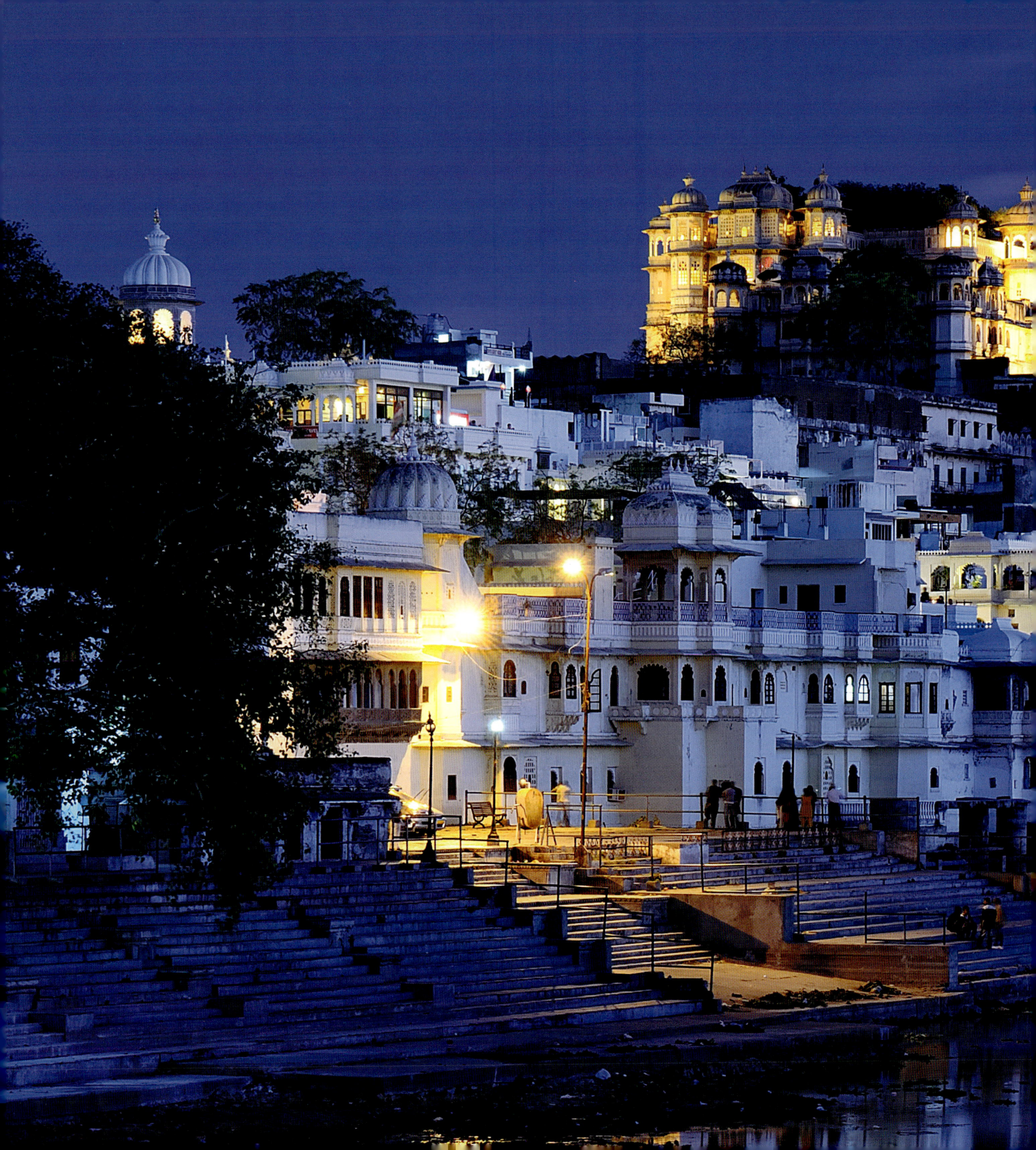

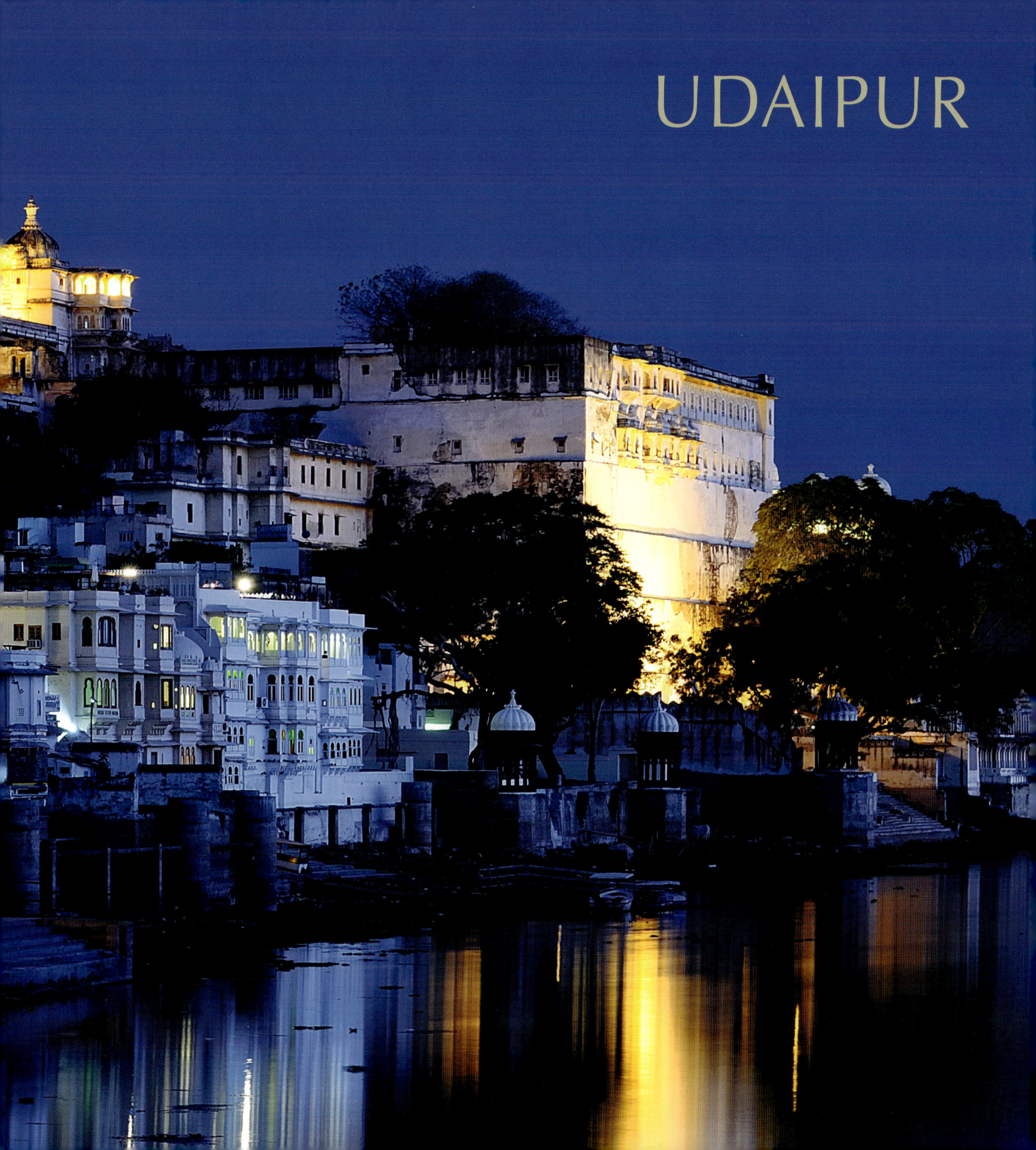

The fort at Chittaur and the palaces at Udaipur illustrate two remarkable traits of the Rajput character. The Chittaur fort stands as a synonym for the legendary courage and fortitude of the Rajputs who thought nothing of death on the battle field and prided themselves on their fierce indomitable spirit and the purity of their blood. The Sisodia Rajputs of Mewar are acknowledged as the oldest known ruling dynasty in the world with its origin going back to Guhil, founder of the dynasty, in 566 CE. The rulers known earlier as Guhilots (cave born) came to be known as the Sisodias when Bappa Rawal came to the throne in 734 CE. Bappa Rawal moved his capital from Ahar, near the present Udaipur, to Chittaur which held this honour till it fell to the Mughals led by Akbar. Rana Udai Pratap moved away to a new settlement at Udaipur. The Sisodias were staunch defenders of the Hindu faith and scorned the Rajput royal houses which entered into marital alliance with the Mughals for the sake of security, convenience and a quick rise at the Mughal court.

The greatest heroes in Rajput history-Rana Sangram Singh, Rana Kumbha and Maharana Pratap defied the Mughals till the end of their lives and steadfastly refused to compromise their honour and besmirch their purity by offering their daughters in marriage to the Mughal princes. This disdain for the Mughals is reflected in the architectural style at Chittaurgarh which has a remarkable originality uninfluenced by trends in the contemporary Mughal architecture. Akbar destroyed most of the buildings at Chittaur with orders that these remained unrepaired reminders of the Mughal victory but the ruins of Chittaur were destined to remain as symbols of the Rajput valour and courage. Chittaur was never again to be the Mewar capital.

Udaipur, founded by Rana Pratap, was built over the lake Pichola. Some residences befitting the royal house came up at the hillock overlooking the lake. This place called Nauchoki or Moti Magri survives to this day in

Previous pages:
View of the city palace from lake pichhola, at night

Clockwise from top right:
Solar motif– the royal emblem; Equestrian statue of Rana Pratap, hero of Mewar; Distant view of city palace

sheer ruins. The hill is dominated by the equestrian statue of the hero of Rajasthan-Maharana Pratap. Udai Singh's escape from Chittaurgarh is one of the most forgettable acts of the Chittaur ruler.

Maharana Pratap, Udai's successor, remained constanly engaged in guerilla warfare with the Mughal armies. He moved from his hidings in the forested hills and mountains of Mewar followed by his staunch supporters. The forested tracts between the Banas and the Berach rivers were rendered *bechiragh* (without a lamp) and no crop grew in the deserted fields, so that Akbar's armies found nothing. All items of luxury were forbidden. Gold and silver dishes were laid aside. Pratap and his men slept on beds of straw and there were occasions when his children ate meals of wild grass. Rana Pratap remained steadfastly dedicated to the only task on hand-drive away the Mughals from Mewar, a burden which never left his shoulders.

Akbar, by marrying into the royal houses of Amber, Mewar, Bikaner, Jaisalmer and even smaller states, made deep inroads into Rajasthan, at once isolating Rana Pratap from his Rajput brethren. Pratap found himself perennially on the move and had but little time to build palaces at Udaipur. Raja Man Singh of Amber, Akbar's trusted general, decided to bring about a reconciliation between Pratap and the Mughal emperor. A feast was arranged where Man Singh was the guest of honour but, instead of the Mewar ruler, it was his son and heir who welcomed the former in a calculated gesture of insult. Man Singh knew at once that Pratap's excuse of a headache was too lame. He made some ritualistic offerings and prayers and got up. "It was for the preservation of your honour that we sacrificed our own, and gave our sisters and daughters to the Turks; but abide in peril if such be your resolve, for this country shall not hold you", Man said. Pratap made a sudden appearance at this point when Man added the parting shot, "If I do not humble your pride, my name is not Man". Pratap answered that he would be only too happy to meet him on the battlefield.One of Pratap's followers asked Man to also bring his *Phupha* (father's sister's husband), Akbar to the battlefield. The ground where the feast was arranged was cleansed with water from the Ganges as it had been polluted by the presence of someone who had brought disrepute to the Rajputs by giving a Rajput princess in marriage to Akbar. Of course, they met at the most famous battle at Haldighati where Pratap very nearly killed Prince Salim, who esaped unhurt and the Mewar hero beat a retreat. This inconclusive encounter immortalized Pratap whereas Man Singh went on various Mughal campaigns rising in stature only as Akbar's military commander.

Another incident during Pratap's warring days with Akbar reflects on the absence of architectural activity at Udaipur during this period. As mentioned by James Tod, Prince Amar Singh had not quite prepared himself for living in the low and humble dwellings. Once, as he was moving around, the projecting bamboo shuttering caught his turban and the prince moved on unaware of the sartorial disarrangement that followed. The Rajput's turban is a symbol of his prestige and honour. Rana Pratap realized that his son and successor might not be able to go through the rigours of a hide-and-seek life which was his own lot, so long as he resisted Akbar. Pratap had a word with his councellors: "These sheds will give way to sumptuous dwellings, thus generating the love of ease; and luxury with its concomitants will ensue, to which the independence of Mewar, which we have bled to maintain, will be sacrificed; and you, my chiefs, will follow the pernicious example". The chiefs promised that they would not permit mansions to be raised till Mewar had recovered its independence. Before his death 1597 CE, Pratap was able to recover a considerable protion of the territories lost to Akbar and was allowed to die peacefully as the Mughal emperor was busy elsewhere. Chittaur, however remained with the Mughals.

The face of Udaipur changed after the death of Rana ratap whose fears came true. Humble dwellings on the lake Pichola were replaced by impressive palaces in stone and the royal children ran around, no longer required to mind their turbans. Little efforts were made to reconquer Chittaur. Rana Amar Singh (1597-1620 CE) started his building activity only towards the end of his reign when Akbar also had expired in 1605 CE. The area around Nauchauki was abandoned since it was too small for future expansion. The new palace came up on the banks of the Pichola lake. The area around the Rajya Angan Chowk, the Chandra Mahal, the Nauchauki Dhuni Mata and the Dikhusha Mahal including the Kanch ki Burj and Chintran Ki Burj belong to this earliest phase of construction.

The grand and massive city palace stands on the edge of the water front. The extremely fascinating island palaces add a wonderful charm to this great architectural composition. The *ghats* are lined with picturesque *havelis*, bathing *ghats* and temples with long stretches of lively *bazaars* lying behind them. The city palace in Udaipur is the largest palace in Rajasthan spreading over an area of nearly 2 acress. The set of structures built by Rana Amar Singh form the core of the palace complex which has grown tremendously into a huge complex with additions made by subsequent rulers over the centuries. Behind the façade of strong high walls, topped by a profusion of graceful balconies, cupolas and turrets, lie narrow passages and steep staircases leading into a congeries of royal apartments each of which has a different style of ornamentation-coloured glass mosaics, Dutch tiles or plain stuccoed wall surfaces getting increasingly decorative towards the nineteenth century.

The City Palace is reached through the grand Tripolia Gate built in 1713 CE. The Ganesh Deorhi admits the visitors to the inner area of the palace. Large frescoes of horses and elephants with riders flank the small entry point. The first chamber here is a small temple dedicated to Lord Ganesh whose image is surrounded by dazzling mirror and glass mosaics. The shrine of Dhuni Mata is the earliest part of the City Palace containing images of Sri Nathji, Sri Eklingaji, Sri Charbhujaji and Amba Mata. The Rajya Angan court leads to the set of rooms housing the Rana Pratap

Museum, displaying the arms and armours of the legendary hero and large paintings illustrating major epidoes in Pratap's life.

The Sabha and the Mardana Deorhi were greatly improved with later alterations. Mor Chowk or the Peacock Square was built over the Sabha with a *verandah* on the eastern front in the nineteenth century. This square is flanked by Manak Mahal on the northern side and the Surya Chopar on the southern side. Both these rooms functioned as throne rooms. The ruler appeared before his people in the ritualistic *darshan* in the morning after he had paid his oblations to the rising sun. The darbar was held at the Mor Chowk. The famous peacock glass mosaics on the walls appeared in the nineteenth century when the open arcaded gallery was closed. However, the pillars supporting the arches are still discernible. Perhaps the desire to create a decorative fecade on the exterior led to the creation of these panels which have received a mixed response from art critics and historians. The splendour of these colourful mosaics has an undeniable charm despite Tillotson's dig at the "execrable glass mosaics".

The architectural style at Udaipur strikes subdued notes of originality. The earliest part of the palaces, built by Rana Amar Singh show a continuation of the Chittaur style with rectangular chambers flanked by small square chambers. The canopy form of the ceiling appears inspired by the ceiling at the Diwan-i-Aam at Amber which in turn was inspired by a ceiling at the Man Mandir at Gwalior. The noteworthy improvement in the existing style appears at the Chandra Mahal built in 1620 CE. It is, as Tillotson called it "a peculiarly Mewari variant of the form" of the arch which shows a definite gap between brackets from the opposite sides, thus exposing the lintel overhead. This has facilitated spaning of large spaces without increasing the height of the arch. "It also results in a curious mixing of modern with traditional form: the fashionable cusped arch is employed, but its traditional, trabeate construction is emphasized; the shape of the

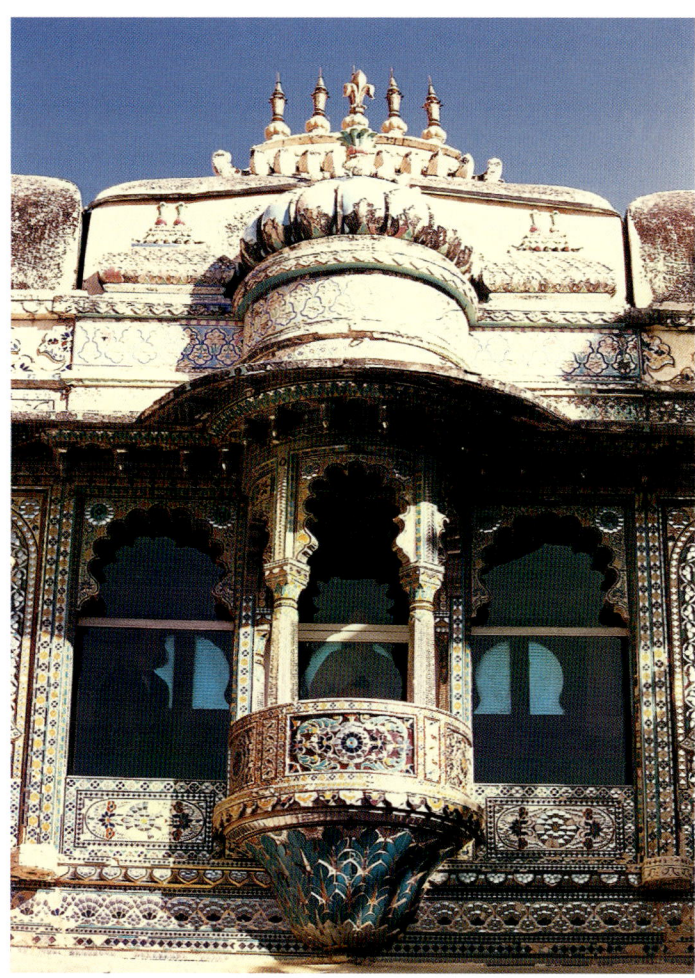
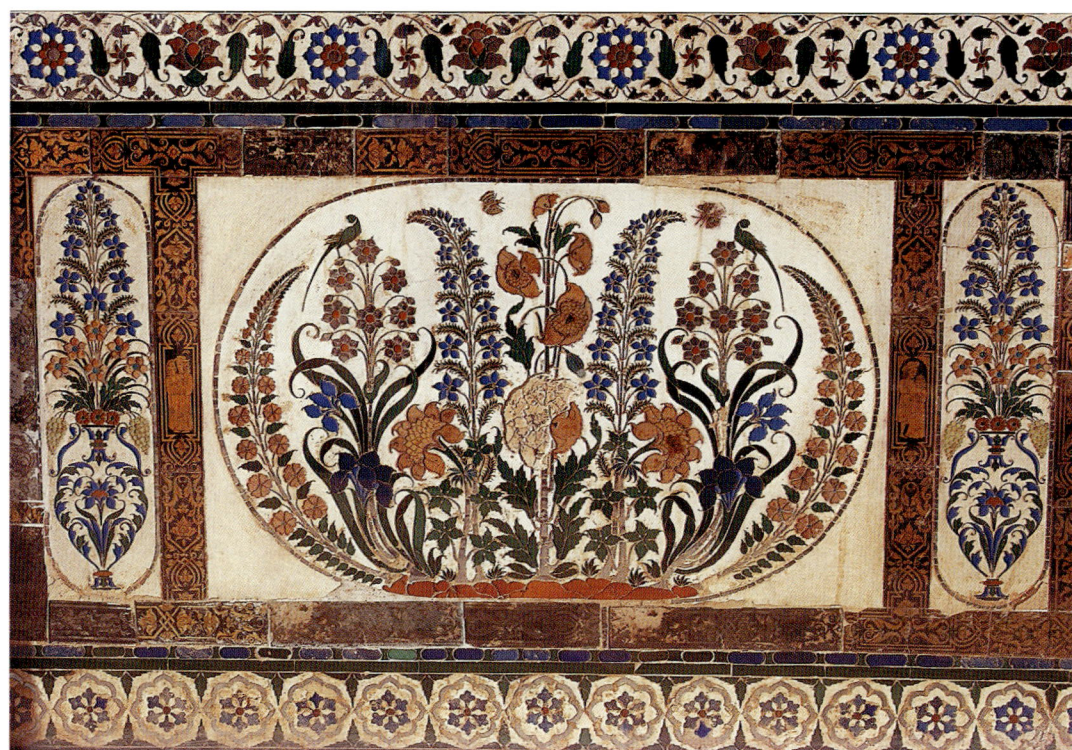

Clockwise from top:
Floral motifs on the terrace court;
Jag Niwas, the lake palace hotel; the
small Ganesh Mandir within the palace;
The balcony over the peacock court

arch lies midway between a regular cusped arch and a traditional corbelled arch. The crucial quality of the cusped arch-that it is a modern form of seemingly modern construction, is apparently willfully reversed."

Badi Mahal or the Amar Vilas, built in 1699 CE, is one of the most frequented areas of the City Palace, chiefly for the splendid garden setting on top of the 27m high hill. All its four sides are enclosed by arcades. The shade provided by the trees makes in an ideal summer retreat in the evenings when the central paved tank would draw inmates to this area for celebrations and festivities. The Badi Mahal also features in many miniature paintings depicting celebrations at the City Palace. The atmosphere is totally relaxed and the Mewari arches add to the openness of the surronundings. In fact, the Badi Mahal does not strive to create any particular architectural effect as is generally seen at the Mughal garden palaces with the formal *charbagh* at the centre and water canals, cascades, pavilions etc. The Udaipur architects have here fully exploited the natural advantage of a hill top by enclosing it with well spaceD arcades.

The later day additions to the City Palace use some more contemporary devices of decorating the interiors. Mirror and coloured glass panels add a touch of intimate luxury to the rooms besides cutting off the glare of the harsh sunlight and heat. The Moti Mahal is ascribed to Maharana Jawan Singh (ruled 1828-38 CE) who nearly lost half of his Mewar Kingdom to a dancing girl if only she could cross the Pichola Lake dancing on a tight rope fastened at both eastern and western ends. She nearly did it but before she could reach to the end, a minister had the rope cut off to prevent the promised reward. Though the story remains unsubstantitated by historical veracity, it is perpetuated for its charm, highlighting the ruler's romantic disposition.

The Bhim Vilas functions as the private royal chapel with images of Hindu deities appearing on all sides of the room. Women of the royal family enjoyed themselves at the Nila Mahal and Priyatam Niwas. The screened windows provided the much needed privacy. The most conspicuous architectural feature here appears in the form of the cusped arches which have extremely narrow foils in sheer whimsical pattern. Surely these meretricious effects have been achieved at the cost of that ruggedness and strength of style which has been the hallmark of Rajput architecture in the preceding centuries. The multi-cusped arches of Shahjahan's palaces seem to have inspired these pale imitations but to little effect.

The Badi Chatur Shali uses Dutch tiles on the main pavilions. For one thing, it looks totally incongruous with the whole setting at the City Palace. There is also some decoration with coloured glass and stone mosaics. But the atrocious ornamentation is amply compensated by the stunning views over the Pichola lake and the two dream-like island palaces-Jag Niwas and Jag Mandir

Amongst these close-set palaces is located the small Krishna Vilas. It is, in fact, a small room or enclosed gallery covered entirely with miniature paintings in the authentic Mewar style. Most of these art treasures are secured within glass cases and photography is strictly prohibited. The room is dedicated to the memory of the lovely maiden Krishna Kunwari, daughter of Maharana Bhim Singh. The young princess met with an extremely tragic end as her life had to be sacrificed as the only way out of the dead lock between her two suitors Jagat Singh of Jaipur and Raja Man of Jodhpur. This happened at the beginning of the nineteenth century. The Udaipur ruler had no courage to fight it out. Who would do it? Daulat Singh, a distant relation of Bhim Singh was asked to carry out the task of killing the princess. He only muttered, "Accursed be the tongue that commands it". The deed was too horrific to be done. Jawan Das, a natural brother of the Rana, agreed to carryout the assignment but the moment he cast his eyes on the charming young maiden who was hardly sixteen, the dagger from his hand fell on the ground. He just shuddered at the heinous job and courage deserted him. But both the rival suitors would settle for nothing less than death for Krishna. Finally it was left to the ladies of the household to administer poison to the princess who had resigned herself to her fate. Her duty to her father and state demanded this sacrifice to which she agreed without any qualms. Krishna swallowed the poisoned drink but it had no effect. Another attempt was made which also proved ineffective.

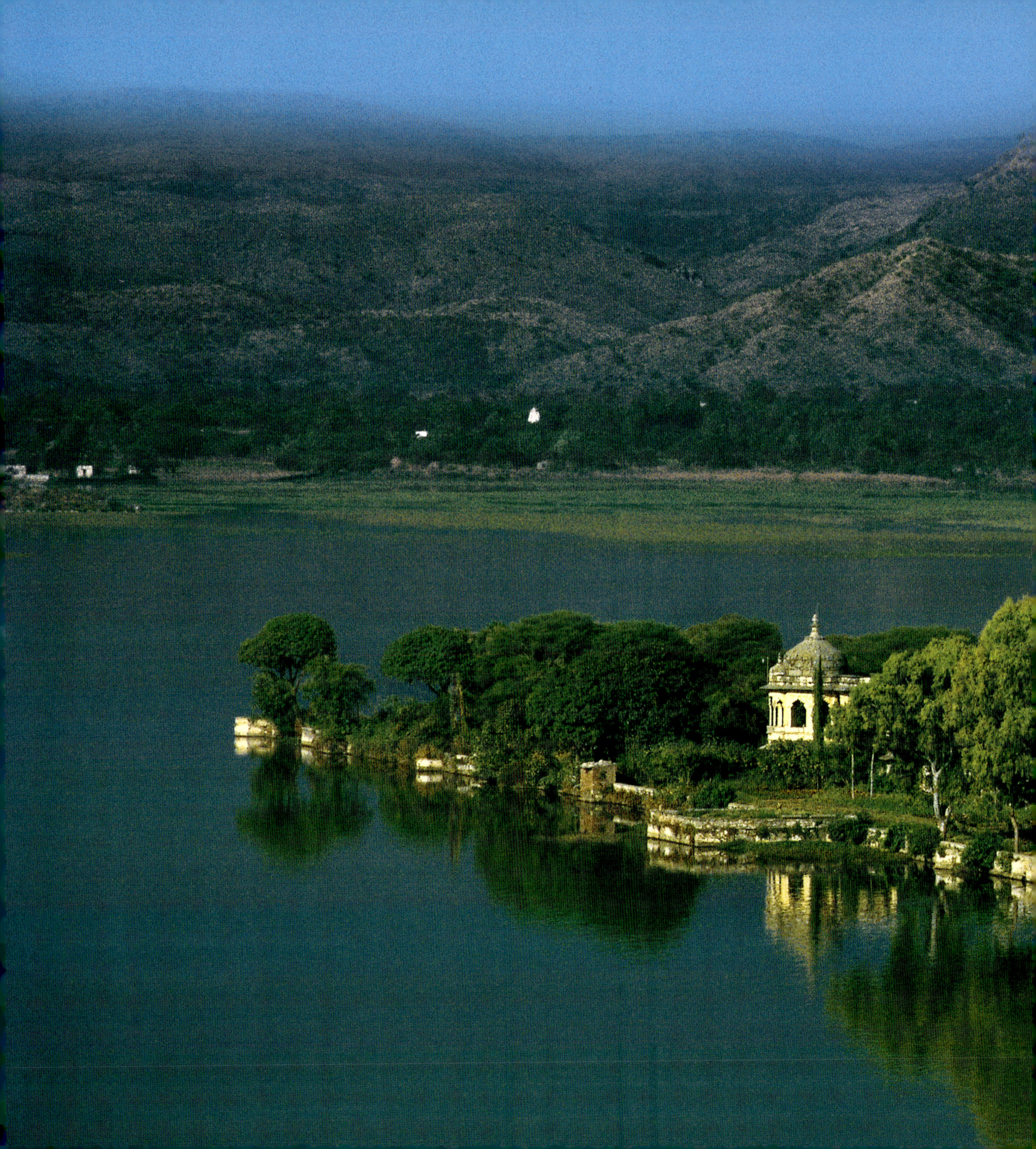

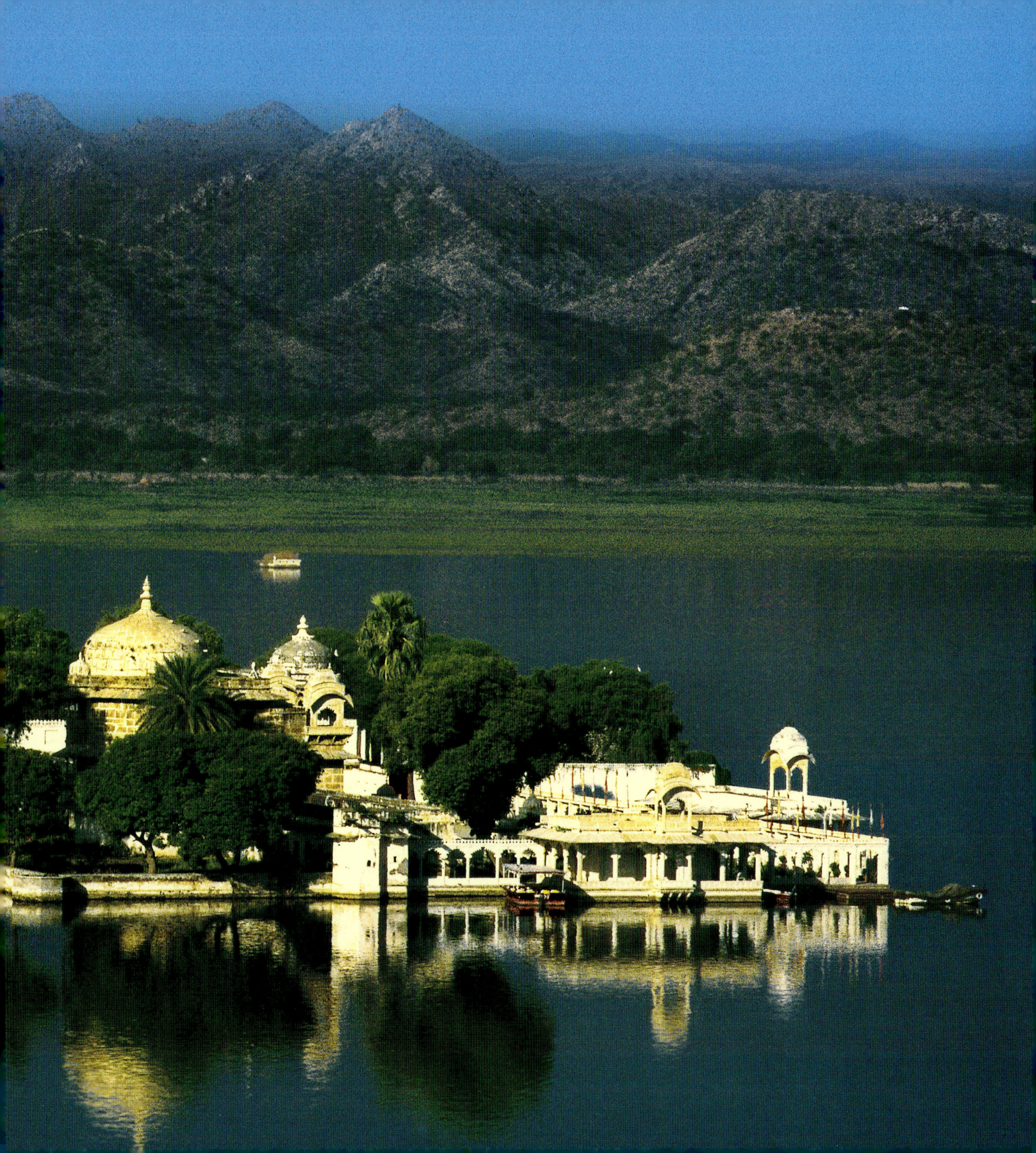

Clockwise from top:
Jag Mandir in the Pichhola lake, where Shahjahan had stayed for some time; James Tod presenting his credentials to Maharana Bhim Singh II; Mewar miniature depicting Maharana Jagat Singh bathing with his ladies at Jag Niwas

The third cup also had no effect. But it had to be done. So, a far more deadly preparation of poisonous opium flowers was administered on her. Krishna drained the contents of the cup and fell into a slumber from which she never emerged. The queen mother died soon thereafter, heartbroken and distraught. There is no cenotaph to the memory of this young princess who happily sacrificed her life to save the honour of her father. It must have been a deadly calm that descended on the palaces of Udaipur after Krishna's death though battle cries and clashing of swords would have been a more Rajput-like solution.

The palace for the queens and princesses or the Rawala is located south of the City Palace Museum. It was built at the beginning of the seventeenth century. The Rang Bhawan houses the museum of royal heirlooms, jewellery and other state treasures. The domed apartments of the queens are to be seen at the Laxmi chowk. Here the interiors are decorated with murals depicting the Krishna legend. The upper storeys of the apartments around the Laxmi Chowk contain an exhibition of Mewar miniatures and photographs depicting political agents and viceroys. One section contains photographs of James Tod, the Resident Representative of the British Crown from 1818 to 1822 CE. Tod is remembered chiefly for his Annals and Antiquities of Rajasthan, the most exhaustive work on the lives, legends and political career of the major states of Rajasthan.

The two other important and extremely well decorated palaces are Shambhu Niwas and Shiv Niwas. Both are closed to the public, the latter functioning as a five-star hotel. Shiv Niwas is built around a grand semi-circular courtyard and the interiors are lavishly covered with mirror-work mosaics and enamel. Also to be seen are some exquisite miniature paintings. Solid crystal furniture in one of its rooms has always been a great attraction. Shiv Niwas has hosted world's dignitaries like Queen Elizabeth II of England and Jackie Onassis among others. It is said that when Maharana Bhagwat Singh was escorting the Queen of England, he gave her precedence but she stepped back and said "Please lead the way. You come from a much older family than I do". To this day, the Mewar dynasty had had more than 76 rulers to commad tremendous respect amongst the royalty all over the world.

Outside the City Palace stands the Jagdish Mandir, built by Maharana Jagat Singh in 1651 CE. It stands atop a small hilly prominence. This immensely beautiful temple is dedicated to Lord Vishnu in his incarnation as Jagannath. The 32 steps to the temple floor have elephant statues flanking the entrance door. It was much destroyed by Aurangzeb but has been restored well to its original glory.

At no other Rajput capital does a lake add so much splendour to the architectural glory as the Pichola lake does to the city Palace. The reflections of the places in the blue waters recall Shelley's words: "Old Palaces and towers/ Quivering within the wave's intenser day, All overgrown with azure moss and flowers/ So sweet, the sense faints picturing them." The two island palaces- the Jag Mandir and the Jag Niwas are the two supremely enchanting palaces of their kind and it is difficult to disagree with James Fergusson who extols their glory: " It would be difficult to find any scene where art and nature are so happily blended together and produce so fairy-like an effect. Cetainly nothing I know of so modern a date equals it."

In the early 17th century, after a protracted resistance against the Mughals, Rana Amar Singh, son of Maharana Pratap bought peace with Jahangir, son of Akbar under one condition; that the Mewar rulers would not be asked to appear at the Mughal court. During this period of uneasy calm, Rana Amar Singh started some work at the island where ultimately the Jag Mandir palace came up. However, it was Rana Karan Singh (1620-28 CE) who nearly completed it. Prince Khurram (later called Shahjahan) stayed here for some time during his days of rebellion against his father- emperor Jehangir. The huge dome crowned with a crescent is the most beautiful part of the structure here which is so reminiscent of S.T. Coleridge's Lines: "In Xanadu did Kubla Khan/ A stately pleasure-dome decree"; The central room in the upper most storey is lined with white marble and decorated with inlaid coloured stones in the Mughal style. In an unusual style, this room and the one below it is round in form. The *chattris* at the corners have *bangaldar* roofs with exaggerated drooping corners. This retreat also contained a small chapel erected to the saint Madar. The small garden contains the royal throne sculpted from a single block of serpentine, supported by quadriform female caryatidae. Here

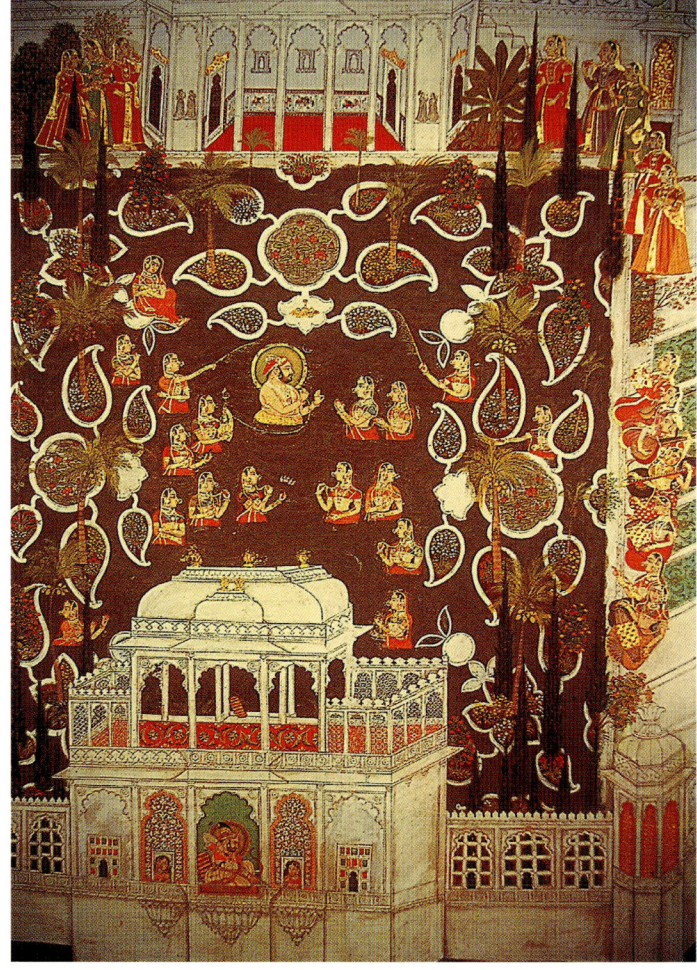

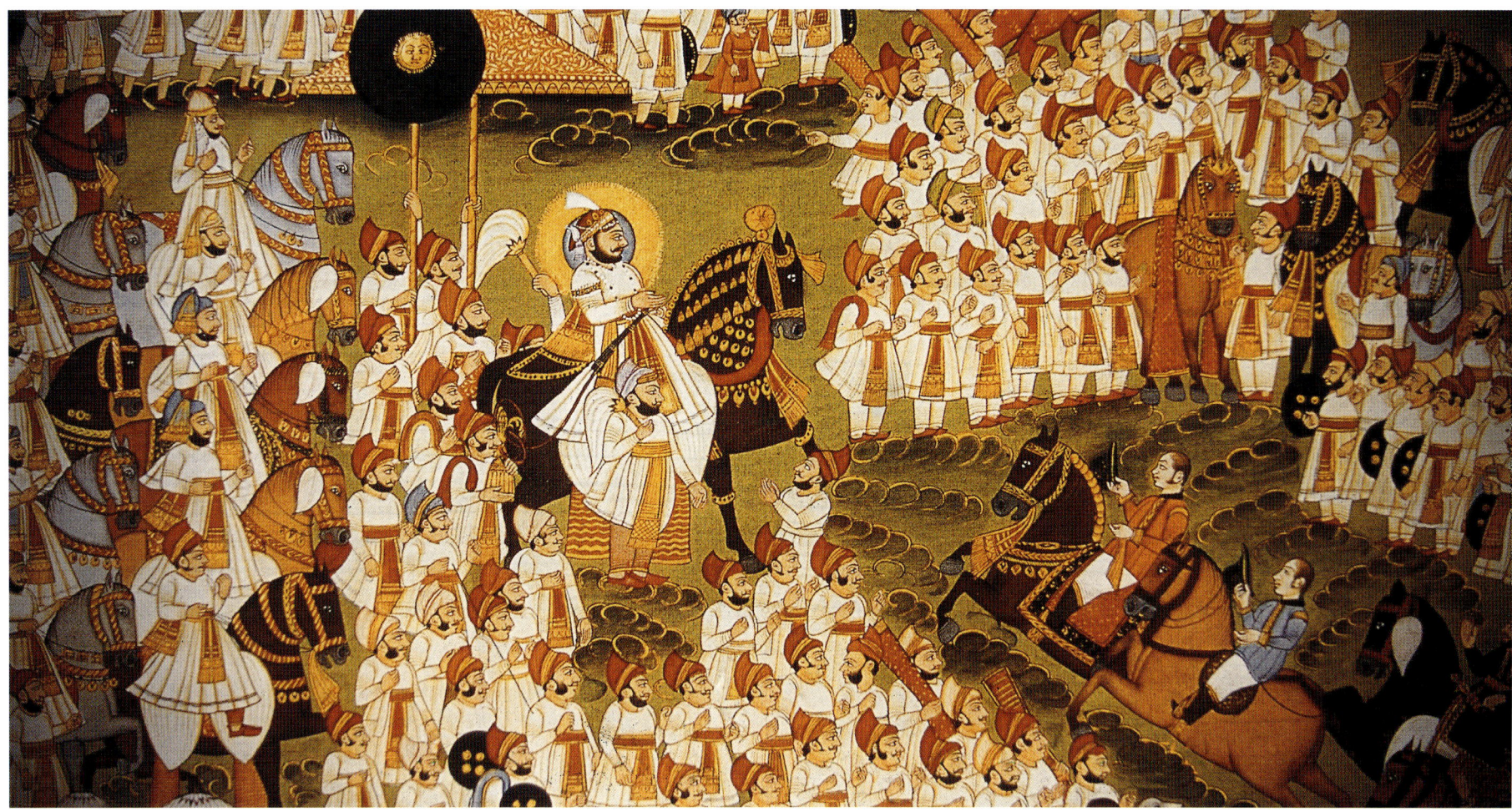

Prince Khurram exchanged turbans with Maharana Karan Singh in a gesture of goodwill and friendship. Khurram was in Surat when Jehangir expired. Udaipur Rana and his entourage escorted Khurram to Udaipur where for the first time, the fifth Mughal emperor was greeted with the title 'Shahjahan'. On this occasion Shahjahan gave the permission for the reconstruction of the fortifications of Chittuargarh, destroyed by his grandfather Akbar. The Jag Mandir is an extremely charming palace which owes its beauty to the lake surrounding it on all sides.

Jag Mandir staged another dramatic episode in modern times. In 1857 CE, when the Rana of Mewar offered refuge to some British families from Neemuch, he ensured their full security by ordering destruction of all the boats so that the angry crowds did not reach Jag Mandir.

Jag Niwas, the other palace on an island, is actually a pleasure retreat built by Rana Jagat Singh in 1746 CE. His father had rejected his request to build for him a palace for entertaining his friends. So he built it himself. It is a sprawling palace with ornamental gardens, pools, galleries and luxurious apartments. James Tod was fascinated by the grandeur of Jag Niwas: " Nothing but marble enters into their composition; columns, baths, reservoirs, fountains all are of this material, often inlaid with mosaics, and the uniformity pleasingly diversified by the light passing through glass of every hue…Parterres of flowers, orange and lemon groves intervene to dispel the monotony of the buildings, shaded by the wide spreading tamarind and magnificent evergreen *khirni*. Detached colonnaded refectories are placed on the water's edge for the chief's use. Here they listened to the tale of the bard and slept off their noonday opiate amidst the cool breezes of the lake, wafting delicious odours from myriads of the lotus flower which covered the surface of the waters; and as the fumes of the portion evaporated, they opened their eyes on a landscape to which not even its inspirations could frame an equal. "Jag Niwas is amongst the most beautiful lake palaces in Rajasthan. Its enchanting location draws honeymooners, millionaires and film producers. Jag Niwas has featured in a great number of films including the James Bond movie-Octopussy.

3 kms east of Udaipur lies the small unsung village of Ahar, a small site called Tambawati Nagari in ancient times. Its origin has been traced back to nearly 4000 years and a small museum here houses bones of fish, deer and pottery belonging to that period. Ahar was the capital of the Guhilots (later called Sisodias) who ruled till Bappa Rawal acquired Chittaur. Ahar functioned as the retreat during periods of invasion of Chittaur. The Gangabhar Kund is held extremely sacred in the region. Each cenotaph, built in white marble and raised on a high plinth, contains an image of Eklingji and a single upright stone covered with the image of the royal couple. The cenotaph of Rana Amar Singh has a four-faced image at the centre. The most magnificent cenotaph, however, belongs to Rana Sangram Singh (rated 1713-34 CE): a grand architectural creation with 56 pillars crowned by an octagonal dome. Ahar was the first capital of the Sisodia dynasty.

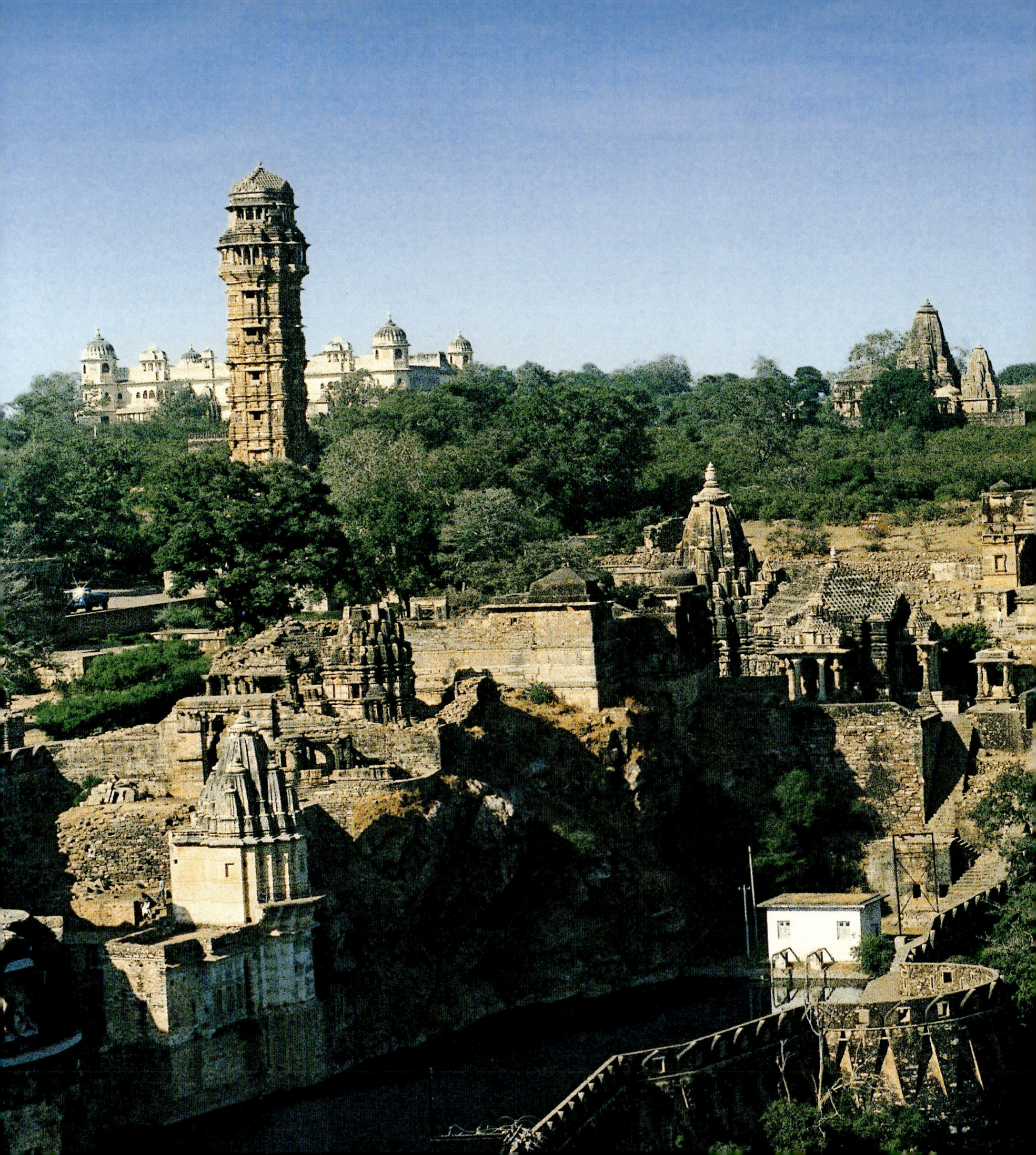

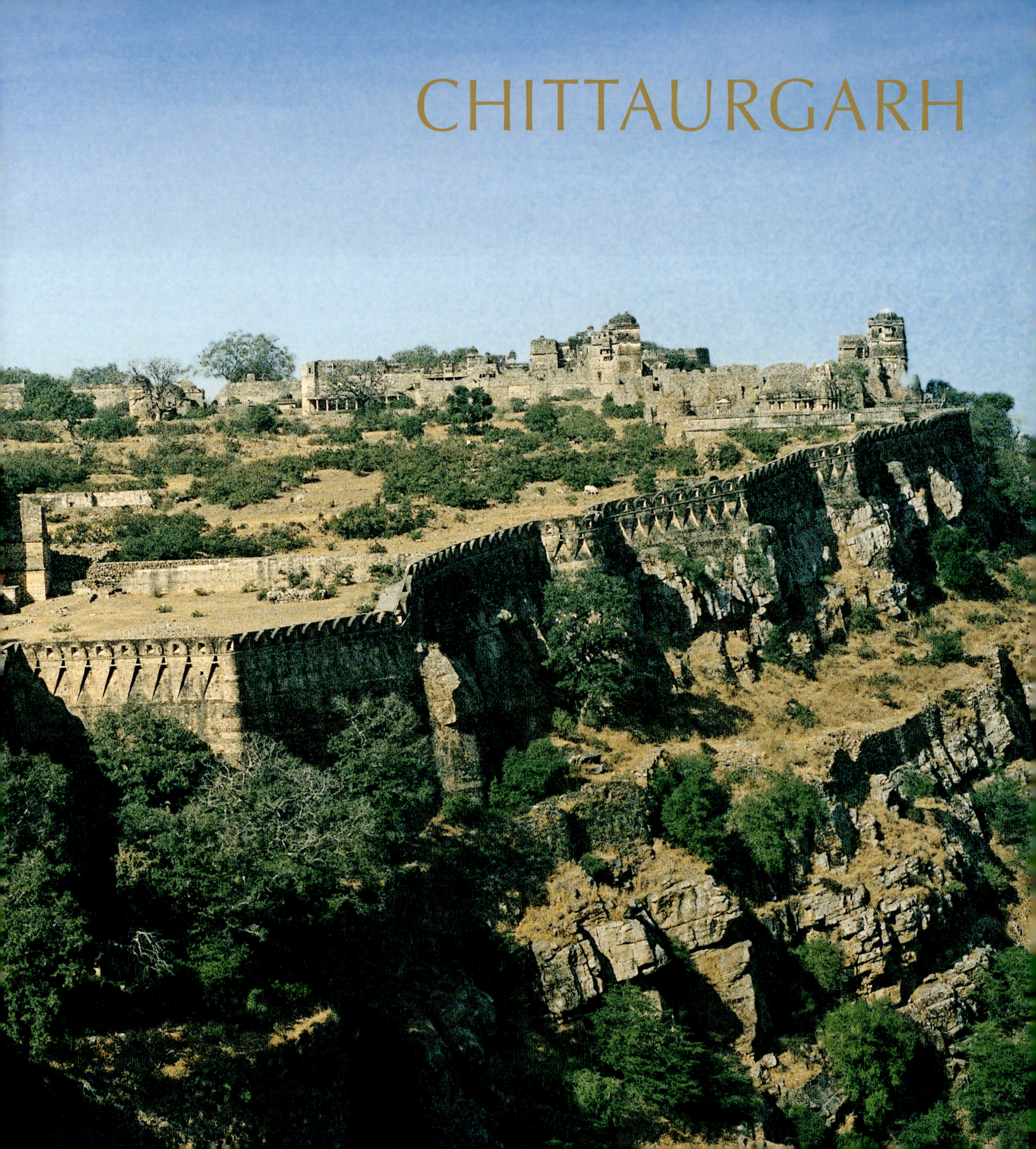
CHITTAURGARH

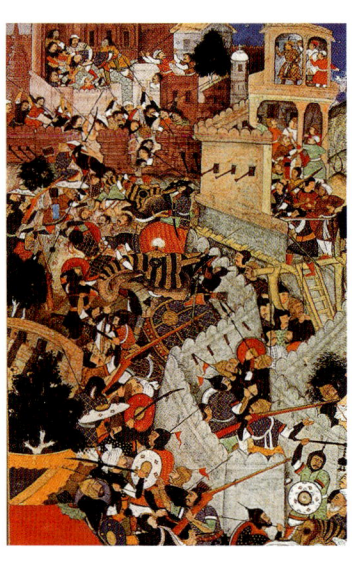

Chittaurgarh is not only the pride of Mewar but of the whole country. This magnificent fort crowns the 5km long narrow ridge, rising abruptly to nearly 500 feet above the plain with awe-inspiring and ipregnable fortifications commanding the landscape. Chittaur has witnessed firece battles in the past when, true to their character, thousands of valiant Rajputs donned saffron robes and plunged head long into battles to embrace death, and multitude of women dressed in their bridal finery marched into fire to commit *jauhar* (self-immolation) preferring death to dishonour. Chittaur is the quintessence of ideals dear to a Rajput's heart.

The origin of Chittaurgarh is popularly traced to the Mahabharata days when Bhima, one of the five Pandava brothers, nearly completed building the fort in one night. In deep anguish over his failure to obtain the magical stone promised by the saints, Bhima stamped his foot on earth. Bhimalat or Gori at the southern end of the fort is the spot where this happened. A water tank here relates to Bhima. The discovery of two Paleolithic sites on the river Berach provides evidence of the historical importance of the region.

More convincingly, the history of Chittaur begins with Bappa Rawal, the Guhilto (cave-born) ancestral hero who defeated the last Mori ruler Chitrangad Maurya in the 4th century CE. The fort built by the Mauryas was called Chitraktoo which later came to be called Chittaurgarh. The Strategic importance of the fort invited frequent invasions from the neighbouring states and the Delhi Sultanate rulers. The Pratiharas, Rashtrakutas and Paramaras ruled over this fort for brief periods. The Guhilots regained Chittaur in the 11th century CE. Bappa Rawal's progeny, later called the Sisodias, epitomised the Rajput ideals of honour, courage, chivalry and sacrifice. Rana Kumbha, Rana Sangram Singh and Rana Partap are legendary heroes of Chittaur.

Over the passage of time, Chittaur acquired its reputation as the most formidable and impregnable fort in Rajasthan but it was sacked thrice with the most terrible consequences.

Chittaur was sacked for the first time in 1303 CE when Alauddin Khilji of the Delhi sultanate laid a protracted siege around the fort but failed to make any headway. He resorted to stratagem. Alauddin had heard of the legendary beauty of Padmini, wife of Rawal Ratan Singh. The Sultan offered to withdraw his forces if he was allowed a glimpse of Padmini. Seeing no way out of this trouble, Ratan Singh agreed but allowed the Sultan only a mirrored reflection of Padmini. Alauddin saw the reflection and withdrew his soldiers. Ratan Singh escorted Alauddin to the gates of the fort where he was ambushed and held as hostage to be released only if Padmini came to Alauddin. Padmini had her own strategy. Gora and Badal, her cousins disguised as women followed by Rajputs disguised as the queen's maids in attendance occupied the palanquins. The soldiers drew their swords the moment they entered the Sultan's quarters, overpowered the Muslim soldiers and released Ratan Singh from captivity. Alauddin was outwitted but more determined to acquire Padmini. Another siege followed. Despite stiff resistance, the fort fell to Alauddin. True to the Rajput traditions of honour, Padmini and hundreds of women immolated themselves and nearly 30000 men perished. In sheer frustration, Alauddin Khilji demolished temples, ransacked palaces and plundered the city. He left Chittaur under the charge of his son Khijr Khan but Padmini's son Rana Hammira recovered the fort in 1313 CE. The Padmini legend has remained largely unsupported by historians but later poetical works lend some credence to this extremely charming episode fondly remembered by people through all these centuries.

After 230 years of comparative peace and intense architectural activity, Chittaur was sacked for the second time in 1535 CE by Bahadur Shah of

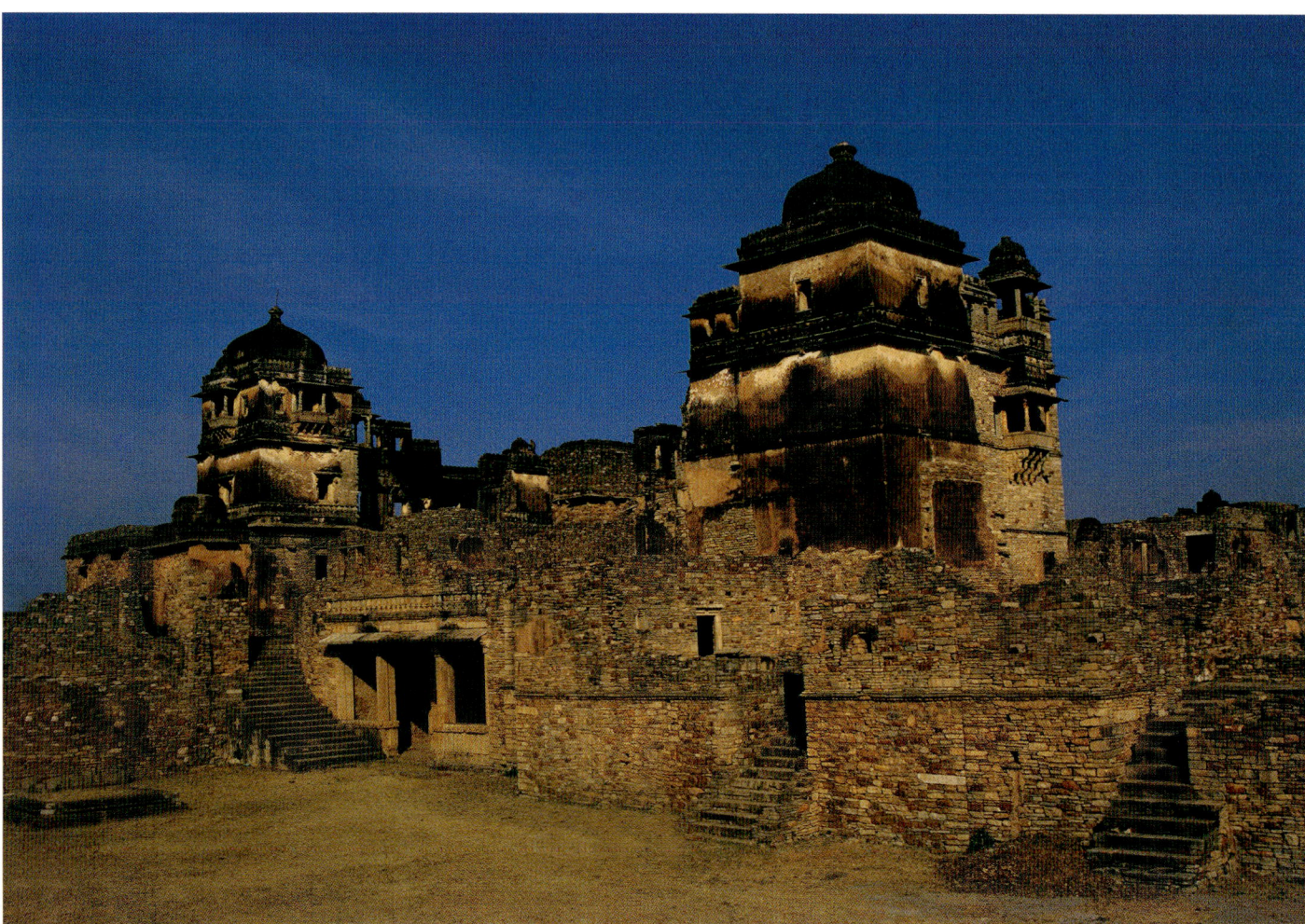

Gujarat, Jawahar Bai, the dowager queen, led some 13000 women to the Mahasati Chowk to enact another *jauhar*. Humayun, the second Mughal emperor, whose help was sought by the queen Karnavati, sent help a little too late. But he did free Chittaur from the forces of Bahadur Shah and gave it back to the Sisodias. Excavations at the Mahasati area have revealed layers of ashes to confirm this massive *jauhar*.

In 1567 CE Akbar laid siege on the fort. The impregnable fortifications of Chittaur presented insurmountable difficulties. Akbar resorted to different techniques. He resorted to mining and *sabat* (covered passage) to destroy the formidable walls. It is believed that Akbar had the hillock-Mohar Magri raised by sackfuls of earth. When the hill top reached the required height on level with the fort walls, grenades were fired into the fort. The young ruler of Chittaur-Uday Singh had already left for a safer destination in the hills. Two valiant youngmen-Jaimal and Patta defended the fort. Akbar killed Jaimal with his gun shot and later Patta, along with his bride and mother, died fighting. As columns of smoke rose high in the sky, it was clear that a massive *jauhar* had taken palace in the fort. Akbar had won the battle but the Rajput musketeers outsmarted the Mughal troops. The Rajputs posing as a detachment of the victorious army, bound their women and children and walked past the Mughal troops to freedom. Enraged at this outrageous courage, Akbar ordered the slaughter of thousands of villagers living in the fort. It was ordered that the ruins of Chittaur remain unrepaired in permanent warning to any Rajput power which dared the Mughal. Jehangir, Akbar's successor, gifted Chittaur back to the Sisodias disallowing any repairs or restoration of the palaces destroyed by Akbar. And so Chittaur has been till today as Sir Thomas Roe found it after the last devastation "a tombe of wonderful magnificence."

The winding road to the crest of the hill passes through seven massive gates or Pols. The first, Padal Pol, is important for the memorial of Bagh Singh who died here fighting the soldiers of Bahadur Shah during the second siege of Chittaur. It was later demolished by Maharana Fateh Singh in the 19th century CE. Further up at the Hanuman Pol stand the memorials to Jaimal and Kalla who died in the battle against Akbar. Hanuman as well as Ganesh Pol have shrines of these gods close to them. Lakshman and Jorla Pols are the next on the uphill road leading to the most important and mammoth Ram Pol built by Rana Kumbha. It is a massive gate with a heavy corbelled entrance, string courses on the wall besides sculptural reliefs. A temple of Lord Rama stands close to the gate. A memorial to the brave fighter Patta stands near the gate. Shahjahan had some of its portions demolished in pursuance of Akbar's orders forbidding repairs on buildings destroyed during his invasion of Chittaurgarh.

Chittaur was held by several dynasties but there are few architectural remains of the earlier periods. In fact, the palace ruins of Rana Kumba (1433-68 CE) are specimens of the oldest surviving architecture at Chittaur. The palace is reached after two gateways. The Badi Pol is a monumental structure with two massive octagonal towers flanking the corbelled entrance. The towers are articulated with string courses and surmounted by two small domes. The Tripolia, a three bays deep structure is a grand structure suitable as entrance to the royal residential area.

The Kumbha palace is a complex of small structures built around a courtyard. The Darikhana or the Sabha is a low hypostyle hall in the 'public' area where the ruler performed his duties as supreme commander of armies and head of the kingdom. Nearly all the rooms are roofless and without any trace of decoration. From the inside it is a mere skeleton of walls. The exterior presents the look of a deserted and haunted palace. First, the lower sections of the wall are flat and without any windows. The uppermost section has balconied windows. Each balcony consists of a rectangular cradle, cantilevered out on heavy brackets and surmounted by a canopy raised over short columns. The complete lack of ornamentation is a statement of the austere style. These balconies are built in stone prominently jutting out of the walls made of rubble stones covered with stucco. These balconies are generally arranged one above the other in a vertical set. The doorways are nearly all modest rectangular openings.

The uppermost section of the walls is not in a straight line but always staggered, rising and falling in short steps of the staircase cantilevered from the wall from inside. The exterior walls are articulated with string courses and large flower-head bosses. The corner towers are in three storeys. The two main storeys are flat-roofed with rectangular chambers. Only rarely does one notice a few blue tiles used for decoration on the exterior.

The Kanwar Pade Ka Mahal or palace of the heir apparently is located in the south-west section of Kumbha's palace. The whole structure is built over subterranean rooms, galleries and passages leading to different parts of the fort. More than the architecture, it is the stage from where legends arise. In the vaulted subterranean chambers Padmini, along with hundreds of other ladies, is believed to have committed *jauhar*. These chambers are blackened with smoke of the fire that consumed the Rajput women. In the Kanwar Pade Ka Mahal, Panna, the wet nurse of prince Uday, sacrificed the life of her own infant son in order to save the life of the prince from the sword of the usurper Banbir. The prince was whisked away to safety. Panna is held as an example of supreme selfless sacrifice in Rajasthan. All structures in the royal area are essentially trabeate in construction but recourse to elementary arcuate technique has never been really unknown to Indian architects. Since there are no ruins of palaces from the pre-kumbha era, in all likelihood these palaces were built over the ruins of the

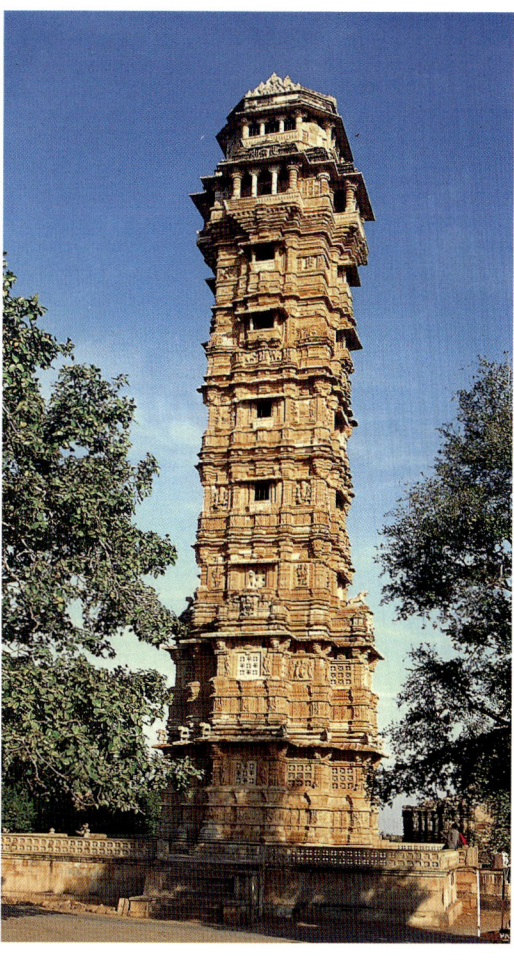

Previous pages:
The massive fort at Chittaur
Clockwise from top:
Vijay Stambha (victory tower) built by Rana Kumbha; Ruins of Rana Kumbha's palace; Mughal miniatures from Akbarnama, depicting Akbar's siege and conquest of the fort

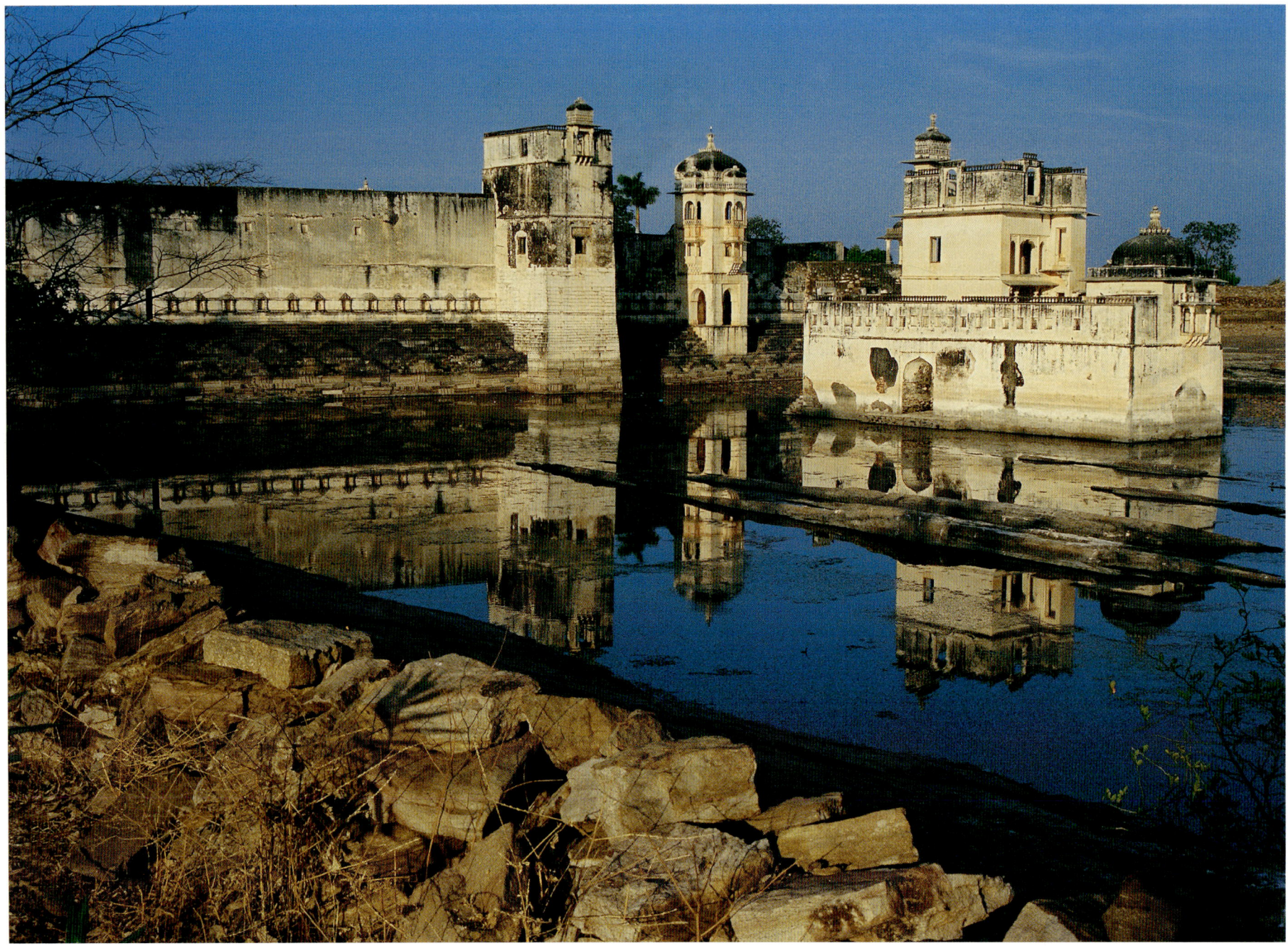

earlier structures in the typically indigenous style.

By and large, the architectural style of the Kumbha palace follows the traditions of the land, limited and relatively pure in the sense that it is mostly derived from the Hindu tradition. Apart from the motifs…such as the temple columns, the *jharokhas*, the *jalis* and the flower bosses-this Hindu vocabulary also includes the richly carved brackets and corbels (supporting some of the balconies) and the *chajja*, here used not only as an eave but also between the storeys as part of the string course.' Still, as Tillotson observes, there are "a few indications of that eclecticism which was to develop and shape the Rajput style in the ensuing centuries present here". The vaulted substructure is one example. Other are the domes and such minor details as the small arches in a central kiosk. These details have been borrowed from contemporary sultanate architecture such as that of Malwa. The ogee pointed arch introduced at Kumbha's palace is used much more prominently at the gateway close to the palace of Ratan Singh (1528-31 CE). This tall gateway with its bold and high ogee arched entrance contrasts markedly with the archaic trabeate, gateways at Kumbha's palace.

The palace of the legendary beauty Padmini stands near the Kalika temple. The main section stands surrounded by a lake. Though it was rebuilt in 1880 CE by Maharana Sajjan Singh, it is not unlikely that the core structure belongs to the original lake palace destroyed by Alauddin Khilji in a fit of impassioned anger for havng lost Padmini for ever. The idea of a lake palace was to appear in full glory at the splendid Jag Mandir and Jag Niwas palaces on the Pichola lake in Udaipur.

There are ruins of large mansions and palaces at every corner at Chitaur, most of them reduced to pathetic heaps of stones. Amid such ruins stands the domed house of Gora and Badal, relatives of Padmini who had rescued her husband from Alauddin's clutches.

The western sector of Chittaurgarh has the largest conglomeration of monuments in varying degrees of ruination. The grandest and relatively least damaged monument is the Vijay Stambha or the Victory tower built by Rana Kumbha as a memorial to his victory over the Malwa Sultan in 1440 CE. This magnificent tower is 37.2 meter (120 Feet) high with nine storeys and 157 steps to the uppermost pavilion. The Vijay Stambha, covered with sculptural reliefs, cornices, niches, *jali* screens, inner columns and

inscriptions of historical importance, is the greatest showpiece of Kumbha's architectural genius. It is a symbol of Rajput pride and valour.

Some distance away from the Vijay Stambha, stands another tower, smaller but more ornate. It is the Kirti Stambha (tower of fame). This splendid architectural creation is 75 feet high with seven storeys and 69 steps to the top pavilion. It stands on a basement of 20 feet square. Each storey has been embellished with mouldings, balconies, windows, turrets topped by the domes' open pavilion. The Kirti Stambha is ascribed to Sri Allata, Mewar King between 953 and 975 CE. But more certainly it is believed to have been constructed by Jija, a wealthy Jain merchant on completion of a piligrimage. He built it as the Man Stambha to the temple of Chandraprabhu, now called Mahavir Swami temple. The tower is dedicated to Adinatha, the first Jain Tirthankara whose five feet high images occupy niches on all the four sides of the structure. Hundreds of miniaturized images of Adinatha appear as sculptural embellishments endowed with immense spiritual significance. Jija's son Punya Singh completed the tower which was consecrated between 1214 and 1239 CE by Bhattaraka Dharamchandra.

The Mahavir Swami temple, though much damaged and repaired, has a glorious ltous ceiling embellished with sixteen divine beauties (one has been removed) in the style of the contemporary Dilwara Jain temples at Mt.Abu. The Kirti Stambha and the Mahavir Swami temple form a small and compact group of structures at Chittaur.

The other two Jain temples stand near the Kumbha palace Satbees Devra (containing 7+20 temples dedicated to Jain deities) is known for its sculptural splendour. There are 24 temples built with in an enclosed area. The Shringar Chauri is also a Jain temple with exquisite decoration in relief depicting deities, dancers and animal figures. The temple was built in 1448 CE by Rana Kumbha's treasurer Belak.

The Samidheshwar temple, perhaps the oldest structure here, was originally built by the Paramara king Bhoj in the 11th century CE and renovated in 1428 CE by Maharana Mokal. The *shikhara* is covered with elegant sculptures of deities and celestial beauties. The sanctum contains a triple-faced image of Shiva. Outside, a Nandi sits in perpetual vigil. The Mahasati area, site of two massive *jauhars* in 1535 and 1568 CE, lies between this temple and the Vijay Stambha and has two magnificent gateways on the northern and eastern sides. Gaumukh, a large and deep pool of water and a source of perennial supply of water to Chittaur, lies close to the ramparts below the Samidheshwar temple. A few small temples stand on the pool held sacred by the people.

Rana Kumbha built the Kumbha Shyam temple in 1448 CE over the ruins of a 9th century temple. The high shikhara of this temple, originally dedicated to Vishnu in his incarnation as a Boar, is very impressive. A small temple, popularly attributed to Mira, the legendary saint-poetess of Mewar in the 16th century CE, also stands in this walled enclosure. Behind these temples lie the ruins of the magnificent Jata Shankar Mahadev temple.

The houses of Jaimal and Patta-two great warriors who defied the might of Akbar's armies stand at a short distance. These houses, roofless and dilapidated are mere skeletons of impressive structures and give some idea of the contemporary architecture. Further up is the Kalika temple, rebuilt a few times over the original Surya temple. An image of Kali has replaced the image of Surya.

The temple of Adbhut Mahadev is a colossal ruin at the center of an enclosed quadrangle. The *mandapa* and the *shikhara* have suffered destruction and stand roofless. Built in 1394 CE by Maharana Raimal, the sanctum has a triple-faced image of Shiva in sandstone. The profuse sculptural decoration on the lower portion of the *shikhara* has a remarkable sensuous quality and exuberance.

Besides these buildings, mostly reduced to splendid ruins, there is only one structure of importance, still in a better preserved state-the palace of Ratan Singh which stands overlooking a lake at the northern end of

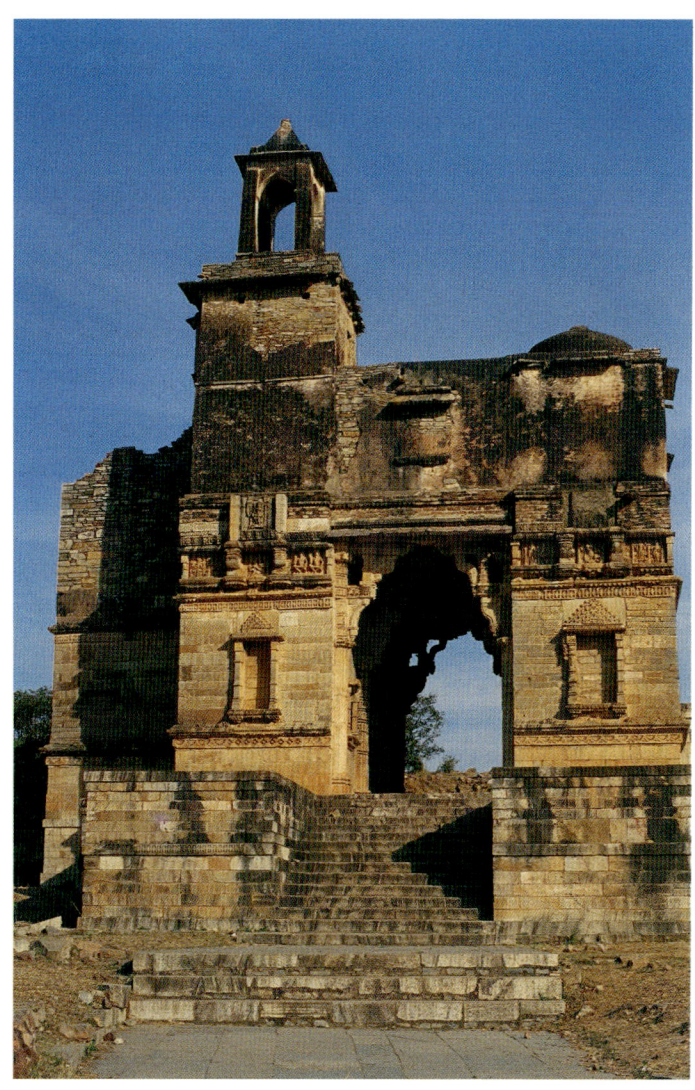

From far left:
Padmini Palace; Gateway to Mahasati square, the place of Jauhar, within the royal area

Chittuargarh. It is a much renovated structure. Only the innermost section of the palace is important for its narrow passage and galleries, small rooms and a closed-in appearance typical of the earliest construction. Security and privacy demanded that all activity and movement centred around the small courtyards. The view of this palace overlooking the lake shows a mingling of different architectural features: two massive angular towers near the entrance flank a projecting section of the wall with circular domes over the two main towers and a rectangular pavilion with a set of triple multi-lobed arches on the front and one each on either side over heavy brackets; a large flower boss on the projecting section, the domed towers with *jharokhas* and crested with decorative elements derived from Hindu temples. The whole appearance of this façade results from much renovation and addition to the original structure which was rubble-built, covered with stucco which survives in patches at a few places. Though set high below the domes, an extremely notable decorative feature comprises merlon-shaped ornament forming the double line of string course below the *jharokhas* and the domes. The gateway with the most prominent ogee arched entrance stands close to Ratan Singh's palace. An elegant temple, complete in its different architectural parts-sanctum, *shikhara*, *mandapa* and *ardha-mandapa*, stands close to this section over the lake.

Below the ramparts of Chittaurgarh flows the Gambhiri river. The long stone bridge over the river was built by Kjijr Khan, son of Alauddin Khilji, who held Chittaur for a few years. He may also have devastated the fort and the palaces but this also has bridge remains; his very constructive addition to the architectural heritage at Chittaur. Even after seven hundred years, this stone bridge serves its purpose well, linking the city with the ancient fort.

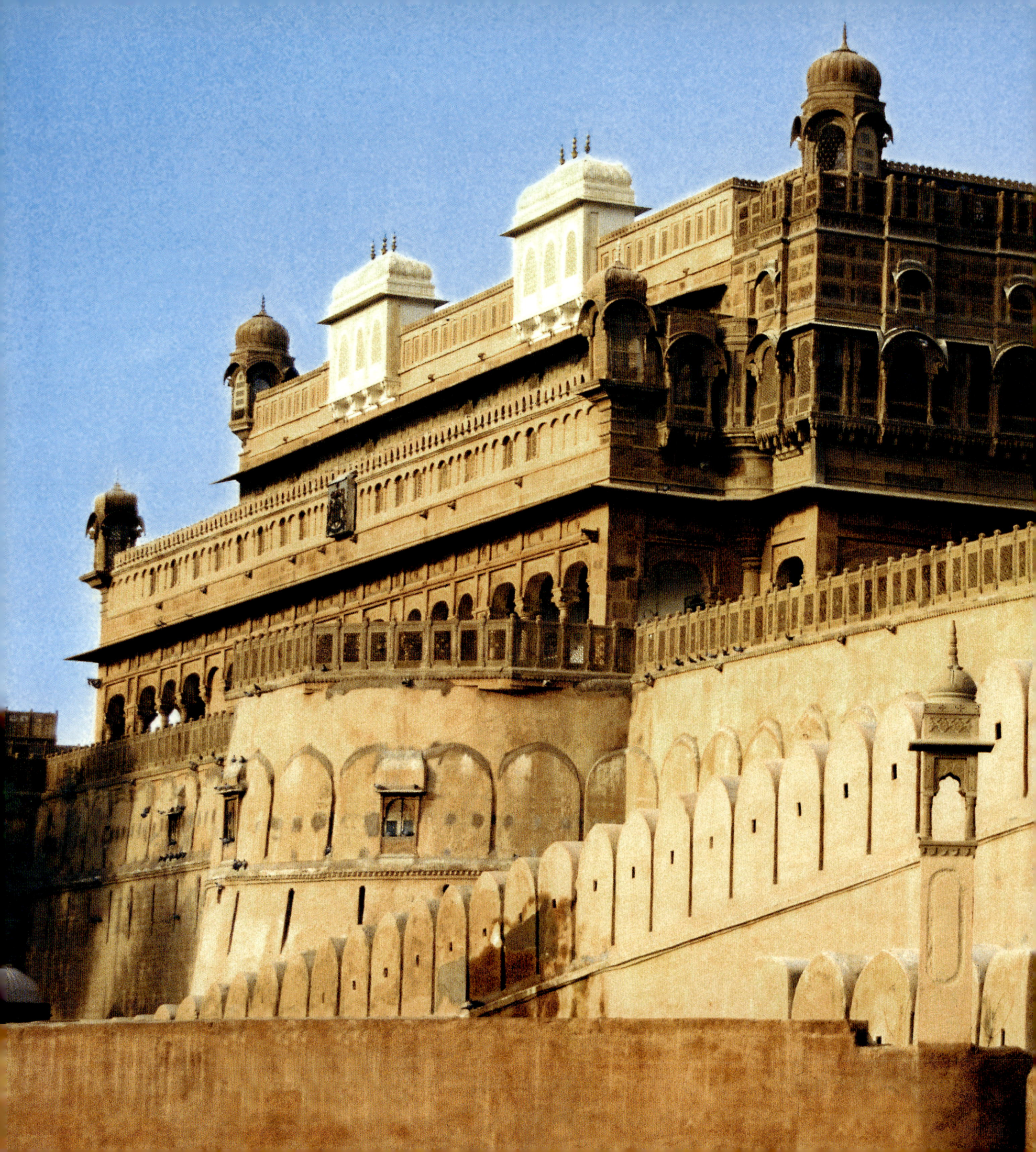

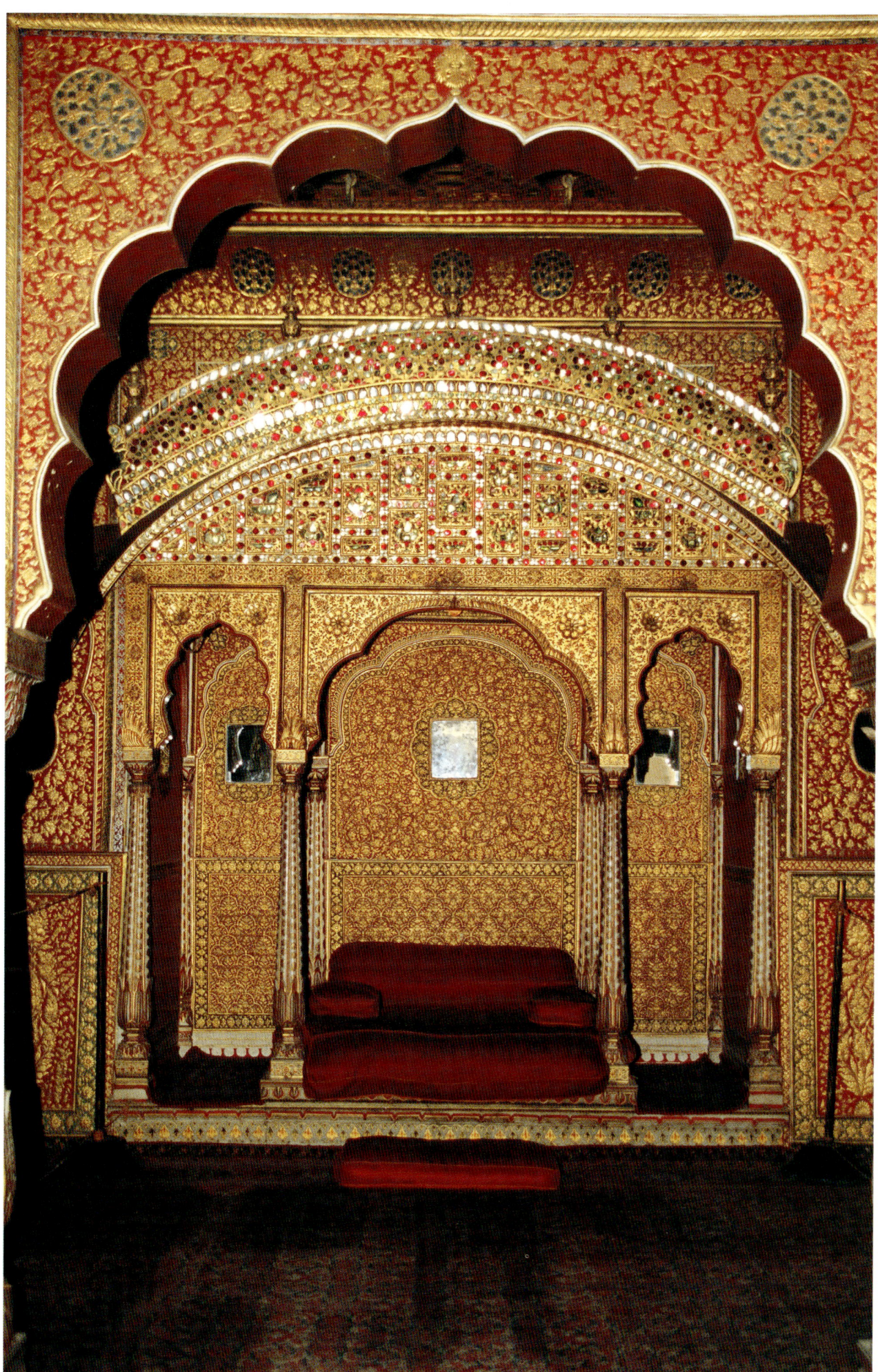

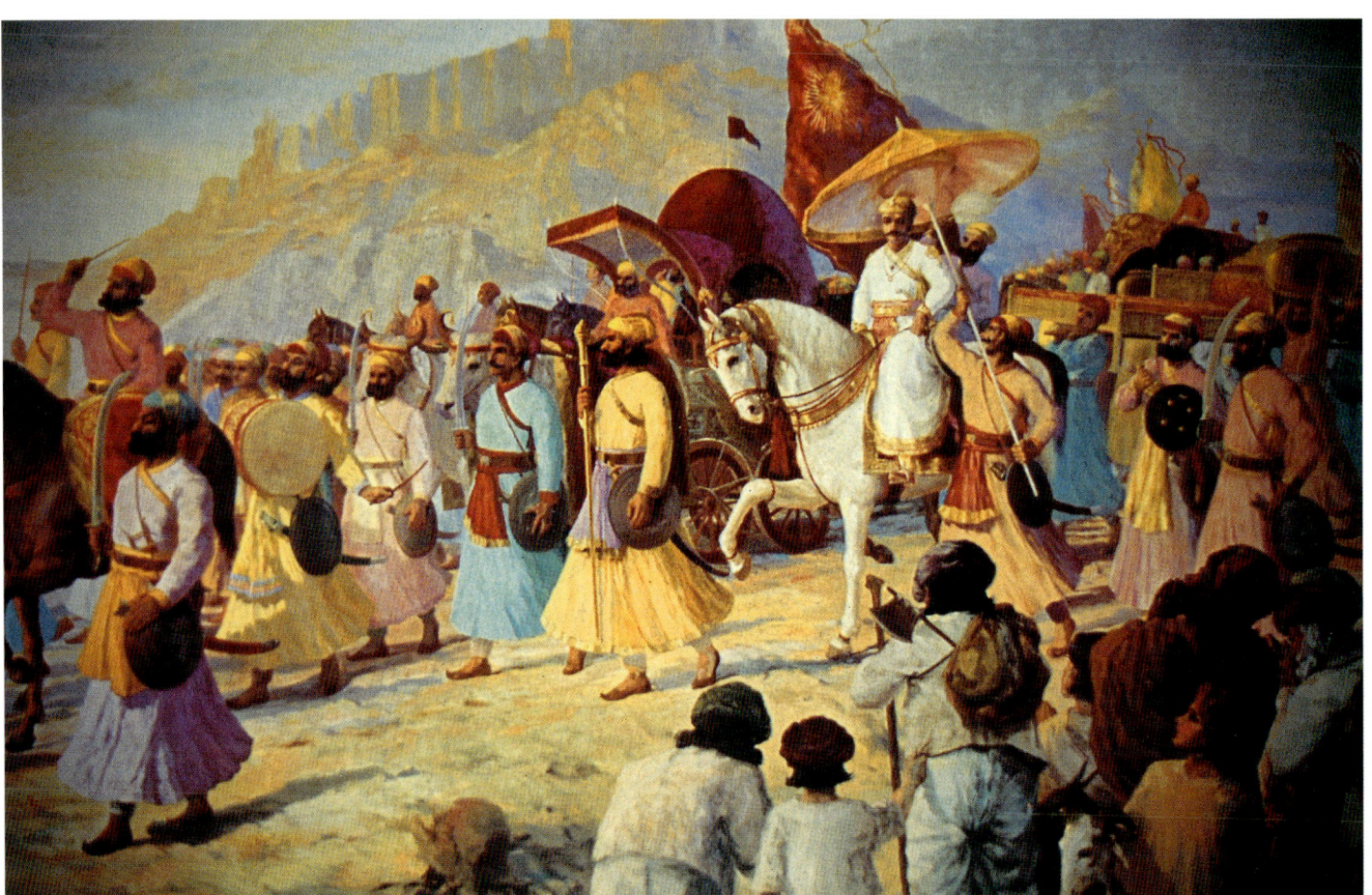

Clockwise from top:
The royal seat of the Rathore rulers from their ancestors at Kannauj, perhaps the oldest piece of extant furniture in India; Pavilion in a pool at Anup Chowk; Chattar Mahal, the royal bedchamber; Painting in Badal Mahal depicting Maharaja Sardar Singh with his chiefs; Rao Bika, founder of Bikaner, bringing home the hereditary throne from Jodhpur to Bikaner

profitted by levying its own tax on the caravans and claiming a share in their profit. But Bikaner remained perennially occupied in skirmishes with the Bhattis of Jaisalmer and their common borders remained alive with frequent battles. Intervals of peace were few and far between. Bikaner soldiers also humbled Kamran, Humayun's brother, and chased him out to Kabul. Both Sher Shah and Humayun had their own roles to play in the battles and intrigues for power in the desert. Humayun had to cross the whole of the Thar with his demoralised men and harem and knew well the hazards of foray in the desert interiors. Bikaner was a relatively safe haven in the desert. With the rise of Akbar as a powerful Mughal emperor, Bikaner hastily accepted political protection.

The fort of Bikaner stands on a level ground, minus the grandeur of a hill-top location as at Jodhpur, Jaisalmer and Gwalior. It was Rai Singh (1572-1612 CE), Akbar's ally, who built a few important structures in the fort between 1588 and 1593 CE. The strong fortifications were the first to be completed. These ramparts are nine meter thick. There are thirty seven bastions on the ramparts which stand behind a 30 meter wide moat. The cluster of palaces stands behind these strong walls of defence. During the three centuries of power and prosperity, Bikaner acquired the status of a greatly reliable and friendly Rajput state.

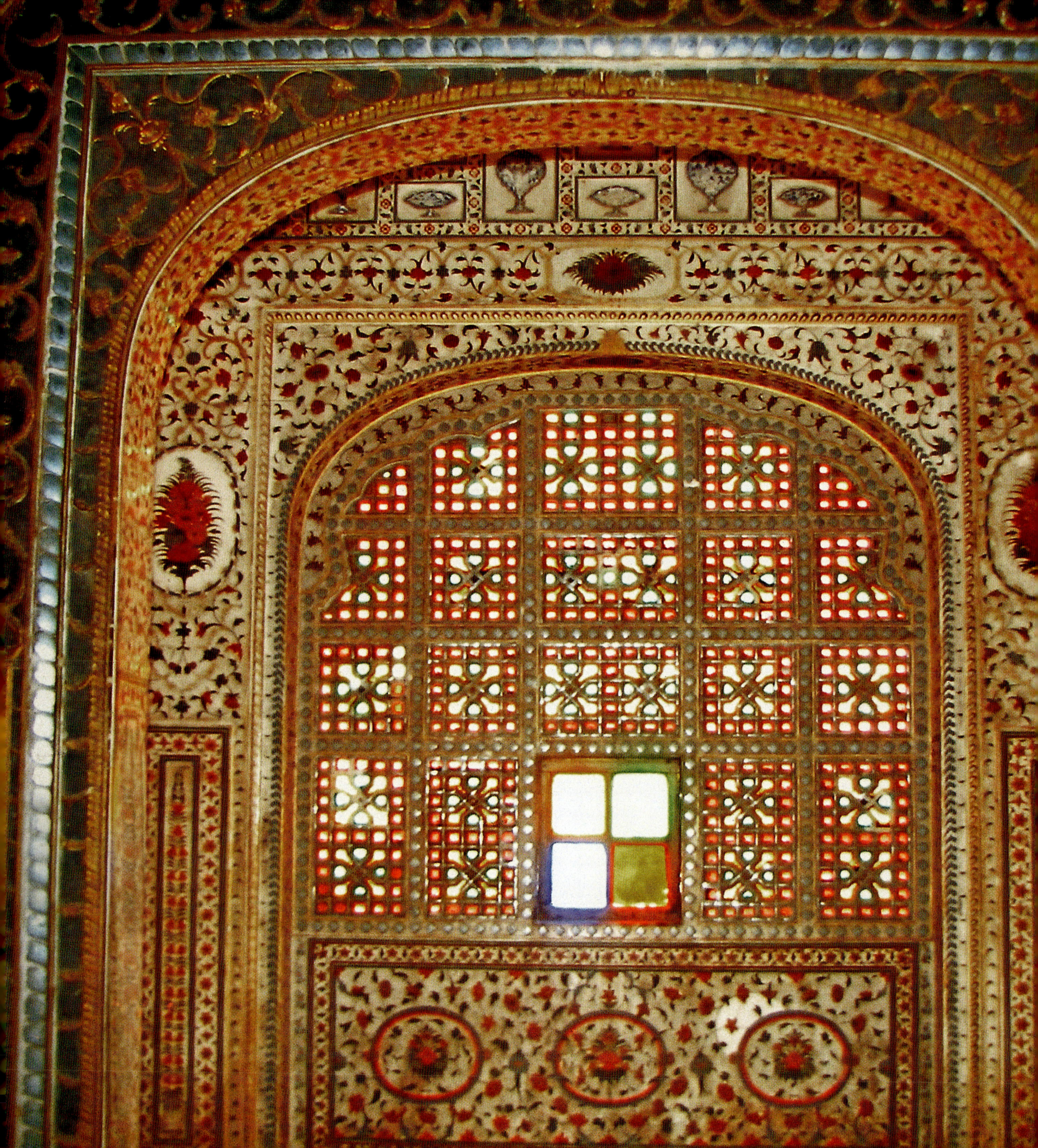

The palaces in the Bikaner fort are built on an east-west axis with a large open space in front of the nortern flank. The first important structure of Suraj Pol is amongst the oldest parts of the fort, built by Rai Singh. It is noteworthy that the style of this gate is essentially trabeate in construction of the Rajput architectural traditions. Built at a time towards the end of the sixteenth century, when the fort and palaces of Agra and Sikri had already been built, the architecture at Bikaner shows little influence of the Mughal architecture. The structural-pointed central arch at Suraj Pol has on an upper level two *jharokhas* and a gallery meant for use by the drummers announcing the arrival or departure of the ruler, and musicians played festive notes on ceremonial occasions. The Suraj Pol, built in yellow sandstone, is different from the rest of the palaces which are built mostly in red sandstone. This gate is guarded by a pair of gigantic elephants with mahouts.

The Lal Niwas n the northern range was amongst the first few structures to be built at the earliest stage of construction under Rai Singh. It is a large room with a low ceiling. The use of tall columns at Lal Niwas went on to be a recurring feature of architecture at Bikaner. The ornamentation chiefly comprises red and gold floral motifs painted against a white background. The laccuered doors at the Lal Niwas are another remarkable feature of these palaces. The balconies opening towards the courtyard are covered with *jali* screens. The interior finds no use of columns to support the ceiling. The width of the room is rather narrow and the dimensions of the room look slightly ill-proportioned because of its length. It was perhaps used as a darbar hall and provided a full view of the audience to the ruler. Compared to Lal Niwas as a darbar hall, the Ganga Niwas appears huge with much improved building techniques used to advantage. It provides a magnificent settting for royal receptions and ceremonies.

The Karan Mahal shows the influence of the Mughal architecture most manifest on the arcade of cusped arches over *baluster* and fluted columns. The use of a blind arcade of plasters carved in relief only show how much the Bikaner rulers were fascinated by ornamental features of the Mughal architecture under Shahjahan. In the absence of white marble on the wall surfaces at this palace, lime plaster has been polished to an exquisite silk-smooth finish. The Karan Mahal was built by Karan Singh (1631-69 CE), who enjoyed a love-hate relationship with Aurangzeb. His sons were admired by Aurangzeb for their valour against Dara Shikoh and their armour dusted by the Mughal emperor himself. But at the end of it all, Karan Singh was deprived of his mansab for his opposition to the emperor's religious policies. The Bikaner ruler was dispatched to Aurangabad where he presided over a small betle garden in loneliness. He built a small temple to Karnji and died there peacefully.

The Anup Chowk is a stately courtyard surrounded by ranges of royal palaces. Here, Badal Mahal is a small rectangular hall covered with glorious frescoes depicting blue clouds pierced with red streaks of lightnng to create the make-belief world of thunder and rain clouds over a land of parched sand. It contains a royal canopy and a huge wall painting showing Sardar Singh amid royal splendour. The costume and jewellery worn by the ruler and his chiefs has been painted in full glory. Next to the Badal Mahal is the most lavishly ornamented small *darbar* hall-Anup Mahal, built by Surat Singh (1787-1828 CE). It functioned as the Diwan-i-Khas or hall for special audience. The walls and the ceiling at the Anup Mahal are covered with scarlet and gold Persian motifs, exquistite mirror-work and inlaid coloured glass. The royal throne is a low cushioned seat in matching colours, set behind slender columns. It is a hall of opulence and splendour. The deep colours of the magnificent carpet are echoed at every corner in the hall which is the most splendid section of the Bikaner fort.

The palaces in the Bikaner fort are not isolated structures but a continuous mass of buildings. In fact, most of these palaces are inter-connected by *jali*-covered galleries. It was demanded of the architecture to overcome or reduce the oppression of the heat and glare of the sun besides providing privacy to the queens, Phool Mahal and Mahal are two lavishly ornamented sets of apartments. The details of murals depicting flowers and mini-images of deities have been executed with a consummate skill, creating the effect of *pietra-dura* on the smooth lime plaster. The narrow galleries opening towards the southern flank of the palaces and the vast courtyard are covered with *jalis* and multi-coloured glass. Off course, these features cannot match the grandeur of marble *jalis* and *pietra dura* ornamentation of the Mughal palaces. Chandra Mahal contains a small bed supposedly used by Rao Bika himself. Bika's grand father Rao Raidmal was

From left:
Interior of Phool Mahal;
Gajner Mahal

murdered in Chittaur, having been tied to his bed by killers hiding under it. To prevent recurrence of any such misfortune, Bika built a bed too small for his size. It is a piece of curiosity for visitors today in that it reflects upon the conspiracies and intrigues against the ruler within his own palace.

The Gaj Mandir, built in the 18th century is a set of five rooms, the central chamber on a level raised by three feet, approached by a small flight of steps. The other four rooms are at a lower level. This is a rather unusual arrangement of rooms in the palace. The Sheesh Mahal is a room decorated with glass panels. The Krishna Lila scenes depicted on the lacquered doors are very charming. The Gaj Mandir also contains a splendid swing seat generally used for the worship of Krishna as a child. It is the only perfect example of a swing with a gorgeous finish.

Chattar Mahal, on the uppermost terrace of the fort, was built by Maharaja Dungar Singh (1827-87 CE). This roof top pavilion is a small bedroom. The absolutely charming Krishna Lila scenes painted on the walls depict the blue god dancing with *gopis* or the cowherd girls. The whole ceiling is covered with a million flowers in the Persian carpet style. A huge *punkah* (suspended fan) with peacock motifs hangs from the ceiling over the single bed. It is a rare example of an exclusively male bed room. The decoration in scarlet and red adds to the magnificent splendour of the chamber. At night it must be the coolest room in the fort but it must have been most zealously guarded, much more so for its isolated location at the top of all other palaces.

The Lalgarh palace, specially built for Maharaja Ganga Singh by Sir Swinton Jacob, stands amidst sprawling lawns and gardens at some four kilometer distance from the Junagarh fort. One fourth of the palace is used by descendants of the erstwhile Maharaja; the rest of it is occupied by a five-star hotel. It is a grand palace with modern architectural features like grand reception halls and open wide galleries while retaining the essential features of Rajput archtitecture- cupolas, pillars, balconies, *jharokhas*, and *jalis*. The library has rare photographs and trophies on display. The Anup Singh library has the rarest collection of manuscripts in Sanskrit saved by Anup Singh during his siege of Golconda and Bijapur in 1687 CE, then campaigning for Aurangzeb.

The cenotaphs of the Bikaner rulers stand in a group at the Devi Kund Sagar. Also worth a visit is the palace at Gajner, 32 km from Bikaner. It a small oasis in the sandy scrub land around Bikaner.

Clockwise from left:
Lalgarh palace; Royal armour and display of arms at the Ganga Museum

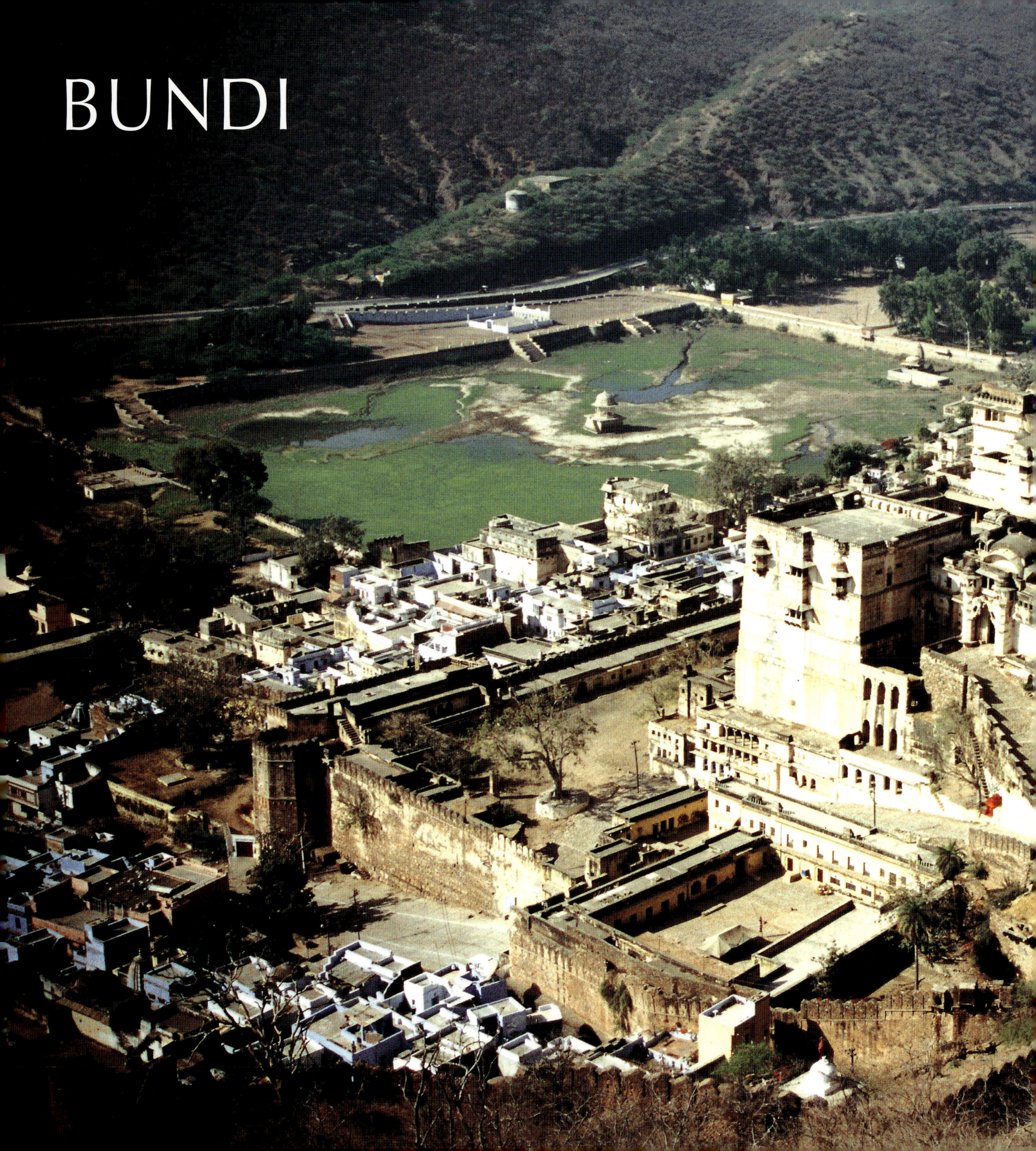

BUNDI

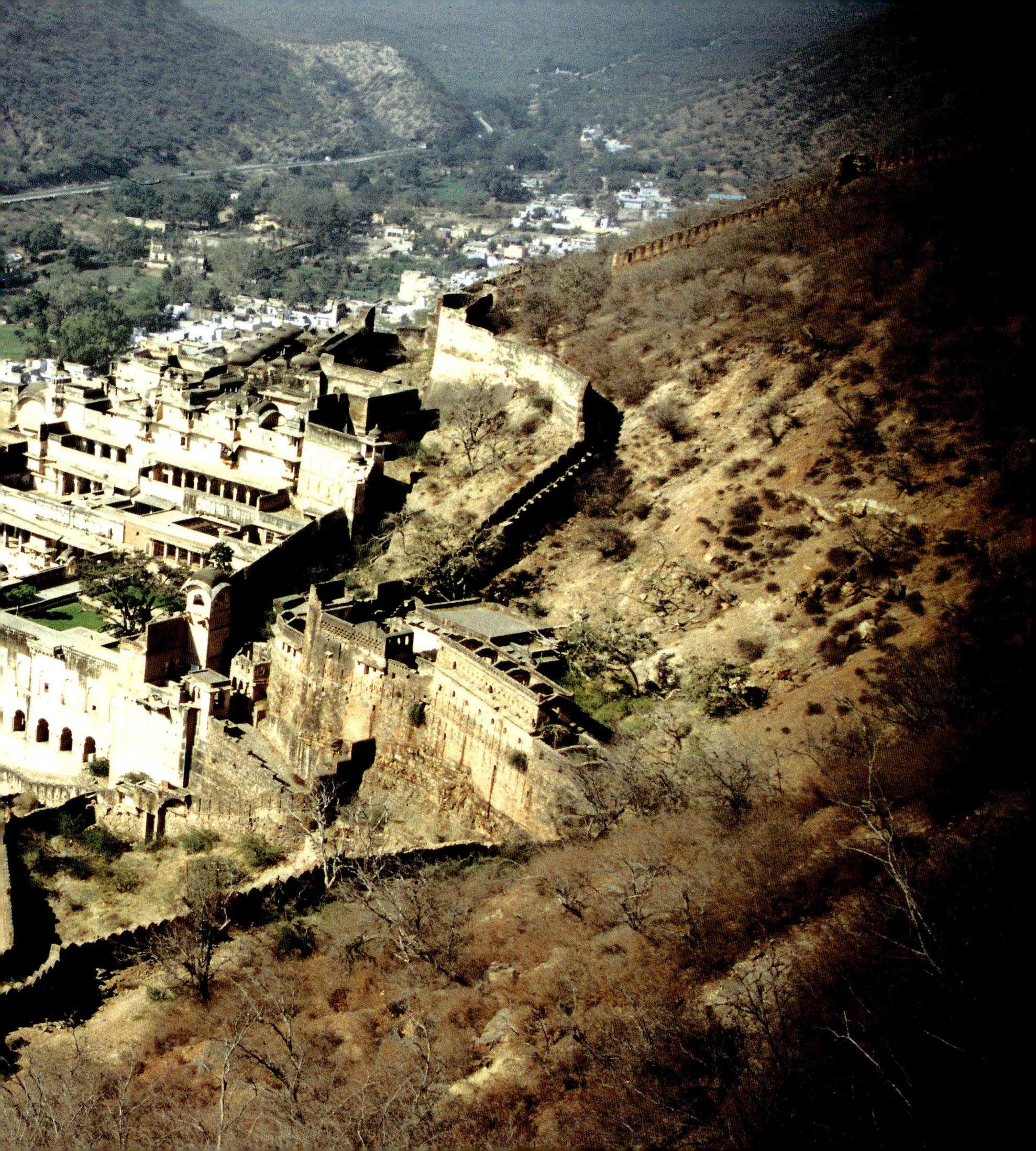

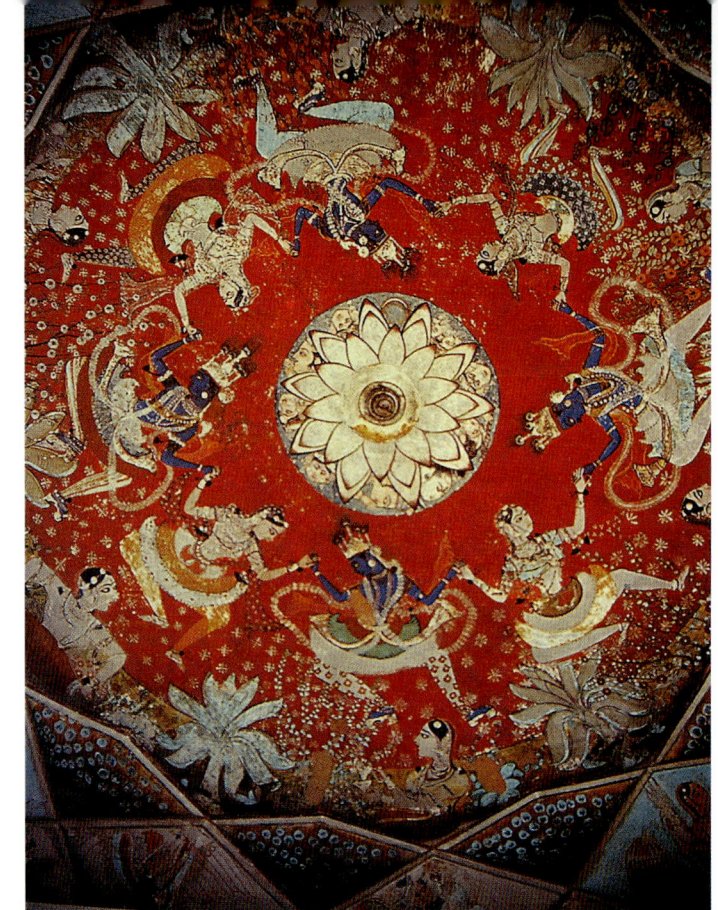

Bundi, along with Kota, is the heart of the Hadoti region-garden of the Hada Chauhan rulers. It was in 1342 CE that Rao Deva Singh conquered the territory from the Mina tribes and founded the small state, independent of the Mewar rulers. The narrow passage between hills meant bindo or bandonal in the local dialect. It came to be called Bundi. This happened centuries ago. Bundi still retains its quintessentially medieval character, unaffected by fast spreading tourism in other parts of Rajasthan. In fact it is supremely beautiful and unspoilt,"a veritable virgin among Rajput cities", observed Philip Ward, a frequent visitor to Bundi.

The Bundi hillscape is dominated by the star-shaped Taragarh fort sprawling across the top of the 500 ft high hill. It was built in 1354 CE and contained a few palaces. The fort today contains derelict structures- abandoned ruinous palaces and three or four reservoirs. The Bhim Burj is a mighty bastion, worth a climb for the famous canon Garbh Ganjam. Completed by Rao Bir Singh, the Taragarh fort is believed to have a vast network of subterranian tunnels and passages connected to the palace below and a few escape routes for use in emergency. You may lose your way in the thick shrubs and wild vegetation growing between the palaces at the western end and the Bhim Burj and a cenotaph at the eastern corner. Moving along the battlemented walls girdling the huge area, you might chance to have some stunning views of Bundi- the stupendous Garh Palace, lakes and spectacular township nestling between the hills and distant views of the unspoilt Hadoti countryside. The views are certainly worth the adventurous uphill climb to the fort.

No other fort palace in Rajasthan owes its grandeur to the natural setting so much as the Garh Palce in Bundi, the jewel of Hadoti. From a distance the full view of the palace is the most perfect. Kipling in 1899 CE wrote: "the Palace of Boondi, even in broad daylight is such a palace as men build for themselves in uneasy dreams-the work of goblins more than the work of men. It is built into and out of the hill side, in a gigantic terrace upon terrace structure which dominates the whole of the city. No one knows where the hill begins and where the palace ends. The dominant impression was of height; height that heaved itself out of the hillside and weighed upon the eyelids of the beholder. The steep slope of the land had helped the builders in securing this effect."

The great pile of palaces appears in varying aspects depending on your viewpoint. From the lakeside it is sheer walls with tremendous heights topped with charming balconies and kiosks. As you stand below the entrance gateway the palaces stand concealed from view completely. A full view of different terraces, courtyard and pavilions in perfect perspective is achieved only from the ramparts of Taragarh.

Today visitors have to pass through the Hazari Pol, near the ticket window. From this point starts the ascent on the steep ramp paved with small rounded stones, smoothened by centuries of traffic-soldiers, courtiers, royal elephants and horses. Today visitors can be observed huffing and puffing their way to the Hathi Pol, balancing their steps on the treacherous stones. The Hathi Pol is noteworthy chiefly for the statues of two garishly painted elephants with interlocked trunks over the semi-octagonal towers. You enter Nathana ka Chowk where the nine steeds of the ruler used to be stalled and people assembled below the royal seat built by Rattan Singh during 1607 and 1631 CE. This hall where the ministers and nobles met the rulers has little decoration.

A small doorway to the east of the marble throne leads into a court with a marble pool. To the right is Hathishala, a hall noted chiefly for its slender columns with corbel capitals incorporating small models of four elephants on each column. Facing it, across the court, is Chattar Mahal, built by the most reputed Bundi ruler-Chattar Sal who was Shahjahan's most trusted general and fought with Dara against Aurangzeb in the battle for succession. The front hall has twelve sided coupled columns. Behind it lies the royal apartment. The central hall is a long rectangular chamber with marvelous murals. It is however the small room on the southern side which is a veritable treasure of gorgeous Bundi murals depicting palace scenes, royal processions, festivities, assembly of nobles etc. For murals, in this small room alone Bundi's claim as the art capital of Rajasthan is amply justified. There is a generous use of blue, green, maroon, black and red on the murals to create an unparalleled grandeur.

Not many sections of the palace are open to public but the Chitra Shali, another gallery of murals, is approachable only through a climb up another treacherous ramp from outside the Hathi Pol. It was built by Rao Raja Umed Singh (1739-70 CE). The most enchanting and glorious murals are painted on three sides of a verandah enclosing a small open quadrangle. Ras Leela secnes depicting episodes from Krishna's life are painted predominantly in green and blues. Most noteworthy are water-birds, lotuses, peacocks, plaintains and ducks included in artistic compositions illustrating Bundi's rich vegetation. Women playing chess, waiting for the lover, lost in self admiration, scenes of worship and royal processions are other subjects appearing in the murals. The two small rooms remain permanently in the dark giving no clue of the murals inside. The picture gallery overlooks a Mughal style terrace garden and spectacular views of the city lying below the ramparts.

The female sections of the palace are closed to the visitors. The two lakes Nawal Sagar and Jait Sagar are the source of water to the town and splendour of Bundi. Sukh Niwas, a pleasure pavilion built by Rao Raja Bishen Singh in 1773 CE, is an exquisite structure on the Jait Sagar. It is a pity now it houses some offices, hence closed to visitors.

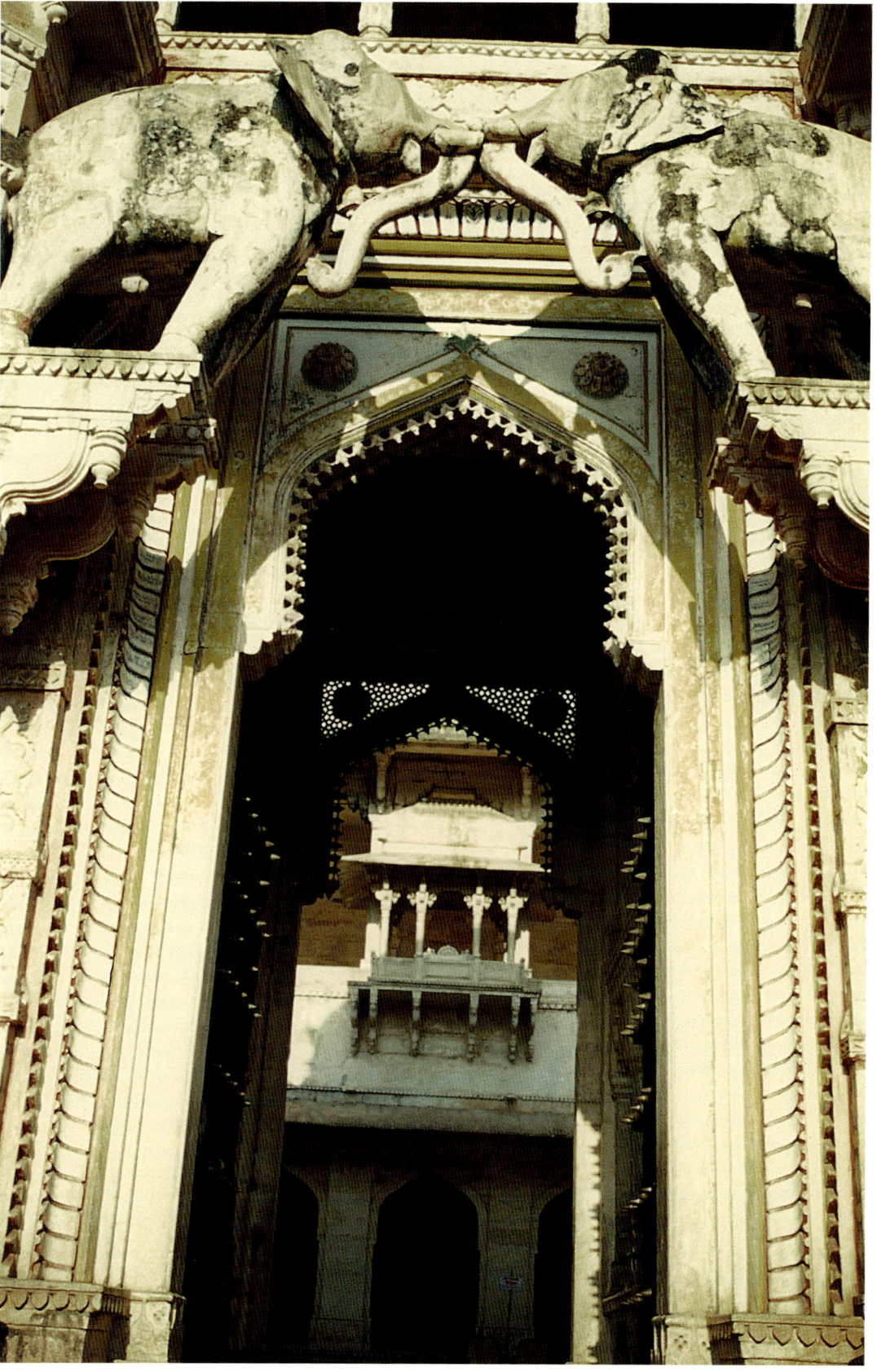

Previous pages:
Garh Palace Bundi

Clockwise from above:
Hathi Pol, main entrance to the palace;
Royal seat in the council hall; Floral
detail from the ceiling; Ceiling depicting
Krishna's Ras Lila dance

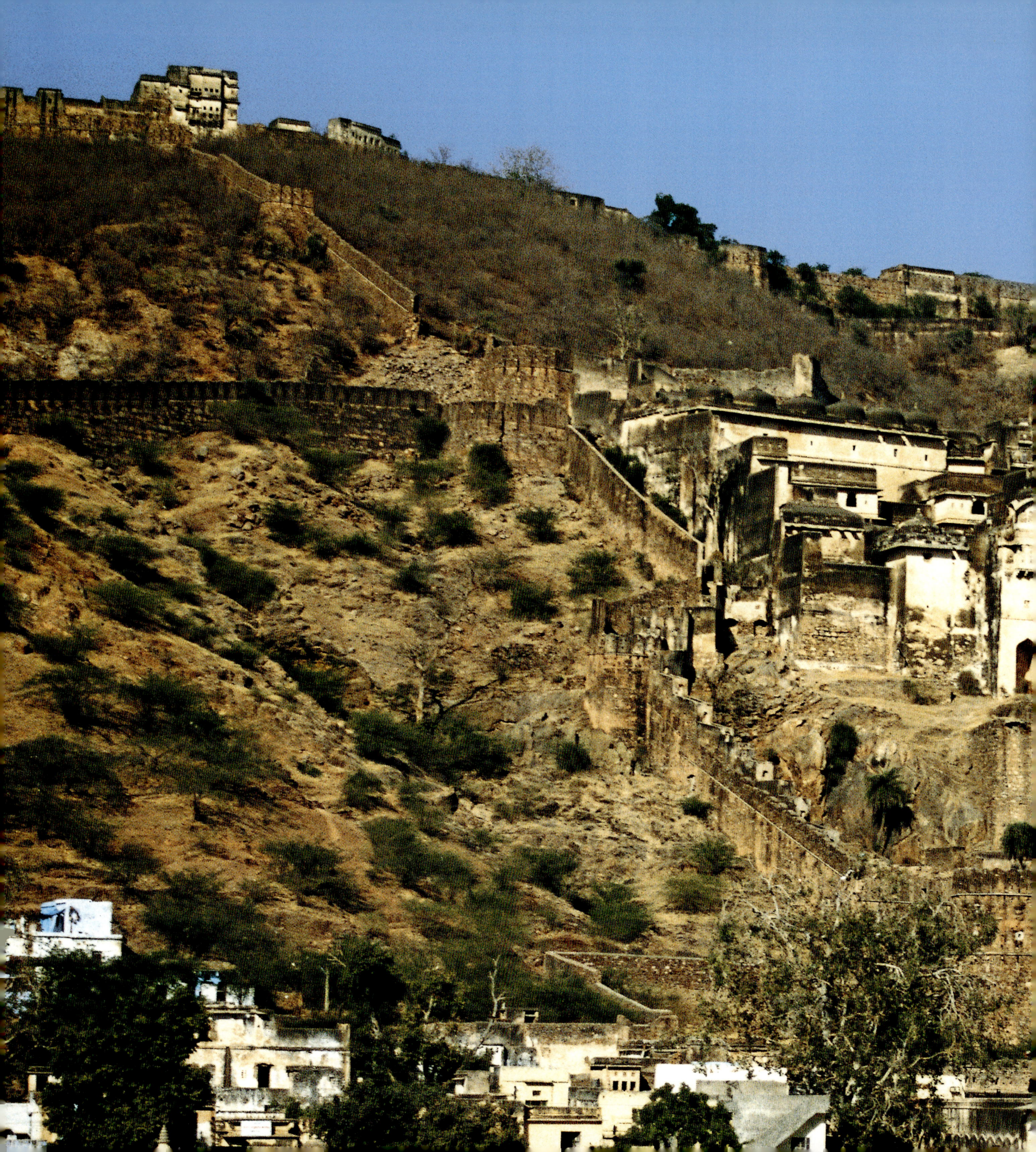

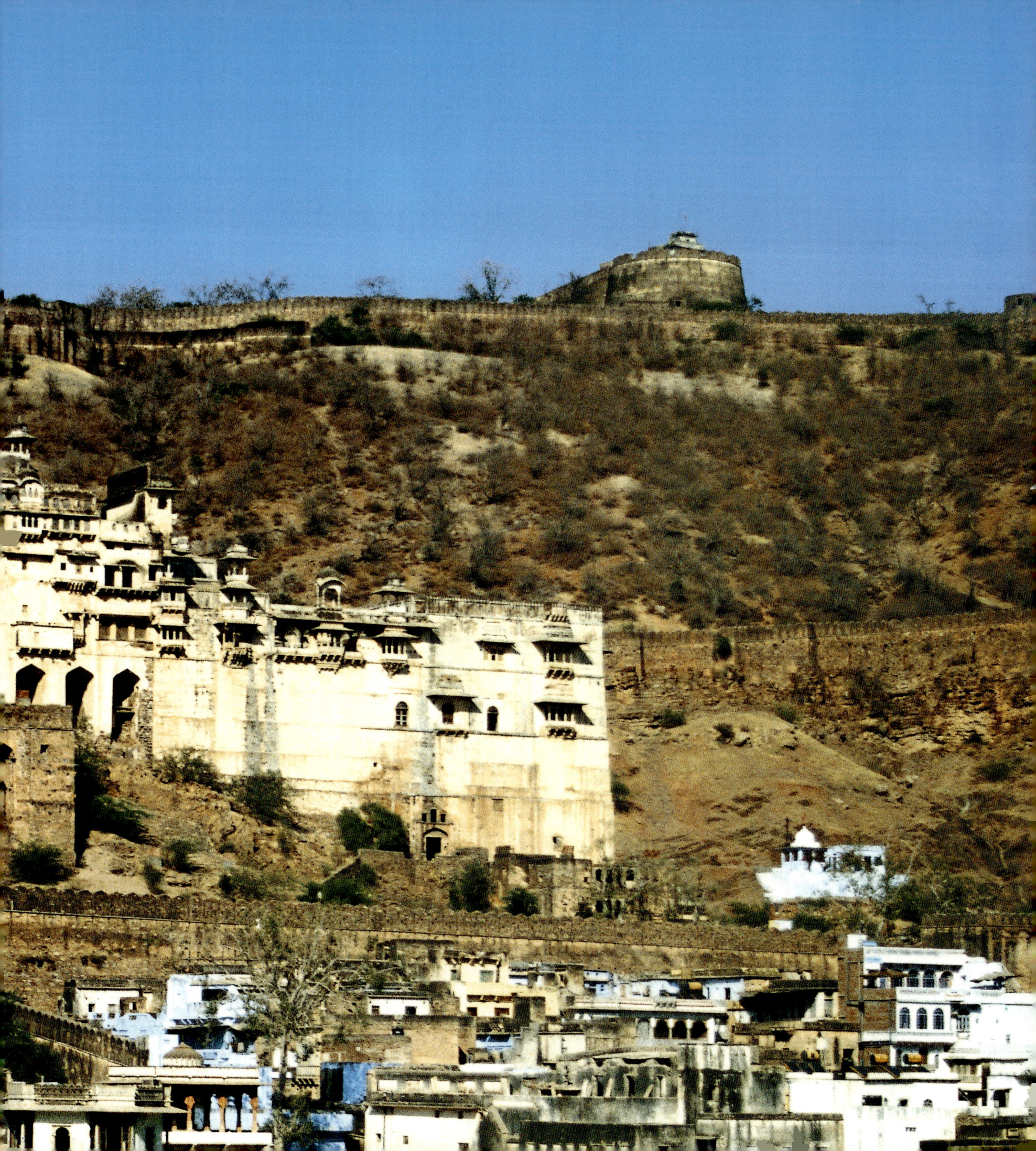

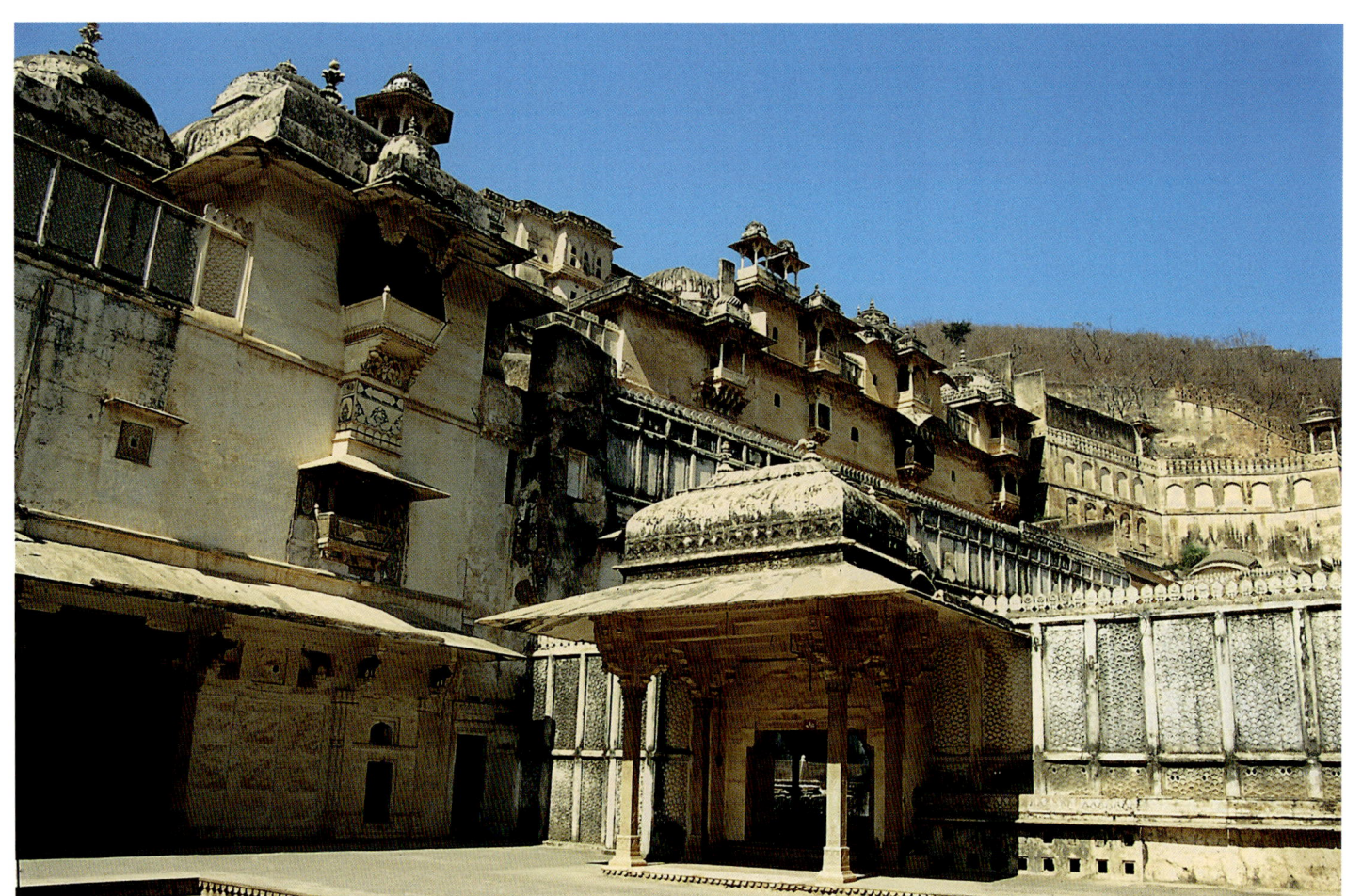

Previous pages:
Garh palace, below the Taragarh fort on the hilltop
Clockwise from far left:
Court in front of the Chattar Mahal;
Derelict palaces in the Taragarh fort

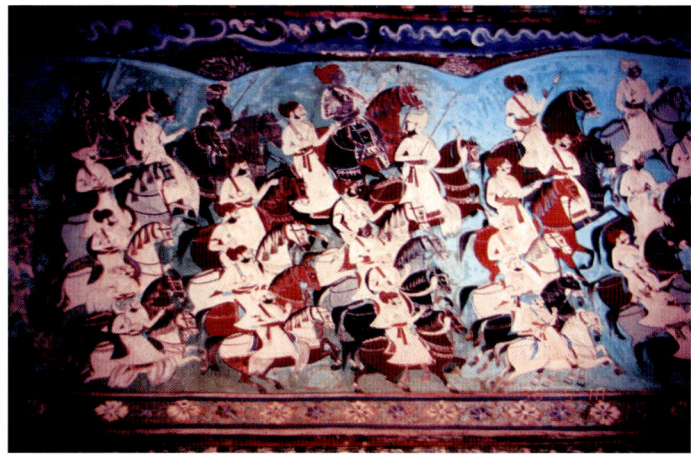
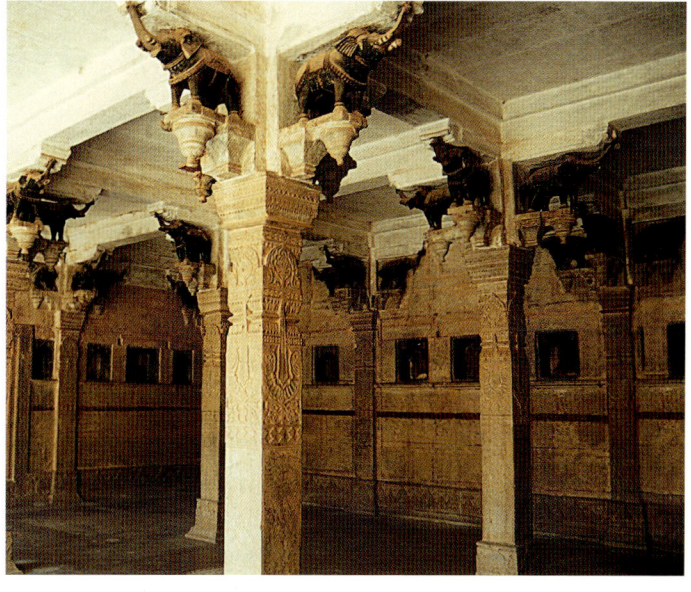

The Rani ki Baoli, the stepwell built by Rani Nathawati ji in 1700 CE is a splendid structure with graceful toranas (multi-lobed arches) and small elephant statues. The structure has a certain ornate quality absent from palace structures. The 84 pillar chattri (cenotaph) built by Dhaibhai Devji in 1683 CE is an imposing structure into a place of worship. The small garden surrounding it and a stately flight of steps to the chattri adds great dignity to the structure.

Clockwise from far left:
Painting of valiant soldiers marching; Hathi Shala, known for the elephant sculptures on the pillar capitals; Miniature depicting a lonesome beauty; Krishna with his Gopis; Chitrashali, an eldorado of Hadoti murals

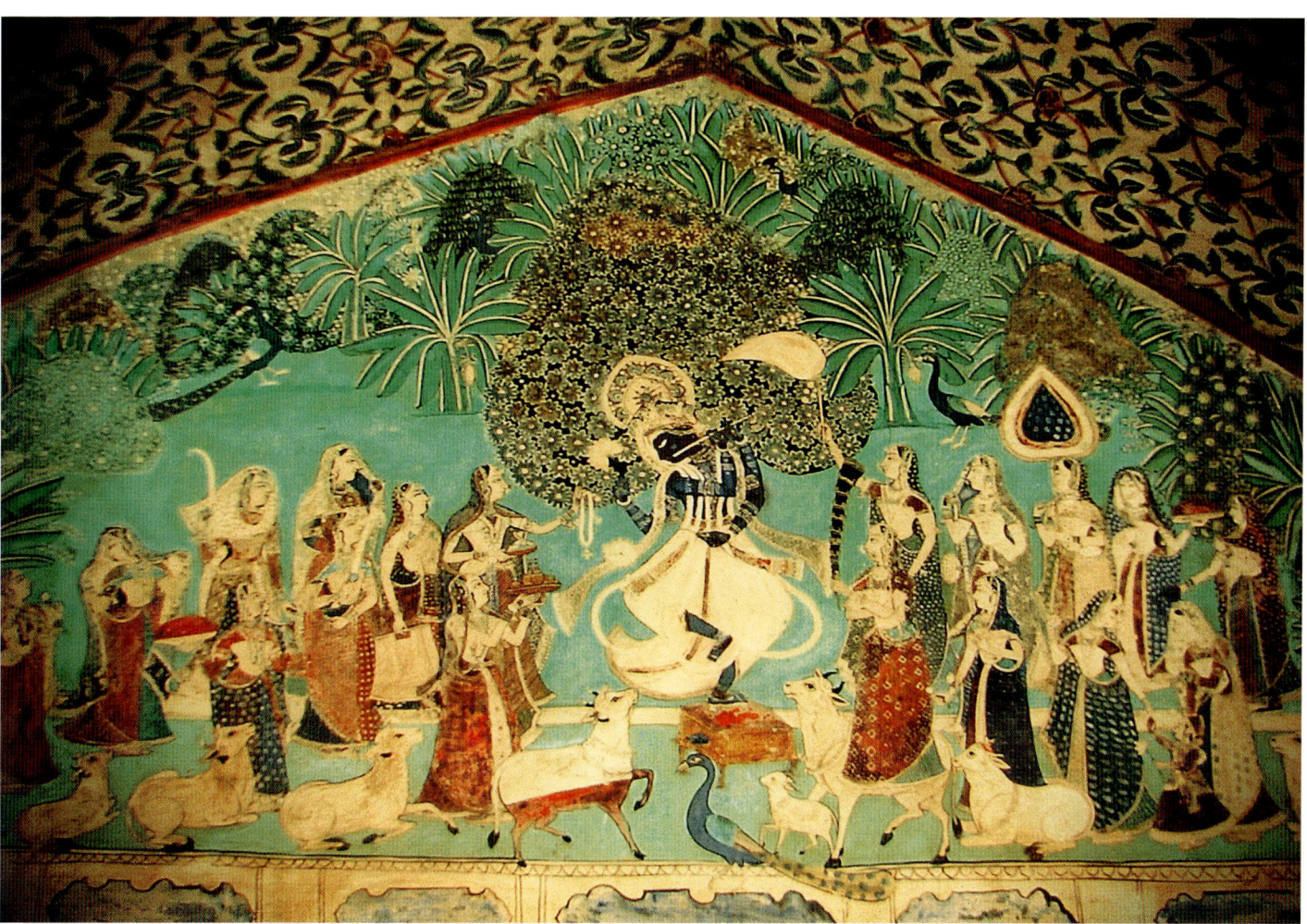

Kota was carved out of the Bundi state in 1624 CE when the Bundi ruler gifted it to his son Rao Madho Singh. Rao Madho lost five sons fighting against Aurangzeb and the sixth son narrowly escaped the same fate despite multiple injuries. Kota, however, never enjoyed peaceful relations with Mewar and Jaipur. Even the later rulers of the parent state of Bundi remained hostile towards Kota. It was only in the early 19th century CE during Zalim Singh's astute Regentship that Kota got a shrewd administrator. Zalim Singh signed a treaty with the British and successfully bargained for a piece of the Kota state for his own successors. Thus, the state of Jhalwad was created in 1838. Together, Bundi, Kota and Jhalawad form the core of the Hadoti region. The city of Kota (originally called Kotha) was built around 1364 CE when Jait Singh of Bundi slew Koteya, a Bhil chief. It is popularly believed that the Bhil's severed head was laid in the foundation of the Kota fort. A small shrine dedicated to Koteya still exists near the Gazi Gate.

Raj Mahal or the City Palce holds the key to Kota's cultural and architectural heritage. The core structure was enlarged by various rulers at different times creating a medley of architectural styles and an utter lack of uniformity in the scheme of palace structure. Mammoth bastions, ramparts, overhanging balconies, cupolas, balustrades and forms of ornamentation betray a striking eclecticism.

The Hathi Pol provides entrance to the Raj Mahal. The stilted pointed central arch was built by Madho Singh (1625-48CE) and the pair of elephants flanking it was added to the structure by Rao Bhim Singh, (1707-20 CE). This magnificent gateway is yet another specimen of the Rajput architecture of power. This gate has been built on a "domestic scale". As it stands today dwarfed in height by the surrounding structure, the Hathi Pol needs more space on both sides to create any powerful impact of royal power and splendour. The façade has a picturesqueness of its own gaining immensely from the spectacular Jaleb Chok lying infront of the

Previous pages:
Grand mural showing a royal procession
Clockwise from right:
Woodwork detail on the gateway;
Royal palaces for the seraglio

118
FORTS AND PALACES OF INDIA

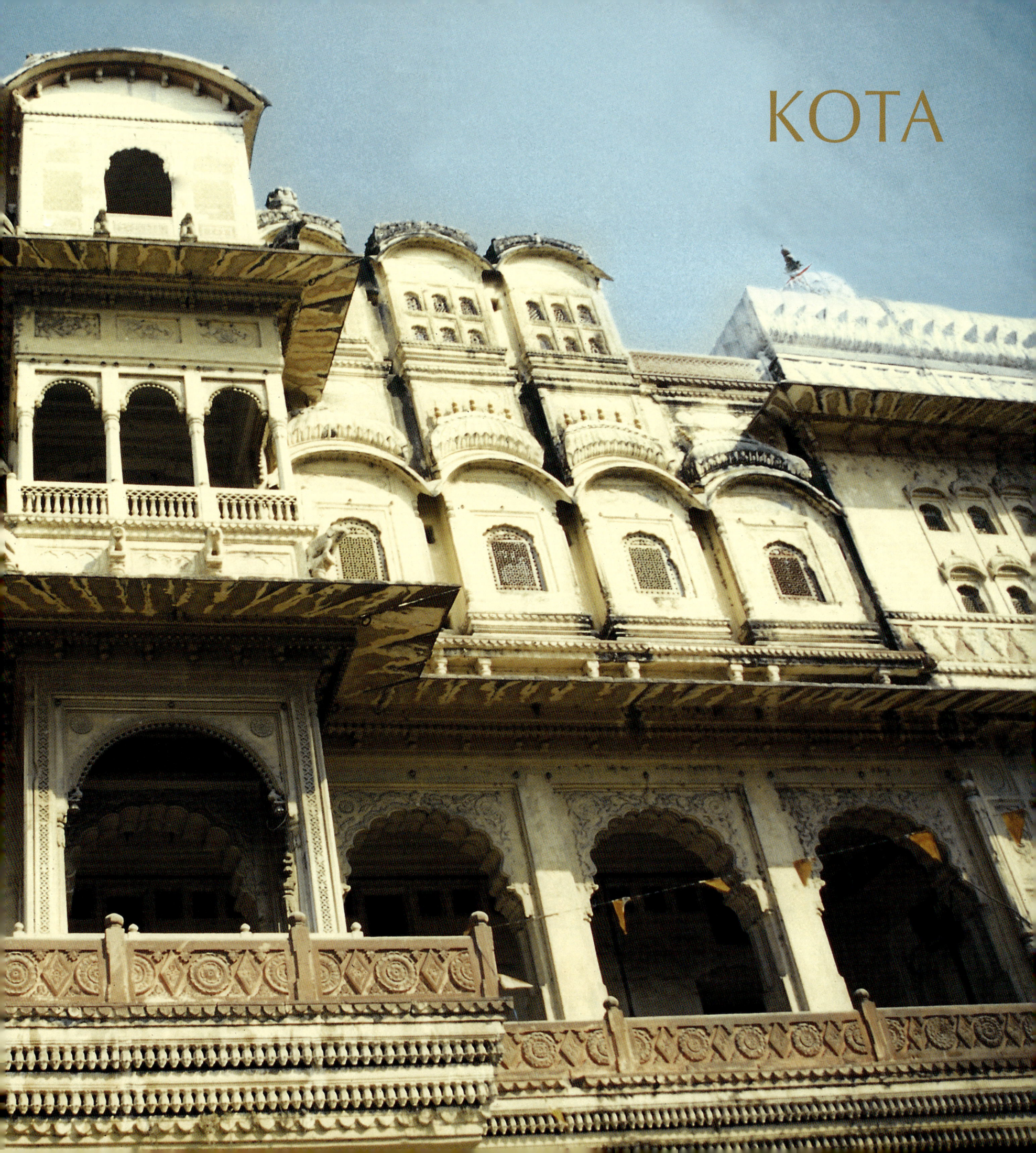

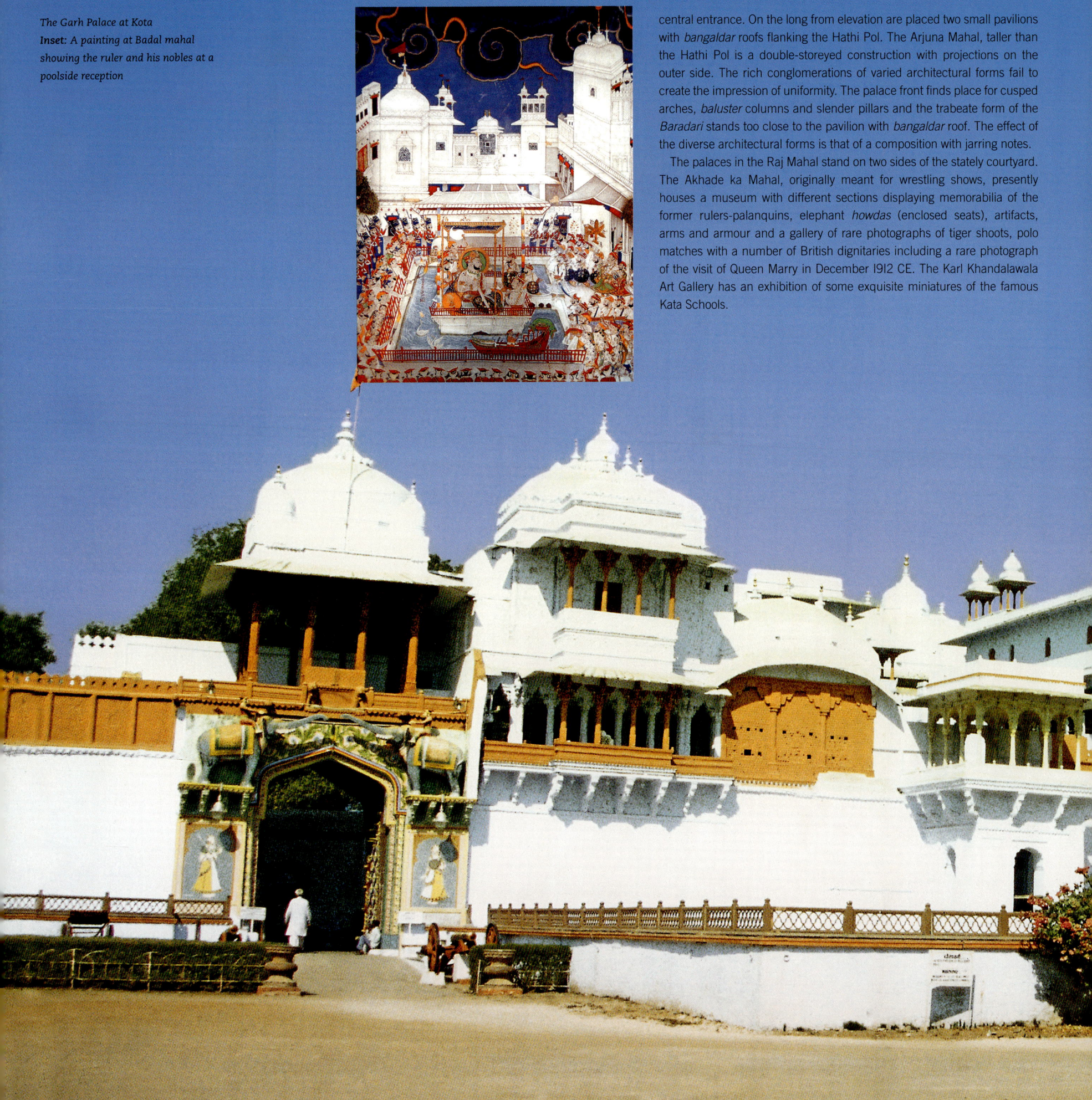

The Garh Palace at Kota
Inset: *A painting at Badal mahal showing the ruler and his nobles at a poolside reception*

central entrance. On the long from elevation are placed two small pavilions with *bangaldar* roofs flanking the Hathi Pol. The Arjuna Mahal, taller than the Hathi Pol is a double-storeyed construction with projections on the outer side. The rich conglomerations of varied architectural forms fail to create the impression of uniformity. The palace front finds place for cusped arches, *baluster* columns and slender pillars and the trabeate form of the *Baradari* stands too close to the pavilion with *bangaldar* roof. The effect of the diverse architectural forms is that of a composition with jarring notes.

The palaces in the Raj Mahal stand on two sides of the stately courtyard. The Akhade ka Mahal, originally meant for wrestling shows, presently houses a museum with different sections displaying memorabilia of the former rulers-palanquins, elephant *howdas* (enclosed seats), artifacts, arms and armour and a gallery of rare photographs of tiger shoots, polo matches with a number of British dignitaries including a rare photograph of the visit of Queen Marry in December 1912 CE. The Karl Khandalawala Art Gallery has an exhibition of some exquisite miniatures of the famous Kata Schools.

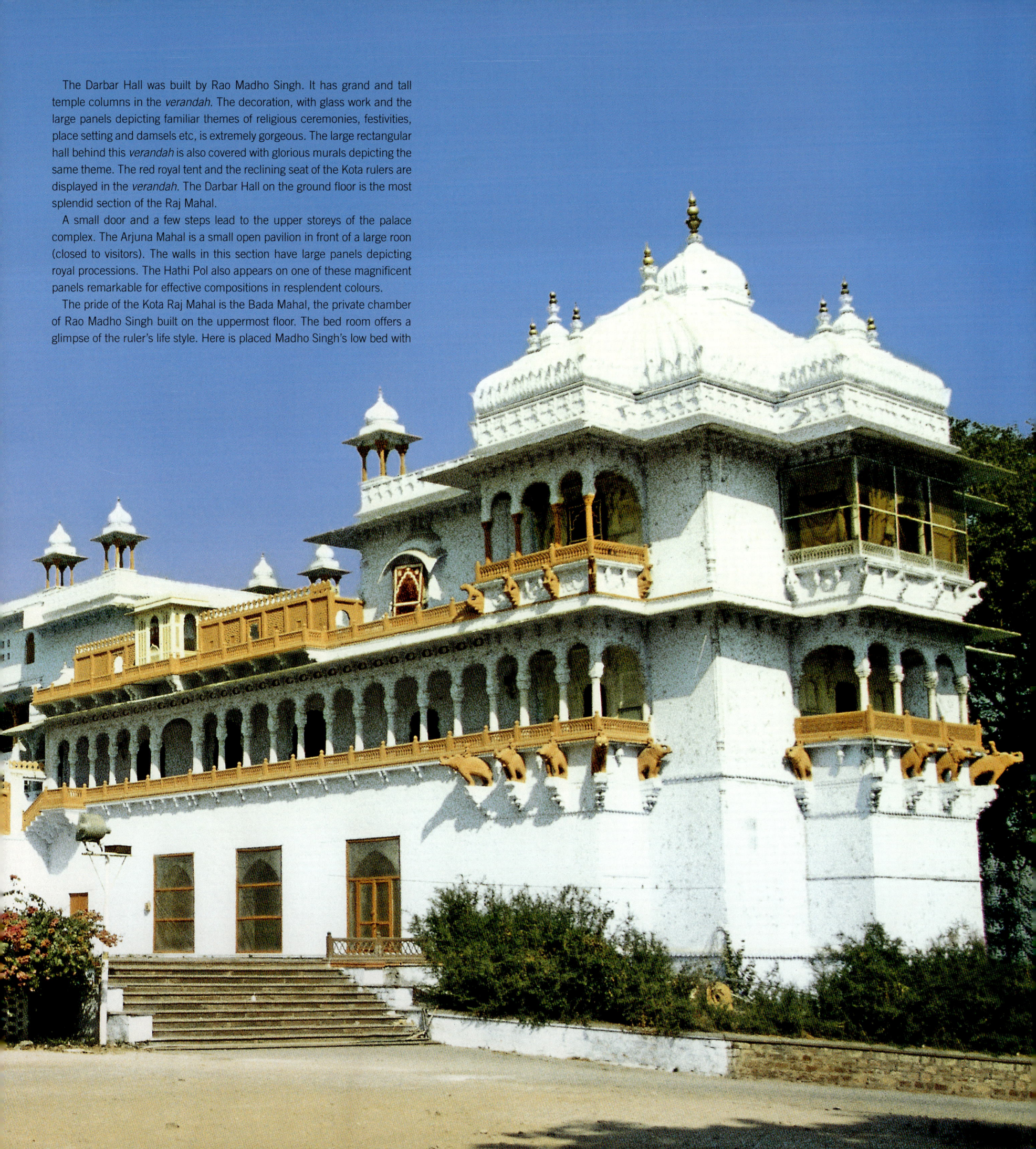

The Darbar Hall was built by Rao Madho Singh. It has grand and tall temple columns in the *verandah*. The decoration, with glass work and the large panels depicting familiar themes of religious ceremonies, festivities, place setting and damsels etc, is extremely gorgeous. The large rectangular hall behind this *verandah* is also covered with glorious murals depicting the same theme. The red royal tent and the reclining seat of the Kota rulers are displayed in the *verandah*. The Darbar Hall on the ground floor is the most splendid section of the Raj Mahal.

A small door and a few steps lead to the upper storeys of the palace complex. The Arjuna Mahal is a small open pavilion in front of a large roon (closed to visitors). The walls in this section have large panels depicting royal processions. The Hathi Pol also appears on one of these magnificent panels remarkable for effective compositions in resplendent colours.

The pride of the Kota Raj Mahal is the Bada Mahal, the private chamber of Rao Madho Singh built on the uppermost floor. The bed room offers a glimpse of the ruler's life style. Here is placed Madho Singh's low bed with

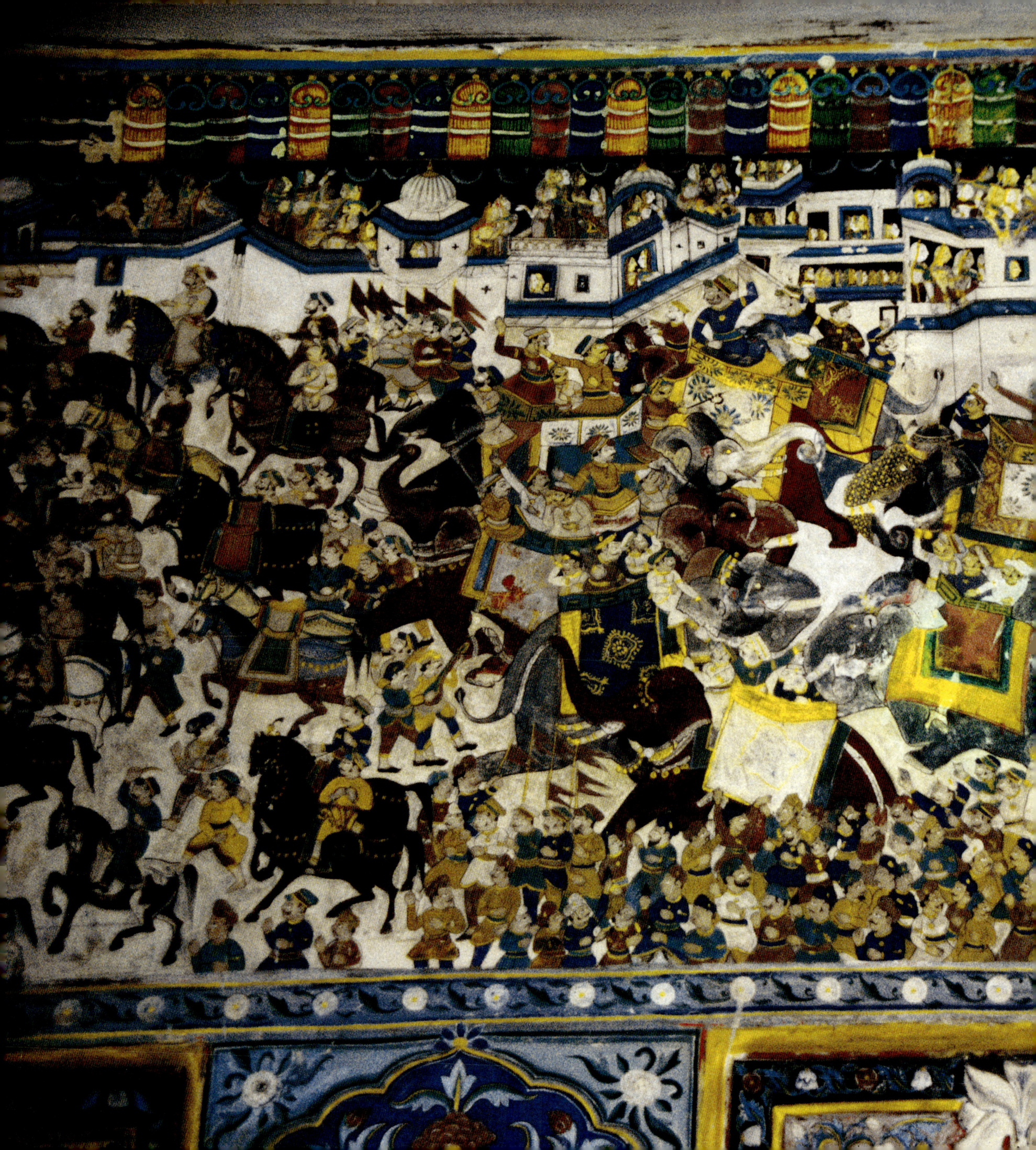

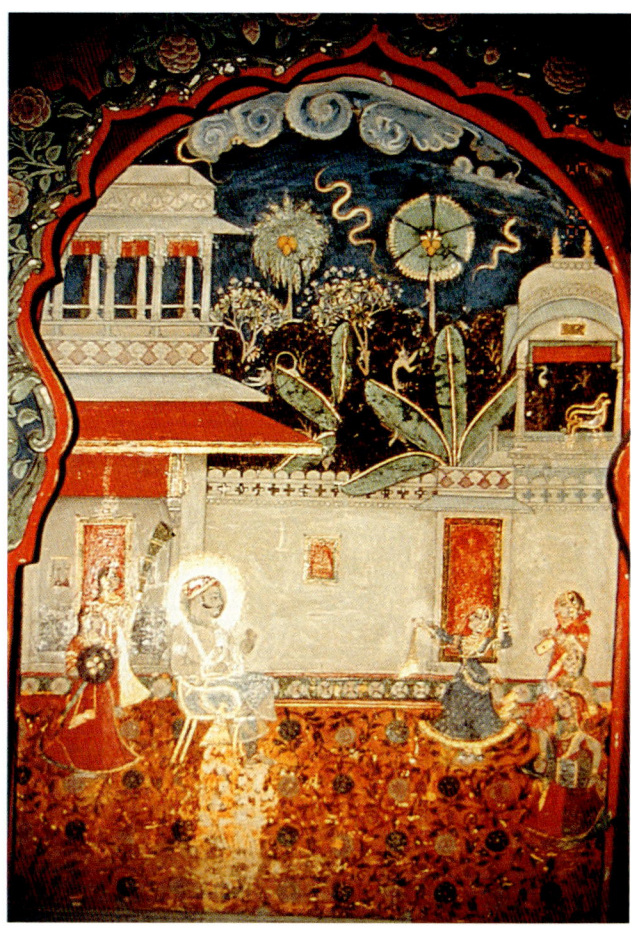
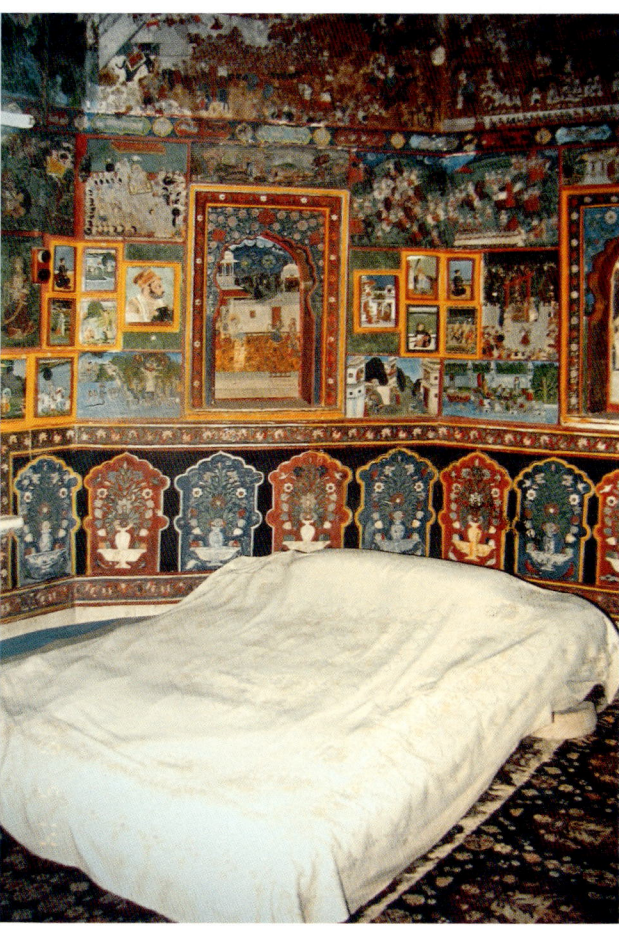

KOTA

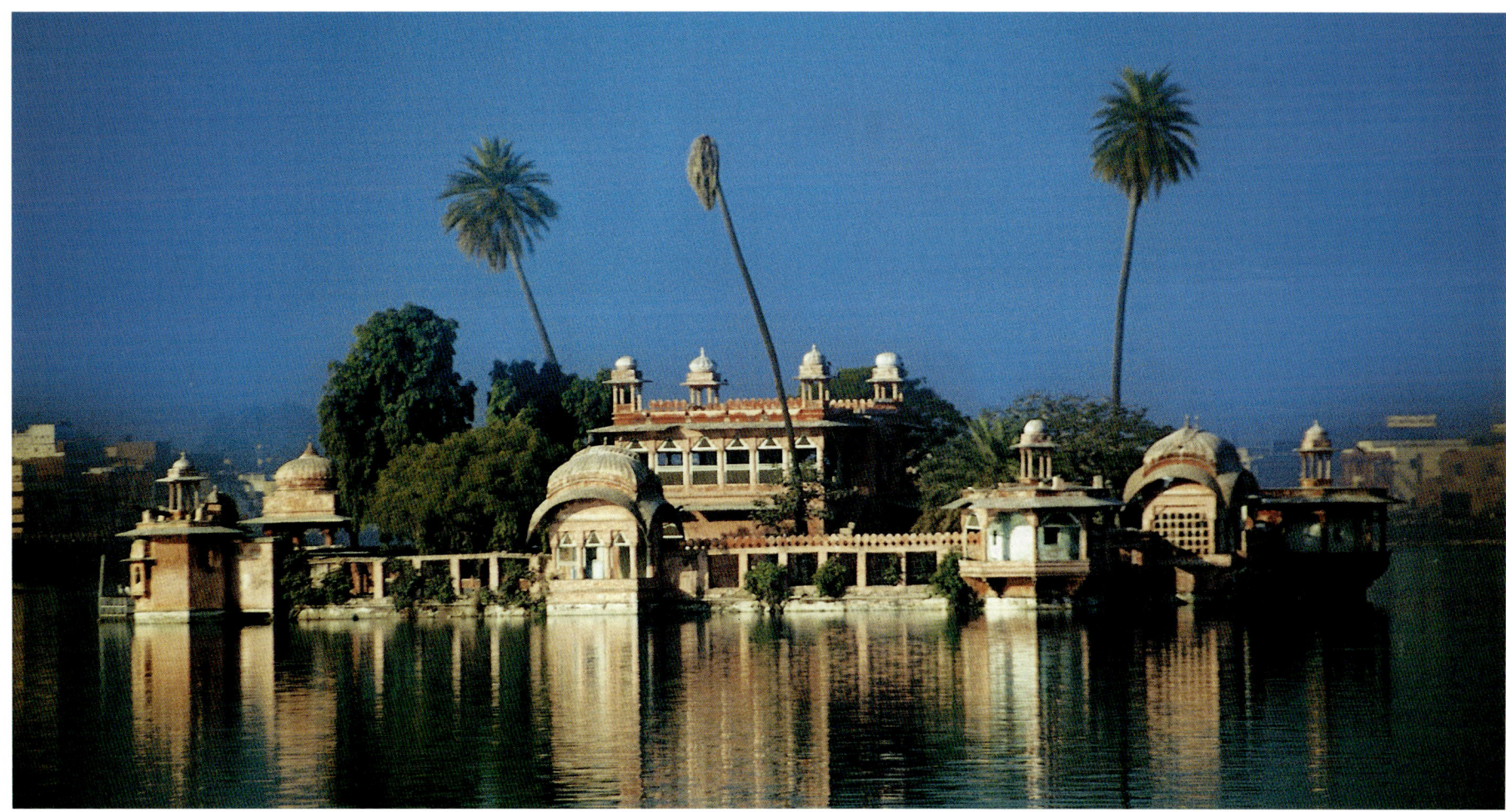

its white pillows and bolsters. The ceiling has been painted in gorgeous red. A small balcony window admits light to the interior. Architecturally, the Bada Mahal is a simple structure a small rectangular room with a verandah on the front opening into a lovely courtyard with a *jharokha* admitting view of the Chambal river and its environs. A seat for the ruler created the ambience required for evening entertainments. It also provides view over the Jaleb Chowk below. The Bada Mahal is an eldorado of wall paintings executed in the Kota style. The inner chamber has large panels depicting spectacular architectural settings, gardens, hunting scenes, processions and enchanting beauties. The *verandah* is similarly decorated with grand panels, small paintings on paper mounted in small frames, niches containing excellent paintings framed within borders painted in bright colours. Despite the effect of the moisture-laden winds from the Chambal, the wall paintings at the Bada Mahal present the most glorious exhibition of art in Rajasthan. The Kota School of painting is known internationally for its vivid depiction of hunting and wildlife.

Many sections in the Raj Mahal are closed to visitors but at every turn the need for better maintenance manifests itself. The small *Baradari* and an open pillared hall opening towards the Jaleb Chowk are elegant structures. From the *baradari*, the view of the Jantar Burj (Zodiac Bastion) is particularly splendid. The *Baradari* is an independent structure with cusped arches supported on *baluster* columns. The balustrade overhanging the basement is upheld by powerful curved brackets. This *Baradari* was used by the ruler for making appearance before the public on ceremonial occasions. The Bhim Mahal was built in the 18th century CE at the northern end of the palace front, projecting eastward. It adds a new dimension to the architectural scheme. A large Darbar hall on the first floor has a lateral arcade of cusped arches. This long line of arches adds immense picturesqueness to the exterior.

The women's section or the *zenana* stands apart from the male quarters. It forms the southern extension of the Raj Mahal complex. The projecting bays and the small arched windows covered with trellis screens create a homogenous but monotonous façade. There is, however, more openness toward the garden on its rear side. The most important addition to the palace was made by Umed Singh who built the Hawa Mahal. It stands high over the southern end of the outer gateway, far away from the Hathi Pol and the Raj Mahal. The outer gateway is itself built as a pile of open pillared pavilions. The Hawa Mahal is a multi-storeyed set of pavilion with screened windows and angled eaves surmounted by domed pavilions with screened window and angled eaves surmounted by a domed pavilion. It is nothing particularly remarkable except that it served well its purpose as a retreat from the intense heat.

The Jag Mandir, also built as a summer palace on the Kishore Sagar, is an enchanting small place. It is a quintessentially romantic structure in the midst of natural charms abundantly supplied by the blue waters and greenery all around. Colonel Tod described it as "a little fairy islet with its light saracenic abode". It was built in 1740 CE by Maharani Brij Kunwar, a princess from Mewar. The Jag Mandir recreates a minor replica of the enchanting Jag Niwas Palace in Kota on the Lake Pichola in Udaipur. Sadly, of the original seven palm trees only three have survived to this day.

Previous pages:
Painted splendour of the ruler's private apartments; A miniature with the famous Kota Kalam in an alcove; The royal bedroom

This page, from left:
Palaces near the Chambal river;
Jag Mandir, lake palace on the Kishore Sagar

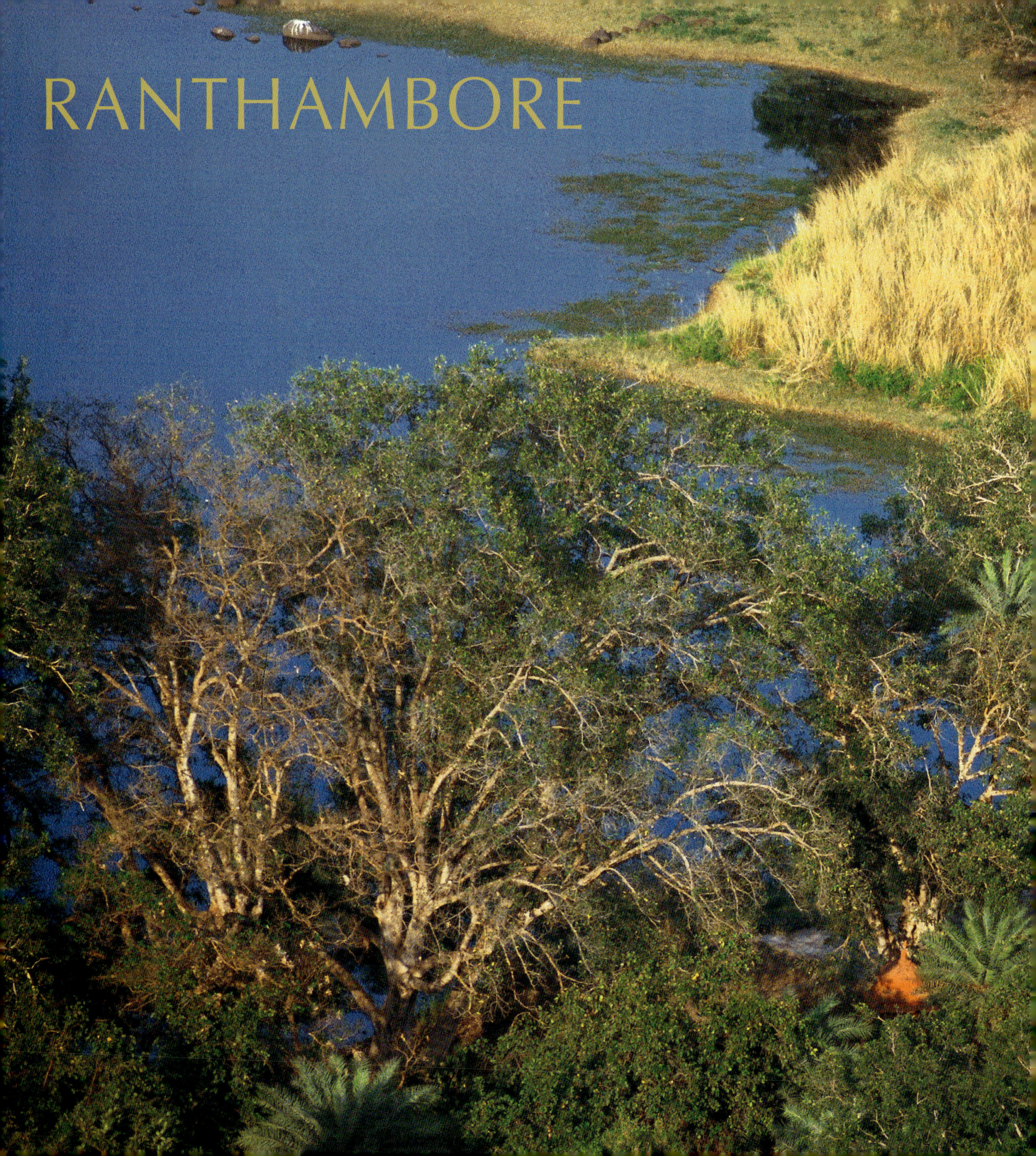
RANTHAMBORE

The most fascinating thing about Ranthambore, "one of the strongest forts of the inhabited world", as the Mughal emperor Jehangir called it, is the tremendous natural splendour surrounding the great hills. The dense forests, chasms, gorges and defiles around the base of the fort provide a natural defence far more effective than the walls raised by man. Ranthambore is the best example of a forest fort or *vana durg*. The stupendous battlemented ramparts rising over the 200 feet high granite hill remain, when viewed from the level ground, half hidden from the eye. Extremely thick and rich vegetation holds a curtain before the eager onlooker. The inaccessibility of the terrain and the sheer precipices of the hill are too daunting even today. One thousand years back or more when the fort was being built, an extremely steep climb was the only way up. The stone steps cut into the granite hill are comparatively modern. The Ranthambore fort, in district Sawai Madhopur (Rajasthan), covers an area of nearly seven kilometers, 1578 feet above sea level.

Ranthambore is believed to have been built between the 5th and 7th centuries CE. There are some conjectures regarding this: 1. It was built by King Jay in the 5th century CE; 2. It was Raja Jaita who built the fort with the help of Min and Bhil tribes in the 8th century CE; 3. Gaur Rajputs who held Ranthambore before the Chauhanas in the 11-12th centuries CE built it; 4. The Chauhana ruler Ranthamban Dev of Sapaldaksha built Ranthambore in c. 944 CE. It is generally agreed that the Chauhanas who were the most powerful rulers in the region alone could have undertaken such a stupendous architectural project. An inscription in the Jain temple in the fort mentions a queen of Prithviraja III who offered a gold finial at this temple in 1161 CE. The political and strategic importance of the Ranthambore fort was realized by all great powers in the region. The Delhi sultans were only too eager to acquire this fort and soon after the establishment of the Sultanate, Ranthambore turned into a fort that the new rulers had to acquire to establish their power.

Previous pages:
Jogi Mahal Ranthambore, now a part of the National Park
Clockwise from below right:
Mughal Army attacking Ranthambore (Akbarnama miniature); Tripolia Gate; The invincible ramparts of the fort overlooking the forest; Steep steps leading inside the fort

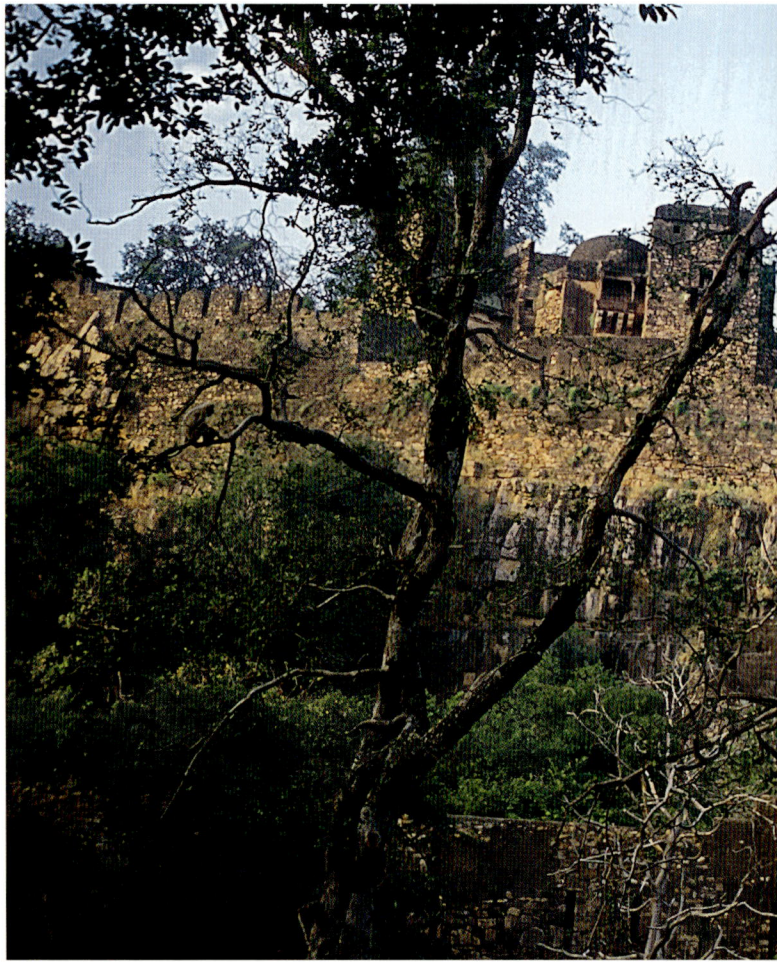

Ranthambore suffered many sieges from the Delhi sultanate rulers- Qutbuddin Aibak (1209 CE), Iltutmish (1226 CE), Razia Begham (1236 CE), Balban (1249 CE), Jalaluddin Firoz Khilji (1290 CE), Alauddin Khilji (1301 CE), Md. Khilji of Malwa (1489 CE), Bahadur Shah of Gujarat (1530 CE), Sher Shah Suri (1542 CE), and finally Akbar (1568-69 CE). The fort was held by the Mughals till the 18th century CE when Shah Alam, apprehending Maratha invasion, handed it over to Madho Singh of Amber for protection.

The Ranthambore fort today contains only a few ruins of palaces and temples, derelict mosques and a *dargah*, huge tanks and gigantic ramparts. The various sieges account for the pictures of destruction that one sees at every corner. The first siege by Jalaluddin Firoz Khilji is important for the technique of battle and attack used on the impregnable walls of Ranthambore: "The Sultan decided on siege and from his camp at Jhain issued orders for the construction of the necessary catapults (*maghrabis*), *sabats* and *gargajes* (the uppermost platform over a gradually rising pathway for firing missiles) and the preparation of a *pasheb*. While the work was in progress, Firuz rode out to inspect. But as he looked at the impregnable fort and considered the cost of the assault in terms of the sufferings of his troops, he became sentimental. Refusing to risk 'the hair of a single *Mausalman* for ten such forts', he ordered an immediate withdrawal".

Alauddin Khilji was made of a different mettle. He never allowed sentimentalilty to weaken his determination. His siege of the Ranthmabore fort began with elaborate preparations. He knew he had to succeed: Ranthambore must be conquered. How? It was futile to assault by horse and foot. The garrison shot arrows and *munjaniqs* (artificially rounded stone- larger than a cricket ball and smaller than a football) on the armies below the ramparts, Alauddin decided to construct a *pasheb*, irrespective of its

cost in terms of money or human lives. Ziauddin Barani informs us: "The fort had already been surrounded; after the Sultan's arrival the siege was pressed with greater vigour. Weavers were brought from the surrounding country and the bags sewn by them were distributed among the soldiers. The soldiers filled the bags with earth and threw them into the ditch. Thus with shouts of "Haiy! Haiy!" they laid the foundation of the *pasheb* and the upper part is the *gargaj*. Despite all hindrances Alauddin pushed his way by threatening to demand back three year's wages from each deserter. It was still not easy. Alauddin had for his adversary Hammir, the legendary hero of Ranthambore. When all these Herculian efforts proved useless, Alauddin resorted to strategem. He bribed two close associates of Hammir to relax the vigil over the fort gates at night and let his soldiers into the fort. It was hell with only darkness visible; war cries rented the air as soldiers of Alauddin and Hammir clashed swords and fought their battle. Hammir lost to Alaudddin. Nearly 10000 women, led by the chief queen Ranga Devi, committed *jauhar*, the first of its kind in Rajasthan. Hammir Dev severed his own head at the Shiva shrine. Alauddin put to the sword the two traitors who had betrayed Hammir and also had Muhammad Shah's head crushed under an elephant's foot. Muhammad Shah had earlier helped Alauddin conspire the murder of his uncle Jalaluddin Firoz Khilji but aroused his master's animosity for a suspected affair with a woman of Alauddin's harem. Fearing for his life, he sought refuge with Hammir, who refused to surrender his new friend to Alauddin; an act which enraged the Delhi Sultan who ruthlessly inflicted this catastrophe on Ranthambore. Hammir's bravery, honesty and unflinching steadfastness are celebrated in literary works.

After a lapse of some 250 years, Ranthambore was again subjected to a protected siege by Akbar. He had heavy cannons hauled up the *pashebs* but he relied more on *sabats* (covered passage) to escape detection by the

Clockwise from above:
Ruins of Prithviraj Chauhan's Hammira Palace, the oldest example of Rajput palace architecture, 13 C; Square watch-towers of the fort; Ruins of Badal Mahal

garrison posted on watch at the ramparts. Jahangir wrote in his memories Tuzuk-i-Jahangiri: "There are two hills close to each other. They call one Ran, and the other Thanbur. The fort is built on the top of Thanbur, and, putting these two names together, they have called it Ranthanbur. Although the fort is exceedingly strong, and has plenty of water, the hill of Ran is an especially strong fortress (in itself) and the capture of the fortresses depends upon the possession of this hill. Accordingly, my revered father ordered that they plant cannons on the top of the hill of Ran, and aim at (*majra girand*) the buildings inside the fort. The first gun they fired reached the square building (chaukhandi) of the palace of Ray Surjan."

What was impossible to obtain despite massive preparations for assault on the fort, was obtained rather smoothly by diplomacy. The Mughal emperor sent an embassy comprising Raja Man Singh and Raja Bhagwan Das of Amber to negotiate with Rao Surjan Hada. It is said Akbar disguised himself as a mace bearer and accompanied the Amber rulers into the fort. The Ranthambore ruler was granted that Bundi, his parent state, would sent no bride to the Mughal harem, no *jizia*, permission to attend court ceremonies fully armed, exemption from prostration (*sijda*), respect for temples, no branding of the Bundi horses, no posting of Bundi chiefs beyond the Indus and only under Hindu chiefs and Bundi to remain their permanent capital. When the terms of surrender were thus settled amicably, Akbar removed the disguise. Rao Surjan Hada surrendered the keys to the fort to Akbar and thus was avereted another instance of victory sullied with the blood of the vanquished.

Today the fort contains only a few structures of any particular worth. The steep path to the fort passes through four mammoth gateways. On way the ascent are the Naulakha Pol, the Hathi Pol guarded by the head of a gigantic statue, and the Ganesh Pol protected by the blessings of the Lord. As the ascent grows steeper, spectacular views of the forest and lakes in their unspoilt splendour are obtained. The Tripolia, leading to the interior of the fort, stands under a splendid oriel window. Secret passages, originally meant for defence and leading through tunnels to crucial areas in the fort, are now sealed for all times. The passage under the Tripolia is dimly lit and the ruins along the ramparts reveal themselves only gradually. These are the sections where Alauddin's soldiers created havoc with their lightning attack on the inmates of the fort. The Khilji soldiers had all the time at their disposal to destroy the architecture in a greatly refined from.

The Hammir palace is built within a high-walled enclosure with a single massive gateway. It stands close to the centoaph of Jaitra Singh. This is one of the oldest surviving examples of secular architecture from the 13th century CE. Though much has ruined, this palace provides enough information on the building technique of that period. The red sandstone from Karauli lends immense strength to the structure which has suffered devastation by invaders as well as time. It is a multi-storeyed structure. The basement is believed to have had four storeys whereas the upper section has only three storeys. The columns are massive and gigantic. The passages and galleries look like tunnels, perhaps, originally lit by torches. The ceilings are plain and rudimentary comprising massive large slabs of stone held together by iron dowels. The decoration is sparse with only flower bosses carved in relief. The residential sections have some openness created by small courtyards and a garden. The uppermost terrace has an open pillared *verandah* in front of a set of rooms. Despite the elaborate restoration work in progress at the fort, the Archeaological Survey of India will have a tremendous task in hand. The Hammir Mahal is putting up a valiant battle against time and laws of nature. The entrance gateway displays some artifacts recovered from the ruins.

The Rani Mahal has been completely destroyed and has disappeared without leaving a trace of its structure. Behind these palaces is the Padmala Sarovar, an artificial lake, an ideal spot for surveying the fort environs.

Close to the lake is the small mosque built by Alauddin Khilji in 1301 CE, the first mosque at Ranthambore. The Jain temples are still older, built

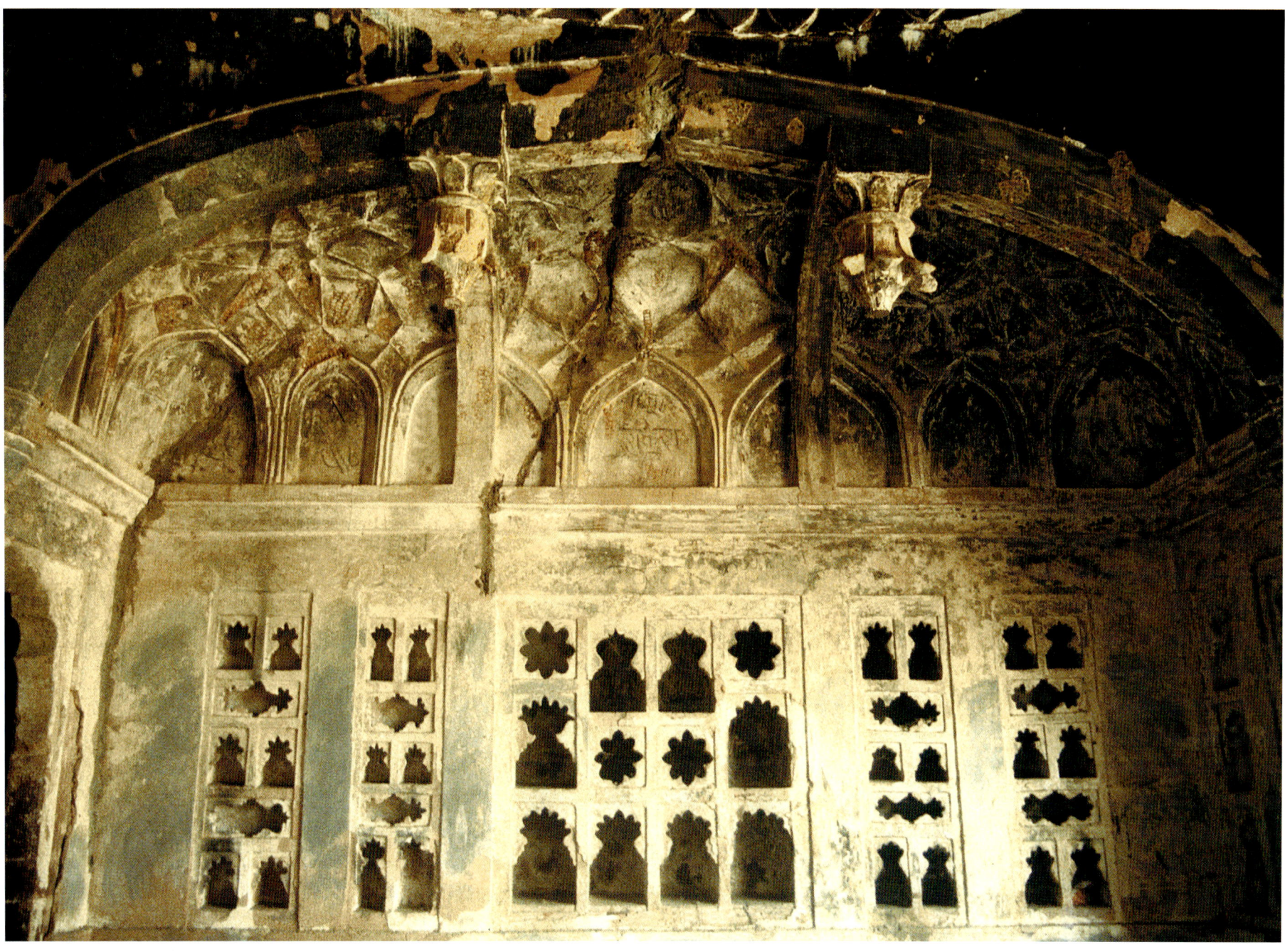

during the Chauhana occupancy of Ranthambore.

The Dargah of Pir Sadruddin stands over the Ranihar tank. It is still being visited by people and is a much renovated and whitewashed structure. A small mosque with triple arches surmounted by triple domes stands over the rocks. It is the most picturesque area of the Ranthambore fort.

The Badal Mahal ruins stand close to the ramparts and the views of the lake in the sanctuary below are exceedingly charming with the red painted Jogi Mahal pavilion, peering over the green carpet of tree tops and the blue waters beyond, disturbed only by alligators and sometimes tigers enjoying leisurely walks. The Badal Mahal is a pleasure-pavilion. The interior contains splendid decorations with small niches on the wall, called *chinikhana*, and lotus blossoms carved on the ceiling. The *verandah* opens toward the ramparts where a gallery of arches stands on the wall.

Ruins of the Hammir Court can be reached through a footpath meandering across dry grass and rocks. Here the Chauhan rulers and Hammir held court. It is a stately building, purely functional in style.

Ranthambore is not a completely deserted fort. It is visited by thousands of devotees on Ganesh Chaturthi when a grand festival is held in the fort at the Ganesh temple. The idol of Ganesh is well decorated. Ganesh is immensely popular amongst the newly wed couples. Those about-to-be married couples send invitations to Ganesh and some even send him a token fare for the journey. These couples also build small symbolical houses by putting a few stones together to invoke the Lord's blessing on their new homes. Then, they also return in thanks-giving. The large number of *langurs* (black-faced mankeys) hanging around gleefully accept whatever you throw at them.

Near the Ganesh Mandir is a palace which has undergone horrifice destruction from the invaders. A steep path leads through a massive but derelict gateway to a small temple dedicated to Chamunda, on the outside below the ramparts. It was the temple of the family deity of the Chauhan rulers and his successors in the fort.

Ranthambore had five gigantic tanks excavated on top of the mighty hill. These tanks could supply water for months during the long and frequent sieges. It is believed that two of these tanks had big holes at the bottom which, opened up, letting the water rush out in torrents sweeping away the unwelcome intruders forcing their way up the steps at the Naulakha Pol.

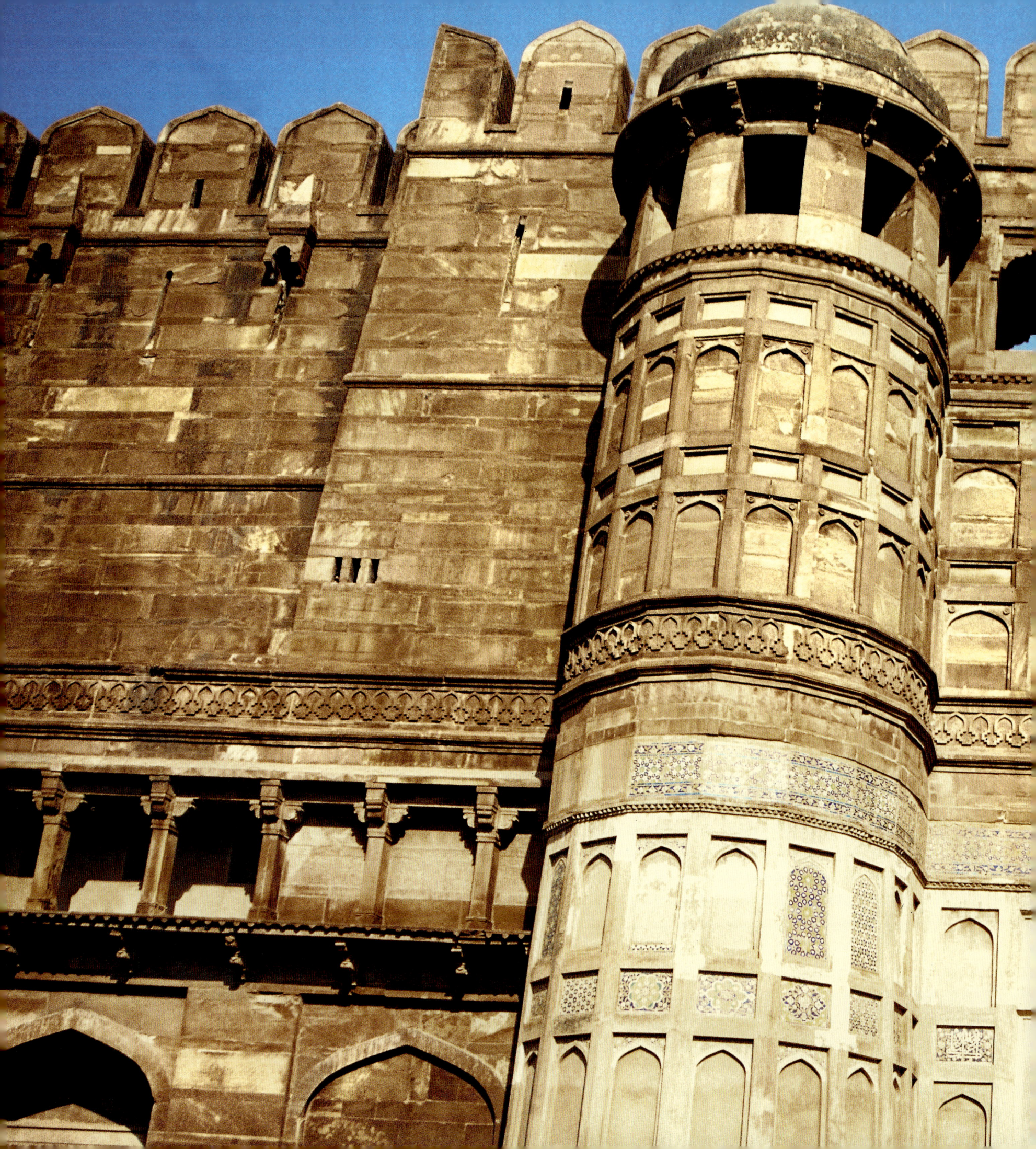

AGRA and FATEHPUR SIKRI

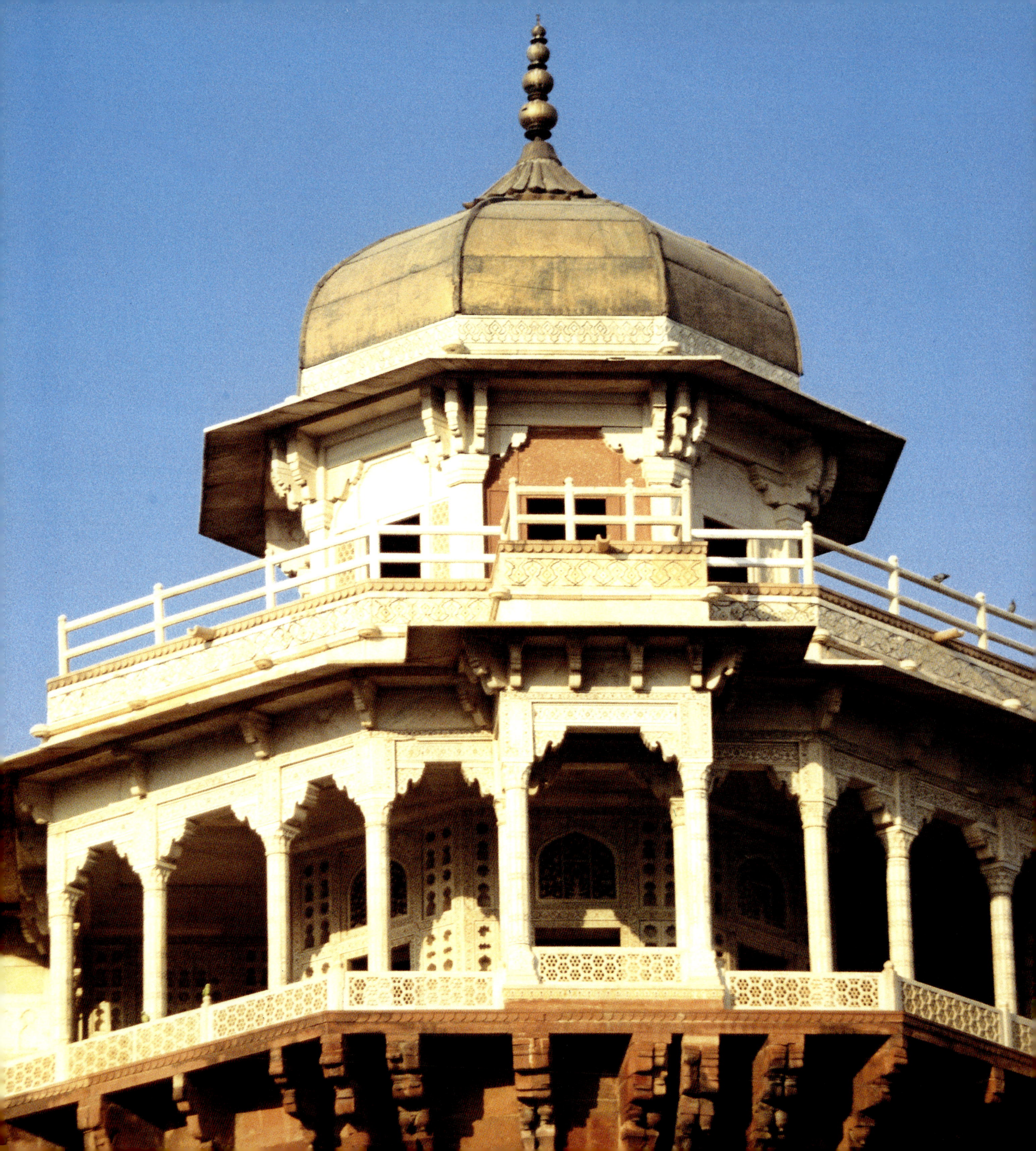

After living for a short period at Dinpanah, the fort built by Humayun in Delhi, Akbar shifted his capital to Agra where in 1526 CE his grandfather Babur had laid the foundation of the Mughal Empire in India. Akbar chose the western bank of the river Yamuna where the ancient brick and mud fort of Badalgarh still served its purpose despite the vicissitudes of fortune. Badalgarh is mentioned as early as 1088 CE. But more prominently it appears as the fort occupied by Sikandar Lodi in 1491 CE whereafter it was held by the Lodis till Babur defeated Ibrahim Lodi in 1526 CE at Panipat. It was at the fort of Badalgarh where the scions of the Gwalior ruling family presented the Kohinoor diamond to Humayun. The Kohinoor was valued at two and a half days food for the whole world. Humayun offered it to Babur who gave it back to him. The Lodis had strengthened Badalgarh but it was a much delapidated structure unfit to function as the key fort of a powerful and rich empire. Akbar, realising the importance of an impregnable grand fort, ordered the demolition of Badalgarh and built this exalted fort in red sandstone under the supervision of Qasim Khan.

Akbar's fort is an impregnable stronghold, a kind of irregular semi-circular structure nearly 2700 feet in length standing in a straight line running parallel to the river which has moved away during the last few centuries. The massive ramparts are nearly 70 feet in height and one and a half mile in circuit. This is the most splendid example of a massive construction, string courses and embrasures making it the strongest Mughal fort in India.

The Red Fort in Agra was intended to be "an impregnable palace, a fortified citadel and a strong fort of hewn stones which should be firm like the fabric of the empire of this exalted dynasty and durable like the sublime basis of its victorious fortune...", Thousands of masons, stonecutters and labourers were employed on this first architectural project for the defence of the empire during Akbar's rule. It took nearly eight years of continuous work and the emperor took personal interest in its construction. The miniatures of the Mughal period show Akbar critically observing the details of the work. It was the strongest Mughal fort which cost nearly three crores of rupees in those days. After its completion, the magnificent fort became the "depository and storehouse of all the gold of Hindustan, and the mnemosynon was found for the date-Shud bina-i qil' ah bahr-zar. The fortress was built for the sake of gold".

According to the description of the fort provided by William Finch (1608-11) who visited Agra soon after Akbar's death in 1605 CE there were four gates. "One was situated on the north, while another was located to the west of the *Bazaar* and was called the Kachehri Gate. Beyond these two gates was a third one where he saw the statues of two Rajas. Passing it, the visitor entered a "fair street with houses and munitions all along on both sides". At the end of the street was another gate which led to the Emperor's *darbar* "always chained, all men but the king and his children there alighting". This gate was situated on the south and was named Akbar Darwaza. Another gate was situated on the riverside and was called the "Darchani", from where the Emperor looked at the sunrise and received *taslim* of the nobles. Here, every noon, he also witnessed the fights of elephants, lions, buffaloes etc'. Nearly all these gates mentioned by William Finch are still to be seen and are easily identifiable.

Delhi Darwaza, or the northern gate, is now closed to public entry but its magnificence can be assessed from the outside. Its grandeur and defence architecture relies on the two massive bastions surmounted by octagonal *chattris*. It is also called Hatya Pol or the Elephant Gate because till 1658 CE there were two elephant statues here with riders installed on both sides of the inner entrance, also noted by William Finch. Aurangzeb had these statues pulled down. This was the first monumental gateway built by Akbar successfully incorporating architectural features from the pre- Mughal period. The bastions are surmounted by battlements with high merlons, loopholes, and embrasures. The crooked entrance to the fort interiors has sharp angled turns and a steep ascent to check the speed of invaders, horses and guns. All attempts to force an entry from this side proved futile. This gate is covered with generous decoration. Oblong panels are covered with relief ornament. The designs used are chiefly geometrical and conventional.

Akbari Darwaza or the Amar Singh Gate, as it is presently called, is the other important gate. It is massive and well-planned. It is named after Rao

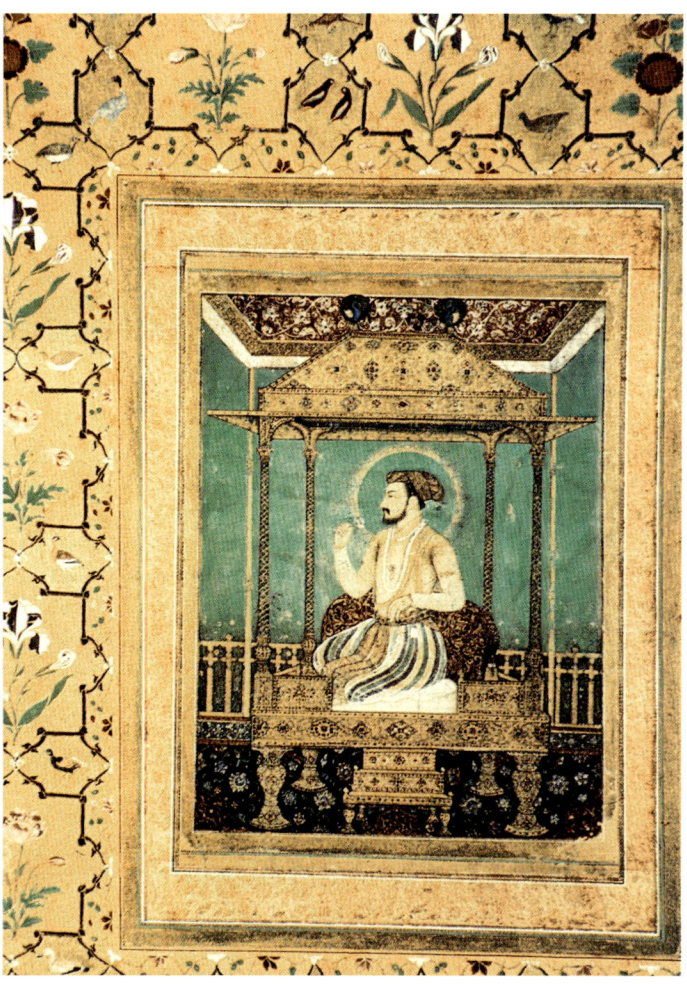

Clockwise from far left:

Akbari Darwaza, or the Amar Singh Gate; Shahjahan on the Peacock throne; Akbari Darwaza entrance

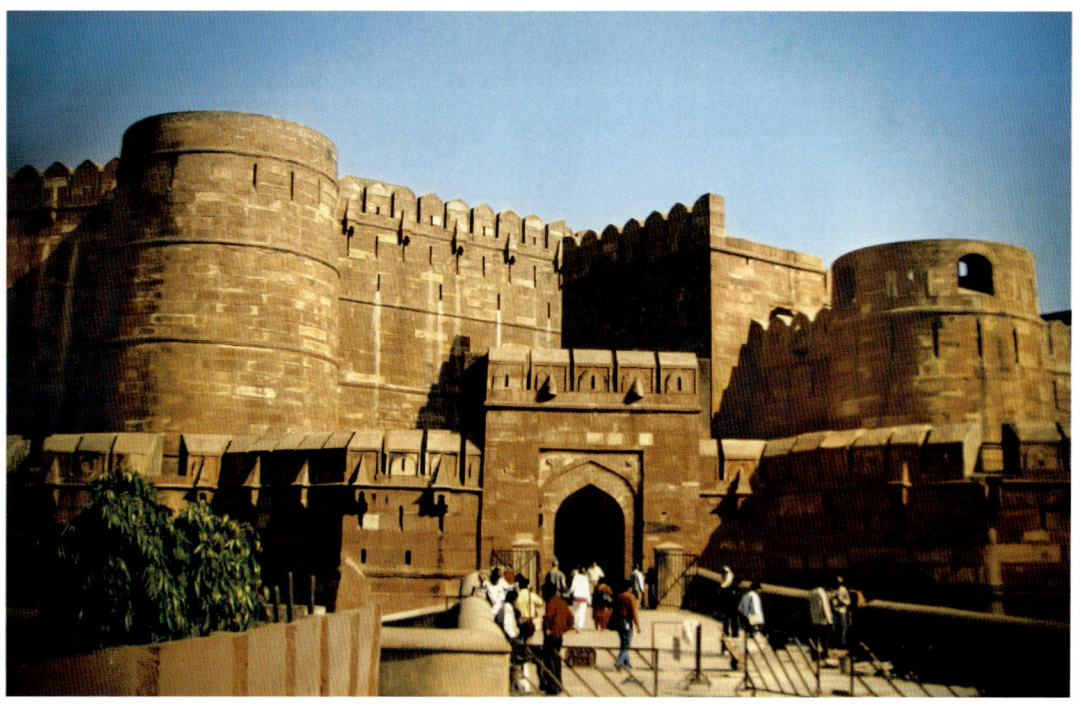

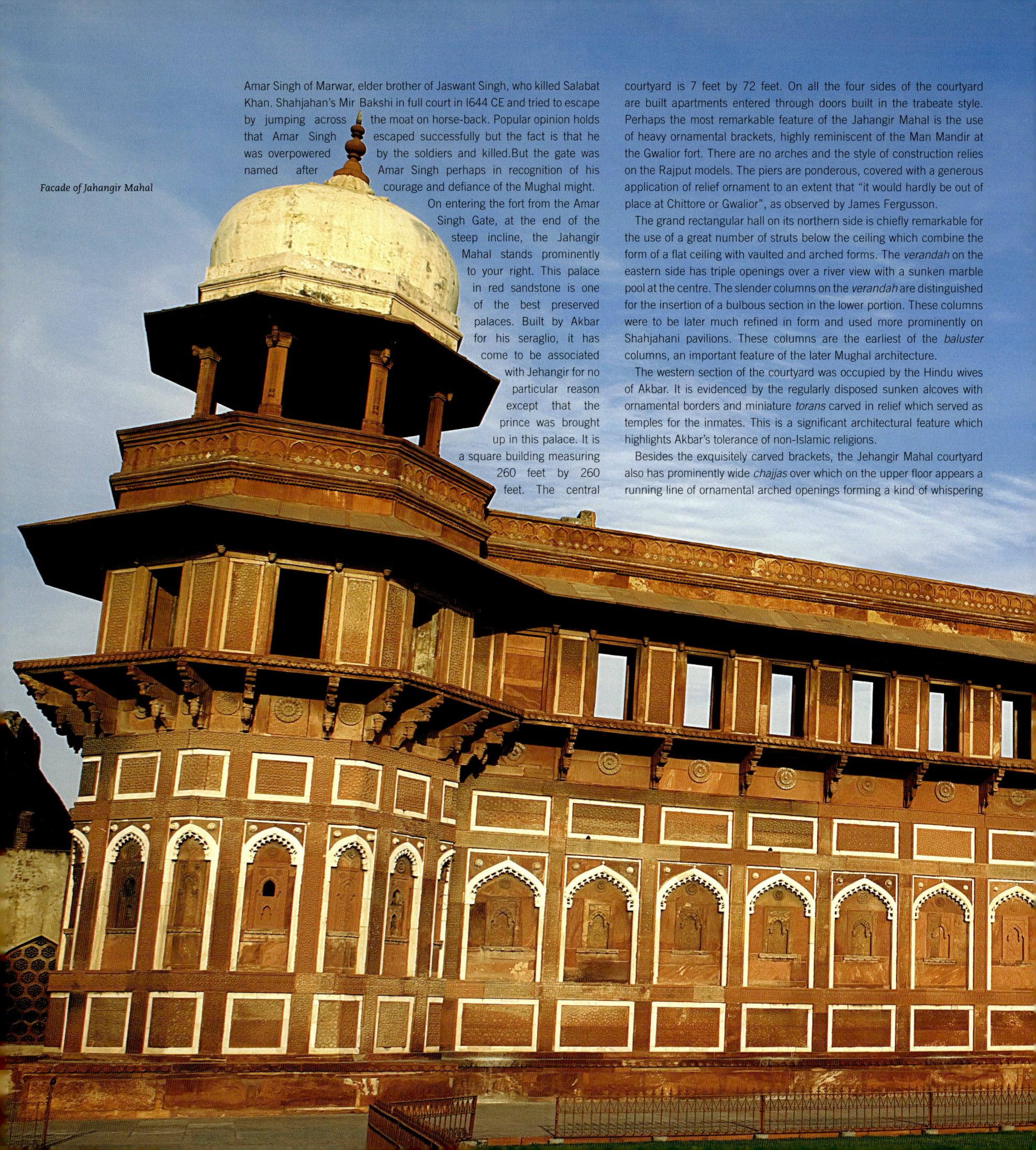

Facade of Jahangir Mahal

Amar Singh of Marwar, elder brother of Jaswant Singh, who killed Salabat Khan. Shahjahan's Mir Bakshi in full court in 1644 CE and tried to escape by jumping across the moat on horse-back. Popular opinion holds that Amar Singh escaped successfully but the fact is that he was overpowered by the soldiers and killed. But the gate was named after Amar Singh perhaps in recognition of his courage and defiance of the Mughal might.

On entering the fort from the Amar Singh Gate, at the end of the steep incline, the Jahangir Mahal stands prominently to your right. This palace in red sandstone is one of the best preserved palaces. Built by Akbar for his seraglio, it has come to be associated with Jehangir for no particular reason except that the prince was brought up in this palace. It is a square building measuring 260 feet by 260 feet. The central courtyard is 7 feet by 72 feet. On all the four sides of the courtyard are built apartments entered through doors built in the trabeate style. Perhaps the most remarkable feature of the Jahangir Mahal is the use of heavy ornamental brackets, highly reminiscent of the Man Mandir at the Gwalior fort. There are no arches and the style of construction relies on the Rajput models. The piers are ponderous, covered with a generous application of relief ornament to an extent that "it would hardly be out of place at Chittore or Gwalior", as observed by James Fergusson.

The grand rectangular hall on its northern side is chiefly remarkable for the use of a great number of struts below the ceiling which combine the form of a flat ceiling with vaulted and arched forms. The *verandah* on the eastern side has triple openings over a river view with a sunken marble pool at the centre. The slender columns on the *verandah* are distinguished for the insertion of a bulbous section in the lower portion. These columns were to be later much refined in form and used more prominently on Shahjahani pavilions. These columns are the earliest of the *baluster* columns, an important feature of the later Mughal architecture.

The western section of the courtyard was occupied by the Hindu wives of Akbar. It is evidenced by the regularly disposed sunken alcoves with ornamental borders and miniature *torans* carved in relief which served as temples for the inmates. This is a significant architectural feature which highlights Akbar's tolerance of non-Islamic religions.

Besides the exquisitely carved brackets, the Jehangir Mahal courtyard also has prominently wide *chajjas* over which on the upper floor appears a running line of ornamental arched openings forming a kind of whispering

gallery punctuated at the centre on each side with an elegantly designed window with four small openings. The terrace is demarcated with a low balustrade formed by *jali* screens punctuated by a square *chattri* rising over the window on each side. The splendour of the relief carving deserves a closer inspection only when its amazing intricacy of pattern and delicacy of craftsmanship reveals itself.

The facade of the Jehangir Mahal has been ornamented with oblong panels combining geometrical and arabesque patterns, and small arches with lotus-bud fringes. The medallions are equally well ornamented with relief work. In front of the arched entrance to the Jehangir Mahal has been placed (retrieved from the debris) a huge stone bowl. This enormous bowl was used by Noorjahan for her bath. The rose petals spread over the water lent their perfume to the bath and, perhaps, led Noorjahan to discover the rose perfume or *attar*.

The south-eastern corner of the fort contains the red sandstone structures of Akbar's palaces. Originally it had nearly 500 palaces or apartments but Shahjahan had most of these demolished at a later stage. Most of the palaces between the Jahangir Mahal and the octagonal pavilion at the farthest corner have been thus destroyed. Francisco Pelsaert (1620 -27 CE) an employee of the Dutch Company who visited Agra during Jehangir' rule, gives an account of the palaces within the fort. The fort was full of palaces and princely edifices, palaces for the harem including palaces for Maryam Makani, the mother of Jehangir and Noorjahan. Amongst Akbar's palaces, Pelsaert mentions palaces named Itwar, Sanichar and Mangal where the emperor stayed on these days. The Bengali Mahal was occupied by women from various nations and states. The whole set of palaces was called 'Bengali Mahal 'because the style of construction was borrowed from the Bengali and Gujarati tradition. It appears certain that the Jehangir Mahal was the north-western extension of the Bengali Mahal now surviving in stray sections. The foundation of the demolished palaces indicates the grouping of these harem palaces. The original Akbari scheme of palace lining the straight line overlooking the river however has remained unaltered during the subsequent demolitions and restructuring of palaces during Jahangir and Shahjahan's rule.

The Khas Mahal, standing next to the Jahangir Mahal on the river side, is Shahjahan's beautiful palace in pure white marble. It is a rectangular hall with *jali*-covered windows providing charming views of river and gardens below the ramparts. The walls of the interior are covered with painting and decorated with gold. Two royal seats each with a semi-globular ceiling were kept here. Originally the wooden ceiling was decorated with the most luxurious ornament in silver leaves and relief in goldwork "executed in such a way that one would say that these are the rays of the sun emitting from the morning light or the rays of the cup of Jamshed glittering on a bed of camphor". This was Shahjahan's *aramgrah* (retiring chamber) hence furnished with the most luxurious carpets and curtains.

The inner chamber has on its front a three aisle deep hall with double pillars and exquisitely fashioned nine cusped arches. The dado of this hall is embossed and the borders are decorated with inlaid cornelians and corals. The marble ceiling is gorgeous. The inscriptions extol the splendour of the palace:

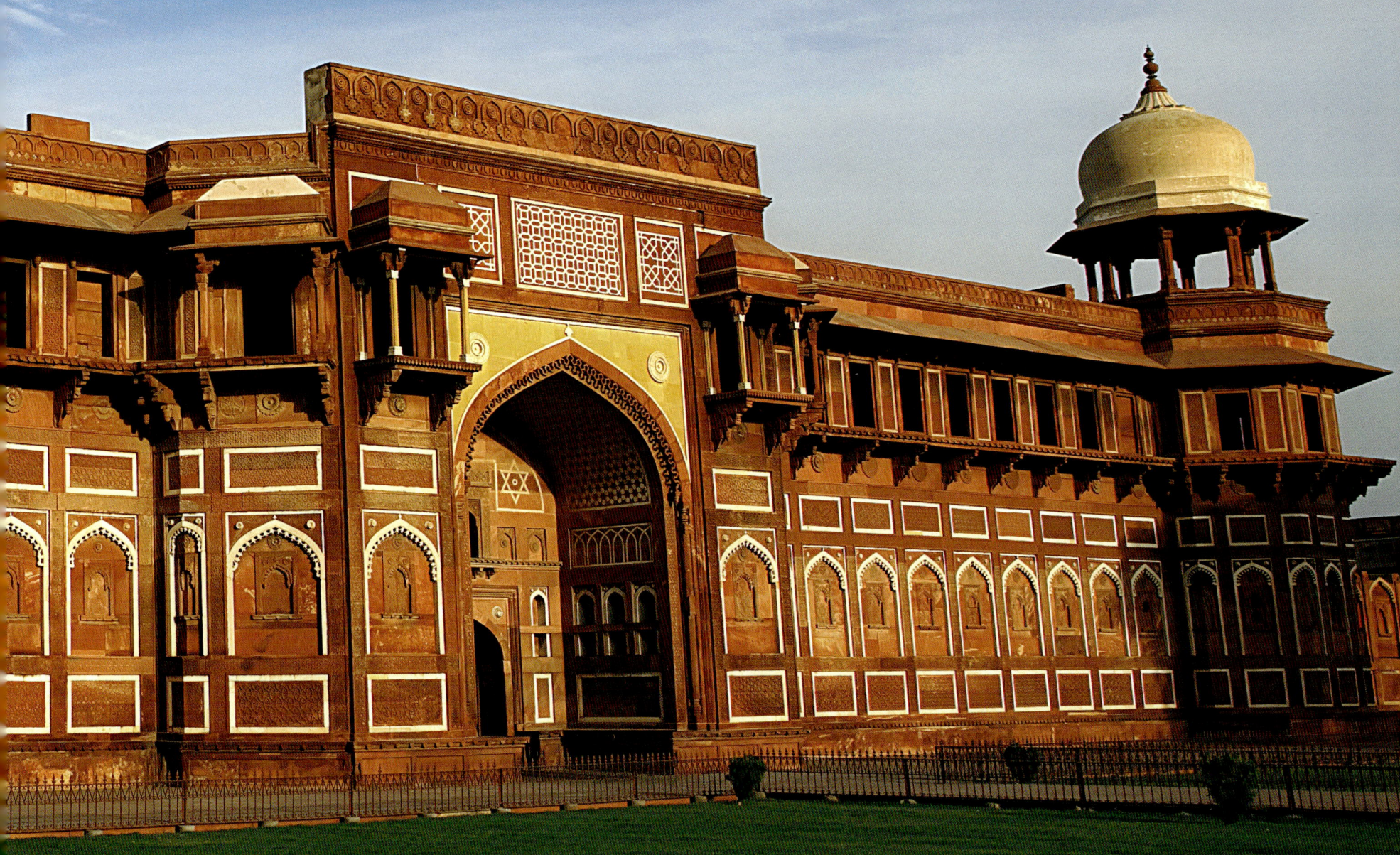

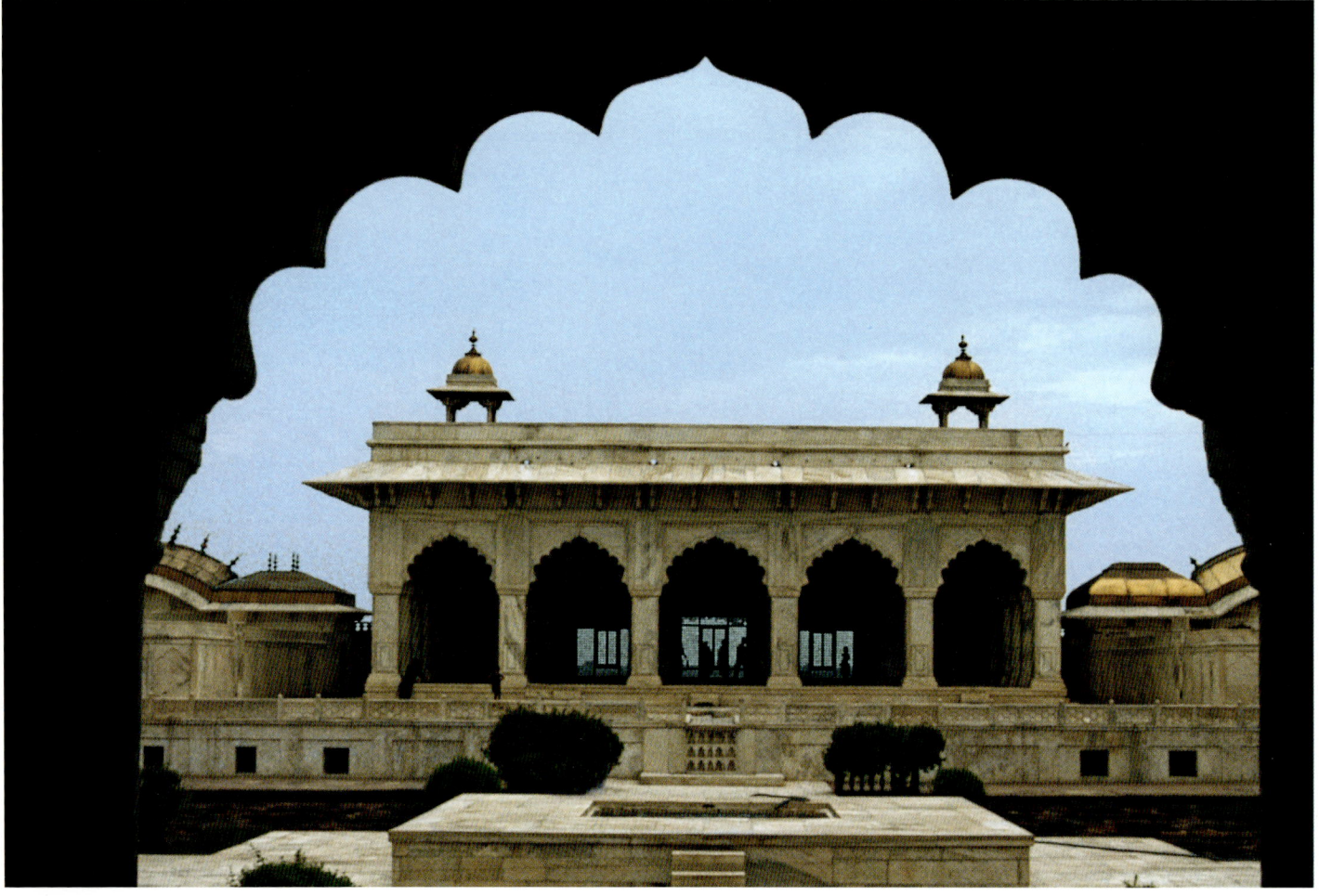

Clockwise from above:
Inlay detail; Khas Mahal; Colonnade at
Diwan-i-Aam; Floral motifs on the dado

"What a happy place that for its elegance
Is to the world the prototype of the exalted Paradise.
In gracefulness and decoration
You would say it is a heaven on earth"

This Paradise imagery runs through the whole range of Mughal gardens and architecture. On both sides of the Khas Mahal are built small pavilions with sloping *bangaldar* roofs. These elegant pavilions in white marble were occupied by the princesses- Jahanara Begum and Roshanara Begum. The whole set of palaces has on its front a small but charming Mughal garden- the Anguri Bagh. It has a central tank –15 yards in length and 9 yards in width containing five fountains: "its water is in purity like an eye. In each drop of it is the brilliancy of hundreds of gems." The flower beds in the garden are divided by low curbs in a complicated interlocking pattern. Originally only small and low flowering shrubs were planted here so that the view of the garden was at no place interrupted by large plants or trees. The Khas Mahal and this small palace garden are amongst the most pleasant spots at the Agra fort.

The Shish Mahal occupies the north-eastern section of the Anguri Bagh. It remains mostly closed to visitors. It is, in fact, the bath for inmates of the harem. It contains some excuistite glass mosaics in essentially geometrical arabesques. The rooms are designed to avoid the harsh sunlight and to exploit the grandeur of reflected candle-lights. Water channels running through the interior and the fountains add to the splendour of this royal bath which has two halls of equal size and unusually thick walls to ward off the heat.

The Musamman Burj has always remained the most charming pavilion in the fort. Built over a projecting secton of the ramparts the pavilion

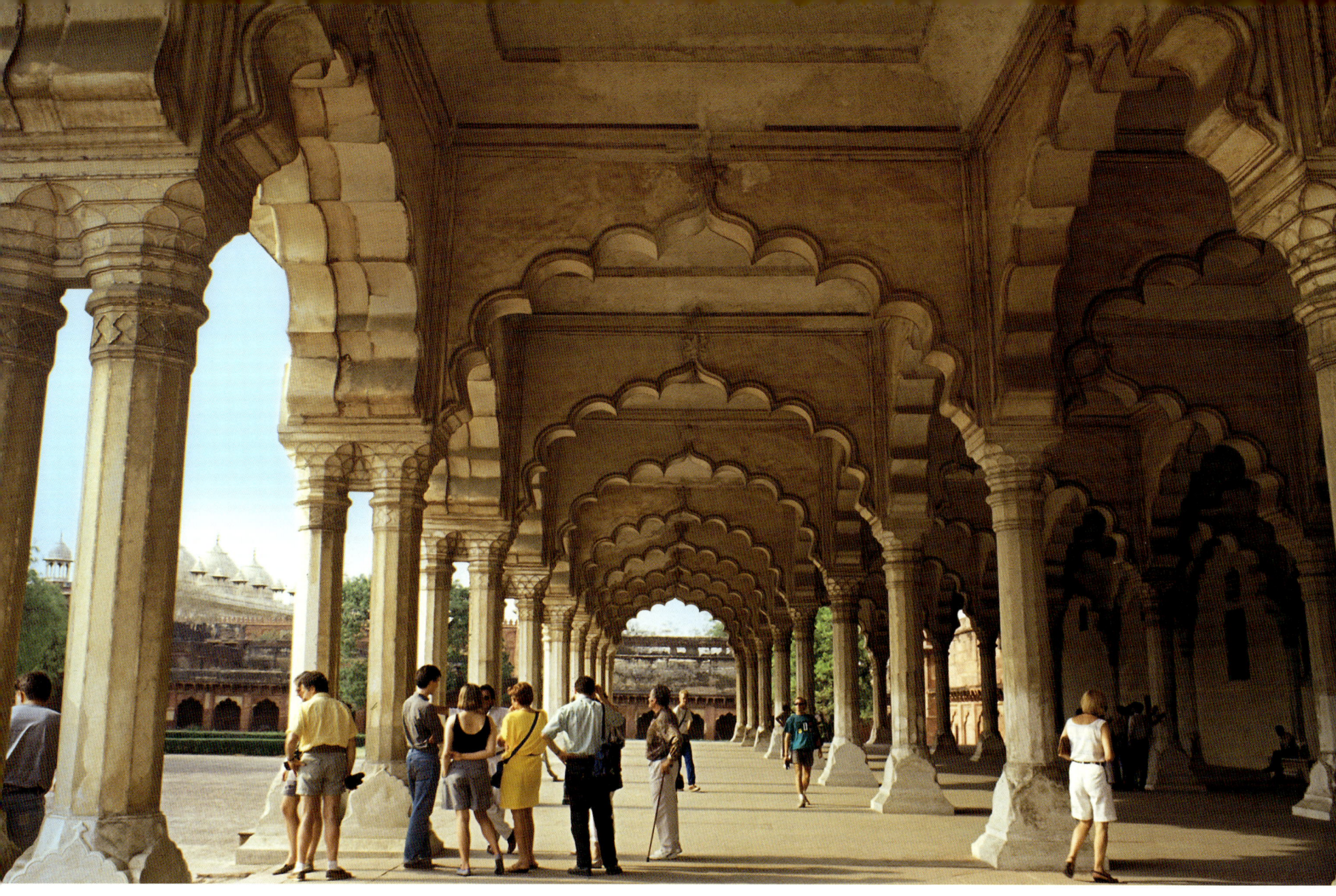

rests upon the small gate leading to the water front. The lower part of the structure is in red sandstone but the upper portion, in line with the other structure, is in white marble covered with a sumptuous ornament. As per an account in the Tuzuk the pavilion has twenty five pillars "all covered with plates of gold, and all over inlaid with rubies, turquoises, and pearls. The roof on the outside is formed into the shape of a dome, and is also covered with squares of solid gold, the ceiling of the dome within being decorated with the most elaborate figures of the richest materials and most exquisite workmanship, from top to bottom of an octagonal shape, a small gallery overlooking the Jamna, from whence, when so disposed, I have been accustomed to view the combats of elephants, nilghaos, antelopes and other wild animals…"

The area below the Musamman Burj had a gate opening towars the riverside gardens where elephant fights were arranged for royal entertainment. Akbar had a known fondness for such sports and the Akbarnama miniatures contain several depictions of elephants. Akbar once arranged a fight between the elephant of prince Salim and Khusrau. Akbar watched the fight intently looking for an omen. Salim's elephant won the fight but an open fight broke out between the supporters of both Salim and Khusrau. Akbar had to send his 13year old grandson Khurram (later Shahjahan) down to tell the two princes to stop this undignified behaviour. "The scene", as Bamber Gascoigne observes, "was pregnant with more omens than those taking part could have realzed." The Badshahnama of Shahjahan mentions an episode when two elephants called Sidhkar with tuskers and the other Surat Sundar without tuskers were pitted against each other in an earth-shaking fight. But, somehow, Sidhkar rushed towards the 15 year old Prince Aurangzeb, rolling down the prince and his horse. Aurangzeb acquitted himself creditably moving smartly away from sheer catastrophy. These fights had their own moments of surprise for both the emperor and royal groups watching the events from the Musamman Burj and the ramparts without diminishing the emperors' fondness for this royal entertainment. Occasionally four or five pairs of elephants were set to fight raising mountains of dust amid nerve-wrecking moments and pandemonium amongst the sea of onlookers. The Musamman Burj was originally built by Akbar when the use of marble was sparse and the decoration very discreet. Jehangir restructured the pavilion and added marble halls on three sides of the core octagonal chamber with a diameter of eight yards. The slender pillars and the interior was covered with inlay work and painted flowers. From the riverside, the view of the Musamman Burj appeared quintessentially romantic with its gallery of slender pillars positioned over a rotating *chajja* supported on brackets. A balustrade with *jaliwork* stands at the edge of the gallery.

Shahjahan made his own alterations in the structure of the pavilion. On the eastern *verandah* an ornamental shallow and sunken fountain adds its own charm. The walls contain the *chinikhana* or miniature niches meant to contain and display small colourful bottles and vases in an essentially

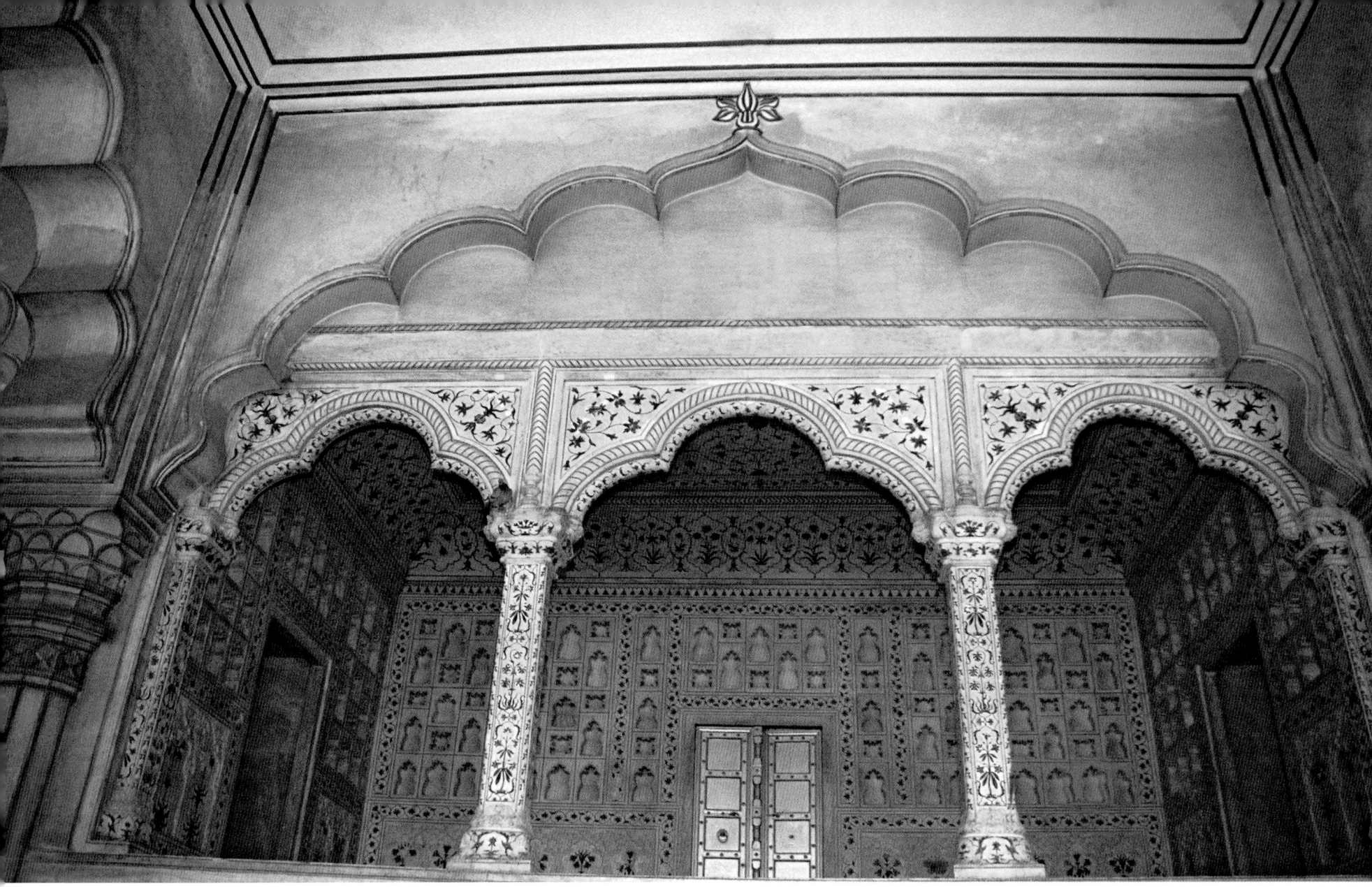

Persian style decoration. The dados have borders inlaid with semi-precious cloured stones around flowers carved in relief.

During Jehangir's rule, a chain of justice was fastened to the pinnacle of the dome of the Musamman Burj with the other end tightened to a stone pillar below the ramparts. This chain of pure gold was 30 yards long consisting of sixty small bells and weighed four *manns* of Hindustan which was equal to thirty two mounds of Iraq. The common man could draw the emperor's attention to any injustice done to him and seek redressal. More importantly, the Musamman Burj and the apartments on its western side were meant for very private and exclusive use by Noorjahan, the most influential queen of Jehangir. Later Shahjahan used the pavilion for his entertainment and royal get-together parties where his most beloved queen Mumtaz Mahal was the cynosure of all eyes. When Aurangzeb imprisoned Shahjahan in the fort, the latter was not allowed movement beyond the Burj. He could seek solace in viewing the Taj Mahal, the tomb of Mumtaz. It is not beyond imagination to picture Shahjahan, master of the universe, passing his last few days in sheer misery and ultimately closing his eyes as life ebbed out of his weak body. The Musamman Burj witnessed both the pinnacle and nadir of Shahjahan's splendid career.

The Diwan-i-Khas, built by Shahjahan, is a small and compact structure standing close to the Musamman Burj. This Hall of Private Audience was used for transacting state affairs of the highest secrecy and importance, admitting only dignitaries of the ministerial ranks for audience with the emperor. On the east, west and northern sides, the hall has double columns with engrailed arches. The columns are noteworthy for the decoration on the lower sections.

The interior has sparse decoration except on the dados which have borders inlaid with coloured stones. The flower plants carved in relief, some with four different plants within the same square, have immense variety and a loveliness of their own. The original ceiling was in wood covered with gold work in relief. The *chattris* over the parapet, a typical feature of Shahjahan architecture, are conspicuous by their absence, perhaps destroyed in later years of neglect. One of the inscriptions at the Diwan-i-Khas likens it to the exalted Paradise:

"When his palace adorned the world,
The face of earth with it was exalted to heaven.
Shahjahan is the Emperor of the world,
With whom the soul of the Sahib-qiran (Timur) is well pleased."

--It was at the Diwan-i-Khas that Shahjahan's coffin was prepared after his death on January 31, 1666 CE. Sheer silence enveloped this magnificent edifice as Begum Sahib Jahanara supervised the proceedings of the final farewell to her father Abu'l Muzaffar Shihad-al-Din Muhammad Sahib-i-Qiran Sani, Shahjahan Padshah Ghazi son of Nur-al-I Jahangir Padshah, son of Akbar Padshah, son of Humayun Padshah, son of Babar Padshah, son of Omar Shaikh Mirza, son of sultan Abu Sa'id son Sultan Muhammad Mirza Shah, son of Amir Timur Sahib-i-Qiran.

An open court lies in front of the Diwan-i-Khas. This is, in fact, the terrace over the chambers lying beneath, which, it is believed, contained

the treasury of gold *mohurs*, the incalculable wealth of the great Mughal emperors. On the western side of the terrace is placed a seat in white marble and on the opposite riverside is the seat in black marble which was specially made for Jehangir at Allahabad. It was brought to Agra in 1610 CE and some inscriptions carved on the sides and stone legs added to support it on a platform.

On the northern side of this open court stood "a hall, 25 *gaz* by 5 *gaz*, adjacent to which is a *hammam* (bath) consisting of several buildings, which overlooks the river Jumna, the garden at the foot of the jharoka-i-darshan, and all other gardens on the other side of the water. The magical workmen and wonder-working artists have so well executed on its interior and exterior, inlay, relief, glass mosaics and other wonderful works, that it is a stumbling block for the sight of the far-seeing fastidious persons". This grand bath had fountains, dressing rooms on the river side, and cold and hot bathrooms. The Aleppo glasses provided clear views of the riverside. Sadly, there is nothing left of this magnificent bath except certain bare brick walls and the marble revetment has been removed from the entire structure. The hall facing the Diwan-i-Khas and its arcades covered with lavish inlay ornament has disappeared.

This is the spot where the British administration created havoc, destroying the heritage they were supposed to protect. The Marquis of Hastings (1813-23 CE) had this elegant bath broken up to be sent to George IV of England and most of the marble removed from the structure was auctioned by William Bentinck (1828-35 CE), Governor General of India. The marble somehow did not reach its destination in England. The auctions of the plundered marble did not fetch any particular profits and discouraged the British from demolishing the Taj Mahal which was next on their agenda. The curios dealers of Agra purchased some marble fragments for sale to the British *sahibs* as paper weights, etc. Some portions of the broken columns found their way to various museums, some lying as discarded, unclaimed pieces and some pieces appearing on the walls of the Circuit House in Agra. This Bath in sheer ruins is a place worth a visit.

The Machi Bhawan court lies on the western sside of the open court. It was once a splendid garden with four water pools, channels and fountains. All this stands replaced by a lawn divided into four sections. On the eastern side of this court are the chambers in which was kept the treasure of the Mughal emperors. On the western side is an open arcade. On the

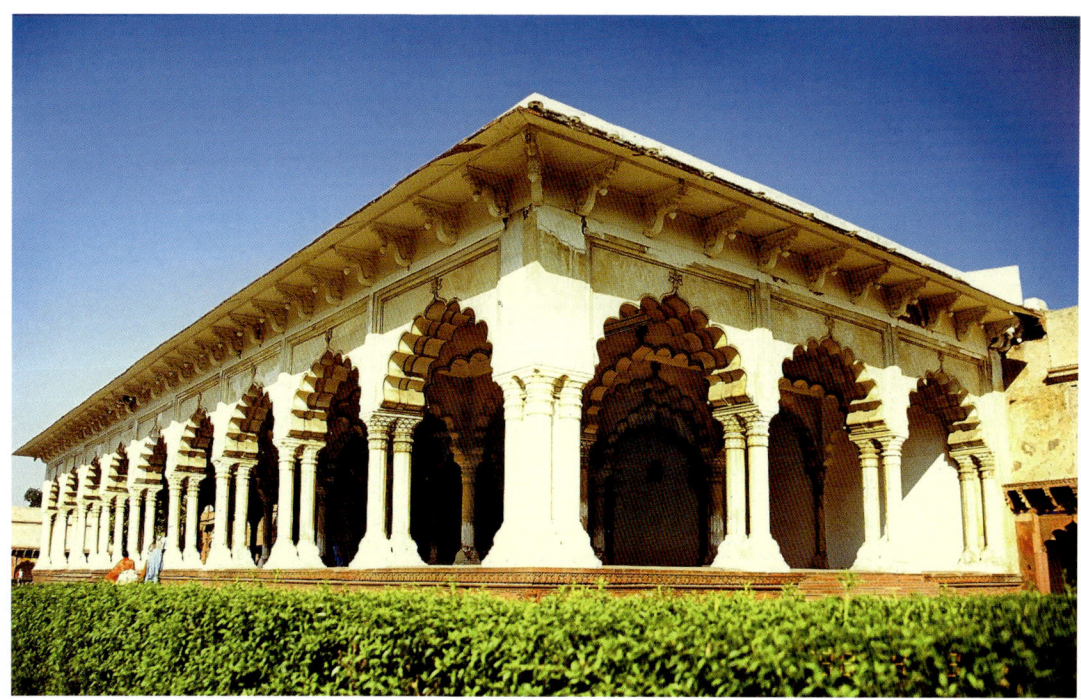

Clockwise from left:
Royal seat at Diwan-i- Aam;
Exterior of Diwan-i-Aam, the hall of common audience; Jodha Bai's palace at Fatehpur Sikri

Clockwise from right:
Birbal's Palace at Fatehpur Sikri;
Jharokha, extension of Jodha Bai's palace

northern side a gateway leads into the Meena Bazar, a shopping centre for the royal ladies. Here the emperor could haggle over the exhorbitantly priced small items sold by *burqa*-covered princesses and other ladies. It is believed that both Jehangir and Shahjahan had memories of shopping at the Meena Bazar and it is here that Akbar saw his slave girl Anarkali exchanging meaningful smiles with prince Salim which ultimately led to the great Mughal tragedy. On the southern side of the great court is an umbrella-like embossed pavilion in white marble. The pillars of this pavilion have elaborately carved *baluster* columns. The Mughal emperors gave audience to the inmates on ceremonial occasions, festivities and marriage ceremonies etc. The western arcade of the Machi Bhawan has a door which leads to the emperor's throne *Jharokha* in the Diwan-i-Aam from where he commanded large gatherings of officials, ambassadors and nobels in great pomp. Members in the audience stood according to strictly followed rankings. The whole space was divided into sections marked by balustrades. The first enclosure close to the royal seat was meant for officials of the highest rank, amirs, ambassadors and nobles. This was the most closely guarded area with strict regulations regarding admittance. The second enclosure contained the larger group of mahasabdars, Ahadis and other important people. The first balustrade was made of silver and the steps to the royal seat also covered with silver. There were also two wooden elephants covered with silver on both sides of the *jharokha*. It was a magnificent *darbar* of the Mughal emperor.

Jahangir's throne stood atop a few steps and was set on four lion pedestals. Silver was the most favoured metal for courtly furnishings. The canopy over the emperor's seat was in pure gold inlaid with precious stones and gems of the highest quality.

Shahjahan made his own alterations at the Diwan-i-Aam to make it a great showpiece of Mughal courtly splendour. Most importantly, the existing wooden pillars which had been so far only painted in splendid colours were replaced by pillars in red sandstone covered with shell plaster: "For the earth it became another heaven". The grandees of the court were asked to decorate the arcade galleries at their own expense so that in a bid to out do other competitors, they put up a great show. These galleries were decorated with brocade and the pavements with glorious carpets.

The throne *jharokha* was also suitably ornamented, being rebuilt enteirely in white marble inlaid with enchanting mosaics and "the ceiling embossed with gold and made a counterpart of heaven. The *chini khana* (niches) of this embellished balcony, wherein are laid vessels set with precious stones, is the embodiment of the world-illuminating morning, and behind the *jharoka* is a chamber facing the Daulat-Khana-i-Khass, the whole of this part being polished like mirror with the plaster of Patyali, which is better than shell plaster in polish and smoothness." (Badshahnama).

The Diwan-i-Aam has an arcade with nine bold cusped arches supported on strong double columns. It is three aisles deep. These arches are very well proportioned and show the most mature form of this engrailed type in red sandstone. During Shahjahan's rule these arches were covered with white shell plaster outlined with gold, giving the most lustrous finish to the whole construction. The Diwan-i-Aam has no *chattris* which is very ususual. Perhaps these characteristic architectural elements were destroyed for the copper plating of the small domes when the Agra fort was occupied by the Jats of Bharatpur.

The Moti Masjid in white marble is the most splendid structure of its kind in the fort. It marks the culminatin of Shahjahan's architectural style. It has three magnificient double domes, each nine yards in diameter, 21 archways in three rows and six towers surmounted by octagonal kiosks each four yards in diameter. The whole architectural composition has a striking simplicity of design. An ornamental tank lies at the centre of the

courtyard which is 60 yards square. "In the centre of the tank, a running marble fountain has reared its head to the sky like the answered prayers from a pious mind", writes Muhammad Salih. Compared to the Akbari structure in red sandstone, the elegance and purity of this mosque in white marble has a grandeur of its own, a perfect specimen of architecture on unexcelled harmonious proportions and a tremendous aesthetic appeal.

As Muhammad Salih, the court historian writes about the Moti Masjid: "…built by the order of the Emperor (Shahjahan), a Solomon in state, a Khalil in reverence, the face-brightener of Islam, the founder of kingdom, king of kings with an arsh-exalted court, the solder of the foundation of justice and mercy…. He is the pole of the heaven of the defence of religion and faith, the pivot of justice and sovereignty."

The Agra fort has two small mosques- Nagina Masjid and Mina Masjid. These were meant for exclusive use by the royal family. The Mina Masjid is enclosed within high walls. The structure is totally devoid of any ornament. Perhaps Shahjahan used this mosque for his prayers in captivity between 1658 and 1666 CE. It is accesible only through passages built within the Machi Bhawan.

The Nagina Masjid is also a royal mosque. The engrailed arches show a little experiment as only the central arch is nine cusped, the two arches flanking it have seven cusps each. Also the bulbous dome over the central arch is larger than the other two domes. Another stylistic variation is achieved by providing an upraised curve to the *chajja* in front of the nine-cusped central arch. The parapet follows the stylistic variation on the *chajja*. The circular *chajja* was apparently included into Mughal architectural vocabulary after the artisans from Bengal introduced the *bangaldar* roof over pavilions during Akbar's rule but really popularized under Shahjahan's patronage. The two small pavilions adjoining the Khas Mahal are the two most eminent examples of this feature.

The buildings at the Agra fort illustrate the most vital feature of the architecture patronized by both Akbar and Shahjahan. The various aspects of ornamentation of these styles are also remarkably different. The Jehangir Mahal remains the most complete and best preserved example of a building in red sandstone and, like the buildings at Fatehpur Sikri sum up, in the words of art historian Ebba Koch, "Akbar's architectural response to the absorption of Gujarat into the Mughal Empire (1572-73)… From diverse sources (Gujarat and the Gujarat-Malwa-Rajasthan tradition, the ornamental style of the Delhi Sultanate, Transoxania and Khurasan) the architectural synthesis drew the elements most suitable for a monumental building programme in sandstone, whose affinity with wood favoured the intergration of forms derived from timber architecture". The Mugal architects aquired a thorough knowledge of the diverse architectural forms and "handled it with a distinct sense of its symbolical and hierarchical potential."

Shahjahani architecture did not tread any new ground. It follows the traditional Islamic patterns like grouping of the single storeyed detached pavilions formally on a piece of level ground and incorporatig familiar architectural forms of the traditional indigineous architecture of Gujarat and Malwa etc, notably the *chajja* and *chattris*. But the various architectural elements are "modulated to form a new style, with its own logic and conventions…ideas from the two widely differing traditions are here not just assembled, but synthesized. This synthesis is given a particular emphasis by the type of arch used most commonly in all of the pavilions: not the Islamic pointed arch, but the cusped arch-a form which had been developed over time by both traditions within India".

As G.H.R. Tillotson remarks, "the stylistic unity is emphasized also by the uniform whiteness of the pavilions, achieved mostly by the use of marble facing. The extensive use of marble and of high quality materials in general, is another hallmark of Shahjahani architecture, as too is the refinement and the opulence of the applied decoration."

FATEHPUR SIKRI

The third Mughal emperor, Akbar ascended the throne in 1556 CE. He won new territories and expanded his empire but was still without an heir causing him immense worry. He visited Ajmer and prayed at the renowned *dargah*. Sheikh Salim Chisti of Sikri, 27 miles from Agra, had earned a great fame. When Akbar sought his blessings, the saint prophesied birth of three children to the emperor. It is a popular belief that an infant son of the saint heard of the emperor's worry. He was told that unless someone sacrificed the life of his own son, the emperor's wish for a child would

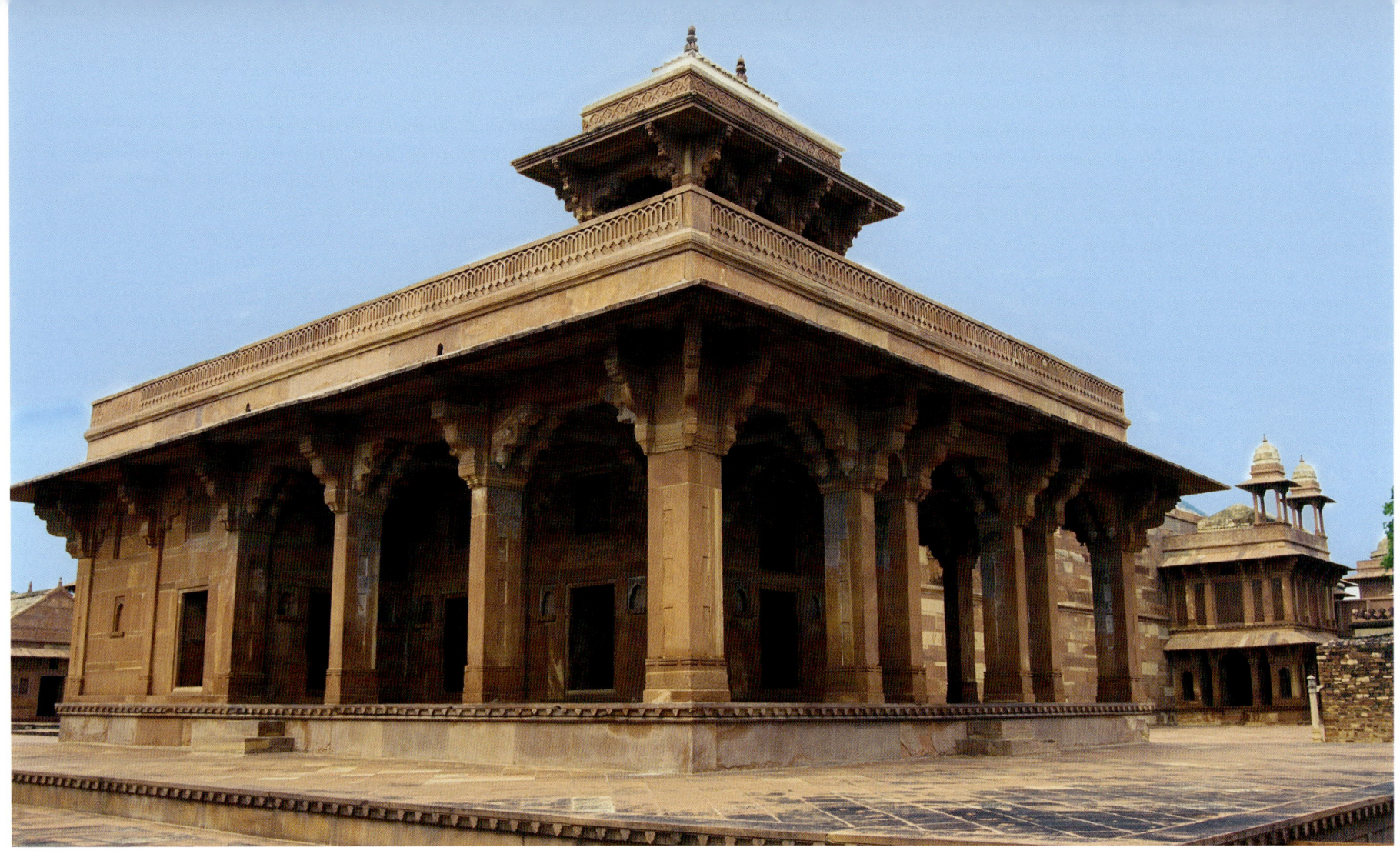

Sunahra Makan, commonly called Maryam-ki-kothi

remain unfulfilled. The child told the saint "if you will allow me, I will die in order that his Majesty may be consoled," and breathed his last that very moment. Nine months later Akbar's queen from Amber gave birth to a son, called Sheikhu Baba and later Salim by the Mughal emperor in sheer gratitude to the saint of Sikri.

There is some truth in the popular belief that Akbar built Sikri as a gesture of thanksgiving towards the renowned Sheikh Salin Chisti. Akbar's historian Abu'l Fazl wrote of Akbar's decision "to give outward splendour to this spot (Sikri) which possessed spiritual grandeur" by building a grand new set of royal palaces on the ridge of Sikri, Akbar regularly visited the tomb and *dargah* of the saint Muinuddin Chisti at Ajmer, the spiritual capital of Muslim India, called "Qaba of the East", Sikri was meant to bridge the gap and bring closer the spiritual and political capitals.

The village of Sikri was a forgotten city of some importance. It was at Khanwa, near Sikri, that Babar, Akbar's grandfather and founder of the Mughal rule in India, defeated the combined Rajput force led by Rana Sargran Singh in 1527 CE. Babar named the village Sikri and built a bath complex, a garden called Bagh-i-Fatehpur and a platform on the northern edge of the ridge. Five decades were to elapse before Sikri revived in political importance. This time as the centre of a splendid new city.

Attilio Petruccioli, a recent historian of Sikri, observes that the construction of Sikri was not such a simple gesture of thanksgiving: "First of all, the romantic hypothesis that the new capital was founded at the sovereign's whim for the purpose of establishing his residence in contact with the saintly hermit Shaikh Salin ad-Din Chisti must be shelved. Fatehpur-Sikri was a political operation implemented to achieve two precise aims. The town was conceived as a seat for the court through an operation analogous to that a century later when Louis XIV established his court at Versailles, centralizing the court in order to keep the nobility firmly under control. It is perfectly possible that Akbar set about controlling the various tribes (Rajput, Turks, Afghans, and Persians), who were continually at war with each other by the simple expedient of uprooting them either from their territories or from an economic centre such as Agra. That Fatehpur-Sikri is a residential city, a "gilded prison" for the court, and not a redundant Agra, is demonstrated by the insufficiency of its military defenses.

"The hypothesis that the whole city was constructed at once is also untenable. The sovereign's fervor for construction, the availability of manpower, the abundance of quarries in the environs, and the ingenious system of prefabrication with a dry-method assembly of elements is not enough to postulate the construction of such an extensive city over a period of just fifteen years".

The Imperial complex at Sikri is arranged in an echleon formation on the east-west axis on the ridge. The layout of palaces follows an irregular plan. The Hall of Public Audience forms the most important centre of this area approached through the Agra Gate, markets and *karkhanas*. This is the "public" section of the palace where Akbar performed his functions as the emperor listening to petitions and appeals of the people. Behind this public enclosure is the *mardana* section including the Diwan-i-Khas and the emperor's private apartments overlooking the ornamental tank. The *haramsara* or residences of the royal women are contained within a well guarded walled enclosure approached through corridors behind the *mardana* section. It is clear that the Imperial Mughal architecture at Sikri followed the layout of Arab and Central Asian tent encompments. The palaces are all built as separate free-standing units on a piece of level ground. This arrangement is vastly different from grouped-together formations of Rajput palaces in Gujarat and Rajasthan. The palaces at Fatehpur Sikri have the appearance of "a comfortable and certainly grand encampment. It was an urban form, somewhere between a camp and an imperial city", as observed by John P. Richards. The uniform look created by the use of red sandstone on all the royal structures has a rare grandeur

of its own, unparalleled in the history of Indian architecture.

The Diwan-i-Aam is the most important 'public' building, at Sikri. It stands at the eastern end of the ridge complex. Visitors and the common folk were admitted to the presence of the Mughal emperor who appeared seated on his throne in the large balcony secured within excuisite *jali* screens. The dispensation of justice was done fast. There is a huge stone hook in this courtyard to which was tied the royal elephant, which crushed the guilty to death. If the pachyderm refused to obey the commandment thrice, the culprit was released as not guilty. This is an interesting story unsupported by any historian but retained in the popular myths about Akbar's justice. However, Akbar's fondness for taming wild elephants is well recorded in contemporary chronicles and miniature paintings.

The most beautiful structure in the royal enclosure behind the Diwan-i-Aam is called the Khas Mahal or Diwan-i-Khas. It appears a double-storeyed structure with *chattris* at the four corners but internally it has a ceiling at double height. A grand pillar stands at the centre of the hall with four stone passages radiating from the central circular seat. This seat is supported by exquisitely sculptured brackets highly reminiscent of the carved brackets on the minarets attached to the mosques in Ahmedabad. The lower portion of the pillar is equally well carved, creating the most representative example of sculptural work in Mughal architecture. Sometimes it is believed to have been used as the Ibadat Khana where Akbar held religious discourses with various groups comprising Zoroastrians (Parsis), Jesuits, pundits and mullahs. Recent research on the architecture at Sikri, however, suggests a different location for this Ibadat Khana. Perhaps this pillar, Nav Rattan pillar as it is called, had a different function symbolising the axis of the world of the Hindu cosmology. The emperor held the most crucial central position. Still, the function of the pillar has inspired many academic conjectures, failing mostly to resolve the mystery and symbolism surrounding it.

At the southern end of the spectacular courtyard lies the Anup Talao, an ornamental tank with a raised platform at the centre and four stone bridges radiating from it. It is generally believed that the court musician Tansen used to hold his concerts here. Also Akbar had the tank filled up with gold, silver and copper coins for distribution amongst the poor and destitutes on special occasions. An admirably carved three-roomed pavilion stands overlooking the tank. It has erroneously been called the palace of Turkish Sultana, one of Akbar's wives. It is located in the heart of the *mardana* or the administrative section and could not have been occupied by a queen. The stone panels at this small palace resembling a jewel casket are carved over with splendid floral and geometrical patterns. The dado panels in the interior are covered with excuited reliefs depicting trees, flowers, birds and animals. The animal figures were defaced sometime after Akbar left Sikri in 1585 CE.

Akbar's private lodgings or the Daulat Khana O' Khas comprise a set of rooms standing on the edge of the Anup Talao. The concept of these rooms is essentially Persian. The central block is raised on a small plinth surrounded by a *verandah*. The vault of the inner chamber (typical for Fatehpur sikri is the ribbed coved ceiling, a convenient vaulting for rectangular halls) was, as usual in secular structure, concealed on the exterior by a flat roof. This design appears mainly on buildings reserved for the royalty. The Diwan Khana O'Khas has two rooms on the ground floor with traces of some paintings in the eastern room. The larger room has a unique structural feature - a platform supported on square shafts with a window opening. These rooms are also supposed to have housed the emperor's library in the hollows in the wall with sliding stone panels for protection from heat and moisture.

The *haramsara* contains the most important and beautiful palace, the Shabistan-i-Iqbal or Jodha Bai's palace. It is the largest residential palace at Sikri, important for its unique compact architectural composition, the finest example of a self-contained Mughal residential palace in the 16th century CE. Here one gets an insight into the domestic life of the great Mughal emperor. It is a well known fact that Akbar came to Fatehpur Sikri to seek the blessing of the Sufi saint Sheikh Salim Chisti. Akbar sent his chief queen, the Amber princess, to live at Sikri at Rang Mahal near the saint's private quarters behind the great Jami Masjid. In due course of time was born the first male child, the heir to the great Mughal Empire. Akbar celebrated the event with great pomp and festivities and called the child Sheikhu after the saint. In the history of the Mughals in India, Sheikhu came to be known as Salim, and, officially, as Jehangir.

This palace has been erroneously called Jodha Bai's palace by ill-informed guides to Sikri. Akbar had no Hindu wife named Jodha Bai. A Rajput queen who could have been so called was the daughter of Mota Raja of Jodhpur, married to Jehangir and mother of prince Khurram (later called Shahjahan). It seems certain that this grant palace served as residence of not only the Amber princess (mother of Salim) but all the other Hindu queens of Akbar's harem (the princesses of different states in Rajasthan). The early years of Salim and the two other sons of Akbar-Murad and Daniyal were spent at Sikri under the benign tutelage of the Sufi saint. This palace is one of the earliest structures built by Akbar at Agra and bears a striking resemblance to Jehangir Mahal at the Agra fort.

The entrance gateway at the Jodha Bai's palace is an impressive example of Mughal architecture, providing utmost privacy and security to the inmates of the harem and easily connected through galleries and covered passages to the emperor's private quarters over the Anup Talao. The palace consists of double-storeyed halls built around a sun-filled spectacular courtyard.

On the western side is the impressive '*thakurdwara*' or the private apartments with niches in the walls for holding images of deities. The architectural scheme and the sculptural embellishment is predominantly Hindu in style. These niches are surrounded with *toranas* as seen in the Jain temples in Gujarat and Rajasthan. Another typically Hindu architectural feature is the provision of narrow drains at the edge of the courtyard on all the four sides. At the centre of this great courtyard is a small but conspicuous raised stone planter, perhaps for the sacred '*tulsi*' plant. In a common man's house the '*tulsi*' plant is traditionally kept out of the house. Here for reasons of privacy of the harem ladies it finds a place within the palace.

There is a provision of stairs leading to the upper floor. On the northern and southern sides, the upper rooms have wagon-shaped roofs covered with blue tiles introducing a patch of colour on an otherwise deep red sandstone structure of the palace. The northern section also contains a large dining room and a section called the 'Hawa Mahal'. It is an extension of the room, like a projecting balcony covered with elegantly carved *jali* screens, providing views over the gardens and the huge lake beyond the Hathi Pol and the Hiran Minar. Just below the Hawa Mahal are passages, pavilions and gardens for the harem ladies.

The most remarkable architectural feature of Jodha Bai's palace is the solid strength of its structure, an unmistable rugged quality of design. The domes at the corners of the high walls add dignity to the structure. The fine projecting balconies provide an element of relief on this sombre but magnificent palace. The palace architecture also includes another feature in eschewing the use of arches. Instead we notice a pronounced preference to brackets and lintels so characteristic of the indigenous architecture in Gujarat and Rajasthan. The bases, columns and capitals at Jodha Bai's palace are fashioned too closely on the traditional temple columns carved over with small lozenges, semi-lotus resettes, and bell and chain motifs. The columns have been indulgently carved, first square in section, then octagonal, sixteen sided and finally circular in form. These soulptured columns are amongst the best examples of the freedom given to artisans and sculptors in building a Mughal palace with predominantly Hindu architectural features. A particularly remarkable feature borrowed from the architecture of Gujarat is the low panelled wall enclosing the ground floor, ornamented with elongated diamond-cut-reliefs and a carved perforated

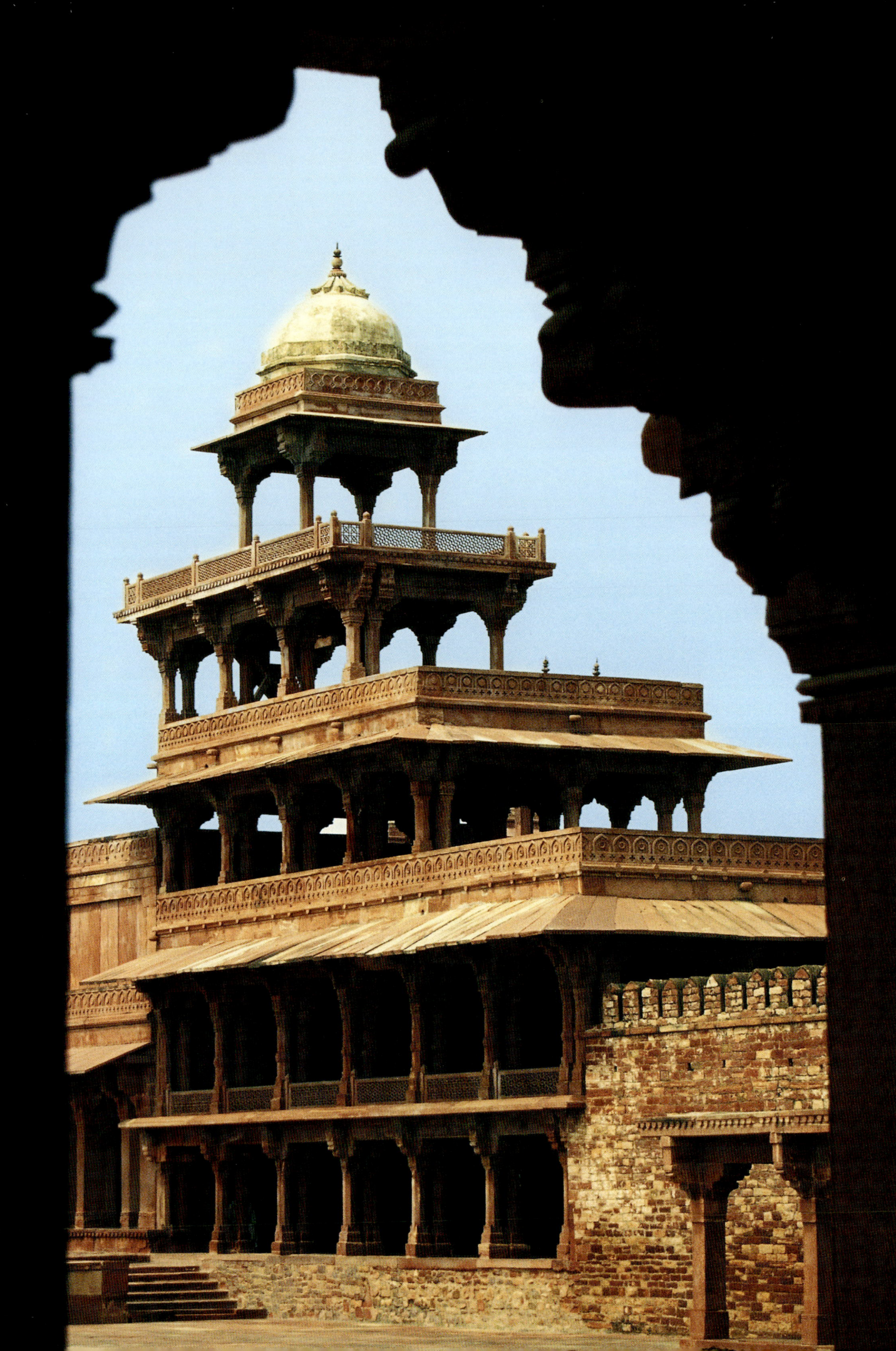

stone rail above it. The sloping eave or *chajja* over the openings went on to become a permanent part of the Mughal architecture in India.

Whereas Blochmann mentions seven wives of Akbar, the Mughal emperor had many more. He had entered into matrimonial alliances with the families of Rajput rulers in the 1560s to honour and conciliate these groups. This gesture also ensured some areas of peace in the vast Mughal Empire. According to Abul Fazl, Akbar's chronicler, the emperor's harem contained nearly 5000 women which, of course, included his wives, family members, relations and a host of "wives of nobles and women of chaste characters, a singular feature, open to misinterpretation. They were permitted to dwell in the harem for as long as a month. There is no evidence that the emperor transgressed the limits of decency; his purpose was to distinguish the family of the women so invited". In fact Akbar's harem was a mini-world in itself. Besides Jodha Bai's palace, there were other important palaces in the haram sara: Maryam's House or Sunehra (golden) Makan, Panch Mahal and Bir Bal's House and many other smaller residences extending well upto the Hathi Pol.

Undoubtedly, the Panch mahal is the most remarkable structure at Sikri. This five –storeyed pavilion is the most extraordinary building in the whole range of Islamic architecture in India. It had no specific purpose excepting its use as an excellent spot for viewing the vast environs and enjoying the cool breezes. It is located on the line separating the administrative or the '*mardana*' area from the haramsara. From the various floors, the women of the royal household could observe activities on the large Pachisi Court.

The Panch Mahal has five floors. The ground floor is divided into cubicles by screening the space between pillars. As it is there are eighty four pillars on the ground floor, fifty six pillars on the first, twenty on the second, twelve on the third and only four at the topmost floor. These short pillars are covered with relief work of an amazing variety and excellence. Each storey or floor was originally provided with *jali* screens between pillars. The Panch Mahal has no dome or minarets: it has wide eaves or *chajjas*.

Sunahra Makan is a small but absolutely picturesque palace within the haramsara. It derives its name from the splendid gilding on its walls both in the interior and outside which gives it the appearance of a picture gallery. It is a beautiful structure meant for the exclusive use of the most important person in the life of Akbar. Its popular name-Maryam ki kothi has led some to believe that Akbar had a Christian wife. This is a fanciful conjecture entirely unsupported by any historical reference. The paintings on the walls depicting winged figures are sometimes interpreted as depicting the annunciation. Stories from the Persian mythology or the Shahnama refer to such figures. In fact, Akbar's palace at the Ahichattragarh fort at Nagaur, near Jodhpur, has its walls and ceiling covered with paintings depicting winged figures.

The Sunahra Makan is sometimes believed to have been the residence of Salima Sultan Beghum, grand daughter of Babur. Another historically wrong guess is made suggesting the Jesuit Fathers as occupants of this palace. This is absurd as the haramsara was meant for the ladies of the royal household and no outsider would have been allowed entry into it. In all likelihood, the Sunahra Makan was occupied by Akbar's mother Hamida Banu Beghum, Humayun's widow, who was entitled Maryam-uz-Makani or Mary of the Age. Akbar held her in the highest regard. She had brought about reconciliation between Akbar and Salim when the latter rebelled against the Mughal emperor and set his own camp in Allahabad.

The Sunahra Makan is a double-storeyed palace. There are four rooms on the ground floor -one large oblong room (north to south) and three small rooms at the back on southern side. The upper floor consists of three rooms over the rooms below. The upper floor consists of three rooms over the rooms below. The larger room of the hall has a ceiling at double height giving it a particularly magnificent appearance. The terrace is surmounted with an elegant pavilion on four pillars.

At the northern end of the harmsara stands Bir Bal's palace, slightly isolated and distanced from the mass of other royal palaces. It is the most exclusively ornamented, double storyed structure used by, in all likelihood, by Akbar's senior queens. Completed in 1571 Bir Bal's palace stands on a high plinth. It has four square rooms on the ground floor and two on the upper floor in a diagonal arrangement. The ornament is profuse; elegant and crisp. *Chajjas* and brackets are the most prominent part of its architectural scheme. The geometrical pattern, the Islamic pointed arch on shallow arched niches and an overall accented relief crumentation is highly reminiscent of the excellence of woodcraft in Gujarat.

The uniformly high standard of craftsmanship on red stanstone veneer creates a rare splendour though the whole effect, according to G.H.R. Tillotson, sums up as a "cabinet of curiosities" and an elaborate medley of diverse architectural traditions. The ornamentation here shows the concrete effect of Akbar's syncretic vision and his liberalism towards Indian craftsmen. It is quite unlikely that the Mughal emperor sought to make any political statement bringing together the best of both architectural traditions.

Besides these palaces within the extensive haramsara, there is another small palace which deserves notice for its tremendous relief and sculptural ornamentation. This is the small three-roomed pavilion, mistakenly ascribed to a lady called Turkish Sultana. It stands close to the Anup Talao. The stone panels both in the interior and outside are covered with the most luxuriantly carved floral and geometrical patterns. The stone panels both in the interior and outside are covered with luxuriantly carved floral and geometrical patterns. The dados are examples of the most exquisite naturalistic carving including trees and lions, birds and flowers. The animal figures were defaced by people after Sikri was abandoned by Akbar in 1585 CE. These lions, like the elephant statues on the Hathi Pol near the Caravasarai, offended the inconoclasts who took over Sikri after the Mughal emperor moved to Lahore to be near the northern borders of his great kingdom.

The desertion of this spendid city has been a subject of considerable debate amongst scholars. Reasons of security on the northern borders were very crucial to the Mughal kingdom but there seems to have been another reason for the abandonment of Sikri. At first Akbar was drawn to Sikri to be close to the Chisti saint Sheikh Salim with whose blessings he got three sons. The saint exercised tremendous spiritual hold over the people. Akbar built a tomb of the saint after his death within the mosque. It was a meaningful gesture as it suggestively brought the Chisti mystical set up within the folds of orthodoxy, "appropriating his friend and mentor to his own imperial purposes". The saint's heirs were enlisted in the imperial service and the emperor held an indirect and unseen control over the Chisti centre. Gradually Akbar's fascination for the Chisti saints started fading and he drifted away.

The influence of the family of Sheikh Mubarak, a free thinking liberal theologian and his two sons-Abu'l Fazl and Faizi, discussions with various religious groups at the Ibadatkhana, growing inclinations towards Hindu rituals like sun worship found a greater response in the imperial heart. The English Victorian poet Mathew Arnold nearly sums up Akbar's mind in these lines from 'The Dover Beach':

"The Sea of Faith
was once, too, at the full, and round earth's shore
Lay like the folds of a bright girdle furled:
But now I only hearlts melacholy, long, withdrawing roar...."

Akbar's own religious thoughts led him towards a new imperial religion away from the orthodox forms of Islamic piety. The Chisti saints at Ajmer and Fatehpur Sikri no longer charmed him and, as John F. Richards argues, "When Akbar abandoned Fatehpur-Sikri, he abandoned one mode of legitimacy for another".

Panch Mahal, a five –storeyed pavilion

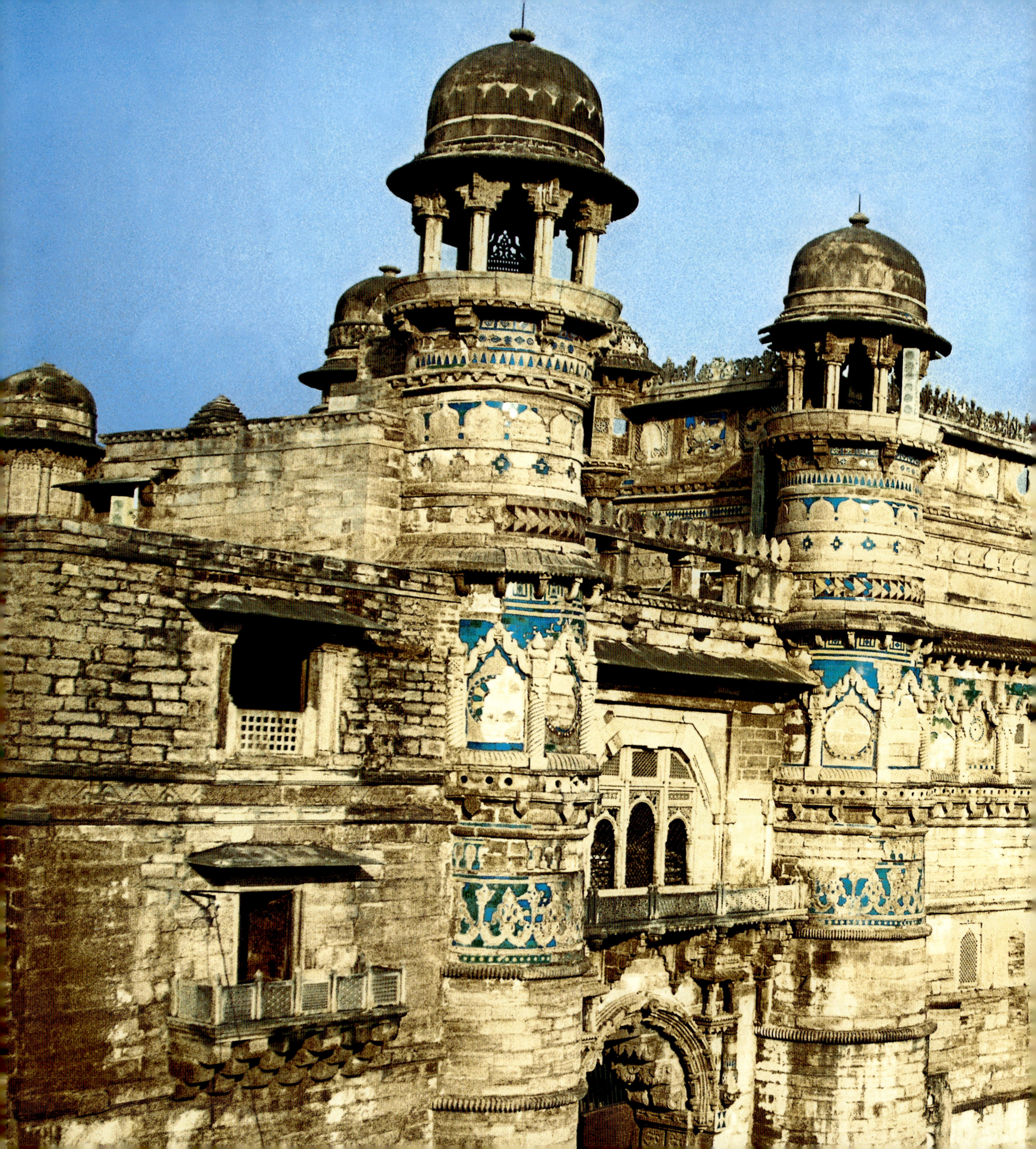

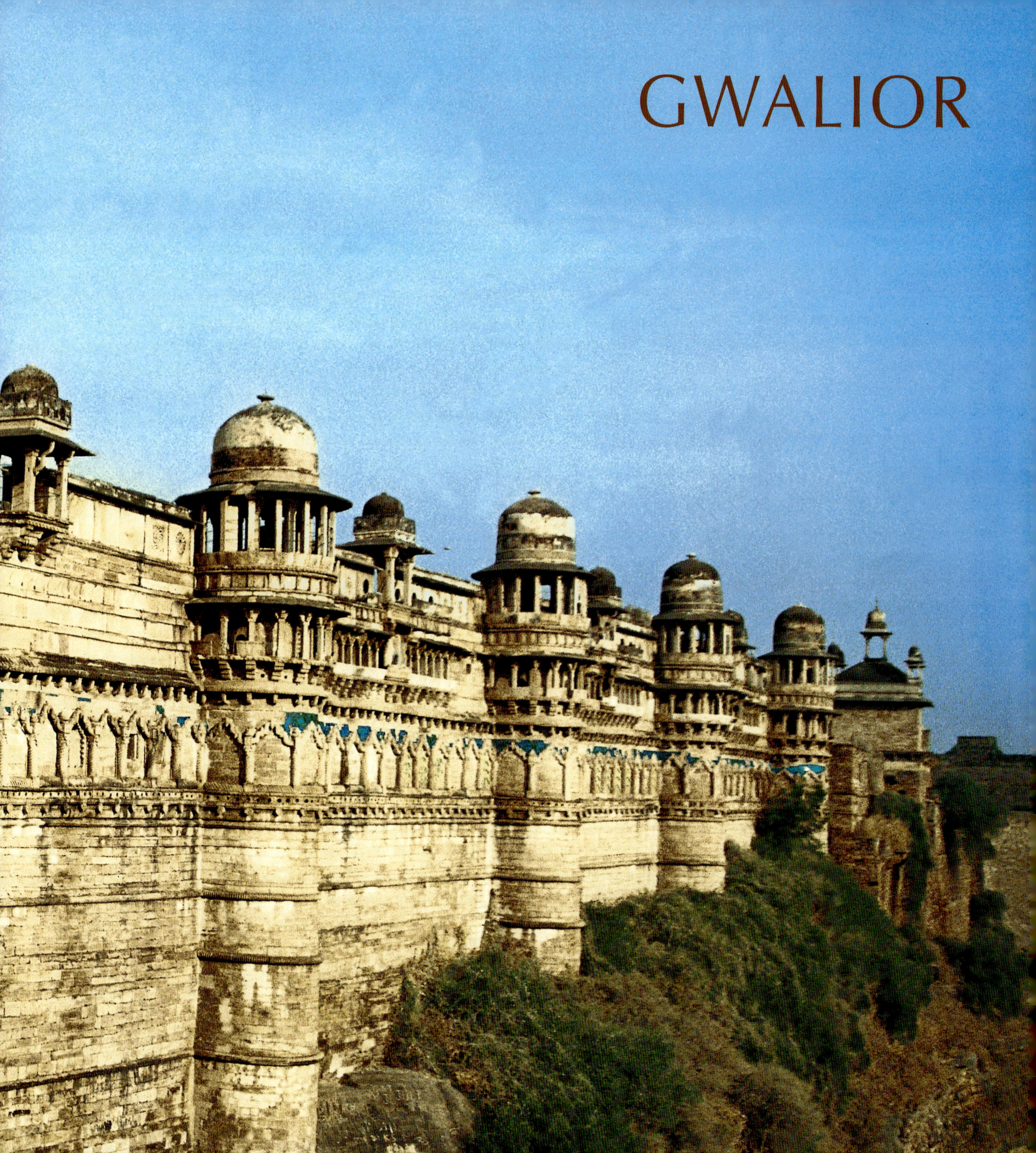
GWALIOR

Previous pages:
Gwalior fort bastions

The Gwalior fort is amongst the most ancient forts of India. It crowns a 300 meter high isolated sandstone hill. From the city sprawling below the ramparts, it presents the most perfect and spectacular setting for a fort regarded as a pearl among the forts of this country. The hill has always enjoyed reputation as a *tirtha*, held sacred by the sages and the people. Gwalior finds mention in the Puranas as Gomanta, and variously referred to as Gopagiri or Gopachala, peopled by the cowherd people who inhabited the region since long forgotten centuries.

It is generally believed that Suraj Sen, a Kachchwaha chief of Kantipuri, was blessed here by a saint known as Gwalipa. The chief was offered water from a sacred tank. The miraculous medicinal properties of water cured him of leprosy. In gratitude to the ascetic, Suraj Sen decided to enlarge the tank called Surajkund after him, and built a magnificent fort on the hill. Gwalipa prophesied that Suraj Sen's dynasty would rule for as long as his successors retained 'Pal' after their name. The Kachchwaha dynasty, believed to have been founded by Suraj Sen began its long rule in 275 CE. The last ruler decided to test the veracity of the prophecy: he changed his name to Tej Karan, instead of Pal. The consequence was predictable. He lost his power and the dynasty's rule came to an end in 1129 CE. The Kachchwahas were replaced by the Pratiharas who ruled over Gwalior till Iltutmish conquered the fort in 1232 CE. The Tomar dynasty came into power with Bir Singh Deo proclaiming his independence in 1398 CE. The Tomars at Gwalior were the descendants of the Tomars of Delhi. The long tenure of these three dynasties was occasionally interrupted by invasions form the neighboring states and a temporary loss of power.

The Chandella ruler Dhanga conquered Gwalior in C. 954 CE. Kirti Raja, Dhanga's feudatory, was in command of the fort when, in 1021-22 CE, Mahmud of Ghazna, attacked Gwalior on his way to conquer the Kalinjar fort. Kirti Raja's courage gave way too soon and he sued for peace by offering 35 elephants to Mahmud. Gwalior had already acquired a tremendous strategic importance amongst forts in north and central India. Both Qutbuddin Aibak and Iltutmish, early rulers of the Delhi Sultanate, conquered Gwalior. It was through the vulnerable western sector of the hill-the Urwahi valley that Iltutmish could force entry into the fort. The terrible battle led to a *jauhar* by Rajput ladies who preferred to immolate themselves rather than suffer dishonour by invaders. The Jauhar Tal in the fort still stands in testimony to the unhappy turn of events following the invasion by Iltutmish. An inscription over the gate of Urwahi built by Iltutmish records the year of his victory as 1232 CE. The Gwalior fort passed through different hands and dynasties for varying periods. The fortifications over the hill were strengthened by different rulers. Also built over the centuries are a great number of wells and reservoirs in the fort and also some of the formidable and massive gateways on the uphill climb from the north-eastern side. The abundance of water resources at the fort enabled Gwalior rulers to put up prolonged resistance against invaders. The forts at Kalinjar and Ajaygarh had to surrender to invaders because of the drying up of tanks and reservoirs within these forts.

The Tomars started a glorious phase in the history of the Gwalior fort. This phase, beginning in 1394, witnessed unprecedented architectural activity in the fort-wells, *baolis*, palaces and strengthening of defence works. Man Singh Tomar, the most illustrations Tomar ruler, is identified as the author of the magnificent buildings on the north-eastern front and the Badalgarh redoubt outside the fort as an independent defence post.

The approach to the central entrance is by a precipitous path, punctuated by six gateways placed at strategic points to thwart the enemy's march to the fort. These gateways, Por as they are called, are built at different times. The Alamgiri Gate, the Hindola Gate, the Bhairon Gate, the Ganesha Gate, the Lakshman Gate, the Hathi Gate and the Hawa Gate. The Hindola Gate stands towards the western end of the hill. The Hawa Gate has now completely disappeared. The winding uphill road terminates at the Hathi Gate or Por. Here the central arch is ensconced between two semi-circular gigantic towers, stylistically similar to the other four towers on the eastern façade. It is not a true arch but a corbelled arch decorated on the outerside with an arc of beeding. In fact, both the projecting corbels and the ornamental arc- "establish contradictory rhthyms". The central arch is flanked by two small *jharokhas* (projecting, canopied windows). A triple-arched pavilion with a long projecting balcony supported by brackets forms the upper storey. The balcony joins the two towers. Babur had noticed the statue of an elephant with two figures, a *mahout* (driver) and an owner (ruler) standing close to the exit gate, also noticed by Abul Fazl. In 1610 CE, the English traveller William Finch mentioned this "curious colossal figure of an elephant in stone". It stood at the Hathi Por for more than one hundred years till Muzffar Khan, Mughal governor of the fort, appropriated it and set it up again at the north gate of the fort as a memorial to an elephant owned by him. Nothing is known about this massive statue thereafter.

The view of the Gwalior fort from the Hathi Por is the most spectacular. The vast expanse of the wall towards the northern section is broken by four massive circular towers, or six including the two towers on the Hathi Por, functioning as pilasters or buttresses to strengthen the construction. These towers are surmounted by cupolas and the parapet between cupolas is further decorated with canopied *jharokhas*. The upper section of the wall is articulated with string course and arcades of *torana* (engrailed arches). The most remarkable part of the ornamentation relates to the profuse application of glazed tiles in bright turquoise, blue, green and yellow colours creating elegant motifs-elephants, peacocks, tigers, ducks and plantains. Under the early morning sun the face of the Gwalior fort presents a picture of unexcelled architectural grandeur unhampered by trees or vegetation obstructing the view.

Babur, the first Mughal emperor, provides the earliest description of the buildings at the fort, following his first visit after the conquest of the fort in 1528 CE: "I visited the buildings (*imaratlar*) of Man-Singh and Bikramjit thoroughly. They are wonderful buildings, entirely of hewn stone in heavy and unsymmetrical blocks however. Of all the Raja's buildings Man-Sing's is the best and loftiest, It is more elaborately worked on its eastern face than on the other. This face may be 40 to 50 *qari* (yards) high, and is entirely of hewn stone whitened with plaster. In parts it is four storeys high; the lower two are very dark; we went through them with candles. On one (or, every) side of this building are five cupolas having between each of them a smaller one, square after the fashion of Hindustan. On the larger ones are fastened sheets of gilded copper. On the outside of the walls is painted-tile work, the semblance of plantain-trees being shown all round with green tiles. In a bastion of the eastern front is the Hati-pul, *hati* being what these people call an elephant, *pul*, a gate, A sculptured image of an elephant with two drivers (*fil-ban*) stands at the outgoing (*chiqish*) of this gate; it is exactly like an elephant; from it the gate is called Hati-pul. A window in the lowest storey where the building has four, looks towards this elephant and gives a near view of it. The cupolas which have been mentioned above are themselves the topmost stage (*murtaba*) of the building; the sitting-rooms are on the second storey (*tabaqat*), in a hollow even, they are rather airless places although Hindustani pains have been taken with them. The buildings of Man-Sing's son Bikramajit are in a central position (*aurta da*) on the north side of the fort. The son's buildings do not match the father's. He has made a great dome, very dark but growing lighter if one stays awhile in it. Under it is a smaller building into which no light comes from any side. When Rahim-dad settled down in Bikramajit's buildings, he made a rather small hall (kichikraq talarghina) on the top of this dome. From Bikramajit's buildings road has been made to this father's, a road such that nothing is seen of it from outside and nothing known of its inside, a quite enclosed road". "Both these palaces-Man Singh's and Vikramamjit's, are still there; Man Signh's palace, called the Man Mandir has survived in its pristine unaltered, undamaged form but Vikramajit's palace is almost completely ruined.

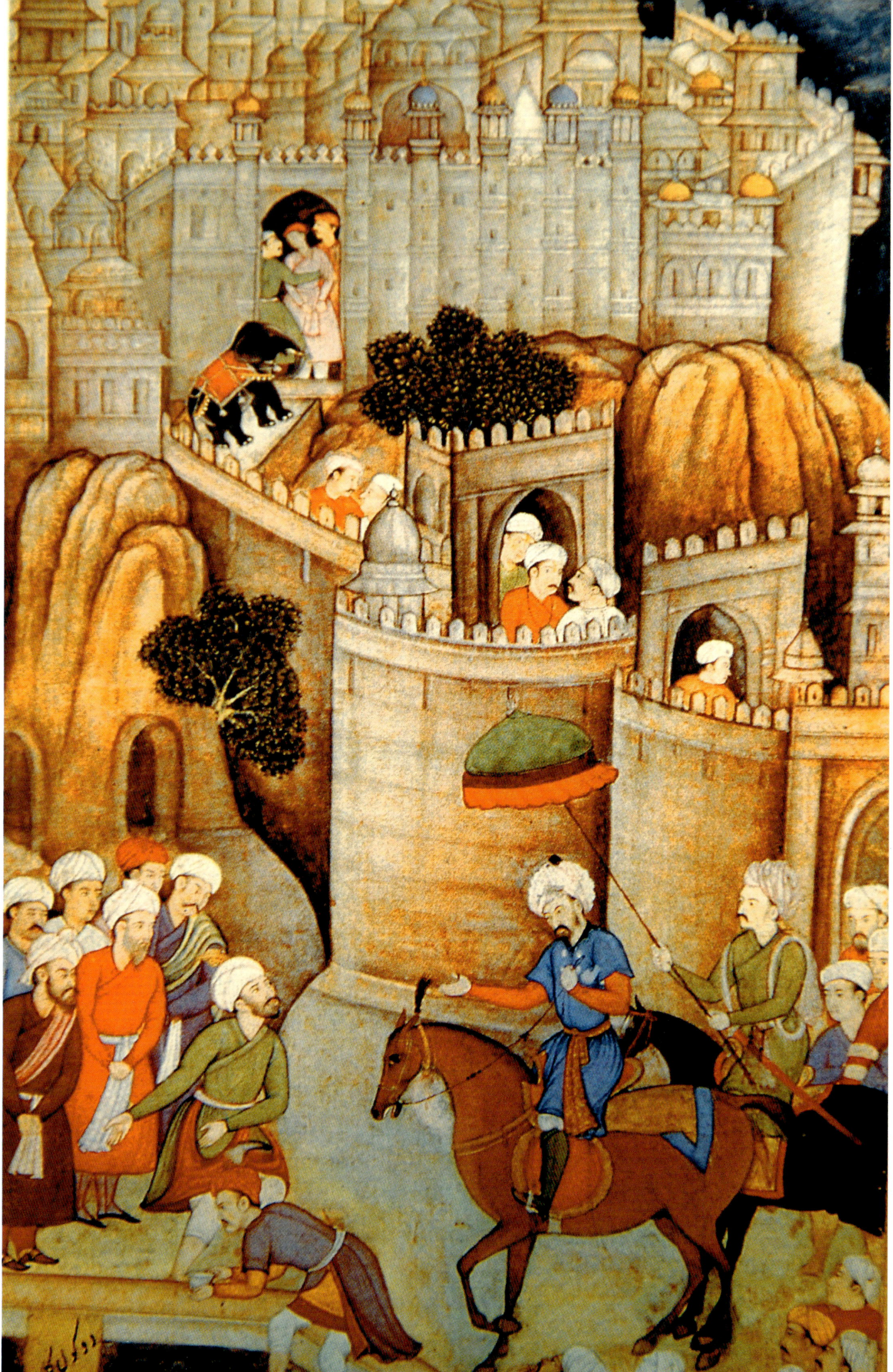

This page:
Miniature showing Babur's visit to the Gwalior fort

Clockwise from top:
Tilework on the balcony; Man Mandir's exquisite circular columns and capitals; Kirti Mandir ruins; The Sas-Bahu temple

The Man Mandir is the pride of the Gwalior fort, the most splendid architectural creation in the whole of northern and central India, inspiring many a Mughal buildings at Akbar's forts at Agra and Fatehpur Sikri. Evidently architects from renowned capital cities like Chittaur, Mandu and Chanderi contributed their knowledge and experience to build this great palace. It is built in two sections. The outer section, a double storeyed construction, was meant for attendants and keepers. The royal section has been built around two small court-yards. It is a double-storeyed construction supported by two under-ground storeys towards the eastern front where the slope of the rock presented this necessity to the architects.

The first courtyard is a modest square of 33 feet surrounded by pavilions. The piers of trabeate arched openings are massive and modest in height. There is a profusion of relief decoration all over the surface of piers, walls and ceiling. The walls are thick enough to contain within themselves secret staircases going up and down, leading to chambers enveloped in darkness. From the south-eastern side one gets into a circular room about 39 feet in diameter with eight pillars arranged in a circular fashion. Heavy iron rings on the beams could have been used for hanging swings for the ladies but more probably this room was used as a torture chamber for royal prisoners-princes and chiefs who had grown too ambitious and inconvenient for the ruler and had to be removed from the scene. Some Mughal princes-Jehangir's eldest son Khusrau and Aurangzeb's brother Murad Baksh were confined here, fed on opium and languishing in the darkness awaiting a sure but delayed termination of their miserable life. Even in broad day light the interiors of the Man Singh palace remain enveloped in semi-darkness. The surfeit of relief ornamentation ntowithstanding, one feels restless to leave the confines for more sun and air.

The Man Mandir is a group of rather small close-set apartments where the want of openness is amply compensated by an amazing variety of ornamental features-the designs of piers and pilasters, trabeate arches and brackets, trellis work and relief carving of an extraordinary standard.

The piers, despite their massive forms have been indulgently covered with lovely patterns-geometrical designs, and diamond patterns half-lotus designs. The flaring lotus abacus on pilasters is the most impressive part of this ornamentation. The reliefs depicting semi-circular formation of lotus leaves fanning out over the arches in the interior are superbly executed. The brackets are equally impressive. The slender serpentine brackets owe their form to similar work at Chittaur and Chanderi betraying an awareness of contemporary trends in sculptural oramentation.

The Man Mandir remains the most beautiful palace at the Gwalior fort. Vikramajit Mandir, as observed by Babur, was connected with the Man Mandir through concealed passages. The structures of the palace were perhaps all demolished and the stones thus obtained reused in building the two Mughal palaces. The only surviving portion of the Vikramajit Mandir is a large square *baradari*. It is covered by a dome supported by eight curved ribs. This open pavilion was converted into a closed hall during the Mughal occupation of the fort.

The Kirti Mandir or Karan Mahal was built by Kirti Singh (1454-1479 CE). It is a double storeyed narrow building with plain stepped walls, small square window openings and projecting balconied windows or *jharokhas*. The structure betrays a striking resemblance to the palace of Rana Kumbha at Chittaur. It has only a single large hall flanked by small chambers. A *hamman* was added to the palace by Rahim Dad for the Mughal emperor Babur. The Kirti Mandir has extreme dimensions of 200 feet by 35 feet.

A palace was also built for Sher Shah at the Gwalior fort but later suitably restructured for Jehangir. It is a large square pavilion with *chattris* at the four corners. The Shahjahan Palace was initially meant for Humayun. It occupies the edge of the north-eastern section of the fort on a precipitous cliff overlooking the old city and providing a grand view over the Gujari Mahal below the ramparts. All these palaces are now in shambles but the Man Mandir, built in red sandstone, predating these constructions, survives in full glory.

Compared to the splendour of the Man Mandir, the Gujari Mahal lying at the beginning of the ascent of the road to the fort is a modest structure. Built for the brave and beautiful cowherd girl called Mrignayani, Man Singh, her paramour, had this palace planned around a spectacular courtyard. Most of the structures here have collapsed. A few suits with their own small courtyards and galleries house a splendid archaeological museum. The exterior walls are relieved by string course and corners surmounted by domed balconied projections. Man Singh Tomar was not only an able and astute ruler but also a great patron of architecture and fine arts. As a musician in his own right, Man Singh was especially fond of the Sankiran *ragas* or mixed modes. Four of such *ragas* are named after his beloved queen Mriganayani Gujari, Bahul-Gujar, Mul-Gujari and Mangal-Gujari. The Gujari Mahal, built for a supremely enchanting beauty, today houses another great beauty-the salbhanjika from Gyaraspur, a damaged sculpture of a divine beauty with a fulsome torso and an inscrutable smile. It is a piece of classic beauty exhibited in art galleries all over the world. This salbhanjika is the most renowned masterpiece of Indian sculptural art.

The Gwalior fort stands over a sacred site and has been a centre of worship for centuries. The Chaturbhuja temple is located half way up the ascent to the fort from the Alamgiri gate. One inscription here refers to Vishnu as Trivikarma and the relevant image appears on the northern bhadra niche of the temple. Dated 875 CE, this temple was built by Alla, son of Vayilla Bhatta, guardian of Gopadiri. In its hewn out of the rock' style, this temple resembles though faintly, the Maladevi temple at Gyaraspur, near Vidisha in Madhya Pradesh. It is a small temple with a garbha griha. The mukha mandapa, facing east, is noteworthy for its two front pillars and back pilasters. Lintels are covered with reliefs of Krishna-lila scenes. The royal patronage assured revenue grants for maintenance of the temple.

Though the original hermitage of the sage Gwalipa was destroyed by invaders, it has generally been identified with a roadside shrine on the road leading to the Hathi Por. The Gwalior fort, however, has two magnificent

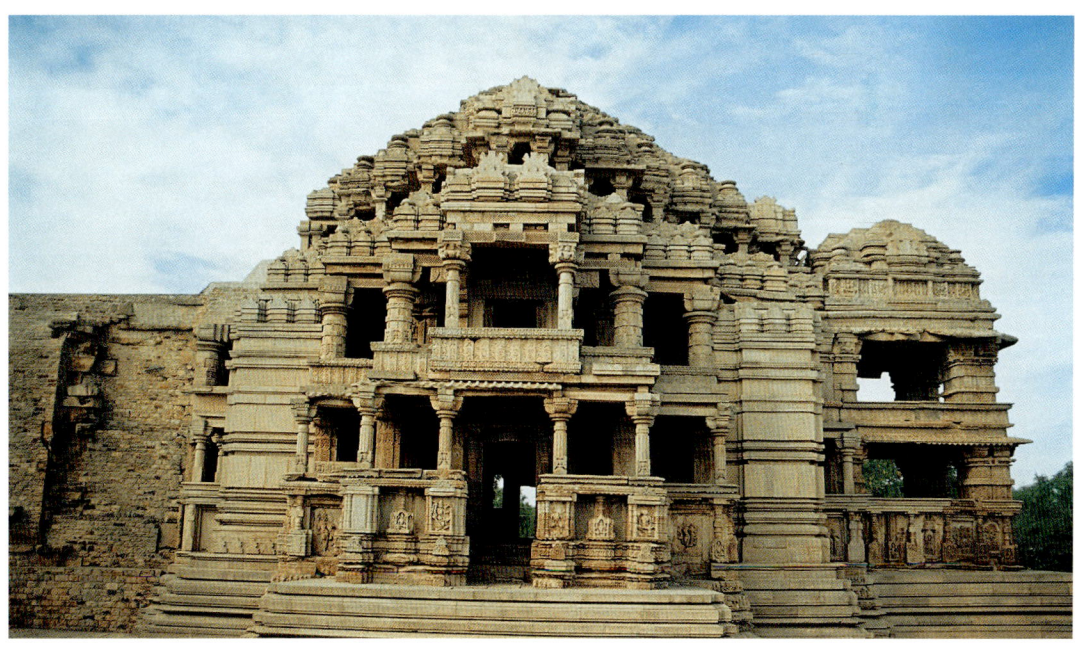

temples noted for their architectural features. The Teli Ka Mandir, so called, perhaps, because of its architects from Telengana or south India and the shikhara, remarkable for its wagon-vaulted roof, making a rather unusual appearance in northern India. It is the tallest and most splendid example of sacred architecture at the Gwalior fort. It has been ascribed to the 8-9th centuries CE. It is the most ambitious architectural work of the Pratihara rulers at Gwalior. The Teli Ka Mandir is remarkable for its rhythmic and elegant proportions, descreet ornamentation, judicious distribution of carved and plain surfaces, and most importantly, of the commanding verticality of its massive structure. The doorway has received impressive

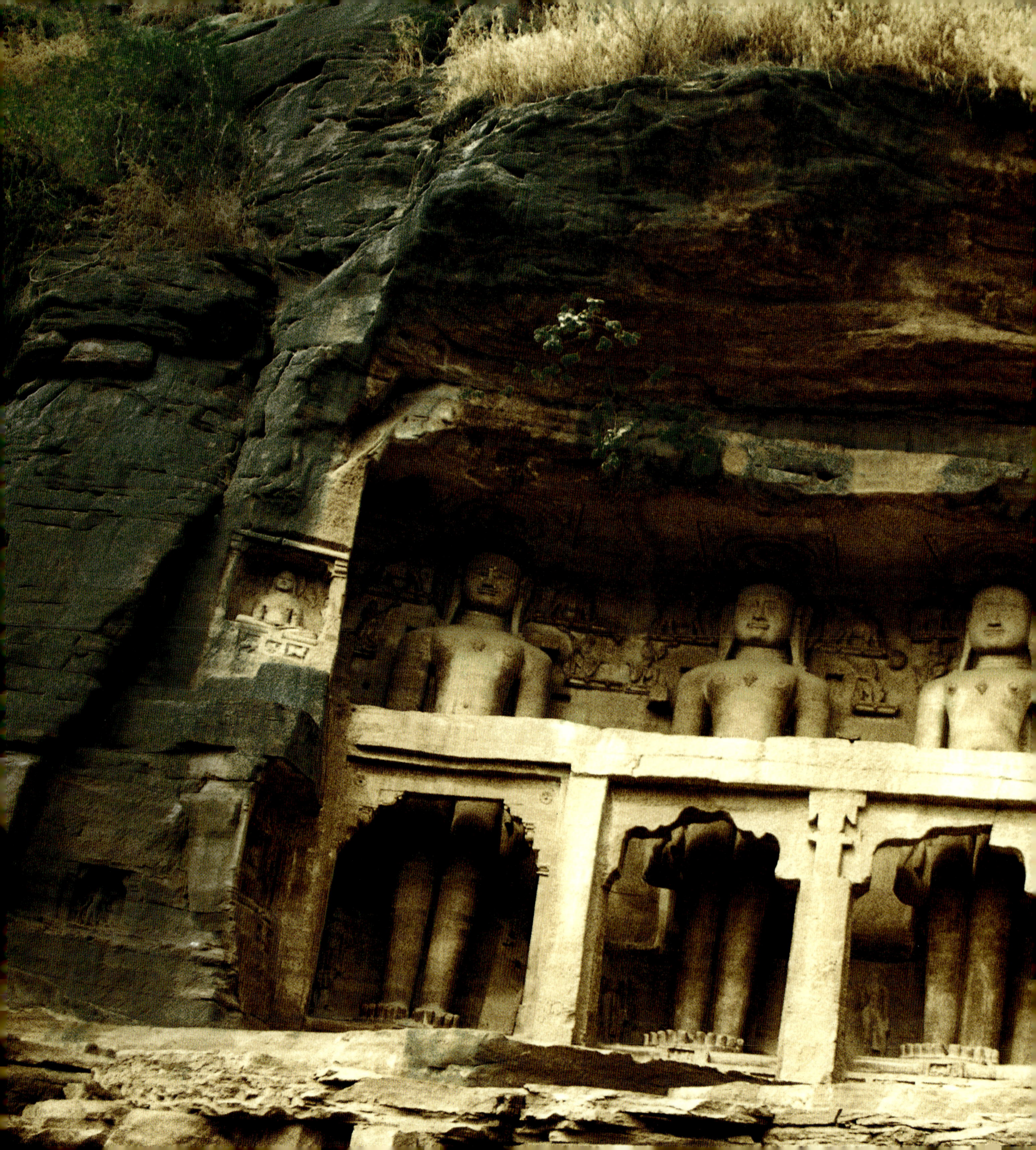

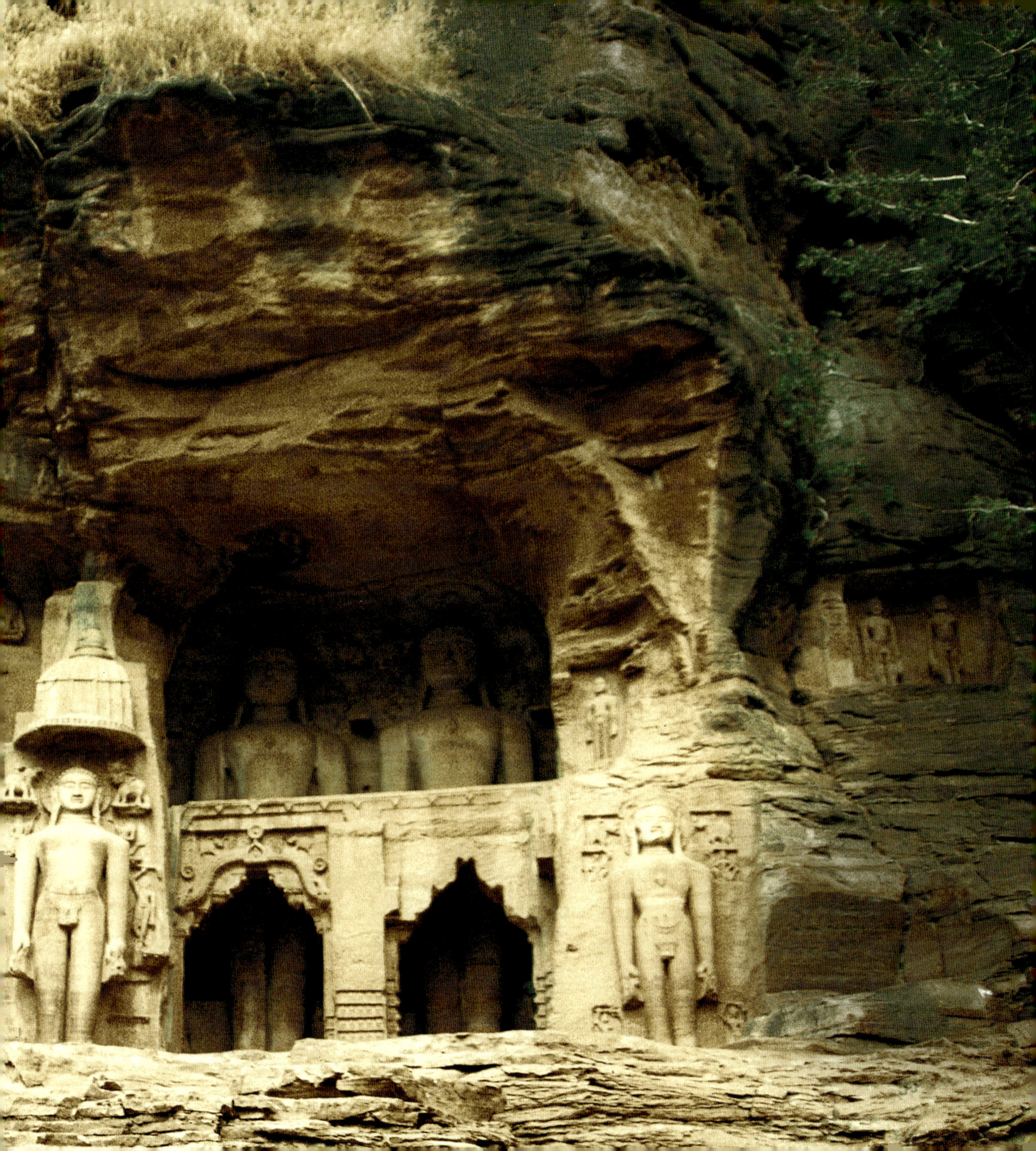

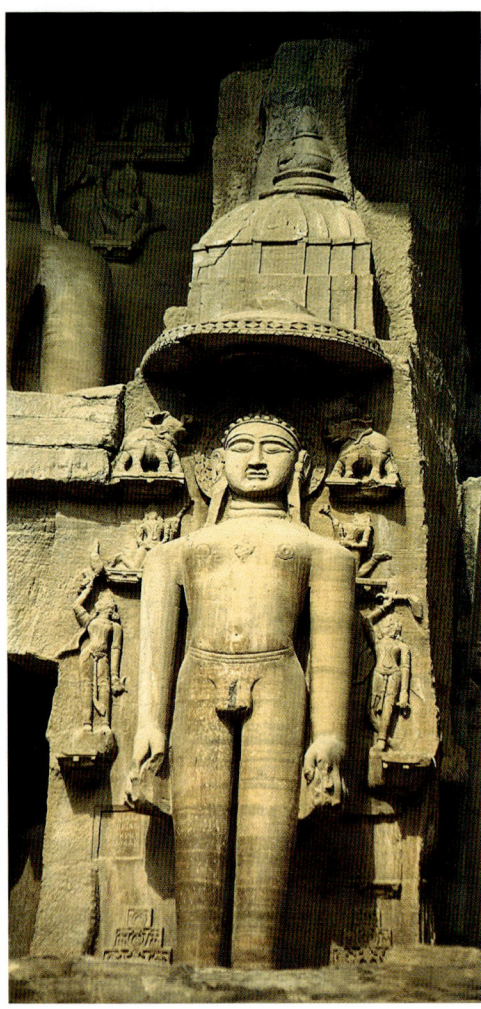

Precious pages:
Gigantic statues of Jain tirthankaras near the Surajkund
Clockwise from top:
A tirthankara in meditation; Jai Vilas Palace; A reception room in the palace

sculptural decoration with river goddesses-Ganga on the right and Yamuna on the left sides.

The Teli Ka Mandir has quite a few distinctive features: there are no projecting windows on the exterior and also no eaves or *chajjas*; the Vallabhi roof appears like a gigantic *surasenaka* (pediment made of large *gavaksha* window) of two stages; large circular apertures, resembling huge chaitya *gavakshas* on both the shortened sides of the Vallabhi roof; and elegantly executed tall, almost exaggerated, pediments comprising chaitya gavaksha motifs.

The other most famous example of sacred architecture at the Gwalior fort is the small group of Sahasra-Babur or Sas-Bahu temples, erroneously called the mother-in-law (*sas*) and daughter-in-law (*bahu*) temples. These are dedicated to Vishnu. The mammoth structure of the larger (*sas*) temple is externally in three storeys with galleries and loggias on all sides interspaced with piers and pillars, skillfully manipulating the effects of large open arcades, solids and voids. Four massive columns in the interior support the huge vaulted ceiling over the height of three storeys with balconies projecting over the space below. This ingenious engineering skill applied to resolve the architectural problems in the interior through the use of beam and pillar device later on was used to tremendous advantage by architects at the mosques in the Ahmedabad and Champaner. The smaller (*bahu*) temple is an open-pillared *mandapa* with balcony seating and a phyramidal roof. The corbelled slabes forming the compelx vaulted ceiling evidence an architectural skill of the highest order. The Sas Bahu temples are ascribed to C.1093 CE. The smaller (*bahu*) temple stands almost on the edge of the precipice.

The Gwalior fort also contains some rare examples of gigantic sculptures of Jain tirthankaras. These nude sculptures are carved out at various prominent spots on the periphery of the stupendous rock on which the fort stands. Most of these sculptures were chiseled between 1440 and 1480 CE during the reign of Durgendra Singh and Kirti Singh. The most remarkable point about these sculptured images is their towering height. The best images are to be seen on the rocks at the Urwahi valley. The largest image is that of Adinatha. It is 57 feet tall. A 30 feet high seated image of Neminatha is equally impressive. These images are fashioned in accordance with the canons of Jain iconography, complete with lotus, parasole, sprinkling of flowers, the gandharvas and the cognizance etc. Some of the standing images are so chiseled as to have their waist section hidden behind the corbelled doorway, also a part of the rock. Babur found the nudity of these sculptures offensive to his taste and "ordered them destroyed". His men, however, only mutilated the images. The broken heads of some images were later restored with coloured plaster by the Jains. The Urwahi valley section of the fort was strengthened by various rulers as a safeguard against the natural vulnerability of the region. Wells and tanks were dug on this side of the Gwalior fort. The Suraj Kund reservoir, whose water had cured Suraj Pal of his affliction, also lies close to the Urwahi sector.

The British added their own military structures near the Vikramajit Palace and demolished many a small buildings to provide space for movement of the troops. The interior of the Teli Ka Mandir was converted into an army canteen and sculptures set up in the open to create ambience of an Italian garden.

Two buildings outside the Gwalior fort deserve a special mention. The tomb of Muhammad Ghaus is remarkable for its architectural details. It is a square structure with hexagonal corner towers surmounted by small domes. The most attractive part of the architectural scheme is the *verandah* enclosing the square structure. The space between the pillars is filled up with exquisitely fashioned trellis screens filtering in enchanting patterns of light and shade creating the enchanting effect of stained glass. Muhammad Ghaus, the holyman of Gwalior, was instrumental in obtaining entry of Babur's forces into the fort. Working on the stratagem suggested by the Ghaus, Rahim Dad offered to send into the fort only a few soldiers to prevent the Tomar soldiers. Tatar Khan, the Afghan governor of the fort accepted the offer. The Mughals posted at the Hathi Por opened the gate at night letting the whole army in. Tatar khan was outnumbered by the Mughals and though the Mughals had entered the fort at his invitation, he had to surrender the fort to Babur's general to inaugurate a new regime, all courtesy Muhammad Ghaus who died in 1563 CE. This magnificent tomb, built during the rule of Akbar, is of the same date as the tomb of Humayun in Delhi, also built by Akbar.

The other important monument in the city is the small tomb of Tansen, one of the legendary musicians at the court of Akbar. It is a rectangular pavilion with twelve outer pillars, built over a platform near the large tomb of Muhammad Ghaus. A music festival here is an annual feature. It is popularly believed that leaves from the tamarind tree at the tomb are particularly conducive to a melodious voice. A visit to the tomb is a not-to-be-missed occasion for aspiring and ambitious singers.

Jai Vilas Palace

The city of Gwalior is famous for its hilltop fort, the most stupendous fort in the country. But the city also contains another architectural work of immense splendour-it is the Jai Vilas Palace or the Palace of victory. This great palace was built in 1874 CE, the time when most princely states in India felt encouraged to build grand new palatial residences outside the massive forts, thus stepping out of the medieval world into the modern period. The British presence and the guarantee of support against any other state in case of any intruson also led the royal families to build palaces in the open country where their most important and prominent guests were the British royalty and officers. The Jai Vilas was itself built to mark the occasion of a visit by the Prince of Wales in 1876 CE. Jai Vilas is the current residence of the royal Scindia Family.

The Jai Vilas Palace was built by Jiyaji Rao, the Scindia ruler whose steadfast loyalty to the British remained unaffected by the nationalist movement during the far-spread Revolt of 1857 CE. It is interesting to note that Jiyaji Rao's treasurer Amerchand Banthia embraced the cause of the rebels and was duly hanged for the crime.

The Jai Vilas Palace was designed by an Italian designer, Sir Michael Filose. Members of his family had served the Indian army and Filose was well known to many royal families. The royal residence of the Scindias presents a medley of different architectural styles from European countries. Here Michael Filose was able to build a magnificent palace 'along the lines of an Italian palazzo'. The ground floor is Tuscan, the first floor is Italianate and the second floor is Corinthian. The most important range in the palace is indicated by the group of small turrets on the roof. The whole structure has been built in sandstone painted brilliant white to simulate the splendour of white marble. The palace has been laid-out in a vast landscaped park. It has four wings around an inner court. The approach to the palace is provided through a gigantic gate in cast iron.

Michael Filose was fully aware of the requirements of an Indian royal residence which also included sections for administrative staff and a great hall for state ceremonies. In almost all the forts and palaces this provision for a grand and separate reception hall had always been a part of the traditional architectural scheme. The Mughals also paid special attention to the Diwan-i-Aam where the emperor sat in full pomp and splendour to conduct business of the empire, dispense justice and watch entertainments etc. The Jai Vilas Palace also follows this time-honoured

tradition. The Darbar Hall where the Maharaja met his peers, ministers, petitioners and visiting dignitaries is the showpiece of splendour at the palace. Internally a crystal staircase leads to the hall which is beautifully decorated in 'a Victorian interpretation of a grand 18th century classical style with ceiling picked out in gilt ... abalze with gilded detail and golden curtains'. The piece d' resistance at the Darbar Hall are the two of the world's largest chandeliers, weighting over three tons each hanging from the magnificent arched ceiling. There is a provision for nearly 248 candles on each chandelier. These massive fountains of glittering light are so heavy that, as per stories about their installation, ten elephants had to be suspended from the ceiling to test its strength and ensure that the mighty weight did not bring down the ceiling. The Darbar Hall also contains the largest carpet in Asia made in the Gwalior jail.

Presently some 35 rooms of the Jai Vilas Palace have been converted into a museum displaying artefacts collected by the Scindias and some of their grand possessions are exhibited here under the hawk-eyed attendants. Photography is strictly prohibited though some of the greatest museums in the world happily permit this. The National Museum, New Delhi, the British Museum and the Victoria and Albert Museum in London, and museums in America and France permit photography of the exhibits, but the Jiyaji Rao Scindia Museum prohibits photography on the premises. However, the museum contains some very interesting personal momentoes of the Scindia family – the jewelled slippers which belonged to Chinkoo Rani, four-poster beds, gifts from all over the world, hunting trophies and oil paintings. Belgian cut-glass furniture, including a rocking chair and so much of crystal objects are on display. The museum provides a glimpse into the lifestyles of the Scindias and the princely India. But the collection betrays no trace of sophistication except following certain trends set by the Europeanised palace acquisitions in the British India. Here at Gwalior there is a surfeit of tasteless opulence and splendour. In fact, as Shobita Punja observes this museum is "the most absurd collection of kitsch, mixing a cocktail of poor western taste and hybrid Indian craftsmanship that made an utter mockery of both".

The banquet hall in the museum has on display a solid silver table-top miniature train with cut-glass wagons chugging around on miniature rails serving cocktails and condiments to guests after dinner. This miniature train is a minor curiosity at the museum fascinating visitors of all age-groups. Also to be seen is the glass cradle swing used by the child Krishna on Janmasthamy celebrations. The swords of Shahjahan and Aurangzeb are amongst the rare objects of historical importance. The museum has a rare section exclusively related to erotica.

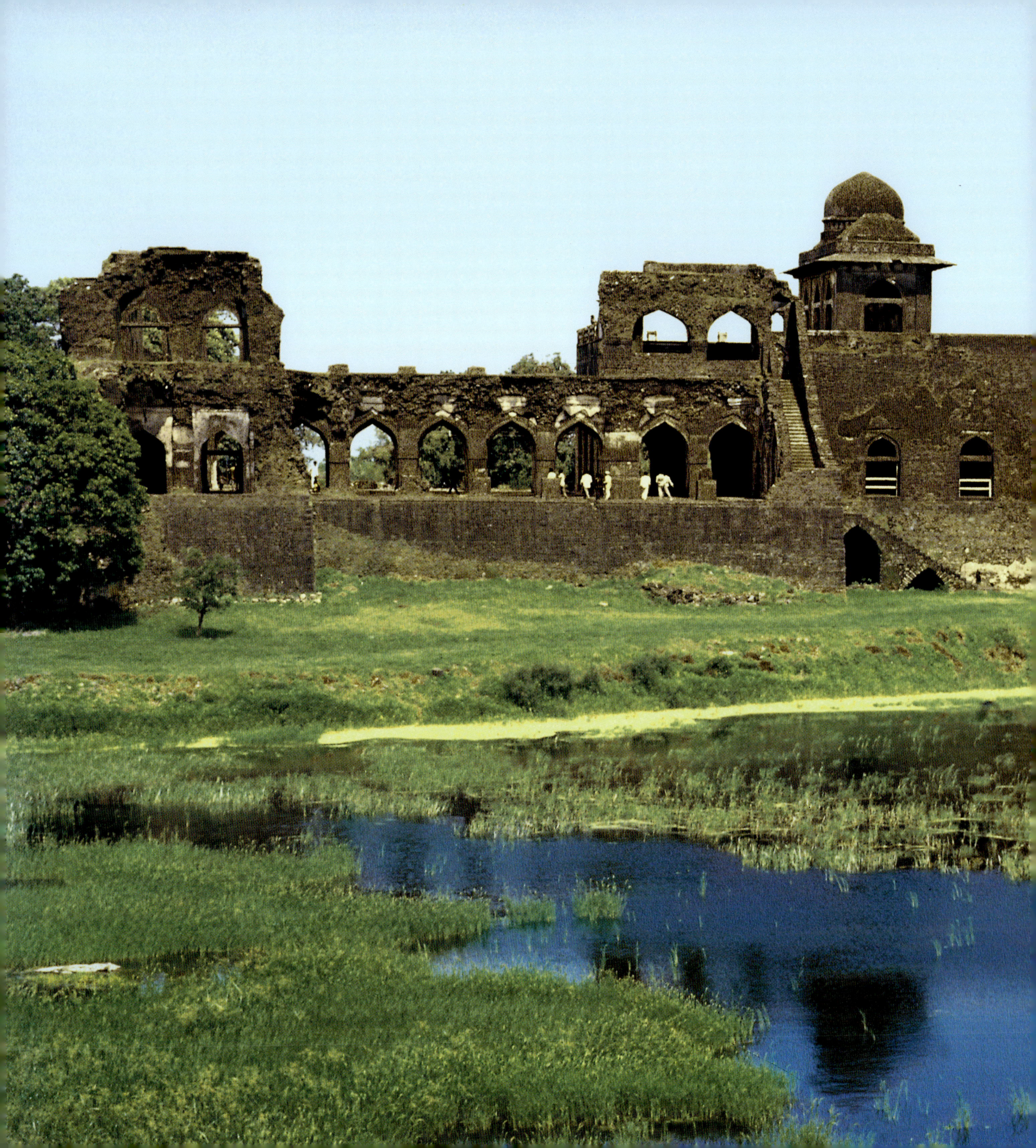

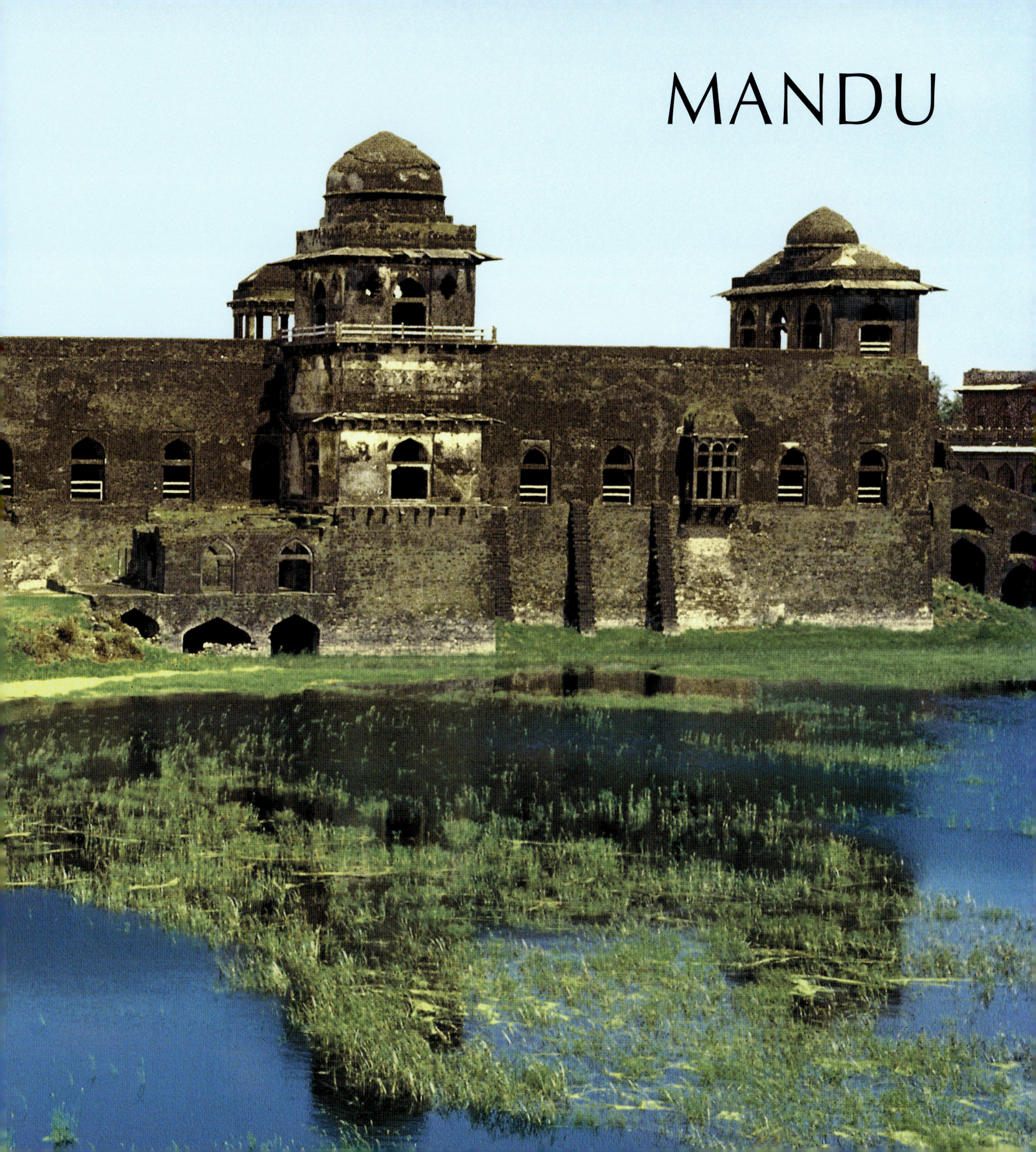
MANDU

Perched at an altitude of 2000 feet on the Vindhyan ranges, Mandu is among the few places in India which are renowned for their picturesque beauty. The road from Dhar to Mandu traverses through spectacular landscape with hills rising gradually on both sides of it. The road soon climbs up to reveal views of fortified walls and crumbling gateways, all the while concealing ruins as you negotiate the final ascent to the Alamgri Gate at the top. A look back from this point, the height of the Mandu hills astonishes you, and the scenery justifies why nestling in the heart of the Khahra Koh hills, Mandu is called a naturalist's paradise.

Called Mandapa Durg, the fort was built by the Rajputs in the 6th Century CE, but came into prominence only in the 10th century with the Gurjara Pratihara and Parmara rulers, builders of strong fortifications. The ancient stronghold of the Gurjara Pratihara and Paramaras in the pre-Muslim period was perhaps Songarh, a small fortified area with a lake and a few temples still standing on a detached portion of the hill. It is called Budhi Mandu (old Mandu) by the local people.

Mandu was reduced to a secondary status when the Hindu rule declined in power following three invasions by the Delhi sultans-Iltutmish (1227 CE.), Jalaluddin Khilji (1293 CE), and Alauddin Khilji (1305 CE). However in 1401 CE, Dilawar Khan, a governor of the Tughlaqs, founded his own independent government. His son, Hoshang Shah, shifted the earlier capital from Dhar to Mandu in 1405 CE and ushered in a glorious era of architectural activity. The Mughal, however, wrote '*finis*' to this golden era. The armies of Humayun, Shershah and Akbar crushed the spirit of Mandu but were enthralled by buildings and the natural splendour surrounding the hill fortress. Akbar visited Mandu four times, and Jehangir with his queen Noorjahan, stayed here for seven months, leaving a glowing account of Mandu in his memoirs.

The royal enclosure near the Alamgiri Gate is the best place to begin a tour of Mandu. Herein stands the cluster of Mandu's splendid palaces

Clockwise from top:
Jahaz Mahal
Clockwise from right:
Lotus pool; Tomb of Hoshang Shah

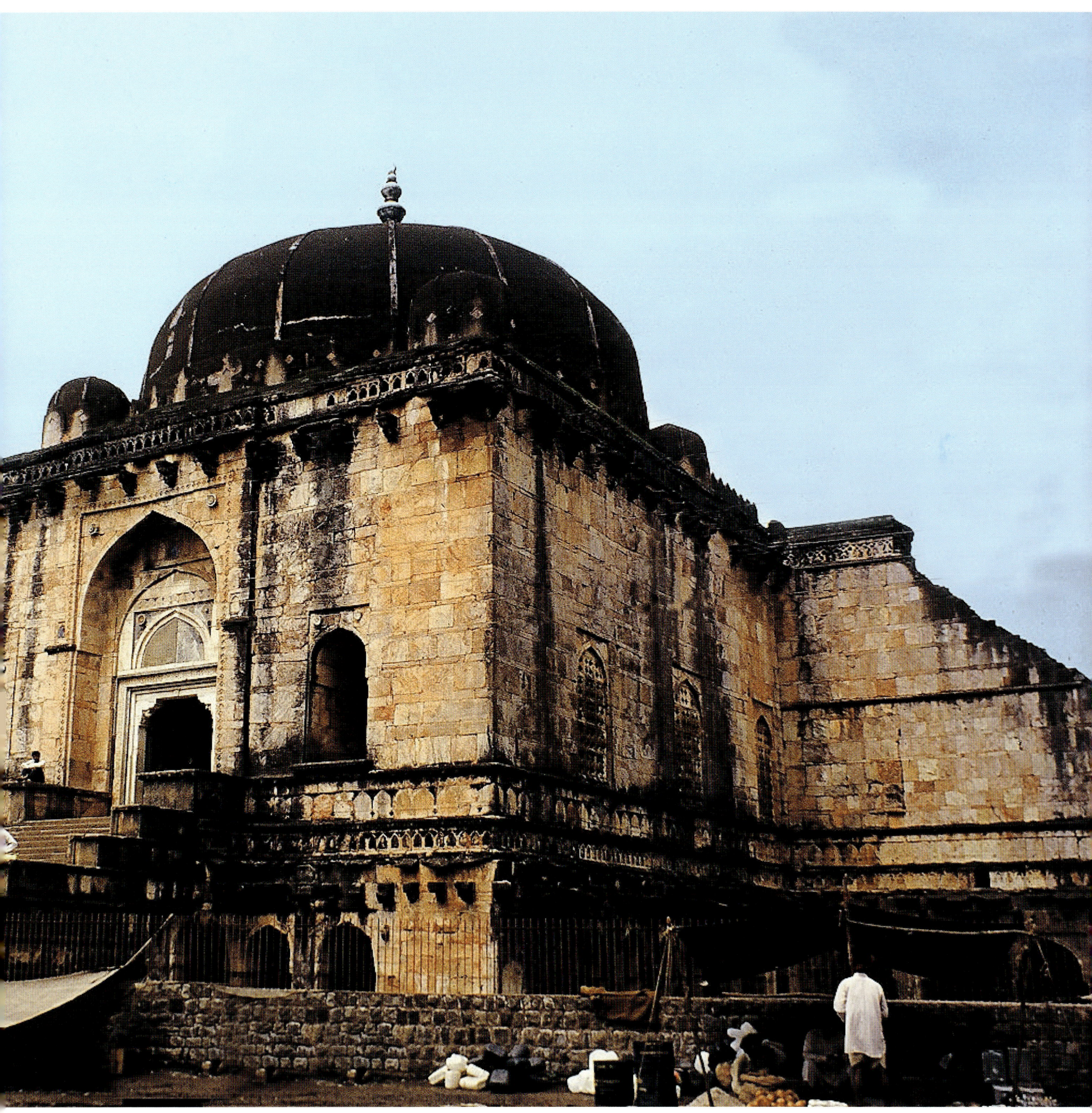

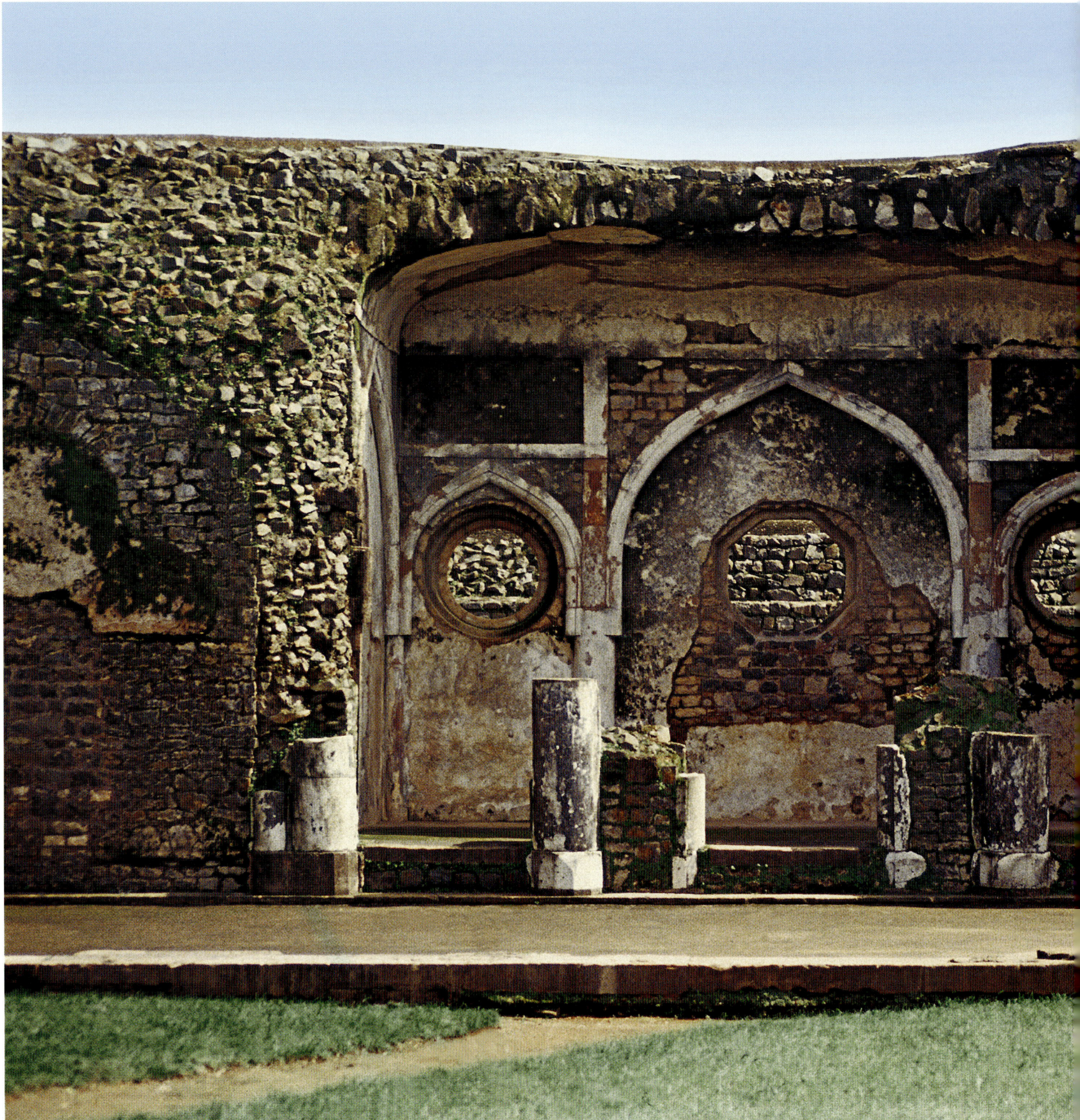

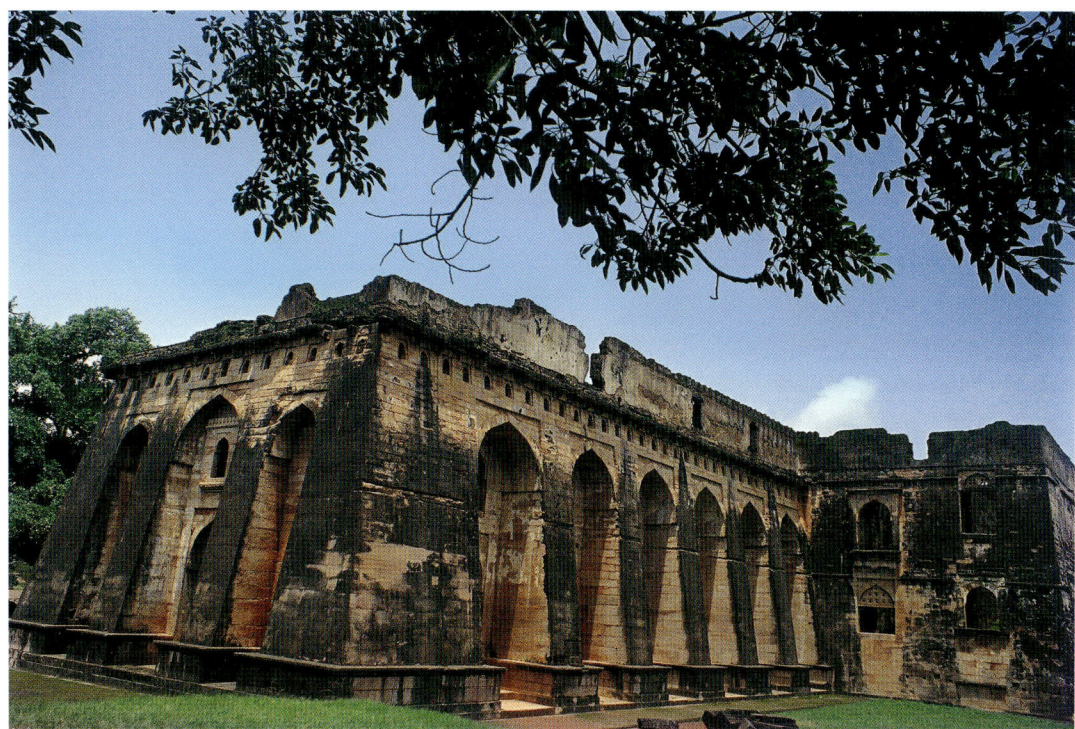

and pools. Jahaz Mahal, the most magnificent and spacious royal palace, is the first royal structure in view as you pass through an elegant arched gareway. One hundred and twenty metre long, it stands between two lakes- Kafur (camphor) Talao and Munja Talao. The grand interior comprises three stately halls, subterranean and ante-chambers, all kept cool by water from the tanks on both sides. Underground channels link the Jahaz Mahal with both the tanks. Though used for lavish royal entertainments the Jahaz Mahal interior is by and large, devoid of ornamentation. In fact, the interior and exterior are plastered and sparsely decorated with blue tiles. The reflection of the palace in the lake makes it look like a gigantic ship in anchor, hence, the name Jahaz (ship) Mahal.

Thousands of candles were lit at night and grand parties organized on the terrace overlooking a grand view of the lakes. The small pavilions, domes and turrets on the lit-up terrace lent a unique romantic charm to Jahaz Mahal. Jehangir gives a vivid description of the parties in his memoris: "It was a wonderful assembly. In the beginning of the evening they lit lanterns and lamps all arounds the tanks and buildings and a lighting up was carried out, the like of which perhaps has never been arranged in any place. The lanterns and lamps cast their relfecton on the water and it appeared as if the whole surface of the tank was a plain of fire. A grand entertainment took place and the drunkards indulged themselves to excesses." Noorjahan, gifted with more fastidious tastes and sophistication, simply stood enthralled by Mandu's charm.

The two cisterns at Jahaz Mahal, as the northern end of the ground floor and on the terrace, have a remarkable design. Carved like a lotus, the lower pool is fifteen feet deep with stone steps descending to its depth. A narrow serpentine channel regulates the flow of water supplied through a system of Persian wheels from a tank at the southern end. An octagonal pavilion hung over the Kafur Talao and is approached through a narrow jetty. Ghiyasuddin Khilji's 31 year reign was largely responsible for the architectural splendour of Mandu.

Hindola Mahal is another structure built by Ghiyasuddin. It is generally called the Palace of Swings because the awkwardly pronounced batter on its ponderous walls. It was perhaps used as an audience hall with a proposal to add another floor for the royal residence. The purpose of this strongest building at Mandu defied explanation. Its striking appearance, however, fails to make up for the seeming illogicality of construction. Perhaps the

Clockwise from left:
Natya Shala, the open-air theatre;
Hindola Mahal

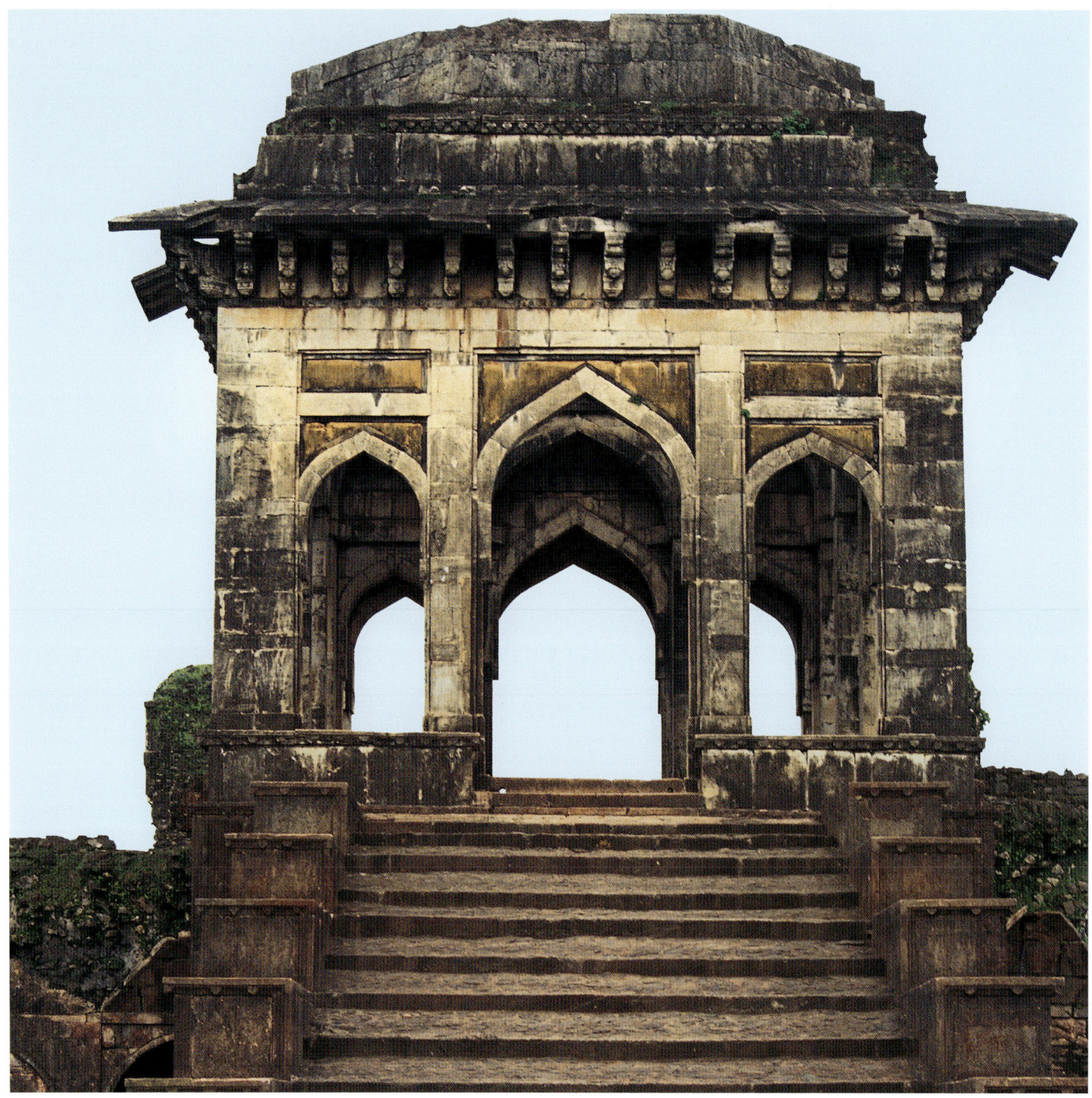

extraordinarly thick pile with a vaulted roof supported on transverse arches contains the ruins of some pre-Muslim structure.

West of the Hindola Mahal lie the ruins of the king's private residence. Some ruins belong to remote past but make a truly charming group. Champa Baoli is actually a well connected to the palace with subterranean passages. Its water smells of the *champa* blossom and it is still in use. Other buildings at this end include Dilawar Khan's mosque which faces a spectacular courtyard and looks very grand, Nahar Jharokha built for Jehangir's public appearances, and an open-air theatre.

Moving towards the Delhi Gate on the eastern side, you can see the double storeyed hall, known as the house and shop of Gada Shah. Built on a grand scale, it wears a slight resemblance to the Hindola Mahal. The impressive hall has a fountain in the central lobby and two murals of a Rajput chieftain and his consort, believed to be Medini Rai and his wife. Two baolis (stepped wells) Andheri and Ujala (dark and well-lit) are in excellent preservation. As you retrace your steps to the royal enclosure, a visit to the Jal Mahal standing just behind the Jahaz Mahal at the centre of the large Munja Talao, is a not-be-missed experience. This is the palace where Jehangir and Noorjahan stayed during their Mandu holidays. Double storeyed, with two large lotus-shaped pools and water tanks, it has steps leading to the lake-a perfect setting for the royal couple. Though much of the Jal Mahal is in ruins, you can still climb up to the terrace for a fantastic view of the Jahaz Mahal reflected in the palcid waters of the lake. It is also assumed to be the site where structural remains of the Pratihara and Paramara rule can still be found. You can walk back along the edge of the lake and ultimately reach Taveli Mahal, now housing the archaeological museum and guest house. It is an ideal spot for viewing the whole royal residential complex and lakes.

At the city centre stands the Jami Masjid (1454 A.D.) included amongst the finest mosques in India and modeled after the great Mosque in Damascus. The grand courtyard of the mosque is enclosed on all sides by splendid colonnades. The western colonnade contains rows of pointed

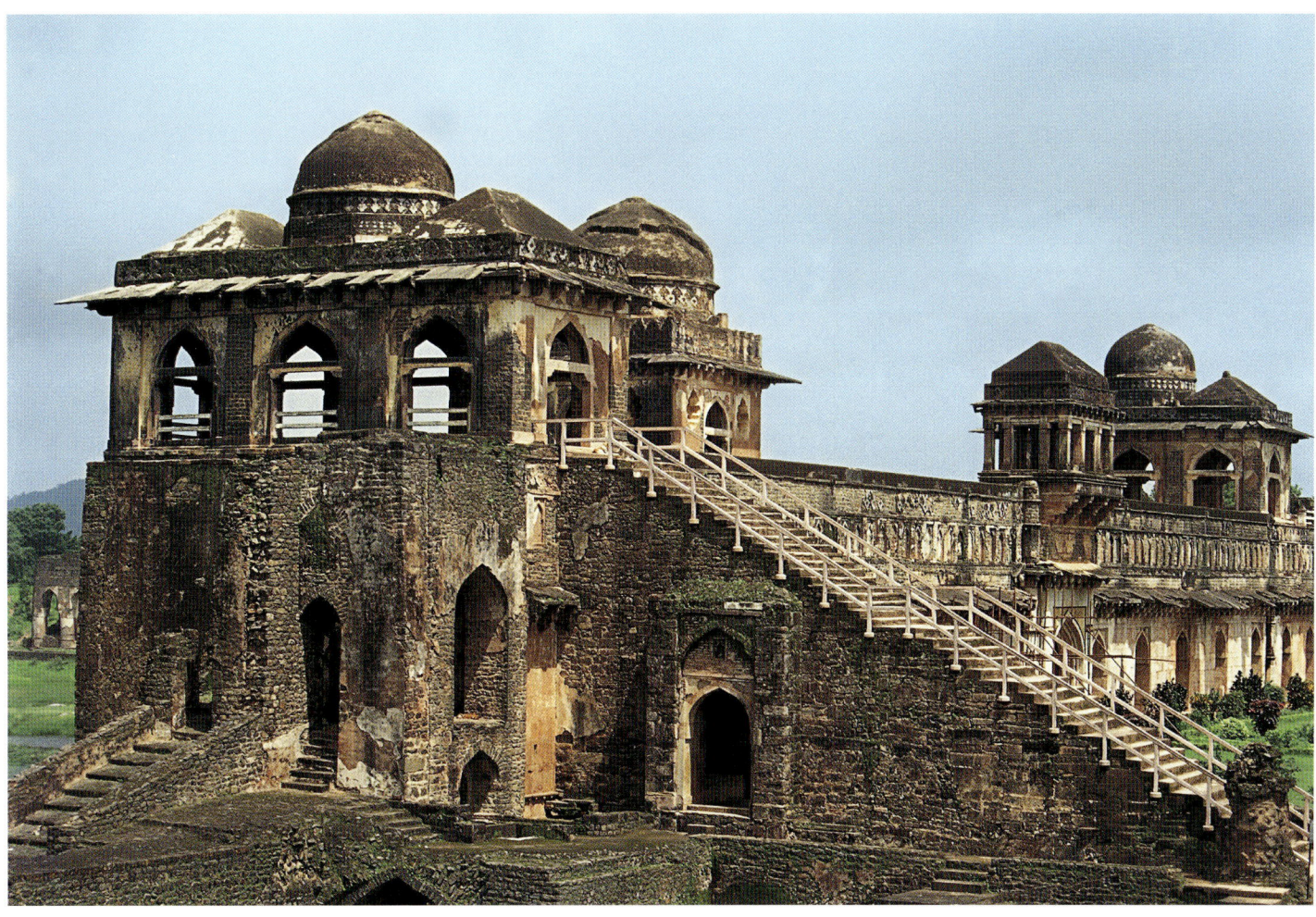

Clockwise from left:
Ruins of Asharfi Mahal; Jahaz Mahal, steps leading to the terrace

arches, and strong unadorned columns. 58 small domes surround the three large hemispherical domes on the roof. The interior has a solemn look, befitting the character and importance of the edifice. The 17 prayer niches provide the only ornamental decoration.

In front of the Jami Masjid stand the ruins of Asharfi Mahal, meant to house a *madarsa* (school for religious instruction). The high terrace of the Asharfi Mahal offers a spectacular view of the Jami Masjid and the local market. Also part of the complex are ruins of a victory tower. This seven storeyed tower commemorated Mahmud Khilji's controversial victory over Rana Kumbha, who also built a victory tower at Chittaurgarh.

Behind the Jami Masjid stands the tomb of Hoshang Shah. The tomb was built in accordance with the clear instructions regarding the austerity and purity of design. He also left a note saying: "If people come to meet me, they should not be inconvenienced to remove their shoes." Built entirely in white marble, this single chamber, high-domed structure closely resembles the Lodi tombs in Delhi. The dome is crowned with a crescent, a distinctly Persian feature. Exquisitely carved lattice screens are the only ornamentation provided. An inscription here records the visit of four architects from Shahjahan's court in 1659 A.D.

In the same quadrangle stands a mosque built from the stones of the pre-Muslim Rajput edifices. From this central group of ruins in the village to Rewa Kund-the farthest point in Mandu-is a long journey. A ribbon-thin road meanders through a thickly forested area, dotted with derelict ruins. These include some hauntingly beautiful places like Malik Muguth's mosque, Dai ki choti bahen ka mahal (Palace of maid's younger sister), Dai ka Mahal, Hathi Mahal, Barya Khan's tomb and Chappan Mahal. Most of these buildings are crumbling and moss-covered. The Kund (pool) is a reservoir built by Baz Bahadur, the legendary lover-prince of Mandu, for his paramour Rupmati. The Rupmati pavilion is a rather austere, uninspiring structure, signally lacking in the romantic ambience that is all but pervasive at the Jahaz Mahal. Baz Bahadur was a great lover of beauty and music but a poor soldier. After his defeat at the hands of Durgavati he completely lost his will to fight. In 1561 A.D. he was comprehensively beated by Adam Khan, Akbar's general at Sarangpur, and fled for his life deserting Rupmati who poisoned herself rather than face humiliation.

The view of the Narmada and the enchanting valley more than 300 metres below, from the wind-swept Rupmati pavilion is unforgettable. On your way back, stop at the palace of Baz Bahadur. Built around a stately lotus pool, with graceful corridors and pavilions on the terrace, this palace is a splendid specimen of Afghan architecture. An inscription in Persian, however, ascribes this building to Sultan Nasir Khan (1508-9A.D.), surely an old structure acquired by the new ruler and suitably altered and decorated for royal indulgence.

The Nilkanth pavilion, now a shrine, is difficult to locate as it lies in the forest interior. It offers a spectacular view of the gorge, a sudden drop of hundreds of feet. Descending 60 steps brings you to the pavilion where both Akbar and Jehangir were entertained and Akbar was presented with a bevy of Mandu dancers which immensely charmed the great Mughal emperor. This pavilion is built amidst stunning natural grandeur.

As you return to the road, you can see visitors taking a break, shouting themselves hoarse towards the sky and hearing seven echoes of their own voice: this is the famous Echo point at Mandu. Many well-meaning school boys point out distant ruins with information created on the spot.

A few days are required to visit all the monuments in Mandu, but if you have seen the prominent ones your visit would still be memorable for the sheer magnificence of natural scenery, and as Jehangir recorded in his memoirs (which has turned out to be the last word on Mandu):

"There is no place so pleasant in climate and so pretty in scenery as Mandu in the rainy season".

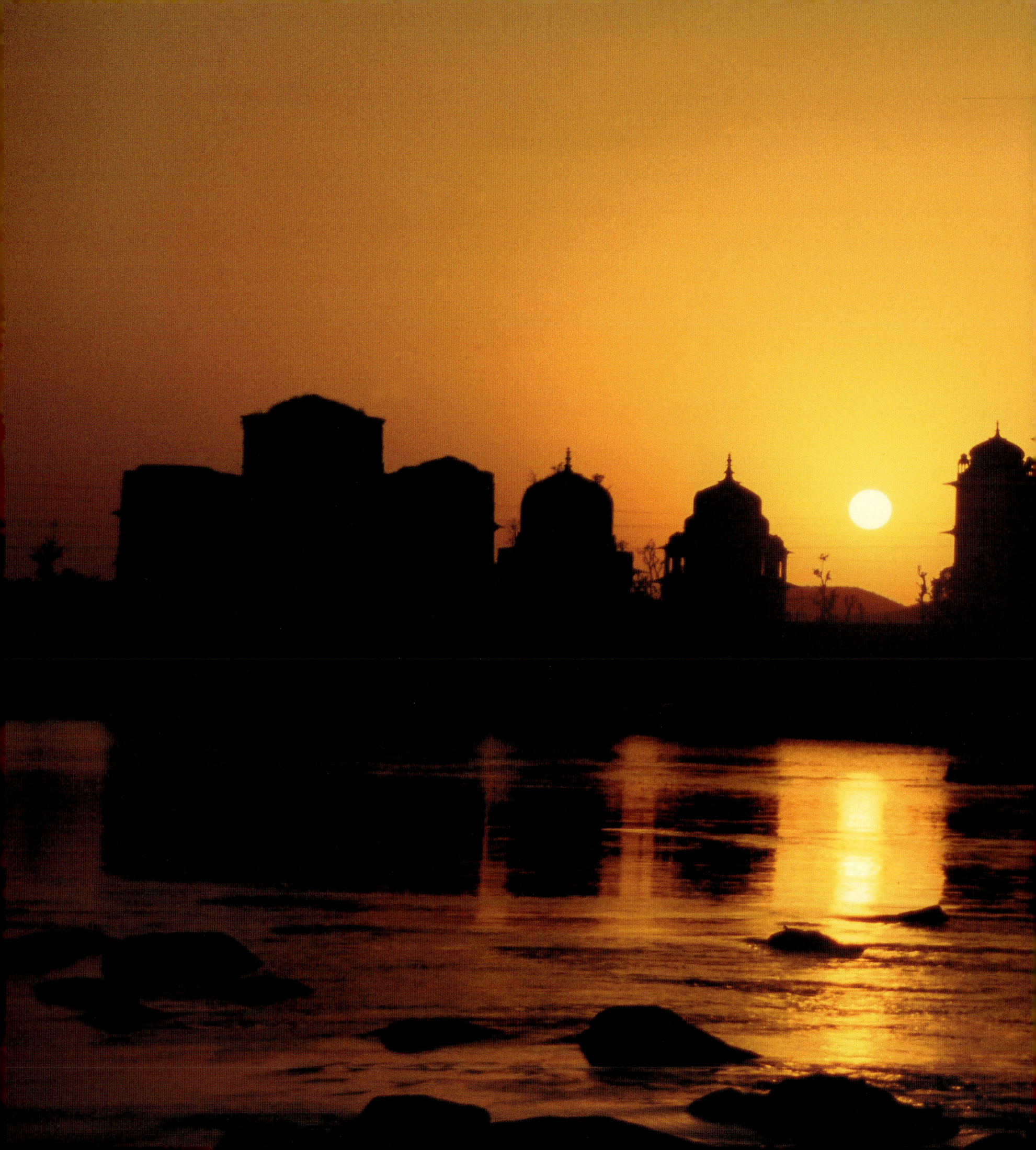

ORCHHA

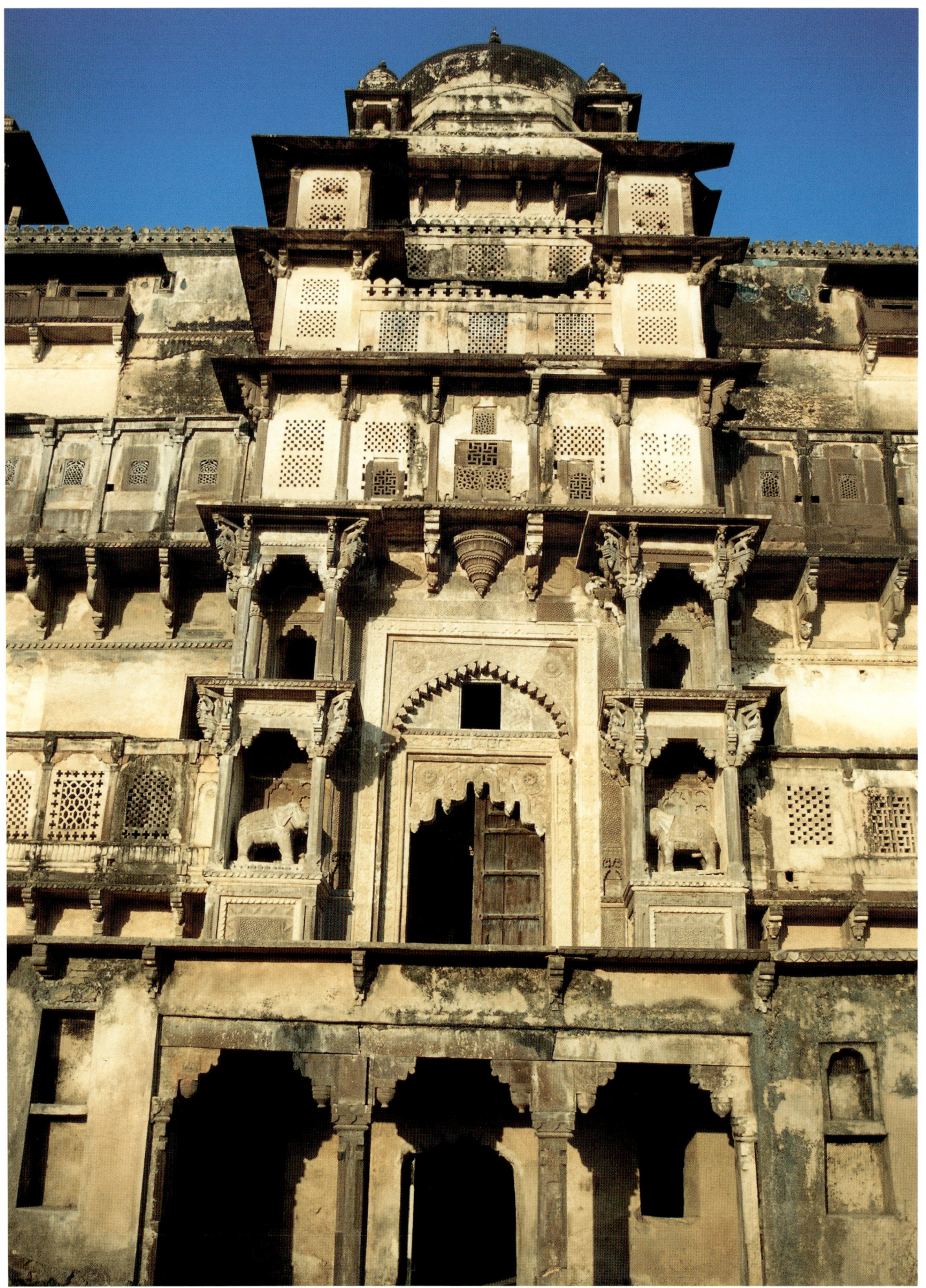

In 1531 CE, Rudra Pratap Singh, the Bundela ruler at Garhkundar, decided to shift his capital to Orcha. Garhkundar fortress was very vulnerable to invasions from all sides. The river Betwa and dense forests around the new city provided a natural defence. From its very beginning the fortunes of Orcha remained linked with the diplomatic equation of its rulers with the Mughal rulers. Peace was but a temporary interlude in the genaral drama of fears, threats, invasions, battles, escape, surrender or death. Mughal favours were meted out to Orcha chiefs in accordance with their usefulness to the imperial authority.

Rudra Pratap, founder of Orcha, died too soon in the same year. Bharati Chand, his son and successor, ascended the throne at a time when Humayun and Sher Shah were battling for the Delhi throne. Taking advantage of the situation, Bharati Shah extended his territories. His help to Kirti Singh against Sher Shah reached too late and Kalinjar was conquered by Sher Shah. Bharati Chand, however, was successful in driving out Islam Shah, Sher Shah's son, out of Bundelkhand. Bharati Chand was a valiant ruler but he is better known as a lover of architecture. He was responsible for the fortifications built around Orcha. He also built the Queen's palace, better known as the Raja Ram Mandir, besides starting work on Raj Mahal- the royal residential palace.

The Raja Ram Mandir was originally designed to function as the queen's palace but subsequently used as a temple. It is built around a courtyard, the area central to the architectural schemes in palaces in both Rajasthan and Bundelkhand. The courtyard is surrounded by ranges on all the four sides, repeated on the second storey which has corner towers or square chambers surmounted by a ribbed dome. The structure is apparently not in its final form since only two sides of the upper storey have domed corners. But Raja Ram Mandir is the first exposition of a structural plan further developed in later buildings.

Raj Mahal (Mandir) was completed by Madhukar Shah (1554 - 1582 CE) who was destined to remain at loggerheads with Akbar. His pride irritated Akbar. Treaties and compromises with the Imperial forces failed to keep Madhukar Shah subdued for long. In 1576, 1578 and 1587 Akbar attacked Orcha. Architectural activities, however, continued unaffected by these skirmishes and troubled times.

Raj Mahal closely follows the basic architectural scheme of the Raja Ram Mandir with a few significant changes. Raj Mahal is a huge palace with two courtyards. The outer and smaller courtyard with double-storeyed ranges was perhaps used as the *mardana* section for special audience to chiefs and ministers. The larger courtyard with double and triple-storeyed ranges around it functioned as the main palace for the ruler and his consort. Both these courtyards have raised plarforms at the centre. The most noteworthy innovation is seen in breaking up the straight lines of the four wings by including at the centre of each range a projecting section whose roof functions as the upper terrace. These chambers are inter-connected with galleries and passages.

Raj Mahal is a triple-storeyed structure over the courtyard level but the whole massive structure is built over arcaded subterranean chambers which, besides adding height to the exterior walls, provide relief from intense heat of Bundelkhand. The Raj Mahal has no domes. Instead, the uppermost parapehts are decorated with small *chattris*, placed at regular distances. These *chattris* are too small to add any splendour to the palace exterior. The corners too are rather weak in the absence of bastions and domes. This experiment in architectural style was not to be repeated at Orcha.

Some sections in the Raj Mahal are decorated with gorgeous murals, depicting the coronation of Rama in the ruler's apartment and Krishna Leela scenes in the queen's apartments on the ground floor. The vaulted ceiling and wall space above the dadoes and niches are covered with motifs in enchanting colours. Vaulted halls on the upper floor are also similarly decorated but mostly with hunting and boating scenes. The lower sections of some large panels depict women on horsebacks playing polo. The river-side exterior wall of the Raj Mahal has some traces of decoration with blue and green tiles.

Previous pages:
Sunset over the cenotaphs, Orchha

Clockwise from left:
Magnificent gateway entrance to the Jahangir Mahal; Riverside view of Orchha palaces

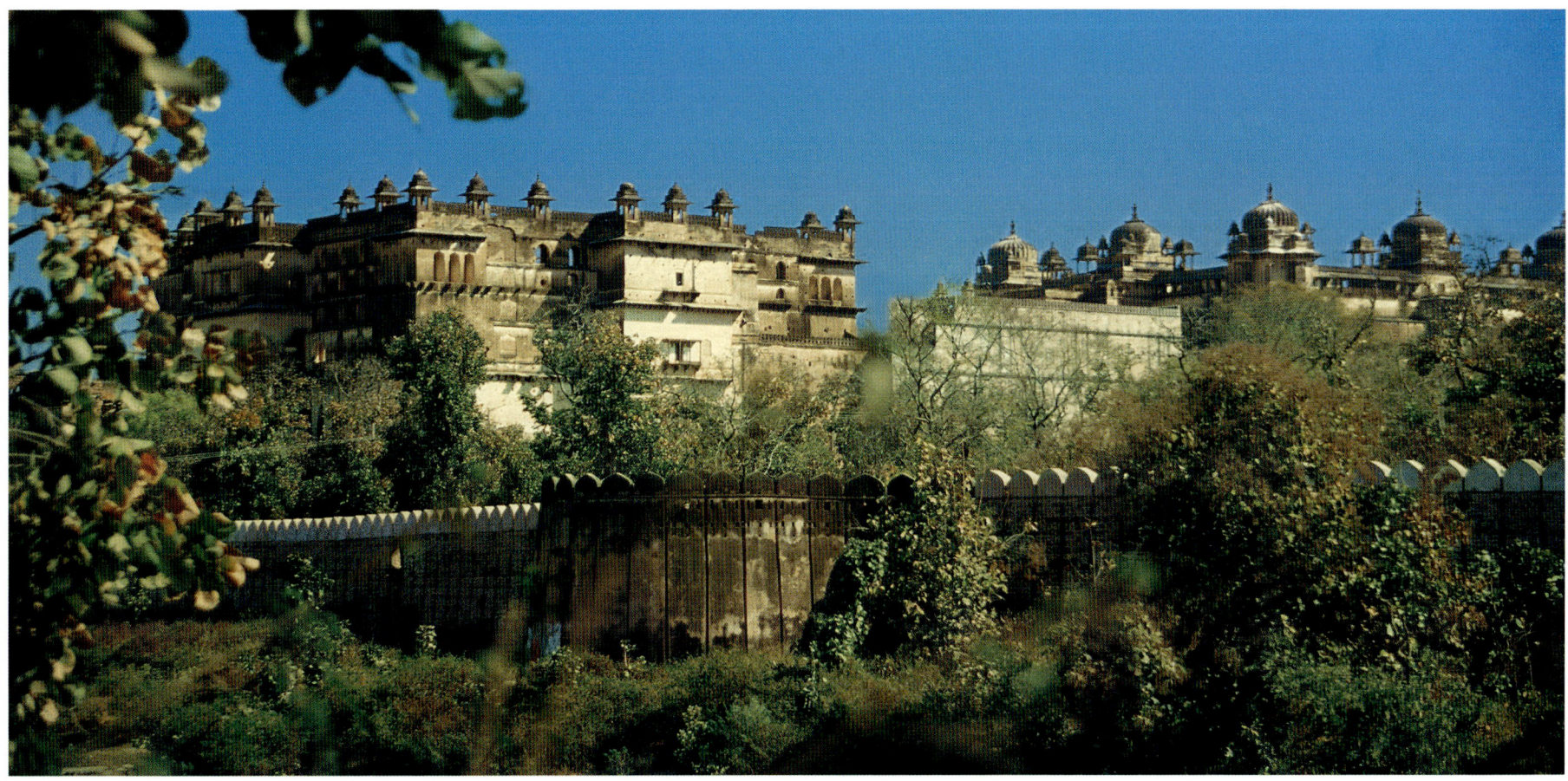

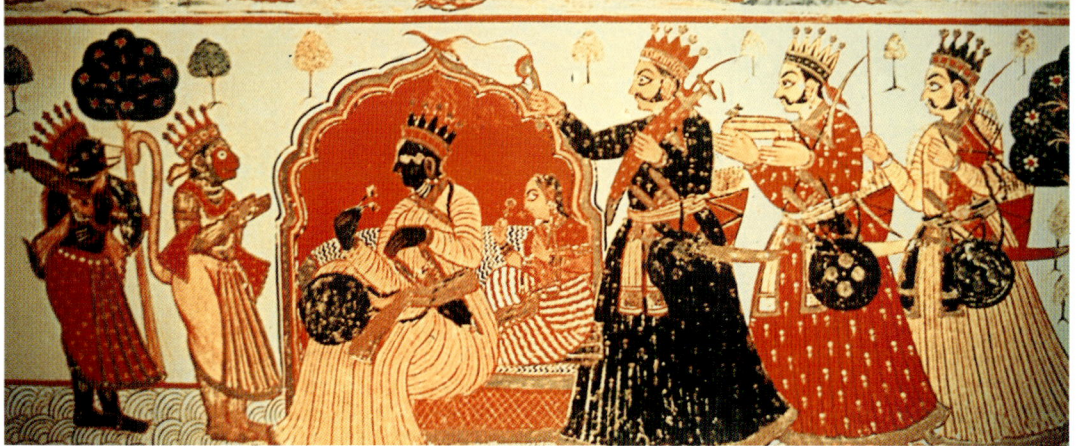

From above:
Raj Mahal, inner courtyard; A mural depicting Ram as ruler of Ayodhya

The Raj Mahal also has a stately Darbar Hall attached to its entrance on the northern side. The huge piers support seven double engrailed arches. It has an unusual structural scheme with three platforms. The royal seats are in a narrow rectangular hall raised on the highest level. Below this royal section is the platform for chief councellors. The lowest level is the largest section with three massive piers on its width and seven similar piers on its entire length. Over these arches are twenty one small arched apertures. The ceilings at the Darbar Hall are covered with murals resembling carpet patterns. The patterns and motifs on these ceilings have only recently been restored to a semblance of their pristine splendour. The murals at the Raj Mahal are rare examples of art traditions in Bundelkhand.

The palace of Rai Parveen is a splendid structure. She was the paramour of Raja Inderjit and known for her beauty, poetry and dance. She was summoned by Akbar, so it is believed, to join his harem. At the Mughal court in Agra, Rai Parveen recited the lines written by the Orcha poet Keshav Das:

Three things one scavenges from others,
Three things only are seen,
Dogs, and crows and the scavenger crew,
Tell me O Emperor, of which breed are thou?

Akbar sent her back to Orcha where Inderjit built a small palace for her. The central hall on the ground floor holds the key to other apartments around it on this floor and above. The landscaped garden with octagonal flower beds still invokes a romantic charm in the city of Bundella warriors, kings and princes.

Madhukar Shah also started construction work on the Chaturbhuj temple, one of Orcha's most incredible creations. This massive structure crowns a knoll outside fortifications of the Raj Mahal. When the image of Rama brought from Ayodhya could not be moved to its ultimate seat at the Chaturbhuj temple, this magnificent building remained unused for quite some time. The Chaturbhuj temple is amongst the most impressive architectural creations in northern India. The interior of the temple is devoid of any ornamentation and the bare walls containing abundance of sun shine and space invite comparison with Christian churches rather than Hindu temples. The enormous congregational area is cruciform in plan and

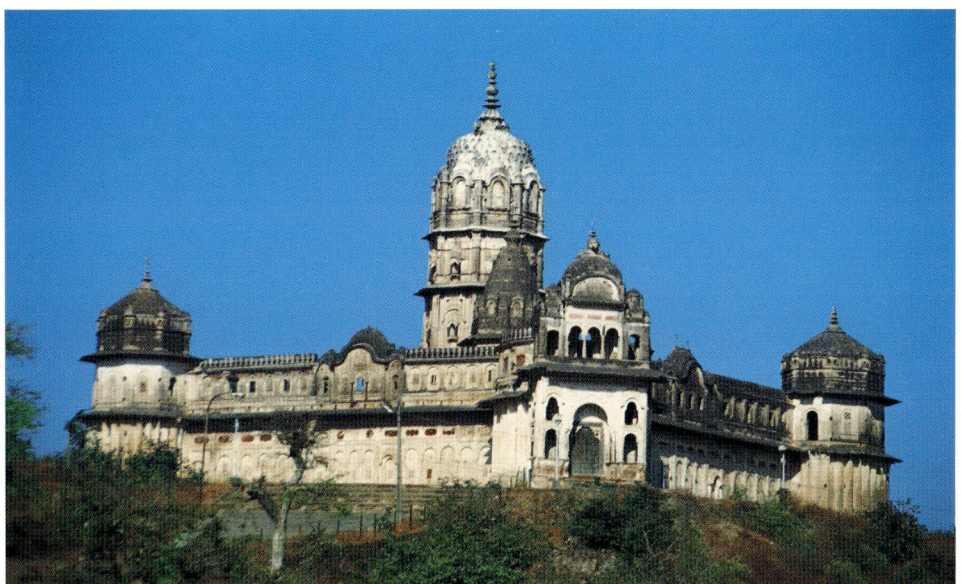

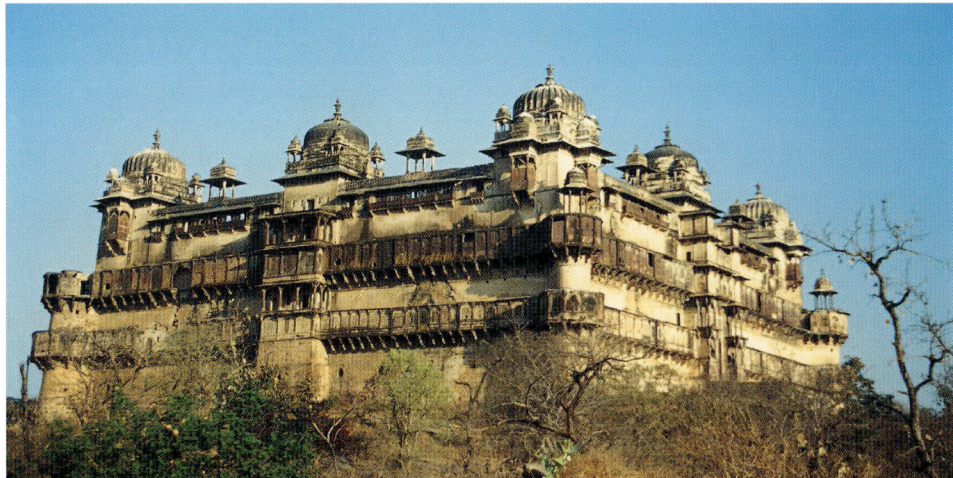

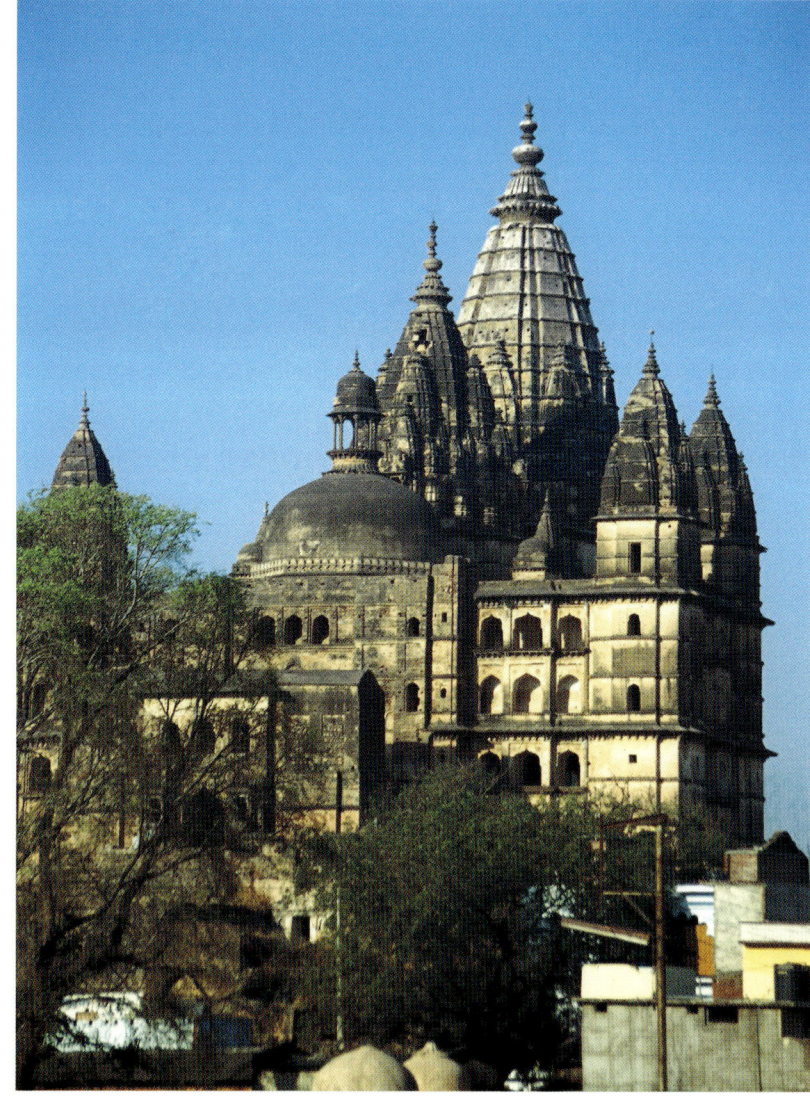

the sanctuary area is pushed back to the rear. The colossal structure looks still more like a small fortress with tall conical *shikharas* around the high central dome. The front section of the Chaturbhuj temple was demolished by Shahjahan who intended building a mosque at this site. The Mughal emperor visited Orcha in 1635 CE to chastise Jujhar Singh for the latter's anti-Mughal activities. The Chaturbhuj temple, despite wilful depredations caused to its structure, is the most commanding architectural achievement of Orcha.

Bir Singh Deo (1606-27 CE) had a comparatively peaceful tenure as a ruler of Orcha and this period is remembered chiefly for the architectural works completed under his patronage. Jehangir Mahal, the most splendid palace was built by Bir Singh Deo as the royal guest house to welcome Jehangir. It is the largest and most elaborately planned palace in Bundelkhand incorporating features from diverse architectural styles. When the Mughal prince Salim (later known as Jehangir) rebelled against Akbar, Bir Singh Deo allied himself with the prince at whose suggestion he had Abul Fazl, Akbar's minister, killed when passing near Orcha. For this outrage against his power, Aknar besieged Orcha twice in 1602 CE and 1604 CE. Jehangir promised to visit Orcha but, perhaps, failed to make it. But Bir Singh Deo built the Jehangir Mahal in honour of the fourth Mughal emperor.

The Jehangir Mahal is built on a raised ground close to the Raj Mahal. The most remarkable aspect of this grand palace is the central courtyard surrounded by double-storeyed ranges of chambers opening into the grand open space within. A double row of eaves or *chajjas* with elegantly carved brackets increases its beauty. The second storey has triple-arched pavilions at the centre of each wing. The third storey has four square chambers and surmounted with ribbed domes at the corners and four similarly domed chambers at the centre of each row. These domed chambers are connected with narrow galleries with trellis screens on the outer side, Small courts at regular intervals create the effect of openness so necessary to relieve the solidity of the whole composition on the ground floor, a small sunken area for the central fountain adds charm to the sun-filled interior besides creating some semblance of Mughal glory.

The magnificent entrance gateway on the eastern side is the most impressive part of the exterior. This tall, multi-storeyed structure projects out marginally from the solid exterior walls. Arches with corbel capitals with lotus-bud fringes, and arches, elephant and peacock brackets, elephant sculptures placed within *chattris* flanking the central entrance and rows of trellis screens placed one over the other make it a very impressive gateway of its kind in the whole of Bundelkhand. The vast exterior of the palace is only slightly relieved by narrow projecting balconies covered with trellis screens demarcating the different storeys. The uppermost parapet creates the most picturesque outline with ribbed domes at corners and domes with a plain plastered surface in the middle of each row and small *chattris* placed in between these. Also, the merlon-shaped battlements in a miniature version appear on the parapets. There are also traces of decoration with blue and green tiles. A small plarform has been built in front of the entrance to facilitate a comfortable landing from the elephant *howdah*. The circular towers at the corners rise to the height of the second storey and there surmounted with a *chattri*. From this point upward the eye moves towards the ribbed dome surrounded by four *chattris*.

Clockwise from above:

Lakshminarayan temple; Chaturbhuj temple; Jahangir Mahal

Bir Singh Deo also built the Lakshmi Narayan temple in Orcha. It is modest in proportions with a triangular arrangement of its double storeyed wings. The entrance follows the familiar plan of a central arched entrance flanked by smaller arches and a triple-arched pavilion on the upper storey, also flanked by small arched openings. The roof has the *bangaldar* form. The temple looks like a small fortress with triple-storeyed tower at the centre. The temple is known for its murals depicting religious themes on large panels on the dadoes, cornices and ceiling. Also noteworthy are the paintings depicting episodes from the freedom struggle against the British. These paintings are gems of the Bundela art at Orcha.

Bir Singh Deo's greatest contribution to the architectural heritage of Orcha and northern India is the Gobind Mahal at Datia built in 1620 CE. Built over a small hill, at first glance this palace appears to be another version of the Jehangir Mahal at Orcha. It only continues the experiment with the same scheme but with one great difference: instead of having a large and vacant courtyard as seen at earlier palaces, the Gobind Mahal has a five-storeyed tower at the centre of the courtyard connected with the surrounding ranges by ornamental arcades or bridges on all the four sides. This tower provides "a dramatic internal focus", to the interior, as George Michell observes. It is not a towering structure but rises a mere 130 feet to the crest of the dome. The Gobind Mahal stands on a hill. The outer wall is raised over an arcaded basement. The austerity of the exterior is relieved by the entrance gateway projecting a little outward. Over the central arch set within a rectangular frame are three sets of balconies each with five arches, piled one over the other. The uppermost balcony is closed with trellis screens. The upward thrust of this pile is further accentuated by the dome at the top surrounded by four smaller domes. This certainly is the most carefully planned section on the exterior. Horizontally, the monotony of the blank exterior is only marginally broken by two rows of four window openings separated by smaller apertures on both sides of the central arch. The running line of the *chajja* demarcates the separate storeys. Two distictive features of the exterior, particulrly noticeable on the rear (western) wall deserve notice. The exterior has a projection at the centre just below the pavilion with painted niches and ceiling on the third storey. From the inside, this projection not only provides increased open space used as terrace in front of the chambers but, on the exterior, relieves the flat unrelieved blankness of the wall. Both the Raj Mahal and Jehangir Mahal in Orcha find this a highly useful device toward creating some structural variation.

Another feature related to the exterior is the positioning of the circular corner towers rising only upto the height of the second storey. If carried further up, the *chattris* crowing these towers would have clashed with the domes on the square chambers at the corners. Besides, these towers serve another more significant purpose: visually they create the impression of greater height of the domes. Still, more importantly, these towers-circular at the Jehangir Mahal and octagonal at the Gobind Mahal, add tremendous

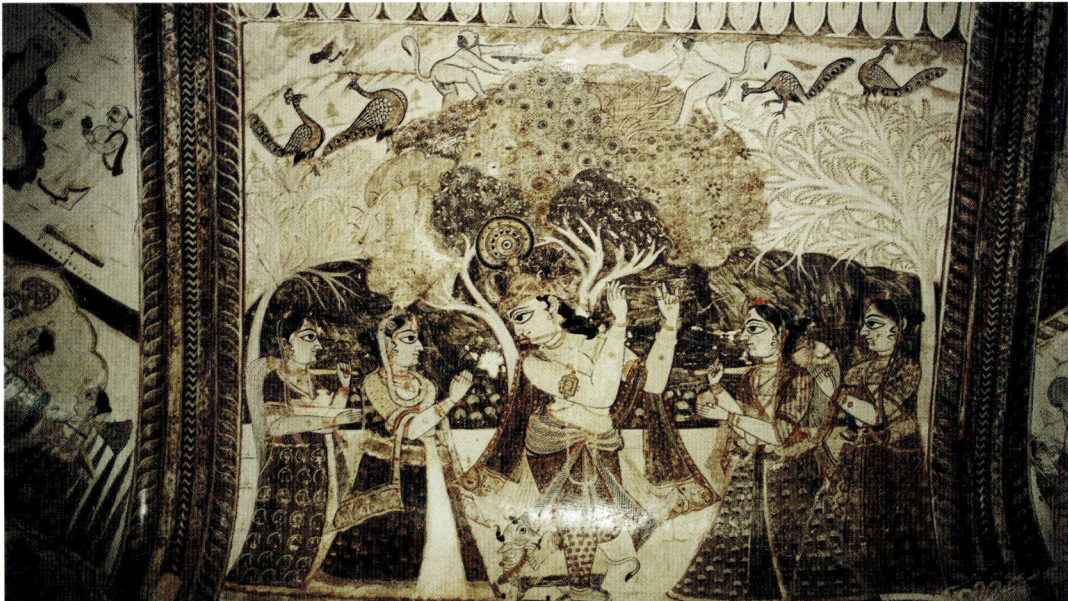

Clockwise from right:
Krishna dancing with gopis, mural at Lakshminarayan temple; Pillared gallery at Gobind Mahal; The five-storeyed tower at the centre of the inner courtyard, Gobind Mahal; Exterior of Gobind Mahal at Datia

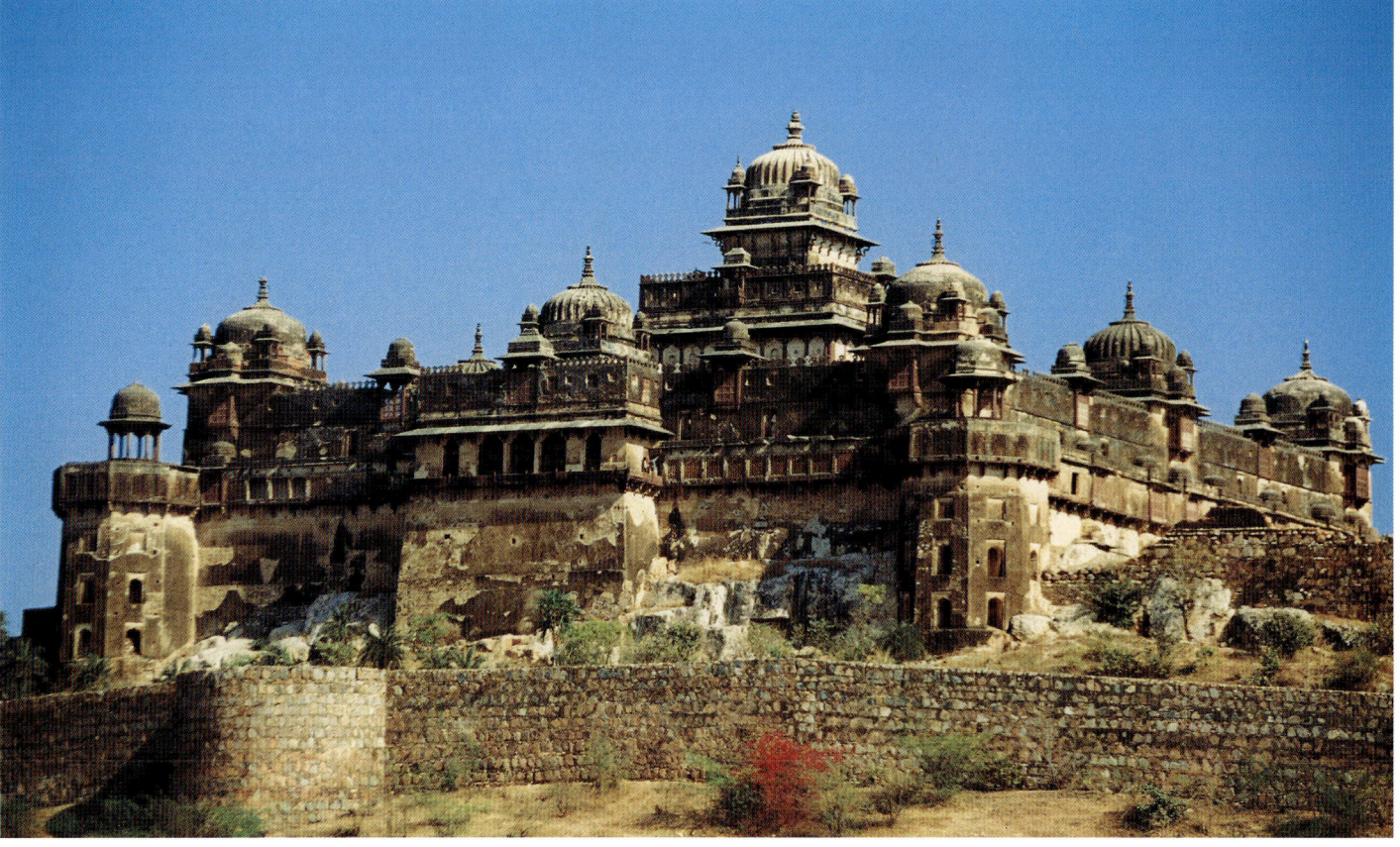

structural support to the corners built over the slopes functioning as an alternative to busttresses as seen on the mosques of the Tughlaq rulers before Rudra Pratap moved to Orcha, has similar corner towers rising only to the height of the second storey. It was simply persisting with the architectural style of their ancestors rather than an innovation "not wholly satisfactory", as Tillotson looks at it. With these corner towers the corners could not remain exposed to the danger of failing apart, as at the Raj Mahal in Orcha which has no such towers at the corners.

The interior of the Gobind Mahal contains double-storeyed ranges on all the four sides. The third storey has much structural variation provided by open courts with low parapets in front of the square domed chambers. The five-storeyed central tower rising above these peripheral ranges can be regarded as a secular version of a temple shikhara since the dynamics of the palace is focused on the tower containing only the ruler's apartments.

The Gobind Mahal also contains some example of the Bundella art on the ceilings of the tower and the rectangular chamber on the storey opening toward the lake below. This chamber has niches, cornices and the vaulted ceiling covered with elegant designs betraying an unmistakable Mughal flavour. Bir Singh Deo, perhaps, intended creating the ambience of the Mughal palaces. The domed ceilings on the three storeys of the tower are also painted beautifully with some geometrical designs, arabesques, dancing figures, pairs of peacocks and a shallow petalled dome at the upper most level. Most of these painted ceilings are still in an excellent state of preservation showing little effect of intense heat and neglect. The Gobind Mahal, like the Jehangir Mahal, was never occupied for residence by any ruler and became a monument from the day of its completion.

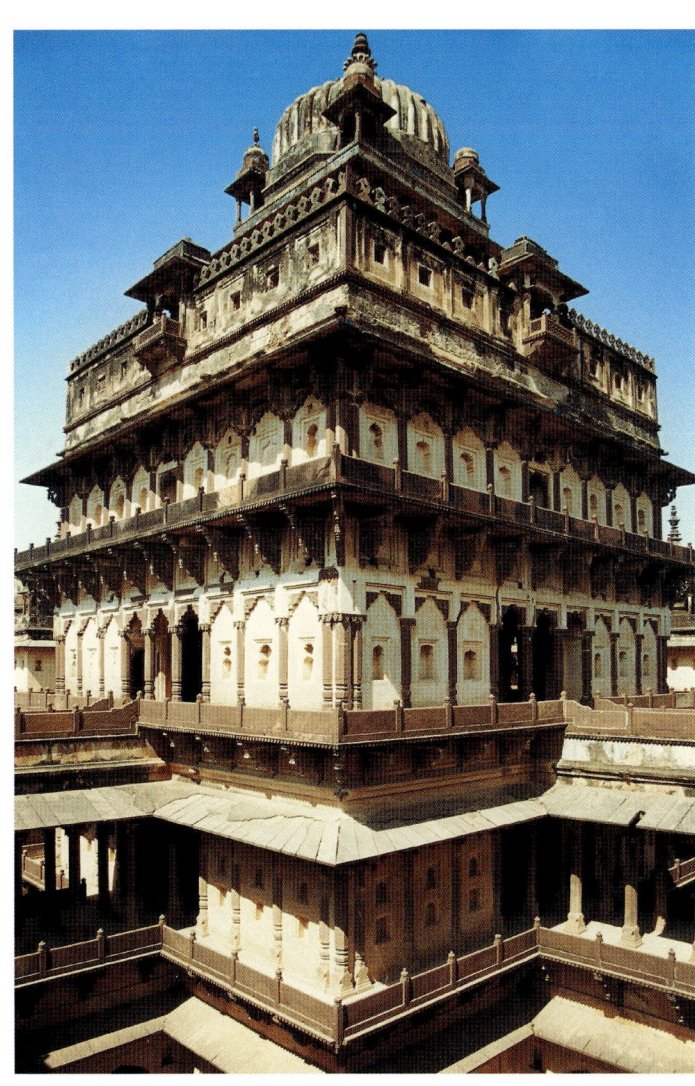

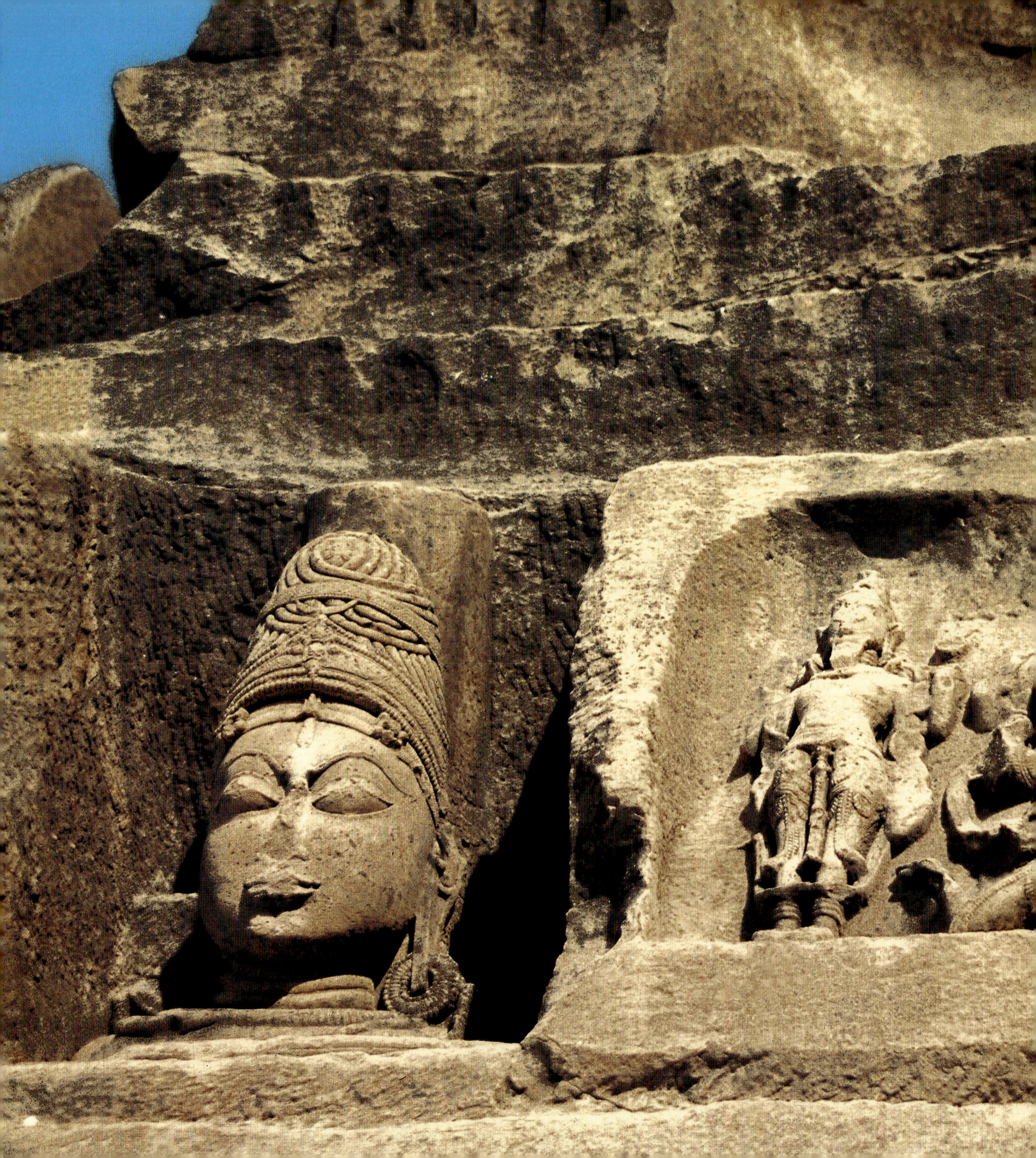

KALINJAR

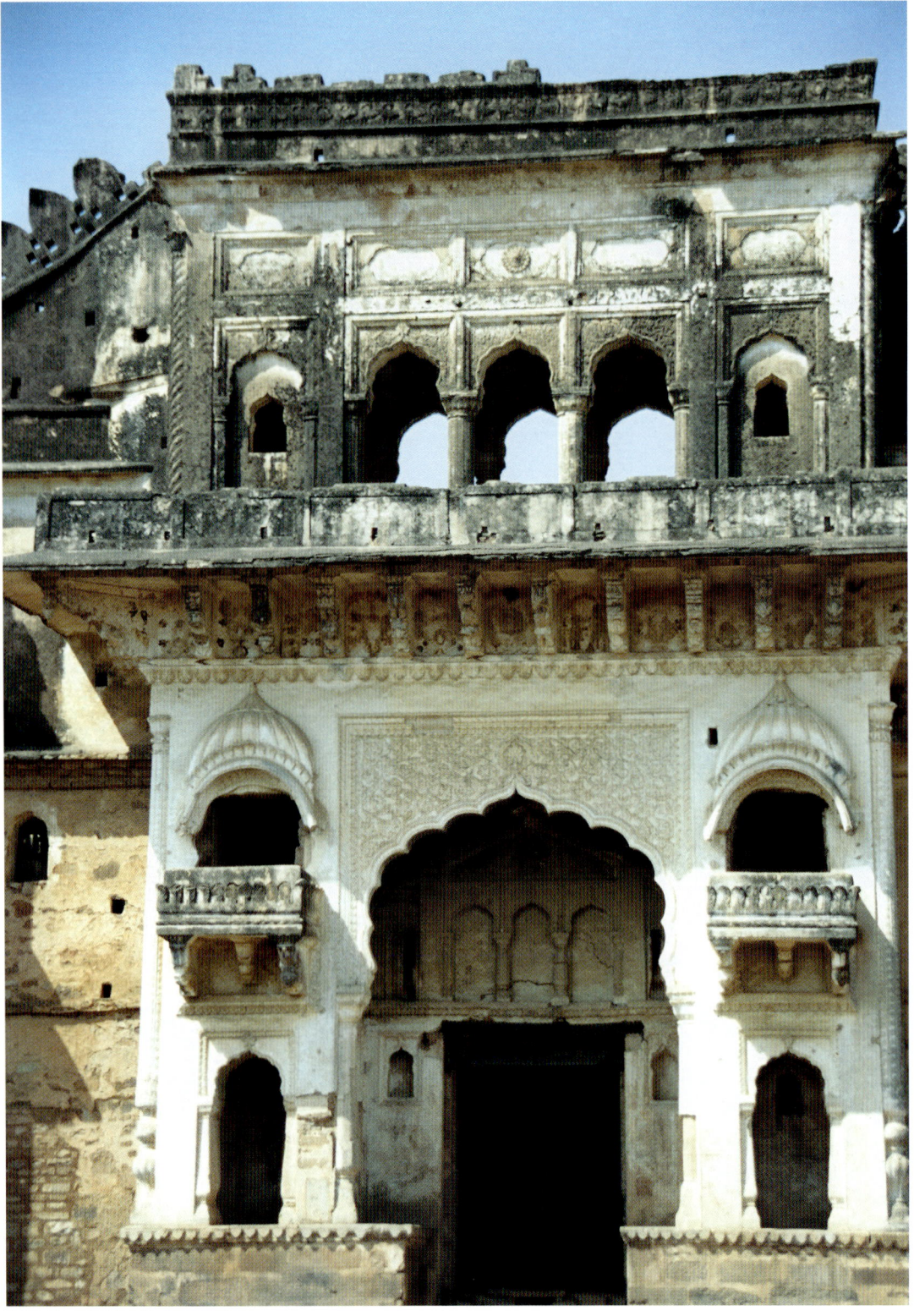

Kalinjar is amongst the most ancient and formidable forts of India with its origin traceable to the beginning of the Christian era. The fort is the most glorious monument in Bundelkhand in central India. The hill of Kalinjar has been a sacred spot of worship since the Vedic times when it was mentioned as one of the *tapasyasthanas* (place for penance or austerities). The Mahabharata also takes note of its sacred lake. Renukuta, Mahagiri and Pingala are some of the ancient names of Kalinjar. It has always been associated with the Chandella rulers whose ancestor Chandravarman, sometimes identified as Nannuka, is believed to have built the Kalinjar fort during the ninth century BCE but as Cunningham observers "the fort of Kalinjar must already have existed for sometime before it attracted the notice of the Kalachuri chief Krishna. It seems highly probable, therefore, that the fortress may have been founded at least as early as the beginning of the Christian era".

The battlemented ramparts of the Kalinjar fort are visible from far distances. It is situated 56 Km south of Banda district in Uttar Pradesh, proudly standing on an isolated plateau atop a 374.9mt high hill of the Vindhyan range. An early description of the Kalinjar fort gives a vivid desription of its awesome proportions: "The summit of the rock (upon which Kalinjar stands) is in structure a kind of table land slightly undulated and between four and five miles in circuit. Throughout its whole extent it is fortified by a rampart rising from the very edge in continuation of the scarp of the rock: at places where the difficulties of the ascent in its natural state might be overcome, access has been guarded against the facing of masonry. The fortifications are massively constructed of large blocks of stone laid generally without cement and about 25 feet thick…Access to this vast circumvallation of the hill is by pathway sloping up the face of the rock in on oblique manner at the south-eastern side. It is a rough and narrow tract through brushwood, and in some places almost perpendicular upto the first or lowest gateway, which leads into the fortified part and is situated at about fourth of the ascent."

Today a motorable road snakes its way up the top but in medieval times it was a hazardous adventure to climb up the treacherous perpendicular ascent passing through six doorways: Alam Darwaza, Ganesh Darwaza, Chandi or Chauburji Darwaza, Budh Bhadra Darwaza, Hanuman Darwaza and Lal Darwaza. The Alam Darwaza was built or restrengthened during the reign of Aurangzeb. Mammoth rocks on both sides of the ascent have reliefs of deities carved on the surface and some pilgrim inscriptions.

Kalinjar enjoyed a tremendous strategic importance in the control over northern and central India. For this particular reason and for its imnese treasures, Kalinjar was the target of frequent invasion beginning with Mahmud Ghazni in the eleventh century CE. Prithviraj Chauhan, Qutbuddin Aibak, Iltutmish, Humayun, Sher Shah, Chatrasal were the other rulers who besieged Kalinjar as a prime military engagement. Mahmud Ghazni who had ransacked the whole north and western India had his eyes set on Kalinjar which he besieged in 1022-23 CE. The Chandella ruler Ganda Deva (called Nanda by a few historians) put up a stiff but ineffective resistance despite his formidable army of more than a million soldiers, 36000 horses and 640 elephants. Realising the utter hopelessness of his situation, Ganda chose to escape in the cover of darkness. Mahmud Ghazni plundered Kalinjar and his soldiers devastated the villages for booty. Soon the Chandella rulers returned to Kalinjar. Mahmud Ghazni returned the following year. Again Ganda Deva made an inglorious capitulation by gifting 300 elephants, immense treasure and poetic compositions extolling the invader. In return, Mahmud conferred on Ganda the government of 15 forts. The Chandellas didn't really cover themselves with glory.

Prithviraj Chauhan of Delhi conquered Kalinjar in 1182. It was, however, Qutbuddin Aibak, founder of the Delhi Sultanate in 1192, who beat the Chandella ruler Parmardideva comprehensively in 1203 CE, He caused terrible destruction at Kalinjar, pulling down palaces and converting temples into mosques. After a brief interlude of peace and uneasy calm, Kalinjar was besieged again. Malik Nusratuddin Taisi, the governor of Gwalior under Illtutmish attacked Kalinjar. Trailokyavarman, the Chandella ruler with his close associates, fled away into the woods under cover of darknes. He was chased. At a clearing in the forest, the ground wetted by the urine of his horses gave clues to his presence in the area. He was captured and stripped of his royal powers.

The inaccessibility and the extremely rough terrain surrounding Kalinjar discouraged conquerors of the fort from settling down here. Left into the care of governors, Kalinjar was always won back by the Chandella rulers. The second Mughal emperor Humayun made three unsuccessful attempts to conquer Kalinjar and prevented by pressing circumstances to leave the

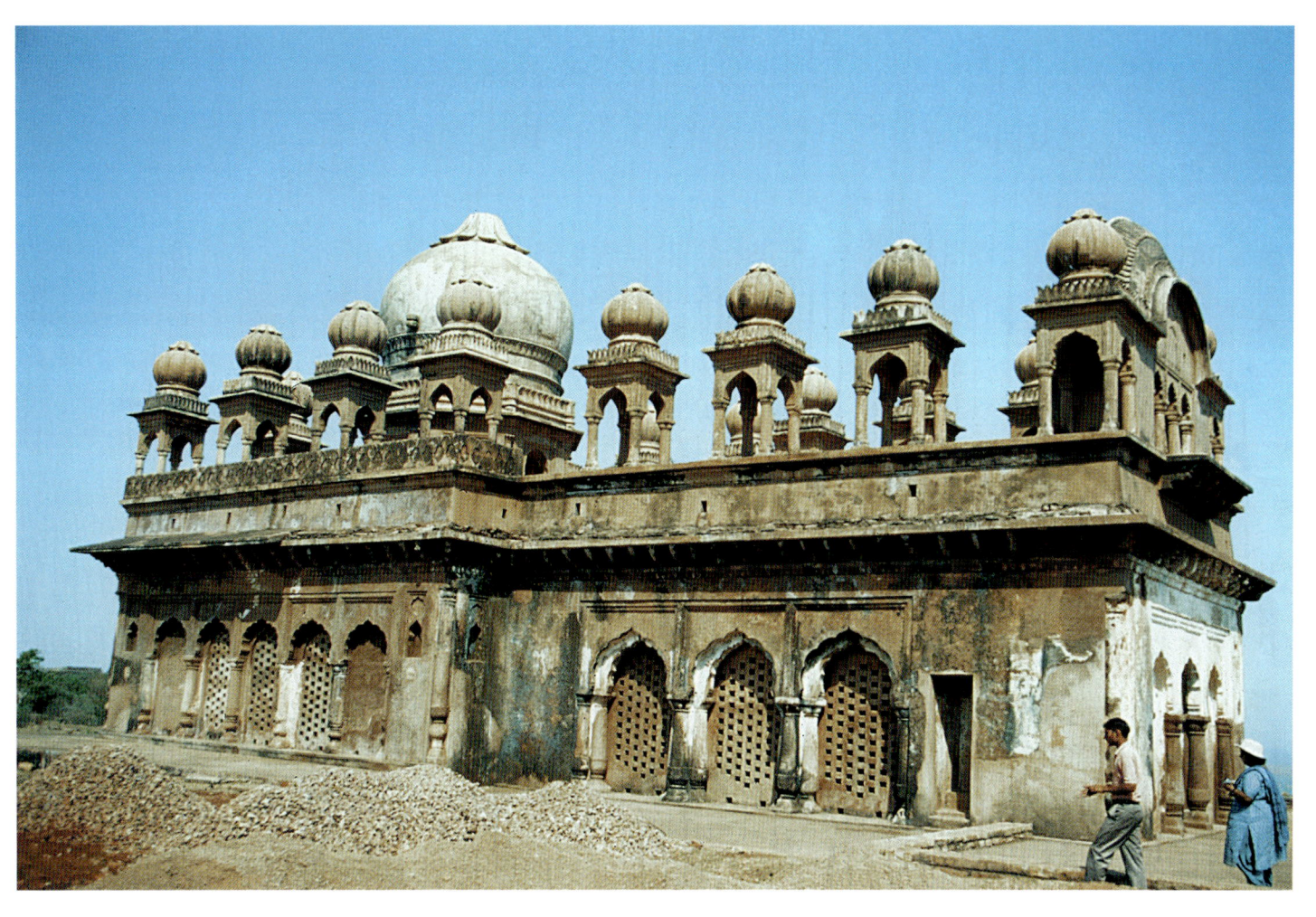

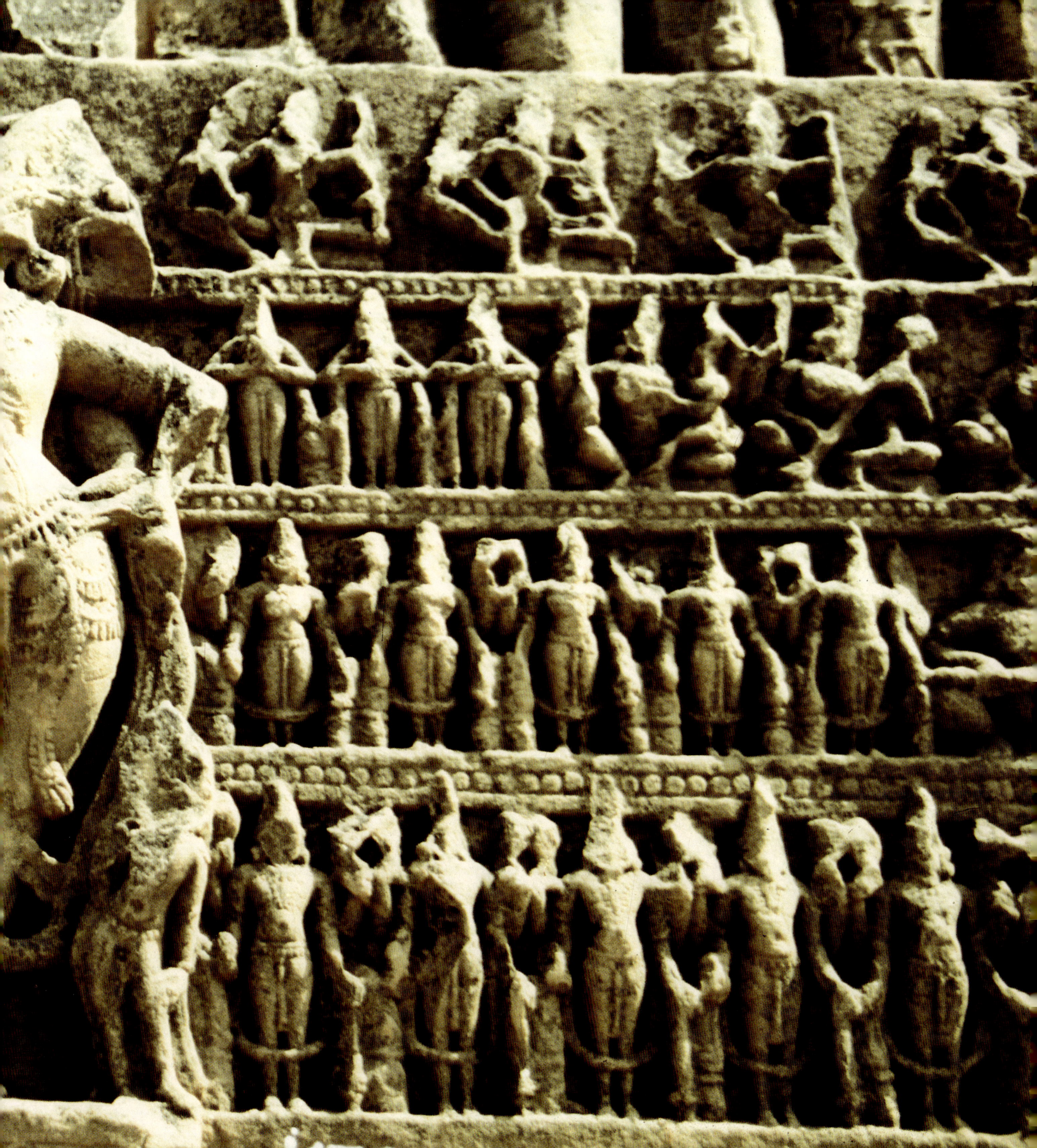

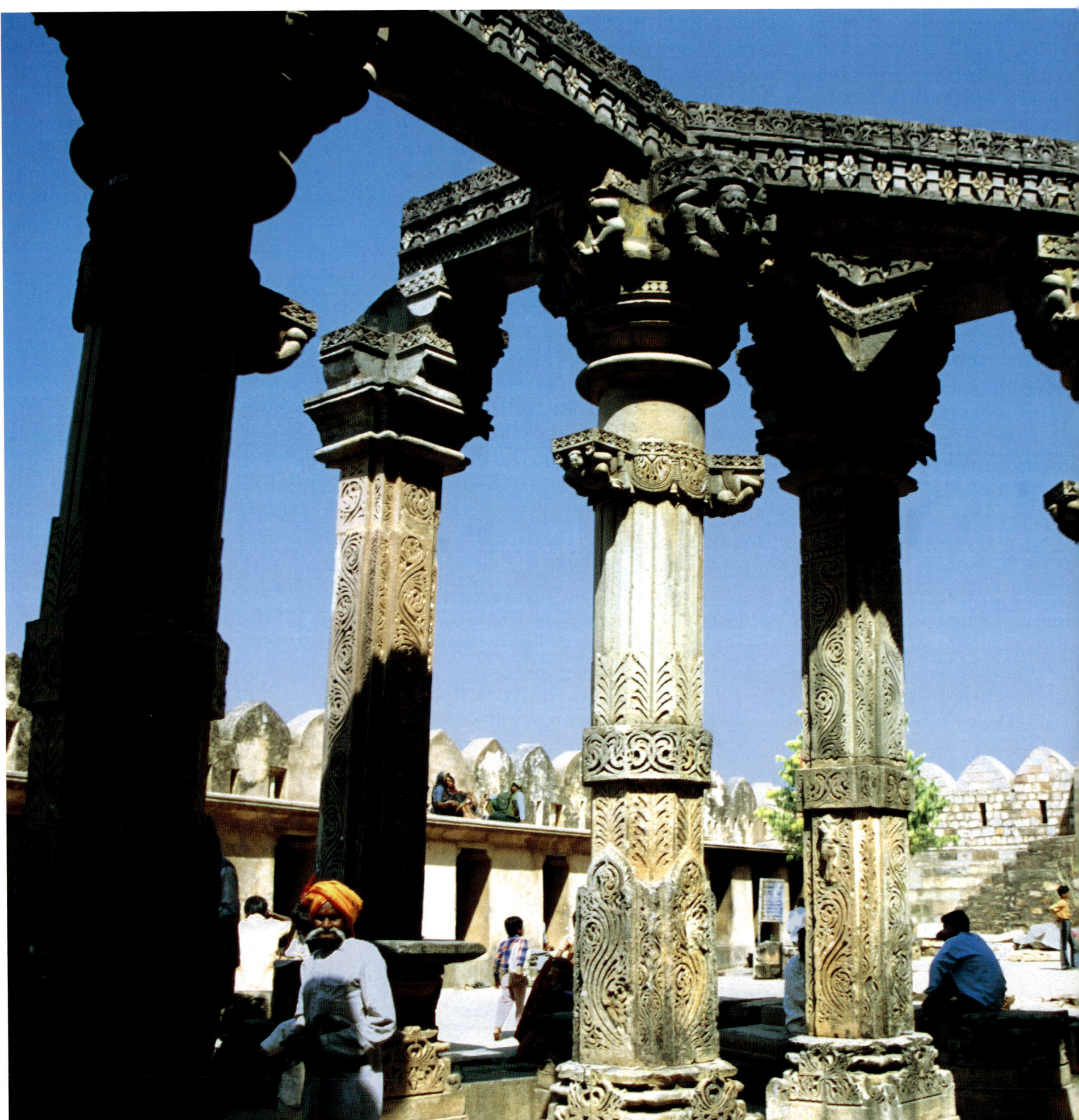

task uncompleted. It was left to Sher Shah, the Afghan chief, to set up the most memorable battle at Kalinjar. Memorable for two reasons: Sher Shah died at Kalinjar and within the next five years his whole dynasty perished; and the Chandella rulers could never regain Kalinjar following the defect and death of Kirat Singh.

Following a tiff over a trifle with Raja Kirat Singh, Sher Shah was in full fury. He summonded up all his energies and determination for the reduction of Kalinjar: "Sher Shah encircled the fort and began to construct mines and a lofty tower for mounting a battery (*sarkob*) and covered lane (*sabat*). The covered ways reached the fort and the tower was made so high that the land within the fort could be overlooked from its top. For the space of seven months the solidiers and camp followers laboured day and night. Day and night two thousand workmen were engaged in the work (of casting canon) and four thousand mortars (*degs*) capable of discharging balls four maunds heavy were cast. Two lakh (Doubtful) *tankas* were daily assigned for the food and wages of the labourers. All these works were not suffered to stop for a single day during the time…" (Tarikh-i-Daudi, M.S.p 239, quoted by Qanungo).

The final assault on Kalinjar was made on Saturday, May 22, 1545 with Sher Shah leading from the front. Arrows were discharged at defenders of the fort positioned on the parapets of the ramparts. "When Dariya Khan brought the bombs, Sher Shah described (from the raised platform from which he had been shooting arrows) and taking his stand where the *huqqas* (bombs) were kept, issues an order to light (the fuse of) the *huqqas* and throw them inside the fort. While the soldiers were busily engaged in throwing these hand-grenades, by the will of the Almighty, one *huqqa* hit the wall (*diwar* not gate as in Elliot) of *huqqas* and fireworks which also caught fire and there was a great explosion. Shaikh Khalil and Shaikh Nizam and other wise men (Danish-mandan) and the soldiers escaped partially burnt but Shershah came out half-burnt… when in that condition he was taken to the interior of the camp, all his nobles assembled in the *darbar*. He sent for Isa Khan (Hajjab) and ordered him to capture the fort while he was yet alive". While Sher Shah battled against intense heat and body-burns, his soldiers surrounded the fort from all sides "like ants and locusts". The battle came to an end in the afternoon. Raja Kirat Singh along with seventy soldiers shut himself up in a house which the Afghan soldiers blocked to prevent any escape by the Chandella Chief. On hearing the news of his victory (May 22, 1545 CE) Sher Shah's last words were "Praise be to God! This was my desire".Kirat Singh was subsequently beheaded by Sher Shah's son, hastily summoned for coronation at Kalinjar.

Battles over the possession of Kalinjar kept on being fought between Hindu rulers of Bundelkhand and their enemies but it was Akbar in 1569 CE, who finally annexed Kalinjar, gifting it to Birbal ultimately. There-after Kalinjar remained part of the Mughal Empire till 1707 CE when it came under the Bundella chief Chatrasal. In 1818 CE the British acquired the Kalinjar fort.

Within the vast stretch of the plateau, Kalinjar has but a few structural remains of palaces besides some decaying pathetic ruins crumbling walls and collapsed roofs, cells occupied by bats and tottering pillars etc. Still, everywhere there are tell-tale signs of Kalinjar's pristine grandeur. Most importantly, some of the ancient ponds and lakes can still be identified. Koth Tirtha lake, the most famous of lakes at Kalinjar, has enough water at its rocky bottom. On its western, side, numerous *ghats* can be seen descending to the water. It was the centre of life at Kalinjar with ruins of palaces, pavilions, temples lined up on the embankments. There are stone steps on all the four sides. The southern side has ruins of a grand portal without its upper portion.

Ruins of palaces, mostly built by the Chandella rulers and Chatrasal, are amongst the most impressive antiquarian remains at Kalinjar. Just as you climb up the road to enter the fort, on your right stands a small palace close to the ramparts. It is a much restored structure still with an engaging

Previous pages:
Exquisite reliefs now mutilated

Left:
Pillars at the Neelkantha temple

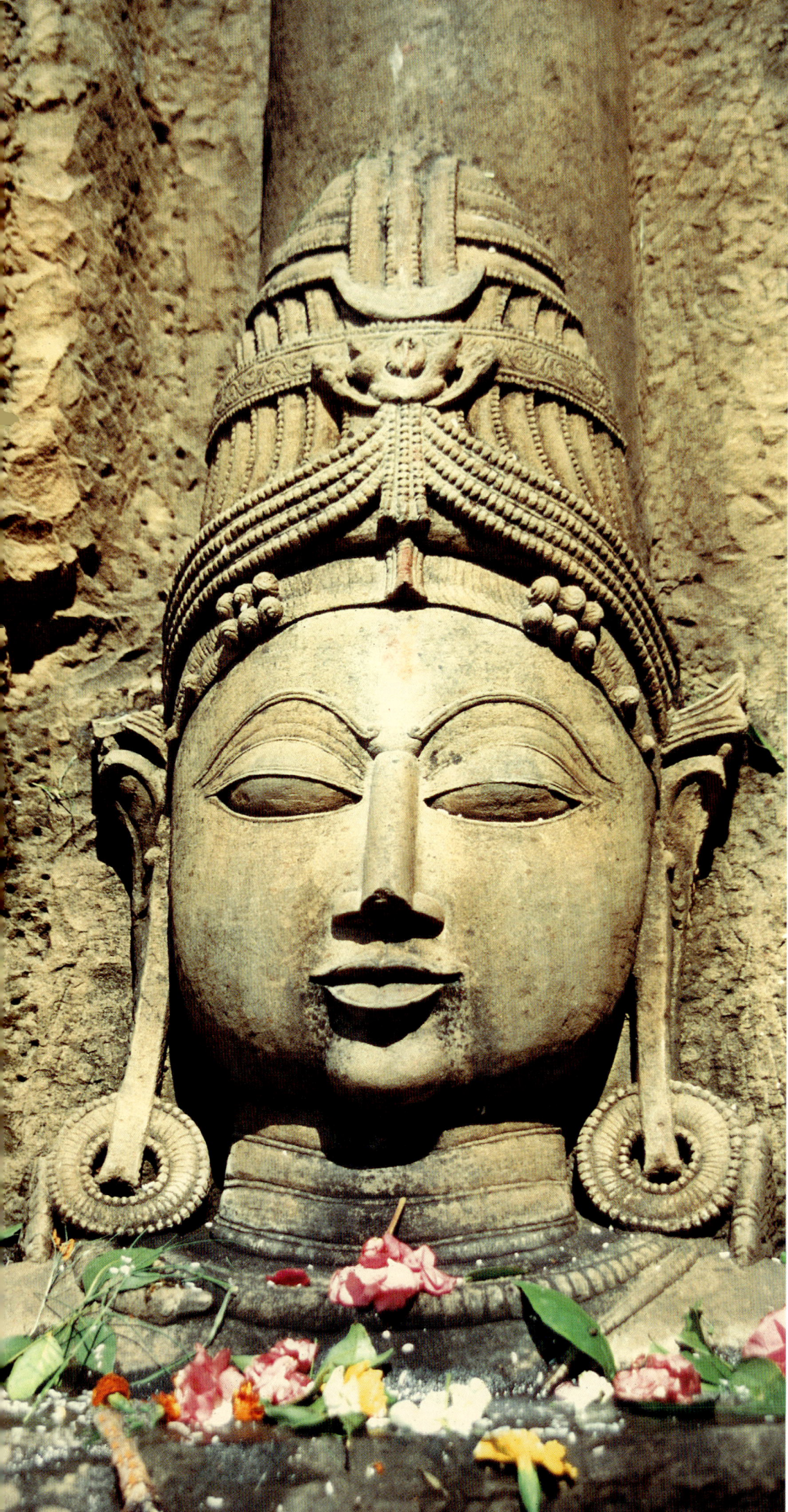

charm of its own. On the front is a large central arch with a rectangular door opening. It is flanked by two blind decorative niches. Over these large niches are two smaller arches carved in relief on stucco. A small *chajja* is placed over this section of the elevation over which rises the triple arched gallery with smaller openings on both sides. On the left wing is a high-placed balconied window covered with a *chajja* of the sloping-roof variety. The structure at the top is protected by a *chajja* supported on small brackets behind which are the roofs of the inner chamber rising above the roof of the front portion. The parapet is decorated with small merlon-shaped battlements. The interior comprises a small sun-drenched courtyard surrounded on three sides by cloisters with arched-facades. The baluster columns are covered with discreet ornamentation. Situated away from other residential buildings, this palace, perhaps, was meant for small celebrations and royal conclaves. Despite its ruined state, it is a very charming palace.

A little distance away stands the Venkat Bihari temple with its roof lined up with a series of small domes rising over arched *chattris*. The interior consists of a large narrow rectangular hall completely devoid of any decoration-structural or sculptural. The most striking part of the structure is the portion over the entrances. It is a triple-arched pavilion with a roof with corners bent as in *bangaldar* roofs. The lower portion with arched openings is protected by a double row of *chajjas*. Most of the arches are now filled up with bricks.

The Venkat Bihari temple faces the rear of the Rani Mahal which is the grandest palace structure at Kalinjar. The chief entrance is approached by moving around the ruins of side wings. The front elevation of the Rani Mahal is magnificent. Entrance is provided through a high engrailed arch covered all around with restrained ornamentation on stucco. On both sides of the central arch are two small openings built over platforms of a modest height, perhaps for use by the guards. Over these arches on each side are balconied windows under elegant arches; each arch has its ornamental roof carved on stucco. A small *chajja* supported on brackets separates the lower section of the structure. The upper section built over the *chajja* adds splendour to the façade. It is a triple-arched pavilion flanked by small arched windows set within frames carved on stucco. On both sides of the pavilion are steps to the uppermost terrace, concealed behind graded walls rising with the steps. Small windows provided views of the outside world. The parapet is decorated with merlon-shaped battlements imitating the style of merlons on the ramparts of the fort.

The interior of the Rani Mahal is built around a spacious courtyard with double-storeyed constructions on all the four sides. The palace structure has square corner towers for security watch. Some restoration work has been done to salvage its original splendour but the roofless galleries, broken columns and damaged ornamentation are so much more eloquent about the glory that has passed away.

On both sides of the Rani Mahal are subsidiary structures. The palace of Raja Aman Singh, a descendant of Chatrasal, stands overlooking the Koth Tirtha. This is the most impressive section of the fort with many big and small ruins of palaces, temples and pavilions lined up on the high embankments. The *ghats* or steps descending to the water level indicate the importance of water sources in these extremely hot and dry regions. The central entrance follows the architectural scheme of the Rani Mahal with splendid high arches at the centre flanked by arched openings meant for guards. Over these small arches are placed two elegant balconied windows. The projecting portion is supported on brackets. A narrow *chajja* extends some shade over the arch. The side wings have a plain wall with arches. A spectacular courtyard lies in front of the grand arch. The whole open area is protected with a boundary wall with a roofless but double storeyed gallery of arches on the right side toward the Koth Tirtha. The interior of the palace presently functions as the museum housing hundreds of broken statues, pillar shafts, Ganesha, Nandi and Shiva, damsels and deities-all

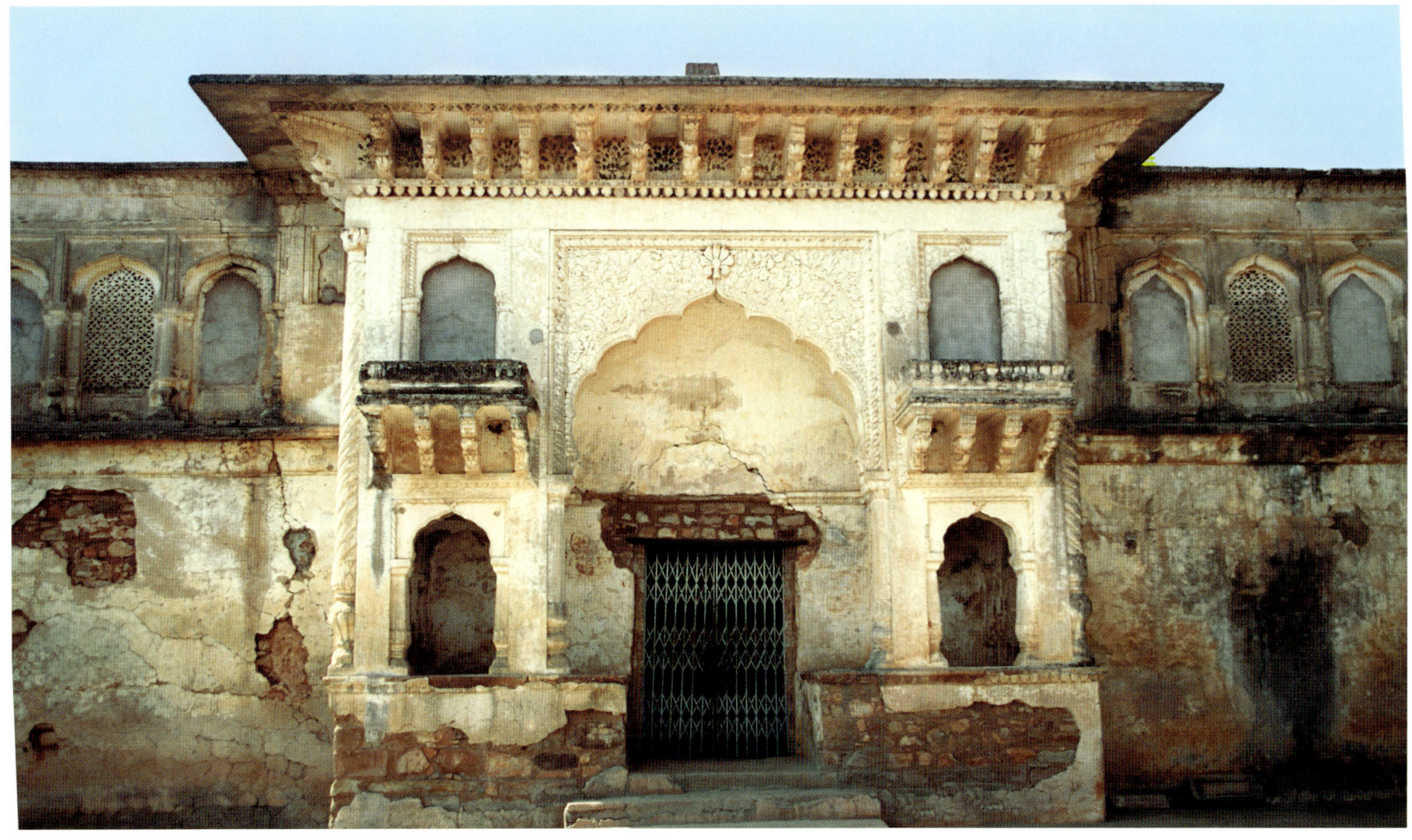

reduced to a pathetic exhibition of sculptural wealth of Kalinjar, most of it the work of Chandella rulers. Since the Cahandellas were renowned Shiva worshippers, the museum has a large number of Shiva-Parvati, Shivalinga and Nandi images. The damaged images in granite and sandstone are arranged in the rectangular courtyard and galleries with *baluster* columns and exquisite ornamentation on stucco. Use of stone was reserved for the houses of gods.

A little distance away a small mosque stands forlorn on the edge of a dried up lake with sunken and broken embankments. At the other end of the lake stands a small palace. The roofs have all collapsed, at places the wooden rafters of the roofs dangle precariously overhead. The silence in these haunted chambers is broken only by footsteps of visitors. Peeping into the dark and smelly interiors can be a memorable experience.

The most sacred and frequented spot at Kalinjar is the Neel Kantha temple reached through a long flight of steps descending to a terrace projecting cut of the rock face. Spectacular views of the Kalinjar hill and the village below can be obtained from here. The rocks along the steps are carved with reliefs of deities. Particularly noteworthy is the life-size sculptures of Ganesha with ankle bells, waist band, necklaces, armlets and crown. The most impressive group of reliefs has a splendid Shiva head at the centre with a royal couple offering worship placed close to it.

Beyond these steps is a hexagonal arrangement of tall columns built to cover the entrance to the natural cave housing the bluestone Shivalingam with silver eyes. For centuries it has been worshipped by millions of devotees. Elegant sculptural reliefs cover the rock-face on both sides of the entrance, the work of Chandella sculptors. The grand columns are covered with exquisite ornamentation-scrolls, garlands of beads and Atlantean heads on capitals supporting beams connecting these columns and keeping them in place. Almost every nook and corner on the terrace is occupied by men, women and children who, after taking a dip in the Patal Ganga-the sacred stream, offer prayers to Shiva. The Neel Kantha temple, reliefs and sculptures and a few inscriptions are the work of people during the Post-Gupta, and Chandella period.

At the extreme and of this terrace is the gigantic relief of Shiva as Kal Bhairava. This 24 feet high relief with its feet perennially dipped in water has an awesome visage with matted hair crowned with moon crescent. A garland of serpents and skulls with snake earrings and snake armlets complete the image of Shiva in full fury. Abul Fazl was quite impressed by its 18 cubits height.

Clockwise from left:

Shiva head sculpture; Amar Singh Palace, built by Chhatrasal

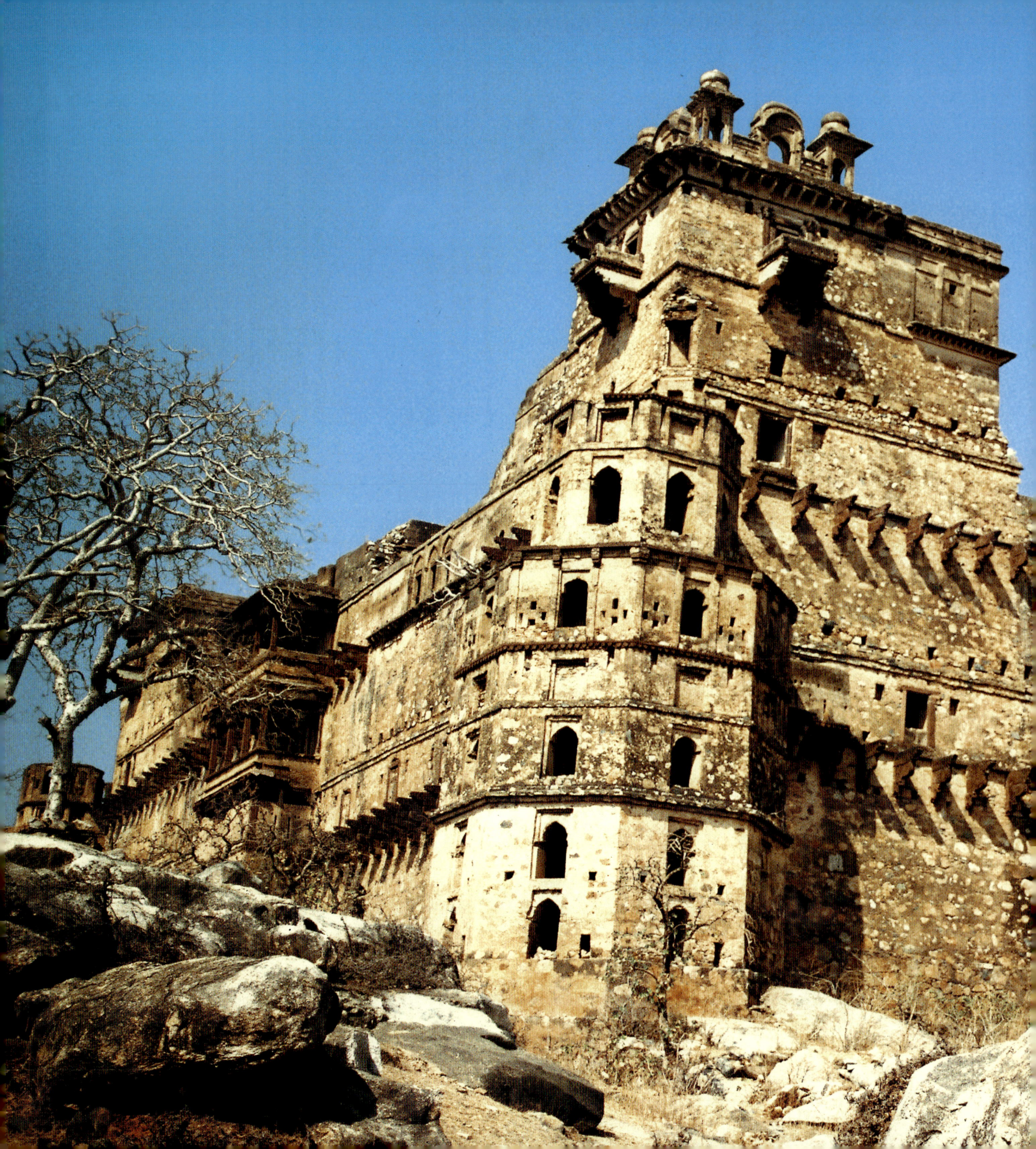

GARHKUNDAR

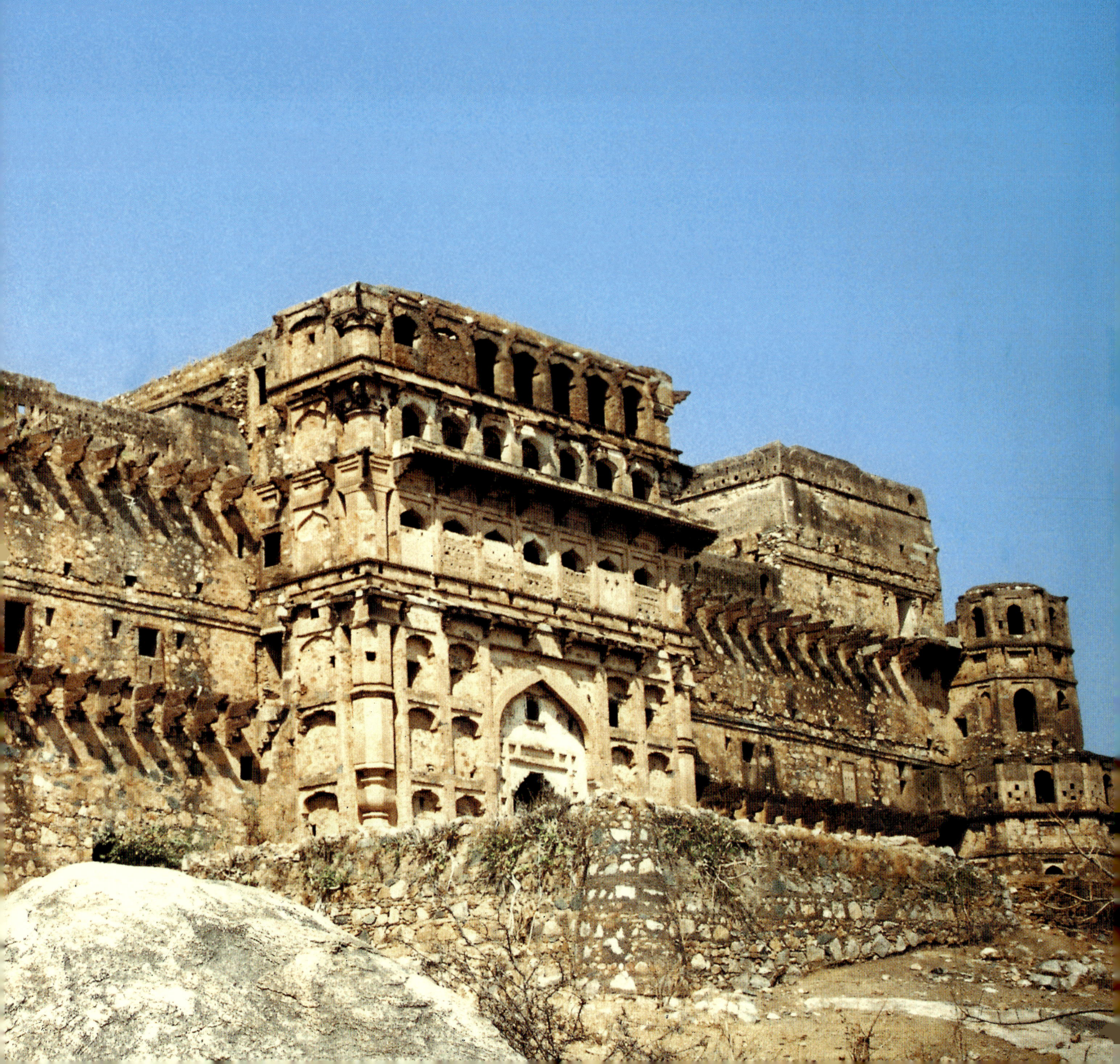

This magnificent fort palace stands on a barren and isolated rocky mountain surrounded by a dreary landscape, nearly 50 km north of Jhansi in Madhya Pradesh. It is visible from far distances but keeps appearing in view and disappearing behind the craggy tops. The road remains mostly unfrequented. The desolate surroundings create an air of mystery about this massive palace surrounded by sheer nothing. Its origin remains wrapped in uncertain conjectures but it has been associated with the Chandelas, Khangars and Bundelas – dynasties which ruled over Bundelkhand between the ninth and sixteenth centuries CE. Garhkundar was part of their territory, witness to internecine clan-wars and invasions. Today, as it stands proudly in its undiminished savage splendour, Garhkundar seems to have been deserted only yesterday.

The history of Garkhundar begins with the rise of the Bundela power coinciding with the decline of the Chandela rulers. The Bundelas trace their origin to Lav, son of Rama, hero of the epic Ramayana. The descendants of Lav were an established dynasty in Kashi (Varanasi) around 674 CE and ruled upto 1042 CE. Their last known ruler was Karanpal. Those were very difficult times and the right to succession challenged on many grounds, chiefly the physical might. Karanpal had chosen Hemakaran, his eldest son, to succeed him but his other two sons wrote another script for the chosen brother. The unsuspecting Hemakaran had to run for his life at the dead of night.

For nearly six years Hemakaran wandered about in the Vindhyan territory and worshipped the local goddess. At last he could rest his feet. His search for a place of refuge terminated at Gohara, near Banda where he organised a small force around him. He came to be known as Panchamvir Vindheyala and inaugurated the Bundela rule in 1048 CE. His successor chose Mahoni as the capital of the new rule. The Bundelas ruled over Mahoni upto 1231 CE when history repeated itself when Sohan Pal, the rightful heir and successor to Arjun Pal, was driven away by his brothers and, like his ancestor Hemakaran, had to seek shelter in the dense forests around the Betwa river. At this time Garhkundar finds a mention as the stronghold of the Khangar clan of the Rajputs. Hurmat Singh, the Khangar chief, had antagonised his neighbours – the Paramaras, Pariharas, Chauhanas and Bhadorias etc. Sohan Pal organised these various Rajput groups and sought Hurmat's support against his brothers now ruling over Mahoni.

Previous pages:
Seven-storeyed corner tower of Garhkundar palace

Clockwise from below:
Balconies on the side wall; Gateway to the palace interior

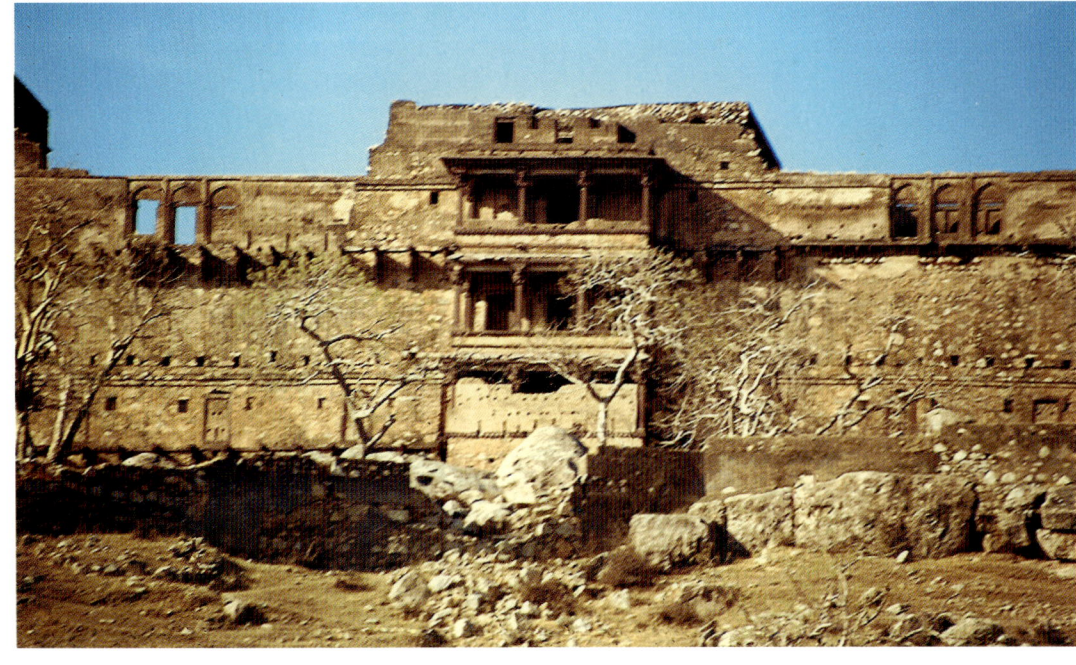

186

FORTS AND PALACES OF INDIA

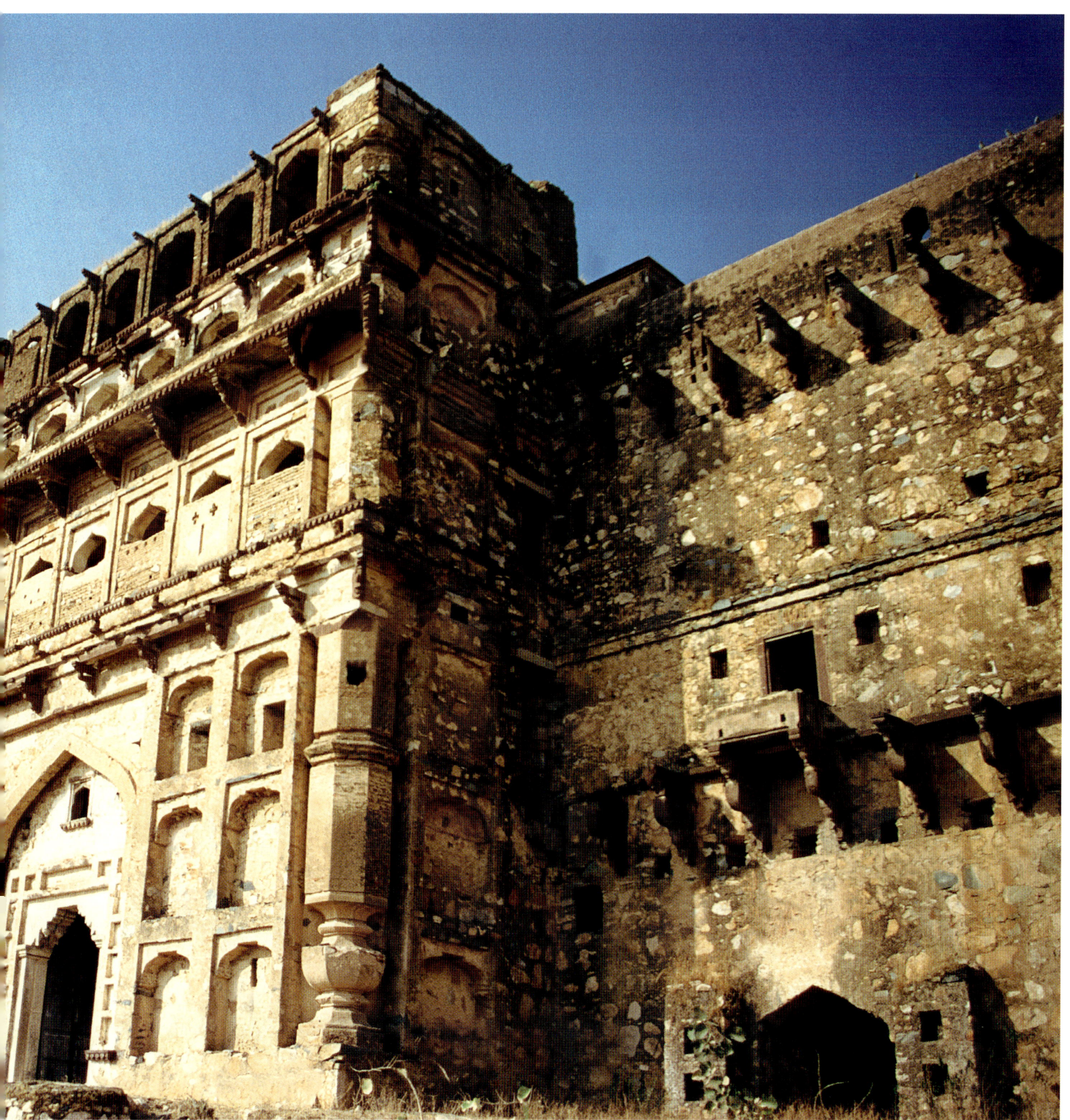

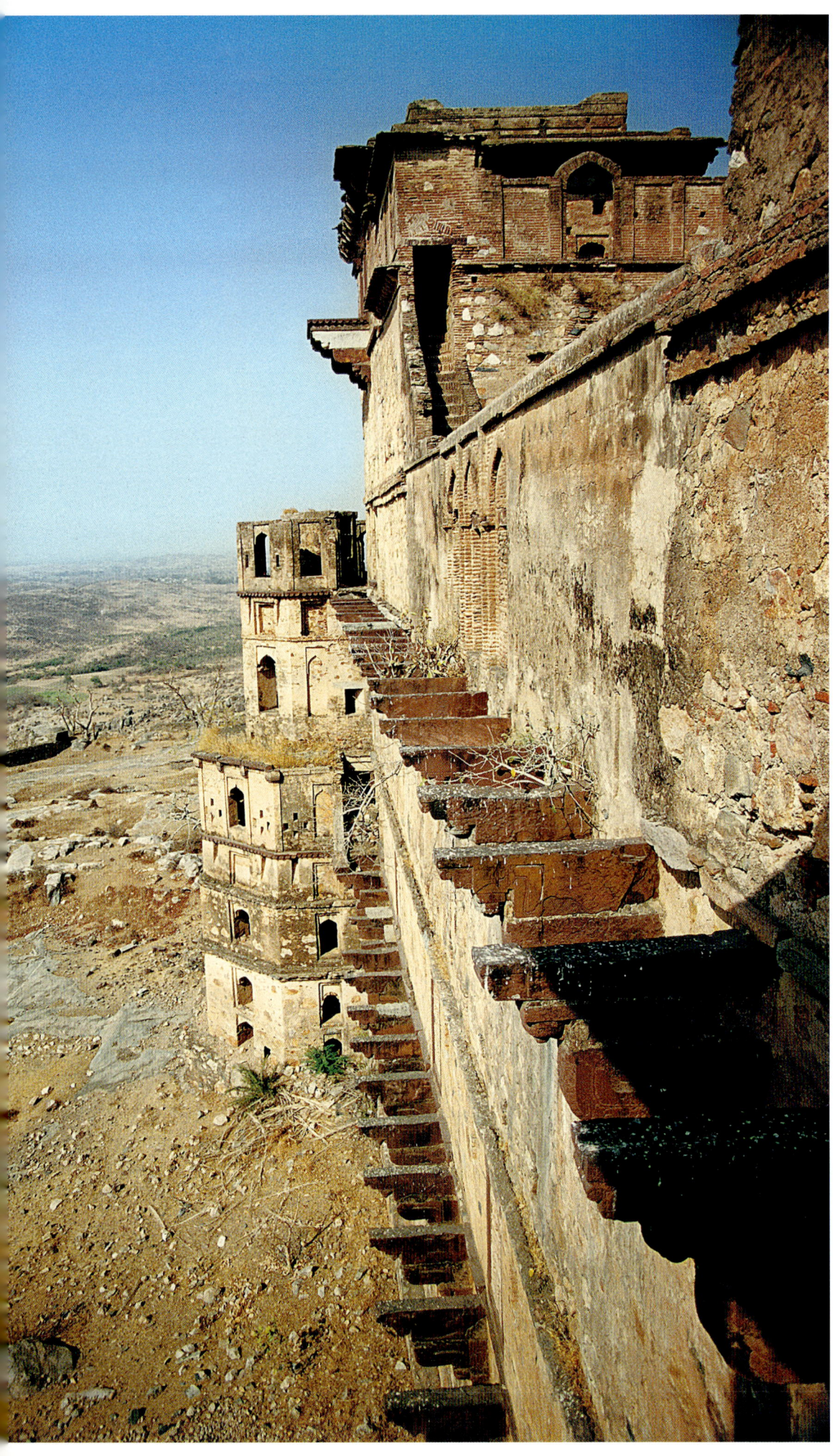

As the story goes, Hurmat laid a condition for his support: Sohan Pal should give his daughter in marriage to Hurmat's son Nag Singh. This infuriated Sohan Pal, who led an attack on Garhkundar in 1257 CE, annihilated the Khangars at the marriage feast and established the Bundela rule over Garhkundar, which remained their capital for nearly three hundred years. Garhkundar remained a formidable stronghold during the Bundela rule. The Bundelas took full advantage of the dwindling power of the Tughlaqs in Delhi in the years following the sack of Delhi by Timuar in 1398 CE. The Bundela rule spread over many adjoining territories. Later on the Lodis tried to subdue the Bundelas but met with no great success. The vulnerability of Garhkundar to frequent invasions was made easier by the open scrub land surrounding it. Rudra Pratap realized the importance of a safer place as his capital. In 1531 CE Rudra Pratap shifted the Bundela capital to Orcha. In an ironical situation, Rudra Pratap died of injuries he had sustained trying to save a cow from a lion as he was proceeding to Garkhundar on a visit. Since then the mighty fort palace has remained consigned to oblivion and forgotten by historians and archaeologists alike. Very few have heard about Garhkundar and still fewer people visit it. The great palace stands like a well decorated soldier dressed for the battle but with no battles to fight.

A narrow footpath cutting across the rock-stewn landscape leads to the short uphill climb where over a stately flight of wide steps stands a magnificent gateway on the strong wall punctuated with massive bastions. This gateway is flanked by double storeyed constructions but with a flat exterior. There is adequate arrangement for security guards. Across the arched entrance lies a vast open area with treacherous rocks jutting out of the dry sun-baked land. The fort palace appeas in full view-a magnificent sight of the east and southern wings of the palace with a tower occupying centrespace. All around are patches of dehydrated grass and leafless bare trees. Here you can actually stare into the face of history.

Garhkundar is believed to be a seven-storeyed palace including a double-storeyed basement. The corner tower has four storeys over which rise the three storeys of the palace. This view shows the military character of the structure remarkable for the absence of any significant ornamental element. The straight walls of the horizontal structure have a severity unrelieved by *jharokhas* and the different levels of floors are indicated by running courses of uncovered brackets.

The entrance gateway is massive and in two parts. The lower portion is square in design over which rise the triple-storeyed arcades. The central section of the elevation is a rectangle containing a large recessed arch occupying nearly the full height of the square section below the arcaded galleries. Set within the recessed arch is the door of the beam and bracket order. The space above is alotted to a small arched opening. The gateway is flanked by two rows of recessed arches, each row containing three superimposed arches. The lower arches are decorative whereas the upper arches are functional openings for ventilation and watch. The central doorway is also flanked by rectangular recessed panels. The shallow monotony of these recessed panels contribute precious little to the ornamentation of the façade which bears a not inconsiderable similarity to the facades of the square Lodi tombs in Delhi known for their trabeated or arcaded portals flanked by blind arcades superimposed in two or three registers, a small entrance under a gigantic recessed arch and a small arched opening set over the top of the lower arch. The gateway at Garhkundar is a grand construction which owes some of its grandeur to the triple rows of superimposed arcades rising over the lower square section.

Garhkundar was believed to have been built by Bir Singh Deo I (1606-27 CE) who built the two famous palaces-Jehangir Mahal at Orcha and Gobind Mahal at Datia. This conjecture is based on certain similarities in the architectural plans of these palaces and Garhkundar. Bir Singh's palaces contain double- storeyed ranges built around a central courtryad. The upper most parapet is decorated with domed *chattris*, *jali* screens and long open corridors. In contrast, Garhkundar is a much more primitive in

structure with no place for such embellishments. It is essentially a trabeate construction with no domes, *chattris* or *jali* screens.

In all likelihood, Garhkundar was built by the Bundela rulers before they shifted to Orcha. The architectural features of Garhkundar appear in a much more refined and developed form at Orcha hence an earlier data of its construction is more probable. Garhkundar is square on plan and the vast courtyard is surrounded by double storeyed ranges with projecting sections with triple-arched opening at the centre of each wing. The roofs of the lower storey serve as terraces at a few open spaces on the upper storey. The four corner sections are surmounted with an additional chamber over them. The rooms have flat roofs. The complete absence of any embellishment emphasizes the military character of Garhkundar built before the Bundelas had tasted the fruits of security and stability against invasions. Garhkundar was a retreat when adverse circumstances gave warnings to remove families to safe places.

The most striking feature of architecture at Garhkundar is the provision of multi-storeyed octagonal towers joined to the corners of the square-in-plan palace. These four storeyed towers rise upto the level of the second storey of the palace and function as bastions attached to the corners providing both strength and security to the palace. The tallest sections of the palace at Garhkndar are the square corner towers. The Bundelas retained these features at their palaces in Orcha and Datia. The Multi-storeyed octagonal corner towers were to remain the recurring features on the later Bundela palaces.

The severity of the whole construction at Garhkundar is relieved just fractionally with the introduction of an ornamental element on the top of each square corner tower. It is a set of small, nearly miniarutized, *chattris* and equally small pavilions crowned with *bangaldar* roofs. Below the parapet are two cantilevered balconies, one each on the eastern and southern face of the corner. The only other instance of decorative element appears in the use of granite on the triple arched entrances on the central projections on each side on the central courtyard. The corbelled brackets assume a grandeur of their own amidst severe looking ranges.

Garhkundar has a grand lake called Sindhu Sagar excavated by one of the Bundela rulers besides some elaborate water works like a deep wall, a *baoli* and a network of clay pipes for distributing water to different sections for the palace.

Garhkundar does not have the splendour of sheesh mahals and painted interiors. There are no grand darbar halls. But it has the most stunning views over a rugged countryside. Garhkundar remains an extremely memorable experience in my odyssey through the forts and palaces of India.

Clockwise from far left:
Massive defence wall; Rows of double-storey apartments around the upper courtyard; Sati stone

HYDERABAD

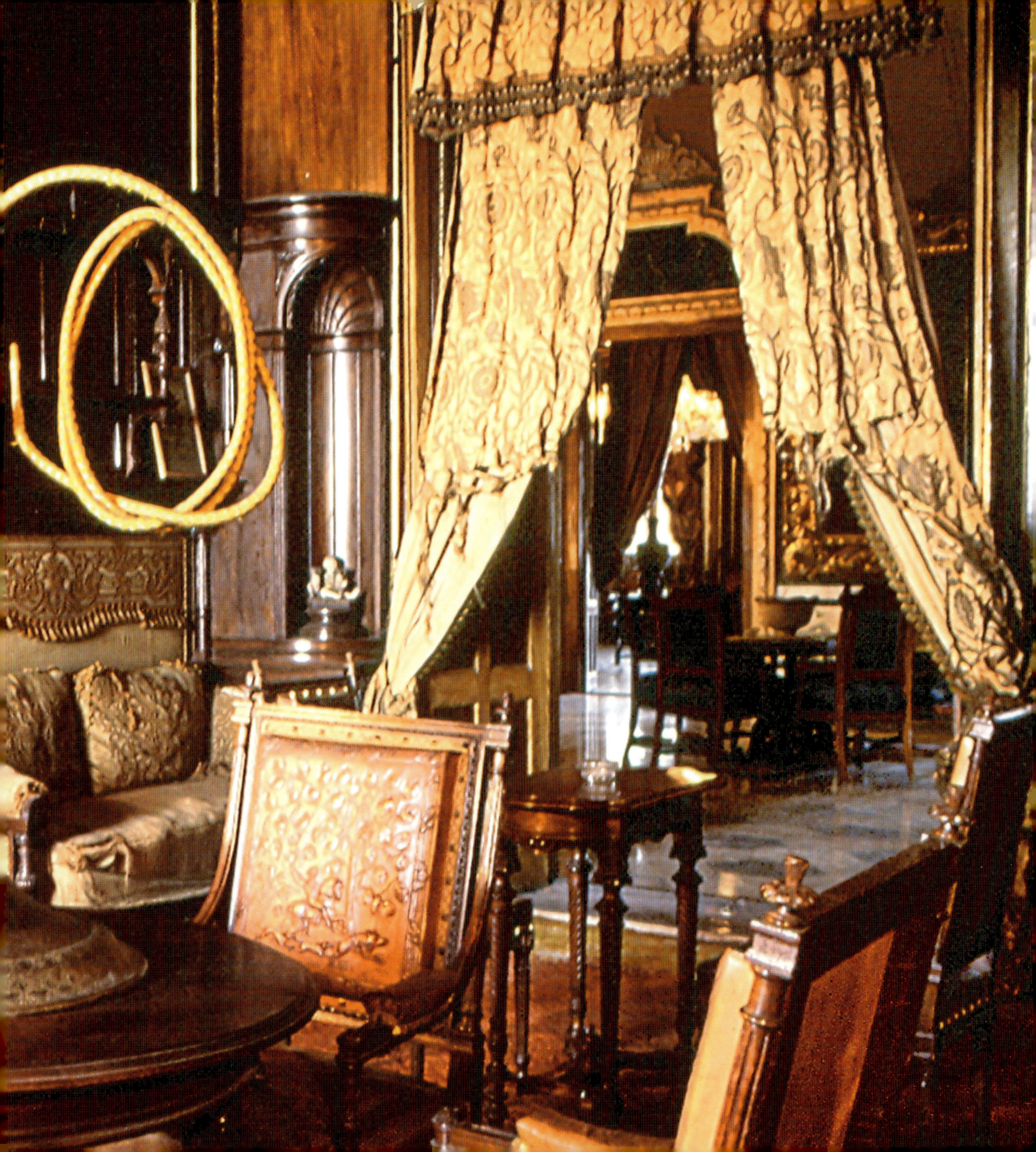

Previous pages:
Reception hall at the Falaknuma Palace

Clockwise from right:
The Falaknuma Palace; Staircase leading to the private chambers; The stately Dining Hall Fountain in the lobby

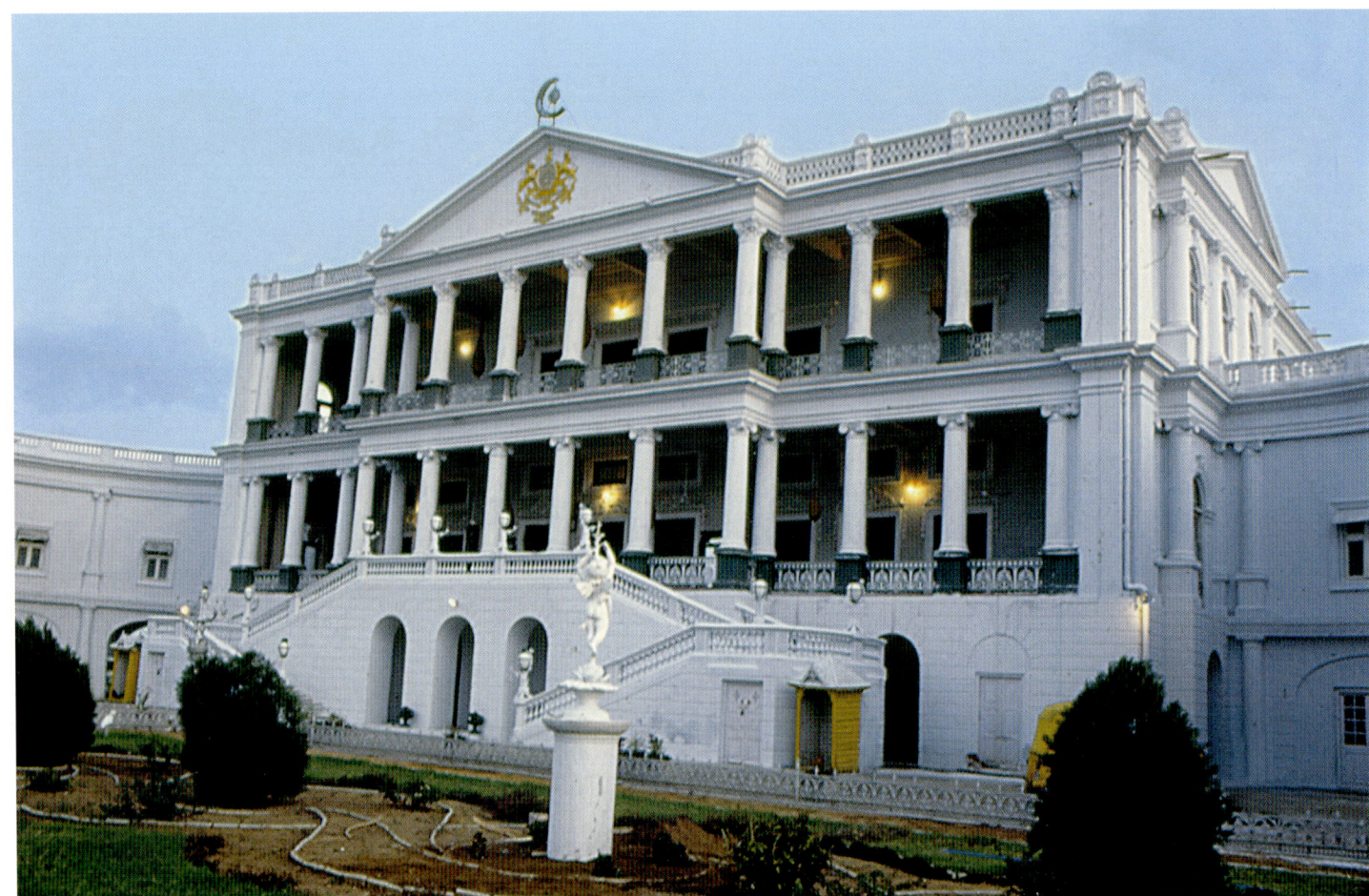

The fabulous Falaknuma Palace ("Mirror of the sky") stands on a hill about 4 km from Char Minar on the southern fringes of the city. The present structure of the palace was constructed at the much older site of the Koh-e-tur palace built by Muhammad Quli Qutb Shah during the 16th century CE.

It was originally built by Vicar-ul-Umra in 1892 CE on a design furnished by an English architect but was five years later purchased by Nizam Mahboob Ali Khan for only 35 lakhs, for use as guest house for his European guests. Towards the end of the 19th century, the British in India were engaged in many a grand architectural project. Their very presence near the seat of power had some far reaching consequences only marginally symbolised by the induction of European architectural styles into the traditional palace architecture of India. The Falaknuma Palace does not represent any particular architectural style but is a mixture of varying forms ranging from the 18th century England to Louis KIV, France. The architects chose a classical style for the principal range which comprises a range of double-storeyed colonnades, rising over a rusticated basement storey pierced by arched openings. The terrace on which the Falaknuma Palace has been built is reached through a double flight of steps. The elevation of the palace shows a clever mixture of diverse architectural strains. It is "Palladian in conception a curious building with reduced proportions and thick stumpy columns, Ionic to the ground floor, Corinthian to the first". Concession to indigenous style has been granted by the *zenana* quarters at the rear of the main building which are in the familiar Indo-Saracenic style.

The entrance hall has a small marble fountain surrounded by four marble benches. The walls are covered in a vivid Wedgewood blue paint articulated with flowering garlands, flying cherubs and grand blind circular arches. Lovely marble vases are kept over high pedetals. The ceiling is decorated with the gigantic figure of a bird. The whole setting creates a rich ambience though highly hybrid in character. The double marble flight of staircases, carved balustrades, marble figures with candlebra, oil paintings of the Nizams of the Asif Jahi family and the Governors – General of India add to the contemporary eclectic style of work in the palace. The furnishings betray a similar predilection for foreign elements. Drapes and upholstery have been imported from France and the marble used in the palace was brought from Italy. These are certain non-indigenous features which are noticeably present in palaces built by the British architects in 19th century India. As in most contemporary palaces, the Falaknuma Palace also has a set of billiard room, smoking room, card room etc. A splendid *hookah* with multi-mouthed pipes, symbol of old-world convivality and bon-homie is placed on a table around which gathered friends and visitors to share the Nizam's hospitality. The long oval dining table in the banquet room offers a seating capacity of nearly one hundred guests.

The Darbar Hall has the throne at one end. French Baroque style is the choice for interior dacoration-mirrors, heavy curtains, dance floors, magnificent chandeliers creating a great ambience of pulence and luxury. The Falaknuma Palace was the residence of Mir Mahboob Ali Pasha but it became famous for the list of illustrious guests who stayed here- King George V, Queen Mary, King Richard VIII, the Prince of Wales, Lord Wavell, G. Rajagopalachari and Dr. Rajendra Prasad. Electric lights were installed at the Falaknuma palace for the visit of the Prince of Wales in 1926 CE.

The VIth Nizam Mir Mahboob Ali was a direct descendant of Asif Jah, a Turkoman who was a Subdedar in the employ of Anurangzeb who later went on to establish his own dynastic rule in Golconda. Mahboob Ali was a romantic at heart and wrote ghazals in Persian. He was also an accomplished player of polo, a crack shot, a great host. He was one of the richest men in the world but he is also equally well known for his utter miserliness. One of the Nizam's eccentricities led him to pick up cigarette

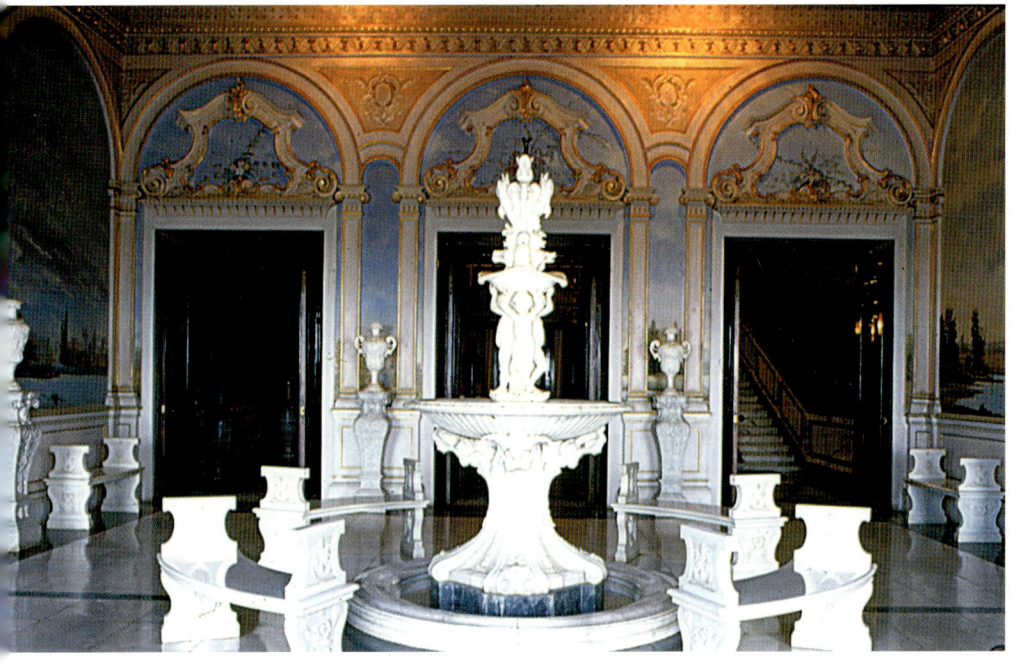
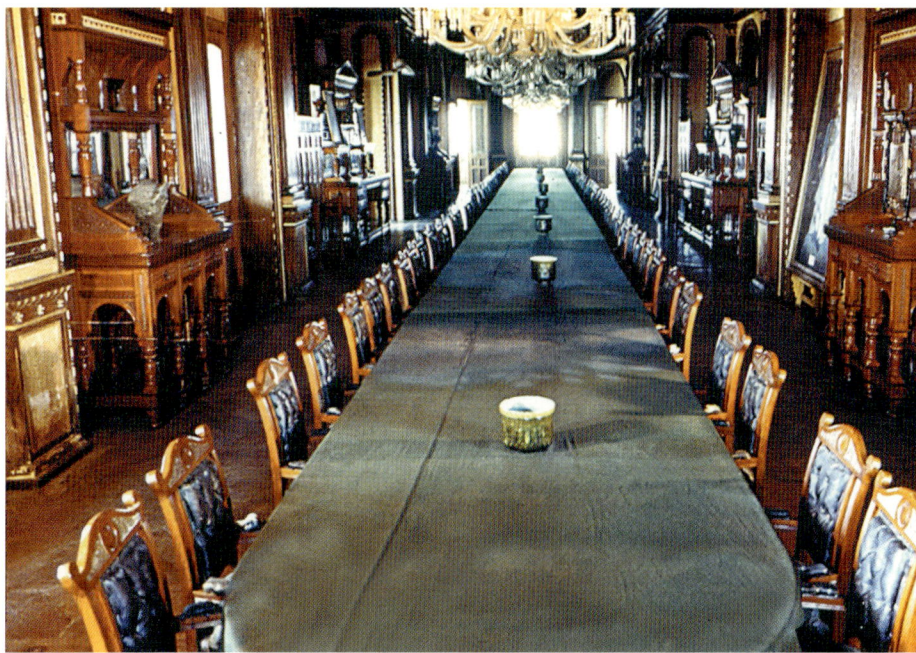

butts left by his visitors, light them up and enjoy the smoke with delight while his left hand toyed with large diamonds on his fingers. The Nizam owned a fabulous horde of diamonds and sacks full of jewels. Once when his jewels had to be washed, these priceless objects had to be spread over the palace roofs to dry, blinding with their effulgence the birds in flight over the palace. Besides these diamonds and jewels, the Falakhuma Palace also had a great collection of oil paintings, marble statues, period furniture, rare books and manuscripts. The collection of jade objects in the palace is believed to be unique in the world. During his last few days, the Nizam suffered a paralytic stroke which ultimately caused his death. The grand old man was at his table when the incident happened. It is said that one of the very large diamonds which the Nizam used as paper weight rolled off the table to settle in the waste-paper basket. The legendary treasures of the Nizam are just too huge. Only rarely, a truly symbolic small portion of jewellery is exhibited at prestigious museums in India and abroad under the strictest security arrangements.

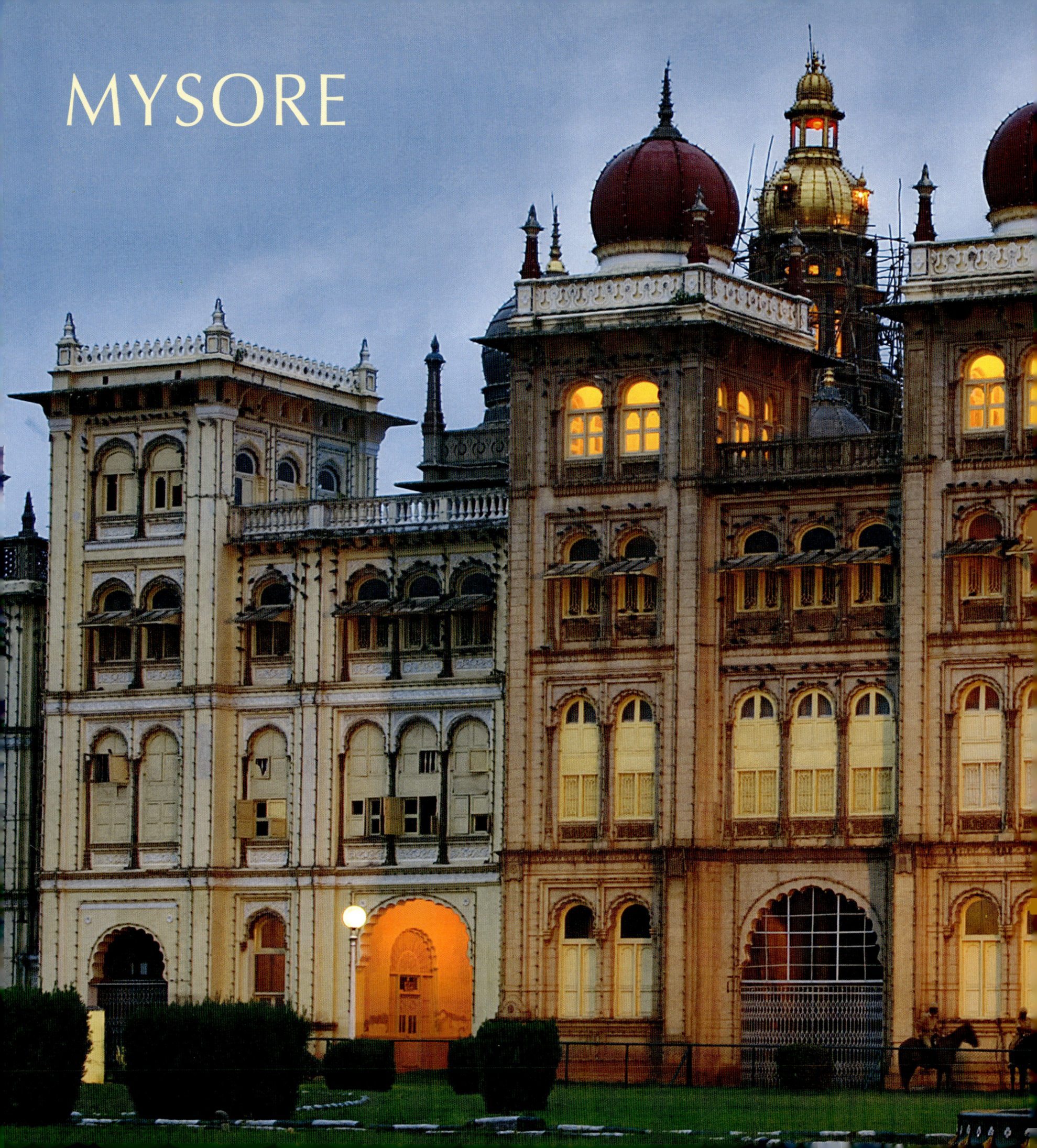

MYSORE

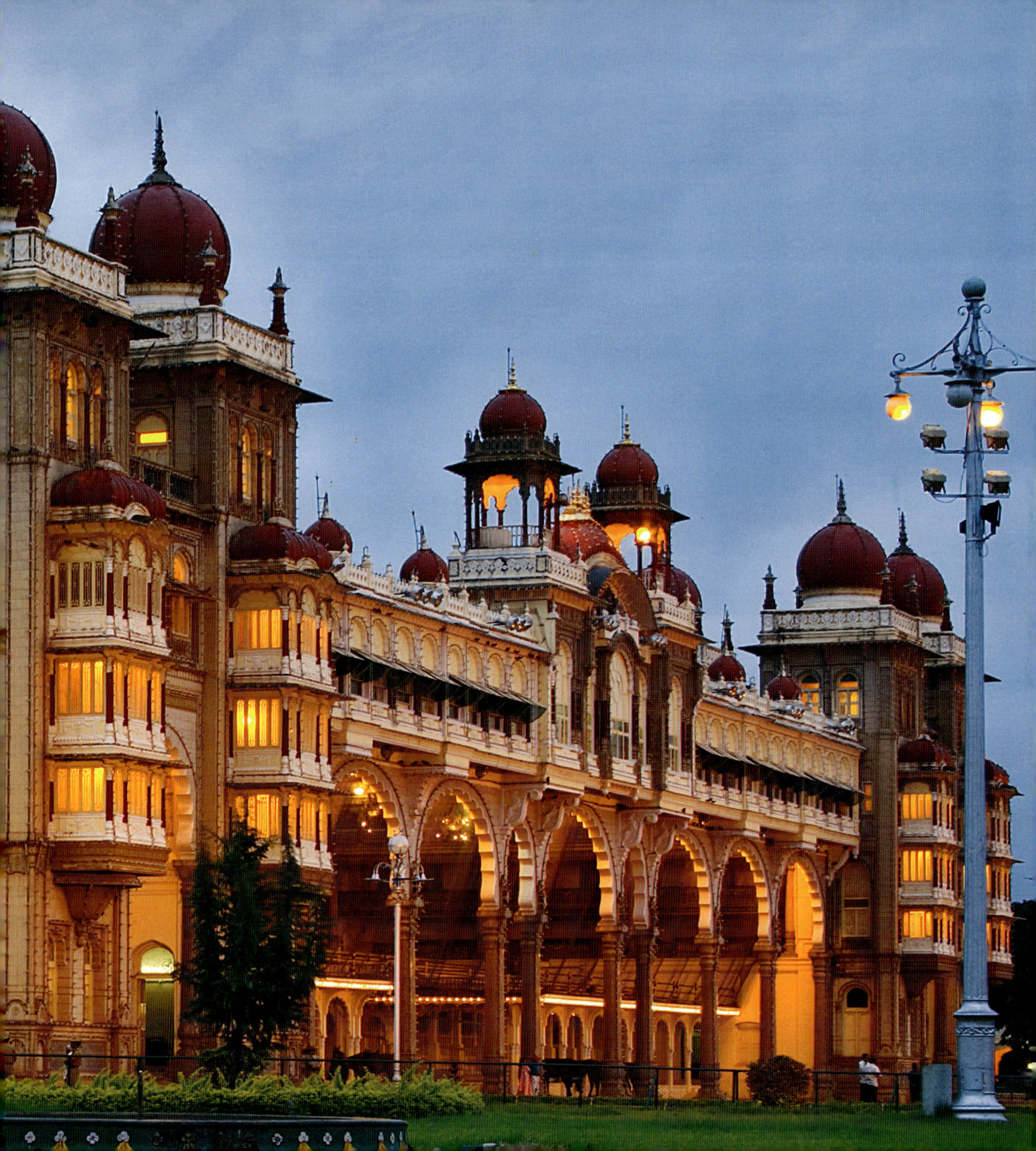

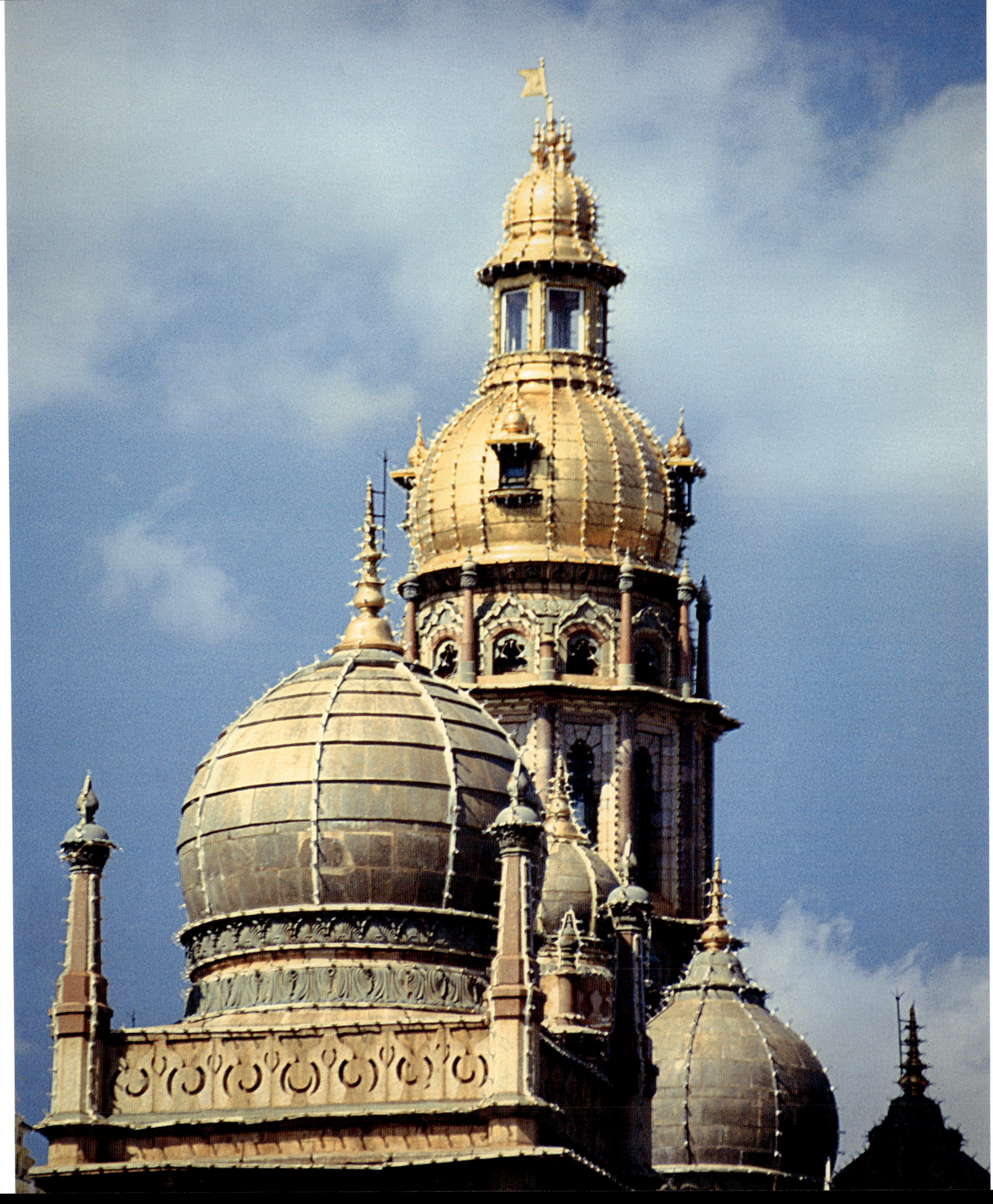

Undoubtedly the Amba Vilas Palace in Mysore is the greatest palace in southern India. Generally known as the Mysore Palace, it is the most important architectural creation of the Mysore rulers. The Mysore Palace is believed to have been first built in the 14th century CE when the rajas of Mysore lived here. But then it was not half as grand as it is today. The place was supposedly rebuilt in 1638 CE over the earlier structures which were severely damaged by lightning. Ranadhira Kantheerava Narasaraja Wadiyar, the ruler, had a few pavilions built. These pavilions-Soundarya Vilasa and Namatitha etc. resurrected the glory and grandeur of the earlier palace. He even had guns placed around the palace, contributing immensely to the majestic structure. In 1760, CE, Krishanaraja Wadiyar II visited the palace at the invitation of his Prime Minister Haider Ali. But soon thereafter in 1753 CE Tippu Sultan had nearly all palace structures demolished, leaving only the temples untouched. He had planned a grand new city called Nazarbad to be built to obliterate the remains of the Wadiyar palace. But Tippu's plans could not be realised. Very little of Tippu's planned splendid city could be built before a reversal of circumstances saw the Wadiyar ruler return to power in 1799 CE in a ceremony held in the open, especially erected *pandal*. In 1803 CE a very small set of buildings stood here. Most of the structures were built in wood which were also consumed by fire in 1897 CE. The wooden palace was completely destroyed. It is, however, believed to have been built in the style of the traditional Hindu architecture with a gaily painted front with four elaborately carved and painted wooden pillars at the Dassara Hall where the Maharaja held his open *darbar*. The royal apartments were surrounded on all sides by smaller structures. The most lavishly ornamented pavilion was called Ambavilasa, sixty five feet square and with a very high ceiling. Here the maharaja presided over royal entertainments held especially for his foreign guests. The royal seat was separated from the guests by an ornamental wooden railing.

The Wadiyars, however, realized that the palace was not large enough to function as residence of their large and illustrious family and decided to rebuild it in accordance with their requirements and tremendous stature. Her Highness, the Maharani Vanivilasa Sannhidhana, C.I., then regent, assigned the task of building a grand new palace to Mr. Henry Irwin who had built the Viceregal Lodge at Simla and also acclaimed for his public works at Madras. It was decided to build the palace in the Indian traditional style incorporating architectural features of buildings in Delhi, Agra and Calcutta. A survey of the grand architectural sites in the country was made by Irwin to select the final version for the design just as Lutyens had studied Indian monuments before deciding upon the features of the Viceregal Palace (presently called the President's House) in New Delhi. The work on this new Mysore Palace began in 1897 Ce and it was completed in 1912 CE. Great care was taken to use local materials as far as possible and take all possible precautions against fire. The use of cast iron pillars at the palace perhaps was necessitated by fears lest the recurrences of fire destroyed the structures yet again.

The new Mysore Palace is a massive grey granite structure in triple storeys. It is dominated by a gilded dome. The prominent tower is 46 feet high. The façade of the palace has seven arches on tall pillars behind which lies the grand Darbar hall where the Mysore Maharaja appeared seated in his magnificent throne on ceremonial occasions. The Darbar Hall faces a large open court for state ceremonies and elephant shows etc. From a distance the Mysore Palace appears in "a gleaming profusion of domes, turrets, archways and colonnades". The visitor today is led through galleries and halls into various pavilions resplendent in multi-hued stained-glass decoration. In fact, it is a riot of dazzling colours in a hugely extravagant exhibition of royal opulence.

The most impressive pavilion in the Mysore Palace is the Kalyan Mandap or the pavilion for the celebration of marriage festivities. It is an octagonal hall with marble flooring in different colours. It has a dome supported on triple cast iron pillars specially made for the palace by Walter Macfarlane of Galsgow. The stained-glass ceiling was also made in Glasgow, later set up in its present position. There is provision of a gallery to enable the royal

Previous pages:
Amba Vilas Palace

Clockwise from left:
Domes at the top of the palace; Lion at the outer quadrangle, work of the British sculptor Robert William Colton

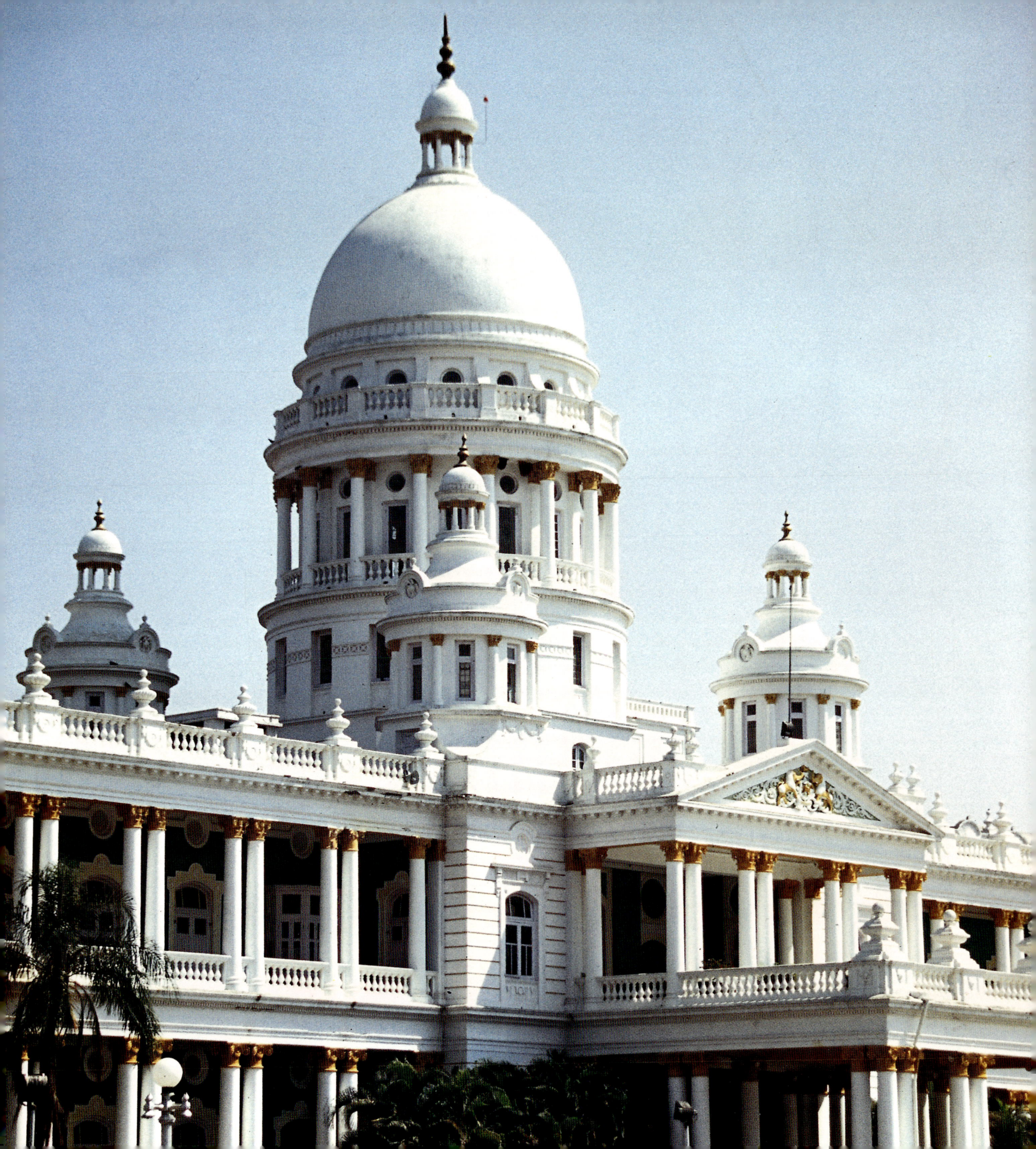

ladies have a view of the proceedings here, a tradition derived from the Indian palace architecture where the *zenana* kept away from the gaze of visitors. The use of stained-glass decoration at such an unprecedented large scale, generally seen in churches all over the world, gives the Kalyan Kandap a very different ambience. The extremely colorful peacock motifs add to the splendour of this enchanting pavilion. A pavilion half as colourful is unlikely to be seen in the whole country.

The Amba Vilasa or the Diwan-i-Khas is the showpiece of the Mysore Palace absolutely fascinating in its gorgeous decoration. The teak-wood ceiling, marble work on the floor and fabulous chandeliers create an excruciatingly ornate ambience. Doors of silver, teak and rosewood with ivory inlay work have exquisite designs depicting the incarnations of Lord Vishnu. The central aisle in this rectangular hall has a stained-glass ceiling supported on cast iron pillars. The ornamentation at Amba Vilasa was carried out by K. Venkatappa, a great artist of Karnataka. Krishnaraja Wadiyar IV was very proud of the work of this artist and took great pride in showing it to his distinguished visitors as "my countryman's work". Krishnaraja Wadiyar IV, like many other rulers of his dynasty was a great patron of fine arts, music, painting, dance and sculpture.

The inner wall of the Kalyan Mandap is lined with an exhibition of large canvases by court artists showing the Dassara celebrations for which Mysore has earned a great reputation. Besides these paintings one can also have a look at the armoury which displays weapons from the 17th country CE. The swords of Haider Ali and Tipu Sultan and the iron claws used by Shivaji against Bijapur's Afzal Khan are particularly noteworthy objects of immense historical interest. Also exhibited here is a five bladed dagger which ensured death to the victim with each blade dipped into poison.

The small exhibition of period furniture is also very interesting as it gives some idea of the royal penchant for the extra-ordinary objects of sheer beauty. The two silver chairs with the royal insignia are the chief attraction in a small display. Flanking the silver chairs are two chairs in cut-glass or crystal from Belgium and a pair of marble vases. Somewhere in the palace is kept a silver chariot used for the royal visit to the Bhuvaneshwari temple only once a year during the Dassara celebrations.

The Darbar Hall at the Mysore Palace is certainly the most spectacular hall of public audience in the whole range of India's architectural heritage. This magnificent hall gives evidence of the Maharaja's love of splendour. The ornamentation on the massive columns and the multi-cusped arches is gold-lined and the whole ambience of opulence confirms popular belief in the Mysore rulers being the richest monarchy in the country. However, the surfeit of rich ornamentation is not of the highest aesthetic order. It might appear excessive to the purist as the "opulence gives way to vulgarity in the carved frames between marble pillars ringed by a marble architrave. Sandalwood spandrels above the doors depicting Hindu divinities are ingenious, but lack the creative spark we find in Hoysala art. The colonnades are connected by Mughal-style arches, the whole facing the open space in front of the hall so that a multitude may see their king enthroned. Now days, the multitude traipse through the hall, sometimes mistaking over–indulgence and stylistic incoherence for authentic splendour. Doors plated in silver grate on the nerves, like the voice of a singer long past her prime who insists on demonstrating her talents".

Still, few palace interiors in India can rival the blaze of colour and exhuberance of ornamentation in the Darbar Hall. It is the grandest and also the largest halls of its kind. The decoration at the Darbar Hall is only a small reason for its grandeur. On ceremonial occasions the golden throne of the Wadiyar rulers is kept here. This legendary throne, it is believed, has a great history of its own and has been witness to the rise and fall of many a ruling dynasty. In its earliest existence, the throne belonged to the Pandavas, heroes of the Mahabharata. Thereafter it disappeared and is believed to have remained buried and forgotten. Harihara, I, founder of the Vijayanagara dynasty was told about the throne by their mentor, the sage Vidyaranya. From Vijayanagara, the throne found its way to Tipu Sultan's Serirangapatnam and finally it came to Mysore. Some believe that the throne was a gift of Aurangzeb to the Wadiyar ruler. The throne is believed to be made of solid gold weighing more than 280 kgs. The golden canopy with inscriptions in Sanskrit over the throne is a 19th century addition. On top of the canopy is the legendary bird *huma* which is said never to touch the ground.

The artistic treasures at the Mysore Palace must include paintings by Raja Ravi Varma. The Darbar Hall also has a painting depicting four generations of Mysore kings- Krishnaraja Wadiyar III, Chamaraja Wadiyar, Krishnaraja Wadiyar IV with his younger brother Kanthirava Narasaraja Wadiyar, the last king of the great dynasty before Mysore merged with the Indian Union after independence.

Krishnaraja Wadiyar IV (ruled 1902-40 CE) is remembered as the most illustrious ruler of Mysore. He was certainly the most enlightened and a visionary who set the state on the path of scientific research and advancement. It was during 1912-19 and 1926-01 that Mysore made tremendous progress to steal a march over other states in southern India under S. Visvesvaraya and Sir Mirza Ismail respective, both acted as Chief Minister of the Mysore state.

Visvesvaraya built the Krishnarajasagar dam on the Kaveri river, the University, Bank of Mysore, Bangalore Engineering College and a Chamber of Commerce. Mirza Ismail contributed as handsomely. He laid the Brindavana Gardens, founded the Mysore Medical College and factories for porcelain, sugar, steel, cement, paper and aircraft. Mysore was no longer a mere sleeping medieval state in southern India. It rose fast to establish itself as the most advanced state in the country. Sri Krishanraja Wadiyar IV, however, found immense spiritual satisfaction in playing the violin and Krishna worship. On a more mundane level, Krishnaraja looked after two hundred polo ponies and a well populated kennel.

The Mysore Palace has five entrances marked by stately triple-arched gateways. The eastern gateway called Jayamartanada, is the most magnificent and its central arch is 60 feet high. The Balarama and Jayarama gates are on the northern side. The Brahampuri and Karikal gates appear on the western line. The southern gateway, called the Varaha Gate, is used the chief entrance for the visitors to the Palace.

The Darbar Hall faces the well-planned semi-circular area generally used for cultural performances and elephant processions during the Dassara celebrations. The most important artistic objects to note in this area are the enormous bronze pairs of tigers on the east, north and southern pathways. These great animal sculptures are mounted on specially erected platforms to remain in view from all sides. Two more tiger sculptures are placed on the platform flanking the steps in the quadrangle north of the Kalyan Kandap. These tigers are attributed to the British sculptor Robert William Colton of Royal Academy of Britain. He worked in Mysore in 1909 CE at the invitation of the Maharaja.

Mysore is a city of palaces. The most beautiful palace outside the city is the Lalitha Mahal at the foot of the Chaumundi Hill. It was built in the 1930s by Krishnaraja Wadiyar IV for his state guests. This stately white palace is built amid highly picturesque surroundings. The high dome bears a strong resemblance to the dome at St. Paul's Cathedral in London. The central entrance is flanked by two wings of paired Corinthian columns leading to the smaller domed pavilions at the corners. The interior is a marvel of elegant grandeur with the stately staircases sweeping up from the reception area, finding little use for the sumptuous, colourful ornamentation on arched colonnades as seen at the Mysore Palace. This palace was designed by E.W Fritchley. From a distance Lalitha Mahal looks enchanting, part of dream imagery. The greenery which spread all around Lalitha Mahal contributes immensely to the ethereal charm of the palace.

Lalitha Mahal Palace, view from Chamunda Hill

MADURAI

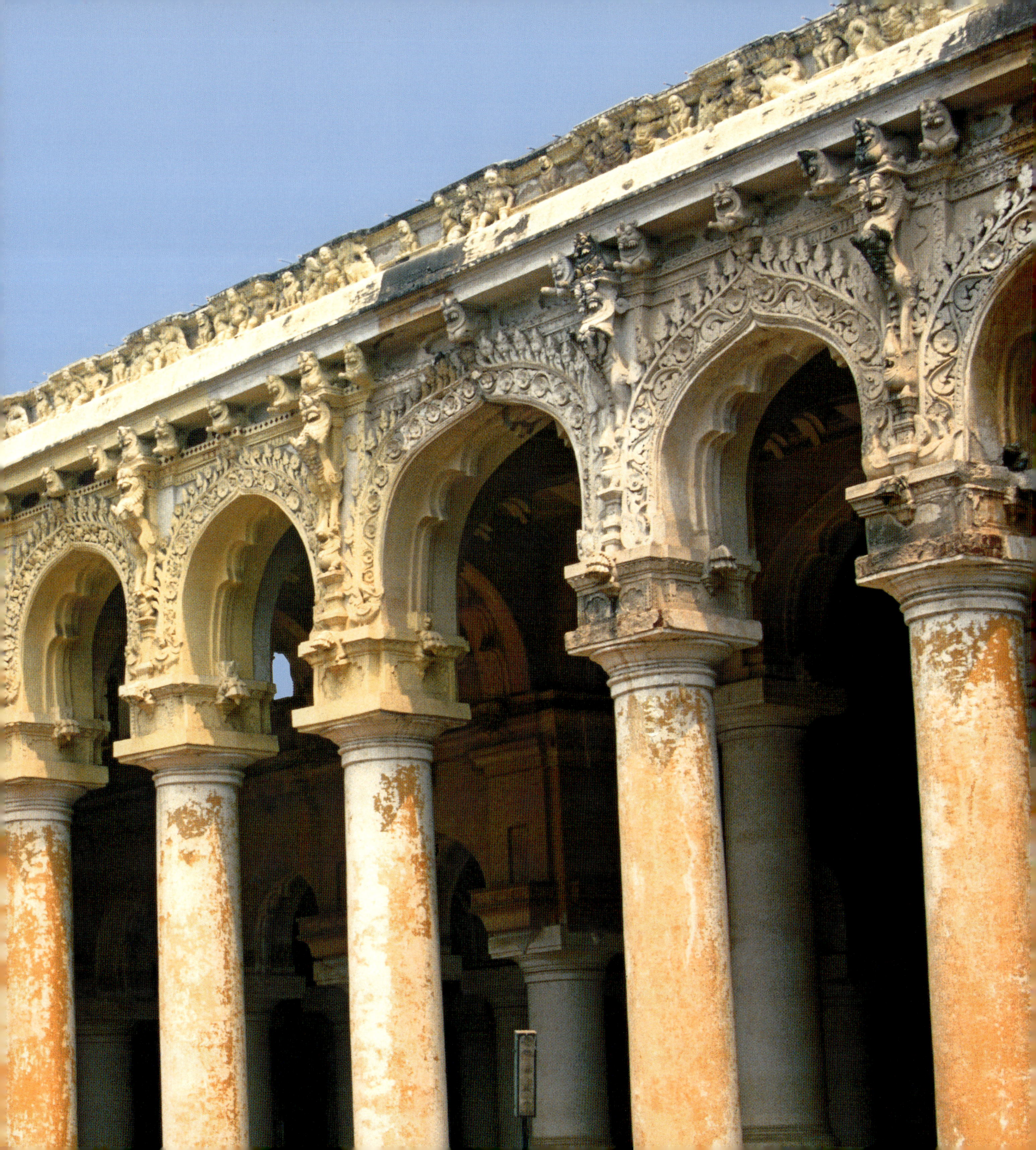

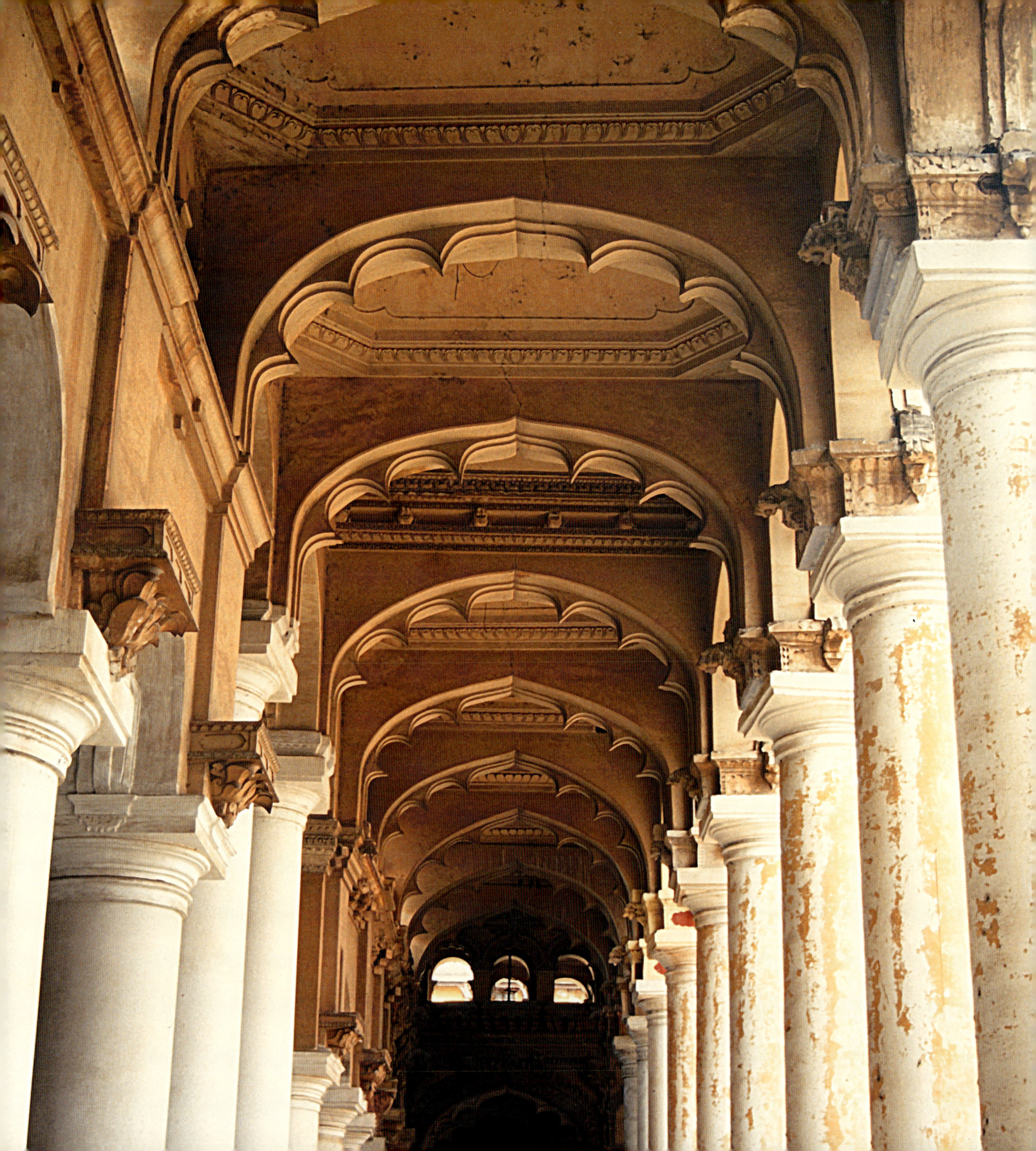

Madurai was ruled by governors of the Vijayanagara kings till it became an independent power following the decline of their overlords in the 16th century CE. Tirumala (1623-59 CE) was the most famous and powerful of these Nayaka rulers. He was also a great patron of fine arts, particularly architecture. He made his own additions to the Meenakshi temple at Madurai and built an extensive palace complex in the vicinity. Later, the Nayaks lost their political supremacy to the Marathas in the 17th century.

The original palace as built by Tirumala was a huge complex but his grandson moved his capital to Trichy and considerably reduced the palace, enclosing it by walls on all the sides. These defensive walls were also removed in the 19th century by the British who used the palace as barracks and convicts were pressed into service at the paper factory organised here. It was at the insistence of Lord Napier that the government took measures towards repair and restoration work at the Tirumala Nayaka Palace. In this work, it was R.F. Chisholm, who did admirable repairs using iron ties to hold together weak structure, rebuilding ruins and restoring plaster work which had peeled off. The Palace was used as the District Court till the 1970s. The place is surrounded by some important structures but their relation to the main edifice remains a matter of mere conjecture.

The most impressive section of the palace is the central courtyard which is a spectacular setting for royal entertainments surrounded by oblong arcades built in a pronounced Islamic style. The columns in the arcade are of gigantic proportions 12. 2 m (40 ft. high), creating a magnificent vista of opulence. The core structure is made of bricks covered with the finest lime plaster. The arcade on three sides has cloisters. The columns are starkly plain and circular in the lower section but the upper sections of the arches are lavishly decorated with geometric and floral designs. Traces of its former decoration in turquoise, orange and red paint are still

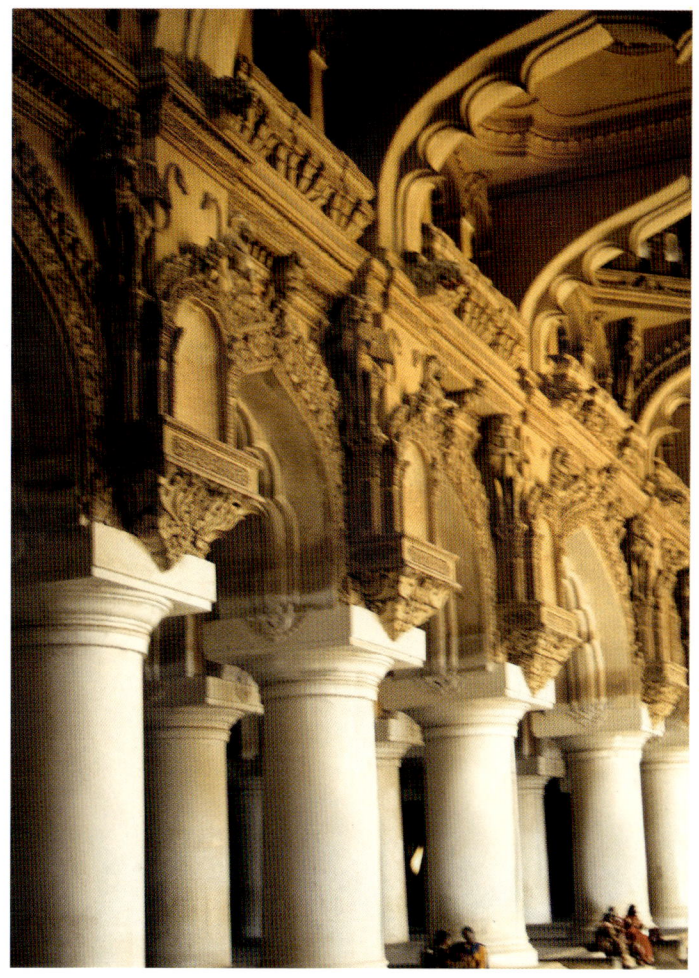

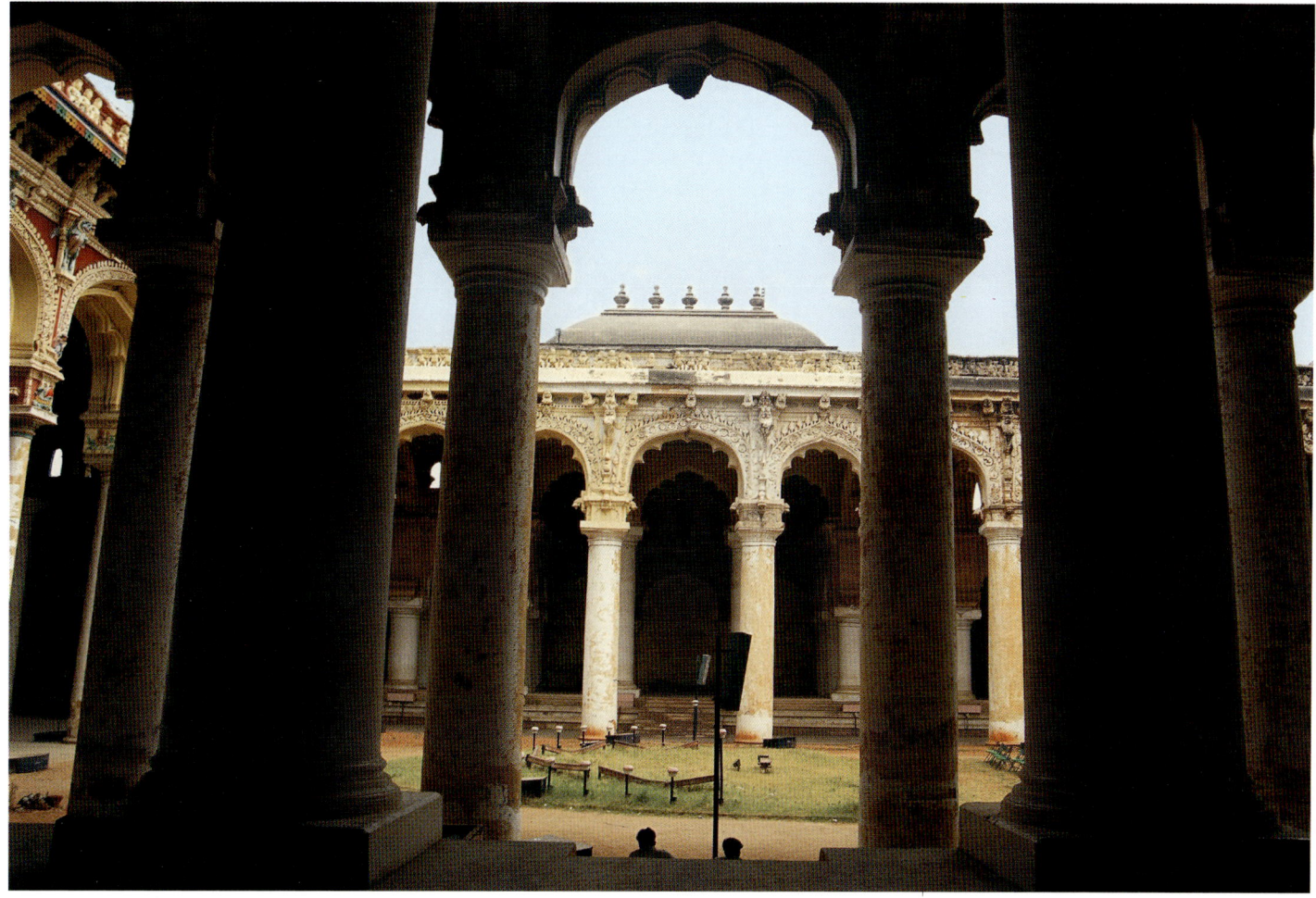

Previous pages:
Grand columns at the Nayak Palace

Clockwise from far left:
Corridor- splendid arches; Massive columns in the corridor; Courtyard for celebrations

Clockwise from right:
Equestrian ornament near the steps;
Upper section of the columns with
figures of warriors; Ceiling at the Swarg
Vilasam, Nayak's private chambers

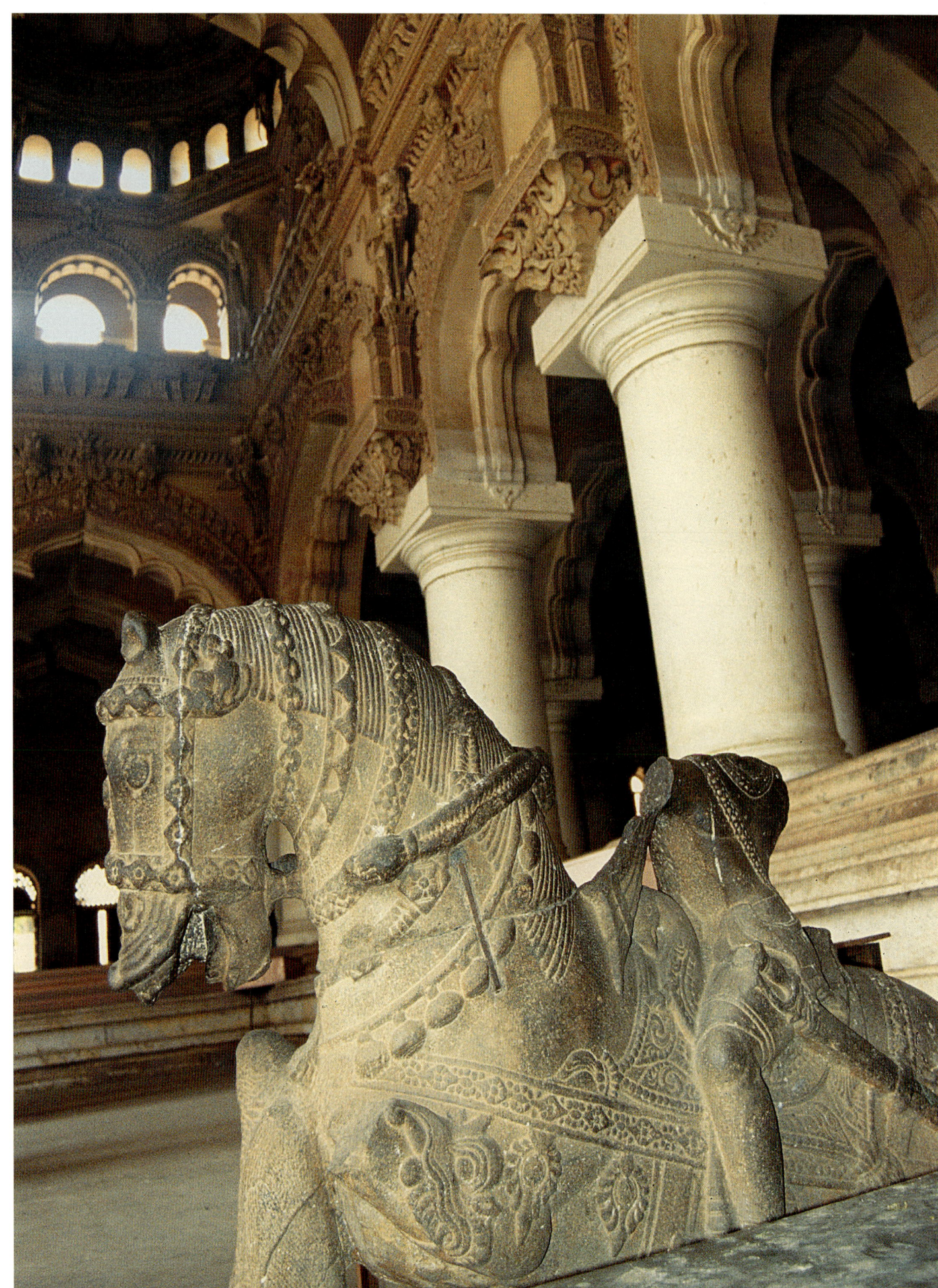

discernible. A great hall at the other end of the courtyard has five rows of massive pillars under three domes, the last 21..3m (70 ft) high and 18.3 (60 ft) in circumference. The main portico with steps flanked by equestrian sculptures was built during the British restoration work at the palace. The most impressive aspect of splendour at this hall which was actually used as the Darbar Hall is its stark appearance.

The other section of the original Tirumala Nayaka Palace is the Swarga Vilasam or the Celestial Pavilion. This is the Private section of the royal residence, generally used for cultural performances. Royal entertainments were held here. It has an arcaded octagon covered by a splendid dome which is 18.3m (60 ft) wide and 21.3m (70 ft) high.

There is another hall of 'cathedral-like proportions', in fact, an extended section of the main hall. It is 41m (135 ft) long and 21.3m (70 ft) high, covered by a pointed arched roof, reinforced by granite ribs which emanate from the double rows of columnar arches placed one above the other. The joints of each corner are marked with the figure of a warrior with a sword. This is believed to have been used as the bed chamber of the Nayaka who, very interestingly, had his bed suspended from the ceiling. This hanging bed, something like a swing, might have had its own particular delights but it would certainly have taken some time before the conspirators reached his bed. In Rajasthan, there are examples of very low beds used by the maharajas to save themselves from enemy conspirators hiding under their beds but this kind of suspended bed is rare to find.

But this swing-like bed challenged a thief's ingenuity. He made a hole in the roof and swung down the chains to the Nayaka's bed to remove the jewels from his person. It was a daring theft. The Nayaka declared a reward of half of his hereditary land and its rent to the thief, if he could be caught. Instead, the thief presented himself in the court to claim the reward. He was duly rewarded for his daring but promptly executed for the crime.

At present the only two surviving portions of the original Tirumala Nayaka Palace are the Darbar Hall and the Swarga Vilasam. Both are chiefly notable for "a monumental scale of the interior spaces and the exhuberance of plaster ornamentation" as observed by George Michell. Both pointed and cusped arches are artistically employed to create an air of lightness over the heavy and solid circular piers. The roofing also shows a considerable engineering skill by alternating pyramidal domes and shallow vaults. The most noteworthy feature of the palace architecture is the provision of the clerestory for admitting light, particularly at the Swarga Vilasam interior which remains untouched by the direct sun light. The light passing through the clerestory apertures focuses on the rich relief work on the upper sections. Lavish plastic ornamentation has been reserved for the arches and valuts which have lotus and foliage motifs, mythical beasts and animal brackets below the eaves. Lotus finials crown the domes and vaults. The immense height of the ceiling at both the Darbar Hall and the Swarga Vilasam facilitates the provision of double-storeyed arcades.

A considerable portion of the Tirumala Nayaka Palace was pulled down by both the Nayaka's grandson and successors and also by the British. There are various structures standing in a ruinous state all around the palace giving an adequate impression of its original vast lay-out and the architectural grandeur.

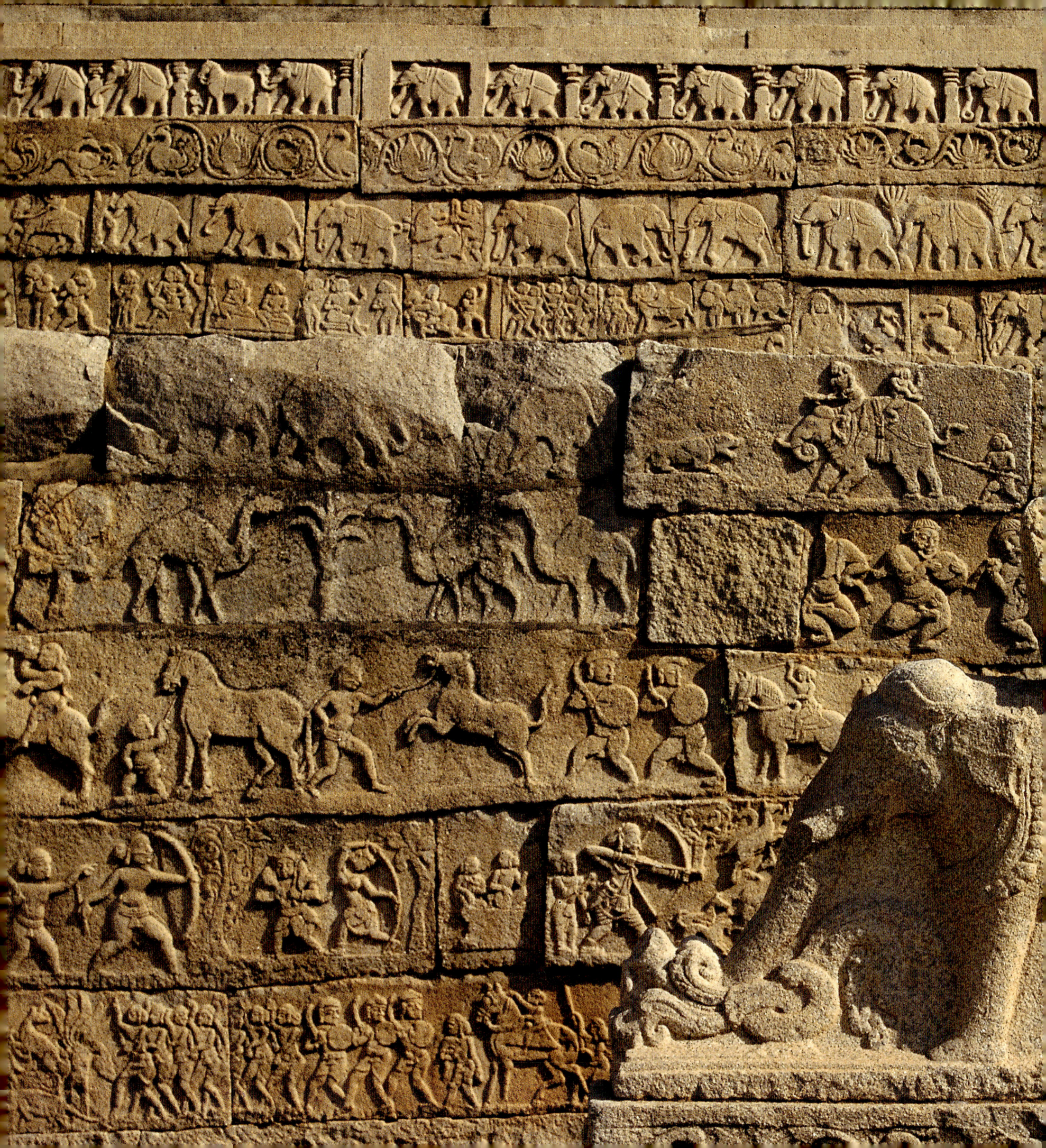

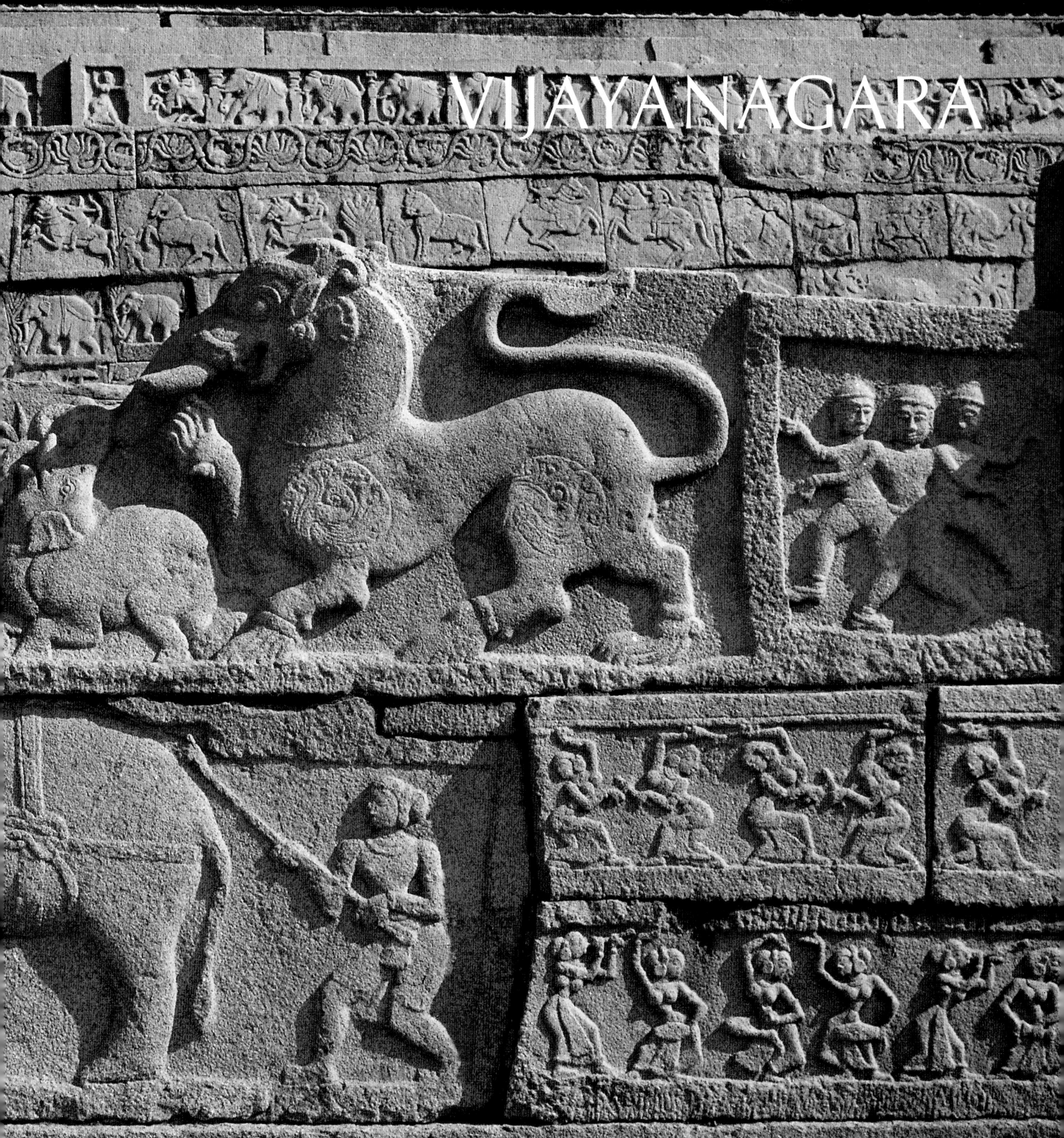

VIJAYANAGARA

Standing amidst the boulder strewn landscape of Hampi, dotted with ruins of palaces and pavilions, temples and towers, reservoirs and aqueducts, it is difficult to believe that this desolate wilderness was once the thriving capital of the last great Hindu kingdom in southern India. Hampi, or Vijaynagara as it was then called, was considered larger and more splendorous than Rome and Lisbon, inhabited by half a million or more people. Today it is a deserted ghost city, a mere skeleton of its former glory with a small village market near the ancient Virupaksha temple selling cold drinks and coffee to tourists arriving in cars, buses and over-packed tempos, and cyclists huffing and puffing their way up and down the narrow roads meandering through banana plantations and strange, mammoth boulders keeping vigil over the decaying ruins spreading over miles and miles under the blazing sun. Whichever way you turn, there are huge rocks fashioned by the elements in fantastic forms. Here, the architecture of nature overwhelms the modest human efforts. Nature wins hands down.

Hampi had been a sacred centre for centuries before it was built as capital of the Vijaynagara rulers around 1336 CE. It formed part of the Kishkindha region ruled by Bali, as mentioned in the epic Ramayana. Rama, the hero of the epic, killed Bali, placed Sugriva on the throne. Anegondi, across the Tungabhadra river, was the capital. A few episodes in the Ramayan relating to Sita and Hanuman took place here in the Pampa region. Pampa, ancient name for Tungabhadra and the gloddess Parvati, still liners in religious texts. Parvati married Shiva and is worshipped at the Virupaksha temple, the most venerated shrine here. Hampi is derived from Pampa. Tungabhadra forms the northern limit of the Vijaynagara.

When the rulers of the Sangama dynasty built their kingdom in 1336 CE it functioned as the bulwark of Hinduism in southern India, effectively resisting the Muslim invasions from the Delhi Sultanate and the adjoining states-Gulbarga, Bidar Golconda, Ahmednagar and Berar which, as combined forces, finally descended on Vijaynagar in 1556 CE and vanquished this great Hindu Kingdom. The glory of Vijaynagara was reduced to a mere heap of ruins. The huge fortifications failed to check the invasion and witnessed helplessly the forces of destruction running amuck. Vijaynagara was soon forgotten and consigned to history books.

It is best to start from the beginning at the Hemakuta hill over-looking the 52 m. high tower of the Virupaksha temple. Spreading over the hillsides are numerous triple-shrined temples built in the Kadamba and early Chalukyan style predating the rise of Vijaynagara. With very little sculptural ornamentation on the walls but carrying stepped pyaramidal roofs these temples are an impressive introduction to the architectural heritagte of Hampi.

The stupendous eastern *gopura* and the grand temple street emanating from it provide the best opportunity to survey the environs in this town. The *gopura* leads into the courtyard. Passing through another but smaller gateway, the inner courtyard is reached where a magnificent pillared pavilion stands infront of the sanctum. Here are some ancient small shrines including one dedicated to Vidyaranya-the saint who had blessed the founders of the Vijaynagara kingdom. Another smaller *gopura* on the northern side leads to the Manmatha Gundam tank around which are built many small shrines including one dedicated to Durga. Most of these structures belong to the pre-Vijaynagara period. The great eastern *gopura* was built, perhaps, by an officer of Devaraya II 1422-46 A.D.). It was Krishnadeva Raya who renovated the eastern *gopura* built the two smaller ones, the Kalyan *mandapa* and carried large scale rapairs. The Virupaksha-lingam in the sanctum draws hundreds of devotees from distant places. This is the only temple in Hampi where worship is still conducted.

Previous pages:
Relief decoration on the base of Mahanavmidibba

Below:
Mahanavmidibba, the royal platform for celebrations

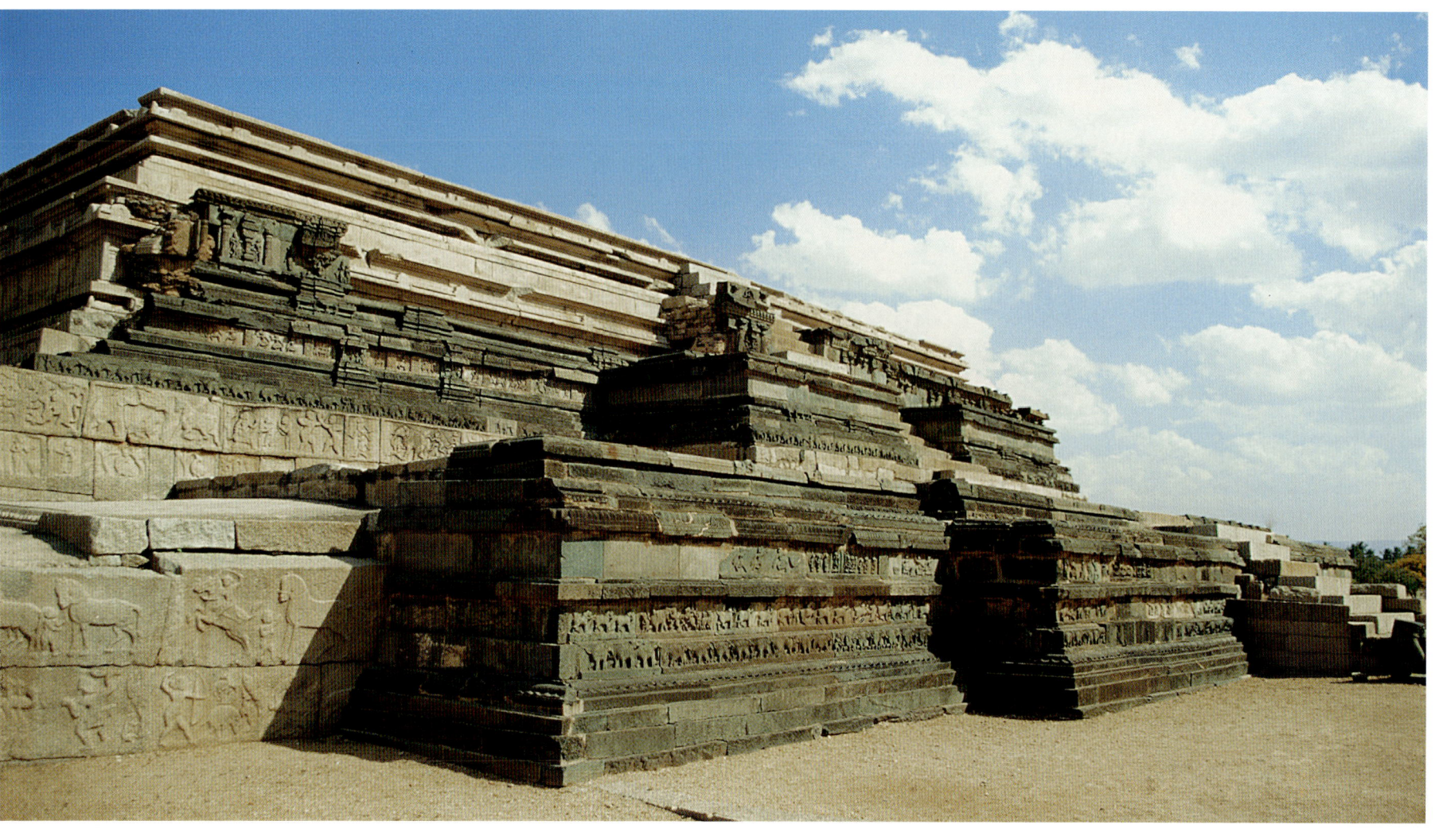

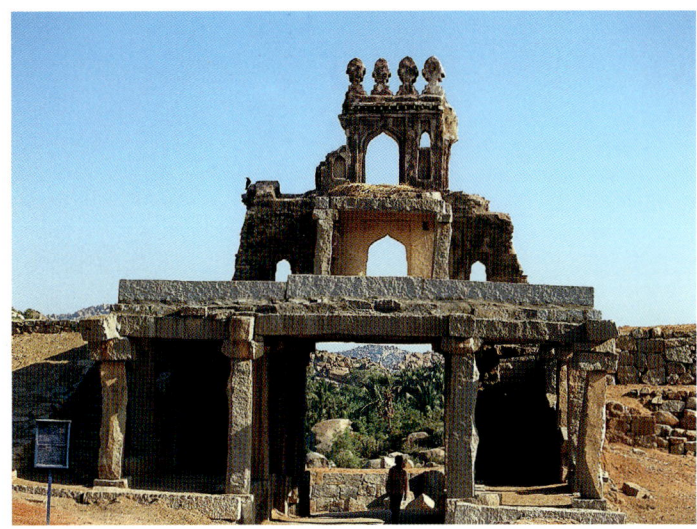
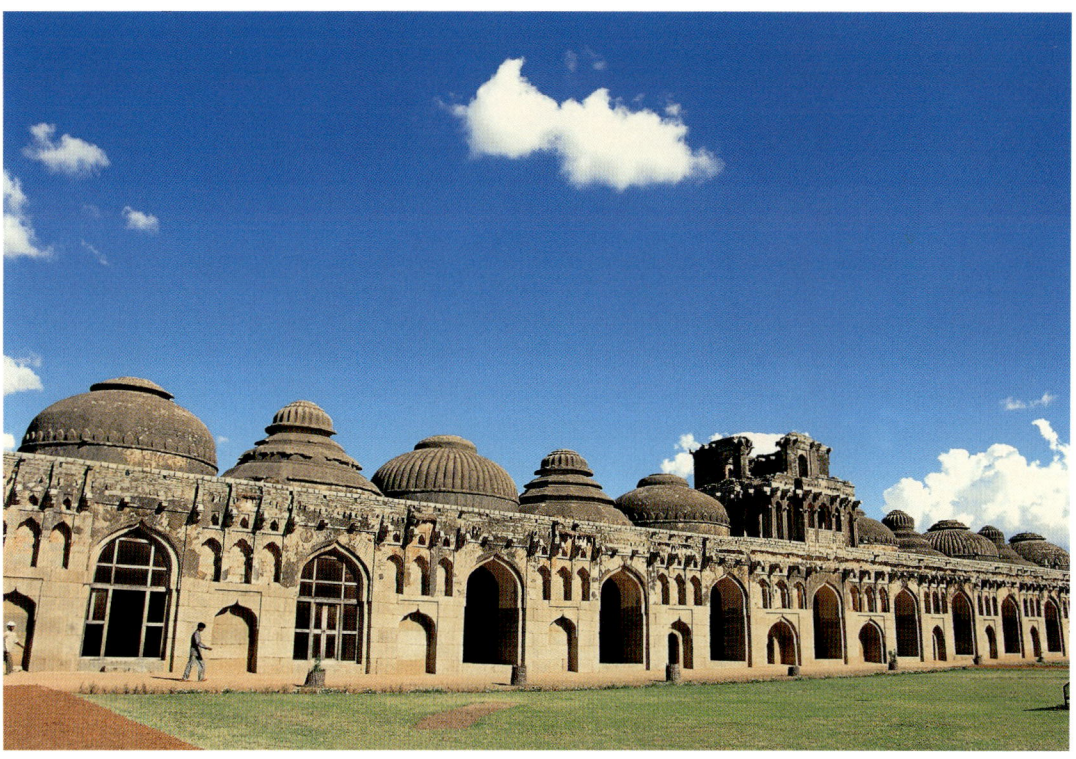

The magnificent sculptural splendour of the Vitthala temple showcases the artistic achievement of the Vijaynagara sculptors. Dedicated to Vishnu in the form of Vitthala, the compact architectural units stand within a walled complex with three *gopuras*. The Kalyanmandap, pavilion for special celebrations, is most exquisitely ornamented with rampant horses or yalis with riders, ornamental balustrades and sculptural reliefs in profusion. The stone chariot in front of the central edifice is the grandest specimen of the great Vijaynagara sculptural art. It replicates in stone the temple chariots used in processions. Originally, the delicately chiseled stone wheels, now cemented, could mutate. The brick tower superstructure has crumbled as in most other structures in Hampi. The chariot at the Vitthal temple is an astounding work of art. The main edifice of the Vitthala temple with a modest tower over the sanctum is a veritable museum of sculpture. Besides the amazing wealth of sculpture, the temple attracts countless visitors eager to tap the slender colonnettes on the front pillar to hear musical sounds. The grand forms of the mandapa pillars and piers are a unique feature of the Vijayanagara style. Equally remarkable is the reverse-curve kapota at the cornice. The Vitthala temple was still incomplete when the Bahmani armies in 1556 CE conquered Vijaynagara. It remains an eldorado of sculptural art to be observed in minute details.

At the King's Balance or talapurushdana the rulers were weighed against gold, jewels or grains on auspicious occasions. At the bottom of a column is a relief depicting a king with his two consorts.

Walking along the river front can be noticed remains of the stone bridge built over the Tungabhadra by a brother of Harihara II in 1383 A.D.

Locals and adventurous visitors use coracles or small circular boats to cross the river. The ancient capital of the region Anegondi lies on the other side but there are a few monuments to make the trip worthwhile. Further down is the old Rama temple, mistaken to be a Jain settlement. In a cave here Sugriva is believed to have kept Sita's jewels in safety. Sita-sarovar is on the left.

The grand Soolai Bazar or the temple street leading to the temple dedicated to Tiruvengalanatha, built by Achyutaraya (1530-42 CE). The setting of this magnificent temple is most spectacular. The huge boulders of the Matanga hill in the background add a rare charm to the environs. The *gopuras*, courtyard, colonnades and the pillared pavilions speak eloquently of the architectural marvels of this place, now generally skipped over by visitors in a hurry. Nearby is a cave containing a magnificent relief of the reclining Vishnu. Near the Chakratirtha, the most sacred bathing *ghat*, is the Kodandarama temple containing a relief of Rama, Sita and Lakshman carved on a boulder.

Midway between the sacred centre on the Tungabhadra and the royal citadel area, stands the splendid Krishna temple built by Krishnadeva

Clockwise from top left:
Harishankha gate over the road to Talarigattu; Elephant stables; Relief showing Krishnadeva Raya with his consorts; Market street in front of the Krishna temple

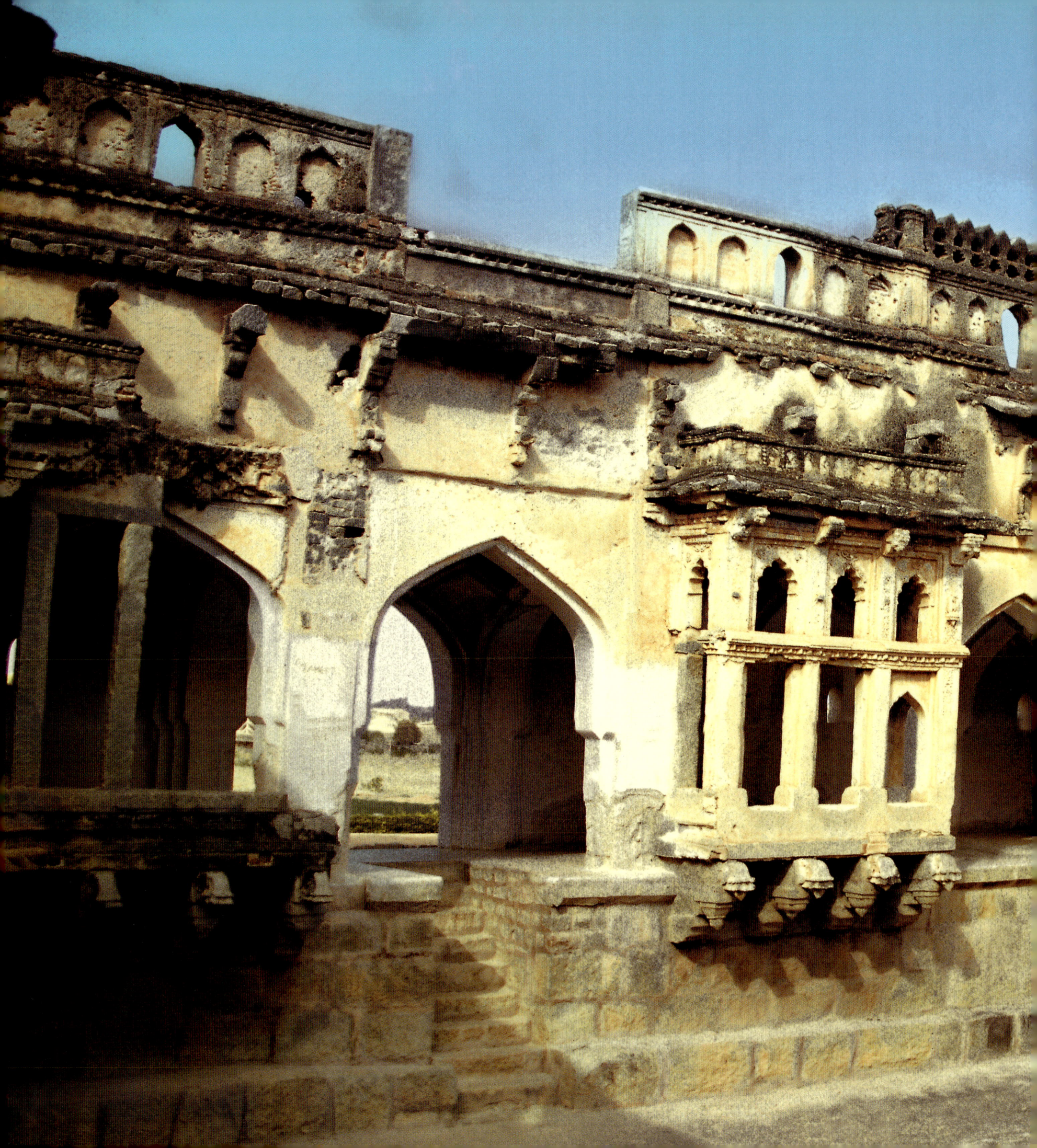

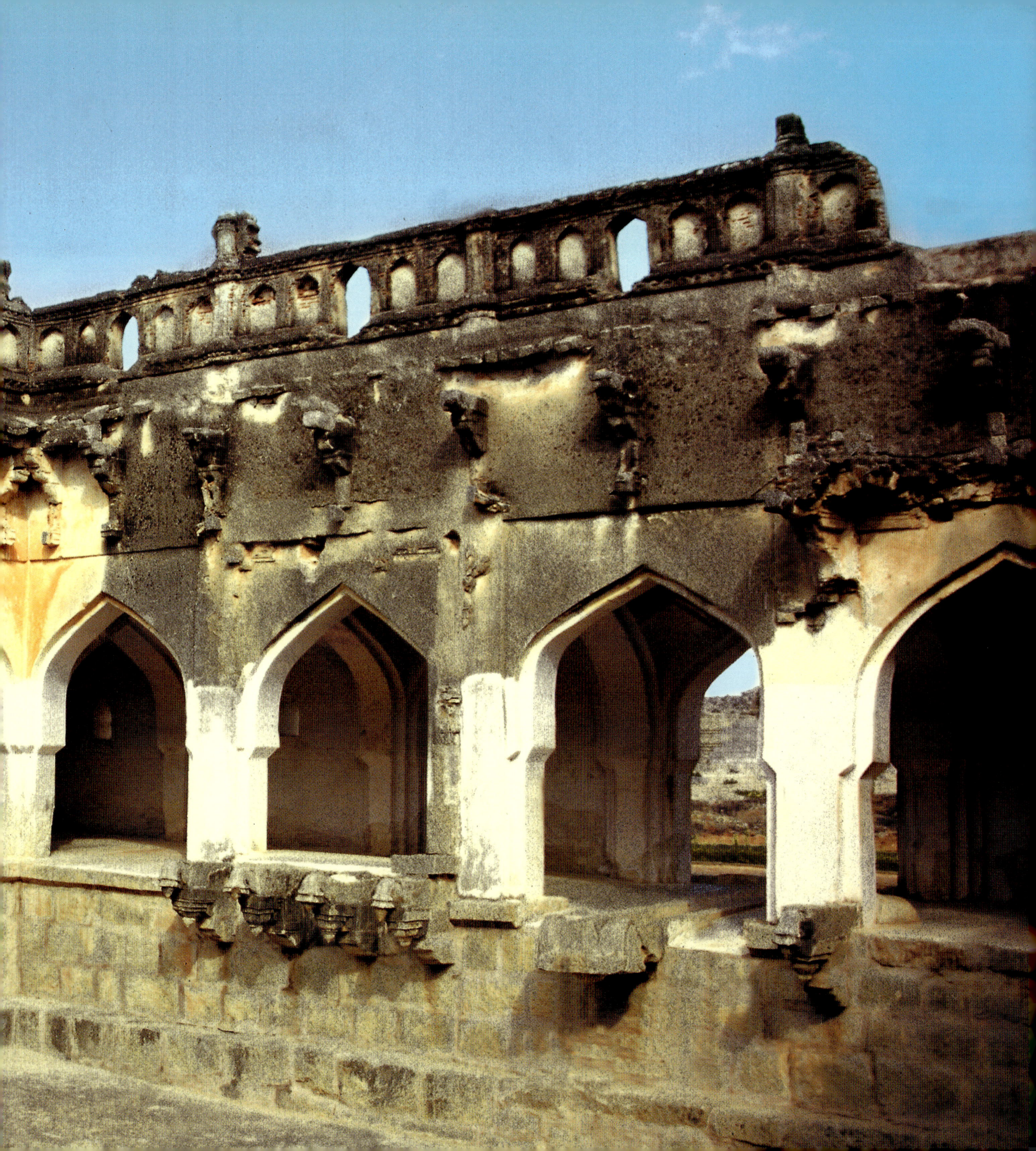

Raya in 1513 CE, in celebration of his successful Orissa campaign. It is a compact architectural composition within a walled enclosure with three *gopuras*. The eastern *gopura* leads into the temple street, now cut across by a modern road. If you are familiar with the Chola temples, the Krishna temple closely follows in style the Airavateswara temple at Darasuram, near Kumbakonam in Tamilnadu. The walled-in compound, grand courtyard, colonnades, sculptural decoration, pillard pavilions and the obligatory Amman (Devi) shrine next to the sanctum-typical features of the Vijaynagara temple architecture only seem to perpetuate the most outstanding features of the Chola architecture.

Amongst the most magnificent images of a visit to Hampi is the splendid free-standing, 6.7 m. high sculpture of Narasimha, a gift of Krishnadeva Raya to his capital. The small figure of Lakshmi, seated on its left thigh, was destroyed by the invaders. Still, this colossal sculpture retaines an awesome presence. The banana planations around, hide the sculpture from a view from the roadside. Close by a Shivalingam, 3 m high with its base perennially submerged in water, is a grand sight. Amongst other memorable monolithic sculptures are the two huge images of Ganesha. The 4.5 m. high Kadalekalu (gram) Ganesh housed in a shrine faced with a magnificent pillared pavilion, and the smaller Sasivekalu (or mustrard seed) Ganesha on the slope of the Hemakuta hill are both outstanding sculptures in Hampi.

On way to the citadel area, are the two magnificent, mammoth rocks inclining toward each other to form a unique grand arch. This wonderful piece of natural architecture far surpasses man-made architecture in sheer awesome grandeur. The road leads into the citadel area via the underground. Further up the road is the Danaik's enclosure with many unidentifiable ruins. The watch tower at the other end is a charming piece of defence architecture. It is difficult to imagine the real splendour of Vijaynagara during its heydays but the ruins of splendid edifices, temples, markets and water reservoirs etc. provide enough information to conjure up a picture of this flourishing capital in the 15th century CE. Abdul Razzaq, an envoy from the Persian court of Shahrukh in Herat, made an official visit to Vijaynagara in 1443 CE and has left a glowing account of the city: "The city of Bidjnagar (Vijaynagara) is such that the pupil of the eye has never seen a place like it... It is built in such a manner that seven citadels and the same number of walls enclose each other. Around the first citadel are stones of the height of a man, one half of which is sunk in the ground while the other half rises above it. These are fixed one beside the other in such a manner that no horse or foot soldier could bodily or with ease approach the citadel.

"The fortress is in the form of a circle, situated on the summit of a hill, and is made of stone and mortar, with strong gates where guards are always posted... The seventh fortress is placed in the centre of the others, and in that is situated the palace of the king..... By the palace of the king there are four *bazars*, situated opposite to one another. That which lies to the north is the imperial palace or abode of the Rai (Raya). At the head of each bazar, there is a lofty arcade and magnificent gallery, but the palace of the king is loftier than all of them. The bazars are very broad and long (with flower sellers and jewellers)..... On the right hand of the palace of the Sultan (Raya) there is the diwan-khane, or minister's office, which is extremely large, and presents the appearance of a chihul-sutun, or forty pillared hall; and in front of it there runs a raised gallery, higher than the stature of a man.... Opposite the minister's palace are the elephant sheds. The large (elephants) are especially reserved for the palace.... Each (elephant) has a separate stall; the walls are very strong and high. The chains on the necks and backs of elephants are firmly attached to the beams above".

Some of the buildings referred to by Razzaq can still be identified despite

Previous pages:
Interior of the Queen's Bath

Clockwise from below:
Stone chariot at the Vitthala temple;
Lotus Mahal; Watchtower

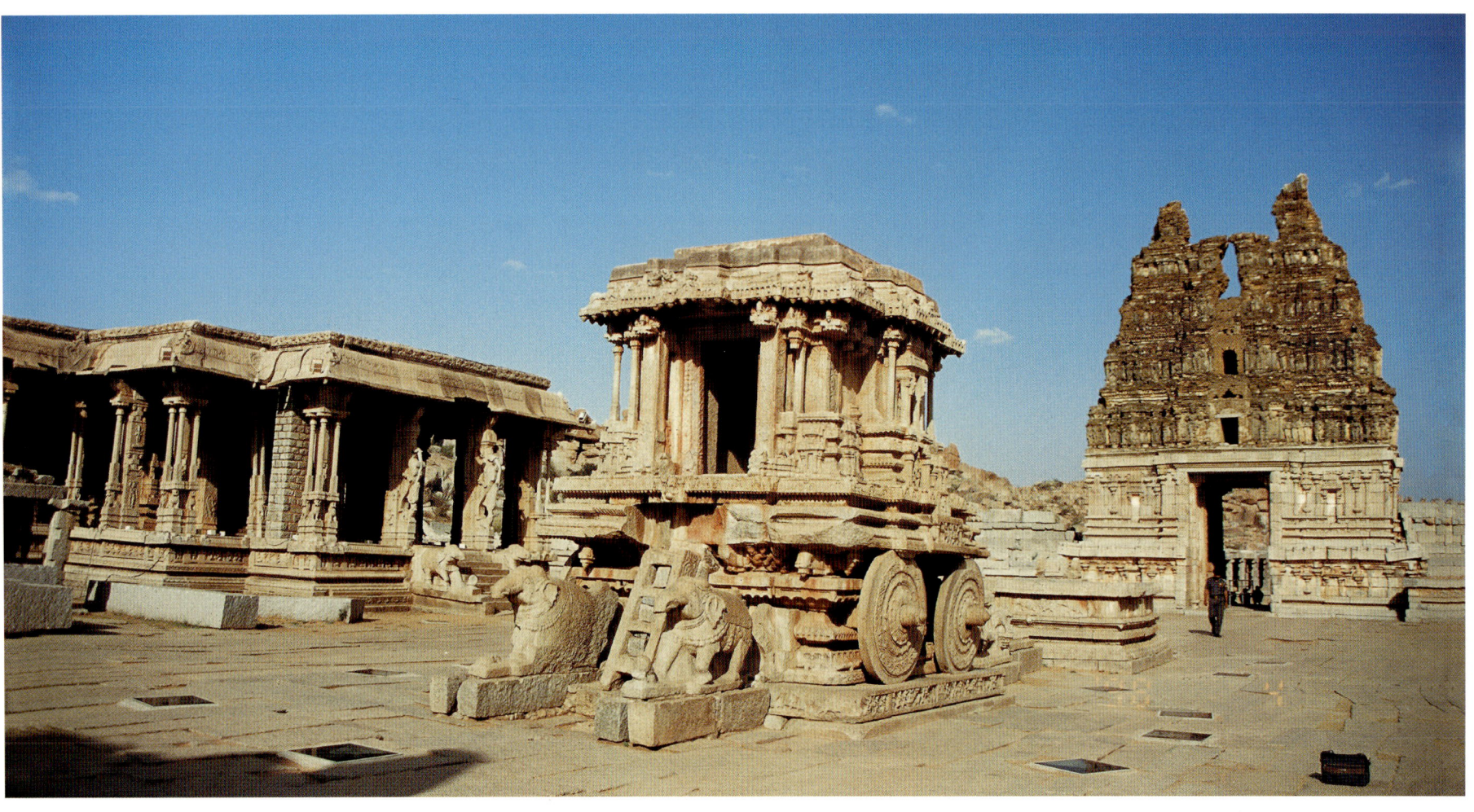

their much ruinous state. In nearly every account of the city left by foreign visitors, the Mahanavami festival at the royal centre features prominently. Razzaq also noticed that the kings "are fond of displaying their pride, pomp, power, and ploy in holding each year a stately and magnificent festival, which they call Mahanavmi. The king of Bidjanagar directed that his nobles and chiefs should assemble at the royal abode. They brought with them a thousand elephants (and) were assembled on a broad plain (where) were raised enchanting pavilions from two to five stages high painted (with) all kinds of figures. Some of these pavilions were so constructed, that they revolved. In front of the plain, a pillared edfice was constructed of nine stories in height, ornamented with exceeding beauty". (Trans. By R.H. Major in Hampi, by Fritz and Michell).

The Mahanavmi Dibba or the royal platform at the royal centre is the most important structure. In fact, it is the base of a grand platform over which once stood splendid superstructures in wood and other perishable materials. It was the stage for spectacular *darbars* and ceremonies, as observed by contemporary foreign visitors to the capital -Domingo Paes and Abdu' Razaac. There are steps leading to the top most terrace. The walls of the base are covered with horizontal friezes of reliefs depicting horses, elephants, dances and royal processions. Close to the platform lies abandoned a huge monolithic stone door. Its use is still to be ascertained but it is simply amazing in stone craftsmanship.

The Pushkarni tank is a magnificent *baoli* with steps cut in green chlorite. It was filled with debris, only recently cleared during excavations. It was fed by an aqueduct still to be seen at the western corner. Yet another bigger water tank lies to the east of this area. The royal centre abounds in ruins of grand royal buildings demolished by the vengeful invaders. The Hazar Rama temple, perhaps the royal chapel, is a small structure noted for its sculptural decoration and the four splendidly carved and polished pillars in black stone. Five rows of friezes cover the exterior walls of this small temple. There is no *gopura* at the entrance.

In the *zenana* complex, east of the royal centre, stands a cluster of structures in an excellent state of preservation. Lotus Mahal, a pleasure pavilion for the ladies, is a double-storeyed structure overlooking an ornamental tank. A grand, three tiered platform lies close to the entrance. A tall square watch tower stands behind the platform. The Elephant Stable has eleven vaulted chambers with different kinds of domes. This picturesque building was used for keeping the royal elephants. Also worth appreciating is the arched façade of the Guard's Quarters. These buildings as well as the Queen's Bath in the vicinity shows how well the Vijaynagara architectes absorbed the architectural influences of Islamic states like Gulbarga. Whereas the rulers fought over territorial aggrandizement and power, architects and artists of Vijaynagara and the adjoining Islamic states had no qualms about fashioning a new architectural idiom. Most of the buildings showing an Islamic influence are outside the royal centre and have been spared the wrath of destruction. Just rest under the shadows of the heavy trees near the Lotus Mahal and give a thought to the magnificence of Hampi's architectural and cultural heritage.

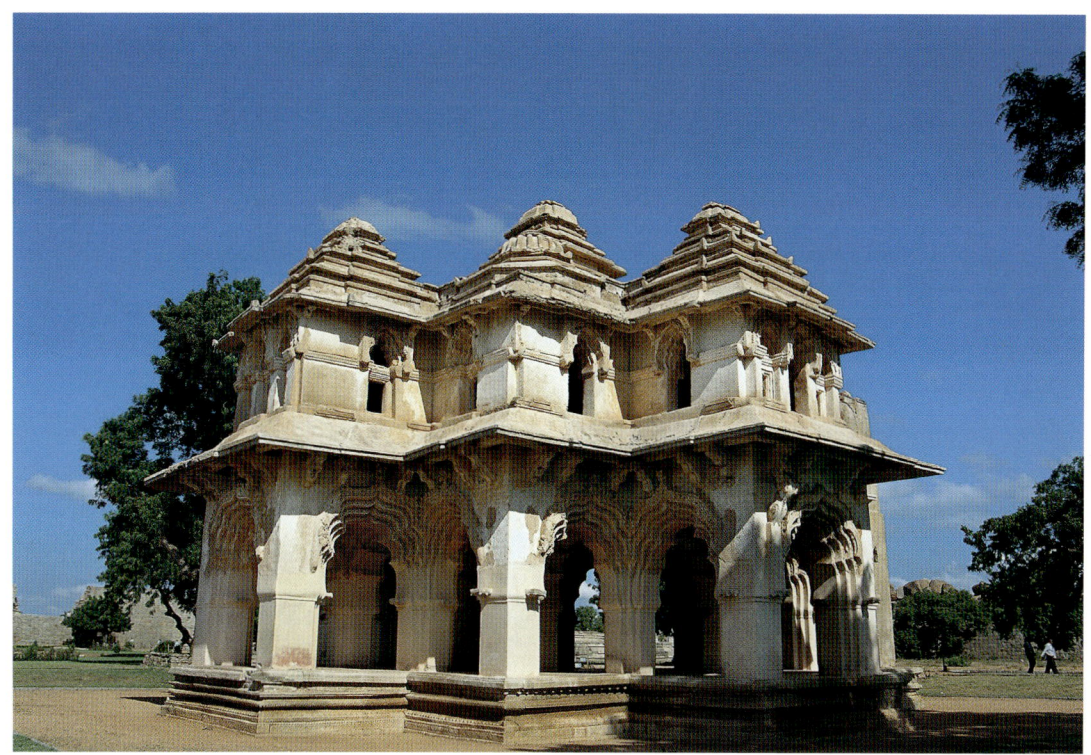

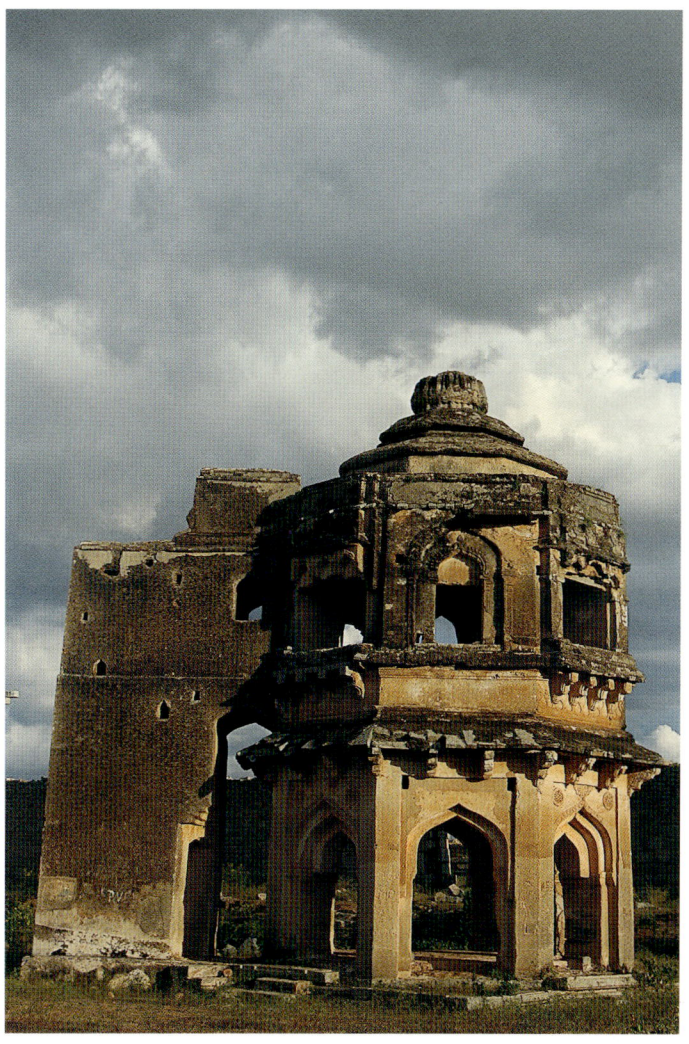

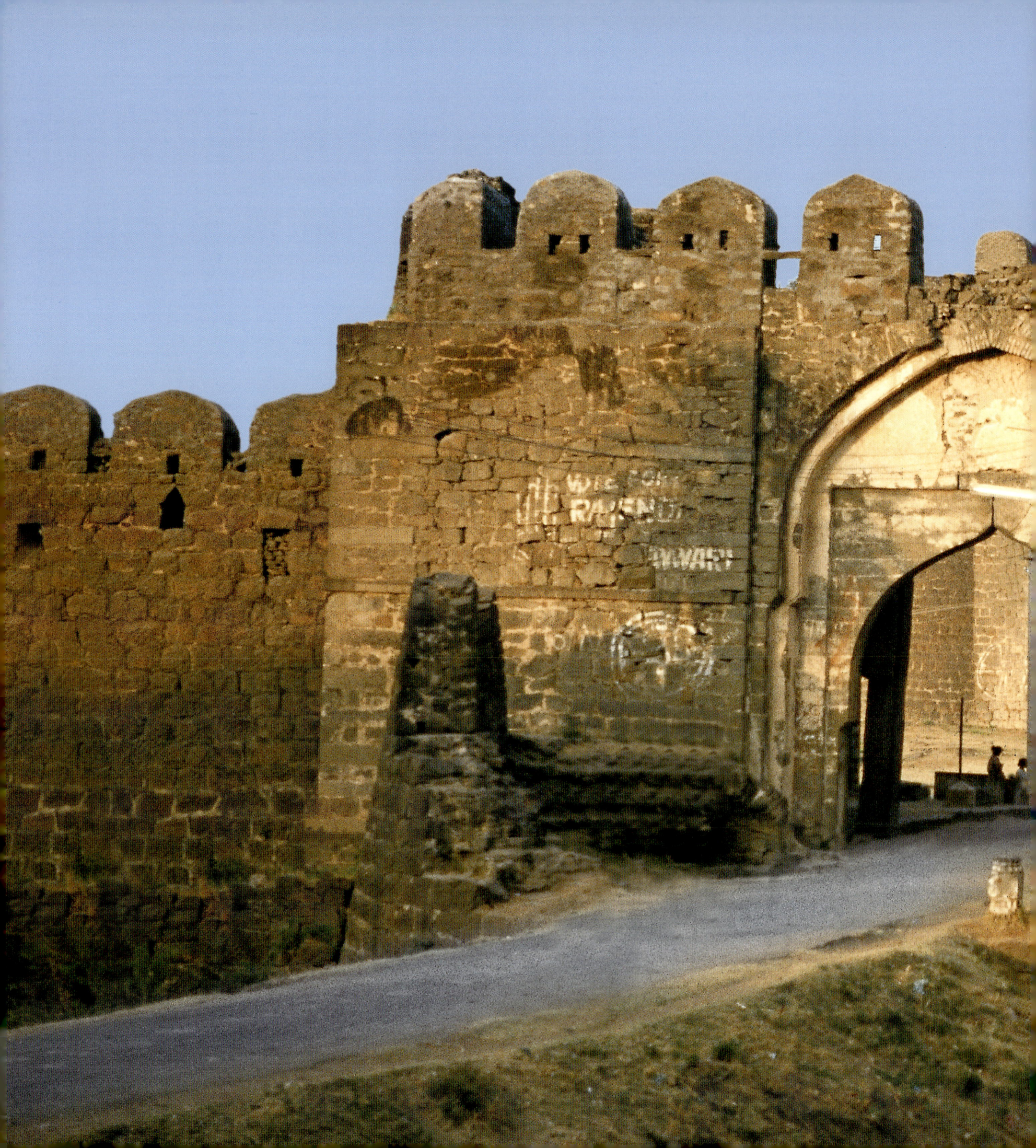

GULBARGA and BIDAR

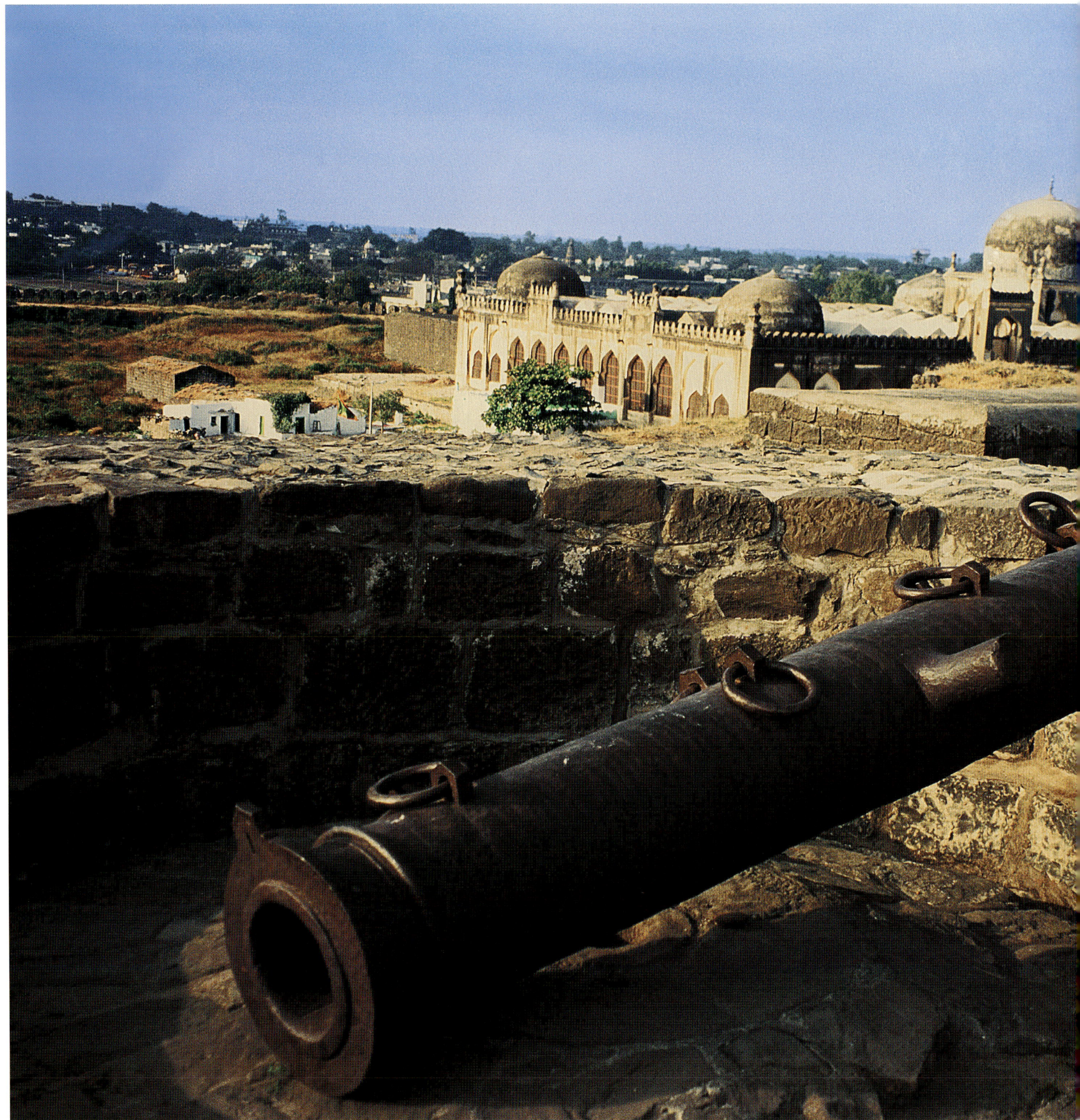

Gulbarga lies 568 km from Bangalore, towards the northern limits of Karnataka. As a rapidly growing city, Gulbarga is fast losing its character as a medieval city, first capital of the Bahmani kingdom. Gulbarga was acquired in 1337 CE by Muhammad Tughlaq, the most powerful sultan of the Delhi Sultanate. It was put under a viceroy. Soon rebellions against the Tughlaq rule, triggered chiefly by the extravagant taxes, caused tremendous agitation amongst the conquered states. In Daulatabad, a small officer called Hasan Kangu declared himself an independent ruler and assumed the title Sikandar-i-Sani, Abul Muzaffar Sultan Alauddin Hasan Bahman Shah al walial Bahmani. Very soon he moved to his new capital at Gulbarga in 1347 CE. He also obtained the blessings of the Sufi saint Shaikh Sirajuddin Junaidi, the preceptor of Muhammad Tughlaq. From 1347 to 1424 CE Gulbarga was to remain the capital of the powerful Bahmani kingdom. Muhammad Tughlaq, made weak by the fatigue of ceaseless campaigns in the Deccan, frequent rebellions and failing health "realized that the power of the Bahmanis was too great to be challenged and reconciled himself to the loss of the Deccan". As Prof. K.A. Nizami obseves, the Tughlaq hold on the Decean rapidly declined hereafter. The Bahmani kingdom was itself divided into five independent segments-Bidar, Berar, Ahmadnagar, Bijapur and Golconda.

The architecture of Gulbarga belongs to the earliest phase of Islamic rule in the southern part of India. Muhammad Tughlaq, who shifted his capital from Delhi to Daulatabad in 1327 CE, had also carried with him a great number of masons and artisans, scholars and sufis, merchants and labour. With the decline of the Tughlaq hold, these artisans and architects found work at the newly founded capital at Gulbarga. The Bahmanis were the first political power in the suhcontinent to exchange ambassadors with Ottomans, recruited skilled personnel from amongst Turks, Persains and Arabs. These foreigners were to form the most influential group, called Afaqis, perennially in conflict with the Dakhnis or the local Sunni population and officialdom, including the Abyssinians. The presence of Persians in the new city exercised a recognizable influence on architecture which shows a remarkably different character. Though the Tughlaq style of architecture formed the core of style, the embellishment, refinement and a distinctive sophistication is clearly of Persian origin.

The first architectural enterprise of the Bahamnis was to rebuild and strengthen the fort of Raja Gulchand. They built 16m thick tapering stone walls and strong fortifications nearly 3 km in circumference with semi-circular bastions and gigantic battlements protected by a 30 m wide moat. The irregular outline of these outer fortifications actually follows the form of the rocky land. The cyclopean constructions make use of ponderous and mammoth boulders similar to huge stones used on the walls of the Tughlaqabad fort in Delhi. The defence of the fort had to be ensured at all cost and these gigantic stones alone could resist invasions. The Gulbarga fort is an excellent example of defence architecture much inspired by similar works in Syria. Still, despite its present dilapidated condition, the fort gives enough indication of its impregnable strength and of its strategic importance for the Bahmani rulers, more so for its dangerous proximity to the Vijaynagar kingdom on its southern borders.

The Gulbarga fort has two main entrances on the east and western sides. These gateways have pointed arched openings flanked by bastions. Entrance into the fort is provided by bridges across the moat. It is, however, the western gateway which is prominent and strongly fortified. The massive walls have the rugged strength of unrelieved exterior. However, the only ornamental feature appears in the parapet of merlons, raised over the gateway. These merlons have narrow margins enabling the defenders to fire muskets at the attacking armies.

The fort contains only a few structures which are still well preserved the Jama Masjid and Bala Hisar. All other structures have been destroyed and the ruins at many places are merely mounds of rubble. The Jama Masjid (1367 CE) is the earliest monumental mosque built during the

Previous pages:
Gateway at the Gulbarga Fort

Left:
View from the top of the Balahisar

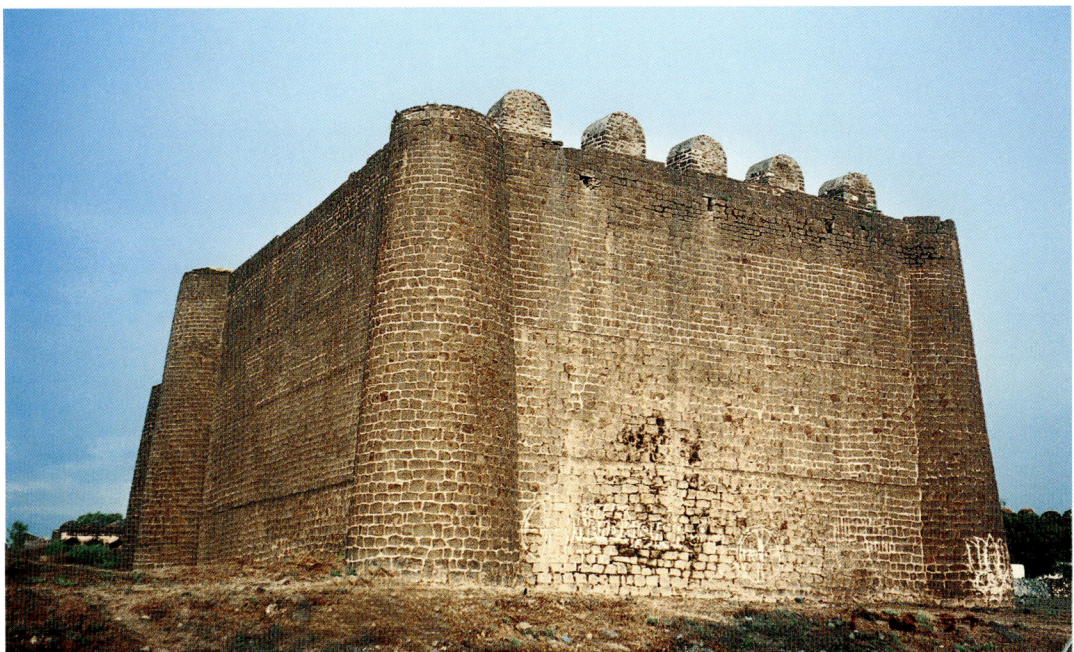

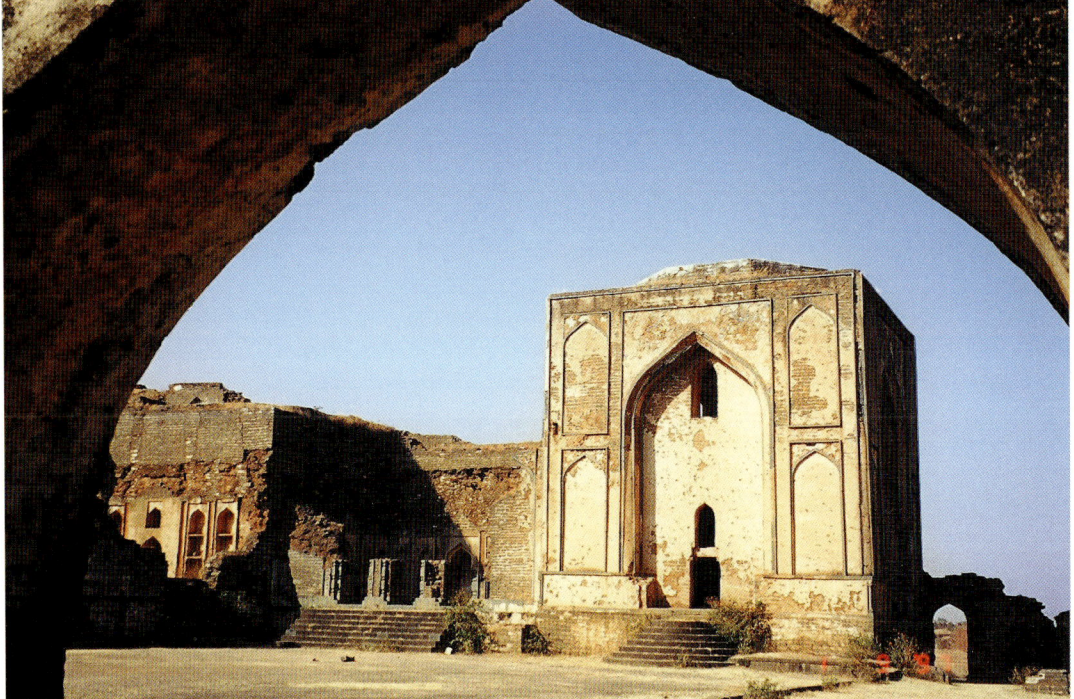

Clockwise from above:
Palace ruins; Balahisar;
Gagan Mahal ruins; Bidar fortifications

The exterior of the Jama Masjid consists of arcaded openings. The northern side has an archad entrance, a later day addition. The Jama Masjid is large enough to accommodate nearly 5000 men at prayer. It has been suggested that the layout plan of the mosque has been derived from Arabic or Persian models. But its unique architectural composition was found unsuitable for Indian conditions where the congregation of thousands of faithfuls required adequate provisions of air and light. The extreme heat in the Deccan would render the covered interior suffocating. Perhaps, as Elizabeth Merklinger suggests, "this mosque may have served primarily as a civic monument, a meeting place of outstanding political significance for the early Bahmani sultans". Excepting the two partially covered Tughlaq mosques in Delhi-the Kali Masjid (1370 CE) and the Khirki Masjid (1375 CE), this style of a fully covered interior remained unabsorbed in the Indian architectural tradition.

Bala Hisar, built by Sutan Alauddin in 1355 CE, is a remarkable structure. It is a massive 85 feet high rectangular structure with semi-circular turrets. It is a rather enigmatic structure at first glance as there is only one entrance over a high flight of steps leading up to the uppermost platform which has now the barest remains of any structure. It was not a palace or a mosque but, apparently, the last resort when surrounded by invaders. Three huge cannos lie on the top which quite well explains the purpose of this structure which for its high unrelieved walls appears a unique defence work.

The Gulbarga fort has witnessed ruination of its structures. There are no palace ruins which may surprise a visitor today. Where did the Bahmani sultans live if not in the fort? However, a market street leading to the western gate of the fort can still be identified. It has rows of arched rooms under pyramidal vaults, almost comparable to the famous *bazaar* street for diamond merchants at Vijaynagar. Local population has appropriated these rooms. Such market streets within the fort can also be seen at many other forts.

Outside the fort stands the Shah Bazar Mosque built by Muhammad I (1358-75 CE.) It is a grand mosque built in a conventional style with no particular architectural distinction. However, its square structure, an arched opening at the centre of each side, a parapet of merlons with corner fluted finials and a flattish dome became the prototype of mosque structure in the subsequent period. This mosque has no cloisters and the hall is divided into bays by severe piers.

The sultans of Gulbarga were not prolific builders because they remained preoccupied with the defence of their kingdom against a possible backlash from the Tughlaqs of Delhi. The influence of the Tughlaq architectural style on the Gulbarga buildings, however, is all too clear not only on the fortification but also on the tombs of the rulers. These tombs are mostly square domed chambers with a battered exterior, low flattish domes and corner finials. The arch is angular and the whole structure is stark and unrelieved by any mark of decoration. These tombs are sturdy and rugged structures. The only experiment made in the form of tomb architecture at Gulbarga appears at the tomb of Sultan Dawud (d. 1378 CEO). Here two domed chambers are joined together by an inner narrow corridor. This double tomb is the first of its kind in the country. The tomb of Tajuddin Firoz (d. 1422 CE) shows a more advanced approach in terms of scale. It is also a double domed structure with a parapet of trefoil merlons and fluted corner finials. The exterior walls are now perpendicular and not battered as in the Tughlaq architecture. The interior also has some decorative panels, roundrels and medalions.

The *dargah* of the sufi saint Hazrat Gesu Daraz, who had migrated from Delhi to Gulbarga in his old age and settled in a monastery close to the Jama Masjid in the fort, is a renowed centre of Muslim pilgrimage in the Deccan. The growing influence of the saint came into conflict with the power of Sultan Firoz who wanted the saint to bless his dissolute son. This denied, the sultan had the saint moved out of the fort to a place on the outskirts of the city. After the death of Sultan Firoz in 1422 CE, his

Bahmani period and has the rare distinction of being the only fully covered mosque in the country. There is no central open courtyard and the tank for ritualistic ablution is also not provided for. The mosque was designed by Rafi, a persian architect from Kazvin. The whole structure covers a rectangular area of 66m by 52m. The three sides on the east, north and south are pierced by three tall pointed arched openings for entrance into wide corridors. The whole interior has been designed on an unusual plan with rows of aisles forming 68 bays, each roofed by a cupola. The bays differ in size and the plain domes are supported on faceted pendentives and starkly plain piers. The majestic spherical central dome rises over a substantial square cleresory letting in light and air. The roof is dominated by the dome over the mihrab and four corner and seventy five smaller domes in an unusual architectural creation. The most distinctive feature of the Jama Masjid is the range of unusually wide archways raised over low imposts. Percy Brown admires the powerful "originality" of the entire composition.

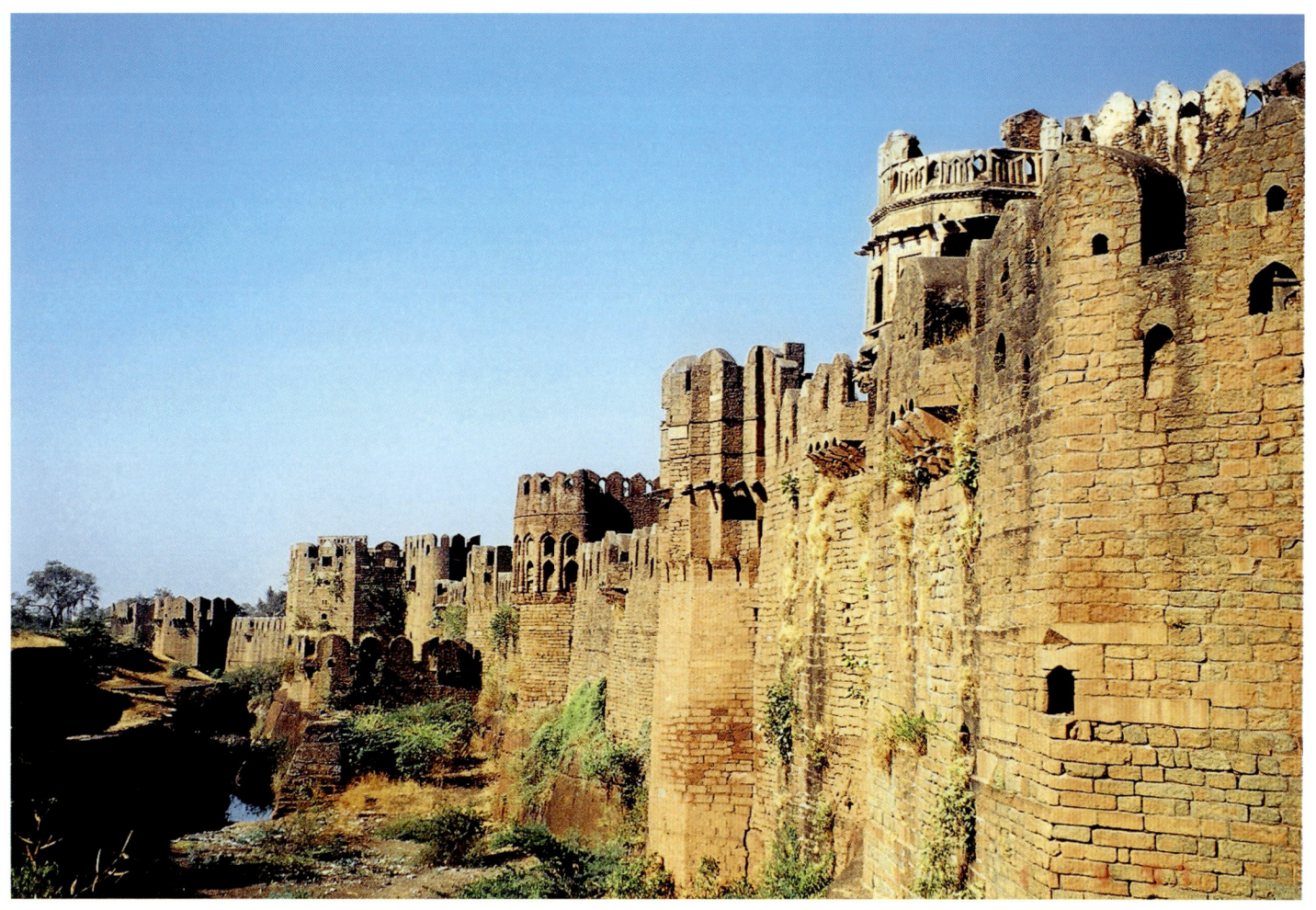

brother Shihabuddin Ahmad I ascended the throne but Gulbarga lost its status as the capital of the Bahmani kingdom in favour of Bidar. Gulbarga was soon consigned to history as the deserted capital. The *dargah* of the saint is a large complex of tombs, mosques and *madarsas* (schools), large courtyards and gateways. Hazrat Gesu Daraz held an eminent place in the religious history of south India and the smaller tombs built around the *dargah* testify the great respect and influence commanded by him. It is one of the holiest Islamic centres in the country visited by thousands of people, including non-Muslims, seeking the saint's blessings.

The tomb of Hazrat Gesu Daraz is a grand but unadorned domed cubical structure. The facade is double storeyed with nine sunken arches above and flanking the central arched entrance. The mausoleum is annually whitewashed which renders its unadorned exterior look more stark and severe. The only decoration appears on the elaborate parapet, corner finials and a frieze of indented squares at the top for the walls in the typically Gulbarga style. The interior shows some lavish painted ornamentation on the ceiling under the dome. The mirror-work and mother-of-pearl decoration on the canopy over the grave is a work of later centuries. The most impressive structure in the vicinity of the *dargah* is an immense arch springing from two high towers pierced with arched window opening. The arch is ornamented with enlarged stucco roundrels containing heraldic animals and fish-like brackets-work of the Adil Shahi artisans. The other important structures include the *dargah* of Shah Mujarrad and the *dargah* of Sheikh Sirajuddin Junaidi. The latter was the preceptor of the early sultans of Gulbarga.

Chor Gumbad, the tomb built for Hazrat Gesu Daraz, was never occupied by the saint who regarded the structure a little too magnificent for a saint. It stands deserted since 1420 CE. It has now been sealed by the government and saved for the posterity as a grand relic of the Bahmani kingdom in Gulbarga.

Bidar today is a small town, nearly 140 km from Hyderabad. During the 15th and 16th centuries CE Bidar was the capital of the Barid Shahi sultans after 1425 CE following the fragmentation of the Bahmani Kingdom into five segments- Bidar, Bijapur, Berar, Ahmadnagar and Golconda. It was annexed by Bijapur in 1619 CE and brought under the Mughal rule by Aurangzeb in 1656 CE. In 1724 CE, Bidar fell under the Asaf Jahis of Hyderabad. It has remained a forgotten city which has dwindled into oblivion. The architectural wealth of this Bahmani capital has now been discovered and placed Bidar as a must-see city among the great places in the Deccan.

The fort of Bidar, made of trapstone and the soft, porous local laterite with a limonitic surface, stands within a walled enclosure which contains a sizeable section of the local population. The fort is protected by five gates with impressive bastions. The cannos mounted on the battlemented bastions, work of Muhammad Shah Bahmani and Ali Barid, still stand though silent. The Sharaza Darwaza is the prominent gateway leading into the fort precincts. The upper sections over the entrance have rooms for the drummers which makes the function of this gateway clear-it was the Naqqar Khana where the drummers announced the entry and departure of the rulers. The figures of tigers on both sides of the gate signify the Shia beliefs in Ali as the protector. Under Ali's watchful eyes the fort would remain safe and secure. The wooden leaves of the doorway are studded with elephant spikes for additional security at the entrance.

The Gumbad Darwaza is the crucial grand gateway of the Bidar fort. It shows the influence of both the Tughlaq and Persian architectural traditions. It was built by Ahmad Shah Wali in 1420 CE. The triple moat between the Sharaza Darwaza and the Gumbad Darwaza still exists in evidence of the strong defence of the fort. Within the precincts of the fort, the first structure of some importance is the Rangin Mahal, a small set of rooms occupied by Muhammad Shah in 1487 CE as a refuge from the Abyssinians. The ruler stayed here till the arrival of the loyalists for his

rescue. Later Ali Barid made great improvements in the decoration of the interior which has elaborate woodwork and ornamentation with mother-of-pearl inlay work and elegant tile work. The museum is housed in the small buildings of the royal baths. The Rangin Mahal is an extremely elegant structure of the Barid Shahi rulers.

Further up, the Solah Khamba mosque, built in 1327 CE, stands in an excellent state of preservation. The rectangular prayer hall is divided into nineteen by five bays. The columns are circular and massive. The *mihrab* is framed by a multi-lobed arch. The mosque is an austere structure without any ornamentation reminiscent of the unrelieved interior of the Jama Masjid at Gulbarga. The mosque stands facing the Lal Bagh where only a solitary fountain basin has survived to give a faint idea of the grandeur of the Diwan-i-Aam. All around the vast expanse encircled by battlemented walls of the fort are piles of ruins. Ornamental lily pools in the courtyard of a ruined palace look sad at the fate of men and women who once inhabited these beautiful pleasure pavilions. The palace ruins have a charming ambience still lingering despite what has happened to them over the centuries of neglect and decay. It is a haunting picture of the glory that has vanished for ever. Close to the fort, stands the Jama Masjid. Takht-i-Kirmani is another elegant structure behind which lies the modest dwelling of the saint. Then comes the Chaubara, a 71 feet high tower at the junction of four roads.

The *madarsa* built by Mahmud Gawan, a minister of Mahmud III, is perhaps the most outstanding building in Bidar. In both concept and execution of the minutest detail, the *madarsa* built in 1472 CE, remains a structure of elegant proportions. According to Percy Brown, the *madarsa* is "a piece of Persia in India". In fact, Mahmud Gawan, spolisticated Persian merchant, emerged as the de-facto ruler of Bidar. He maintained a delicate balance between the Afaqis and Dakhnis by giving high offices to both sections but ultimately failed to please the latter who held a permanent grudge against the influential Persian. They forged a treasonable letter supposedly written by Mahmud Gawan to the ruler of Orissa. Muhammad III gave his Persian minister a summary trial. Gawan was beheaded for treason. When the Bidar King discovered the plot behind the whole affair, he tore his hair in sheer remorse. Muhammad III is a forgttoen ruler but Mahmud Gawan still lives in the heart and memory of men. The *madarsa* is a magnificent work of architecture with accommodation for lecture halls, liberary and residence for teachers. The library contained some 3000 volumes of valuable manuscripts.

Built around a spectacular courtyard, the *madarsa*, is triple storeyed with four arcaded portals surmounted by fully bulbous domes. The eastern façade has two tall domed minarets. Only one minaret has survived to this day. The whole exterior of the *madarsa* is covered with glazed tiles in glowing hues-green, yellow, blue and white. The loveliness of colour has a unique splendour unexcelled by any other structure in the tradition of Islamic architecture in India.

The tombs of the Bahmani rulers at Ashtur Village, the Bidar necropolis show a general acceptance of the bulbous Tartar dome over a cubical structure. The exterior is articulated with superimposed rows of recessed arches, merlons on the parapet with miniature corner finials and some decoration in Persian tiles on panels. The tombs of Shihabuddin Ahmad I (d. 1436 CE) and Alauddin II (d. 1458 CE) are very impressive. Tomb of Sultan Mahmud was struck with lightning and the huge dome torn asunder. One can still see specimens of 'sponge' bricks used here. The tomb of the Shia saint Khalil Ullah (d. 1460 CE) is a square domed chamber encased within a double-storeyed octagon. He was the preceptor of the Bidar ruler Alauddin.

The later Bahmani rulers chose to be buried to the west of the Bidar city. These tombs used four- centred arches and openings with the central arch being the widest, elaboration of the parapet and foliate bands around bulbous domes. In fact, compared to the tombs at Ashtur, these tombs show a remarkable improvement in architectural detail. The heaviness of structure and emphasis on strength has been replaced by an emphasis on verticality of structure, elegance and ornamentation. The tomb of Ali Barid Shah (d. 1580 CE) is the most impressive tomb at Bidar. The high stilted domb chamber is open on all the four sides. The western side, generally closed to include the *mihrab*, is also open. Traces of some exquisite tile work on bands and panels in the interior shows considerable refinement. The dome, 84 feeet high from the ground level, is supported on pendentives forming a net-like pattern and arabesques in stucco. The tomb, built in a sprawling garden, has the appearance and lightness of a delicate and structure looks more like a pleasure pavilion than a somber memorial to a deceased sultan.

It is said that Ali Barid wished that his grave be open from all sides to let in the sun, wind and rain. One of the inscriptions at the tomb rings in a philosophical note:

*"Friends and relatives will come to visit my remains,
And enquire about my destination and whereabouts,
If they shift the earth of the whole world,
By truth: They will not find any trace or sign of me".*

From far left:
Blue tilework at the tomb of Alauddin Ahmad II; Gate with elephant spikes

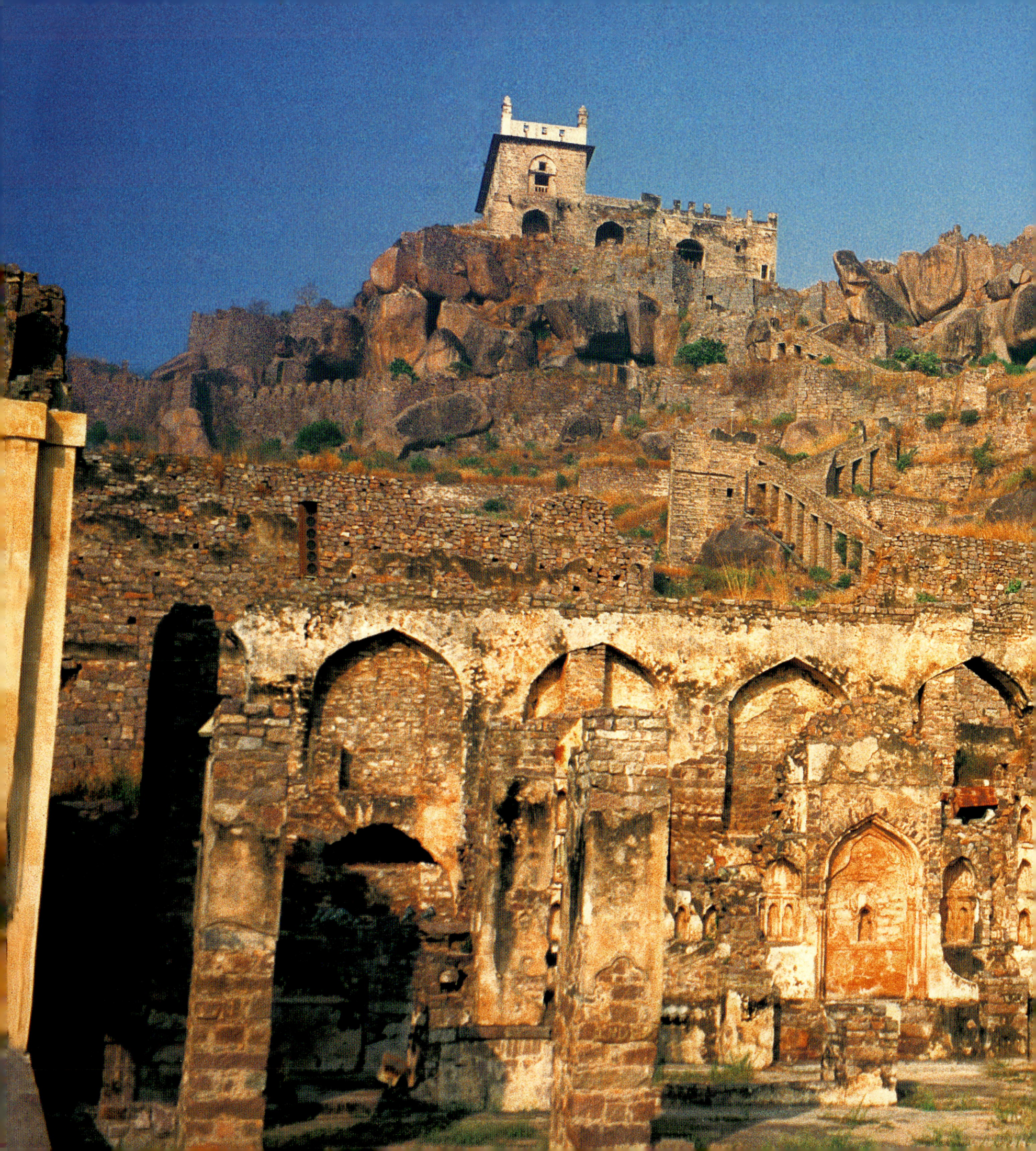

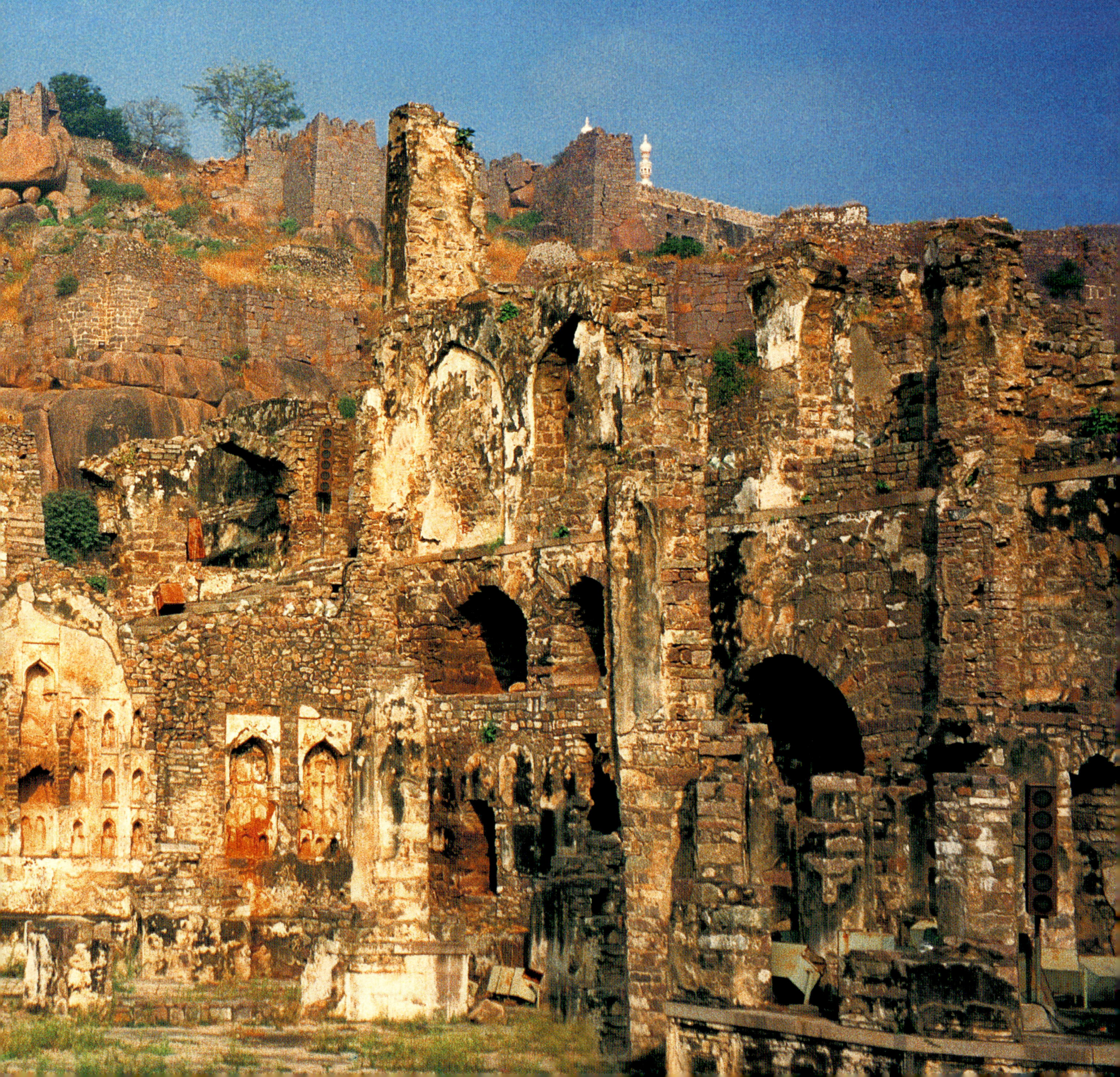
GOLCONDA

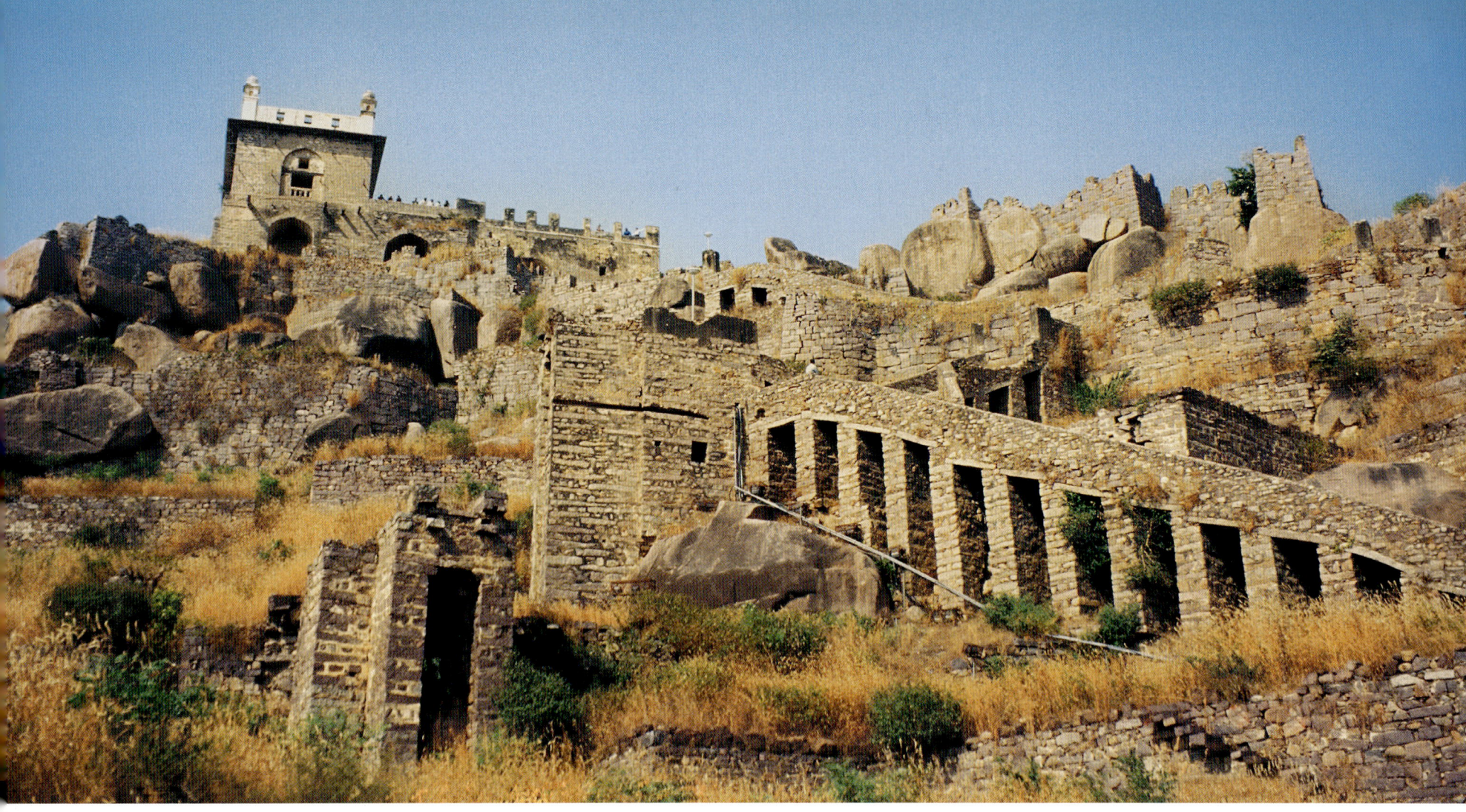

Previous pages:

Baradari at the crest of the Golconda Hill

Clockwise from top:

Golconda Fort; Painting showing Rao Anup Singh of Bikaner attacking the Golconda fort; Gateway to the inner citadel at Golconda

The Golconda fort, II km from Hyderabad, crowns a 128 m high granite hill littered with mammoth boulders. Once a deserted hill only frequented by cattle grazers, it rose into prominence when the 12th century Kakatiya rulers of Warangal built a mud fort on the crest of this hill. Mangalawaram or Mankal, as it was called, held a tremendous strategic importance. In 1364 CE the Kakatiyas surrendered the fort to the Bahamani Sultan Muhammad Shah of Gulbarga. The decline and ultimate disintegration of the Bahamani kingdom towards the end of the 14th century signalled the insurgence of its various partners who carved out small kingdoms of their own in the Deccan: the Adil Shahis in Bijapur, Imad Shahis in Berar, Barid Shahis in Bidar, Nizam Shahis in Ahmadnagar and the Qutb Shahis in Golconda. The original Bahamani Kingdom thus gave rise to five independent sultanates. The mud fort of the Kakatiyas was soon replaced by stone battlemented fortifications. Finally, in 1510 CE Quli Qutb Shah claimed complete independence and the small fort at Golconda emerged as the centre of a powerful kingdom. The Qutb Shahi rulers were destined to enjoy a period of prosperity running parallel with the glorious days of the Mughal dynasty. The Mughal emperor Aurangzeb destroyed the Golconda kingdom in 1668 CE. Golconda-the name of this fort is derived from Golear, meaning a shepherd or the hill frequented by the shepherds.

The Golconda fort is an example of military architecture, giving defence priority over architectural embellishment. The fort is an irregular rhombus with a rough pentagon (known as the Naya Qila or new fort) added to its north-eastern side. Though now in sheer ruins wrapped in an eerie grandeur, the fort contains palaces, mosques, baths and, gardens protected by impregnable walls. Three ranges of walls provide great defence to the citadel. The first wall is nearly 7 km long, 6 to 12 mt thick over a splayed base and rendered immensely strong by 87 semi-circular bastions. The second range is a convoluted double-wall beginning at the base of Bala Hissar Gate. The third wall links mammoth rocky outcrops dividing the different sectors within the fort.

"'The eight massive gates could have safely difed any artillery known to the seventeenth century", observes Sir Jadunath Sarkar," but Golconda really consists of four distinct forts joined to each other and include within the same lines of circumvallation. The lowest of these is the outermost enclosure into which we enter by the Fateh Darwaza (Victory Gate), so called after Aurangzeb's triumphant army marched into the fort through this gate near the south-esatern corner." The Fateh Darwaza has a barbican of semi-circular spur walls providing a passage through two well guarded gates with elephant-spiked doors. The upper portions of these entrances are decorated with some traditional Hindu motifs in testimony of the religious tolerance of the Qutb Shahi rulers who also gave high state officers to non-Muslims. Within the fort, mosques and temples stand together in peace.

The fantastic acoustical effects at the Fateh Darwaza are amongst the seventeenth century engineering marvels. A clap of hands at the portico is heard at the top most pavilion in the fort. This acted as the warning signal in case of danger. The mortuary baths are built close to the great portico. Here several large cisterns stand connected with earthern pipes providing hot and cold water for the ritualistic last bath of the deceased person. Perhaps, these chambers were used for the royal ladies. A small raised circular platform was where the coffin was prepared before being taken out through the Banjara Gate to the royal tomb area.

Many small structures appear along the ascent to the upper citadel. It is difficult to identify the function of these structures as they are so much a part of the huge boulders jutting out of the rugged hillsides. Here is the Barood Khana, for the storage of gun powder. The gigantic weighing scales are still there. Further up appears the small mosque of Taramati, minus domes and minarets. The mosque is built on a small terrace.

This elegant mosque was built for reasons of sentiment and not for any particular architectural excellence. The arched façade, pretty parapet and fine finish of the mosque are still impressive. Taramati was Abdulla Qutb Shah's paramour and buried amongst the royal tombs.

The stable for camels is reached before arriving at the Hall of Justice. The stone steps and the narrow pathways connect one huge boulder to another huge boulder, the gap filled up with bricks and mud. Almost everywhere is noticeable the network of clay pipes and also numerous small and large cisterns. The whole supply system at Golconda is a marvel of medieval civil engineering. A series of Persian wheels transport water from the lower sectors of the fort to the upper citadel. Hundreds of men were employed to keep this exercise functional.

The mosque built by Ibrahim Quli Qutb Shah stands near the top of the Golconda fort. Magnificent views of the ruins are obtained from the small court of this mosque. Close to this mosque is the small Rama Mandir built under the shadow of a gigantic boulder. It was built by Ram Das, a revenue officer of Abul Hasan Tana Shah. He was jalied for misusing state funds. He carved the images of Rama, Lakshman and Hanuman on the rock surface to pass his time.

Balahisar Baradari, the uppermost pavilion at the Golconda fort, is a wind-swept, twelve-arched, triple-storeyed structure used as the *darbar* hall. On the open terrace stands a stone throne from where the view of the Golconda environs appears most spectacular. The Baradari exhibits a synthesis of Hindu and Persian styles of architecture. Near the entrance to the Baradari is a filled-in hole which is believed to be the mouth of a tunnel leading to Gosha Mahal in Hyderabad, an escape route for use during emergency. The Baradari is also remarkable for another architectural feature- the natural air-conditionning system provided by a gap between the double walls which sucks the air and releases it with accumulated pressure in the chambers. It is quite a clever harnessing of a natural advantage.

The Baradari is also known for another reason. It is said that Abul Hasan's beloved Taramati lived some distance away in the valley below. She would come running on a tight rope fastened between her pavilion and the Baradari. She was an accomplished dancer and musician whose charm had enslaved the sultan. The tales of love between Abdulla Qutb Shah and Taramati are part of the folklore woven around Golconda. Close to the open terrace of the Baradari is an ancient small temple nestling under gigantic boulders, a relic of the past when the Kakatiyas held Golconda. A few constructions and decorations in garish colour appear extremely jarring-concessions to modernization and growing number of visitors.

From the Baradari, narrow pathways descend to the lower level containing the *zenana* quarters. These palaces, now in complete ruins, are built on massive platforms. Some of the surviving walls indicate the high level of ceiling. These walls are covered with a great number of decoratve niches and cronicles. During the heyday of the Qutb Shahi rule, these palaces contained a world of luxury. Persian carpets, splendid chandeliers, stuccoed ornamentation and armies of fawning dancing girls to attend on queens and princesses. The *mehfils* in the evening saw the interiors transformed into sheer splendour. Aurangzeb's forces reduced thses luxury palaces into shambles. Bare roofless walls stare at the visitor today.

From this gate had enterd the Mughal soldiers to capture the last Qutb Shahi Sultan in 1687 CE. Abul Hasan Tana Shah bade farewell to his harem ladies, took his bath and breakfast. He then prepared himself to receive the Mughal commander. The sultan greeted Aurangzeb's representative in full royal protocol and, offered him refreshment. Throughout Abul Hasan conducted himself with dignity and calm, admirable in these circumstances. This was the last glimpse of Sultan Abul Hasan as a ruler of Golconda. He was taken to a prison in Daulatabad where he expired in 1700 CE. He passed through the Fateh Darwaza studded with giant spikes to prevent drugged elephants batteing it with their heads. Indeed the eight month long siege had frustrated the Mughal soldiers who took recourse to the only alternative way left to gain entry into the fort-deceit and bribe. Abdullah Khan Pani, a Qutb Shahi general, was bribed to leave the gate open at night to let the army in. A great number of defenders were slaughtered but it was the traitor's day. Golconda fell to deceit. The harem ladies chose to end their lives rater than sufer indignity and humiliation. They drowned theselves in a well.

Near the portico at the Bala Hisar Darwaza stands a double storeyed

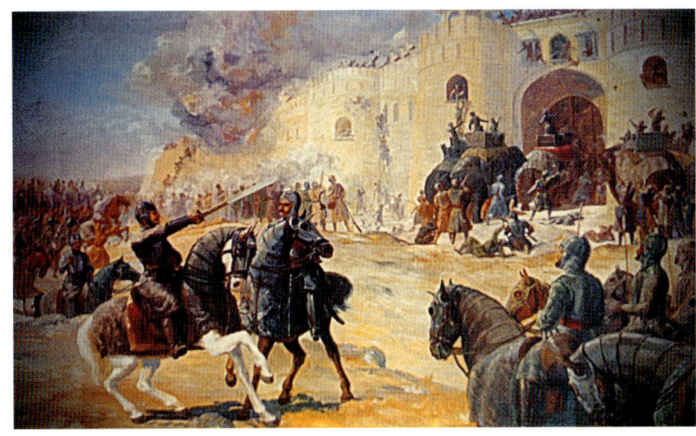
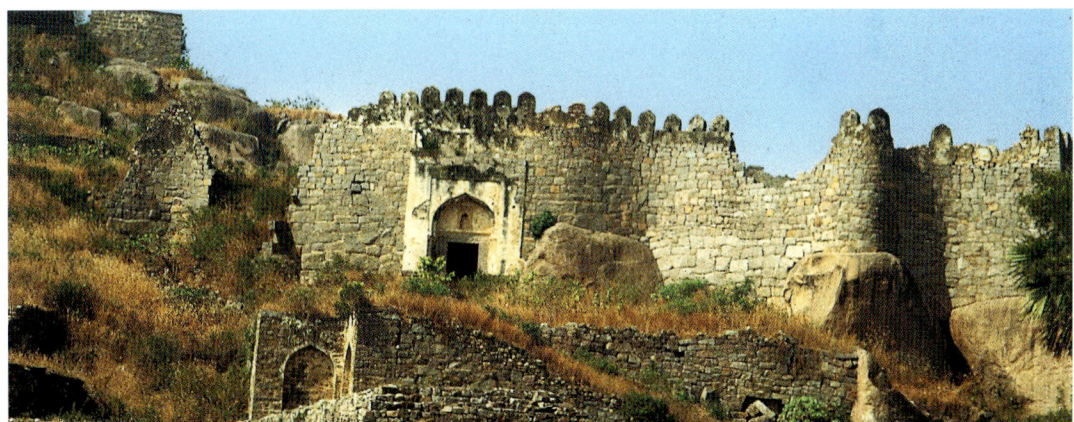

pavilion, office of Akanna and Madanna, Hindu ministers of Abdullah Qutb Shah. Ruins of a garden called Nagina Bagh can also be spotted here. Habshi Kaman-two grand arced quarters of the Abyssinian guards stand near this garden. Naubat Khana, where they beat the ceremonial drums, stood atop these arches. It is through the Banjara Gate of the fort that the visitor moves into the landscaped gardens housing the tombs of the Qutb Shahi rulers excepting the tomb of Abdullah Qutb Shah-the last ruler who is buried in Aurangabad.

The Ibrahim Bagh contains the twenty tombs of the Qutb Shahi family. The seven royal tombs are splendid structures. The most significant tombs belong to Quli Qutb-ul-mulk (died 1543 CE), Ibrahim (died 1580 CE), Muhammad Quli (died 1612 CE), Mahmud (died 1626 CE) and his queen Hayat Bakshi Begum (died 1667 CE). Sultan Quli's tomb stands at the centre of the enclosure. Mahmud's tomb is the most impressive, standing on double terrace with a façade noted for its pillar-and-lintel style and slim octagonal columns rising to 22 feet in height.

The Qutb Shahi tombs, by and large, follow a uniform architectural style. Thses tombs, according to George Michell, are "typically square buildings with arcaded lower storeys, supported on massive plinths which may also be arcaded. The lower storeys are surmounted by crenellated parapets with small bulbous minarets protruding at each corner. Rising above the middle of the structure is a tall drum, which may be arcaded and balustraded. This supports a single dome, slightly bulbous in contour, rising from a frieze of

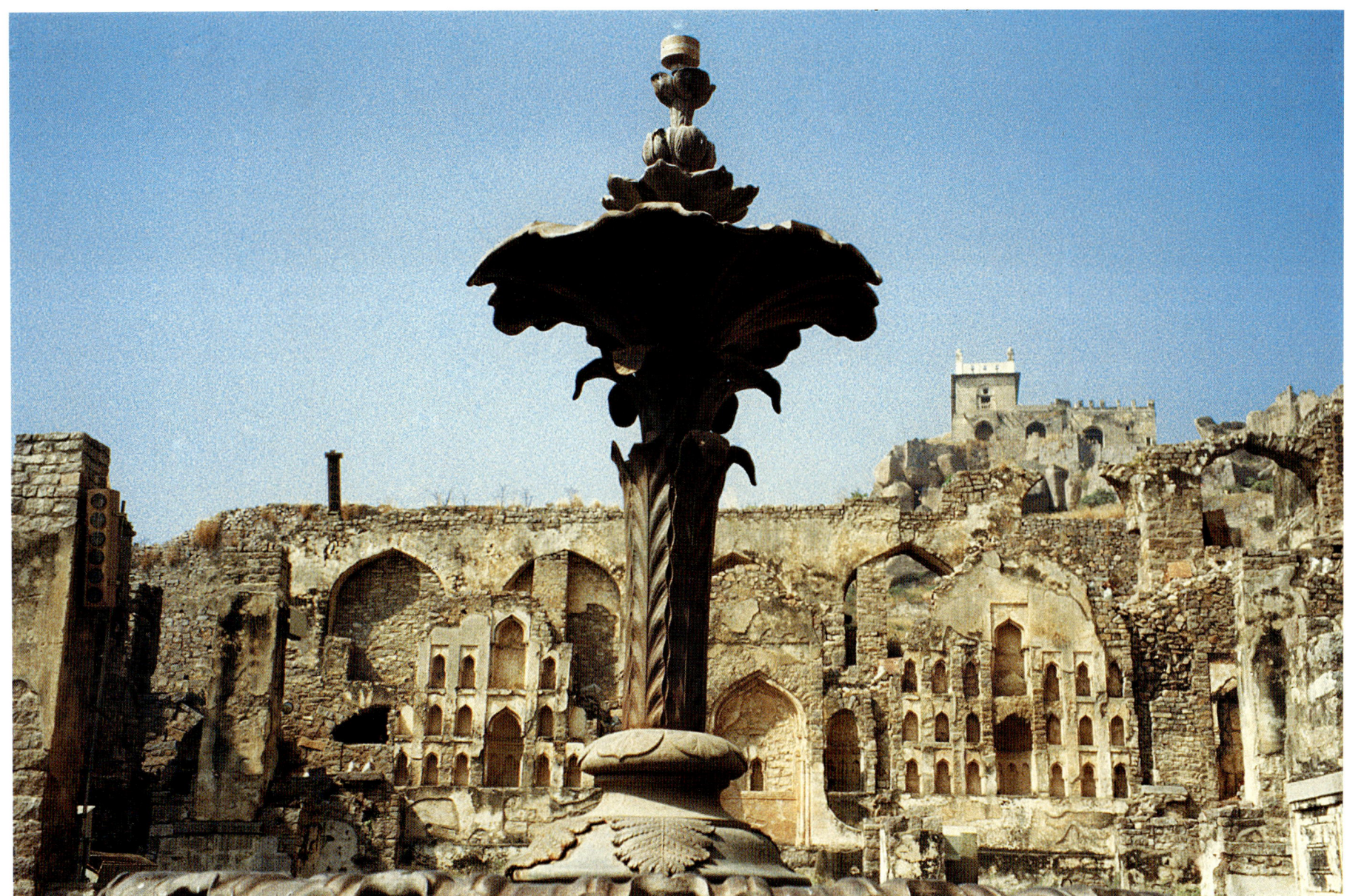

From left:
Palace ruins; Derelict fountain amidst the ruins

petals or trefoil merlon motifs". The construction in granite is covered wit stucco and, occasionally, with coloured tilework. The distinctive Qutb Shahi style includes miniature arcaded galleries encircling the corner minarets. The decoration of the exterior surface with relief carving or stone intarsia work, which characterizes the Mughal buildings is completely missing. Instead, the ornament in stucco at these tombs, in the opinion of Percy Brown, appears "of a meretricious kind, enfeebling the oulines of the building and confusing its surface". The red sandstone and white marble which is used profusely in Mughal architecture and accounts for much of its splendour is sadly missing at the Qutb Shahi architecture.

The tomb area has some small mosques, mortuary bath chambers and gardens. Originally each royal tomb had an adjoining small mosque. Most of these have disappeared. There are also some small graves which are canopied. Just outside the magnificent tomb of Hayat Baksh Begum, wife of Muhammad Qutb Shah VI, stands the small mosque built by Aurangzeb during the days when the Mughal army camped around Golconda. It is a small and austere structure. Premamati and Taramati, the Hindu courtesans at the Qutb Shahi court, are also buried in this garden enclosure. Ibrahim Qutb shah built the Katora Hauz, a gigantic bathing bowl. The tomb of Jamshed Quli Qutb Shah II is a small structure with a different architectural style. It is a double-storyed structure with vertical proportions and the storeys demarcated by a projecting open gallery supported on brackets. Jamshed is also remembered for his alleged hand in the murder of his sire Quli Qutb-ul-Mulk, founder of the dynasty. The 97 year old sultan had lived too long for his son's patience. Golconda has been known as an extensive and fabulous centre for diamonds attracting Turkish, Persian and Arabic traders. Sometimes the Golconda mines are believed to be the 'Valley of gems' in the Arabian Nights. Marco Polo's description of an inaccessible valley from where only eagles could retrieve huge diamonds for merchants could be Golconda in the fourteenth century.

Some of the world's legendary diamonds-the Kohinoor, Orloff, the Pitt and the Great Table belonged to Golconda. The Kohinoor, after a chequered history ultimately found a place amongst the British Crown Jewels now housed in the Tower of London. The Orloff was actually stolen by a French soldier from a temple, sold to the Russian prince Orloff who gifted it to his beloved Catherine the Great. The Nizam of Hyderabad used the 280 carat diamond, named after him, as a paper weight.

The Qutb Shahi rulers were great connoisseurs of music, poetry and dance. Muhammad Quli was himself an accomplished poet, author of a published anthology of his poetical creations Saheb-i-Diwan. A contemporary of Akbar, Muhammad was the progenitor of a cultural synthesis, a composte culture which had its roots in the Telegu people. Ibrahim Quli, his father, regarded Telegu his second mother tongue and called himself a 'Mulki Brahm'. Golconda and later on Hyderabad, attracted scholars and poets from distant lands to settle here mainly for the highly congenial cultural climate of the land.

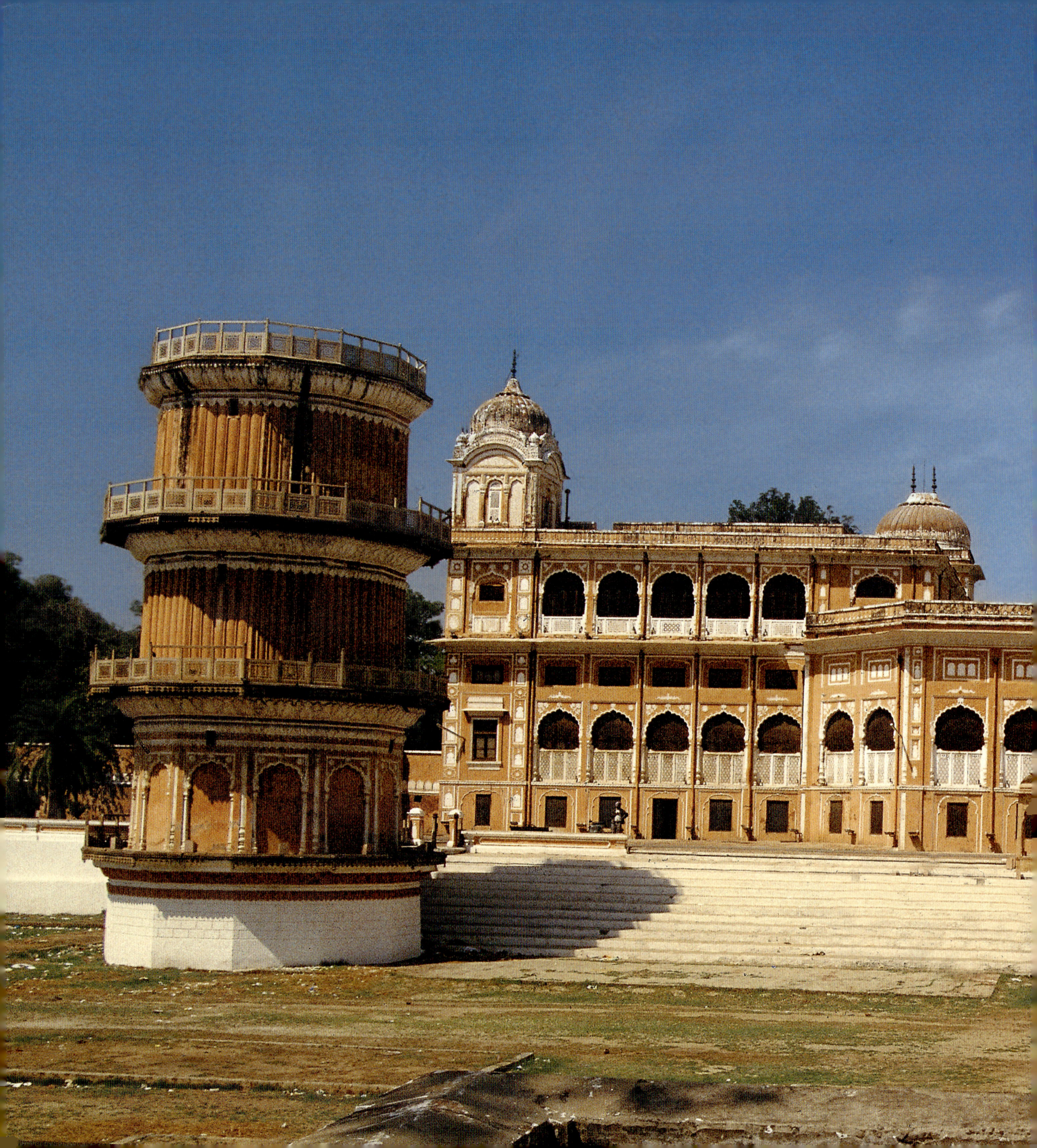

PATIALA

Patiala is not an ancient town. It was founded in the 18th century CE. It belongs to the Phulkian houses, Sikh families of Patiala Jind and Nabha. Phul, an agrarian leader founded a village in Nabha in mid 17th century CE. Sirhind, a township 35 km from Patiala, had been a very important entry point into the Punjab region since the Afghani invasions led by Mahamud Ghazni underlined its strategic importance in the 11th century CE. Later, the Mughals also let Patiala remain a mere sleeping village, inconsequential to their conquest over India. But Patiala rose to prominence when Ala Singh, grandson of Phul, subdued the Bhattis and other rival claimants to political power in the region. Ala built the fort in Patiala but his power was reduced to a naught by the Afghan forces led by Ahmed Shah Durrani at the battle at Barnala in 1762 CE. Still, the state of Patiala had made its mark on the political map of north-western India at a time when, under Muhammad Shah, the Mughal Empire was fast declining. Ranjit Singh consolidated Patiala state by entering into a political alliance with the British in 1809 CE. This ensured a comparatively peaceful era for this Sikh state which was to remain loyal to the British, even extending their support to the British in the Nepal War of 1815 CE and 1845-46 CE. Patiala watched with an unaffected unconcern the tumult of the Mutiny against the British in 1857 CE and, much later, during the two World Wars.

Patiala today, like other important cities in Punjab, is getting rapidly modernised. It is a clean city with a few buildings of royal grandeur standing amidst sprawling residential colonies, and a great number of well-maintained gardens.

The most impressive structure belongs to the Old Motibagh Palace which is generally believed to be one of the largest private residential palaces in the whole country. It certainly is a grand edifice with sprawling lawns, charming gardens and a tree-linked avenue leading to a spectacular fountain. The Old Motibagh Palace is, as Gorge Michell observes "an eclectic Victorian mixture of Rajput and Mughal styles". This palace built in the late 19th century CE finds use for some of the characteristic Rajput and Mughal architectural features but makes no stylistic statement of its own.

The Old Motibagh place contains fifteen dining rooms and a large central saloon. The furnishings in this huge palace show a marked preference for European fashions. The palace hosted many a foreign dignitary to keep intact its relations with the British. Today it houses the National Institute of Sports. The lawns in front of the palace are immaculately lined with flower beds. The fountain at the centre of four canals is still beautiful but some of its plaster figures show the effect of heat and rain.

Standing behind the old Motibagh palace is the Sheesh Mahal, originally meant for the royal ladies. Between the two palaces lies a garden which must have been grand at one time. The Sheesh Mahal is a triple storeyed structure with small corner pavilions with *bangaldar chajjas* and ribbed domes. In front of the palace lies a spectacular tank with steps leading to the edge of water. A rope suspension bridge built over the tank is in an excellent condition but rarely used. Sheesh Mahal was built by Maharaja Narendra Singh in 1847 CE and cost nearly five lakhs of rupees. This splendid palace today houses a museum displaying a fascinating collection of miniatures, sculptures, medals and decorative art objects. The palace derives its name from a large room decorated with coloured glass panels and exquisite wall paintings in enchanting colours. This section is in dire need of restoration by specialists in this task.

The collection of miniature paintings deserves special attention. Maharaja Narandra Singh had employed artists from Kangra and Rajasthan to work at Sheesh Mahal. The themes chosen for illustration on the wall panels are derived from the romantic vision of great Indian poets like Surdas, Keshav Das, Bihari etc. Mythological legends, musical modes (Ragas and Raginis), Nayak Nayika and the Baramasa (the twelve months of the year)

Previos pages:
Sheesh Mahal

Anticlockwise from below:
Portrait of Maharaja Bhupinder Singh; Entrance to Androoni Qila; Splendour of chandeliers at the Darbar Hall; Darbar Hall facade

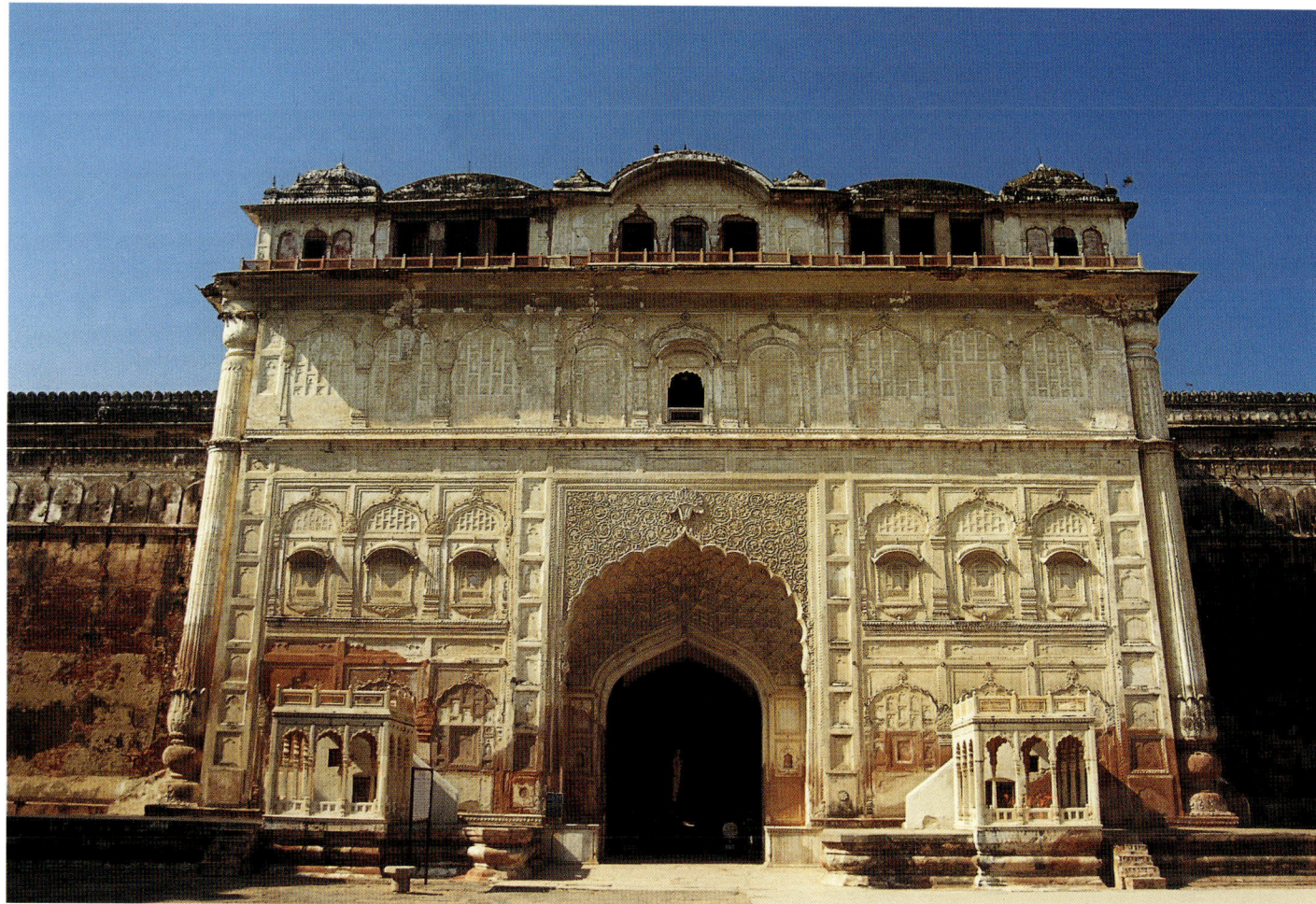

Clockwise from right:
Royal carriage at the Palace museum;
Small cannon; Sheesh Mahal exterior,
Interior of Sheesh Mahal

have been painted in exquisite colours. Such themes have been the source of inspiration behind the tremendous artistic heritage of Indian miniature paintings. The portfolio on the Gita Govinda has a rare lyrical charm. Krishna Lila paintings of the Kangra school are noteworthy for their delicate lines and splendid colours.

The Sheesh Mahal Art Museum also contains some exquisite specimens of Tibetan art in gold and silver metals. The sculptures of Yamantaka, Havajra, Sari-Putra, Buddha, Lamas and monks in different attitudes and an apron made of human bones are amongst the rare treasures of art. The ivory work displayed here includes chessmen, horse riders and a perforated ivory piece with carved deities inside.

The central large room has the most important gallery of portraits of the erstwhile Patiala rulers. Here also is a gigantic cut-glases chandelier fashioned at the centre in the form of a full blown lotus with upturned petals. It is supported on cut-glass columns of sheer splendour. The Sheesh Mahal Art Museum has on display a few rare manuscripts. The most notable exhibit is the Gulistan-Bostan by Sheikh Sadi of Shiraz, purchased for the Mughal emperor Shahjahan by his son Aurangzeb. It is illustrated with motifs of flora and fauna. The illustrated manuscript of Guru Nanak Dev's Janam Sakhi and some Jain manuscripts add to the greatness of the collection on display.

The Qila Mubarak or the old fort is the most important work of architecture in Patiala. It was the residence of the Patiala rulers upto the middle of the 19th century CE. The outer wall is made of bricks covered with stucco. Though the market of small shops under the shadow of the formidable fort walls on all sides of the exterior obliterates a full view of the entrance gateway, it is still a magnificent sight. The Quila Mubarak was built by Maharaja Amar Singh in the 18th century CE. It is a very formidable and impressive structure. The outer area is meant for official business. Within it is built the Qila Androoni or the inner citadel which has rounded bastions and corner towers surmounted with domed cupolas. The entrance is provided by a huge, line-plastered arched gateway. The exterior is articulated with rows of blind arches. The grand arch is flanked by arched pavilions standing independently on high plinths. The Qila Androoni is believed to contain palaces and apartments decorated with well preserved frescoes depicting Hindu and Sikh themes. But this area is completely closed to visitors and no outsider is allowed to enter the zealously guarded interiors.

The only building of the palace where visitors are allowed is the Darbar Hall. It stands on a high raised ground, reached through a stately flight of steps. From this high ground the visitor can look around and notice on the inside of the exterior walls splendid double-storeyed arcades. The columns are singularly without any ornament in imitation of the European style. The Darbar Hall is a splendid structure with a five-arched façade, the openings now covered with none-too-impressive wooden doors. It has a roof built with tin sheets covering a false ceiling which has been painted with star-shaped patterns. There are no pillars or any external support to the ceiling. This magnificent hall was originally meant for the assembly of nobles in the presence of the Maharaja. The Darbar Hall is now a state museum displaying arms and armours. The most important exhibit here is the sword of Nadir Shah decorated with hunting scenes. The sword of Shah Abbas of Persia has the owner's name and seal. Also on display are the personal arms of Guru Govind Singh.

The Darbar Hall has earned a great reputation as the grandest exhibition of gigantic chandeliers. Some of these cut-glass chandeliers have an extraordinary splendour and make one wonder at the strength of the ceiling which supports such massive creations. It is said that Maharaja

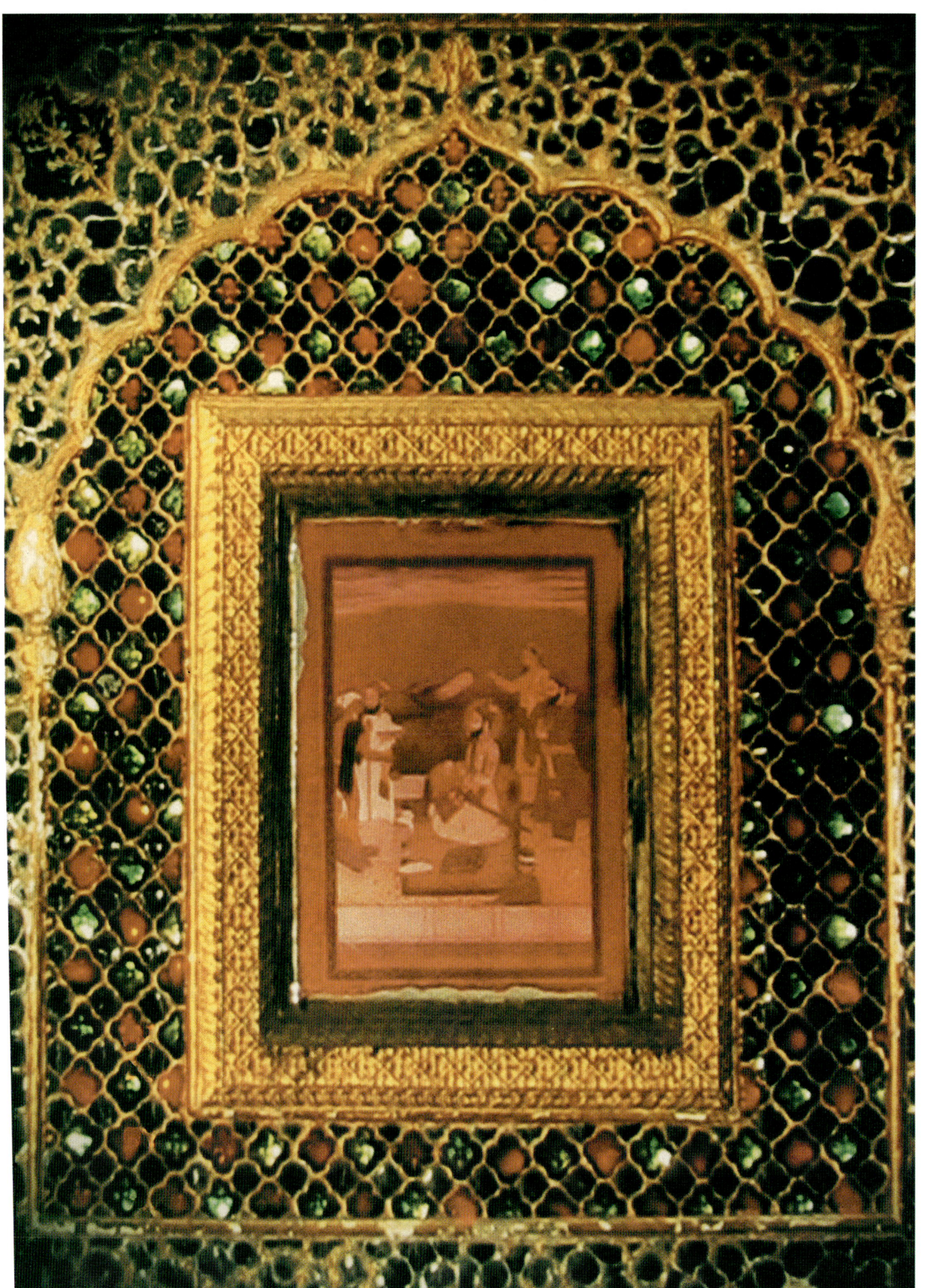

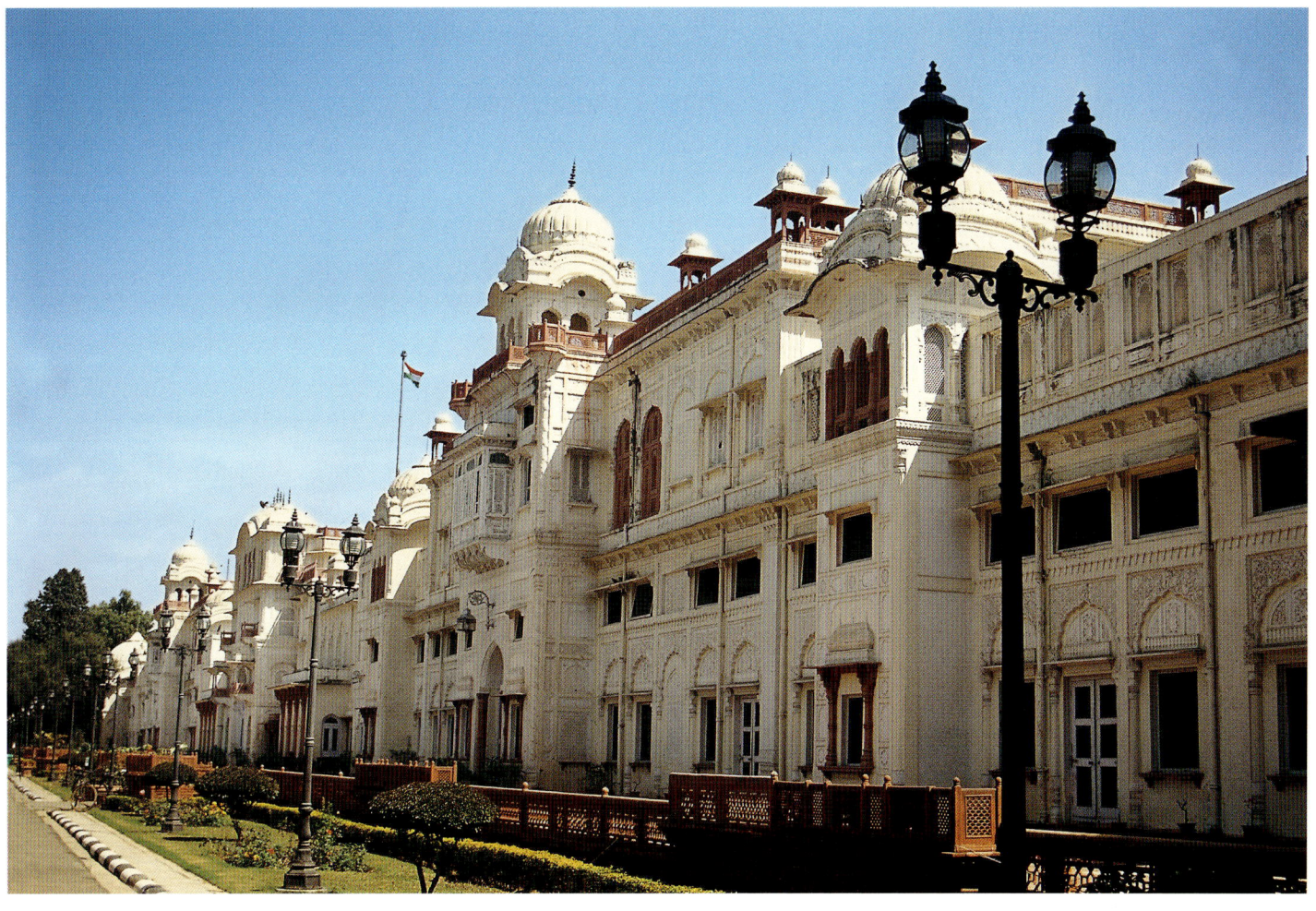

Mahendra Singh purchased these chandeliers in Calcutta. Once, when he enquired the price of a particular chandelier at a shop, he was rather curtly told that no ordinary person could afford to pay its price. Apparently the salesman had failed to recognize the Patiala Maharaja at his shop. Piqued at this rude response Maharaja Mahendra Singh offered to purchase all the chandeliers on display at the shop. The salesman was stunned into silence when he learnt about the identity of the royal visitor. The deal was done. The Maharaja made on-the-sport payment for all the chandeliers in cash and ordered the transportation of consignment to his state. The magnificent array of chandeliers at the Darbar Hall provides an insight into the nature of Patiala rulers who thought nothing of the price of objects of art which caught their fancy.

The Darbar Hall also exhibits the state carriage of the rulers. It is a splendid piece of exquisite woodwork complete with all the trappings of royal transport. On ceremonial occasions the carriage would be driven by magnificent horses with a retinue of liveried soldiers marching at the head of the procession.

However, the collection of huge paintings depicting King George and Queen Victoria, Princess Alexandra and Queen Mary should be ranked amongst the most impressive paintings of the British royalty. The Darbar Hall also displays portraits of some Patiala rulers including a study of Baba Ala Singh who founded Patiala and built the fort. Ahmad Shah Durrani led the Afghan forces against Patiala in 1762 CER and subdued its supremacy for a while whereafter Patiala regained strength enough to sack the Afghan governor at Sirhind and recaptured power and supremacy in the region. Treaty arrangements with the British in 1809 CE ensured power and peace to the Patiala rulers.

Visitors to the Qila Mubarak are not allowed entry into the royal palaces but a leisurely walk around the high walls of the citadel is amply rewarded by views of derelict structures which have outlived their utility and are now taken over by wild vegetation. One such a structure is the Jilau Khana. It is a rectangular assembly hall for the retinue of the Maharajas built close to the Darbar Hall. This structure is particularly notable for the use of high columns on the verandah enclosing the structure. These columns add a non-Indian look to the structure which was built at a time when the British registered their presence in Patiala.

The cannons displayed in the lawns between the Darbar Hall and the Jilau Khana are impressive reminders of troubled times. The famous Kare-Khan gun was used by Maharaja Ranjit Singh on his campaigns. The British captured this gun during the Sikh Wars and carried it to Calcutta from where it was returned to the Patiala rulers for their goodwill. Another great gun belongs to the Nawab of Jhajjar. It was given to Maharaja Narendra Singh.

From left:
Painting of a musical mode 'Ragini' framed by glass mosaics at the Sheesh Mahal; Moti Bagh Palace

KAPURTHALA

The state of Kapurthala was founded in 1777 CE by Jassa Singh Ahluwalia who started his own rule after defeating Ibrahim Bhatti. The one ruler of this dynasty who distinguished himself not so much for his diplomatic skill as for his colourful lifestyle was His Highness Farzand-i-Dilband, Rashikul-Itkad-i-Daulat-i-Inghlishia, Raja-i-Rajagan Maharaja Sir Jagatjit Singh of Kapurthala who remained at the helm of affairs from 1890 to 1947 CE and expired in 1949 CE. Jagatjit Singh's father Randhir Singh (ruled 1853-70 CE) remained loyal to the British during the Indian mutiny in 1857 CE for which service he was allowed to retain his small kingdom.

Jagatjit Singh was extremely fond of fine arts and beautiful women. He was educated in London and Paris and knew French and Spanish. In fact, he married a Spanish dancer and travelled across Europe, South America, Egypt and Morocco. He loved France, French wine and French architecture and made French the language of his court. For this obsession, he was awarded the Grand Cross of the Legion d'Honour by the French government. When Jagatjit Singh decided to build a new palace in Kapurthala it was towards France that he looked for inspiration.

The palace built by Jagatjit Singh is built after the Versailles Palace, albeit on a smaller scale. It is also called Elysee palace. The structure stands on a slightly raised ground amidst magnificent sprawling landscaped gardens studded with ornamental fountains and life-size animal sculptures placed on pedestals.

The Elysee Palace was planned in red sandstone but had to be finished in pink stucco. It was designed by a French architect M. Marcel and comprises a central bay, cribbed from Fountainebleau with a high pavilion roof and oeil-de-boeuf window, flanked by two symmetrical wings with blind arcades terminated by secondary pavilions. The palace was completed in 1902 CE at the staggering cost of 3.4 million rupees. The palace was

Previous pages:
The Elysee Palace, Kapurthala

Clockwise from far left:
Ceiling at the Banquet Hall; Marble statue of Jagatjit Singh, Maharaja of Patiala, Royal emblem of Patiala State; Sculpture of a wild stag in the palace garden

Clockwise from top:
Sculptures at the glorious fountain; The palace as seen from the rear garden; Marble sculpture atop one of the corner towers; Detail from fountain structure

acquired by the State Government in 1961 CE and the royal family moved to the Villa Buena Vista (1894 CE), a retreat on the Karanji lake, 4 km from Kapurthala. It is built in an Italianate style.

The Elysee Palace these days houses a Sainik School which occupies the main sections of the building. The Maharaja's office or the administrative block is a grand hall with a wooden gallery in the upper section. The walnut and gilt panelling lends it a very sleak and elegant look. The main hall now houses the school library.

The palace today is without any royal charms but a few objects displayed here evoke a nostalgia for days when the Maharaja had eyes for things only French - a tiny marble puzzle replica of the St. Petersburg Winter Palace, a monster Swiss clock-cum-barometer, jewelled mechanical contrivances, Louis XIV furniture, Gobelin tapestries, Carrara marble chimney pieces and Aubusson carpets specially woven for the palace rooms at Kapurthala. The Elysee palace today stands as a little piece of France in Kapurthala but it was once the whole world for Jagatjit Singh who built it.

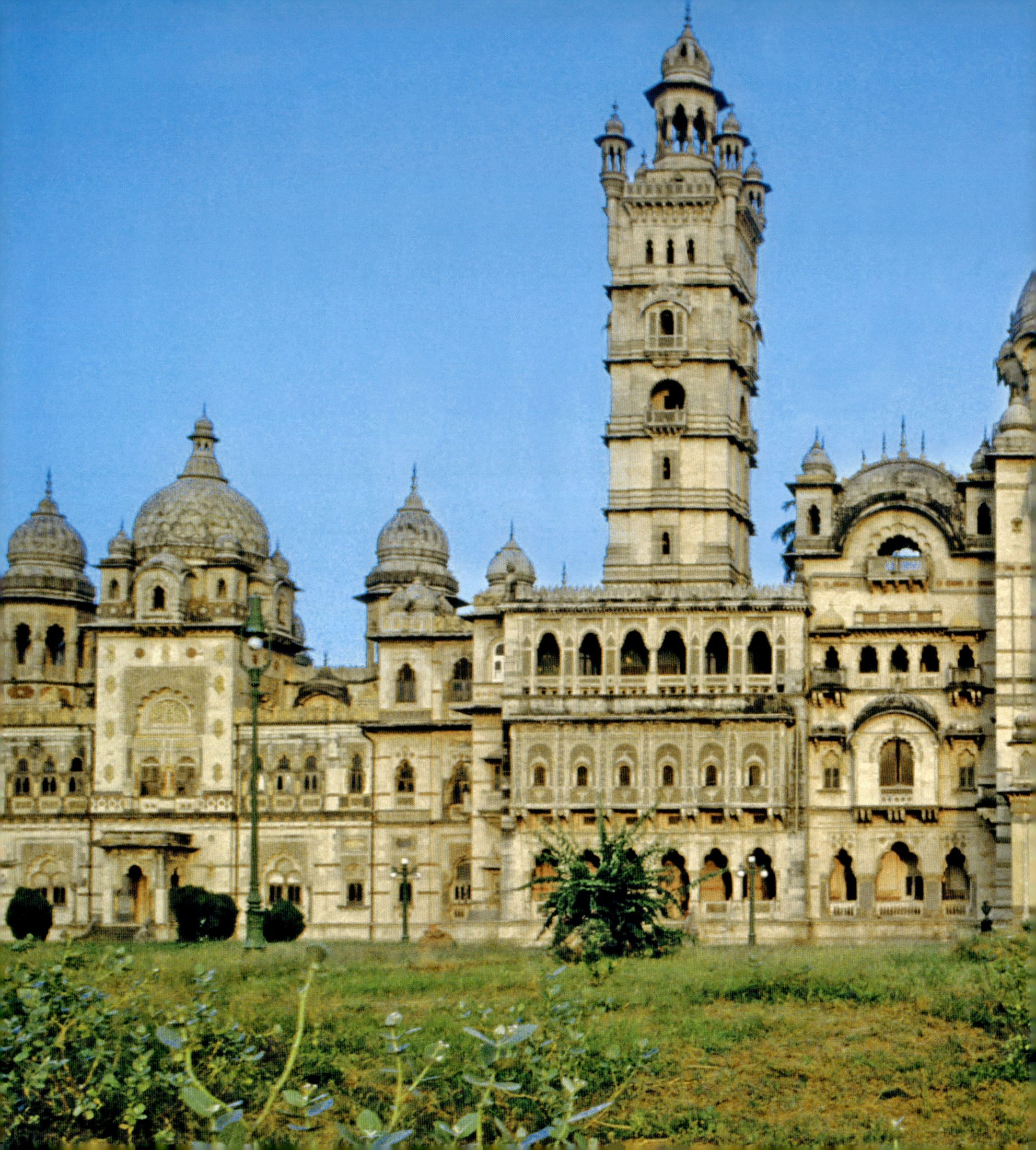

VADODARA, WANKANER and MORVI

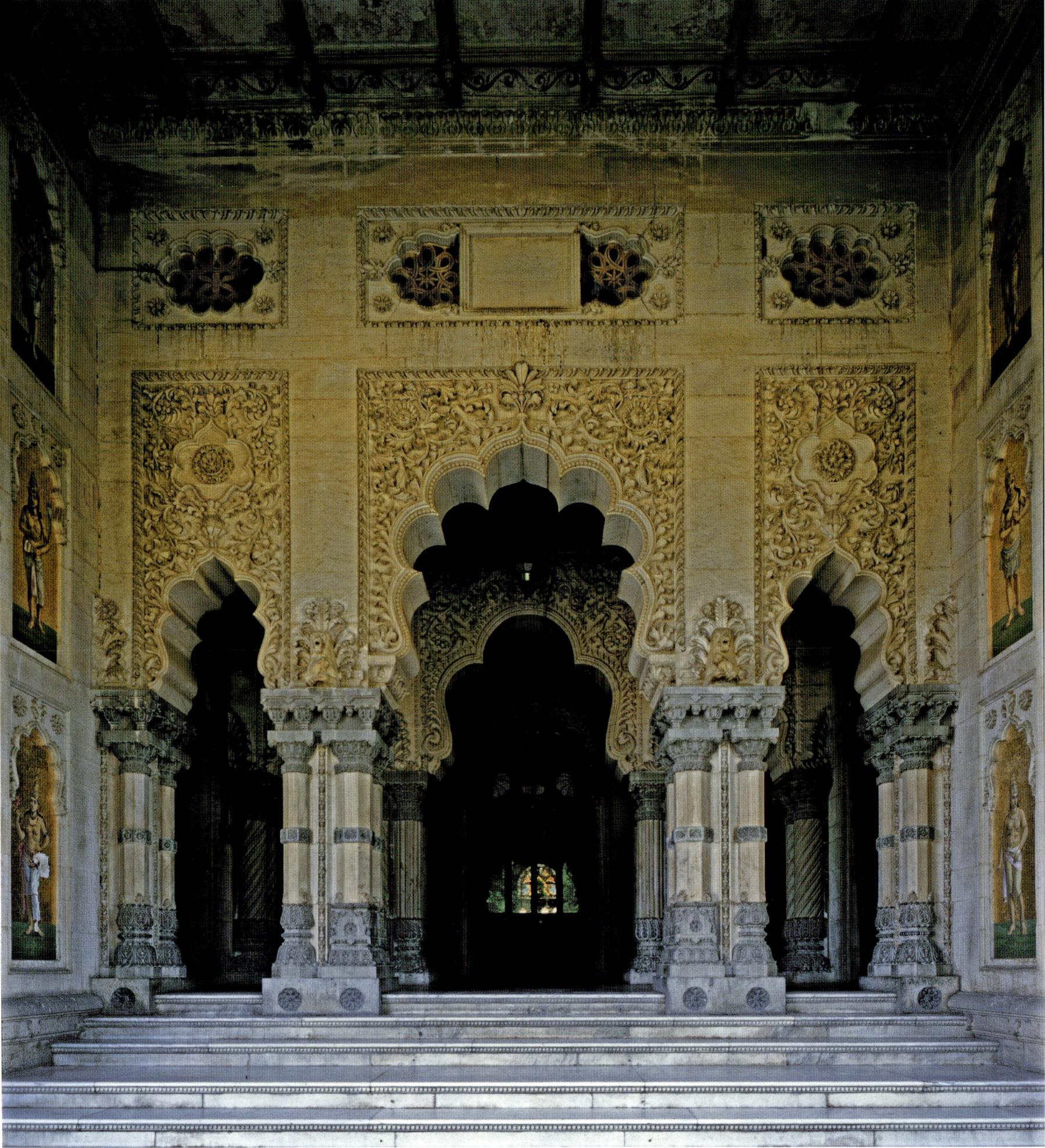

The Lakshmi Vilas Palace at Vadodara is one of the most impressive royal residences in Gujarat. It is still partly occupied by members of the royal household. Only a small section is open to visitors with special permission. Its huge exterior gives a fair idea of the world of opulence contained within, hidden from the common man's eyes but not beyond imagination.

This splendid palace was commissioned by Maharaja Sayaji Rao Gaekward III (ruled 1875-1939 CER) in 1878 CE and finished in 1890 CE. Initially the palace was designed by Major Mant who appeared obsessed with his own notions of architectural grandeur for the Gaekwad's palace and included all the characteristic elements from the diverse styles seen on the Indian soil. Consequently, the Lakshmi Vilas Place turned out to be a mere conglomeration of ornamental forms derived from the architectural vocabulary of traditional Indian architecture without achieving a harmonious blend of styles. Mant found complete failure staring at him and is believed to have lost his sanity. The uncompleted work at the Lakshimi Vilas Palace had to be completed by Robert Fellowes Chisholm. As it stands today, the Lakshmi Vilas Palace shows a valiant attempt at a fanciful architectural composition with cusped arches, double columns, *bangaldar* roofs, domes, Gothic and classical forms and Hindu martial architecture. Amidst these divergent forms rises a six storeyed square tower crowned with a small domed open-pillared pavilion. The elevation is articulated with red sandstone in the Mughal tradition. Also noteworthy is the ornamentation with blue trapstone from Pune and marble from Rajasthan. The Lakshmi Vilas Place in Vadodara is a fabulous creation illustrating architectural eclecticism at its peak, a riot of columns, cupolas, arches and a tower.

One of the earliest descriptions of the Lakshmi Vilas Palace is provided by Edward Weeden, one of the earliest European who was quite excited at the splendour of the palace: "In the centre are the Maharaja's apartments. They are approached by a portico of noble dimensions, under which the tallest elephant with the largest *howdah* on his back can pass with plenty of room to spare. Three broad steps, on which the sentries in gorgeous uniforms are posted, lead into a lofty hall of white marble, opening at the top into a gallery of carved cedar. The hall is paved with a vary rare green marble of great beauty which is found only in the Geekwar's territory, and in the middle is the table of the same marble, at which His Highness can transact any business…" The section of the palace described by Weeden is the entrance porch at the administrative area.

Visitors today are not allowed entry into the interiors and the residential sections are closed to the public. The Lakshmi Vilas Palace comprises three sections-public and administrative section, the Maharaja's private apartments and a separate unit for the royal women in the southern wing which has been provided with a temple dedicated to Lakshmi, the goddess of wealth and prosperity.

The Maharajas were immensely inclined towards the favourite pastime of the royalty-tiger shoots. These royal hunting parties and the trophies of Shikar give an idea of the physical image. The visitor can see large stuffed tigers and other animal heads exhibited with pride in a hall. The upper terraces are approached through a stately marble staircase inlaid with mosaics leading into a gallery. Another gallery leads to the drawing room, library, reading room (study) etc. These rooms have been furnished for their specific purpose and function.

The British architect showed his awareness of the need for complete privacy and made discreet provisions for this in the lay out of different sections. Courts with palm trees and fountains add a charm of their own to sections under constant use. There are also modern provisions like a billiard room and a smoking room with wood paneling and leather furniture etc. The small Darbar Hall has crystal chandeliers of immense size and beauty, imported stained-glass windows depicting mythological figures such as Rama and Krishna, brackets with figures of musicians supporting the balcony. The lobby is especially impressive for its Italian marble floor with central marble vase adorned with bronze figures. Moorish arches form the surrounding arcade in the central lobby. There is also a small marble pool guarded by marble statuary. The floor of the pool is covered with blue Venetian tiles.

The rooms are stacked with treasures and objects of art-royal portraits, paintings and sculptures by European artists, enchanting collection of Japanese and Chinese porcelain, jewel-studded tables, crystal sofa sets, ivory-framed beds etc. In fact, these highly expensive works of art were

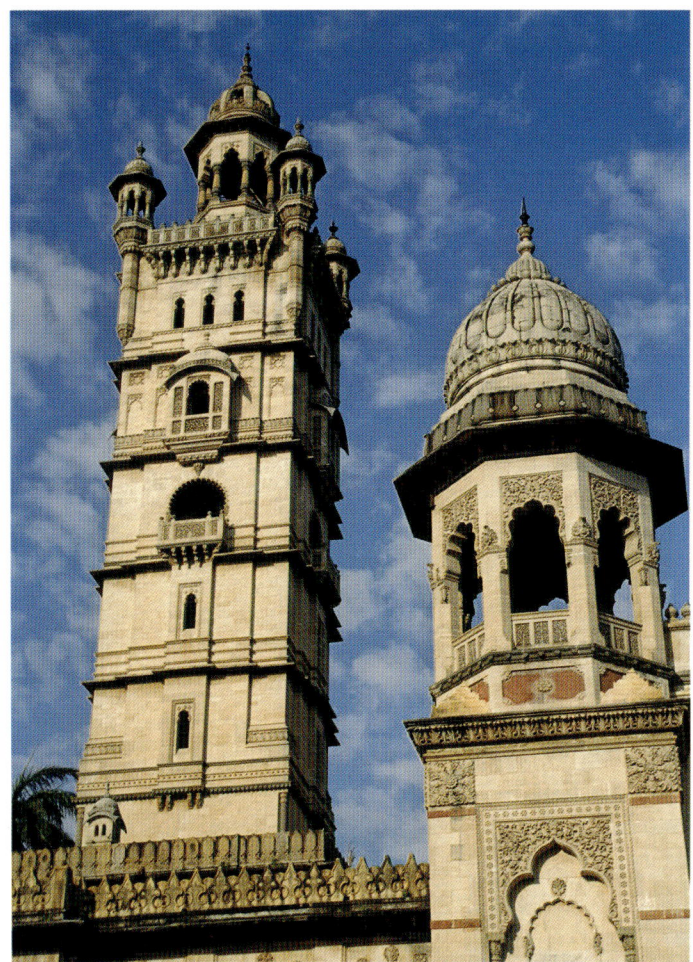

Previous pages:
Lakshmi Vilas Palace

Clockwise from far left:
Palace interior; The six-storeyed square-tower; Reception area in the Palace wth a viewing gallery

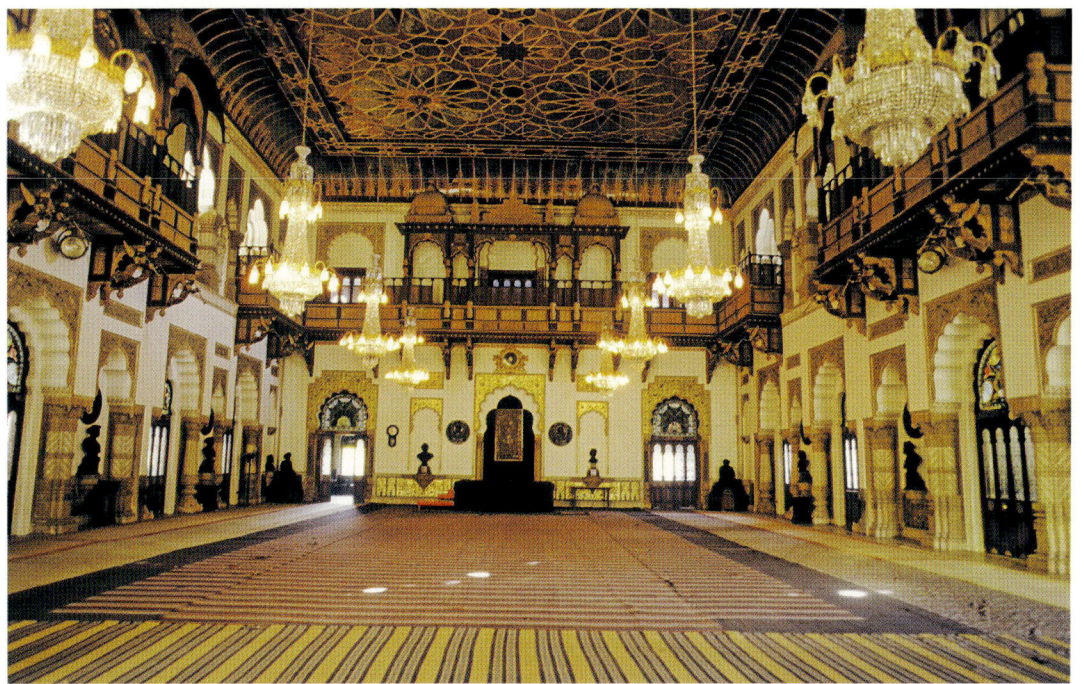

chosen to establish the maharaja's credentials as a lover and connoisseur of art. Price was no consideration when the object of desire caught of ruler's fancy. But apparently the choice of these objects reflects more the mind of the architect designer who endeavoured to create a world of luxury and splendour in the Europeanised style.

It is believed that Maharaja Sayaji Rao Gaekward III owned a diamond larger in size then the world famous Kohinoor and his collection of diamonds and jewels was tremendous. He was a seasoned cricket player. This love for cricket among the Gaekward rulers continues to this day. Sayaji Rao was also a patron of race courses in India and Europe besides being a connoisseur of fine arts. Besides the magnificent Lakshmi Vilas palaces, the great Maharaja also built Makarpura Palace (presently occupied by the Indian Air Force), Pratap Vilas Palace (New the Railway Staff College) and Dhariya Prasad Palace in Vadodara.

Most of the ambitious architectural projects of the Indian princes reflected their response to the growing influence of the British in India. Some of the early buildings in the 18th century like the Government House in Calcutta and others in Madras were built by architects for their British masters in a neo-classical style. But palaces built for the Indian princes show a different approach based on a 'compromise' with the Indian traditional styles of architecture-Rajput and Mughal. The appearance of typical Indian architectural elements on palaces built by British architects for the Indian princes created a medley of styles with the predictable failure to make a clear-cut statement of any particular style. An assortment of different architectural features become apparently an end in itself, "some following the western 19th century passion for a diversity of styles; and some reflecting a growing taste for more fanciful and decorative designs that fused European models and indigenous traditions", as George Michell observes.

The apparent imperfection in the ultimate form of these new palace buildings is chiefly because of poor execution and a certain want of 'vision'. The architect had to make several compromises by having had to accommodate elements from the traditional Indian architecture into any plan, if they had one. Also, their understanding of the building techniques perfected by Indian artisans whose families had practiced these for centuries was inadequate, if not poor. The whole exercise led to the creation of what is, for no particular research, called 'Indo-Saracenic'. Michell explains: "Indo-Saracenic architecture juxtaposes Rajput balconies, curved cornices, open pavilions and bulbous domes with Gothic pointed arches, areades and towers. Though the results are a stylistic hybrid, they are consistently picturesque; more importantly, they are easily adaptable to different uses. Innumerable Indo-Saracenic law courts, clock towers, railway stations, art galleries and government colleges sprang up all over the subcontinent in the second half of the 19th century".

The Lakshmi Vilas Palace is the most successful example of the Indo-Saracenic style. It is an architectural extravaganza which compels the viewer to observe minutely each and every element demanding attention- the tower, balconies, domes, the *bangaldars* etc. This style was to be imitated, albeit on a much more modest scale, at Wankaner and Morvi, both in Gujarat.

WANKANER

Wankaner belongs to the Jhala Rajputs. It was once the capital of the Rajkot state which is best known as the birthplace of Mahatma Gandhi. It signed a treaty with the East India Company in 1807 CE and was assured protection and recognition.

The Ranjit Vilas Palace was built between 1907 and 1914 CE. Work at the palace was personally supervised by Maharaja Amar Singhji (ruled 1881-1948 CE). This palace is another example of Indo-Saracenic architecture illustrated best by the Lakshmi Vilas Palace at Vadodara, completed in 1890

CE. The flaws in the over-all design of this palace are the flaws inherent in the Indo-Saracenic style-a medley of the Victorian Gothic, Italianate and the indigenous styles. The architect's problem here is all too apparent: how to reconcile the divergent stylistic elements into a harmonious form. The Ranjit Vilas Palace is built in a warm brown stone. The whole elevation is dominated by a huge central tower crowned by an onion dome. The tiple-storeyed main structure has a flat-roofed open pavilion with five arches on the front. The foyer has pointed arches and is flanked by a set of another five arches, half closed by lattice screens upto the capital of the pillars. Open-pillared sections are placed at both the ends. The façade is thus formed entirely of arches closed with lattice screens. It is a more compact structure than many other examples of Europeanised palaces of the Indian princes. The interior shows an unrestricted use of the new elements – a double marble staircase, classical balustrades, and Grecian urns creating an ambience of opulence. The stuffed animal trophies of large hunting parties appear on the walls as symbols of the maharaja's shooting skills.

The Ranjit Vilas Palace has a rare exhibition of the maharaja's most prized vintage cars. Particularly noteworthy cars are the 1921 Silver Ghost, a Rolls Royce raised on jacks to protect its antique tyres. The number plate has white letters against a red background-Wankaner-I, Buick (Wankaner IO), a 1948 Ford Super De Luxe (GJY-3907), and a 1951 Ford Custom (GJY 8128). No other palace in Gujarat holds such an exhibition for the conneissures of vintage cars.

The huge ground lying in front of the palace provides uninterrupted views of the massive royal structure. The Ranjit Vilas Palace also functions as a heritage hotel and resort.

MORVI

Morvi was one of the numerous minor states in the peninsula of Kathiawad but it rose into prominence after signing a treaty with the British in 1807 CE. Thakur Sahib Waghaji, the ruler, remained in power between 1879 and 1922 CE. He got the small state of Morvi on the road to modernization by improving roads and ports, also introducing a railway and a tramway.

The Thakur Sehib Waghaji Palace (c. 1800 CE) is essentially an oriental palace with a curious mixture of architectural styles. Designed in a Venetian Gothic style, the palace is embellished with classical balustrades and a few oriental conceits. The traditional elements include cusped arches, and domes etc. The elevation follows the familiar patterns of European features introduced into the Rajput and Islamic styles. As seen at the Lakshmi Vilas Palace at Vadodara and the Ranjit Vilas Palace at Wankaner the Waghaji Palace also makes an ample allowance for incorporating the obligatory European features, thus creating a medley of divergent styles.

Morvi is better known for its New Palace built between 1931 and 1944 CE by Lakhadiraj (ruled 1922-47 CE). This palace is a modern functional building with no particular architectural splendour. The exterior is a plain double-storeyed construction covered with a pink coloured plaster. However, the New Palace is "an extraordinary exercise in late Art Deco". The simplicity of its exterior is compensated by paintings on the interior walls, the work of the Polish artist Julius Stefan Norblin who also worked at the Umaid Bhawan Palace in Jodhpur. Norblin's work creates an artistic ambience, a very modern dimension to the interior decoration. A circular painting recessed into the ceiling depicts Surya riding in his chariot drawn by four horses. The use of gold paint creates a splendour of its own, gleaming in dim lights. A mural depicting dancing girls on the wall behind the bar is a particularly lively composition with the dark skinned beauties, one playing the violin, adding a charm of their own against the nude female figures. The small swimming pool with grey marble on the floor and aquatic motifs etched on the glass panels help in creating an intimate interior. There is a marble fountain set in the semi-circular recess at one end of the pool. The new European ambience is emphasized by a billiard room at the south-east corner.

A green marble staircase leads to the upper section which is the ruler's private area with its own reception rooms, bars and bed chambers. A large painting by Norblin is set behind the Maharaja's bed which has a black marble podium and a built-in canopy. A massive marble bath tub set in an alcove extends from a carved shell, is a new feature. The banquet hall is equally well decorated with blue-carpets. The Art Deco style introduces immense sophistication and simple elegance into the interiors. Even the interior lighting is very elegant. The old world charm is not entirely forgotten: there are two large stuffed tigers proudly exhibited in glass cases. The New Palace is one of the few unique palaces in Gujarat where interior decoration in the Art Deco style renders need for splendid architecture a matter of secondary importance.

Clockwise from far left:
Glass panel at Wankaner; Ranjit Vilas Palace at Wankaner, The royal crest of Wankaner

COOCH BEHAR

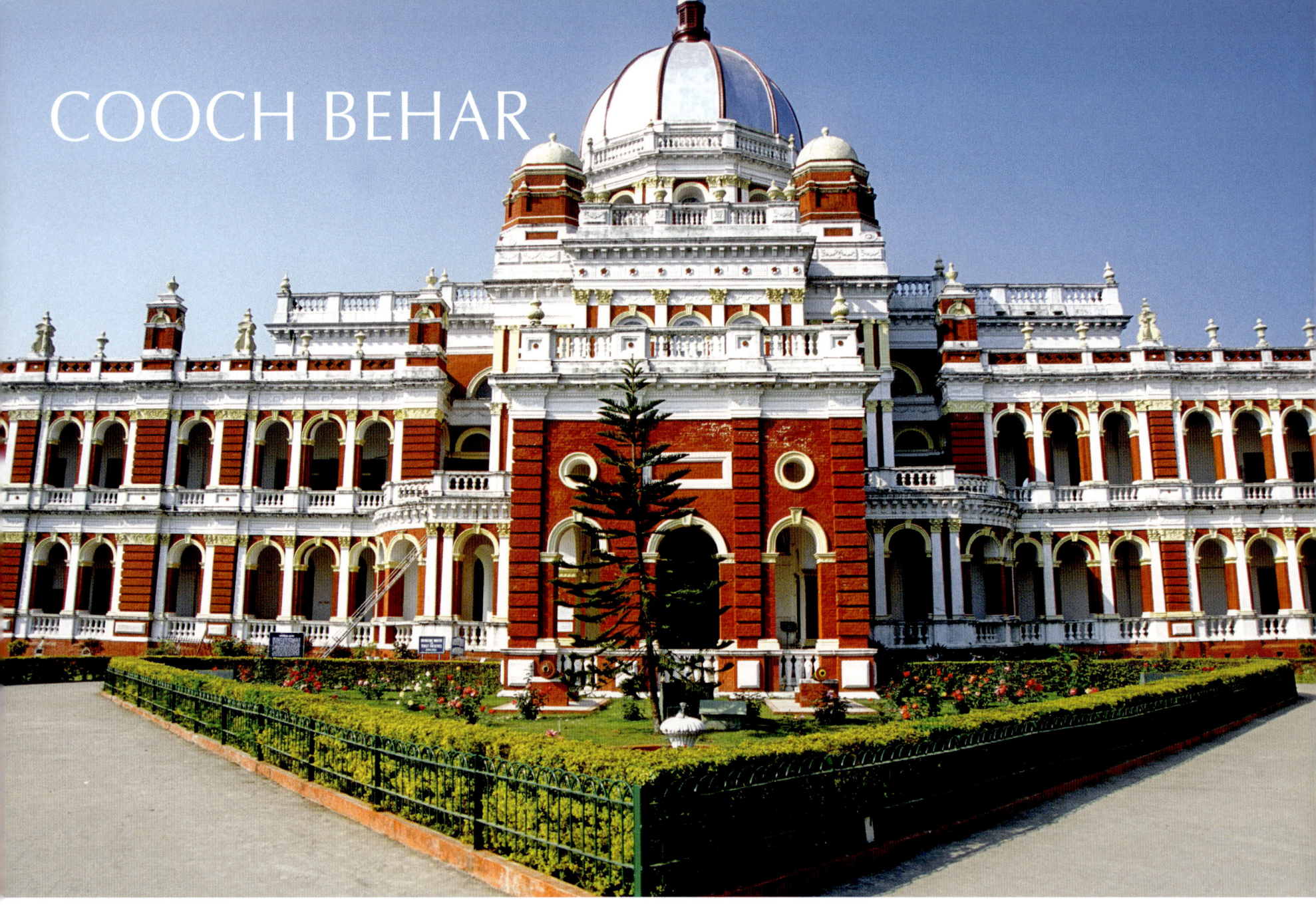

Rajbari, the Palace of Koch Kings

Cooch Behar is one of the lesser known destinations in West Bengal and certainly deserves much more publicity as a tourist spot. Cooch Behar is situated in the area between the last stretches of the eastern Himalayas and the plains north of West Bengal leading into the far North-East of India.

Cooch Behar is surrounded by a few international boundaries - Nepal, Sikkim, Bhutan and Bangladesh but it remains unfrequented by tourists from anywhere. The town lies close to the Brahmaputra and Teesta rivers which cause floods regularly.

In ancient times Cooch Behar (the present name is rather recent) was part of the territory of Kamrupa which finds a mention on the Allahabad Pillar inscription of Samudragupta in the 4th century CE. Kamrupa fell under the rulers of the Khen dynasty during the 15th century CE. Kamrupa, also referred to as Kamata Koch, was invaded by the armies of Alunddin Hussain Shah but the Muslim rule did not last long and Hussain's successors were defeated by Vishwasingha, a Koch chieftain who founded his own dynastic rule in 1510 CE. In 1661 CE, Cooch Behar was acquired by Mir Jumla on behalf of the Mughal emperor Aurangzeb and renamed Alamgirnagar. Maharaja Pran Narayana, however, won it back from the Mughals. In 1773 CE, Cooch Behar was attacked by the Bhutanese which led the rulers of this small kingdom to sign a treaty with the British East India Company which took great care to consolidate its own interests. Still, the British introduced a few social and educational reforms and decided to 'educate' the young prince Nripendra Narayana who was sent to Banaras (Varanasi) and Calcutta for his school and college education and lastly to Europe for acquiring a modern outlook which alone could put Cooch Behar on the road to progress. The Company even chose the life partner for the prince. It was Suniti Devi, daughter of the Brahmasamaji leader of Calcutta Babu Keshab Chandra Sen who was a known intellectual and reformist. This Company-sponsored marriage proved a tremendous success. Cooch Behar soon acquired schools, a court, a state record room, a printing office and a jail. Nripendra Narayana and Suniti Devi were to be known as architects of a new Cooch Behar.

Besides adding a number of public utility buildings to Cooch Behar, Suniti Devi also decided to build a new palace – the Rajbari Palace. It was designed by a western architect who was inspired by the known examples of European architecture, a factor illustrated by nearly all palatial buildings constructed for Indian rulers and princes by foreign architects during

the British period. The Rajbari has been apparently built in an Italian renaissance style with arcaded courtyards and a magnificent large central dome modelled after the dome of St. Peter's at Rome, The harmonious and splendid proportions of the palace make it one of the most beautiful buildings in this part of the country. It incorporates some functional elements like the arcaded courtyard derived from the indigenous architectural traditions. It is in the style of decoration of the Rajbari where the European influence makes itself most clearly manifest with the Raphaelesque decorations on the ceiling and walls, the Chippendale-style mirrors and the elaborate French furnishings etc. The Rajbari contains nearly 50 rooms for various purposes including a billiard room, dance hall and library.

The Rajbari Palace is built on a plinth raised to 1.5 mtrs in height. The whole structure is double storeyed covering an area of 4768 sq. mtrs (51309 feet), extending 120 mtrs north to south and 90 mtrs east to west. The façade comprises a series of arches resting on an alternating arrangement of narrow and broad piers to contain single and double Corinthian pilasters respectively. At the centre of the façade stands the porch formed by four arches. The most remarkable aspect of the Rajbari Palace is its construction in red bricks. The arches are outlined by white plaster, rescuing the exterior from unrelieved monotony of the red-brick-exterior. Perhaps the non-availability of stone for construction in the region accounts for the use of bricks on such a massive structure. In marble or red sandstone, the Rajbari Palace would have acquired great splendour.

The porch leads into the Darbar Hall lying under the splendid dome which is grand and impressive. The lower portion of the dome has twelve windows at the base chiefly for the purpose of admitting light into the interior. The royal insignia of Cooch Behar appears as a design in pietra dura on the floor below the dome. The art collections of the Cooch Behar rulers which were once proudly displayed here have all disappeared but the walls in the corridors still exhibit trophies of shikar parties - stuffed animal heads. The tusks of the ruler's favourite elephant are planted at the foot of the staircase. Some rooms, occupied by the royal family, are believed to be lined with yellow brocade. Carpets from Iran cover the floor in many a state room. The Rajbari Palace remains a very charming place which has seen quite a few romantic dramas played out in the gardens and intimate interiors. It was here that the supremely beautiful Gayatri Devi, daughter of Maharaja Jitendra Narayana, fell in love with Man Singh II of Jaipur and tied the nuptial knot bringing the two royal houses together.

During the British period the small kingdom of Cooch Behar was recognized as a princely state ruled by the Koch rulers. But gradually Cooch Behar lost its political importance. This ancient kingdom finally merged with the Indian Union of States in August 1949 and now exists as district in the northern part of West Bengal.

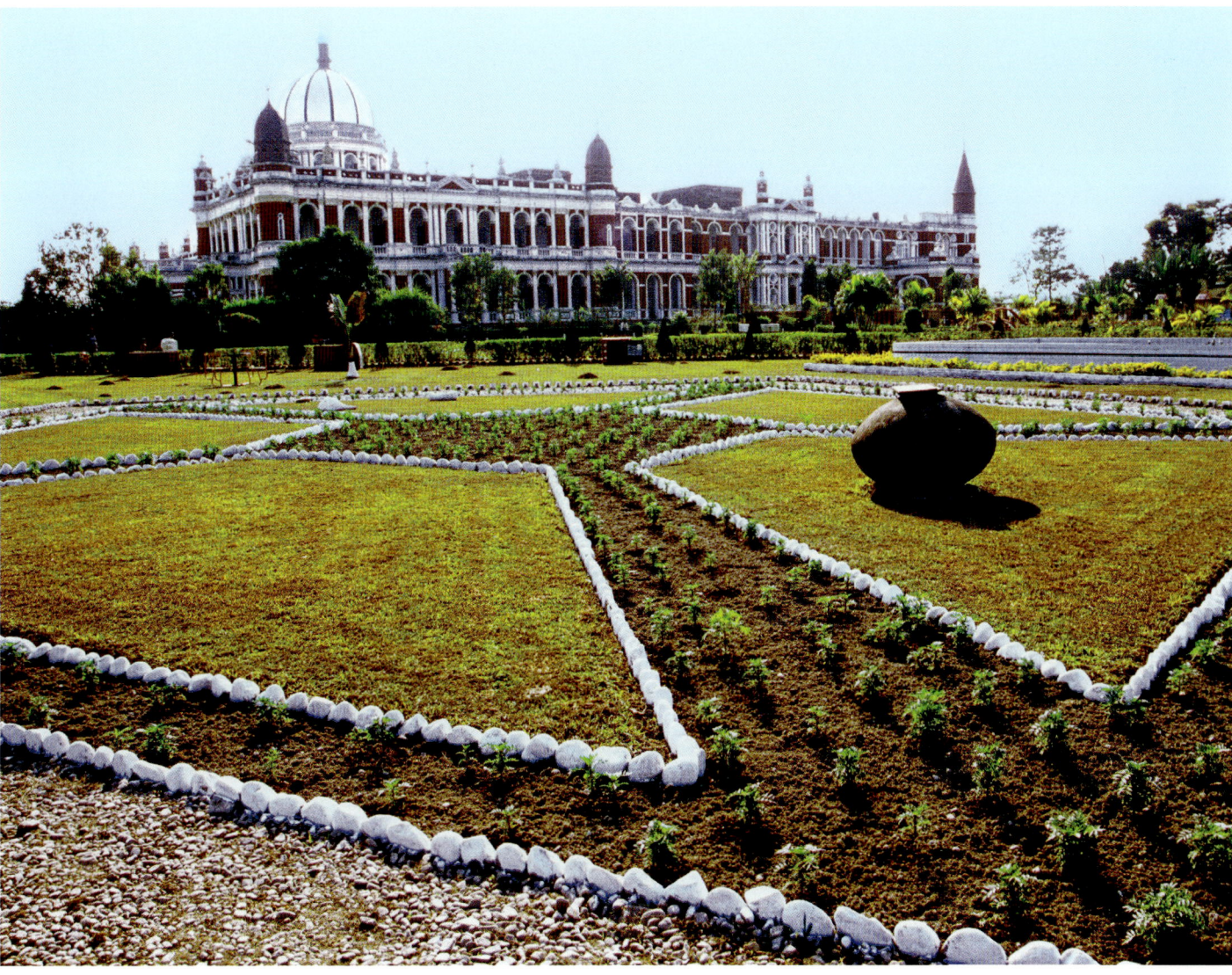

From far left:
Rajbari Palace Facade, and its extensive gardens

GLOSSARY OF TERMS

Abacus slab above the capital on a column
Aisle lateral divisions on both sides of the nave
Alcove a vaulted recesss in a wall
Arabesque typical Islamic ornament, intertwining of floral and geometrical forms
Arcade range of arches raised on piers or columns
Arcuate building style using arches in place of beams
Ashlar hewn blocks of masonry
Bagh garden
Baldachin canopy or covering over a throne or statue
Baluster cypress bodied column with a tapering shaft forming a bulb at the root
Barrel vault cylindrical form of roof or ceiling
Baoli underground stepwell
Baradari rectangular or square pavilion with 12 pillars
Bangaldar curved roof or vault with eaves curved on both axes as on the huts in West Bengal
Bas relief low-projection carving
Batter slope on the wall
Bay a compartment between pillars
Beam projecting support, below a lintel or eave
Burj tower
Buttress support built against a wall
Chadar sloping chutefor water channels and ornamental effect
Chajja overhanging eave, dripstone
Char-bagh four-fold garden; the Mughal form of char-bagh has the square plan divided into four quarters by paved pathways (khiyabans) and water courses, generally with a water pool at the centre
Chattri a small domed kiosk, open-pillared construction
Chinikhana wall with panels of small niches for placing vases and bottles; also a decorative motif
Corbel blocks of stones projecting from the wall
Crenellation battlements or loopholes
Cusp projecting points between small arcs of an archway
Dargah shrine complex of a Muslim saint
Daulat Khana-i-khas Hall of Private Audience, term introduced by Shahjahan, earlier called Ghusl Khana
Daulat Khana Khaso-Aam Hall of Public Audience a hypostyle construction.
Double Dome dome with an outer and an inner shell of masonry
Embrasure splayed opening in the wall or fortification.
Engrailed foliated, cusped
Flange projecting flat rim, collar, rib
Foliated carved with leaf ornament
Gumbad dome or domed tomb
Hammam bath; bath house with separate room for hot and cold water and changing rooms; Turkish bath
Hauz pool or tank
Hypostyle hall with ceiling supported on columns, not walls
Imambada tomb of Shi'ite holyman
Impost architectural member on which the arch immediately rests.
Intarsia mosaic of tinted or natural wood
Intrado inner curve of an arch
Jali perforated screen with ornamental design on wood or stone
Jama Masjid congregational or Friday mosque
Jharokha overganging oriel window, supported on brackets
Kopota eave-like cornice, roll cornice, overhanging cornice.
Khiyaban paved (raised) pathway
Khwabagh sleeping apartment
Kumbha bulbous water pot and derivative torus moulding
Lat column
Liwan hall for prayer, covered part of a mosque
Loggia an open-to-the-air gallery, verandah
Machicolation projecting parapet carried on brackets
Madarsa school for religious instruction
Mihrab arched niche in the Qibla wall of a mosque indicating the direction of Mecca
Naqqar Khana drum house or gallery
Nashiman pavilion, seat
Pietra dura inlaid mosaic of hard and expensive coloured stones
Pilaster quare pillar projecting from the wall
Qutb axis, pivot
Sheesh Mahal palace with glass mosaic decoration
Stylobate a platform on which stands a colonnade
Trabeate beam and lintel construction
Turret small tower, chiefly ornamental
Vussoir series of wedge-shaped stone forming an arch

SELECT BIBLIOGRAPHY

Asher, C.B.,	*The new Cambridge History of India: Architecture of Mughal India*, Cambridge, 1992.
Bakshi, N.,	*The Agra Fort, and its Buildings*, Annual Report of the ASI, 1903-4, Calcultta, 1906.
Begde, P.B.,	*Forts and Palaces in India* Delhi, 1987
Brown, Percy.,	*Indian Architecture: Islamic Period* Bombay, 1968
Darlymple, W.,	*The Last Mughal: The Fall of a Dynasty*, Delhi 1857, New Delhi 2006
Fasss, Virginia	*The Forts of India*, London, 1980
Hambly, G.,	*Cities of Mughal India*, London, 1968
Koch, Ebba.,	*Mughal Architecture: An Outline of its History and Development* (1526-1528), Munich, 1991
Mathur, L.P.,	*Forts and Strogholds of Rajasthan*, New Delhi
Michell, G.,	*The Royal Palaces of India*, London, 1994
Michell, G., and Martinelli, Antonio.	*Palaces of Rajasthan*, Mumbai 2004
Misra, Brig. B.D.,	*Forts and Fortresses of Gwalior and its Hinterland*, Delhi, 1993
Nath, R.,	*Agra and its Monumental Glory*, Bombay, 1977
	History of Mughal Architecture, Delhi, 1987
Nicholson, L.,	*The Red Fort*, Delhi London, 1987
Peck, Lucy.,	*Delhi: A Thousand Years of Building*, New Delhi, 2005
Ramachandra Murthy, Dr. S.N.,	*Forts of Andhra Pradesh*, Delhi 1996
Rani, A.,	*Tughlaq Architecture of Delhi*, Varanasi, 1991
Roy, A.K.,	*History of the Jaipur City*, New Delhi, 1978
Sahai, Dr. S.,	*Rajasthan: Colours of a Desert Land*, Delhi, 2002
	Indian Architecture: Islamic Period, New Delhi, 2004
Sanderson, G.,	*Shahjahan's Fort-Delhi*, Annual Report of the ASI (1911-12), Calcutta, 1915.
Sharma, Y.D.,	*Delhi and its Neighbourhood*, ASI, New Delhi, 1974
Singh, A.P.,	*Forts and Fortifications in India*, Delhi, 1987
Tadgell, C.,	*The History of Architecture in India*, London, 1990
Tillotson, GHR.,	*The Rajput Palaces*, London, 1987
	Stones in the Sand: Architecture of Rajasthan, Mumbai, 2001
	Mughal India, London, 1990
Toy, S.,	*Strongholds of India*, London, 1957
	The Fortified Cities of India, London, 1965
Ward, Philip.,	*Rajasthan, Agra Delhi*, New Delhi, 1992
Yazdani, G.,	*Bidar: its History and Monuments*, Oxford, 1947